W9-CEF-611

Redefining American History Painting reassesses an important genre within the history of American painting, from prehistoric times to the present. By broadening the parameters of history painting to include works by previously marginalized groups, this anthology collectively extends the genre's traditional time frame well beyond the eighteenth and nineteenth centuries to which it has been traditionally confined. The essays recapture the importance of history painting for contemporary readers, decode meanings of significant works in new ways, and demonstrate the ongoing and vital role of the genre as well. Situating the enterprise of history painting within a theoretical framework that analyzes how it actually works, *Redefining American History Painting* includes eighteen chapters that range from investigations of individual paintings to patronage and reception studies incorporating diverse methodological approaches.

Redefining American History Painting

Redefining American History Painting

EDITED BY

Patricia M. Burnham
University of Texas at Austin

Lucretia Hoover Giese
Rhode Island School of Design

CAMBRIDGE
UNIVERSITY PRESS

Published by the Press Syndicate of the University of Cambridge
The Pitt Building, Trumpington Street, Cambridge CB2 1RP
40 West 20th Street, New York, NY 10011-4211, USA
10 Stamford Road, Oakleigh, Melbourne 3166, Australia

© Cambridge University Press 1995

First published 1995

Printed in the United States of America

Library of Congress Cataloging-in-Publication Data has been applied for.

A catalog record for this book is available from the British Library

ISBN 0-521-46059-X Hardback

to *Dean* and *Paul*

Contents

List of Illustrations

Contributors

Ann Uhry Abrams, Independent Art Historian

Patricia M. Burnham, Lecturer in American Studies and Art History, The University of Texas, Austin

Lisa G. Corrin, Curator, The Contemporary, Baltimore, MD

Emily Fourmy Cutrer, Associate Professor, American Studies Program, Arizona State University West, Phoenix

Lucretia Hoover Giese, Assistant Professor of Art History, Rhode Island School of Design, Providence

Shifra M. Goldman, Art Historian, Research Associate, Latin American Center, University of California, Los Angeles

Wendy Greenhouse, Independent Art Historian

Patricia Hills, Professor, Art History Department, Boston University, MA

Joni L. Kinsey, Associate Professor, School of Art and Art History, The University of Iowa, Iowa City

Alexander Nemerov, Assistant Professor, Department of Art, Stanford University, Stanford, CA

Francis V. O'Connor, Independent Art Historian

Susan Noyes Platt, Associate Professor, Department of Art, The University of North Texas, Denton

Stephen Polcari, New York Director, Archives of American Art

Carrie Rebora, Associate Curator of American Paintings and Sculpture, and Manager of The Henry R. Luce Center for the Study of American Art, The Metropolitan Museum of Art, New York

Eric M. Rosenberg, Assistant Professor, Department of Art and Art History, Tufts University, Medford, MA

Diana Strazdes, Curator of American Art, Stanford University Museum of Art, Stanford, CA

Mark Thistlethwaite, Professor, Department of Art and Art History, Texas Christian University, Fort Worth

Bryan J. Wolf, Professor and Director of Graduate Studies, American Studies Program, Yale University, New Haven, CT

Preface

This book had its tentative beginnings in informal conversations between the co-editors concerning history painting – Burnham on Trumbull, Giese on Homer. These meetings took place under the auspices of the Association of Independent Art Historians that met in the greater Boston area in the late 1980s. We then organized a session for the College Art Association Conference held in 1990 in New York City entitled "History Painting in America: A Reassessment." In this setting we brought together five panelists and a respondent to discuss for the first time some of the issues bearing on this topic. Grateful as we were to the participants (four of whom appear in this book) and pleased by the intense interest expressed by the overflow crowd, we realized there was more we wanted to accomplish than was possible in such a format.

We decided the answer lay in a book such as this, authored by many scholars investigating many issues from a variety of perspectives. Only in this way can the diversity and range of history painting in North America begin to be probed. It seems to us that of the five principal genres of painting in America – portraiture, history painting, landscape, genre painting, and still life – history painting has not attracted adequate scholarly notice until quite recently. Indeed, since the advent of modernist criticism at the turn of the century, history painting has been consistently undervalued. We seek to rectify this situation and believe this book represents a significant step toward reevaluation.

We realize we do not include mention of every issue or track every development or enumerate every artist involved in history painting in America. That would be a practical impossibility. However, inclusivity, diversity, and originality were values that shaped our choice of topics and we wished especially to give previously marginalized groups a voice. We have also extended history painting beyond the conventionally held time frame, broadened the range of its thematic concerns, and, we trust, demonstrated a variety of methodologies that energize traditional history paintings and provocatively confront the nontraditional. Topics and writers were carefully selected on the basis of to what extent the essays would enhance the reader's understanding of how history painting works and, in sum, recapture the importance of history painting, decode its meaning in fresh ways, and demonstrate its continuation to the present. Although there are of course many excellent scholars laboring in the vineyard who are not represented in this volume, their absence should not

be taken as criticism by omission. Their achievements appear elsewhere and continue in that way the investigation of the subject we have reopened here.

A collection of essays like this one is able to pursue other frontiers because the basic work on the subject has already been done. We refer to the work by William H. Gerdts and Mark Thistlethwaite encompassed in *Grand Illusions: History Painting in America* published in 1988. This book set a high standard for the study of American history painting. We are also aware of other fine publications within the past ten to fifteen years that have touched on aspects of history painting and *Picturing History: American Painting 1770–1930,* edited by William Ayres and published in 1993, which had a concentrated focus. We trust our book will find a place in this distinguished company.

Acknowledgments

There are many individuals and institutions whose assistance and attention have helped make this publication possible. We wish first to acknowledge the six participants in the College Art Association session: Henry Adams, Wendy Greenhouse, Gail Husch, Eric Rosenberg, Diana Strazdes, and Mark Thistlethwaite (respondent). They substantially contributed to what was to become the germ of this book. We wish also to thank our present authors for their support of the project, their fine essays, and their patience throughout the long process.

We wish also to thank Beatrice Rehl, our editor at Cambridge University Press, for her receptivity to our project from its early stages and assistance through the long process to completion; our thanks extend to her assistant, Janet Polata, as well. A short-term Smithsonian Fellowship at the National Museum of American Art during the summer of 1990 helped Patricia Burnham in the early stages of the Introduction and her own essay. She is particularly grateful for the encouragement given by Lois Fink at that time. Lucretia Giese gratefully acknowledges the support of the Rhode Island School of Design over the course of the project.

Finally, we thank Dean Burnham and Paul Giese for their constant understanding and encouragement.

Introduction
History Painting: How It Works

Patricia M. Burnham and Lucretia Hoover Giese

Nations and societies have a fundamental need to tell stories about themselves in art: to recount their past, make sense of their present, and project their future. Their desire is to embody their concerns, achievements, and aspirations as a people in visible form. This is certainly true of Americans. From the dawn of history to the present, Native Americans and other Americans have produced art that purports to "tell" their history. The great moment of canonical history painting coincided with the period of the Revolutionary War and the formation of a national culture. If we limit the definition of history painting to that kind of art and to that period, however, we abbreviate the lifetime of history painting and cut ourselves off from a fuller understanding of how our society images its history in artistic form. It is our contention that history painting engages the twin discourses of history and art today as it has in the past and continues to make a vital contribution to our self-understanding.

History painting suffers from a deficiency in definition, which we address in the final paragraphs of this chapter. We seek a definition that attempts to explain the distinctive operation of history painting and can be modified to apply to the present as well as the past. In its most traditional form as codified by French academicians in the seventeenth century, history painting portrayed incidents of actual or fictive history involving significant identifiable personages; it tended to be large in scale, lofty in tone, noble in expression, and didactic in intention. Despite some modification, such as a tendency to depict events and individuals of lesser historical consequence and of more recent time, history painting retained an essentially conservative cast up to and throughout the nineteenth century. Postmodernist history painting, on the other hand, varies greatly in scale, often teaches by means of irony, and is frequently iconoclastic in its message. The figures may or may not be particularized, and an elevated manner is frequently absent. Yet both traditional and postmodernist historical art attach significant issues of historical import. Our task here is to look closely at how historicizing art works in order to formulate a definition that is more comprehensive, yet historically grounded.

Much of the confusion about history painting arises from its twin roots in the early Renaissance: that of *istoria,* meaning story (that is, narrative), and

history proper, which is a particular story of actual events.[1] Confounding the matter is Renaissance fealty to the notion of classical rhetoric, which emphasized the persuasive power of the speaker/speech and was then loosely adapted to the pictorial arts. The theoretical work that established the foundation for European history painting was Leon Battista Alberti's *On Painting,* published in Florence in 1436. Tantalizingly vague on central matters of content, Alberti nevertheless made clear his preference for an *istoria* derived from "tragic and comic poets" that would "move the soul of the beholder."[2] The seventeenth-century French formulator of academic theory, Roger de Piles, specified sacred and ancient history as the appropriate material for history painting. Sir Joshua Reynolds, the eighteenth-century English arbiter of the arts, echoed this sentiment in calling for subject matter derived from similar sources but adding, significantly, the structure of historical prose. The episodes "ought to be either some eminent instance of heroick action, or heroick suffering. There must be something either in the action, or in the object, in which men are universally concerned, and which powerfuly strikes upon the public sympathy," such as "the great events of Greek and Roman fable and history" and the "capital events of scripture history."[3] The theoretical base for history painting in America derives from such writings of Reynolds, who was not only a painter but first president of the Royal Academy in London.

The practical base for history painting in America comes from Benjamin West, the American-born painter active in London at the same time as Reynolds, who with Reynolds helped to found the Royal Academy. Thus it was West who was most responsible for enlarging the possibilities for history painting subjects beyond Alberti and Reynolds to include the recent past. A defining moment in Anglo-American history painting took place when Benjamin West was forced to justify his strategies in *The Death of General Wolfe* (1770), an event that took place in 1759. To counter the two main criticisms leveled against the painting – that he offended the conventions of decorum by depicting the participants in contemporary dress and at the same time violated historical truth by misrepresenting some of the other facts of the event – West mounted two separate defenses. In portraying contemporary costume he was pursuing "the same truth that guides the pen of the historian," but "[a] mere matter of fact" could never produce the effect of inflaming the mind.[4] West added historical objectivity to the notion of epic representation in the service of rhetorical persuasion. Such contradictory aims of course produced conflicting results. Nevertheless, West can be credited with launching "modern" history painting. Based on past theory and contemporary practice, it was to consist of a narrative of a single action, an attempt to reproduce or synthesize what happened, and a will to instruct the viewer about what happened. History painting since then has devolved around these principal issues: historicity, narrativity, and didactic intent. Before considering them individually, we examine the problematic relationship between artist and historian that was raised by West.

The "pen of the historian" indeed guided painters; West's uncritical accep-

tance of the historian's craft set a far-reaching precedent. His generation looked to the Enlightenment's rational approaches to history to explain the causal factors of life's events in a way that religion no longer could. Thus the course of history painting is yoked to that of the discipline of history and cannot really be understood apart from it. The historian's research often served as authoritative source for the artist. The interest in all this for art historians is twofold. First of all, the artist may depend on a text for information. Second, this text may set forth a point of view, an ideology, which the artist consciously or unconsciously adopts. Thus it is possible for a picture to take a historiographical position, usually but not always reflecting the dominant mode of historical interpretation of the time. Instances abound in American history painting in the eighteenth and nineteenth centuries. This system finally broke down, as we see, later when the profession of historian came under attack in the mid-twentieth century.

America's principal history painter of the eighteenth century, John Trumbull, was perfectly in tune with the "philosopher-historians" of the Enlightenment in his exaltation of the neoclassical hero, concentration on a precise moment in linear time, and advancement of a general set of normative principles governing ideal behavior. For instance, Trumbull claimed to have read "with care" Charles Rollin's eighteenth-century *Roman History* in which deeds from antiquity provided the basis for moralizing; this text informed Trumbull's *The Death of Paulus Aemilius at the Battle of Cannae* (1773).[5] In the nineteenth century, Washington Irving's biography of Christopher Columbus (1828) served as the main source for "discovery" pictures at mid-century. Other biographical accounts also directed artists. For example, William Ranney appropriated John Mason Peck's interpretation of Boone as a "gentle and approachable man of the people" rather than a backwoodsman or Manifest Destiny figurehead from Peck's *Life of Daniel Boone, the Pioneer of Kentucky* (1847) for his *Daniel Boone's First View of Kentucky* (1849).[6] The greatest historian of the era, however, was George Bancroft, whose ten-volume *History of the United States* (1834–75) may lie behind Frederic Church's beatific epic *Hooker and Company Journeying Through the Wilderness from Plymouth to Hartford, in 1636* (1846). Church may have in addition consulted an earlier historical text, Benjamin Trumbull's *History of Connecticut.*[7] Whatever the case, the writings of Bancroft and his colleagues were regularly used by artists and their points of view often absorbed. So too, in his use of William H. Prescott's *Conquest of Mexico* (1843) for *Storming of the Teocalli by Cortez and His Troops* (1848), Emanuel Leutze found not only information but an ideological position.[8] To Prescott, the non-Christian status of the Aztecs justified their destruction by the Spanish and the conquest of Mexico; in Leutze's painting, similarly, agents of Christian "civilization" combat "barbarians" defending a structure redolent of pagan exotica and brutal practice.

With the impact of Charles Darwin's *The Origin of Species* (1859) came "the ideology of the rigid neutrality of science" and the generation of scientific historians, which coincided with realism in American painting.[9] Darwin,

although not a historian, greatly influenced the history profession. As far as art and artists were concerned, it was not a matter of direct text dependency as such, but pervasive attitudes that grew out of his writings. The kind of empirical fact encouraged by post-Darwinian scientific historians is in full display in Thomas Eakins's *The Gross Clinic* (1875), despite Eakins's references to artistic tradition. Even in the case of Albert Bierstadt, strong attention to "fact" underlies his pictorial rhetoric. In his "historic landscape," *The Rocky Mountains, Lander's Peak* (1863), his fidelity to certain aspects of western topography and his depiction of the Indian can be understood to reflect, respectively, scientific historicism and Darwinian thought.[10]

It was in this other arena – the public discourse about race and class – that Darwin's writings also had considerable impact on artists. For example, although Frederic Remington never acknowledged Darwin as a source of influence, Remington's vocabulary often contained Darwinian phrases, and his paintings pictorialized his "Darwinian" notion that "The Man with the Bark On" came out of a struggle against frontier conditions. A well-read man, Remington could not have escaped knowing of Darwin's ideas; a more immediate source could have been William Graham Sumner, "the most vigorous and influential social Darwinist in America," a prominent and controversial academic at Yale while Remington was briefly there.[11] Likewise, although it cannot be proved that artists, including Remington, necessarily read Frederick Jackson Turner's frontier thesis as enunciated in 1893, there is no doubt that it influenced how people thought about the west in the late nineteenth and early twentieth centuries. William Truettner credits it with having "canonize[d] the frontier past," as found in the work of Remington, Charles Russell, Charles Schreyvogel, and others.[12]

In the period just before World War I, an "enlargement of the scope of history to include the social, economic, and intellectual as well as the political and constitutional" occurred, according to historian Peter Novick. Thus general themes related to modern "progress" – no longer the "old-fashioned history of battles and kings" but histories of economic, industrial, and technological change – often appeared in public spaces as pictorial ornament.[13] For instance, Francis Davis Millet undertook for his mural *The History of Shipping from the Earliest Recorded Use of Boats to the Present Time* (1908) in the Baltimore Custom House "'as careful research as for a written history.'"[14] Yet most scholars date the lessening of confidence in the reliability of historians to sometime around 1910 and the end of World War I. The war itself was a prime factor. Clarence W. Alvord confessed in 1927 that "the pretty edifice of . . . history which had been designed and built by my contemporaries was rent asunder. . . . The meaning we historians had read into events was false, cruelly false."[15]

Grand assumptions expressed in historical writing and in art collapsed at this point, and attention was given instead to the smaller, more easily comprehended areas of one's own backyard. A regionalist focus developed both in the hands of artists and historians. Local "histories" informed many a regionalist mural, such as Thomas Hart Benton's multipart *A Social History of the State of*

Missouri (1936), and many a New Deal mural, such as Ben Shahn's Jersey Homesteads mural (1937–8).[16] An exception to an ongoing relationship between history and painting occurred during and after World War II, although artists did produce wartime imagery. In the case of the Abstract Expressionists, artists did not depend on outside sources. They did not seek information about specific events because none were represented. The Abstract Expressionists confronted the war and its aftermath more on an emotional and philosophical level, as some have argued, despite differing opinions on this subject.[17] But modernism's focus on "pure form, abstraction, or myth" is interpreted by Linda Hutcheon as universalizing in intent, as an "attempt to be *outside* history" or "to *control* it through theoretical models of closure."[18]

With the 1960s, "external" subject matter and figural representation with historical resonance became reinstated often but in ways that were oblique and ironic, lacking grand rhetorical gesture and noble intention. Perhaps John Higham's observation that in the 1960s "the significance of history as a dimension of experience and understanding diminished" can be taken as corroboration.[19] One of the major casualties was traditional historical interpretation and the respect artists may have had for it. According to Novick, "the notion of a determinate and unitary truth about the physical or social world, approachable if not ultimately reachable, came to be seen by a growing number of scholars as a chimera."[20] Vietnam, American overseas ventures, the arms buildup, and later Watergate fragmented whatever ideological consensus may have held sway in the aftermath of World War II. Reliance on received truth diminished in an atmosphere of lying and cover-up, to be replaced by a pervasive cynicism. American culture became politicized, and art, politically charged. The media achieved a competitive edge over the discipline of history in explaining the meaning of public events (often co-opting the historical profession in the process) only to suffer the same backlash of distrust. Andy Warhol's *Jackie* series (1964), for example, owes little to historians' accounts of the Kennedy assassination but offers as part of its very content, media coverage of the tragedy in all its sordid detail.

Historiography and history painting are further linked in that history painting usually involves a historiographical stance. Whereas in the past this was usually either neutral or positive, in the twentieth century, historiographical comment can be quite direct, acerbic, and deeply critical. Grant Wood's *Parson Weems' Fable* (1939) mocks Weems's creation of the "historical" legend of George Washington and the cherry tree even as Wood mocked the historians who found Weems out.[21] Even the much belabored "genrefication" of history in the nineteenth century, whereby historical events were narrated in incidental, personal, and informal terms, can be understood to construct a historiographical position. Artists lost confidence in the hortatory power of narratives that depicted the single-handed ability of historical figures to communicate didactic lessons. Rather than indulging in what they considered pompous rhetoric, artists depicted history instead as genrelike situations

involving historical personages, such as *Washington and Lafayette at Mount Vernon, 1784* (1859) by Thomas Rossiter and Louis Remy Mignot.[22] Corollary to this idea was the conviction that large events did not in fact have an omniscient observer but were seen only in part and incompletely by bystanders and participants (the Stendahl effect, in other words). This, too, is a lesson in how to historicize: It instructs the public as to how and by whom historical understanding is transmitted. Edwin Blashfield literally positions the historical event offstage in his *Suspense, the Boston People Watch from the Housetops the Firing at Bunker Hill* (c. 1880) allowing the battle to take place only in the eyes of its spectators. In the postmodern era, historiographical issues can become the fundamental content of the work of art. Fred Wilson's installation *Mining the Museum* at the Maryland Historical Society in 1992 severely faulted the representation of history as transmitted by such institutions as the Society and called into question the reliability of historical truth as mediated by professional brokers.

Clearly the ways in which the past is understood and valued have changed. Although historical interpreters continue to be a resource for visual artists, they are not the ultimate authorities they were in the past. One factor has been developments in critical theory and the "linguistic turn" that has overtaken scholarship. These developments have combined to render knowledge incomplete, fragmentary, and subject to doubt and (re)interpretation. Revisionist social history constitutes another significant critical development in the writing of history in the late twentieth century. The problem of whose history was to be "explained," by whom and how, grew out of resistance in the early 1970s to hegemonic, unitary historical explanations and a desire for group cultural identity and affirmation. Revisionist social history remains one of the thriving legacies of sixties radicalism. Among its achievements is consciousness-raising among discrete subgroups that has resulted in particularized histories and therefore particularized history painting.

Much of the historical explanation of history painting derives from the internal life of art and art history, but some of it unquestionably lies within the discipline of history itself. History's very status as a discipline, its relation to science and to art, has been and continues to be debated. Particularly in the past two decades of the twentieth century, the sense of historical meaning – that is, history's very epistemological foundations – has been contested. Surely the crises of history painting in the twentieth century, involving sources and manner of representation, are not unconnected.

Historicity

Let us now examine the three components we have identified with history painting: historicity, narrativity, and didactic intent. That aspect of history painting which seeks to ground the matter depicted in "objective reality" (through the mediation of reliable written histories) we are calling historicity. The crux of historicity has traditionally been its claim to historical truth; the

proof of that credibility, accuracy in handling details. In recent times, however, the claim of historical writing to historicity has been challenged, with broad implications for history painting. According to F. R. Ankersmit, writing in 1989, "we no longer have any texts, any past, but just interpretations of them."[23] Hayden White goes further to contend that there are "*many* correct views" of facts. The problem is "*what constitutes the facts themselves*," a problem which the historian and, White adds, the artist attempt to work out by using artistic/literary devices for ordering and representing and giving data meaning.[24] "How can a historian (or a novelist) check any historical account against past empirical reality in order to test its validity?" Linda Hutcheon asks, if events have "no meaning in themselves" and facts are "given meaning."[25] Compare these positions to that of the colonial historian Thomas Prince, who expressed simple pride in the historical evidence he had acquired preparatory to writing. Lionel Gossman's postmodern contention that "Evidence – texts, documents, artifacts – is by definition a sign, and it signifies within a system of signs" sharply points up the distance traveled.[26]

The history of Anglo-American history painting offers many examples of painters' punctilious regard for accuracy in small details in pursuit of larger truths. At least during the formative period of the eighteenth century, artists did not make the mistake of equating such minor accuracies with truth. Anglo-Americans, basing their strategies on solutions worked out by such theorists as Roger de Piles and Jonathan Richardson, negotiated the competing claims of different kinds of truth with judicious practical wisdom.[27] West himself drew upon historical sources for his *The Departure of Regulus from Rome* (1768). To these he added, as Ann Abrams has uncovered, effects based on two theater pieces produced a decade or two before and reference to a contemporary public controversy.[28] Mid-nineteenth century, critical opinion and artistic practice continued to emphasize larger meaning over strict accuracy. Fundamental inaccuracies in Leutze's *Washington Crossing the Delaware* (1851), for instance, despite the artist's care with particulars of dress and physiognomy, did not tarnish its acceptance in 1851 as "the most effective painting ever exhibited in America."[29] Yet as late as 1895, the critic Clarence Cook complained that artists "must be accurate to a gaiter-button or a fibula, or they lose all rank."[30] It was as if such small accuracies could act as guarantors somehow of the truth, metaphors for the concept of historical objectivity itself. A notorious example involved Remington's and Schreyvogel's dispute over the exactitude of myriad details in the latter's painting *Custer's Demand* (1903).

Preoccupation with accuracy to the level of "a gaiter-button or a fibula" was a direct outgrowth of nineteenth-century positivist philosophy. By now, at the end of the twentieth century, positivist philosophy has lost much of its earlier power, although it still permeates popular culture to a remarkable degree. Twentieth-century psychology has taught us to question superficial readings of individual behavior, and media criticism has alerted us to the distortion of truth possible through modern modes of communication. More importantly, the organized study of the past has itself, as Linda Hutcheon has observed, undergone a "shift from validation to signification."[31] In this light, perhaps the

best response to the gaiter/fibula position at this point belongs to Ankersmit: "Criticizing metaphors on factual grounds is indeed an activity which is just as pointless as it is tasteless. Only metaphors 'refute' metaphors."[32]

Narrativity

It is on this point that historicity connects with our second component of history painting, narrativity. Let us begin with a simplified definition of narrative – a temporal sequence, first and foremost, of several events cohesively organized, involving specific place and time. By extension, the historical narrative is a story comprised of "actual" events having a beginning, middle, and end. The implication here is that the historian "finds" rather than creates the story. Hayden White argues the opposite, however, that "no given set of casually recorded historical events can in itself constitute a story; they are given story form by the historian's use of literary devices."[33] In other words, "casually recorded historical events" need to be made into a story, that is, made to take on narrative structure in order to function as "true" history. He argues further that "the very distinction between real and imaginary events, basic to modern discussions of both history and fiction, presupposes a notion of reality in which 'the true' is identified with 'the real' only insofar as it can be shown to possess the character of narrativity."[34]

As this comment and others on previous pages suggest, one of the gravest controversies in modern historiography centers on the collapse of the carefully tended boundary between historical recounting and fictional narrative. When Hayden White and others began to perceive deep affinities between historical writing and fiction via narrative structure, based in part on linguistic theory, they precipitated a dispute in both disciplines that is not yet resolved. Insightfully extrapolating from the etymological root of the word *narrative*, White generalizes narrative of whatever type to be "a solution to a problem of general human concern, namely, the problem of how to translate *knowing* into *telling*."[35] He draws the two enterprises of knowing and telling together:

How a given historical situation is to be configured depends upon the historian's subtlety in matching up a specific plot structure with the set of historical events that he wishes to endow with a meaning of a particular kind. This is essentially a literary, that is to say fiction-making operation. And to call it that in no way detracts from the status of historical narratives as providing a kind of knowledge.[36]

Two observable developments in painting by the 1980s suggest the relevance of the controversy over the relationship between historicity and narrativity: the resurgence of interest in narrative painting in general and in art concerned with historiography. Without intending to overlook others, we offer here the names of artists Roy Lichtenstein, Robert Colescott, and Mark Tansey.

Narrativity need not, however, be the only way to express historicity. In historical writing, annals and chronicles offer alternative approaches – the set-

ting down of unconnected events or events not brought to conclusion – that are non-narrative. So, too, in painting we note that there may be historical comment without recourse to the narrative mode, but we would question whether such painting is "full" history painting. The matter is not a simple one. Historical reference through emblematic sign can powerfully persuade and inform, despite the missing narrative. Such painting thus has some but not all of the ingredients of history painting. What is at issue is the importance of the function of narrative in history painting.

How then does narrative relate to history painting? The connection between history painting and narrative turns on three principal factors: the notion of story, the phenomenon of time passing, and what we are calling a sense of causality. With regard to the question of temporality, G. H. Lessing long ago characterized literature as temporal by nature and painting spatial and therefore atemporal, or by implication, non-narrative (Lessing was writing about one-point perspectival Renaissance painting).[37] Contemporary scholar Wendy Steiner seems at first to agree with Lessing's formulation when she calls painting "not sequence but pure configuration." Acknowledging that modern linguistics has found a way to bridge the gap between literature and painting on the issue of temporality, Steiner later avers that "[v]irtually every narratologist finds narrative dependent on both its sequential and its configurational qualities."[38] Likewise, narrative theorist Paul Ricoeur distinguishes in literary narrative between "the episodic dimension, which characterizes the story as made out of events," and "the configurational dimension, according to which the plot construes significant wholes out of scattered events." He even borrows the concept of "colligatory terms" from theoreticians of history in his eagerness to make the point that the configurational dimension "displays temporal features."[39] From such an analysis of time, Steiner adds the fact that visual clues within a painting can refer to sequentiality (metonymically) and causality (metaphorically) and when they do, as in pre-Renaissance art, they generate a sense of narrativity. By repetition of elements within "the differential context of realist space and time," it is possible for "a design to give birth to a story."[40] Historian Michael Kammen, using a less theoretical vocabulary, calls this phenomenon "implied narrative" in an effort to enlarge the purview of history painting.[41] He calls attention to the narrative implications of displacement by movement through space over time, change over time, and history as process.

A theory of narrative's dual structure – "content time," or time of the story itself, and "discourse time," or time of its telling – has led some proponents such as Seymour Chatman to argue that a pictorial narrative is a "contradiction in terms."[42] He does not understand, for instance, the time spent viewing a Titian (he does not say whether he means a history painting or one from another category) to be discourse time, for there is no way of ordering the sequence of viewing elements within the painting. We, however, position ourselves with Steiner who contends that a painting can tell a story and not be merely "configurational" when it attempts to do so. The sequentiality implied in traditional history painting is that of the passage of time in its linear aspect, that which proceeds by regular, measurable increments from past to future. In

such painting, an artist selects a significant moment from the ongoing narrative, halts it, and makes of it a still picture. Nonetheless, the larger context in the sense of before and after is suggested either from hints within the painting itself or by the assumption that the viewer is familiar with the story. In the latter case, context is supplied by the viewer. Nelson Goodman observes in a discussion of pictorial as well as verbal narratives "[t]hat what is implicitly or explicitly told must take time hardly distinguishes narrative, for even description or depiction of a momentary and static situation implies something of what went before and will come afterward." Narrative is thus not "the peculiarly temporal species of discourse" it is claimed to be.[43] Nevertheless, to return to Ricoeur, narrativity is "the language structure that has temporality as its ultimate referent."[44]

Temporality as a concept is of course itself subject to changing interpretation. Since the Enlightenment and the development of modern science, understanding of time in the West has emphasized its linear progression. Other societies in other parts of the world understand time, and therefore history, differently, as A. J. Gurevich has described.[45] In what he terms "archaic" society, time is thought of not as linear but as immobile or even renewable. Similarly, David Carr has noted that in the case of most non-Western religions, linear time is "a mere appearance, [and] reality . . . atemporal or cyclical."[46] In most of the Western world, however, the concept of time has been further modified in the twentieth century by Einsteinian physics with significant ramification for historians. Gossman states that today we no longer think of time as "a uniform medium in which historical events occur or historical phenomena, have their existence, and which in itself establishes a continuity among these diverse phenomena but seems rather to be multiform. . . ."[47] Perhaps this is why some modern artists such as Andy Warhol often selected discontinuous moments with historical reference and expressed them through nonlinear multiplication of one image. Steiner argues that narrative is thereby subverted by repetition, although "the borderline between repetition and narrative progression is a precarious one."[48] To expand on Ricoeur, temporality may be the ultimate referent even of pictorial narrative, but one must be aware of which construction of time is involved.

Time expressed through natural processes became a particular feature of many American paintings in the nineteenth century as natural history assumed the role of substitute/complement to event history. It can be said that landscape painting beginning in the late 1820s absorbed many of the functions of traditional history painting. Borrowing a phrase from Barbara Novak, there actually was a "transfer of the rhetoric and aims of history painting to landscape."[49] William Cronon, writing of landscape painting, uses *The Oxbow* by Thomas Cole (1836) as his example in observing that "[t]o learn the story each painting tells," the viewer must discover the painting's "snapshot record of a particular instant, a chronicle of past use, and a vision of future change."[50] In this way, the static painting could take on the narrative's beginning, middle, and end, and shows and teaches (as Raymond Williams says history ought to

do) the ecological history of a particular location.[51] In a sense, Jacob Lawrence's *The Migration of the Negro* series (1940–1) also conveys the passage of time through peoples' passage through landscape. In the latter part of the twentieth century, other artists have shown their awareness of time in nature in new ways by investigating temporality and change through earthworks (which may be reclamation projects) and the photographic narration of ecological damage. We thus concur that in the hands of many artists, the land itself can be the primary locus for investigations of pastness, combining nature and time in a unified narrative.

There is one further point in this discussion of narrativity. It concerns causality having to do with the sense that because this happened, then that happened; this happened *because* that happened. Steiner has noted that a painted narrative may establish such a sequence.[52] To take that further, the narrative structure that provides events with beginning and end may then suggest consequence. In this fashion, whether in nature history or event history, significance is given to the "before" and the "after." It is the reason why a moment in time is granted epistemological sanction. The motives that inform change over time therefore constitute not only the story but the "moral" of the story.

Didactic Intent

Our third component of history painting has to do with teaching or showing. Didactic intention assumes there is a moral center, a hortatory aim, and exempla or principles to teach. History painting had customarily been invested with such high intentions; it was more than a mere depiction of miscellaneous past events. As in the tradition of classical rhetoric, viewers were to be persuaded by the eloquence of the messenger to think higher thoughts, modify their conduct, or entertain feelings of patriotism. Peter Rothermel provides a paradigmatic image for such solemn exhortation, *Patrick Henry in the House of Burgesses of Virginia, Delivering His Celebrated Speech Against the Stamp Act* (1851), which shows Henry declaiming in the pose of a classical orator on the subject of American rights. The story of the *exemplum virtutis* is narrated by himself from within the picture. The painting thus attempts to be what it depicts: a rhetoricizing agent.

The question becomes persuasion to what end, inviting us to consider the question of ideology. White is quite forthright in his statement that "every representation of the past has specifiable ideological implications" and even more when he avers that "The issue of ideology points to the fact that there is no value-neutral mode of emplotment, explanation, or even description of any field of events, whether imaginary or real, and suggests that the very use of language itself implies or entails a specific posture before the world which is ethical, ideological, or more generally political. . . ."[53] White's use of the term moves away from a Marxist definition to an expanded meaning which, in the words of Raymond Williams, consists of "[a] set of ideas which arise

from a given set of material interests or, more broadly, from a definite class or group. . . ."[54] The field of history painting is replete with examples of how ideology in that sense affects meaning. We cite as possible readings: for John Trumbull's *The Declaration of Independence, July 4, 1776* (1787–1820) – republicanism; for John Vanderlyn's *Landing of Columbus at the Island of Guanahani, West Indies, October 12, 1492* (1846) – the doctrine of Manifest Destiny; for Ben Shahn's *The Passion of Sacco and Vanzetti* series (1931–2) – democratic idealism; and for May Stevens's *Soho Women Artists* (1977–8) – a feminist ideology. In each instance, the painting has in part a political agenda. There is no harm in this, as long as the presence of the ideological component is recognized. Such acknowledgment does not necessarily constrict the meaning of the painting but can instead amplify it.

For our purposes here, it is significant that White attributes a very particular role to the narrator. He asks, "Has any historical narrative ever been written that was not informed not only by moral awareness but specifically by the moral authority of the narrator?" He explains that the historian asserts his moral authority in determining "the true account of what really happened." He takes this further with his intriguing query, "Could we ever narrativize *without* moralizing?"[55] Cronon echoes these thoughts in general when he calls narrative "our chief moral compass in the world," adding that "it is because we care about the consequences of actions that narratives . . . have beginnings, middles, and ends." Completion of the narrative is significant, for as Cronon points out, "[t]he moral of a story is defined by its ending."[56] Such attitudes do not represent a nostalgic return to the simpler times of philosopher-historians but seek to promote the rhetorical function and moral role of the historian in reaction to positivism and structuralism. They may also be applied to history painters and their concern for didacticism.

Now let us return to those three principles of history painting with which we began: historicity, narrativity, and didactic intent. To summarize our arguments: First, we feel the sense of the historical significance of a particular person, event, or system must be present in at least implied form. Historical referents by themselves are not sufficient. Unless the "longer-term or larger-scale sequences of actions, experiences, and human events" that Carr associates with narrative in (written) history are also included or suggested, the result has more the effect of a visual billboard.[57] Indeed, secondly, it seems to us that narrativity is thus essential to the enterprise of history painting. It provides the sequence of causality critical for history painting's third component, didactic intent. It is possible of course to moralize or comment without narrativizing, but we argue it is didactic intent conveyed through narrative that distinguishes history painting past and present and that history painting can convey Cronon's "consequences of actions" through implied or provoked narrative sequence. Third, we concur with White that narratives have moral meaning and with Cronon that narrative and teleology together generate history's "moral center."[58] In applying these concepts to art, we repeat that history painting ought to convey a sense of seriousness and purposefulness and that it

accomplishes this by incorporating references to causality and consequence. Finally, paying heed to artist David Avalos, we feel that history painting's potential as work which "can affect people's consciousness in a way that has concrete benefits for society" is best realized through narrative and historicizing devices.[59]

One question ultimately remains: Why history painting at all? In the case of American history painting, Reynolds's theoretical bias toward the genre undoubtedly propelled artists of his own generation and others well into the nineteenth century. The elevated status given history painting in the past, however, no longer applies. Nor consequently does the market, though even in Reynolds's time actual practice did not match up with theory. Nor, arguably, has there since been a theoretician of Reynolds's influence and artistic position advocating what we are here labeling history painting. It is only postmodernist theoreticians in other fields who may offer other answers for today to the question just posed. Interestingly, some of Hutcheon's observations about postmodernist strategies in history and literature seem to parallel developments we see in art affecting history painting: involvement with current history, conscious display of and/or play with formal means, a challenging and questioning posture.[60]

White, for instance, perhaps provides one answer with his own question: "[w]ith what *kind of meaning* does storying endow those events which are products of human agency in the past and which we call 'historical events?'" His response is that "story forms not only permit us to judge the moral significance of human projects, they also provide the means by which to judge them. . . ." That is, from the presentation of past events within the framework of the historical narrative, one can learn "what it means to have intentions, to intend to carry them out, and to attempt to do so."[61] White appears to endow the historical narrative with important, possibly even necessary, instructive purpose. Or Barbara Herrnstein Smith who applies narrative (albeit verbal) discourses to the larger arena of social behavior. That is, she locates narratives within a *"social transaction"* of narrator and audience in which "each party must have some *interest* in telling or listening to that narrative."[62] She sees narrative as acts, "verbal acts consisting of *someone telling someone else that something happened*" with audience participation needed to infer from the narrative what is not explicitly set forth.[63] Narrative here is clearly part of a broad and powerful social transaction, involving narrator/painter and audience/viewer. These recent understandings of narrativity give new value and life to the activity of making pictorial narratives or history painting and their didactic function.

It is hardly surprising, then, that we see the most effective historical art at the moment to be attempts to engage as well as, of course, to "tell." This art tends to be nontraditional in media and fabrication, and often takes the form of installations involving painting, text, photography, artifact, video; and mural projects. Such work we find compelling because it requires the viewer's participation in the completion of the narrative (involving time and sequenced action)

and/or assessment of the work's historicity. We offer the following examples dating from the 1990s: installations *Mining the Museum* by Fred Wilson, which questions the reliability of history by means of a coruscating critique of museum acquisition and exhibition policies; *Los San Patricios* by Luis Camnitzer, which investigates historiographically an episode of the Mexican-American War of 1848; *Chicago Stories* by Deborah Bright with Nancy Gonchar, which explores Chicago workers' labor history; and a collaborative mural *History/Our History* by Heidi Schork and the Youth Clean-Up Corps in Dorchester, Massachusetts, which concerns Rodney G. King and the 1992 Los Angeles riots using material researched by the teenagers. That we have come to view such work in this light may of course reflect a crisis in easel painting more than in history painting as such. But where we see positive change, others see the death knell of history painting. Adam Gopnik's 1992 assertion that "All the old functions of image-making (preserving faces, conserving historic moments) have passed entirely into the hands of photography and mechanical reproduction," reflects not only the old canard that photography did in painting in the mid-nineteenth century, but also a traditionalist's view of history painting as concerned only with facts and their pictorial itemization and preservation.[64] What we are calling history painting here is art capable of narrating, historicizing, and exhorting. These capabilities we see as constants. Only the means and making of "history painting" are currently in flux.

We see no shortage of or end to history-referencing art that encompasses a broad spectrum of possibilities. In style it has ranged from the most traditional to the avant-garde. In content it has ranged from simple commemoration of specific events and personages to sophisticated, grand themes, some of which thematize historicity itself and some of which have didactic or moralizing effect. As to the future of history painting, we decline to offer a definitive prediction. Let the future declare for itself. We have no doubt, however, that there will continue to be historical art that is serious, deep, and rich in its ramifications, and historical art that strives to make sense of our human actions and communicate profound truths about them in visible terms.

To point up our sense of the continuity of history painting, we have organized the chapters that follow as "case studies" in three parts. These relate to the definition of history painting just posited, that is, to how history painting works, rather than to a chronological order. We use the parts, historicity, narrativity, and didactic intent, not to isolate, for we are fully aware of cross connections, but to link each chapter to broader history painting concerns. We want to make clear that we consider the issue of whose history is depicted and for what purpose, involving matters of race, gender, and class, historical "truth," and type of narrative, to be of paramount importance. Without awareness of this issue, not unrelated to history's "moral center," history painting might as well be labeled "'*disgusting, dead* and *absurd*.'"[65] Our contention is emphatically otherwise.

Historicity

The three constitutive structures of meaning – historicity, narrativity, and causality/didacticism/ideology – that work together to explain history painting are also amenable to analysis as separate entities. The first, historicity, is that aspect of history painting which has to do with the *knowing* of history before it becomes the *telling*. Each chapter grouped in this part therefore has as its principal (although not exclusive) concern the problematic way history is known and selected for (re)presentation. Francis O'Connor begins by appropriating the term *hoop of history* to establish that the "historicity" of prehistoric and later Native American art is nonlinear and non-narrative. Native Americans used myth, visions, and symbolic relations, which although lacking the historicality, sequentiality, and narrative coherence of modern history painting, nevertheless communicated basic truths about their communal life and destiny in rich and monumental form. The first "modern" history painting discussed is a Revolutionary War battle painting by John Trumbull. In her analysis of Trumbull's engagement with the historicizing enterprise, Patricia Burnham moves between image and accompanying text. Challenging the painting's iconic status, she seeks to excavate deeper levels of historicity in Trumbull's presentation of class and race. Ann Abrams writes about altered interpretations of a specific historic incident during the American Revolution. What changed was not the historic "fact" of the capture of the British officer Major André, but attitudes toward America and its citizenry. By the 1830s, it was Asher B. Durand's *The Capture of Major André* that best expressed the emergent "egalitarian" pride in individualism and regionalism. The Civil War precipitated a crisis in history painting, Lucretia Giese argues, when the artistic community could no longer accept the terms of historicity laid out by previous generations. Her reception study indicates a distinct shift in the verbal and visual rhetoric – not so much in a single direction (impossible in the "absence of a critical consensus") as away from a time-honored tradition. She situates the crisis not only in the specifics of artistic production or even in the rival claims of photography, but in critical attitudes and ultimately the nature of

the war itself. Alex Nemerov sees a dramatic change in historical understanding in turn-of-the-century paintings on western themes by Frederic Remington. In thrall to the principles of evolution by way of social Darwinism (as were so many of his contemporaries), Remington incorporated evolutionary thinking into his understanding of the historical process. He constructed not only western types (Indians, white men, himself) but even developments within art according to this new basis for historicity, that is, the story of competition and the grim new lesson of survival of the fittest. In her study of two Chicano history painters, Shifra Goldman confronts one of the central questions of historicity: whose history gets to be told. Leo Tanguma and Emigdio Vásquez depicted the hidden histories of the Mexican American people in the 1970s, fashioning narratives expressive of their subject and its underlying ideology. Goldman's methodology is to uncover their hidden histories and to structure the (his)story of them from a similar ideological position. Finally, Lisa Corrin writes about artists whose work intentionally problematizes the concept of historicity itself: confronting, denying, renegotiating the relationship between artist and viewer, the notion of unitary truth and history. For Corrin, "historicizing installations" most effectively address these issues. What they emphatically interrogate is "*how* historical images mean" as they critique histories constructed by the very institutions in which they are often sited.

The Hoop of History
Native American Murals and the Historical Present

Francis V. O'Connor

Introduction: A Painted Tipi and the Mural as an Art Form

The mural, as an art form, is best defined as any pictorial composition executed for a particular exterior or interior wall, or situated on a ceiling, or in a natural context, which defines, through visual images, the purpose of its environment. Put another way, a mural is a complex of images on a wall (which may – but not exclusively – contain decorative elements), that articulates what went on before or behind that wall.[1]

This chapter is about how Native Americans, from prehistory to the end of the nineteenth century, utilized this art form to define their conception of themselves in space and time. As we see here, Native Americans employed all the variants on wall painting used today. As history painting, however, their murals embody and express an understanding of past, present, and future events quite different from our own. History for them was immediate, spatial, and cyclic, rather than a linear, temporal phenomenon.

Let us begin, then, with a mural that sets the Native American sense of history in direct encounter with our own: the *Horse Dance Tipi*, which dates about 1880. Its owner, the Oglala Sioux shaman, Black Elk, provides us in what follows with the only known firsthand account of the creation of a Native American mural before 1900:

[The two, wise old medicine men] sent a crier around in the morning who told the people to camp in a circle at a certain place a little way up the [river] from where the soldiers were. They did this, and in the middle of the circle [the old men] set up a sacred tepee of bison hide, and on it they painted pictures from my vision. On the west side they painted a bow and a cup of water; on the north, white geese and the herb; on the east, the daybreak star and the pipe; on the south, the flowering stick and the nation's hoop. Also, they painted horses, elk, and bison. Then over the door of the sacred tepee, they painted the flaming rainbow. It took them all day to do this, and it was beautiful.[2]

It was traditional among the Plains Indians for a young brave coming of age to seek a vision that would induce a personal myth and determine his place in the tribe. As we discuss in greater detail later, a spontaneous vision was valued more than one sought. Black Elk's took place spontaneously at the age of nine. It is worth recounting, since it documents not only the "program" for a painted tipi, but is an accessible account of the experience of a Native American shaman on the cusp between his sense of a vision's "eternal present" and our understanding of "history" – as represented by those soliders downriver.

Black Elk was born in December 1863. He was a Lakota of the Oglala band of Sioux and second cousin to Crazy Horse, one of the last leaders of his people. At nine he became seriously ill. Lying unconscious in his parents' tipi for about twelve days, he experienced a vision that became the basis of his future shamanhood. He kept this secret until seventeen, when he told an older shaman, and was advised to reenact his experience with the participation of his entire tribe. This was done in 1880. In 1886 he agreed to join Buffalo Bill's Wild West Show, hoping the experience of the white man's world would help him be of greater assistance to his people. He was taken to New York, and later to London, where he danced before, and was presented to, Queen Victoria on the occasion of her Jubilee in 1887. In England he left Buffalo Bill and joined a smaller company that took him to Germany and France. He returned to his people in 1889, was a participant in the futile Messiah Movement, and witnessed the massacre of Wounded Knee in December 1890. He lived thereafter on a reservation and practiced as a medicine man. Forty years later, at sixty-seven, he agreed to preserve his vision and experiences by telling them to the poet John Neihardt.

His vision, which anticipated the eventual destruction of his people, divides into three episodes. The first revealed symbols of the four directions in terms of four groups of a dozen horses each, the black, white, red, and yellow horses to the West, North, East, and South respectively. (See pp. 22–3 for a discussion of the directional symbolism alluded to in what follows.) At the center was his mount: a bay stallion. These horses performed an elaborate dance, changed into all the other animals of the earth, and then returned to their directions.

The second episode took place in a vast tipi fashioned of clouds and sewn by lightning, with a rainbow for a door. Within, six Grandfathers, whom he recognized as the World's Powers, presented him with gifts in the same order as the directions were revealed: The Grandfather of the West's opposites offered a cup of life-giving water, and a bow and arrow with which to kill. The mysterious North presented a sacred herb and a white goose wing, suggestive of the inner mystery of plants and the migrations of winter. (It is interesting that the darker directions preceded the lighter and more hopeful.) The revivifying East proffered a peace pipe, perhaps in hope that peace might be accepted by those who threatened from that direction. The nurturing South bestowed a red staff sprouting leaves and the nation's hoop in keeping with that direction's power over growth and wholeness. The Grandfather of the sky revealed a spotted eagle, which would become Black Elk's totem, and the last

of the six elders, representing the earth, metamorphosed from extreme old age to youth and back as a sign of Black Elk's own longevity.

Leaving the Grandfather's tipi, Black Elk beheld the third episode. The squadrons of horses changed: the blacks of the West into thunders, the whites of the North into geese, the East's reds into bison, and the yellows of the South into elks. He then found that a red road, leading from North to South, was the best way to go, whereas a black road from East to West was negative. He proceeded nevertheless along the black road through various encounters (best read in the original than summarized here), which culminated in another horse dance and a panorama of the hoop of the world. Returning to his body through the Grandfather's tipi, he awoke cured of his sickness, and afraid, because of his youth and inarticulateness, to reveal his vision until years later.

That a child should have such a vision, couched in the symbols of its culture, although rare, is not unprecedented in the history of mysticism – nor are the psychodynamics of fever dreams all that mysterious; it is what is made of the vision that counts. By the last third of the nineteenth century, Native American tribes were doomed as free societies – and they knew this in the souls of their shamans. Thus the ambivalence of Black Elk's vision: its giving primacy to the opposites of the West and his taking the ominous rather than the safe road. But, as with all proud and courageous people, his tribe would not surrender without a fight, and to resist it needed the moral support of seers.

A shaman fulfills his role by healing individuals or through ceremonies conducted in behalf of the entire tribe. A shaman is successful because he has been able, as Stephen Larsen points out, to conjure imagery whose implications transcend personal experience.[3] In the same way, any authentic work of art is not just a pastiche of another's discovery or construct, but a socially oriented enactment of something both personal and universal. It thus becomes a compromise between a spiritually specific vision and an object generalized in terms of the exigencies of medium and received myth. Black Elk's art form was ritual embodied in imagery. His Grandfathers' cosmic tipi, recreated in hide and paint, defined the values of his culture and the purpose of its environment – which is the function of any mural.

The tipi was not the only thing painted. Black Elk described himself at the center of the reenactment: "My bay horse had bright red streaks of lightning on his limbs, and on his back a spotted eagle, outstretching, was painted where I sat. I was painted red all over with black lightning on my limbs. I wore a black mask, and across my forehead a single eagle feather hung. When the horses and the men were painted they looked beautiful; but they looked fearful too."[4] Inside the tipi, the nation's hoop and the red and black roads were painted, and six old men presented the various directional symbols as in the vision, while the painted horses, and the people of the tribe, marched, danced, and sang outside in a joyous pageant – not unlike those staged just a bit later in eastern cities on Grecian or patriotic themes.[5]

The fate of Black Elk's "mural in the round"[6] is unrecorded. The tipi would have become his, emblazoned with the power signs of his shamanhood.

It was probably lost in the forced relocation of his tribe that occurred shortly after the reenactment of his vision. With it was lost a living sense of history as an eternally present, ever-renewing hoop, to be replaced by one that saw it as progress through time.

Imagining and Imaging the Historical Present

In an era when awareness of history is being mediated by a deeper comprehension of the scholar's participation in its processes, a fresh look at an art that was independent of time as such (until western cultures, embedded in their belief systems, undertook to "civilize" Native Americans) might help to raise questions about current historical and multicultural methods – and the nature of history as we construe it. Native American murals, centered in an immediate space, illustrate their creators' sense of a "historical" reality that contrasts with our usual commitment to temporal linearity.

The traces that tribal cultures inhabiting our continent from roughly 3000 B.C. left behind are mostly basketry, pottery, weaponry, textiles, leather- and featherwork, ritual and domestic objects, and architectural ruins. But few such objects provide in themselves any overt trace of specific continuity or event, except murals. Of the tribal cultures, the prehistoric, Pueblo, Northwest Coast, Plains, and Forest, only the latter seems not to have created wall paintings. There is an abundance of prehistoric "rock art" murals as well as Pueblo kiva "frescoes," Northwest Coast decorated houses, and Plains Indian painted tipis. These, unlike the general remnants of everyday life normally studied, and occasionally valued for their "aesthetic" quality, often provide graphic evidence of a Native American's sense of origins, natural continuity, and specific occurrence.

It is, however, one of the mental characteristics of aboriginal humankind that history is more a matter of spatial than temporal reality. Siegfried Gideon put it this way:

It is ever more evident that man developed a comprehension of space before he developed a sense of time. In the perceptions of prehistoric man, the sense of space became supreme and acquired surprising power. Indeed, it was in prehistory, when man had no realization of time in its later meaning, that his space sense reached its highest level. . . . Beforehand, afterward, and at the same time are often difficult to distinguish from one another; today, tomorrow, and yesterday are similarly interwoven. All is an eternal present.[7]

Our traditional expectation of "history painting" involves the depiction, however abstracted from documented fact, of a past event. In contrast, Native Americans lived within "sacred circles," as Ralph T. Coe expresses it,[8] or, to use Gideon's just quoted phrase, in an "eternal present." This all-encompassing present provided a spatial focus and context for those mythical, agricultural/astronomical, and occasionally intrusive, events that determined an immediate existence.

Here an effort of historical imagination is needed. To understand Native

American perception it is necessary to place ourselves in a situation without any sense of accumulated past events, or ambition to influence a future, and to consider living in a world that is an isolated present. This is easier if one has traveled through the canyon lands of Utah, or gazed from the heights of the Pueblo cultures in New Mexico, or seen the rugged encounter of ocean and forest in the Pacific Northwest, or known that continuous horizon of the continent's flatlands which leaves you alone at their center. For the tribes, terrain dominated physical survival, and the vastness of the sky and its cyclical events determined "history." Images served to illustrate the oral tradition of tribal myth, preserved by image-making shamans. Their power came from the synergy between the perceiving individual, shamanic vision, and the context of land and sky. To understand specific murals, then, it will be necessary to define Native American "aesthetics," the symbolism of the four directions, and the role of the shaman as "artist."

NATIVE AMERICAN AESTHETICS

It is very easy to dismiss what is called primitive art as beneath or beyond the concerns of so-called fine art. Yet the human behavior of making art – here understood as environmental wall painting – shares a number of constants among all humans, and can help us understand and interpret traditional art.

We find, for instance, that all the general methods of wall painting in the United States after about 1750 find independent precedents in the native cultures. Thus the prehistoric tribes left images on exterior walls, just as the community mural movement does in our own day. The Pueblo cultures of the Southwest "frescoed" the adobe walls of their kivas and multistoried houses and created interior wall shrines comparable to our murals in churches or courthouses and what we call "installations." The Plains tribes painted heraldic "murals in the round" on the exteriors of their portable tipis, just as we paint airplanes, trucks, and vans. And the Northwest Coast cultures, influenced by Oceanic art, created environments imaged with their totemic myths as settings for potlatches worthy of the opulence of our Gilded Age.

This does not mean to suggest a direct causal influence of Native wall art on America's later acculturated murals. We must argue from the analogy of human behavior, not causality, and point out four general areas where the aesthetic practice of native and "civilized" mural artists coincide. These similarities prove that the very impulse to image environments is a primordial instinct, shared by humans back to the beginnings of communal experience:

1. the creation of ceremonial environments sacralized through imagery;
2. the orientation of such environments to the cardinal points;
3. the utilization of both interior and exterior walls; and
4. the heraldic use of mural imagery to define community status.

There are also two areas where native practice would seem, at least until recently, to diverge from ours:

5. the psychodynamic origins of imagistic conventions; and

6. the renewal, rather than the preservation, of murals for ritual and practical reasons.

Native Americans felt themselves to be at one with nature, which was their ceremonial environment. For these peoples, the seasons and heavenly bodies, their cycles and locations, regularities and anomalies, all took on symbolic or mythic meanings – which came to be the essence of their aesthetics.

Native Americans had no words in their languages either for "art" or "religion" despite the powerful images they created for the seasonal cycles of their ceremonies.[9] For them what we call a work of art was a ritual instrumentality dedicated to rites connected to initiation, healing, fertility, rainmaking, or to preparation for hunting or war. Imagery was seldom varied within a tribe, being handed down by shamanic tradition. New imagery was occasionally introduced by a shaman who had an exceptionally powerful vision relevant to the communal welfare (as did Black Elk). All imagery was derived from nature and oriented to the cardinal points of the compass.

THE ICONOGRAPHY OF DIRECTIONAL ORIENTATION

For the Native American, the four directions were the coordinates within which heavenly bodies moved, seasonal cycles proceeded, and life was lived. They articulated and emblemized space – whether the layout of a tribal encampment, the orientation of a Pueblo sand painting, or the direction a mural faced. They were constants in an unmappable landscape and fathomless sky, and their relationship to the daily cycle of dawn, day, dusk, and dark defined the community's location in that eternal present that was "history."

The cosmic environment was seen to consist of two directional planes intersecting at a center that was the community's location. The four cardinal points encompassed the horizon plane; the center, zenith, and nadir a vertical axis plane of height and depth.[10]

The East was of greatest importance, being the direction from which the light of the sun first comes. Virtually all prehistoric and ancient shrines and temples in both the old and new worlds have entrances oriented East, most often to that point at which the sun rises at the summer solstice. Thus the East took on a positive symbolism: It illuminated and regenerated, whereas the West reduced light to dark.

The West swallows the sun. It is a place of opposites: light and darkness, and by extension life and death and all dichotomies. Artistic manifestations oriented to the West are amazingly consistent in the duality of their iconography. The Christian "Last Judgment" on a west wall is a classic example; Black Elk's life-giving water and life-taking weapon, typical.

Whereas the East and the West were clearly defined in terms of this drama of the solar passage, the North and South found universal import in contrast to each other. The sun shone from the South and was associated with fertility and a wide range of positive values. It was the direction of daylight, noon,

bright skies, and reflecting surfaces – opening nature's infinite splendors to vision and enterprise in contrast to the cold, lightless, mysterious North.

Of the four directions, the North was the only one not a source of light, except at night, when the Pole Star became the hub of the heavens and the determinant of the other three directions. It was associated most frequently with the nocturnal powers and their impenetrable mysteries. If the South was a place of external tangibilities, the North was the place of the inner mysteries of things.

Western symbolism (with the exception of centrally planned churches) has no specific symbolism of the center as a fifth direction. Other cultures associated it most frequently with the altar or hearth, the place of worship or family – as we see in the Pueblo kiva. Similarly, the Zenith and Nadir, associated with the opposition of height and depth, survive for us in terms of various positive and negative attitudes toward the ideas of "up" and "down" – as with heaven or hell, transcendence or burial.

It was within these universal coordinates that the shaman found a coherent cosmos to image upon walls.

THE SHAMAN AS IMAGE MAKER

Of the six characteristics of native murals just listed, the two areas of seeming difference from Western practice – psychodynamics and preservation – are the more aesthetically revealing and are best understood in terms of the shaman's role in their creation; the positioning of walls, and heraldry, will become apparent when we discuss the murals.

Among aboriginal societies the world over, shamans have served as priest, physician, psychiatrist – and "artist" or image maker.[11] He (sometimes she) became a shaman either by inheriting the role or consciously seeking initiation, although it was recognized that those persons spontaneously called to shamanhood possessed the greater power. Initiates underwent a severe ordeal either physically imposed upon those seeking shamanhood or psychically from within when the call was spontaneous.

The general pattern of the mental or visionary ordeal, which all evidence indicates is cross cultural and similar for African, Australian, Asian, and North American shamans (not to mention certain Christian mystics), consisted of the envisioning of symbolic human or animal guides or totems and the self-observation and acceptance of one's own physical dismemberment, often down to a skeletal state, followed by some form of reincarnation. This basic death/rebirth experience – paralleled in our culture by extended monastic novitiates, freemasonic rituals, medical internships, and training analyses – provided the foundation for the shaman's ability to induce it in others and to be accepted by his society as a healer and seer despite eccentricities. The shaman became for his community what Mircea Eliade has called a "technician of the sacred" – given to, and capable of, inducing trance, ecstasy, psychosomatic healing, and other psychic manifestations, not the least of which was a penchant for powerful image making.

The imagery of Native American wall painting is rooted, for the most part, in the shamanic vision quest. This was essentially a matter of free association with visual phenomena, or "psychic automatism" as the Surrealists called it. The totemic imagery found in such a quest became, for the shaman and his community, a symbolic matrix capable of integrating the individual with the oral mythology of the tribe. Needless to say, shamans had no self-conscious idea of free association. They simply saw the god, felt the site holy, and commemorated the vision with an image. It is from that pure, timeless, psychodynamic origin of art – and the religious impulse it has always served – that the aesthetic power of our continent's first murals is derived.

Stylistically, native art is often highly stylized and spatial, although seldom nonreferential, even when seemingly abstract. It is usually set on a neutral background, whether a cliff, kiva, house screen, or tipi. There is an almost complete lack of Western perspectival devices: diminution, overlapping, atmospherics, and so on. This art is direct, explicit, highly discrete in its elements, and unified by subtly occult symmetries that never permit the balance of a configuration to be taken for granted.

Native American art was never intended to be permanent. We idealize art, and find it hard to comprehend or countenance the systematic renewal or abandonment of murals for ritual or practical reasons. It is useful, perhaps, to recall that two Peruginos on the west wall of the Sistine Chapel were destroyed without a qualm to make room for Michelangelo's *Last Judgment,* and that a future pope valued propriety more than the art of Michelangelo when he draped the master's nudist colony of a paradise. But the fact remains that Native American art, as with all so-called primitive image making, was never intended to be institutionalized. The Indians did not value the thing, but the power it represented. Paradoxically, this purity of motivation almost always resulted in objects of extraordinary aesthetic power, for such quality is a function of the psychic authenticity and intensity that integrated its elements to wholeness. Native American murals radiate a certain awe-inspiring aura and display a natural rightness as they record the eternal present of those spatial universes in which Native Americans lived before the introduction of time and history as we experience them.

The Exterior Universe: Rock Art Murals

The rock art murals of the Southwest,[12] confusingly ubiquitous in their geographic distribution, nevertheless are found at their most artistically impressive in clearly defined exterior precincts, presiding over spaces that were obviously used for cult purposes. These earliest examples of our mural art embody the seasonal and cyclic patterns that were, for Native Americans, what we today call history.

The earliest surviving murals are found in the states of the Southwest: Utah, Nevada, Arizona, and Southern California. These works are either incised or painted on exterior rock surfaces, although some have been discov-

ered in the mouths of caves. Those incised are called *petroglyphs,* and are created with a variety of intaglio techniques that leave the image either graven, pecked, or stunned into the stone. Images painted with a variety of mineral or organic pigments are called *pictographs.* Occasionally these two techniques are used at the same site or even combined in the same image. Given the arid climate, they have survived for millennia. The pigment used in the pictographs inheres in the pores of the rock, which tends to give the painted surfaces a certain vividness in a raking light. The petroglyphic techniques, which can render sometimes surprisingly delicate lines, produce their effects in tonal contrast to the wall surface by cutting through the darker and denser "desert varnish" to reveal the lighter stone beneath.

It is clear that rock art is not just doodling. Its location near the runs of food animals or in imposing natural precincts, the evidence of both ancient and recent cult activity related to it, not to mention the imagination and skill involved in its crafting, all point to the reasons for its creation. Yet the precise intention behind any particular example can be elusive, and no one general theory, such as rock art being the records of migrating peoples, esoteric maps, the commemoration of important events, or a form of writing, however true in certain instances, can be universally sustained.[13] One scholar, approaching the problem from the native's point of view, states, "The idea that the Indian set out to record some knowledge for posterity . . . is a profound misreading of his mind, for he, like any 'early man construed his history on a cyclic basis, as opposed to a lineal perception of time.' He related, not to the unknown generations of the future, but to unseen, mystic forces that governed the world in which he lived."[14]

This sense of history as repetitive or cyclic order, not progressive events, provides at least three plausible contexts in which to interpret the meaning of prehistoric rock art murals – as well as those of the later tribes. The first would be ceremonial magic related to hunting, war, agriculture, and human propagation; the second, the spiritual realities of shamanic life: vision quests, initiations, and healing; and third, the involvement of cosmic phenomena in conjunction with the first two. Most scholars stress the importance of understanding shamanism, and the iconography related to it, for the interpretation of rock art,[15] so it is, therefore, not surprising that we find such a personage at the center of the first rock art mural to be considered.

Hunting Mural, Cottonwood Canyon, Utah, a.d. 1000 (Fig. 1)

This petroglyph is an excellent example of the Fremont style of rock art found throughout most of Utah, and named after Col. John C. Fremont, who explored the region in the 1850s. It can be dated roughly a.d. 950 to 1200.[16] It depicts a flock of some 36 mountain sheep consisting of 21 mature animals and 15 young, dominated by a hornèd shaman at the top, and attacked by hunters with bows and arrows. One of the mature sheep lies isolated from the flock in the foreground, perhaps meant to represent the first kill, and serves (like a fallen warrior in Uccello) to guide the eye up into the composition,

FIGURE 1

Hunting Mural. Cottonwood Canyon, Utah. Prehistoric people, c. A.D. 1000.

Collection U.S. Bureau of Land Management, Interior Department. Photograph by Leon C. Yost.

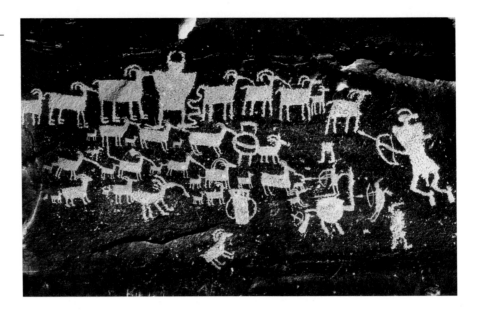

where we immediately see two mysterious humanoid figures, possibly drivers, standing one above the other amid the flock. To the lower right three (four, if the indistinct figure at the very bottom is included) of the hunters are grouped around a large round object with projections that probably represents a circular blind common in the region; a curious pair of disembodied legs (perhaps some residue of the shaman/artist's own vision experience) strides above these. To the far right a much larger, ithyphallic hunter, with a distinctive feather in his hair, kneels in ambush.

The most notable detail of this mural, however, is the linkage of the hornèd shaman to all the animals in the flock by a cord leading from his left foot (our right) that connects him to the tier of sheep at his left, which in turn makes contact with the tip of the large hunter's arrow. All the other mature sheep, and a few of their young, are either linked to him directly (as are the three to his right, the largest of which licks his shoulder) or from him to each other. That this linkage is intended is seen in the deliberate elongation of the snouts of some of the sheep to reach the tails of others – like elephants in a circus parade.

This mural, therefore, depicts the shaman's power over the animals, symbolized by the umbilical tether from his body to theirs. Like a great psychic magnet, he aligns the flock so all the beasts meekly face toward the hunters in ambush. Bighorn sheep are not prone to such docility when in danger. Their favorite habitat was the precipitous terrain of mountaintops.[17] This mural, then, is hardly a naturalistic rendering of such a hunt, but rather the entire configuration constitutes the hunters' fantasy of the perfect hunt – the ritualistic domestication of the prey, tamed by the power of the shaman and led by his tether to their death. Such an ideal rendering must have had a profound effect on the primitive hunters (as certain overly idealized history paintings of recent times can stir up our patriotic fervor[18]), preparing them psychologically for the rigors of the chaotic actuality they had to face to live. One can specu-

late that this hieratic image was used over a long period as a shrine – a place of preparation before the hunt, and possibly a place of propitiation after it, when the spirits of the victims, symbolized by the dead bighorn at the base of the mural, would be placated.

The location of this relatively small mural – about 6 feet across – is on an outcropping of rock that overhangs a present-day road along the west side of the canyon. The image faces a cleft in the opposite cliff to the East; the viewer faces West, the direction of opposites; the tamed animals face North to the hunters. The site contains numerous other images, with a row of pictographic discs to the South, and adjoining the main mural to the North, petroglyphs of snakes and a buffalo. Further North along the canyon wall are faint pairs of handprints raised as if greeting the rising sun. These scattered discrete images are beyond specific interpretation. They do emphasize by contrast the aesthetic unity and iconic legibility of this masterly mural.

Having seen a small regional example of this style, let us consider its origins by turning to an earlier and larger mural.

ROCHESTER CREEK, UTAH, C. A.D. 500 TO 1000 (FIG. 2)

At Rochester Creek one approaches the site along a north to south ridge that leads to a promontory in the center of the confluence of the Creek with Muddy River. One does not really see the site, since it is difficult to read the layout of the situation. You approach what appears to be a great pile of geometric rocks. Nearer, the rocks fall out into two rows, with a path or defile up between them to a higher point that proves, once there, to jut out into the center of an extraordinary space. Standing at the site, it is very plain that the

FIGURE 2

Fertility Mural.
Rochester Creek,
Utah. Prehistoric
people, c. A.D.
500–1000.

*Collection U.S. Bureau
of Land Management,
Interior Department.
Photograph by Leon C.
Yost.*

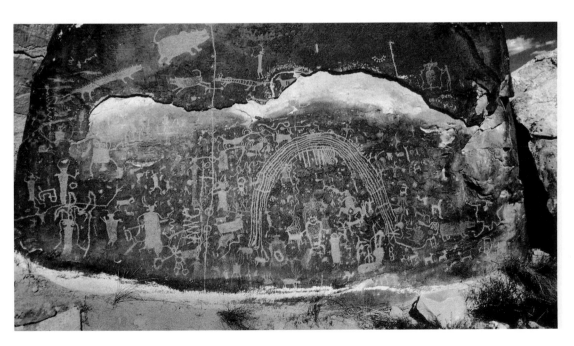

streams had eroded their way through an initial layer of rock – say 30 feet in depth – and then through further strata of rock and earth down about 300 feet. The initial layer was decidedly geometric in aspect, and the rocks that formed the top of the ridge site were of the same geometric kind as those which formed the topmost stratification of the vast sweep of the canyon walls that curved about to the East and West at the same height. These rocks formed, or may have been moved to form, what can only be called a primitive temple, with the walls of the major stones creating a slanting defile that led up to the elevated "altar" area. To the right as one entered the lower part of this precinct was the petroglyphic mural.

Facing East, as do most major rock art murals, one's first impression is of utter chaos as one looks West into its world of opposites. Careful examination reveals the wall, which is about 20 feet long by 14 feet high, to be divided almost exactly down the center by a continuous line toward the top of which is a bodyless humanoid figure with raised arms. To the open South of this line, near the start of the defile to the upper level of the temple, are numerous anthromorphs and fantastic animals, with several beasts of pronounced ferocity in the vicinity of the figure toward the top of the central line. To its left (i.e., to the North), the dominant motif is a mysterious arch of eight lines. Around this are grouped a profusion of mostly beasts and birds; within it are more discrete figures, including a male and female on the verge of copulation. What is going on?

Two things stand out as comparatively familiar. The central line bears seven circles superimposed on it, the last being the head of the figure at the top of the composition. One immediately thinks of the seven lotus centers of the Kundalini and their universal appearance in images of spiritual development. The line would be the figure's body, attenuated in the process of spiritual purification and forming a stabilizing axis for the surrounding chaos. The arch of eight lines and seven spaces suggests a rainbow, and the straight and curved lines dropping from beneath it, the familiar native image for the fertilizing rains. Beneath and to the right is the image of a sexually explicit female. One also thinks of the many images of the Egyptian sky goddess Nut, her body arching the earth, swallowing and giving birth to the sun, with nourishing milk falling from her breasts upon the crops. But aside from these comparisons, which take their validity from the obvious shamanistic origin of this wall and the symbolic parallels to be found in world religions,[19] one must leave to others a more specific interpretation, if such can ever be possible.

The images to be found in the defile proper are similarly universal in import and suggest that this "temple" was dedicated to fertility rites. The main mural, as noted, was given in part to this theme, but perhaps more striking was an image on the defile's left-hand wall that graphically depicted an ithyphallic male lying on the ground with a female leaping above him with her legs spread. If you stand with your head at this image and looked out through the crevice between the two enormous geometric rocks opposite it, you can see the western horizon, and well imagine the setting sun at some point in its yearly cycle, perhaps the dusk of the summer solstice, sending a shaft of red

light through that narrow crevice to unite the potential lovers – and thus symbolize the impregnation of the earth. (Given that the sun would be in the Northwest at dusk, it would be in the Southeast at dawn – suggesting some time in summer – perhaps at the equinox? But here one must defer to the archeo-astronomers, such as Anthony Aveni, who have been doing some of the best creative work in this field.[20])

It is clear that many of the pictographs contiguous to hunting sites can be construed as male and female symbols.[21] It is also useful to recall here that the largest hunter to the right of the Cottonwood Canyon mural was ithyphallic. The blood lust of the hunt can translate into sexuality, and the integration of sexual symbols with others related to hunting, sky watching, and agrarian fertility seems natural and necessary. So also was the sacrifice of the year king in Archaic Greece and the sowing of his phallus in the new-sown earth. For the hunter, ranging over the landscape for prey, the taking of life was balanced and propitiated by the engendering of life, which, in itself, was another manifestation of the Native American's sense of a cyclic "historical" process.

The Interior Universe: Pueblo Kiva Murals, *c. A.D. 1300 to 1475 (Fig. 3)*

For the primarily agrarian cultures of the Pueblo Indians, however, these complex and vital natural rhythms find a more interiorized expression in the murals painted over time on the underground walls of their kivas.

Although all the Southwest peoples created rock art, interior mural painting as we would recognize it is first found in the Pueblo cultures about A.D. 1000. It developed out of pictographs and initially consisted of essentially

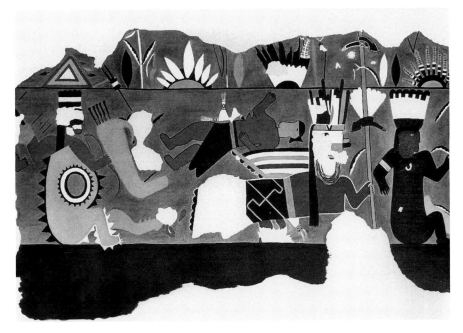

FIGURE 3

Kiva Scene. Pottery Mound, New Mexico. Anasazi, c. A.D. 1300–1475.

Courtesy K.C. Publications; © *Frank Hibben.*

decorative patterns and abstractions. It reached its pictorial peak about a century before the Spanish invasion.[22]

The oldest murals consist of those found in ceremonial kivas. These are either a rectangular, circular, or polygonal chamber about 15 feet across, which is most often partly or entirely constructed beneath the earth. It is entered through the roof by a ladder, the aperture for which also serves as a smoke hole for the hearth directly beneath it. To one side is a hole in the floor. To the other is a table-high deflector erected in front of a ventilator shaft to prevent the stream of air from extinguishing the fire. The walls of the kiva are usually of stone covered by adobe, with a built-in seating ledge. The roof is of logs covered in the same material. The ceremonies held within a kiva are carefully oriented to the cardinal points, as well as to the nadir and zenith, and the kiva itself is thus, according to Frank Waters, "a carefully constructed model of the universe." He goes on to explain,

In the floor is a small hole, the *sipapu*, leading down into the first underworld. The floor level is the second world into which man emerged. The raised seating ledge represents the third world. And the ladder rises up to the roof opening, the fourth world to which man has climbed. . . . In the kiva, man is ever reminded that he lives in the whole of the immense and naked universe. And he is constantly made aware of the psychic, universal harmony which he must help to perpetuate by his ceremonial life.[23]

Inevitably, such a place would be a site for image making, and archeologists have found a wide variety of wall paintings done in a fresco secco technique with natural pigments on the adobe walls. Each shaman would paint his own visionary version of the cult experience celebrated in the kiva, obliterating, in the process, that of his predecessor. By peeling away layer after layer of these primitive "frescoes," we can now see down into the "history" of these cults, and reconstruct their ever-evolving reinterpretations of the seasonal and cosmic cycles.[24]

The image here is from the ruins of an ancient Puebloan or Anasazi community, which is known today as Pottery Mound. It was chosen because it depicts a kiva ceremony involving either the healing or funeral of an Anasazi woman. She lies on an altar carried on the back of a masked priest. Other participants hold bows, arrows, a shield, a club, and staffs decorated with feathers and rattlesnakes. Headdresses and ceremonial implements can be seen on the shelf above the figures. The image is typical of the stark but elegant style of these murals.

The Domestic Universe – Pacific Northwest House Murals, c. 1835 to 1870

The Northwest tribes, coastal- rather than desert-oriented, elaborated a rich mythology couched in images of fish, birds, and beasts. For these peoples,

"history" was centered in an individual's or a clan's totemic identification with natural entities – the whale, the raven, the "thunderbird" – that provided a sense of origins, and in a culture of studied one-upmanship and status seeking, a sense of social continuity.[25]

The mural art of the Northwest coast tribes was essentially made to proclaim the power of its owners. Allen Wardwell puts the matter succinctly:

Although some examples of Northwest Coast art were purely utilitarian in their purpose, most of the art was made for heraldic display, for complex secret society initiation rites, or to represent certain spirit alliances on which a shaman would rely for magic and power in ceremonies which he performed. In the first category, the art reaches its most spectacular and monumental forms. Such creations as totem poles, house posts, grave markers, painted house fronts and screens, gigantic feast dishes and large carved and painted canoes were all made to impress those who saw them with the ancestry, status and wealth of their owners.[26]

This art is also more stylistically unified than that of other Native Americans. Its essential characteristics are a pronounced axial symmetry, an ingenious, elegant, and instantly recognizable formal complexity, and a penchant for metamorphic iconography. This last, perhaps most strikingly seen in shamanic transformation masks, which open to reveal a female within a male or a raven within a wolf's head, inheres in various forms throughout most of the monumental art. There is a constant interplay of what is within and without.

The Whale House of the Chilkat, c. 1800 to 1833 (Fig. 4)

The great housefronts and interiors of these peoples are elaborately carved and painted. One typically enters through an orifice of the animal portrayed on the exterior, into an interior space dominated by totem-pole–like houseposts, which hold up the roof beams. At the back of the main space is a house screen that leads through another similarly situated aperture into an inner chamber.

One of the most spectacular surviving house screens was made for the Whale House of the Tlingit clan known as the Chilkat.[27] It was at the back of a large communal house that measured about 50 feet square, and separated the chief's space from that of his extended family and the fire pit in the center of the outer room. The screen, known as the Rain Wall, measured 20 feet wide by 9 1/2 feet high. It did not reach the ceiling, thus allowing in some light from the smoke hole in the center of the roof. It was carved in low relief, and painted in black, red, and blue. The image is that of the Rain Spirit surrounded by crouching figures representing the raindrop's splashes – and thus is to be seen as from above. The carved housepost to the left tells the story of the clan's ancestor, a young girl who fondled a woodworm, nursed it to human size, and died of grief after her family killed the monster. This event led to the

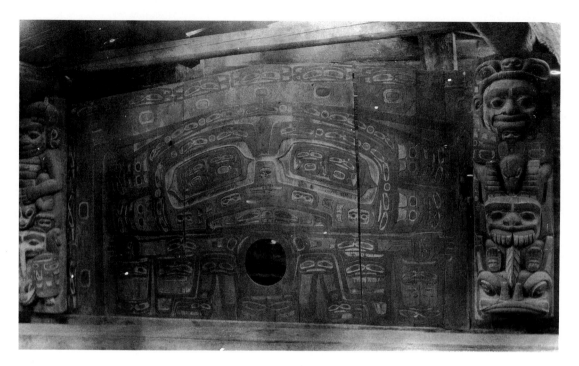

FIGURE 4

Rain Wall and House-posts. Whale House of the Chilkat. Tlingit people, Klukwan, Alaska, c. 1800–33. Houseposts attributed to the woodcarver Kadjisdu.axtc, who flourished c. 1810.

Collection undetermined. Photograph neg. no. 336140. Courtesy Department of Library Services, American Museum of Natural History.

migration of the clan to the site of the Whale House. The housepost to the right presents the clan's totem, the Raven, and relates how it cheated some birds out of feasting on the King Salmon, whose head is at the bottom of the post. These myths conveyed an important part of the clan's history, and dominated the iconography of its art.

Nootka Tapestry with Thunderbird and Whale, c. 1860 to 1870 (Fig. 5)

Similarly, a Nootka painted muslin tapestry shows the thunderbird of the upper world and the whale of the underworld in contention. The great eagle spreads out its wings, which bear lightning serpents, while the whale feeds on a creature and has wolves in its belly – perhaps the better to describe its character than its normal diet.[28] Joining both is a human figure, its head within the body of the thunderbird while its legs are within the whale, aptly situating humankind in its "historical" situation between the higher and lower depths of its cyclic world.

This tendency toward metamorphic symbolism is rooted in the mythology of these peoples – an important record of their sense of "history" – which has as its hallmark shamanistic visitations to the interiors of sea and forest where the mysterious powers of life and death resided. And the idea of ingestion cannot be separated from the great feasts or potlatches by which tribal leaders boasted of their mythic origins, showed off their wealth, and maintained their status.

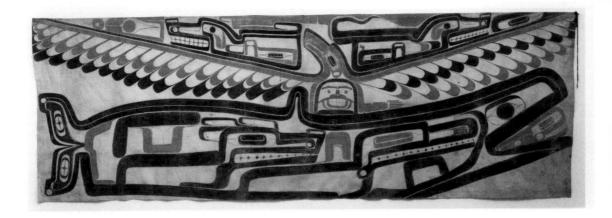

The Universal Hoop: The Painted Tipis of the Plains Indians, Second Half of the Nineteenth Century

FIGURE 5

Curtain with Thunderbird and Whale. Nootka. Nitinat people, Canada, West Vancouver Island, c. 1860–70.

The Menil Collection, Houston, Texas. Photograph by Hickey-Robertson.

The painted tipis of the Plains Indians, renewed each year, provided another approach to Native American sense of history: an emblematic display of the shaman's or warrior's latest dreams or exploits.[29] Some of these tipis graphically depict the death-rebirth experiences of the tribal shamans and the battles engaged in by the warriors. Indeed, some tipis from the late nineteenth century – such as Black Elk's described earlier – provide dramatic evidence of Native Americans' desperate battle against the "bluecoats" who were threatening their tribal existence. Here we obtain a glimpse of the "history" we usually associate with Western narrative art as it impinged on the "sacred circles" of these peoples and broke the hoop of their history.

Nomadic tribespeople, they carried their homes with them in the form of roughly conical tents called tipis. Made of buffalo hide stretched around a frame of poles, these collapsible dwellings were transported by dog sledges until the Spanish introduced the horse about 1600. When erected, tipis were entered through a door that always faced East, and were ventilated by a set of flaps at the top. The exterior sides of the tipi, echoing the all-encompassing round of the horizon, were sometimes emblazoned with images narrating the exploits or dreams of its owner. These designs were handed down through families, even though they were renewed each year as the skins decayed and the pictures faded. They were owned by important chiefs, war leaders, and shamans, and were seldom actually lived in except at tribal encampments, such as the famous Sun Dance, where each participant would wish to display his personal heraldry (like medieval knights at tournament). At times, special tipis were painted for ceremonial purposes. Although the Spanish explorers noted the existence of painted tipis in the late sixteenth century, and artists such as George Catlin recorded them in the 1830s, the transient nature of the art form leaves us today with detailed examples that date only from late nineteenth-century models and accounts of the originals, aside from early depic-

tions in anthropological surveys. The best record of them is a group of models made for the Smithsonian ethnologist James Mooney long after the originals had vanished, and published by John Ewers as "murals in the round." They are shown in Figures 6 and 7, laid out flat. Since the straight top of the half circle represents the east face of the tipi, where the door flap would be located, the left side would thus have faced North, the often divided center West and the right South.

Because the imagery on most painted tipis was dreamed or envisioned by its first owner and was thus psychodynamically specific to him, it is difficult to assign meanings to particular patterns or motifs. Certain overall configurations tended to be repeated, the most popular being a lateral tripartite division from top to bottom, with the central register the usual zone of pictorial motifs. Tipis painted a solid color, or divided down the west side, were numerous; rarer were those whose design consisted entirely of stripes.

Fair-Haired Old Man's *Leg Painting Tipi*, c. 1830 (Fig. 6)

This tipi was conceived in a dream by Fair-Haired Old Man, who later gave it to another Indian before 1857; it may have been remade by a son of that friend as late as 1890, and was later described to Mooney. The imagery, painted on plain hide, consisted of disembodied pairs of arms and legs with circles and feather tufts at the joints, blue to the South and red to the North. There is a row of ten red tobacco pipes down the west side, and a small animal with a blue circle is toward the Northwest. The eastern door is edged with two rows of a dozen feathers each.

This most unusual of Kiowa tipis most likely represents the vision of

FIGURE 6

Leg Picture Tipi of Fair-Haired Old Man. Kiowa-Apache people, United States, first half of nineteenth century. Rendering in miniature from verbal account of tipi as it was seen c. 1890.

Catalogue No. 245,024, Department of Anthropology, Smithsonian Institution, Washington, D.C. (neg. no. 77-7712).

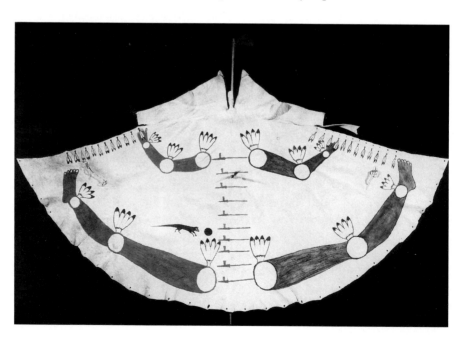

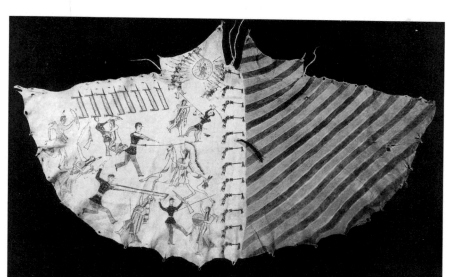

FIGURE 7

Little Bluff's Tipi with Battle Pictures. Kiowa-Apache people, United States, c. 1860s. Rendering in miniature from earlier reproductions.

Catalogue No. 245,001, Department of Anthropology, Smithsonian Institution, Washington, D.C. (neg. no. 77-7705).

physical disintegration typical of shamanic initiation (see p. 23), and would suggest that its originator was adept at healing and took as his heraldic totem his own limbs embracing the circle of his home.

LITTLE BLUFF'S *TIPI WITH BATTLE PICTURES*, C. 1845 TO 1890 (FIG. 7)

This was the last surviving tipi from the Kiowa that Mooney saw when he began his studies. Its provenance could be traced to the Cheyenne about 1845, and it was last lived in during the winter of 1891–2. The yellow stripes on the southern half, which seem to have been a record of successful battles, were apparently already on it when it was received from the Cheyenne to commemorate a peace treaty with that tribe. Little Bluff added the black stripes to represent war parties he led. The series of a dozen tomahawks and eight lances had similar quantitative meanings. The battle scene on the northern side was changed with nearly every renewal of the tipi and those seen on the model were probably invented, although certainly recollective of those last encounters with the U.S. Army in the late 1880s that led to the tribe's defeat and transfer to a reservation. There, they no longer needed their portable tipis and, being perishable by nature, few painted ones have survived.[30]

Conclusion

To sum up, one might say that in the exterior universe of the earliest primordial tribes, history did not exist. Only the mythogenetic powers of the shaman imposed an order on the vast world of space and sky, in part by creating exterior murals that provided environments for hunting and fertility rituals. The directional coordinates, correlated with the seasonal agricultural cycle, pro-

vided the spatial locus of an ever-renewing present, which became for the later tribes the basis for whatever immediate sense of "history" they may have had.

For the Pueblo peoples, a sense of history is found in the highly developed mythos of the community, symbolized by the continuity to be found in the interior universe of the kiva murals and the sequence of their image layers.

The Northwest peoples, placed by circumstance between the two vast and mysterious depths of forest and sea, imaged their actual and mythic environments within the domestic universe of their walls – literally passing through and into their totemic world.

For the Plains tribes, the universal hoop, so literally depicted in the shape of tipis emblazoned with their occupants' heraldry, gave them a center in space if not in time, and time eventually overwhelmed them.

These tribal universes were suppressed as the inevitable result of the incursion of European culture onto the continent. Indeed, on April 16, 1605, Don Juan de Oñate, the Spanish governor of New Mexico, on returning from discovering the Gulf of California – and soon to bring the Pueblo people under his rule – had carved on a cliff at El Morro in western New Mexico, a place once inhabited by the earliest of the primordial tribes, the news of his feat. The boastful inscription obliterated an ancient petroglyph.[31]

The very same year, Cervantes published the first part of his Don Quixote, Shakespeare produced *King Lear* – and James I granted a charter to the Virginia Company to colonize those new lands Sir Walter Raleigh had named after his "virgin" queen. Two years later, Capt. John Cook and a band of English worthies greedy for gold founded the first English settlement at Jamestown, Virginia – with the result that, roughly a century and a half later, the history of American history painting, as we have come to understand such matters, officially begins with images of Native Americans kneeling before, or killing, their conquerors.[32]

John Trumbull, Historian
The Case of the Battle of Bunker's Hill

CHAPTER
2

Patricia M. Burnham

*A given socio-historical moment is never homogeneous; on the
contrary, it is rich in contradictions. It acquires a "personality"
and is a "moment" of development in that a certain fundamental
activity of life prevails over others and represents a historical
"peak": but this presupposes a hierarchy, a contrast, a struggle.
The person who represents this prevailing activity, this historical
"peak," should represent the given moment; but how should one
who represents the other activities and elements be judged? Are
not these also "representative"? And is not the person who
expresses "reactionary" and anachronistic elements also represen-
tative of the "moment"? Or should he be considered representative
who expresses all those contrasting forces and elements in conflict
among themselves, that is, the one who represents the contradic-
tion of the socio-historical whole?*

– Antonio Gramsci[1]

The American Revolution in all of its ambiguity, complexity, and contradic-
tions presents an enormous challenge to historical understanding. In their
efforts to reconstitute the "truth" of that era, historians have grappled with
such questions as to what extent it was a revolution at all, the influence of
English political thought, the lag between developments in the political and
cultural spheres, and related issues. Of particular use in their task have been
the memoirs and histories of the war constructed by people of the period.

The work of the artist John Trumbull (1756–1843) provides a particularly
revealing set of interpretations of the armed struggle for independence. A
member of a politically engaged family, he served briefly as an officer during
the war and in the diplomatic corps afterward. Building on such experiences,
he painted four of the eight paintings in the rotunda of the U.S. Capitol, which
thematize the Revolution. The paintings on the Revolution for which he is best
known are the set of eight at the Yale University Art Gallery, three of which
depict major military encounters.[2] Trumbull also wrote about the Revolution

37

in the autobiography he fashioned toward the end of his life and in catalog notes he created to accompany exhibitions of his Revolutionary War paintings.[3] In his introduction to the catalog of 1832, he defined his goal as that of "graphic historiographer" of "the great events of the time" (p. 3).

My reading of one of the eight small canvases, *The Death of General Warren at the Battle of Bunker's Hill, 17 June 1775* (1786) (Fig. 8), and of the catalog notes that were written as a complement to it, seeks to understand Trumbull's ability as historian in text and image, and to situate his interpretation of that event in terms of historiography, artistic convention, and biography, as separate but related processes.[4] Trumbull images not just the death of a single hero, a specific battle, or even war more broadly understood, but the hesitancies, anxieties, and ambiguities of a congeries of people poised between colony and nationhood. Far from creating a "master" narrative of the American Revolution with full explanatory power for future generations, Trumbull instead constructed an image and text that, although informative and persuasive, were necessarily partial and incomplete.

The battle itself was fought at the beginning of the war, only two months after Lexington and Concord, on Breed's Hill near Charlestown, Massachusetts.[5] The British Army, licking its wounds in Boston after the Lexington/Concord engagement, decided to extend its reach by seizing the peninsulas at Dorchester and Charlestown. News of the plan reached the Americans, who reacted by setting up defenses at both sites. Overlooking Charlestown and the

FIGURE 8

John Trumbull. *The Death of General Warren at the Battle of Bunker's Hill, 17 June 1775.* 1786.

Yale University Art Gallery. Trumbull Collection.

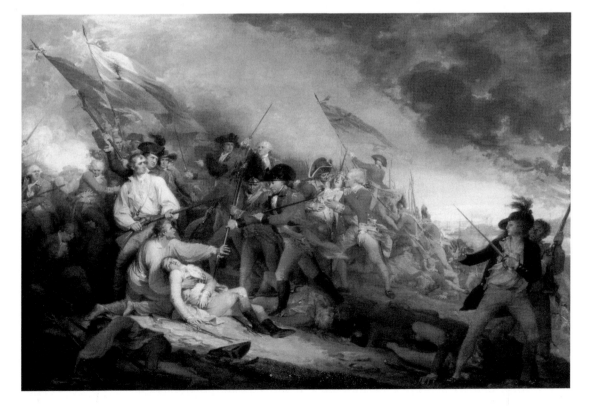

harbor, they built a redoubt on Breed's Hill. The British, who tried to retaliate without success by firing from warships in the harbor, decided finally on a frontal assault with troops. General Howe crossed the harbor and landed on the northeastern tip along the shore of the Mystic River. He made two desperate tries to climb the hill, taking many casualties in the process. (In the meantime, the warships set fire to the town of Charlestown.) Howe succeeded with the terrible, murderous third charge. The British took the hill and the patriots retreated. The colonists, who had the advantage of high ground, essentially lost because they ran out of ammunition. No one is quite sure what would have happened if the ammunition stores had been full.[6] At the time, Trumbull himself was attached to the First Regiment of Connecticut troops under Gen. Joseph Spencer stationed across Boston at Roxbury, where he observed the progress of the battle with field glasses. "The roar of artillery," he remarked, "the bursting of shells . . . and the blazing ruins of the town, formed altogether a sublime scene of military magnificence and ruin."[7]

The casualty figures are horrendous. Of the approximately 1,600 Americans, 441 were either killed, wounded, or captured. The British lost 40 percent of their men. Nineteen of their officers and 207 enlisted men were killed, and 758 wounded. Especially heavy were losses in the officer class – one-eighth of all of their officer losses in the Revolutionary War.[8] The *Annual Register* in London for 1775 lamented, "Thus ended the hot and bloody affair of Bunker's Hill, in which we had more men and officers killed and wounded, in proportion to the number engaged, than in any other action which we can recollect."[9] The British lost Lt. Col. Sir Robert Abercromby and Maj. John Pitcairn; the Americans lost Gen. Joseph Warren. The British were stunned at their losses and amazed at the strength and tenacity of colonial resistance. The Americans, at first embittered because of their defeat, eventually came to understand what a moral and psychological victory they actually had won. As the *Annual Register* stated, "They had shewn a great degree of activity and skill in the construction of their works; and of constancy, in maintaining them under many disadvantages. . . . though they had lost a post, they had almost all the effects of the most compleat victory; as they entirely put a stop to the offensive operations of a larger army sent to subdue them."[10]

In terms of the military history of the war, the battle of Bunker's Hill stood out from among the other major engagements in several ways. Inspirational though it may have been, it lacked major strategic importance. It was a militia action undertaken before the formation of the Continental Army. Perceived, therefore, as an amateur effort by yeomen fresh from the fields, it fed the myth Americans later created for themselves that innocence and moral superiority counted for more than military professionalism. The battle was also pre-Washington; to be more precise, Washington had been chosen to head the Continental Army on June 15 but did not arrive in Massachusetts until July 3. Therefore it neither took from nor added to Washington's reputation. The moment was also prerevolutionary. The American combatants at Bunker's Hill were not consciously fighting for independence but for justice

and fair treatment by the English. The decision to separate was yet a year away. Yet this battle, despite such particularities, has served as the paradigmatic image of the Revolution because of the fame of Trumbull's painting.

John Trumbull painted *The Death of General Warren* in Benjamin West's painting room in London in 1786, when he was thirty, three years after the conclusion of the war, eleven years after the battle took place. In 1780, with the war still in progress, he had made the audacious decision to study with West in London, which ended in his imprisonment and expulsion on charges of spying. As soon as peace was declared at the end of 1783, he returned to England and to West. It was West who proposed to him that he consider doing a series on the American Revolution. His first sketches date from 1785; he began the painting later that year and completed it in March of the following year (it is signed and dated 1786).

A quick review of the narrative sequence in the painting indicates the following. Red-coated British troops ascend the hill from the water in the center and tumble into the foreground of the picture. Sword piercing the sky, Colonel Putnam of Connecticut sounds the retreat at the far left. Flames erupt from burning Charlestown at the right. In the lower right-hand corner, Lt. Thomas Grosvenor of the Third Connecticut Regiment, wounded in the hand, pauses. He is accompanied by his "negro servant." Another African American appears as a hatted head visually pinioned between the upraised arm of the chaplain from New Hampshire and a British officer at the upper left (Fig. 9). The principal action involves six characters: three British officers at the right and three Americans at the left, focused on the dying hero, Dr. Joseph Warren. Abercromby's dead body parallels Warren's at the right. Pitcairn is shown dying in the arms of his son just above. A remarkable secondary action is taking place around Warren: An American subaltern joins forces with British major John Small to prevent an unidentified British officer from bayoneting Warren.

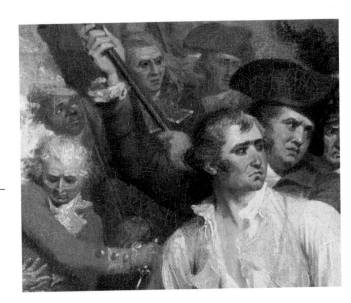

FIGURE 9

John Trumbull. *The Death of General Warren at the Battle of Bunker's Hill, 17 June 1775* (detail).

Photograph by Carl Kaufman.

The catalog description scans differently. It makes grand leaps from the general to the particular, from the high-blown rhetoric that Trumbull seems to associate with historical writing to details of battle tactics. In this, the first of eight entries, he takes on the entire Revolution as subject, beginning by extolling the virtues of democracy. He moves quickly from this opening statement on the importance of the Revolution to world history to mention of a governmental measure that accelerated the conflict, to the conflict itself as it began at Lexington. His summary of the action on Bunker's (Breed's) Hill is remarkable for the precision of its description of logistics and topography. Inserted at this point in the text, like a small cameo, is a paragraph devoted to Joseph Warren (p. 9). It eulogizes without dominating. Trumbull then mentions the painting for the first time, letting us know that Warren's death "is the moment chosen for the painting." He tells the reader that "of course" the depiction is limited to "that part of the scene" where the action takes place, implying the reader's knowledge of neoclassical historical composition without further comment or theorizing.

In the following paragraph, he widens the "moment chosen" to include that time in the battle when "the British troops became completely successful and masters of the field" (p. 10). Here he also explains briefly the secondary action as an act of magnanimity on the part of Major Small (see later). This is followed by identification of some of the historical personages represented. He ends with casualty statistics culled from the *Annual Register* [London] of 1775. His last sentence states that he had been an eyewitness to the event. He does not, for once, exaggerate the importance of his combat experience, but the implication is clear that the artist's personal witness (even though from a distance) adds to the authenticity of the visual/verbal account and thereby to its historicity.

The title that Trumbull gives the painting in the catalog is *The Battle of Bunker's Hill, June 17th, 1775* (p. 7). Its official title at the Yale University Art Gallery is *The Death of General Warren at the Battle of Bunker's Hill, 17 June 1775*, which emphasizes the death-of-a-hero motif. Theodore Sizer's catalog raisonné lists it under a similar title (although the caption for the illustration is closer to Trumbull's).[11] The other two death-of-a-hero references in the catalog notes bear the names of the fallen generals in their titles – all of which indicates that there was some confusion in Trumbull's mind as to which "moment" he really wished to emphasize in this picture. The double "moment" referred to in the notes is readily apparent in the picture, a point to which I return later.

Trumbull's verbal text is a tour de force. It appears to be truly original and not one of the plagiarized accounts so common in the immediate postrevolutionary years. Certainly the "voice" is authentic Trumbull – sturdy republican prose embellished from time to time with eighteenth-century fustian and furbelow. Trumbull shows himself to be a thoroughly competent historian, especially of military action. He thinks like a historian – sequentially, causally, comprehensively, morally – and evidently takes great pride and conscious satisfaction in doing so. The length and substance of his commentary are especially impressive when compared to similar efforts by others. The verbal text

accompanying John Singleton Copley's *Death of Major Peirson*, for example, is considerably less intellectually ambitious.

Embedded in the opening paragraph of the catalog notes is a reference to the divine: "The experiment [democracy] is sublime – has hitherto proved successful; and may Providence secure its lasting success . . ." (p. 7). This is the one place in the text where Trumbull permits himself to make a connection between Divine Providence and historical outcomes, the kind of biblical typology that characterized his overarching view of life and history. He tended to express himself more freely in private correspondence, as can be seen in an excerpt from a letter to a family member in which he hoped to

be spared to complete the work, for the accomplishment of which I seem to have been sent, & continued here. – that is – to shew to posterity the wonderful things which it pleased God to do for our Fathers. – for it was not their own wisdom, nor the strength of their own right hand, which founded & reared the mighty fabric under which we live.[12]

This part of himself – the Puritan legacy of his ancestors – coexisted sometimes easily, occasionally uncomfortably, with his other self, which was that of a thoroughly modern person with Enlightenment values. The fact that the rest of the catalog text reads like late Whig/early Romantic historiography is thus not surprising.

The profound regard Trumbull showed for the (secular) discipline of history can paradoxically be understood as expressive of his religiosity. As political scientist Anne Norton observes about the neo-Puritans of Trumbull's generation, "[History] partook of the nature of Scripture, revealing to man the divine will by inscribing it in the material world."[13] (Re)inscribing the divine will in the interrelated texts of history painting and historical writing would thus have been an act of deep piety for Trumbull – which may or may not explain why he produced such a lengthy written text. The catalog notes constitute much more than simple exegesis of the painting or even extended (con)text and can stand by themselves as historical commentary. The content of the notes sometimes parallels but often widely diverges from the text of the painting itself. Which returns us to the task of reading the painting.

If Trumbull had been primarily interested in communicating the overall facts of the battle, his painting might have looked like a more sophisticated version of *The Battle of Bunker Hill, 1776*, by Winthrop Chandler (1747–90) (Fig. 10). Chandler's painting, although naive and unconvincing in its depiction of the action, nevertheless gives an impression of the whole that Trumbull's painting lacks. Trumbull preferred to concentrate on the single moment (or moments, as we have seen) that focus on the death of the martyr-hero. In so doing, he aligned himself directly with the practice of the two Anglo-American artists who dominated history painting in England at this time, Benjamin West and John Singleton Copley. Of the two prototypes, West's *Death of General Wolfe*, 1770, and Copley's *Death of Major Peirson*, 1782–4, the *Death of Major Peirson's* greater animation, more realistic battle action, and richer color have obviously influenced Trumbull more. Trumbull took pains to put his own

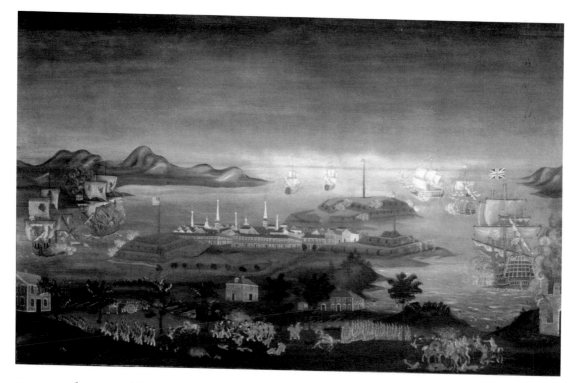

FIGURE 10

Winthrop Chandler.
*The Battle of Bunker
Hill, 1776.*

*Gift of Mr. and Mrs.
Gardner Richardson.
Courtesy Museum of
Fine Arts, Boston.*

stamp on the type – his action is closer to the viewer, the violence more pronounced, the reds even redder, and so on – but he remained committed to the models established by West and Copley compositionally and conceptually. He did not wish merely to transmit information about the event as Chandler had but to inspire the viewer about heroic death for a sacred cause.

Trumbull found an authentic hero in Joseph Warren III (1741–75). Warren's American ancestors were of modest origin; only in his father's generation did the coveted leap to gentleman take place. Joseph Warren himself, a Harvard graduate, became a prosperous and highly esteemed physician in Boston. His political activities began as early as 1765 with the passage of the Stamp Act. Appointed to the Committee of Safety after the Boston Massacre in 1770, he made his greatest intellectual contribution to the Revolution by his authorship in 1774 of the Suffolk Resolves, a paper that argued for revolution. Just a few weeks before the battle of Bunker's Hill, he was chosen president of the Provincial Congress of Massachusetts, and he was named major general the day before he was killed. His death assumed special poignancy because of his young age (he was only thirty-four) and the fact that his participation in this particular battle was not strictly mandated.[14]

Warren's death occurred just after Putnam called for retreat. As soon as British bayonets began to hit their mark, Putnam decided to get his men out but Warren didn't make it. He was felled by a musket ball to the head and probably died immediately, certainly without the protective encirclement depicted in the painting. The body was buried with all the others by the British on the field. It was not until a year later, when Boston was recaptured,

that an official entourage dug it up and buried it with honors in the Granary Burying Ground.[15] Rumors circulated at the time that the British had cut off Warren's head in a mad fit of vengefulness. Abigail Adams even wrote to her husband that "the savage wretches called officers consulted together and agreed to sever his head from his body and carry it in triumph to Gage," but there is no evidence that this happened.[16] If Trumbull knew of the rumor, he ignored it in the painting (and the text) – either because he considered it untrue or ignoble (or perhaps untrue because ignoble).

Warren was valorized in sermons, annals, histories, poetry, music, and drama. There are even towns named after him, such as Warren, Pennsylvania. Invariably, three kinds of characteristics were noted: his personal graces, participation in revolutionary activities, and social rank. The English historian William Gordon rhapsodized about his "powers of speech and reasoning," "his engaging manner," and how "the ladies pronounced him handsome."[17] Even the democratically minded American historian and litterateur Mercy Otis Warren (who was related to Joseph Warren by marriage) remarked that "he was the first victim of rank that fell by the sword [sic] in the contest between Great Britain and America."[18] Although likewise impressed with these qualities, Trumbull in the catalog notes is comparatively reserved, noting only that Warren was an "eminent physician . . . an ardent and eloquent supporter of the rights of his country" (p. 9). Within the painting and the group of paintings of which it is a part, however, Trumbull makes it quite clear that the most significant and compelling heroes are those of elevated rank.

Gentlemanly conduct – second only to heroic death as a principal theme of the painting – is seen in the gesture by British officer Small preventing Warren from being bayoneted. In the catalog notes, Trumbull describes the incident:

Colonel Small (whose conduct in America was always equally distinguished by acts of humanity and kindness to his enemies, as by bravery and fidelity to the cause he served) had been intimately connected with General Warren – saw him fall, and flew to save him. He is represented seizing the musket of the grenadier, to prevent the fatal blow, and speaking to his friend; it was too late; the general had barely life remaining to recognize the voice of friendship; he had lost the power of speech, and expired with a smile of mingled gratitude and triumph. (p. 10)

The incident did not take place as depicted, however. Warren's nineteenth-century biographer Richard Frothingham reported a different version, that the friendship was actually between Small and General Putnam (who served together in the Seven Years' War, as had many of the antagonists), that Putnam saved Small's life, and Small, "out of gratitude, endeavored to save Warren's life" but arrived too late.[19] Years earlier, William Dunlap recounted that it was Putnam who had performed the chivalrous act on behalf of Small, and expressed anger that Trumbull had seen fit to reverse the circumstances.[20] Benjamin Silliman, husband of Trumbull's niece and close friend during the artist's declining years, asserts in his memoir of Trumbull that the artist made

up the incident out of whole cloth. Silliman quotes Trumbull as describing the Small incident as a "pictorial liberty" – "analogous to the licentia poetae . . . the scene was introduced to afford an opportunity to do honor to Major Small who . . . was distinguished for his humanity and kindness to American prisoners."[21] Thus Trumbull set himself up as judge and jury in an artistic court of justice, meting out pictorial rewards and punishments. Even though Benjamin West on an earlier occasion had justified a similar embellishment of the death scene of Wolfe by invoking the principle of a "higher" level of truth, Trumbull's little deceit comes as a surprise, probably because of his known penchant for exactness in details. But as Trumbull scholar Irma Jaffe wrote in 1975, "What mattered to Trumbull . . . was not the outcome, but the behavior of the participants. He was concerned with personal morality as the virtue of the aristocratic and wealthy, and as an attribute of the officer class, whether British or American."[22] The conscious construction of the episode on Trumbull's part alerts the viewer to another possibility – that gentlemanly ways are also being contested in this revolution. More than Warren is dying on the battlefield. Class relations are also in the process of dissolution, not as an acknowledged goal of the Revolution (especially so early in the war), but as a potential offshoot of the struggle. The fear and anxiety of the ruling class in the colonies are here expressed. How far would this rebellion go? For whom, by whom, was it to be? Would magnanimity to the people of one's class, or in this case, to the officer class, continue into the future? Could such a gesture as Major Small's survive the battle of Bunker's Hill and the American Revolution?

The enactment of the incident on canvas plays out these and other currents. The young men close to Warren provide the other half of the dialectic between the "cool" magnanimity of gentlemen officers and the "hot" ardor of the revolutionaries. Captain Knowlton's emphatically aggressive stance, bared chest, and flushed cheeks epitomize the patriotism of the young colonials and their will to win. His bullnecked compatriot holds Warren tenderly with one arm as he indignantly pushes away the bayonet with the other.[23] Muscles swell his shirt, pure energy surges through his ballooning sleeves, righteousness covers his countenance. The patriots are characterized as young, strong, and virtuous. It is significant, however, that the protective impulse toward Warren, shielding him from the ignominy of the bayonet, is jointly shared – by the generous-minded British officer as well as the zealous young patriot, as if the two parts of John Trumbull were vying for supremacy – that which remained unabashedly British and identified with the officer class and that part of him which was resolutely American.

Scripted into the role of the subaltern who so defiantly repels the bayonet is a significant counter indication, however. The kneeling pose he assumes to cradle the head of Warren almost suggests "feminized" tenderness, meekness, and submissiveness. Furthermore, he is shown as barefoot. A possible answer from social history and material culture might be that the day of the battle was insufferably hot. The soldiers in actuality did not remove their shoes to fight, of course, but one can imagine Trumbull using barefootedness to indicate heat

(neither of the other two battle paintings in the series shows barefooted combatants). A second possibility emerging from source finding in art history might note Trumbull's reliance on the Bartoli engravings after Trajan's Column, one of which shows a barefoot Roman soldier kneeling on both knees.[24] But this explains too little and ignores the metaphorical implications of Trumbull's choice. It is more likely that Trumbull intended the bare feet to proclaim the virtues of the patriot soldiers – their innocence, humble status, vulnerability, and willingness to serve. Through artistic precedent as well as sacred Scripture, he would have been aware of the charged meaning of barefootedness – Moses removing his sandals, the humble Virgin, Bernini's discalced Theresa, and so on.

Bare feet occur often in Trumbull's oeuvre, partly because he did so many religious paintings. Usually they were shown as the appendages of supplicants (many of whom were women). In the same year he painted *The Death of Warren*, Trumbull made a little drawing, *The Death of Hotspur*, that shows a man kneeling over Hotspur's dead body. The fictional character de Wilton kneels to accept knighthood in a later painting. Probably the best known of Trumbull's kneeling figures is the adulteress in *The Woman Taken in Adultery*, 1811, who kneels to accept forgiveness from Christ. From the general pattern that he established, one can conclude that Trumbull equated bare feet with humility and general piety, worship of God and sacred occasions. In the *Death of General Warren*, the discalced motif is part of a larger symbol system worked out by Trumbull that declares the ground of Bunker's Hill sacred, the dying general martyr, and the subaltern a devout attendant in the Christian tradition.[25] Just as General Wolfe died in the Lamentation pose in the painting by West in 1770, so does Warren. Contradicting the message that this is a war conducted by class equals who perform virtuous deeds on each other's behalf is this second communication – that here is a deadly serious conflict in which God is on the side of the martyred general and his "holy" attendant. The effect within the painting of Trumbull's playing to class interests and invoking the deity in the same intricately plotted space is to strike a discordant note and dilute the force of the narrative. Ideologically, however, it makes perfect sense, for it expresses class tensions between 1775 and 1786 as Trumbull would have experienced them.

The reference to religion looms larger in the painting than in the catalog notes. Ironically, the visual language that Trumbull uses cannot be associated with the kind of dissenting Protestantism that Trumbull represented, but derives instead from classic Catholic-Christian iconography. The use of such language, so long banned in England, had recently been relegitimized in the writings of Sir Joshua Reynolds and the paintings of Benjamin West. Their enormous contribution to the revival of religious art in late eighteenth-century England cannot be overestimated.[26] West's use of the Lamentation motif in *The Death of General Wolfe* seems awkward and contrived, however, as if he lacked complete confidence at that early stage either in art as a vehicle of religious emotion or in the infusion of a secular event with religious meaning.

There is less awkwardness in Trumbull's rendering, by contrast, partly because the pose of the dying hero is decidedly less wooden and more realistic, but also because the religious reference is more subtly indicated. The irony here is that, even in dealing with matters so close to his heart as God's blessing on the American enterprise, Trumbull appropriated lessons learned in England.

The presence of African Americans in the painting presents different issues from those of class relations and religious allusions. It directs the attention of the viewer to one of the most vexing problems that faced the country on the eve of its liberation from tyranny – its enslavement of an immense number of black Africans. The placement of the two African Americans in the picture has been carried out with singular eighteenth-century discretion. Their participation is neither denied nor emphatically affirmed. Trumbull includes the African Americans but marginalizes them: The person at the left is barely visible and the one at the right is, typically, shown behind and slightly lower than his white counterpart.

It is estimated that of the 300,000 soldiers who served in the war, 5,000 were African Americans. Thanks to modern research, we know by name at least fourteen African Americans who fought in the battle at Bunker's Hill, from both Connecticut and Massachusetts.[27] African Americans had been forbidden by law to participate in militia activities ever since the seventeenth century, but in fact they fought in all of the colonial wars, including the recent French and Indian war. During the freewheeling days of the early part of the Revolutionary War, African American help was welcomed. Washington's Council of War declaration on July 9, 1775, however, forbade African American enlistment; this policy was reversed only when the British offered freedom to slaves who would fight for them. By the end of the war black participation was so numerous in some of the northern states that there were black companies, in one case in Massachusetts under the leadership of a black officer. Most of Connecticut's militia companies included at least one African American, probably including the First Regiment in which Trumbull served.[28]

Shortly before the battle of Bunker's Hill, the Committee on Safety headed by Dr. Warren and John Hancock declared that only free blacks would be permitted to fight, since the involvement of slaves would be "inconsistent with the principles that are to be supported."[29] Yet this policy was not followed in its entirety, and slaves as well as free blacks fought – side by side, it should be noted, with whites. At Bunker's Hill, two African Americans made reputations for themselves for daring and bravery: Peter Salem for allegedly killing Major Pitcairn, and Salem Poor, who was possibly responsible for the death of Lieutenant Colonel Abercromby. In his 1835 recounting of the battle, Samuel Swett recalled that the surviving members took up a collection to reward Peter Salem and later recommended him for special commendation to General Washington.[30] Both Peter Salem and Salem Poor were former slaves who received manumission at the time of their enlistment.[31] It is possible that Trumbull had either or both of these persons in mind when he included the black at the upper left of the picture. If so, he withheld from the picture the

kind of attention that their feats were accorded in the press and subsequent histories. Instead, he foregrounded the African American who was in a position of subservience.[32]

Who, then, was this person? The figure has consistently been misidentified over the years as Peter Salem, which is an impossibility for many reasons, the most likely being that, as a soldier in Massachusetts, he would not have been serving under an officer from Connecticut.[33] In the catalog notes, Trumbull refers to the figure as "a faithful negro" attending a "young American" (p. 11). The Caucasian has since been identified as Lt. Thomas Grosvenor (1744–1825), a thirty-one-year-old Yale graduate and practicing lawyer from Pomfret, Connecticut, who served with the Third Connecticut Regiment.[34] Neither the name nor the exact status of the "faithful negro" has been established with certainty, although David O. White has concluded that the man was indeed Grosvenor's slave.[35] It is certain that Grosvenor was a slave owner at one point because the first national census of 1790 so indicates; but no link can be made between the census list and the figure in Trumbull's painting.[36] To the contrary, in his memoir of Trumbull, Benjamin Silliman goes out of his way to characterize the "faithful African attendant" as "a brave man and not a chattel," repeating information that would have been given him by Trumbull.[37] It is possible that, whatever the objective circumstances, Trumbull thought of him and presents him to the viewer as free.

Slavery and race were obviously on Trumbull's mind when he painted *The Death of General Warren.* There would have been no public outcry or critical outrage if he had failed to acknowledge an African American presence; his inclusion of not one but two armed African Americans can be understood therefore as satisfying some internal necessity. In his self-appointed role as arbiter of pictorial rewards and punishments, he seems to have wanted to "reward" the African Americans for their valor and perhaps also to comment on the scandal of slavery among a people striving for freedom. Trumbull's voluminous writings, including the catalog notes, contain no mention of slavery. The visual record in this painting only hints at the problem. His equivocation is a manifestation of his personal limitations and also the contradictions in the culture itself. The positioning of the two figures tells its own story: the one, fully integrated and involved in the action, but almost invisible; the other, at the extreme other end of the picture, forthrightly and vigorously portrayed, but tied by an unspecified bond to a white person. Not for nothing did Alberti emphasize the centrality of composition to *istoria.*

But there is more to the story of race at the battle of Bunker's Hill even than this. African Americans were a visible and vocal component of life in Boston. The first victim of prerevolutionary violence at the Boston Massacre in 1770 was the former runaway slave Crispus Attucks. In 1773 a group of slaves petitioned the General Court of Massachusetts for release from slavery through the judicial system. It is estimated that one of every five households in Boston owned at least one slave.[38] Joseph Warren joined their number in 1770 when he purchased a "Negro boy."[39] In the painting, Warren functions as the

psychological, dramatic, and spiritual crux of the action, but he can also be understood as the still center around which the narrative of slavery comes full circle. Once again, the placement of the figures is all-important. The African Americans exist at the periphery of the picture; the symbol of the paradox of their situation lies at its heart.

The Death of General Warren is a careful survey of the political landscape of the time, offering significant glimpses of class and race relations. I would argue, however, that its ideological content exists at an even deeper level. Above all, The Death of General Warren pays homage to an institutionalized system of deference in society. What stands out most clearly in the painting is the extent to which a general, deeply pervasive system of deference is thematized. Profane defers to sacred, servant to master, black to white, enlisted man to officer. There are plays on the system and oppositions within it. In the act of dying, Warren in a sense "defers" to the young man who will take his place in the new nation even as the younger man more explicitly defers to him as leader and hero. Small, stepping out of his oppositional role as enemy, "defers" in this instance to Warren because of previous moral debts.

By foregrounding the system of deference on the battlefield so dramatically, Trumbull reminds us how important it was to the social and economic life of Great Britain and its colonies. In a social system that had so little of the force of the modern state, deference was what powered the engine. Englishman James Wilson explained it simply if somewhat cynically in 1774 as "an obligation to conform to the will . . . of that superior person . . . upon which the inferior depends."[40] Such a hierarchical concept, implying connectedness and mutual dependence in the great chain of being – politically, physically, and spiritually – was ideally suited to a monarchical system of government. Its continued acceptance in the colonies, despite our more egalitarian ways, is a forceful reminder of the hegemonic influence of English thought on the American consciousness of the time. To see it so emphatically represented in Trumbull's painting is to realize the power of this principle to shape reality and to influence Trumbull's worldview. The Britishness of Trumbull the so-called revolutionary is nowhere so apparent as in his replication on the battlefield of Bunker's Hill of the system of deference that sustained the Anglo-American way of life. The system permeated Trumbull's image making not just in The Death of Warren but throughout his work in the number and variety of "supplicant" images he produced (shod and unshod). The act of kneeling, whether for religious or political purposes, is a ritual gesture indicating a condition of subservience, and is eloquently expressive of a system that used it as a method of social control. Gordon Wood recounts how "condemned persons usually pleaded for their lives on their knees in open court" in the colonies.[41] As the son of a governor (although corporate rather than royal), Trumbull may even have witnessed such an action.

Trumbull would have been socialized to the notion of deference from early childhood. As local gentry in Lebanon, Connecticut, the Trumbulls were known for their intelligence, gravitas, and civic virtue. When the artist was

born in 1756, his father was a moderately successful merchant. The family home, although hardly manorial by English standards, was outstanding locally for its size and capaciousness. By any measure, the Trumbulls would have been the recipients of considerable deference. John Adams once complained that Connecticut was run by an aristocracy "more decisively than the empire of Great Britain."[42] Although there were more obvious candidates for his diatribe, he might also have had the Trumbulls in mind. He was not thinking of aristocracy in the formal sense of being based on land ownership and the principle of perpetuity, of course, but rather on power relations.

The artist's father, Jonathan Trumbull, suffered a major business failure in 1766, however, which resulted in an immediate and drastic loss of economic means, although he clung tenaciously to his class position. Even though he went on to become governor, his financial status was permanently altered. John Trumbull wrote about the experience candidly and feelingly in his autobiography, blaming "the ruined state of my father's fortune" for preventing "my having seen much of elegant society."[43] He was socially ill at ease all his life – in the company of General Washington and his "ladies" and never more so than in English society. Social relations were a source of acute anxiety for him. It can be assumed, nevertheless, that Trumbull took in lessons on deference with his porridge, which would have been further elaborated at Harvard and completed in England. The most demanding school was the military, exposing him for the first time to the niceties of neocavalier life among the officers from the South. The complexities of Trumbull's personal situation as well as the dynamics of America's upper classes no doubt gave him special insight into the intricacies of the social system.

Trumbull's almost obsessive preoccupation with kneeling figures and "supplicant" motifs possibly reveals anxiety about the issue of deference and social class, but if so, it was a nervousness that was widely shared in the colonies. It is not difficult to imagine that he might have feared the dismantling of the system, which, although it occasionally caused him personal pain, was one in which he devoutly believed. In 1775 he had sought only the minimal goal of independence, if that, certainly not a social revolution. By the time he completed the painting in 1786, he was well on his way to becoming a staunch Federalist. Deference might loom large in the painting because in Massachusetts in 1775 it truly had been contested ground (although largely unrecognized as such) and was emphatically so in 1786, that fateful year of social conflict and Shays' Rebellion. If, as Clifford Geertz maintains, "the function of ideology is to make an autonomous politics possible by providing the authoritative concepts that render it meaningful, the suasive images by means of which it can be sensibly grasped," then *The Death of General Warren* makes a powerful ideological statement.[44] It is a suasive image of the precariousness of the system of deference in an age of revolution, and as such helps to provide the ideological underpinnings for what will later become the Federalist party in American politics.

The Death of General Warren can perhaps be understood as Trumbull's ultimate gesture of deference. The debt to Benjamin West and John Singleton

Copley is clear. Trumbull enthusiastically embraced the prevailing English style in order to make his American picture. His picture-making principles also owe much to the great theorists of the seventeenth and eighteenth centuries, particularly to Sir Joshua Reynolds's set of discourses written between 1769 and 1790. The *Discourses* functioned as a model for deferential attitudes – to the ancients, to one's artistic betters, to the masters of the rule. As Robert Uphaus points out, "Explicitly and implicitly, Reynolds's entire formulation of aesthetic education is based on a defense of authority."[45] Reynolds writes about the early stages of an artist's education as "a time of subjection and discipline" when the artist "must still be afraid of trusting his own judgment and of deviating onto any track where he cannot find the footsteps of some former master."[46] This point of view is analogous to Edmund Burke's dictum in the political realm that our liberties are "an entailed inheritance derived to us from our forefathers" – the principle of perpetuity applied to intellectual property, in other words.[47] To this can be contrasted the ringing words of Thomas Paine that "the Vanity and presumption of governing beyond the grave is the most ridiculous and insolent of all tyrannies."[48] Trumbull's sympathies would have been more toward Burke than Paine.[49]

The Death of General Warren thus presents us with an insuperable paradox: a feistily nationalistic work that appropriates the style of the hegemonic culture. The kind of transformation of "the symbolic framework through which people experienced social reality" (the phrase comes from Clifford Geertz) that one might expect from a modern liberation movement had not yet taken place in America, or at least in Trumbull's mind, in 1786.[50] The symbolic framework he uses to define his picture is mixed. The picture is painted in an English style on English soil while presumably extolling the values and premises of the American Revolution. The confounding result is that Trumbull addresses his people on the subject of revolution in the language of the parent culture. The aesthetic strength of the work is at the same time its political weakness. It is worth noting that Winthrop Chandler, despite (perhaps because of) his poor training, constricted horizons, and provincial taste, produced a work that was essentially more American in character. By dint of geographical origin, Trumbull had once been that provincial; because of personal ambition growing out of social status, he overcame the "disability." England was deemed the summum bonum of artistic life for aspiring colonial artists, which is why West, Copley, and eventually Trumbull went there. That English artistic practice was still, although decreasingly, "provincial" by continental standards is, of course, a matter of supreme irony.

According to interpretive models of modern cultural development, such a situation can be thought of as no more than the usual capitulation to the cultural hegemony of the parent state, but there are anomalies in eighteenth-century Anglo-American culture and aesthetics that need to be examined further. Chief among them is the fact that two of the principal luminaries, West and Copley, were American born. Because of the infusion of their colonial innovativeness and energy into the staid tradition of English art, the parent culture itself ceased to be conservative and took on part of the coloration of its colony.

A reversal of influence began to take place – the kind of reversal familiar to students of colonialism.[51]

When Edward Said talks about the "cultural horizons of nationalism" as "fatally limited by the common history of colonizer and colonized assumed by the nationalist movement itself," he points to one of the major obstacles to new-nation cultural development.[52] As the first modern new nation, the United States was the first to make this journey. A complicating factor in the application of developmental theory to the American situation is that both parties to the conflict were basically English. There is no adequate terminology to describe the in between position of the white American, who was both colonial and colonizer. (The truly colonized of course were the indigenous peoples.)[53] Although Said decries this common history of colonizer and colonized as fatally limiting, in the American experiment it turned out not to be so. "Dependent development" in the cultural sphere continued until the 1830s, but eventually a breakthrough did take place. In the fine arts, William Sidney Mount's refusal to go abroad in the 1830s is usually understood as a marker for cultural independence (although even in that case, the process was far from complete). Perhaps Clifford Geertz's term, "incompletely decolonized," can be used as a descriptor not only of Trumbull's mind-set in 1786, but of the general postrevolutionary culture until the 1830s.[54]

John Trumbull's *Death of General Warren at the Battle of Bunker's Hill, 17 June 1775* has served as a principal icon of the American Revolutionary War since it was painted in 1786. Passionate, colorful, and patriotic, it has transformed the original event into one of the foundational myths of America: a people of innocence and righteousness, courageous in the face of insuperable odds. Engraved several times in the nineteenth century, used to illustrate countless history books, and even made into postage stamps, the image has helped frame the national discourse about the American Revolution. One should note that the transformative process worked both ways, however. The painting has been subsumed into the rhetoric about the revolution it attempted to describe. Its very passion, color, and patriotism – the qualities that make it such an exciting work of art and interpreter of the Revolution – also render it more vulnerable to such cooptation. Over the two centuries since its creation, many of the nuances have been lost.

Originally, the image was exhibited with the catalog, offering a unified text of word and image. Unfortunately, the text is considerably less well known today than the painting, which diminishes our sense of the full measure of Trumbull's historicizing effort. The breadth of that address, as well as its decidedly more American tone, has been lost except to specialists in the field. It is one of the contradictions of Trumbull's makeup that he who argued so heatedly for the claims of art on the public imagination and against the domination of American culture by a logocracy should not only have written so much but tried to "complete" his paintings by words. Is there not something particularly fitting in that case about the more national character of his *logos* in contrast to the internationalism of his art? As exhibition practices have

evolved, the painting has been left to communicate Trumbull's historicizing intent by itself. Robbed of the discursive explanation that one part of Trumbull obviously felt it needed, the painting presents a condensed image that concentrates on the death of Warren and the final minutes of the battle. Judged on its own terms, it nevertheless succeeds brilliantly in collapsing within itself many of the principal issues that beset the era it images.

All that Trumbull wished to do, so he said, was to function as the "graphic historiographer" of the event. We may now ask if he succeeded in that endeavor. Acting according to neoclassical principles of history painting, he sought to present facts, tell a story, and teach lessons about self-sacrifice, patriotism, and magnanimity. His presentation of basic facts is impeccable: an array of battle statistics in the text; strict accuracy in matters of costume, arms, and topography in the painting; identification of the historical personages in the text; precisely rendered portraits (for the most part) in the image. It is in the area of story, of "emplotment," to use Hayden White's term, that complications begin to occur – the neoclassical veneer begins to crack and ideology peeps through.[55] Trumbull emplots the story of the battle with narratives of class and race as well. The lessons he wished to impart were greatly affected by the emplotment strategies exercised. For Trumbull made significant choices. It is not the one who survives that is depicted, but the one who dies. It is not one of the regular soldiers whose death is glorified, but that of the young physician-general. What if Trumbull had decided to forecast ultimate victory instead by showcasing Peter Salem killing Pitcairn? One can imagine how the discourse might have been altered.[56]

What Trumbull succeeds best in doing is representing "the contradiction of the socio-historical whole." By inscribing his class bias, ambivalent feelings about race, and reservations about the course of revolution into the matter of history, he offers an interpretation that is, finally, more personally honest and considerably more complex than his public has understood. In light of Gramsci's wise and profound understanding of how human beings behave in revolutionary situations, perhaps we may finally grant to Trumbull this measure of achievement.[57]

Democracy, Regionalism, and the Saga of Major André

Ann Uhry Abrams

Asher B. Durand's *The Capture of Major André* (Fig. 11) was first exhibited at the National Academy of Design in 1835. The composition pictures four men grouped together on a knoll above a gently sloping landscape. André, second from the left, wears a dark waistcoat in contrast to the homespun breeches and jackets of his captors. This simple narrative exemplifies a new approach to American history painting, for not only does the mood and method differ dramatically from grand-style compositions of an earlier generation, but Durand's rendition encompasses issues of egalitarianism and regionalism often associated with the Jacksonian era.

Durand was, in fact, reinterpreting an episode that had taken place in the heat of the American Revolution in the neutral zone bordering British territory near Tarrytown, New York.[1] At the time, bands of marauders roamed Westchester County, conducting vigilante-style raids and accosting soldiers as well as civilians in search of bounty. Those sympathetic with the British were known as "cowboys"; their counterparts on the American side were called "skinners." The illustrious capture on the evening of September 22, 1780, may have begun as just such a maneuver, although the captors – John Paulding, David Williams, and Isaac Van Wart – claimed to be conducting a routine patrol of their neighborhood when they intercepted a man wearing no uniform and carrying suspicious identification papers. Believing his assailants to be pro-British "cowboys," the man identified himself as Maj. John André, adjunct general for Sir Henry Clinton. At once, Paulding, Williams, and Van Wart seized the young major and submitted him to a thorough search, during which they uncovered papers hidden in his boots that revealed he had been conspiring with Gen. Benedict Arnold to place the strategic fortress of West Point in British hands. Despite André's efforts to bribe his captors with a gold watch, he ended up in an American jail. A hastily formed military tribunal found him guilty of espionage, and ten days later he was hanged. In the meantime, Benedict Arnold escaped into British territory on a sloop aptly named *Vulture*, the same vessel that had transported André to West Point.

Americans were shocked. Arnold, a respected leader of the Continental

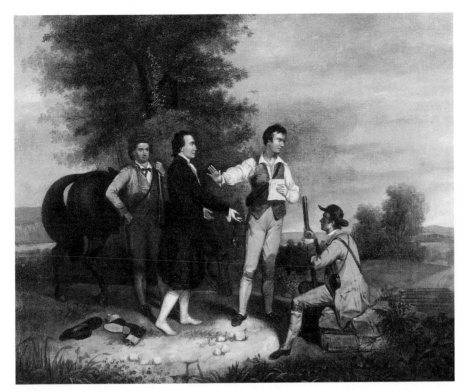

FIGURE 11

Asher B. Durand.
*The Capture of Major
André.* 1835.

*Worcester Art Museum.
Worcester, Massachu-
setts.*

forces often cited for valor, had committed wartime's most heinous crime. In a letter written from Philadelphia on the day of André's execution, Ebenezer Hazard told Jeremy Belknap: "It is mortifying that . . . [Arnold] should have any claim to humanity, and that better men should be obliged to belong to the same genus of creatures." Philadelphians were so outraged, Hazard added, that they burned "Arnold and the Devil" in effigy.[2]

Whereas Arnold's treason horrified the majority of Americans, the hanging of André evoked sympathy and pity. Critics complained that the trial was rushed, the captors fortune seekers, and André a helpless pawn in Arnold's nefarious plot. Not only had the young major been a regular visitor in the drawing rooms and parlors of Philadelphia and New York, but he had won the respect and admiration of numerous civic and cultural leaders. American soldiers around the Tappan area – scene of the trial and execution – wept for André's plight and lauded his bravery. In most cases, their compassion for the "unfortunate" British officer was entirely separate from their fidelity to the revolutionary cause.

In an era when heroic deaths were celebrated in verse and on canvas, André's demeanor after his capture exemplified the most laudable form of valor. The Reverend Jedidiah Morse (father of Samuel F. B. Morse) wrote in his *Annals of the American Revolution:*

During his confinement and trial . . . [André] exhibited those proud and elevated sensibilities which designate greatness and dignity of mind. . . . He betrayed no want of

fortitude, but . . . stepped quickly into the waggon [sic], and . . . instantly elevating his head with firmness, he said, "It will be but a momentary pang." . . .[3]

Philip Freneau's unfinished play *The Spy,* written only months after the execution, mirrors Morse's sympathy for André. The poet-playwright portrays André as a repentant messenger who had been unfairly duped by the unscrupulous Arnold and his superiors in the British Army.[4]

If Arnold was the villian and André his victim, then what role did Washington play? It was he who held the power to reverse the military tribunal and stay the execution. Instead the general refused to acknowledge the pleas for leniency emanating from all quarters. Even André, using all of his diplomatic and poetic skills, failed to move him. In a series of letters, the young officer begged Washington to reconsider the case, adding that if the sentence had to be discharged, he wanted to be shot like a gentleman, not hung as a criminal. Washington apparently did attempt to promote a compromise by offering to exchange André for Arnold, but when British authorities refused to comply, he upheld the court's decision, explaining that André behaved as a spy when he met secretly with Arnold and passed through enemy lines dressed in plain clothes under an assumed name.

For the most part, Americans accepted Washington's decision as justified in the heat of battle, but the English public responded with rage.[5] Full accounts of the arrest and trial in *Gentleman's Magazine* and other British publications turned André into an overnight martyr and inspired an outpouring of public mourning. Poet Anna Seward composed a melodramatic poem entitled "Monody on Major André," which included a severe criticism of George Washington:

> Oh WASHINGTON! I thought thee great and good,
> Nor knew thy Nero-thirst of guiltless blood! . . .
>
> Remorseless WASHINGTON! the day shall come
> of deep repentance for this barb'rous doom!
> When injur'd ANDRE'S memory shall inspire
> A kindling army with resistless fire; . . .[6]

So widely publicized was Seward's criticism that Washington felt compelled to respond after the war ended, explaining he had "labored to save" André through unsuccessful negotiations with British authorities.[7]

Artists in England also memorialized the major with retrospective portraits, two reportedly by Reynolds and one attributed to Sir Thomas Lawrence.[8] Within only months after the execution, a monument designed by Robert Adam appeared in Westminster Abbey (Fig. 12). Atop the stone sarcophagus – which then did not contain André's remains – a weeping Britannia sits between the British lion and a shield bearing the Union Jack. The relief carving by Peter Van Gelder pictures André carrying a flag of truce to an unbending Washington, thus reinforcing Seward's accusations.

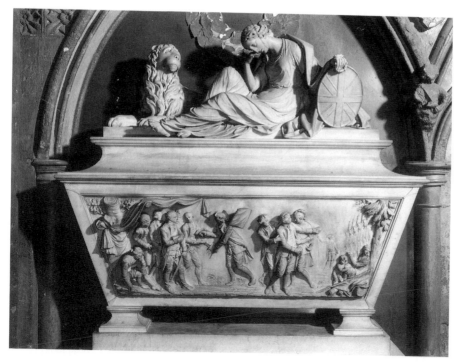

FIGURE 12

Robert Adam and
Peter Van Gelder.
*Monument to Major
André.* 1780–1. West-
minster Abbey, Nave
S. Circle.

*Royal Commission on
the Historical Monu-
ments of England Crown
Copyright, London.*

British and American interpretations of the André saga during the late eighteenth century varied only in emphasis. In England, the captors were criticized for accosting an innocent man; in America they were praised for uncovering Arnold's treachery. André, on the other hand, was lauded as "a martyr" in his native land, but in the new United States, he was pitied as "a victim." Yet Americans and Britons alike commemorated the slain major as an "unfortunate" and tragic hero.

This conciliatory and sympathetic attitude pervades William Dunlap's *André: a Tragedy in Five Acts,* which opened at New York's Park Theater on March 30, 1798.[9] Even though the play closed after only three performances because of temperamental actors, technical difficulties, and financial setbacks, it remains a constant feature in anthologies of early American theater. Dunlap used the André episode to create a moral drama based on universal questions of guilt and innocence, obedience and defiance, loyalty and treason, touching sensitive issues during a time when most Americans were torn between pity for André and pride in the revolutionary cause that led to his death.[10]

The production of *André* in 1798 also found itself mired in a sensitive political issue. At the point in the play when Washington refused to stay the execution, one actor yanked a black cockade from his hat and flung it to the ground. This triggered pandemonium in the audience because the black cockade had just been adopted as an emblem of the Federalist party. In the body language of that time, the gesture implied criticism of the Adams administration, then embroiled in a dispute over the controversial Alien and Sedition Acts.[11]

Dunlap's *André* also suffered in 1798 because the British major received star billing while the American captors played only secondary roles. The playwright

rectified this error five years later by changing his tragedy into a musical renamed *The Glory of Columbia – Her Yeomanry,* a success from the moment it opened. Dunlap derisively remarked that the revised production, with its overt patriotic symbolism, had been "murdered for the amusement of holyday [sic] fools."[12] He neglected to mention, however, that rejoicing about American nationalism was far more in the spirit of the times than sermonizing about misplaced justice and undeserved punishment. The new production contained all the trappings of a comic opera including a number of stirring ballads, elaborate pageantry, and a spectacular conclusion in which the stage was illuminated by a transparency that pictured an eagle suspending a laurel crown over the head of the now sacrosanct Washington. The *Glory of Columbia* succeeded where *André* failed because it achieved a delicate, if contradictory, balance: André was depicted as the exemplar of moral fortitude, Arnold fell to new depths of villainy, Washington grew in stature as a firm yet sympathetic administrator, and the three captors rose to new prominence as paragons of selfless bravery.[13]

During the opening years of the nineteenth century, Americans were developing a set of heroes and symbols to define and represent their young republic, among them Mason Locke Weems's famous biography of George Washington. In his narration of the André episode, the flamboyant parson condemned Arnold yet lauded the British major as a capable "scholar, soldier, gentleman, poet, painter, musician, and, in short, EVERY THING that talents and taste can make a man." Like historians of a more scholarly bent, Weems was repeating the prevailing opinion: André, the quintessential enlightened gentleman, was an unwitting victim of treason and treachery.[14]

American artists during the first quarter of the nineteenth century also seem to have been torn between sympathy for André and respect for his captors. A *Capture of Major André* by the youthful Jacob Eichholtz portrays the major as if he were a triumphant hero riding a white horse and towering over the three uniformed Americans. Similarly, Thomas Sully's now unlocated painting of the same subject (exhibited at the Pennsylvania Academy of Fine Arts in 1812) makes Paulding, Williams and Van Wart look like surprised and dismayed interlopers.[15] Most revealing is a mezzotint by an anonymous early nineteenth-century American artist (Fig. 13) in which all the characters are identical. Were it not for the dark boots and hand extended with the pocket watch, the British major would be indistinguishable from the three men who arrested him. A verse printed below the image supports that ambiguity:

> Ye Foil'd, Ye Baffled Brittons This Behold
> Nor longer urge your Pardons, Threats or Gold;
> See in each virtuous face Patriotic Zeal
> To save their Country and Promote its Weal
> Disdaining Bribes to wound a righteous Cause
> While ANDRE falls a victim to the Laws.

This rhyme reflects prevailing American opinions of the André case. No need to differentiate the captors from each other or from the British "victim,"

because all were puppets in a scenario influenced by "Patriotic Zeal" in defense of a "Righteous Cause." André, in other words, was a scapegoat manipulated by forces beyond his control.

Although artwork of the early nineteenth century still treated André as an unfortunate victim, signs of a changing interpretation were on the horizon. The impetus was twofold: increased politicization of the André episode and an upsurge of interest in regional history. The two came together in August 1821, when a group of New Yorkers – most with Federalist leanings – rallied to memorialize André. Their objective was removal of his remains from a hillside near Tappan, New York, for shipment to England where they would rest in Westminster Abbey under the monument erected for that purpose over forty years earlier. In an elaborate ceremony, dignitaries placed garlands of flowers on the mahogany sarcophagus, read poetic tributes to the British major, and presented a myrtle tree to accompany the bier on its journey across the ocean.[16]

While the Federalists were paying tribute to André, Democrats were honoring his American captors. The issue came to the forefront in 1817 when an aging John Paulding petitioned the House of Representatives for an increase in the annual $200 pension that Congress had awarded the three captors during Washington's administration. Leading the opposition against Paulding's request was Benjamin Tallmadge, a former colonel in the Continental Army whose duties had included supervising André during his imprisonment. Now a well-respected Federalist congressman from Connecticut, Tallmadge angrily protested Paulding's bid for additional funds, claiming that Major André described his assailants as corrupt fortune hunters. The celebrated removal of

Ye Foil'd, Ye Baffled Brittons This Behold To save their Country and Promote its Weal
Nor longer urge your Pardons, Threats or Gold; Disdaining Bribes to wound a righteous Cause
See in each virtuous face Patr'otic Zeal While ANDRE falls a victim to the Laws.

FIGURE 13

Anonymous American. *The Capture of Major André.* 1780–1810.

Courtesy Winterthur Museum, Winterthur, Delaware.

André's boots, Tallmadge explained, did not occur in anticipation of uncovering subversive documents but as part of a routine search for additional cash and other valuables. Tallmadge's criticism failed to sway congressional opinion and the House approved an increased pension for Paulding, Williams, and Van Wart. As part of their defense, the three captors presented lengthy explanations of their faithful service in the New York militia and disavowal of the disreputable "skinners" with whom they were so often associated.[17]

John Paulding's successful bid for an increased pension is but one indication that attitudes toward the André case were changing. The writings of James Fenimore Cooper offer another. His popular second novel, *The Spy,* was set in Westchester County only miles from the site of André's capture and execution. Cooper included several conversations about Major André in the text to act as metaphors for his developing plot. These references delineate the dangers of spying, the questionable character of those who perform such missions, and alterations of ethical standards in wartime. The heroic vagabond Harvey Birch might be interpreted as a composite fictional equivalent of John Paulding, David Williams, and Isaac Van Wart. Birch – who pretended to be a peddler and was often arrested as a British agent – really contributed to America's eventual victory, just as André's captors appeared to be marauders but were really unrecognized patriots. Cooper went to great pains to distinguish these regional heroes from the odious "skinners," whom he described as self-serving opportunists.[18]

In *Notions of the Americans,* first published in 1824, Cooper wrote specifically about André's captors. Although "the English were known to pay well, and to possess the means of bribing high," he wrote, "these young yeomen were true to the sacred cause of their country. Neither gold nor honours, nor dread of the future, could divert them from their duty." André, in Cooper's estimation, was less than honorable because he lacked the "quickness of intellect" so long associated with his legend. Not only does the mantle of heroism belong to the captors, but the moral issue itself needed reevaluating:

The question was not one of vengeance, or even one of mere protection from similar dangers in future. It involved the more lofty considerations of Sovereignty. It was necessary to show the world that he who dared to assail the rights of the infant and struggling republics, incurred a penalty as fearful as he who worked his treason against the majesty of a king.[19]

As Cooper's words indicate, Americans of the 1820s were eager to "show the world" that in their "infant and struggling" republic no king's agent could triumph over the "Sovereignty" of the people.[20]

The early writings of James Fenimore Cooper appealed to the regional pride of New York's young Democrats then trying to unseat old-line Federalists in city, state, and national legislatures. Among the more visible was Cooper's friend and fellow author, James Kirke Paulding, a powerful figure in New York political and cultural circles and first cousin to one of André's captors. In 1823 his brother William was elected mayor of New York City.[21]

The Paulding brothers played significant roles in redirecting the spotlight from André to his captors when they persuaded the state legislature to erect a monument to their cousin at the scene of the capture near Tarrytown. Because John Paulding had been the first to die, the ceremony of 1827 was the earliest public tribute to one of the captors. In a speech at the dedication, William Paulding denounced all previous evaluations of the André case. There was no question that the British officer was an enemy spy who had been "elevated by a false estimate, and a mistaken sympathy, into a Hero and a Martyr. . . ."[22] This speech by a prominent local politician signaled a reversal of rhetoric, particularly notable because six years earlier New Yorkers had gathered a few miles away to glorify André in an elaborate ceremony accompanying exhumation of his body.

James Kirke Paulding was perhaps more responsible than anyone for reversing the emphasis of the André story. In his description of the episode in his popular *Life of Washington* published in 1835, he wrote, "The real heroes of this striking tale are the honest and lowly youths who saved their country from such imminent perils, by the simple exercise of an incorruptible integrity, animated by an ardent patriotism." André's role has been seriously misinterpreted, he claimed:

By his countrymen he was considered a martyr to his loyalty, and by the Americans the hero of a romantic tale of unmerited misfortune. They forgot that he had been deep in a dastardly plot of treason against a people long struggling in vain for liberty. . . .[23]

Most New Yorkers agreed with Paulding's transformation of the three captors into "saviors" of the American republic, especially those working hard to emphasize the cultural and scenic benefits of their state. From Washington Irving's *Knickerbocker Tales* to James Fenimore Cooper's *Last of the Mohicans*, New York had become the setting for the first internationally recognized American fiction. It was during those same years that the spectacular banks of the Hudson River were enticing an increasing number of artists and poets.[24] Dramatic vistas from West Point were particular favorites, often accompanied by reminders about the historical significance of the heights near West Point where "Arnold plotted the subjugation of his Country." Artists were also focused on the Military Academy because it was the center of a fierce competition for drawing instructor, a position awarded to Robert Walter Weir in 1834.[25]

British visitors traveled to Tappan and Tarrytown on specially designed memorial excursions. Frances Trollope recalled on such a journey: "It was not without a pang that I looked on the spot where poor André was taken and another where he was executed."[26] Coupled with the increasing prominence of the three Westchester County residents who had "saved" the Hudson and West Point for future generations of Americans, the capture was now ripe for serious artistic consideration.

Asher B. Durand undoubtedly realized the local relevance of the subject he chose for *The Capture of Major André* (Fig. 11).[27] It fit quite nicely with other works from those years when he was moving away from his lucrative career as an engraver to devote full time to painting. His primary subject matter during this transitional period was New York. His landscapes were almost all Hudson River scenes, and his narrative compositions – *The Wrath of Peter Stuyvesant* (1835), *Rip Van Winkle's Introduction to the Crew of Hendrick Hudson, in the Catskill Mountains* (1838), and *Dance on the Battery in the Presence of Peter Stuyvesant* (1838) – all came from local history and literature. In fact, place and setting were so important to Durand that he traveled to Tarrytown for the explicit purpose of obtaining accurate sketches at the site of André's arrest. His son John even referred to *Major André* as an example of his father's "local art."[28]

James Kirke Paulding was also very instrumental in shaping the composition and content of Durand's *Capture of André*, although the original commission came from New York frame maker and print dealer, Lewis P. Clover. Within a few years, however, the painting ended up in Paulding's collection.[29] The first clue to Paulding's input can be found in the following inscription, printed in the 1835 National Academy of Design catalog:

Mr. Paulding looked at the papers, and said he was a spy. He said, if we would let him go, he would give us his horse, watch, any amount of money, and bring it to any place that we might pitch upon, so that we might get it. Mr. Paulding answered, "No, if you would give us ten thousand guineas you shall not stir one step."[30]

The last sentence bears a striking resemblance to a similar one in Paulding's *The Life of Washington*, published that same year. It was John Paulding, wrote his cousin, not Williams or Van Wart, who refused André's bribe. Evidence indicates that Paulding provided Durand with details about the costumes, setting, and historical data as well as posing for the figure of his relative.[31] John Paulding clearly dominates Durand's composition, the center of interest to whom all diagonals point. Dressed casually in an open-necked white shirt and darker vest, he holds the incriminating document while forcefully refusing the watch offered by André.

A critic for *The Knickerbocker* complained that Durand pictured Paulding as "an affected fine gentleman, instead of what he really was, a rough and not particularly sensitive, but honest yeoman-ranger, who would be more likely to answer a bribe with a blow, than to throw himself into a stage position about it."[32] That critic failed to realize Durand had no intention of portraying Paulding as a unpolished "yeoman-ranger" accosting the British major in search of a reward. Rather, at the suggestion of James Kirke Paulding, he metamorphosed his protagonist into a respectable leader delivering an oration on the sins of bribery and espionage.

Although New York boosterism and Paulding family interests may have provided the inspiration for Durand's *Capture of André*, Democratic politics fashioned the setting. On the most obvious level the subject duplicates

rhetoric of the Jacksonians by featuring frontier-type American heroes triumphing over a British aristocrat. Beneath this story line there were more subtle suggestions. Toward the end of his second term, Jackson's personal popularity was waning, partly because of his verbal war with Calhoun over nullification and partly because of the ongoing battle with the U.S. Bank. Actually, Jackson's campaign against the U.S. Bank had a direct effect on Durand's engraving business, for the newly created independent institutions were suddenly demanding paper currency that Asher Durand and his brother Cyrus were then producing.[33]

Regional political concerns also contributed to Durand's painting. In 1835 New York's favorite son – Vice President Martin Van Buren – faced an uphill battle to gain the presidency. His greatest political handicap was an urbane eastern image associated with the so-called Albany Regency that formed the nucleus of his support. One of the most active New York Democrats was none other than James K. Paulding, soon to become secretary of the navy in the administration of his close friend and political ally, Martin Van Buren.[34]

For the hundreds of Americans who purchased the print when it was sold by the American Art Union in 1846,[35] Durand's *Capture of Major André* synthesized regional and national interests. It was a new kind of genre/history painting that spotlighted ordinary Americans as heroes and an aristocratic Englishman as the villain. By stressing the individual differences between captive and captors, Durand's composition contrasts with earlier prints and paintings of the same subject. It was people, not abstract ideals, that lay at its core. Indeed, the dramatic change in the André saga over the previous half century indicates how the egalitarian generation of the 1830s transformed an incident glorifying an intellectual and abstracted "everyman" into a celebration of individualized citizens living and working within their own territorial space. Pride of region and the merits of rugged individualism had become synonymous with the national interest, thus forecasting a new brand of sectional chauvinism that would divide the nation into warring camps only a few decades later.

"Harvesting" the Civil War
Art in Wartime New York

Lucretia Hoover Giese

"A period of civil war is not usually a harvest time for artists."[1] So began one of the earliest articles on art and the American Civil War in the May 1861 issue of *The Crayon* entitled "Artists going to the seat of war." The war was two months old. The effect of the war plainly concerned the journal and its constituency. Clearly there would be some impact, but what form it would take and what strength it would have was unclear. Two months later, *The Crayon* itself became a war casualty and ceased publication.

From hindsight, *The Crayon* surprises with its reference, however oblique and tentative, to art and civil war. The experience of civil war was, after all, unknown to all segments of the United States, including the art world. The curious language used by *The Crayon* suggests shock, puzzlement, and indecision. George Fredrickson has shown that these states of mind were shared by others in the North at the time – intellectuals, statesmen, and participants in the war itself.[2] There was no consensus of thought on the existing state of affairs. The Union was literally and figuratively under fire as were its social and political realms. In the face of such confusion, it is not surprising that artistic certainty faltered also.

The difficulties of producing art during the Civil War revolved around circumstances of art making, art reception, and the nature of the war itself. During wartime, artists must determine appropriate subject matter and hone technical skills to deal with war's special demands. In the case of the Civil War, artists were ill equipped, and competition from photography further complicated matters. In terms of art reception, public taste and critical support are factors. Here, consistency and articulateness are crucial. During the Civil War, public taste was erratic, and critical commentary often confused or opaque. Lastly, the nature of a war, its course and ultimate objectives, affects artistic response. The exceptionality of the Civil War (for Americans) and its uncertainty, defined by James McPherson as "the recognition that at numerous critical points during the war things might have gone altogether differently," destabilized forces within the art world.[3]

This chapter probes these issues by concentrating on painting and follows the chronology of the war from the perspective of the New York art scene.

Artistic responses to the war changed each year as did critics' understanding of their roles and those of artists. As for New York, the city harbored a range of ideological factions representative of the fractious body politic. More importantly here, New York was then the center of art and publishing in the United States. The city boasted a high concentration of artists and national art institutions, and critical commentary about their activities appeared regularly in daily and periodic publications. Examining material drawn from these sources establishes some purchase on critical (and public) reception during the Civil War.[4] Examining the work of certain artists known in the New York art world by 1861 serves as the basis for hypotheses about actual art practice. Six artists selected for mention – Albert Bierstadt, Frederic E. Church, Edwin Forbes, Sanford Gifford, Eastman Johnson, and Emanuel Leutze – reacted to the Civil War in their work of the war years. A seventh, Winslow Homer, turned to painting just as the war was escalating and concentrated on war imagery until its conclusion.[5]

The day Fort Sumter in Charleston harbor fell to rebel forces, April 13, 1861, an optimistic assessment of the condition of the arts in America appeared in the New York *Leader*. Although previously "only the cultivated sort in this country had any care for pictures," some painters in the last decade had "struck a chord in the heart of the people . . . [making] art somewhat a household word."[6] With the declaration of war, art's newfound relevance changed. *The Crayon* reported that "few people remain sufficiently withdrawn from the popular movement" to consider peacetime pursuits. *The Knickerbocker* concurred: "Little or nothing is now being done in the studios," artists having decided to lend their fighting arms rather than their mahlsticks to the conflict.[7]

In fact, artists had several options. Some artists enlisted out of patriotism, a desire to be useful, or perhaps even simple expediency. Enthusiasm was high in the early months of the war and the tour of duty generally short. Even so, the number of artist enlistees named in the press – George A. Baker, Charles Temple Dix, Sanford Gifford, James M. Hart, James Hope, David Johnson, Jervis McEntee, Henry C. Shumway, and Worthington Whittredge, all National Academy of Design Academicians – was small.[8] Other painters did enlist later in the war, Henry Bacon, for example, Francis D. Millet, Francis A. Silva, and J. F. Weir.

Not all artists at the front were soldiers. Some "visited" out of curiosity or to obtain visual material firsthand. Temporary passes from the Union Army permitted on-site access. It was also possible to be in the field for prolonged periods. Special artists covered whole campaigns or theaters of engagement, sometimes remaining with the army for most of the war. These artists, attached to journals such as *Harper's Weekly, Frank Leslie's Illustrated Newspaper,* or the New York *Illustrated News*, produced drawings used for illustration. This work meant exposure to the hazards of war and was more likely followed out of a sense of participatory duty or the basic need for a job rather than the search for pictorial ideas. Among those working for New York journals during the war years were Edwin Forbes, E. L. Henry, and Alfred Waud and his

brother William. Thomas Nast, although not strictly speaking an artist-correspondent, did visit the front and submitted relevant drawings for publication, as did Winslow Homer. Homer freelanced for *Harper's Weekly,* his work appearing November 23, 1861, to December 3, 1864.

Most artists avoided physical engagement of any sort. They found other practical (and safer) ways to serve. Whittredge articulated one position. Hurriedly trying to enlist with his friend Gifford in the flush of excitement and urgent need for men in May 1861, Whittredge disingenuously claimed he had been refused for want of a knapsack. He came to realize he could help with the war effort while at home. When it became apparent the war would not be short lived, he busied himself "with fairs, exhibitions of pictures, sewing societies and what not for the benefit of soldiers."[9] Fairs became fund-raising and promotional showcases for contemporary artists, especially those organized from late 1863 on for the Union Army's Sanitary Commission, the equivalent of the modern Red Cross. In the popular New York Metropolitan Fair of 1864, for example, there hung a "collection of pictures with frames inscribed, 'Pro Patris,' the gifts of the patriotic brotherhood of artists – many of them painted expressly for the Fair."[10] Additional pieces by American and European artists were displayed (although not offered for sale) to entice a paying audience and not incidentally to increase a painter's visibility.

One private fair, the Artists' Patriotic Fund, sprang from reaction to events in the spring of 1861. Artists meeting in the rooms of John Kensett and Louis Lang formed a "Committee for contributions from the artists of New-York, towards prosecuting the war."[11] Again, many were Academicians such as George A. Baker, Albert Bierstadt, J. W. Casilear, A. B. Durand, Daniel Huntington, Eastman Johnson, and John Kensett. Their names gave purposefulness to the auction held on May 29. Helping in another way, Frederic Church donated the proceeds of the showing of his painting "The North," or *The Icebergs,* at Goupil's to the Fund. For at-home painters, then, it was possible to be patriotic and continue a career. Numerous articles in the press praised this level of involvement by artists.

Some critics found further reason for optimism; the war generated new subjects. Those described in an article of 1861 in *The Crayon* were largely reportorial in nature – "the parting of friends; the enlisting rendezvous; the return of the slain of Baltimore to their homes; the faces of eager recruits and earnest debaters."[12] That no front-line action was included perhaps explains the *New York Times* assertion that "An artist [in the field] is never so much pressed that he cannot take a sketch. HOGARTH and many others used to turn the nail of their thumb into a cartoon. Many a rough idea of a great work has been limned on that brief canvas."[13] The article went on to declare that from such miniature and "rough materials" the war would sooner or later be "illustrated perfectly." It can only be assumed that the writer could not conceive of the war as so engrossing as to prevent artists from doodling while in military service. Or perhaps artists would be too absorbed in observing to be able to complete work.

Despite such naive expectations, war soon made its own demands. The light note in *The Crayon* in June 1861 that it would have been "easy to order Corporal [Sanford] Gifford to stand by his colors at a landscape, and Captain [Henry C.] Shumway to take off the heads of his company – professionally of course"[14] ended with the realization that "Desirable as this would be, we fear the opportunity is gone, never to return." Although the talents of artists in the ranks still mattered in June – the taking of portraits of fellow regimental members or landscapes of encampments – the situation changed once a regiment went to war.

In July a five-page call to arms of another sort was published in *The Knickerbocker*. It contained an impassioned appeal for American art in time of war. That such a lengthy article appeared within months of the start of hostilities is reason enough to suspect there was concern about the welfare of artists and art, but this suspicion is heightened by *The Knickerbocker*'s defensive labeling of American art "a necessity."[15] Worried that American painters were prostituting themselves by mimicking popular French, Italian, and German genre scenes instead of painting national art, the critic understood that the health of the arts depended on three interconnected agents:

AMERICANS! will you leave them [artists] and their families *to starve* or worse than that, to *prostitute our nationality for bread?* ART PATRONS! would you evince your patriotism? lay down your gold on the shrine of your country by placing it in the hand of the struggling American artist. ARTISTS! yield not up the sacred heirloom committed to your charge for a mess of pottage; remember that your eloquent brushes are recording the history of a nation.[16]

Yet it is striking that in the text of the article "the history of a nation" did not include the issue of slavery, which had politicized the nation the decade before the outbreak of the war and had stimulated numerous antebellum paintings, or the war itself, however young it was. What of the present "political chaos" could be painted or what benefits could accrue from war's "wholesome electric shock upon national art" – a metaphor conceivable only in early 1861 – the critic did not say.

Using milder language, the New York *Daily Tribune* agreed the effect of the war on the fine arts would be positive. After all, the American Revolution had produced "one of our greatest painters [unnamed], whose battlepieces have never been equaled by any of his successors," and wars in France had succeeded in stimulating its artistic genius. Presumably American artists would continue France's lead and that of John Trumbull (no doubt the unnamed artist referred to). Although a cautionary note did appear later in the article – the National Academy of Design in New York City had reportedly closed on Thursday "last week" in the face of a threatened attack on the nation's capital, sapping public inclination and time to look at paintings – the overall message remained positive. The Civil War would "not set us back in our art career, but infuse new strength into our system."[17]

How could painters meet such critical expectations? As *The Knickerbocker* recognized, public and institutional support (on the part of "AMERICANS" and "ART PATRONS") and pictorial and technical skill (on the part of "ARTISTS") mattered greatly. The actual situation, however, was not that simple. At the outbreak of the Civil War, landscape was the category of painting most avidly pursued by artists, most strongly advanced by critics and publicly supported. Landscapes, however, do not necessarily lend themselves to wartime content. As one landscape painter, probably Gifford, remarked almost immediately after the war began, "for the landscape painter the camp and surrounding country offer but little material. For the figure painter, however, there are innumerable scenes and episodes full of interest of all sorts, 'from grave to gay, from lively to severe.'"[18] Although he found landscape a weak vehicle for wartime subjects, Gifford did not offer clear alternatives, recommending only vague options for "the figure painter."

But war places its own demands on the figure/history painter, as a postwar commentator for the New York *World* made clear. The "new generation of figure painters" coming out of the horrors of war had been hampered by "the difficulty of procuring models. In this particular the National Academy of Design is utterly feeble and inefficient. The battle-fields of the war were but too prolific of models. Comparative anatomy was simplified for the student of art where the warrior and his horse lay dead together on the blood-soaked slope."[19] The war, not the National Academy of Design, had given artists opportunity to observe real life with all its horrors. The writer's facetious assertion that anatomy was better learned from the stiffened war dead than from the Academy's curriculum brought home his point about the difficulties confronting wartime figure painters.[20]

At its inception, neither landscapists nor figure painters rushed to paint the war. They did not radically redirect their careers, being largely unpressured by either exhibition or market conditions. For instance, subject matter was not a factor in an 1861 notice to American artists of a compatriot's intention to establish an London outlet for their art.[21] Nor did exhibitions at home seem to require specific subjects from contributing artists. In the Patriotic Fund exhibition of 1861, only one painting seems to have been connected to the war, *Beef for the Rebel Army* by W. H. Beard, and even then presumably only in jest. War-related themes were also the exception among works exhibited in the war year Annuals of the National Academy of Design.[22] Likewise, war imagery rarely figured in paintings exhibited in the Artists' Fund Society Annuals customarily held in the Academy galleries. Although the Fund's objective of benefiting needy artists in difficult times rather than promoting the Union cause specifically seems a reasonable explanation, a paucity of war subjects also prevailed in the Sanitary Fair exhibitions.[23]

The practice of the European-trained figure painter Emanuel Leutze corroborates these facts. A traditional history painter having studied in Düsseldorf, Leutze returned to the United States early in 1859. By March 1861 he was in Washington working on his allegorical mural *Westward the Course of Empire Takes Its Way* commissioned for the west staircase of the Capitol. That

same month Leutze reportedly visited army camps near Washington making studies of "military subjects" and in May was sketching "military scenes around the Capitol, which will be worked up by and by into elaborate pictures."[24] Despite time-consuming work on the mural, Leutze made the effort to accompany fellow artist Albert Bierstadt beyond the outskirts of Washington in October 1861. Sketches survive from this five-day trip, but they too did not fuel his National Academy of Design Annual submissions or apparently anything else.[25] A reviewer in 1862 described Leutze's *Westward the Course of Empire Takes Its Way* as "an epical view of the future of America," a historical painting in that sense.[26] But Leutze never painted the country's present history, the war, although he did embark somewhat later in the war on a project of military Civil War portraits.

Eastman Johnson is another case in point. He too was capable of figural work at the start of the war. Trained in Düsseldorf, Johnson there assisted Leutze on a second version of Leutze's *Washington Crossing the Delaware* (1851). He studied portraiture and Dutch genre painting in The Hague, then briefly with Thomas Couture in Paris before returning to the United States in 1855. Despite this background and the popularity of his 1859 topical American genre scene *Life in the South (Old Kentucky Home)*, Johnson only rarely depicted soldiers or camp life during the war years. One painting, *News from the Front*, of 1861 shows figures well outside the war zone and downplays the trauma of the war itself. The domestic tableau consists of a woman holding a letter (possibly a death notice) in her lap accompanied by a child and a wounded soldier whose condition and uniform are only oblique references to the war. War is front parlored. In Johnson's hands, no more than in Leutze's, did the Civil War stimulate a history painting in 1861.

The response of landscapists was similar. The war did not cause them to modify substantively their painting habits either. Frederic E. Church, whose study with Thomas Cole prepared him for a career of landscape painting, continued to produce allegorical landscapes and those of specific sites. Soon after the outbreak of war, however, Church did produce one work with wartime meaning – *Our Banner in the Sky* (Fig. 14). An "evening scene," according to one contemporary description, the sky filled with twinkling stars situated "in a corner for the Union."[27] To William Russell, the London *Times* war correspondent, this "'flag of our country'" seemed "an angry blue sky through which meteors fly streaked by the winds, whilst between the red stripes the stars just shine out from the heavens, the flag-staff being typified by a forest tree bending to the force of the blast. The Americans like this idea – to my mind it is significant of bloodshed and disaster."[28]

A skeptic might see strife represented by the glowing sky, mangled tree, and darkened land of *Our Banner in the Sky*. To most others, the image of the Union flag composed of nature's own elements withstanding threatened dissolution signified the legitimacy of the war whose cause had God's sanction. However interpreted, the painting's symbolic power was acknowledged by an accompanying brochure and Russell's review.[29] Church's landscape not only was a national emblem, but, in Russell's words, the carrier of a "visual sermon."

By 1862 a sermon was certainly needed. The cumulative effect of the Union's horrifying losses in the first year of the war made it clear the war would not be resolved quickly or without suffering. At its start, critics and artists had clearly been unrealistic, confused, even ambivalent about the relationship of art to war. Suggestions for artists' involvement had been very nearly frivolous. Although some critics had prodded, artists had felt little responsibility to depict the conflict. Even the sometimes expressed conviction that the war would stimulate an artistic nationhood had not been securely tied to pictorial treatment of the war. But as the war dragged on into 1862, more perceptive critics began to discuss with greater seriousness the possible relevance of the war to artists and the artistic possibilities it might provide.

This shift assumes embryonic form in a review of the 1862 National Academy of Design Annual.[30] Despite fine paintings on display, the year had not been "very happy . . . for painters, the war itself not inspiring many works." "Chief of these," however, was Gifford's *Sunday Morning in the Camp of the Seventh Regiment near Washington* (Fig. 15). (Another Gifford, *Bivouac of the Seventh Regiment at Arlington Heights, Va., 1861* [1862] was in the same Annual.) To the critic, Gifford's painting represented a positive approach to wartime circumstance. The artist had put his experiences in the army to artistic use; he had "preserved the traditions of Michel Angelo, by patriotic service under canvas as well as on it." Gifford's exquisitely rendered tableau of regimental colleagues in a specific wartime encampment congregated before an army chaplain took on reassuring biblical connotation.

Another war-related painting appeared in the same Annual, *The Halt by the Stream* by Edwin Forbes. Although its merits cannot be judged (its present location is not known), Forbes's penchant for simple anecdote suggests that *The Halt by the Stream* probably represented soldiers resting from a long

march. A basically self-taught graphic artist and painter, Forbes spent much of the war as an artist-correspondent for *Frank Leslie's Illustrated Newspaper*.[31] Probably the demands of this job prevented Forbes from being very involved with painting during the war years, although another work, *Sounds from Home*, was praised early in 1865 for its "truth to that camp life."[32] Only after the war did Forbes capitalize on his wartime sketches, often sentimentalizing them into works such as *Mess Boy Sleeping* (1867)(Fig. 16).[33]

Growing sensitivity to war's artistic "potential" is further evidenced by work Johnson completed in 1862. Never an artist-correspondent or a soldier, Johnson did concern himself with more pertinent imagery as the war progressed and he experienced it at or near the front. Johnson had reportedly witnessed fleeing slaves. In his rendering *A Ride for Liberty – The Fugitive Slaves*

FIGURE 15

Sanford Gifford. *Sunday Morning in the Camp of the Seventh Regiment near Washington*. 1862.

The Union League Club, New York.

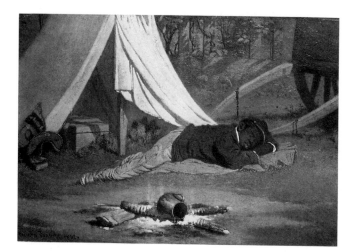

FIGURE 16

Edwin Forbes. *Mess Boy Sleeping.* 1867.

Wadsworth Atheneum, Hartford. The Ella Gallup Sumner and Mary Catlin Sumner Collection Fund.

(c. 1862), a young family clings to the back of a galloping horse, terrified of unseen pursuers, their pyramidally arranged forms piniomed against a generalized landscape. Even though *A Ride* conveys no specifics about that escape or the horrific conditions of slavery in 1862, the painting does extract meaning from the particulars of war – in this case, the tragedy of slavery.[34]

Even the landscape painter Albert Bierstadt took up war-related material in 1862. Like Johnson and Leutze, Bierstadt had been grounded in figural work from earlier training in Düsseldorf but became renowned at the start of the Civil War for his vast canvases of western scenery based on his travels with Gen. Frederick Lander's expedition of 1859. Time spent near the front with Leutze in the fall of 1861 could have stimulated Bierstadt's first Civil War scene, *Guerrilla Warfare (Picket Duty in Virginia)* (1862), but the composition derives from a stereography by his brother Edward taken of a *Picket Guard on the Alert, Near Lewinsville, Va.* (1861).[35] Bierstadt's sharpshooters fire from behind a picket fence in the foreground on rebels riding in a distant sunlit field. Their figural scale in relation to the attractive surroundings defuses the deadliness of the action. For Bierstadt's one other Civil War painting, *The Bombardment of Fort Sumter,* he must have again relied on published sources of information.[36] And here again, the panoramic prospect belies the tense purpose of the actual bombardment and the rupture of North and South that resulted. Only the placement of the fort at the center of the composition hints at the event's significance. Despite its historical reference, the painting remains first and foremost a landscape.

A last example, Louis Lang's *The Reception of the Old Sixty-Ninth Irish Regiment in July 1861* (1862), presumably documents an enthusiastic welcome given parading soldiers. Despite misgivings about the painting's artistic merit, the New York *Leader* recognized that its subject matter gave it "peculiar" appeal and went on to refer indirectly to the artistic "usefulness" of the Civil War:

American art has given but few indications that it recognizes the facts of war. And yet, for the past year, war has been creating an order of events and incidents which, in dramatic character, scenic beauty, and pathetic interest, as well as historic importance, absolutely demand the perpetuity which great art has to offer every worthy reality of life.[37]

To this frustrated critic, artists (presumably Lang an exception) had shrunk from their ill-defined responsibility. Yet judging from the title alone (the painting is unlocated), it is hard to credit Lang's work today with any of the virtues the critic called for. The historic information conveyed seems vapid, and indeed after two more long bloody years of war *The Round Table* dismissed the painting as unworthy of serious criticism.[38] The painting avoids the serious business of war and sets forth no lesson. Even so, when displayed at Goupil's gallery in 1862 *The Reception* received the accolade "the first really important representation of the new class of facts which characterize the history of the time."

Very different and particular claims were being made for images of war in

a rival medium by 1862 – that of photography. Photography took on significance as an alternative means of representation during the Civil War. By July 1861 photographers were already active in the field. One critic praised Mathew Brady (whose imprint absorbed many other photographers' work) for successfully documenting the war and commended him for having taken advantage of the "fortunate idea" of photographing the conflict early in its course. That artists themselves had not "taken the field with their sketchbooks, and gathered themes which should bring sure and speedy harvest of fame and wealth," the *World's* critic thought strange. Artists could have recorded the war but had shrunk from "comprehend[ing] the era," painting instead prewar "pastoral vistas." Among these "effeminate limners" were "no [Jacques-Louis] Davids and [Horace] Vernets, equal to the grand tableaus [sic] of battle charges." That is, no American painting matched those by France's respected history/military painters of the nineteenth century. Americans might capture the "glimmering beauties of the forest march," something of the "turmoil of forming columns," the merging of moonlight and campfire light, but nothing of substance.

"Brady's" photographs instead, the critic went on, must soon be purchased by "every refined and patriotic household." For, unlike its more timid sister, painting, photography provided "inestimable chronicles of this tempestuous epoch . . . truthful as the records of heaven appealing with ever increasing interest to the art-lover – the historian, and the patriot –." Who else was there? Photography had effectively cornered public attention, if not the market. Everyone, in the reviewer's extraordinary conceit, could "sail down . . . the whole river of war – widening, ever widening, ever growing deeper and more crimson with noble blood – ah! when shall we reach its mouth, and the broad ocean of a just peace?" on the metaphoric craft of photographic images.[39]

Public and critical interest in the mimetic properties of photography might well have dampened painters' enthusiasm for taking on "hard" events of war. Lang's painting, for example, had shown war far removed from the trenches, its wartime particulars being the regiment's portrait, and the other paintings discussed had similarly referred to war only tangentially. Yet technical restrictions hampering photography of the period caused certain resemblances between photographed and painted images of the war. Action could not be caught by the cameras of Brady and others, only unrelenting stills of the residue of battle or scenes of camp. Unidealized anonymous war dead and not the individual hero, halted images not imagined frenzy, epitomized military photographs. Just as the *World's* reviewer had noted there were no painters of the Civil War to match certain French battle painters, so too did Oliver Wendell Holmes, Sr. acknowledge differences between photographic images and those of war by the French artists Baron Gros or Horace Vernet. All the same, Holmes gave pride of place to photography, claiming that "[t]he honest sunshine [photography] 'Is Nature's sternest painter, yet the best.'"[40] Although modern scholarship has uncovered instances of photographers staging material, that material was nonetheless "real." Holmes celebrated this aspect of photography, but he also knew that photography's veracity could horrify and

sicken as well as fascinate. Holmes's perception was shared by a more pithy writer, who observed that the public "would jostle less at their ease [to see photographs of the Battle of Antietam then displayed on gallery walls] were a few dripping bodies fresh from the field laid along the pavement."[41] Painters could not match that degree of verisimilitude, even had they wanted to.

But painters could have benefited from certain other limitations of the photographic process. In "reading" Civil War photographic albums' historicity and ideology, Alan Trachtenberg has observed that photographers for the most part worked with single images, "[o]perating on the scene, without opportunity for advance planning or for retrospective decisions about pictures already taken, and without the means to idealize persons and actions. . . ." The resulting photographs have affected what Trachtenberg has described as "our sense of what suffices as an historical account."[42] That is, generally speaking, a single frame image can only suggest a historical narrative; it cannot encompass the totality of an event that in time of war is often a battle. Even if, as Keith Davis has reasoned, photographs approach narrativity by stimulating empathetic thoughts or recollections, or by capturing a significant moment in a narrative, they cannot convey the passage of time or causal sequence and hence do not moralize.[43] Surely there was room for painters to take on tasks other than those of which photography was capable.

By and large, painters remained reluctant, perhaps discouraged and confused about what approach to take and what audience they could count on if they followed critics' inexplicit directives. The supposition seems confirmed by pieces appearing in the press. Commenting on a painting by Victor Nehlig of a Civil War cavalry charge exhibited in 1863, a writer for the New York *Leader* blamed the evident lack of interest in Nehlig's work on the fact that "he does not know how to put himself before the public, and until lately has not known what class of subject is most likely to interest the common mind."[44] But Nehlig's active battle scene, which incidentally photography of the 1860s could not have captured, did catch the public eye. This happened despite Nehlig's probable fabrication of his subject; cavalry fulfilled scouting and raiding functions during the Civil War, only rarely becoming an offensive tactical force.

Other commentators expressed more acute concern about public attitudes and taste. *The Knickerbocker* condemned the public for

becoming wonderfully reconciled to a long war, and its countless horrors and disasters. . . . Our craving for excitement is rather increased than diminished by the events which are passing daily into history. It would seem as if we . . . had a strong natural desire to have our feelings worked up to the intensely emotional point, and that we thirst equally for tales of blood and scenes of pleasure. Yet we grieve but little over the sacrifice of life on the nation's battle fields. . . .[45]

In the face of tragedy, *The Knickerbocker* critic saw excessive and idle merriment, indulgence everywhere, and extravagance fostered by wartime profiteering. People closed their eyes to events around them, seeking vicarious means

of excitement and pleasure including the "unscrupulous" replenishing of "private purses." A subsequent article in *The Knickerbocker* reported caustically that the "war has lost its novelty" – no wonder by 1863 – and that one "hardly give[s] a second thought to a battle." Pecuniary concerns were uppermost in the minds of those "whose motives are purely selfish." The writer then went on to label members of society who "have more of it [money] than they know well what to do with" as "shoddy aristocracy."[46]

The word shoddy, referring to a material manufactured from reconstituted wool for Union army uniforms, came to be applied not only to "Flimsy work" but, by extension, to vices such as "Dishonesty . . . Pharisaic pretense . . . Art of selfishness" and ostentation, bristled the New York *World*.[47] As the New York *Leader* explained, "The fluctuation of events disturbs the old crystallizing processes of wealth, and enables a new class to indulge in the luxury of being patrons of art."[48] A piece later that year castigated "Shoddy" patronage of art. The "Shoddy" bid eagerly for "flower and fruit pieces, bacchanalian pictures, paintings of the animals and the chase" from the hands of an "unctuous tongued auctioneer," disdaining old masters or paintings of history as the territory of the well educated and those with inherited wealth. A facetious suggestion followed; "managers of the Shoddy Art excitement" should direct the attention of their artists to the subject of war: "Brady's gallery has issued its photographic bulletins of that kind, to the world that knoweth not Shoddy. But the world that doth know Shoddy wants plenty of carmine and vermilion, as illustrating Bull Run and Fredericksburg before its warlike associations are complete."[49] That is, before the truth was known about those battles and their gruesome specifics. The "Shoddy" preferred pointless "'bootyful'" pictures. The pun, if intended, suggests a more serious charge, that the "Shoddy" viewed war's bloodletting as a mechanism for profit.

Not content to point their collective fingers at patrons, critics chastised artists as well. The author of a lengthy article in *The New Path* noted with disgust the apparent capitulation of artists to shoddy taste. To his rhetorical question, "What ought our artists to do for us?" he retorted that they had simply provided the public with meaningless "furniture," paintings made expressly for sale and purchased without consideration of merit.[50] Artists had painted to suit patrons, reacting to what they believed the public wanted instead of seeking to "observe and record truths." War's everyday reality, its "unalarmed" and "business-like" aspects, rather than the imagined made good art. A cavalry charge (possibly like Nehlig's), for instance, was "lifeless." Having little to do with "the real thing," the subject encouraged exaggeration and artistic license.

To *The Round Table* as well, paintings ought to convey "true human feeling and not mere blood and horror." With these words the critic compared Eastman Johnson's 1863 "finely finished drawing" *Wounded Drummer Boy* with a painting by Paul-Alexandre Protais recently exhibited at the Paris Salon. Protais, the critic claimed, had "opened a new path in military painting," and then borrowing from an English colleague, praised Protais for having "'discovered that the sublimity of battles is neither in the smoke of gunpowder, nor in

the flash of steel, nor in the glare of madder-dyed breeches, but rather in the faces and feelings of men.'"[51] (Although Protais cannot be solely credited for the shift from histrionic battle and military painting by mid-nineteenth century – the same aesthetic as in Civil War photography – his work is representative.[52]) Johnson does show war Protais style at the level of the common soldier in *Wounded Drummer Boy* and in another work, *Civil War Scene* (Fig. 17). There is no pomp in the image of a young wounded drummer atop an older veteran's shoulder, attempting to rally fallen comrades by "drumming them through" a difficult battle.[53] Nor are there heroes in *Civil War Scene* among the disconsolate soldiers who shuffle wearily through a defile, only victims (present and future) of war's merciless and indiscriminate expenditure of men. Johnson is said to have gathered material for these images when at Antietam and Gettysburg, respectively, but war's gory mess does not appear.[54]

Just as artists fluctuated between denying and downplaying such horror, so too did critical opinion range widely. Some critics stubbornly continued to "urge the subject of our battle-fields, and the stirring incidents of this war, to the most earnest study of our artists."[55] Others, such as a reviewer of the 1863 National Academy of Design Annual, unperturbedly observed that the pictures which did appear on the Academy walls were "more remarkable for sweetness and delicacy in feeling than grandeur or force."[56] Unruffled too was the colleague who neither chastised artists for having inadequately treated the present conflict that "should have furnished forth many a theme for the pencil" nor criticized them for having preferred to paint primarily "peaceful subjects." Even so, he went on to say, the "nameless enthusiasts [who] send in works which shadow forth some of the incidents connected with the war" contributed work that was "with scarcely an exception, profoundly unsatisfactory."[57]

Harper's Weekly, however, singled out a few works in the 1863 Annual for

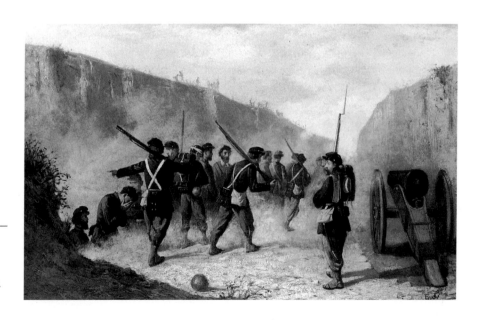

FIGURE 17

Eastman Johnson.
Civil War Scene.
c. 1863.

The Brooklyn Museum.
Dick S. Ramsay Fund.

praise because they referred to war, even while questioning whether the war that "so absorbs the public mind . . . will make itself felt in art."[58] Curiously, Gifford's *Baltimore in 1862 – A Sunset from Federal Hill* (1862), in which a lone sentry and cannon loom in silhouette against the evening sky, the landscape apparently signifying the Union being intently watched over, attracted no notice. But Homer's first submissions to a National Academy of Design Annual – *Last Goose at Yorktown* and *Home, Sweet Home* (1863) of foot soldiers foraging or musing in camp, respectively – did.

Homer plunged into war subject matter from its start, apparently grasping with his very first painting, *Sharpshooter* (1862/63), the war's relevance for his career. In *Sharpshooter* a marksman takes deadly aim at an unseen adversary from his concealed treetop perch. In 1861 and 1862 (and possibly later as well), Homer spent time behind the lines observing and sketching, occasionally sending drawings back to *Harper's Weekly*. These drawings sometimes directly informed Homer's oils but more often were simple jottings perhaps to rekindle on-site impressions. Even a camp scene such as *The Brierwood Pipe* (1864) – two soldiers at a campfire reflecting on home, their thoughts wafting in the evening air like smoke from their pipes – is a sober, unsentimentalized rendering of war. In fact, this Protaisian "unalarmed" work prompted *The Round Table* to label Homer "our most promising young battle painter." Today the statement seems exaggerated, but it makes sense when one realizes it was applied by the same critic who linked Johnson to Protais.[59] At this point in the war, perhaps "battle painter" meant a painter of war on any level.

But Homer in 1864 did complete two paintings – *Skirmish in the Wilderness* and *Inviting a Shot Before Petersburg, Virginia* – which are battle paintings in the sense that they concern the front-line business of war (Fig. 18). In *Skirmish in the Wilderness*, Union soldiers tangle as much against a natural enemy, the terrain outside Fredericksburg known as The Wilderness, as against the unseen human enemy; and the taunting Confederate in *Inviting a Shot* rages as much against the horrific war-scarred landscape near Petersburg as against men in distant trenches who fire two futile shots. Not aggrandizing images, these paintings are nonetheless serious statements about soldiers' responses to war's horrific confusion or unbearable stagnation in specific theaters in 1864.

How different is John Kensett's painting of 1864, *October Afternoon, Lake George*. Described as "an opiate, dulling our critical senses," its beauty neutralized "the dreadful tumult of war," soothing and diverting attention from its "agitations."[60] Emotional weariness with the protracted conflict, perhaps even apathy to be ungenerous, might be behind the critic's response. He had, after all, admitted that Kensett's painting "pleases so much that we forget to be critical."

That a conciliatory tone also colored a New York *Evening Post* review of the 1865 National Academy Design Annual comes as no surprise.[61] The surrender at Appomattox that April had virtually ended the war. The critic pardoned "our best" artists for having consciously avoided the "agitating influence of this great epoch of our national life" and for making art instead a "pleasant

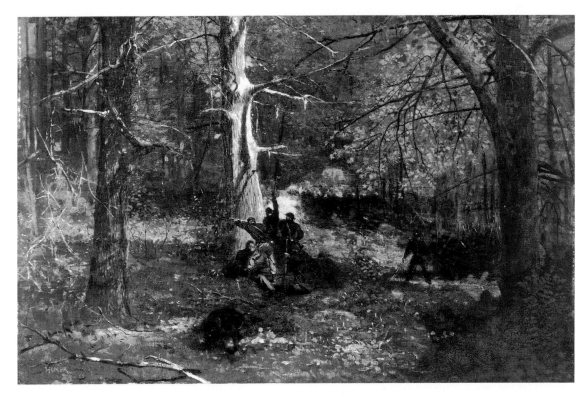

FIGURE 18

Winslow Homer.
*Skirmish in the
Wilderness.* 1864.

*From the collection of the
New Britain Museum of
American Art, Connecti-
cut. Harriet Russell
Stanley Fund. Photo-
graph by E. Irving Blom-
strann.*

refuge from the toils and ardors of a sublime struggle." The time called not for
"art to stimulate patriotism with pictures of heroic deeds of a noble cause; but
the time requires that art soothe us with its beauty, touch us with its finer
fancy, and counteract the fierce energy of these days with beautiful images." An
artist's work "is determined by his nature, not by the events whose fame fills
the world."[62] It was time for forgetting and restoring. Works like the "noble"
Twilight (on the Shawangunk) of Worthington Whittredge and the "tranquil"
Early Morning of Victor Griswold were seen as "worthy of this great year."

Again, there was no critical consensus. Quite different paintings in the
same Annual caught others' attention. And again, among them were three by
Homer each pertaining to facets of the war. In *The Initials,* the disruption of
civilian life caused by war is suggested by the image of a young woman who
distractedly traces the initials carved in a tree of her absent or dead cavalry
officer.[63] The simple game played in *Zouaves Pitching Quoits* by soldiers in
camp waiting out pauses in the fighting points up war's tedium and ordinari-
ness; and in *The Bright Side* the problematic place of blacks in the Union
Army and in the nation under siege is at least acknowledged by the depiction
of black teamsters "lying in broad sunlight" against an army tent.[64] *The Nation*
commended Homer for the very reason that he had found "a class of subjects
worthy of his most careful painting, and is, in this, wiser or more fortunate
than most of his contemporaries. He paints the scenes and incidents of our
great war, and paints them well."[65] Acknowledgment of Homer's treatment of

the Civil War just as it was ending substantiates the supposition that most other artists were inattentive to it.

Homer found his pictorial path during the Civil War, but none of the other painters cited focused so intently on war imagery. During its course, the war did not serve or strengthen their painting careers, nor did it seem to have greatly stimulated them. Of the landscape painters, Bierstadt and Gifford at least had opportunities to collect wartime material. Yet Bierstadt, no stranger to exaggeration when painting the American west or the European Alps, presented psychologically remote glimpses of war, and Gifford mainly placid panoramas of wartime terrain. Church, who was never at the front, so far as is known, treated the war symbolically through landscape. Nor can it be said that the figural painters mentioned confronted the actuality of war in their art. It would have been possible for them to do so. They, too, had seen military camps and battle sites. Leutze and Johnson were capable by nature of their training, and Forbes's draftsmanship was adequate for the task. But what work they produced has little intensity and purposefulness.

James Jackson Jarves, the preeminent critic of the period, had flatly declared painting the war to be difficult, if not impossible. Hardly a partisan of American art, Jarves laid blame on the shortcomings of the American public and the American artist. Like the earlier cited critic for *The Knickerbocker,* Jarves realized that art required public support for inspiration and life, which he saw as not forthcoming in America. The "sublime, impassioned, or spirited, is an unknown tongue" to the public, Jarves drolly observed. Americans preferred "materialistic landscape" and paintings of "dead game and ordinary genre subjects" instead. Added to the problem of a public without taste was the problem of missing artistic skills, as perceived by the New York *World* commentator. Jarves understood that "realistic scenes of strife" required the ability to render the human figure and the "delineation of strong passions and heroic action." In this regard, he noted Americans' "inaptitude."[66] Although his preference for Italian art may have fueled Jarves's lack of confidence in Americans' ability to paint the war, the reasons he offered for their failure are worth noting.

Public reception to topical art during the Civil War was unpredictable, sometimes bordering on disinterest. Artists were reluctant to take the lead, to direct public opinion, and increasingly limited access to the front lines created another kind of stumbling block. Whatever stood in the way of establishing effective pictorial claims on the war, it cannot, however, have been simply a matter of hesitancy with subject matter or artistic adequacy and lack of public support, regardless of Jarves's opinion.

Some blame must be laid on critics. They offered very contradictory advice. They implored artists to depict the war and the public to support their efforts, but with few exceptions, critics did not see art as a vehicle for propaganda or political message; perhaps they too could not conceive how art could bear that load. The general absence of propagandistic motive on their part perhaps increased critics' difficulty in determining how art could confront the "lofty character and vast issues of our civil war" as it was in progress.[67]

But there was arguably another, more basic impediment. It lay with the character of the war in military and national terms. Paul Kennedy, in discussing the role of military events in the formation of the great powers, has suggested that the Civil War marked a turning point in modern warfare. The Civil War lasted four years and ranged over a large geographic area involving almost constant fighting. For a conflict of the magnitude and duration of the Civil War, the American people were wholly unprepared; they had never experienced a large-scale war or maintained a large standing army.[68] Civil War military strategy differed also from that of earlier wars. The conventional tactic of "over-matching [the enemy] . . . on field of battle" was supplanted by that of "depriving the enemy of his supplies." The North's goal became the "extinction of the Confederacy," and in that the North succeeded.[69] Thus Civil War battles were not decisive or even heroic in the traditional sense. Individually or even cumulatively they alone did not determine the outcome of the war. Certainly attrition in battle was a factor in the defeat of the South, but so too was economic strangulation, destruction of industry, international isolation, and so on. Whatever apparent tactical advantage, gained on the battlefield was often inconclusive and temporary at best because what really mattered were the resources and the continuing resolve of the opposing sides.

Because the war was not a series of set battles or show pieces but "total war," the standard artistic fare of wartime – battle "portraits" foregrounding military leaders – could not be painted of this war. Compounding the problem was the North's unsuccessful search for a victorious and consistent leader. Few heroic figures emerged until the last year of the war. Fredrickson has pointed out that although the war became confused and bloody, civilians tended to see the war as an opportunity for glory. For combatants, however, a distinctly "new ideal of heroism," emerged, which Fredrickson has described as "grim and stoical . . . [with] little of the dashing and chivalric"[70] In contemporary participants' words, the Civil War hero was not the "'lunatic'" who "'does not dread to die or to be mutilated'" but one "'who, dreading these things, still faces them for the sake of duty and honor.'" Or, one dutifully obedient to "'a cause which he little understands, in a plan of campaign of which he has no notion, under tactics of which he does not see the use.'" Causes themselves lost their appeal.[71] How Protaisian seem these unflamboyant notions of war and soldiering.

Surely contention over the war's principal causes – slavery and the preservation of the Union – thwarted facile and even more considered attempts at their pictorial definition or commodification for the public. Eric Foner has argued that the lack of a "community of interest" and goodwill between the North and South before the war, despite commonalities of "ethnicity, language, religion," intensified into deep hostility once war was underway.[72] The fact that this hostility existed within the North itself led to confusion, misunderstanding, and disagreement over the direction of the war and uncertainty about its ultimate resolution. It is surely relevant in terms of this chapter that New York remained a hotbed of Copperhead and antiblack sentiment throughout the war and periodically boiled over with war-related unrest, experiencing some of

the worst draft and labor riots. And in New York, the North's commercial center, profiteering in "shoddy" merchandise was rampant.

For a variety of reasons, then, the war proved pictorially awkward, if not intractable, while being fought. At its finish, the opportunity for a conventional history painting presented itself in a meeting proposed in October 1865 on the Gettysburg battlefield between Gen. Winfield Scott Hancock, historian George Bancroft, and painter Emanuel Leutze.[73] Under consideration was a painting of the three-day battle in July 1863 in which Hancock had been a critical participant and hero. But Leutze died in 1867, and his chance was lost. Homer's postwar painting *Prisoners from the Front* (1866), epitomizing past, present, and future confrontation of North and South can be read (and was) as a history painting, but Homer too did not pursue this line.[74] He left for Europe that year, turning his back on the subject that had made his reputation – the Civil War. Forbes's recapitulations of camp life and the landscapists' established paths prevailed instead.

The Crayon's long-ago prediction of 1861 was fulfilled. The war years were "not . . . a harvest time for artists." Perceiving no emphatic celebratory or edifying subject matter, no decisive public and critical support, no certainty in the course of the war – props of conventional history painting – artists hesitated. Small wonder they shied away from imaging the war or resorted to innocuous scenes. What significant narratives could be extracted from such confusion while experienced? What moral could be drawn? How could artists "harvest" such a war? Certainly not in terms of conventional history painting. It too was a casualty of war.[75]

"A Stirring and Crawling of the Yeasty Thing"

Evolution and Misogyny in the Art of Frederic Remington

Alexander Nemerov

In 1908, the year before he died, Frederic Remington painted *Apache Medi-cine Song,* an image of seven Apaches seated around a campfire (Fig. 19). Like other night paintings from late in his career, the work self-consciously recalls a scene from Remington's earlier life in the West. "I am now painting the things

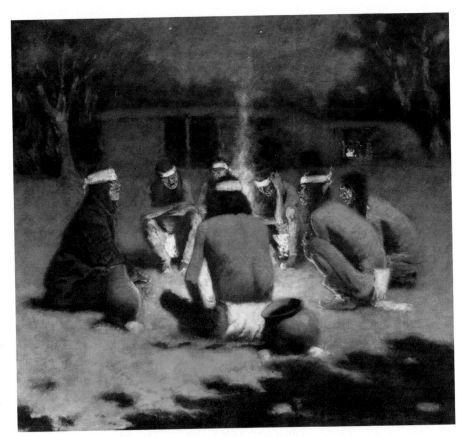

FIGURE 19

Frederic Remington.
*Apache Medicine
Song.* 1908.

*Courtesy Sid Richardson.
Collection of Western
Art, Fort Worth, Texas.*

which I saw as a boy or things which I heard about from men who took active part in the stir of the early West," he told an interviewer in 1907.[1] *Apache Medicine Song*, in fact, recalls at least three campfire scenes that Remington either witnessed or participated in during the late 1880s and early 1890s. The first, pointed out by historian Brian W. Dippie, is a firelit medicine song the artist had heard on an Apache reservation, "a strange concert" full of "strange discordant sounds" and "shrill yelps," in which "half-naked forms huddled with uplifted faces in a small circle around a tom-tom."[2] The second is a campfire before which Remington himself is readying to sleep when "I felt moved to sit up. My breath went with the look I gave, for, to my unbounded astonishment and consternation, there sat three Apaches on the opposite side of our fire with their rifles across their laps."[3]

A third and still more powerful firelit moment involves not an Apache but a Sioux. In South Dakota one night Remington "sat near the fire and looked intently at one human brute opposite, a perfect animal, so far as I could see. Never was there a face so replete with human depravity, stolid, ferocious, arrogant, and all the rest. . . ."[4]

Of the seven Apaches seated around the fire, the one second from left – the only one fully facing us – most vividly recalls this figure. He sits across the fire from the vantage point of viewer and painter, duplicating that moment in South Dakota, and his countenance is all menace. He is indeed a "human brute," a "perfect animal."

Here as elsewhere Remington's language is that of social evolution. His writing and painting repeatedly refer to evolutionary processes that, he believed, would eventually leave all but the Anglo-Saxon race extinct. He referred to Indians and so-called half-breeds, for example, as part of "the scrap-heap of departing races."[5] In these views, typical of his time, Remington voiced the ideas of well-known evolutionary theorists such as John Fiske, several of whose books he owned. Within three days of purchasing Fiske's *A Century of Science and Other Essays* in 1908, Remington reported in his diary that he was reading it.[6] In "The Doctrine of Evolution: Its Scope and Purport," an essay in *A Century of Science*, Fiske laid out the tenets of social evolution. Following the approach of Herbert Spencer, the theorist who was his mentor, Fiske believed that history is synonymous with progress, and that consequently no historian can operate without a theory of progress. "[Spencer] could see that the civilized part of mankind has undergone some change from a bestial, unsocial, perpetually fighting stage of savagery into a partially peaceful and comparatively humane and social stage, and that we may reasonably hope that the change in this direction will go on."[7]

Spencer's observation of this change, continued Fiske, caused him to look to the biological development of human beings as a way of understanding history. Hence the turn to nature to understand culture. "Between a savage stage of society and a civilized state," Fiske wrote, "it is easy to see the contrasts in complexity of life, in division of labour, in interdependence and coherence of operations and of interests. The difference resembles that between a vertebrate animal and a worm."[8]

FIGURE 20

Frederic Remington.
Paleolithic Man.
1906.

*The Rockwell Museum,
Corning, New York.*

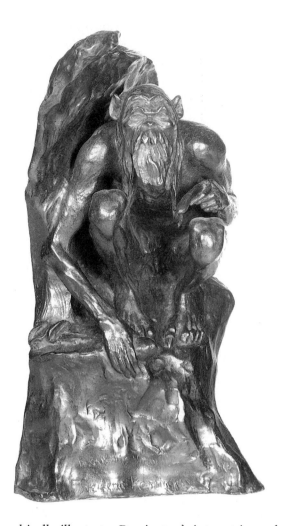

The work that most graphically illustrates Remington's interest in evolution is a little-known sculpture, *Paleolithic Man,* from 1906 (Fig. 20). The sculpture shows a crouching prehistoric man holding a club in one hand and a clam shell in the other as he stares intently (note the furrowed brow) from the mouth of a cave. With his strange appearance (the animal-like face, the pointy ears, the fin back, the talon toes), *Paleolithic Man* is an evolutionary prototype of a human being. Moreover, his rudimentary activity, cracking open clams with a stick, tells us his way of gathering food (and by extrapolation his technological knowledge generally) is of an easily superseded, primitive kind. It was not for nothing that Remington gave a copy of the sculpture to his friend Theodore Roosevelt, himself a staunch evolutionist historian.[9]

Paleolithic Man transforms our understanding of *Apache Medicine Song.* Crouching by the fire, the Apaches are much like the prehistoric man crouching at the lip of his cave. Indeed the figures crouch not very far from "caves" of their own – the blackened entryways of their primitive huts. In particular the Apache second from left, the "human brute," closely recalls the pose of Rem-

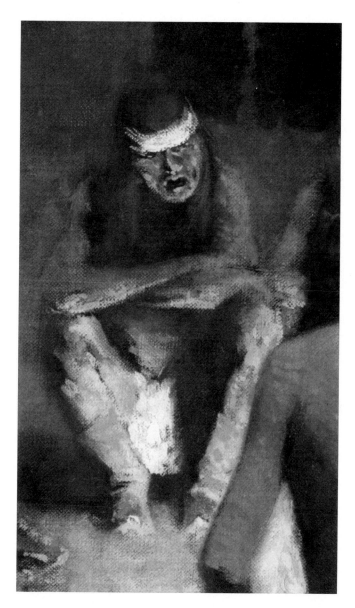

FIGURE 21

Frederic Remington.
*Apache Medicine
Song* (detail).

ington's caveman (Fig. 21). The relationship is no coincidence. For Reming-
ton, Apaches were modern-day cavemen, primitive beings permanently
arrested at an earlier stage of evolutionary development. This was a pejorative
connection, to be sure. The Apaches in Remington's painting are nothing less
than members of "the scrap heap of departing races." Yet clearly, in its fetishis-
tic examination of the assembled warriors – he "looked intently" at the human
source for his image – Remington's painting also exhibits an evident if not
quite laudatory fascination with Apaches and "primitives" in general.

Fight for the Water Hole, one of Remington's most famous works, can tell
us why (Fig. 22). In that painting, made in 1903, five cowboys fight desper-
ately to defend a water hole against surrounding Indian interlopers. Some of

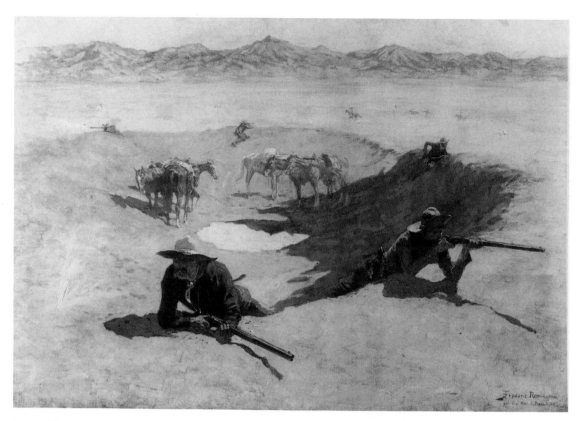

FIGURE 22

Frederic Remington. *Fight for the Water Hole.* 1903.

The Museum of Fine Arts, Houston, Texas. The Hogg Brothers Collection. Gift of Miss Ima Hogg.

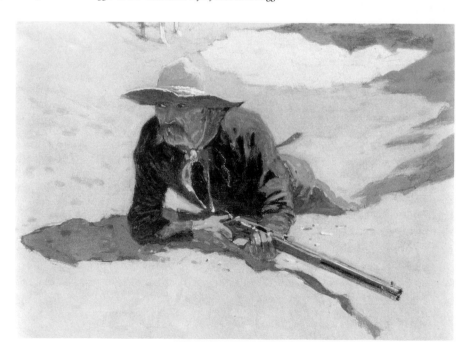

FIGURE 23

Frederic Remington.
*Fight for the Water
Hole* (detail).

the Indians are visible in the distance; the gaze of the foremost cowboy implies other attackers in front of the picture plane. Without question it is this foremost cowboy that mainly attracts our attention (Fig. 23). He is more carefully and richly painted than any of his fellow defenders; he is also, of course, nearest to us; and his vigilant pose – rifle at the ready, eyes narrowed, body tense – epitomizes the bravery of all five cowboys. This pose epitomizes something else about the defenders as well. Crouched in a defensive posture, peering from a cavity in the earth, holding a long weapon, and even sur-rounded by shells (bullet shells instead of clam shells), the cowboy is himself a species of caveman. Far from being pejorative, such a link was in perfect keep-ing with Remington's social evolutionism. For him, as for Roosevelt, modern Anglo-Saxons had grown soft behind their big city desks. They had lost touch with the race's conquering, martial spirit – the very spirit that had gotten them behind the desks in the first place. What was needed to restore that spirit was extreme, violent action – a reversion to a less civilized state.[10] "Out on the frontier," wrote Roosevelt approvingly, "life is reduced to its elemental conditions."[11]

In *Fight for the Water Hole,* the cowboys find themselves in just such "ele-mental conditions." It is kill or be killed. Fighting for water, they are cast into a primordial situation, defending their lives and the little they have in exactly the manner of their prehistoric ancestors. Thus the familial resemblance between Remington's cowboy and caveman is neither accidental nor deroga-tory. The cowboy, in his desperate situation, recovers the latent beast, the cave-man, within himself. At the lip of the cave once more, he incarnates the spirit of that first cowboy, that first mountain man, that Wyatt Earp of Olduvai Gorge. He is like Humphrey Van Weyden, formerly "Sissy" Van Weyden, hero of Jack London's *Sea-Wolf* (1904). Finding himself stranded on an uninhab-ited northern island, clubbing seals for food and shelter, Van Weyden marvels that "The Youth of the race seemed burgeoning in me, over-civilized man that I was, and I lived for myself the old hunting days and forest nights of my remote and forgotten ancestry."[12]

This brings us back to *Apache Medicine Song.* For the *Water Hole's* fore-most cowboy recalls not only the caveman but of course the crouching Apaches, in particular the one second from left. Each painting features a circle of men; each circle is deployed at roughly the same place on the canvas; each includes a second, smaller circle echoing the larger one – the circle of water in the *Water Hole* and the circle of the nearest basket's lip in *Medicine Song;* finally, wrapped around the nearest cowboy's hat is a telltale band of white exactly like the Apaches' headbands. Each painting represents a "tribe" of primitives. These tribes are similar, with one exception. On the one hand, for Remington, Apaches were innately primitive; possessed of a "demon nature," as he once wrote, they were permanently prehistoric. On the other hand, Anglo-Saxons kept a primitive, bestial spirit *latently* within themselves. This spirit, mostly dormant, emerged only in moments of the direst exertion. Thus Remington's fascinated portrayal of the Apaches: Stopped on the evolutionary ladder, they incarnate the image of the Anglo-Saxon race many thousands of

years earlier, at a comparable evolutionary stage. They embody the brutish beast, the "perfect animal," stirring in every Anglo-Saxon.

<p align="center">✳ ✳ ✳</p>

Even so, we have still not explored the most graphic of the evolutionary metaphors informing Remington's work. A side view of *Paleolithic Man* shows the caveman crouched in his cave unmistakably like a baby in a womb (Fig. 24). According to social evolution, he is humanity in its infancy. The sculpture thus makes explicit Spencer's equation between biological and cultural development. Spencer asked the following question, as Fiske relates it: "Where do we find the process of human development most completely exemplified from beginning to end, so that we can follow and exhaustively describe its various phases?" The answer: "Obviously in the development of the ovum. There, and only there, do we get the whole process under our eyes from the first segmentation of the yolk to the death of the matured individual."[13]

On an evolutionary scale, Spencer and Fiske regarded primitive cultures as equivalent to an egg in the womb; Anglo-Saxons were equivalent to human

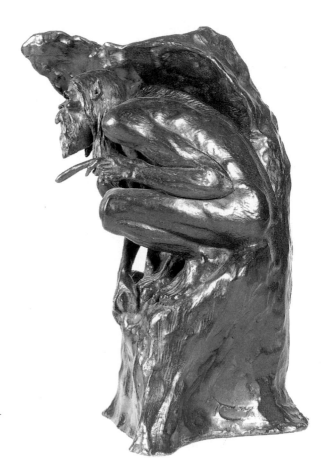

FIGURE 24

Frederic Remington. *Paleolithic Man* (side view).

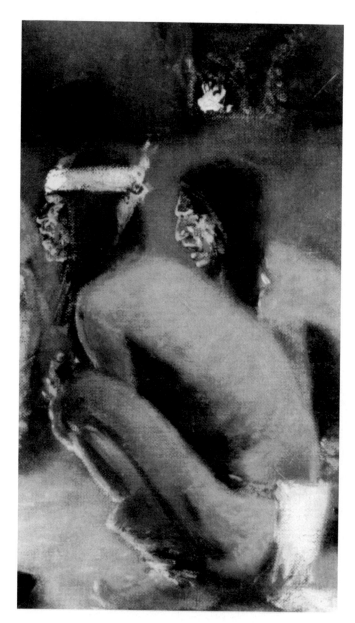

FIGURE 25

Frederic Remington.
*Apache Medicine
Song* (detail).

adults. Remington voiced this view, referring to "the savage child-mind" and in *Apache Medicine Song* representing a remarkably infantilized group of Indians.[14] Like children, the Apaches (at least all but one of them) are near naked; like children, they communicate with incoherent, bawling cries: "the strange discordant sounds" and "shrill yelps" of Remington's description. But it is the figure second from right – the one whose fetal crouch almost exactly repeats that of the cave-bound *Paleolithic Man* – who is most strikingly childlike (Fig. 25). This figure's pose was especially important for Remington to convey. The figure immediately behind and to the right of the fetal Apache – and thus less prominently shown – is in a similar though far less fetal position: His knees are

thrust forward instead of pulled up into his body; his weight rests on the balls of his feet rather than the heels (see Fig. 19). That Remington granted such a conspicuous fireside place to his most explicitly childlike Apache suggests the symbolic importance he attached to the fetal position. Gathered round their fire, the Apaches are simultaneously cavemen and infants, ancient newborns.

Apache Medicine Song is one of several Remington works thus making an evolutionary link between birth and death. *The Story of Where the Sun Goes,* painted in 1907, shows an old man telling three boys about the sun whose setting rays illumine them (Fig. 26). The painting's clearest symbolism is familiar: As in other Remington paintings, and in dozens of works by other western artists, the sun is setting on Indians. Their day is passed. Yet this interpretation does not explain why Remington chose, of all people, an old man and three children to contemplate this augury. In similar works, such as *The Outlier* (1909), he depicted warriors. Remington's choice is all the more odd when we consider the infrequent appearance of children in his art. Certainly his comparative lack of skill in drawing children – a lack never more in evidence than with the wide-eyed boys of *Where the Sun Goes* – helps explain their rarity in his art. Only an explicitly allegorical purpose, one feels, could persuade him to try not once but three times a kind of figure at which he did not excel.[15]

FIGURE 26

Frederic Remington.
*The Story of Where
the Sun Goes.* 1907.

Private collection.

Evolution is the allegory. *The Story of Where the Sun Goes* does not so much contrast the old man and young children as link these two extremes. The sun's golden glow unifies the four figures, casting each in an identical coppery hue. Sitting down, the old man literally lowers himself to the children's level, a visual embodiment of what he presumably does in the telling of his story. His pose is not that much different from the notably fetal pose of the child above him. In all of these ways the primitive man is a child. The children are not so much auditors of the old man's story as personifications of his own childishness. By the same token, the children are ancient. Evolutionary theory, as we have seen, cast Indians as remnants from an ancient and even prehistoric time. Thus the old man personifies the paleolithic age of the racial child. Together, these four ancient children are linked to the deathly sun. They watch it; the old man, as if out of sympathy with its sinking, lowers himself; the boys, or "sons," will presumably go the way of the sun itself; and they are all cast in that coppery glow, as though the light on their bodies were the expression of their own fading, as though the heated color of their skin, in the painting's social-evolutionist view, were but the sign of that skin's eventual immolation. Born old, Indians die young. Death dawns on them.

Apache Medicine Song, painted a year later, is more naturalistic, less of a deliberate allegory. Yet it tells the same story of birth and death. The childlike Apaches are surrounded by signs of their doom. A palpitating light plays over their bodies, functioning simultaneously as a primal source of heat and as memento mori, as though the warmth for which the evolutionary baby clamors was identical to the flickering candle flame. The night, here as in all of Remington's nocturnes, suggests an elegiac mood, a fading of remembered figures from view. The shadow of a tree, in the lower right corner, seems to move in the Apaches' direction, as though to eclipse them. Finally, though, it is this principle of movement, of flux, that most powerfully evokes change and death. Although *Apache Medicine Song*'s composition is stable, here Remington attends to movement – very slight movement – with an acuity, a sensitivity, powerful enough to suggest it is one of the painting's most important themes. Although the night is virtually windless (note the vertical column of smoke from the fire), the shadowed foreground branches and leaves nonetheless appear to move. This is the shadow of a tree whose leaves flutter, we feel, in the breeze; a shadow, moreover, whose very flutterings bend upon an uneven ground; it is thus at least a threefold sign of evanescence, a picture not only of a shadow but of a shadow that slightly moves, bent by wind and ground, disturbed by earth and air. Remington shows more movement here than he does in all of his rip-roaring action pictures. For here, speaking the language of social evolution, he evokes a principle of silent, creeping, imperceptible forces – forces of nature, or rather forces of history construed as natural – that imply, ever so gradually, the evolutionary eclipse of the figures gathered round the fire.

Just such a shadow, of course, extends ominously across part of the *Water Hole* (see Fig. 22). The shadow is part of the painting's network of temporal

symbols. The bullet cartridges strewn around the foremost cowboy, the evaporated water, and the Ozymandian desert sand itself all suggest passing time. The painting comes in fact from a culture obsessed with time: One thinks of Frederick W. Taylor's theories of scientific management, designed to maximize output among factory workers, and of Henri Bergson's and William James's writings on time and memory. In this context the shape of Remington's water hole becomes particularly interesting. The hole bears a strong although certainly unconscious relationship to a clock, replete with the eleven, twelve, two, five, and six o'clock positions marked and the two nearest guns suggesting hour or minute hands in motion. As in combat terminology, the field of battle is transformed into a huge timepiece, with enemies said to be at points on the clock; except for Remington this terminology expresses not only the position of the combatants but the expiration of time as they fight.[16] The time that passes so relentlessly in *Fight for the Water Hole* refers not just to the cowboys' desperate situation but to the entire historical era they represent. In a modern world (the painting was first reproduced on December 5, 1903, twelve days before Orville and Wilbur Wright's first flight), the primitive white man is as doomed, the picture tells us, as the Indians he fights. Moreover, the cowboys are doomed by a specifically modern kind of time, one measured in precise Taylorian increments. Roosevelt's "elemental conditions" will soon be gone. The hole is clock, cave, and grave.

Yet there is still more to this hole. If *Paleolithic Man* peers from a geologic womb, Remington's *Water Hole* cowboys find themselves in a similar situation. It is difficult to imagine a more graphic feminine symbol in Remington's art, indeed in any art, than the hole that confronts us so directly in this painting. Remington's contemporaneous novel, *John Ermine of the Yellowstone* (1902), explains some of the hole's feminine symbolism. *John Ermine* tells the story of a man – biologically white but culturally Indian – tragically ill equipped in both worlds. As a boy, Ermine is captured and raised by Indians. As a teenager, he learns white languages and customs from a white man, a hunchbacked recluse the Indians call Crooked Bear. Eventually, after his tutelage with Crooked Bear, Ermine becomes an army scout, and it is in a cavalry camp that he meets and falls in love with Katherine Searles, the daughter of an army officer. Katherine is attracted to this Indianized white man – "he seems to have the primitive instincts of a gentleman," she says – especially after he rescues her when she falls from her horse. But she has no intention of marrying him. "I am truly sorry that our relationship has not been rightly understood," she tells him after he proposes. Rejected, Ermine flees the camp, returns, and is shot – in the heart, as it turns out – by a sluggard Indian with whom he had once quarreled about Katherine.[17]

Ben Merchant Vorpahl has argued that *John Ermine* is Remington's strongest statement of the irreconcilability of America, past and present, wild and civilized.[18] In Remington's novel it is not possible for an Indian, or even an Indianized white man, to join the civilized Anglo-Saxon culture represented by Katherine Searles. Instead primitive men such as John Ermine must

die out. What is also interesting about this novel, however, is its portrayal, full of longing and hatred, of the relationships between men and women. Ermine's desire for Katherine is graphically sexual. After an early meeting with her, during which he is clearly her second choice (after a white lieutenant), the reader is treated to this truly eye-catching series of autoerotic metaphors:

He wanted to do something with his hands, something which would let the gathering electricity out at his finger-ends and relieve the strain, for the trend of events had irritated him.

Going straight to his tent, he picked up his rifle, loaded it, and buckled on the belt containing ammunition for it. He twisted his six-shooter round in front of him, and worked his knife up and down in its sheath. Then he strode out, going slowly down to the scout fire.[19]

As the references to weaponry make clear, Ermine's sexual feelings are violent. In *John Ermine of the Yellowstone,* relationships between men and women are called "hostilities." Crooked Bear sets the tone. He is alone in his wilderness den because of a woman's rejection. "*She* could see nothing but my back," he says bitterly. He also scorns the feminized nature that has left him deformed: "Nature served that boy [Ermine] almost as scurvy a trick as she did me, but I thwarted her, d__ her!" A subsequent battle scene reintroduces this feminized nature in a way that suggests rape: "[Men] sweated and grunted and banged to kill; nature lay naked and insensate."[20] The men – in this case Sioux and soldiers – bond in Remington's generic description; their enemy, lying vanquished at their feet, is not one another but the feminized nature in which they fight. Like this nature, it is Katherine, a little later, who lies "insensate" in Ermine's arms, the victim of her fall. Ermine, looking at her, fantasizes about stealing Katherine away; although he ultimately does not adopt this plan, as the literary historian John Seelye writes, "to kidnap, rape, and keep Katherine with him in the mountains," his sexual aggressions are clear.[21]

Women are not just the objects of aggression in *John Ermine,* however, but themselves imperiling to men. "She played the batteries of her eyes on the unfortunate soldier," the narrator says of Katherine, "and all of his formations went down before them." *John Ermine,* in fact, abounds with descriptions of lethal eyes. Katherine's gaze "penetrated Ermine like buckshot." Before her eyes Ermine "could not use his mind, hands, or feet; his nerves shivered like aspen leaves in a wind. . . ."[22] In particular, in Remington's novel eyes eat what they see. Says Katherine, eyeing Ermine, "I wonder if he would let me eat him."[23] Perhaps this is why the hole of *Fight for the Water Hole* unmistakably resembles an eye. The hole's circularity is foreshortened into an oval and its limpid blue iris centrally placed, perfectly mimicking the pools of the nearest cowboy's vigilant eyes. As much as the nearest cowboy trains his vision on the enemy, so a larger and vaginized eye rapaciously consumes him.

The hole victimizes the cowboys in still other ways. As the camp awaits a Sioux attack, the narrator makes this odd analogy: "To the silent soldiers this

was one of the times when a man lives four years in twenty minutes; nothing can be compared to it but the prolonged agony between your 'will you have me?' and her 'yes' or 'NO.'"

Later Ermine is terrified of the object of his desire: "He wanted her body, he wanted her mind, and he wanted her soul merged with his, but as he looked at her now, his mouth grew dry, like a man in mortal fear or mortal agony." At one point Ermine prays to his personal god: "Why did you not take the snake's gaze out of her eyes, and not let poor Ermine sit like a gopher to be swallowed?"[24]

Gophers in their holes – prey ready to be swallowed – the image again recalls the *Water Hole.* (In fact, ermines, like gophers and like the cowboys in Remington's painting, do live in holes.) In the painting, as in the novel, women more than Indians are the most dangerous enemy. As much as the cowboys fight the surrounding Indians, it is really by the enormous hole that they seem most threatened. The distant Indians, as Remington scholar James Ballinger has pointed out, are in fact unnaturally small.[25] It is as though it were not with the Indians as enemies that Remington was concerned. The hole itself, richly modeled, dominating the canvas, is in fact far more prominent than these minuscule assailants. It threatens to swallow the cowboys. Katherine's "I wonder if he would let me eat him" again comes to mind.

Operating within Remington's imagery is a fear and hatred of women. The sheer monstrousness of Remington's evolutionary infants, for example, suggests that for him the womb – and feminine space in general – was itself monstrous. The swaddled savages of *Apache Medicine Song,* not to mention clam-drooling *Paleolithic Man,* could hardly be more antithetical to other contemporary renditions of childhood, such as those of Mary Cassatt. There is also the symbolic sexual violence of Remington's work. *Paleolithic Man*'s use of a notably phallic club to crack open clams – clams that formally duplicate the feminine cave – suggests the kind of sex and aggression so insistently thematized in *John Ermine.* (The phallic club is best seen in Fig. 24.) Remington's hunched caveman is all but an image of the freakish hermit Crooked Bear, peering from his mountain den, hating the woman who rejected him. He is also an image of Ermine, who, rejected by Katherine, reverts to the evolutionary status, the narrator tells us, of "a shellfish-eating cave-dweller."[26] Similarly the vaginal hole of *Fight for the Water Hole* conjures the nature "lay[ing] naked and insensate" as "men sweat and grunt and bang to kill." The painting's resonance with the novel's imagery of rape suggests a theme of sexual aggression informing the manifest theme of racial warfare. Racial and temporal divisions are cast in gendered terms.

For Remington, Roosevelt, and others, women symbolized the advent of civilization on the frontier. It is no coincidence that Katherine arrives on a steamboat: The two are icons of progress. The heading of Chapter 12 reinforces this, showing a picture of a steamboat above the chapter's title, "Katherine," as if to imply the steamboat's name *is* Katherine.[27] Nor is it a coincidence that Ermine first glimpses Katherine in a photograph, itself an emblem of

technology that anticipates his first view of the thousands of white soldiers among whom he will be doomed: "[T]he camp slowly developed before [his] eyes like a photographic negative in a bath of chemicals."[28] And, in fact, when we consider that Katherine is literally the death of Ermine, she comes to appear as toxic an emblem of civilization as any of the army camps, locomotives, steamboats, or telegraph wires that routinely allegorize the doom of the Old West in paintings of this era.

Misogyny, then, related to the discourse of the "strenuous life." Motivating Roosevelt's endorsement of this concept was a fear of the fatal feminization of American men, especially of Roosevelt himself. "The cowboy," wrote Roosevelt in *Ranch Life and the Hunting Trail*, "possesses, in fact, few of the emasculated, milk-and-water moralities admired by the pseudo-philanthropists; but he does possess, to a very high degree, the stern, manly qualities that are so valuable to a nation."[29] Just keep him dirty and out of civilization's chemical bath. Development is death. *Fight for the Water Hole*, a picture of just such "stern" and "manly" cowboys (in fact it was the frontispiece for Volume 4 of Roosevelt's *Winning of the West*), addresses the fear behind Roosevelt's statement. As pathfinders, the water hole cowboys carve settlements in the vast American desert, but in doing so they create the feminized culture that will devour them. Ermine, the narrator tells us, "was to aid in bringing about the change which meant [his] passing."[30] For the pathfinder, to carve a settlement is to dig one's own grave.

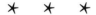

It is odd then that *Apache Medicine Song* departs somewhat from this hatred and fear of "feminized" civilization. The half-naked savages are types of Remington's monstrous infant, as we have said, but much else in the painting softens the artist's stance in earlier paintings such as *Fight for the Water Hole*. Probably baskets, the two foreground containers are rounded, swollen, pregnant forms recalling the classical imagery of women as vessels. In one sense these feminized baskets augment *Apache Medicine Song*'s theme of evolutionary birth. The vessels' curves echo those of the Apaches' backs and the sloping huts, emphasizing the link among these three icons of primitiveness. Yet the baskets serve another purpose. The center vessel is the nearest human-made object in the entire painting, an artifact shown seemingly for its own sake, apart from any narrative role. In light of the artist's misogyny, what sort of Remington painting would thus give pride of place to an art object – moreover, an art object with distinct feminine connotations?

The answer concerns Remington's self-conscious late career change from documentary to fine artist. In the last few years of his life, as Peter Hassrick and others have demonstrated, Remington sought to shake the role of illustrator and become known as a serious painter. For Remington, this meant emphasizing the formal as much as the narrative qualities of his art. Partly the change involved study of impressionist brushwork such as that of his friend

Childe Hassam. Partly it involved studying the work of James McNeill Whistler. In 1908, the year he painted *Apache Medicine Song,* Remington wrote in his diary, "There is a Whistler [at] the Met Museum as black as the inside of a jug."[31] Remington's own nocturnes manifestly owe more to the work of the California artist Charles Rollo Peters than they do to Whistler, but by 1908 he was clearly interested in Whistler's work. In that year he made two trips into New York to see it, examining it in January at the Metropolitan and in March at Macbeth Gallery. He commented on it in his diaries and owned Arthur Jerome Eddy's *Recollections and Impressions of James A. McNeill Whistler* and E. R. and J. Pennell's two-volume *Life of James McNeill Whistler.* His sculpture scrapbook includes a reproduction of Victor D. Brenner's commemorative *Whistler Plaque.*[32] Remington's interest was natural enough: As a well-known painter of nighttime scenes – he made approximately twenty in the period 1906–9 – he wanted to examine the work of the most famous nocturne painter of all, indeed the artist whose night images had originated the very use of the words moonlights and nocturnes as titles for his own nighttime scenes.

Remington's admiration carried powerful gendered associations. For him, Whistler epitomized art-for-art's-sake aestheticism. Whistler's paintings seemed to be just paint, devoid of subject. "Saw some 'punk' Whistlers and how people can see everything in there I do not know," Remington wrote after his trip to Macbeth Gallery.[33] Although the Whistlers he saw at Macbeth and the Metropolitan were darker than Whistler had intended (the result of too much bitumen), Remington's comment reveals that, as far as he could see, the paintings contained little or no subject.[34] They were just paint. For Remington, paint – without being subsumed into subject matter – was feminine. Upon seeing impressionist paintings of the kind he himself was making, he said, "I've got two maiden aunts in New Rochelle who can knit better pictures than those."[35] He is still more explicit in a letter he wrote to his friend Al Brolley in 1909: "I stand for the proposition of 'subjects' – painting something worthwhile as against painting *nothing* well – merely paint. I am right – otherwise I should as soon do tatting, high-art hair pins or recerchia ruffles on women's pants."[36]

Nor was Remington alone in thinking of paint in this way. In *White Fang* (1906), London describes Beauty Smith, a primitive and exceptionally ugly character: "His eyes were yellow and muddy, as though Nature had run short on pigments and squeezed together the dregs of all her tubes."[37] In London's passage, nature is not only figured as a painter before her easel; strikingly, the phrase "her tubes" recalls a woman's reproductive organs as much as it does tubes of paint.

Paint for its own sake was like Katherine Searles: pretty, lacking in ideas, and utterly insincere. "Sir Walter Clark lecture says, 'American Art must have ideas. Paint for paint's sake is out of date,'" Remington reported in his diary. The implication was that "paint for paint's sake" was wholly lacking in intellectual content. Along these lines, Remington regarded his little landscapes as "merely pretty." Privately he criticized the impressionist work of Robert Reid:

"Bobbie's hand is cunning at small landscape but it lacks sincerity – [the paintings] have a paint for paint's sake draw to artists but [are] d__ by public. The public while not knowing why can detect sincerity."[38]

Whistler consequently was a very feminized artist for Remington. In *John Ermine* the hero's first feelings of love for Katherine evoke both feminized paint and Whistler himself. Ermine's love is "a new emotion, indefinite, undefinable, a drifting, fluttering butterfly of a thought which never alighted anywhere. All day long it flitted, hovered, and made errant flights across his golden fancies – a glittering, variegated little puff of color."[39]

This "little puff of color," calling to mind a bit of paint, is also likened to a butterfly. The butterfly – clearly feminized in Remington's description – was, of course, Whistler's private emblem, a device he used in his signatures.

The hostility of each of these three quotations indicates that Remington's interest in Whistler – and in painted "mood" generally – was halting and ambivalent. Yet his move toward this more feminized form of art is easily tracked. In his serialized novel, *The Way of an Indian* (1906), White Otter, the hero, approaches an Indian man playing a flute to woo a lover to a secluded forest. In a passage that demonstrates Remington's antipathy to such sentiment, White Otter viciously kills the man: "[The] knife tore its way into his vitals – once, twice, three times, when, with a wild yell, he sank under his deluded infatuation."[40] In 1909, however, Remington made a painting, *The Love Call,* showing a solitary Indian man playing a flute beside a tree. He was now depicting the feminized scenes he professed to hate. Moreover, he would have understood not just the painting's subject but its style as feminine: Remington completed *The Love Call* in one day – an unusually fast period for him – implying his method for this now lost painting, as in many of his late works, was more bravura and impressionistic.[41] He had "knitted" the surface.

Remington's many late nocturnes also signaled his turn to a feminized art. The moon, in *John Ermine,* is "She of the night, soft and golden, painting everything with her quiet, restful colors, and softly soothing the fevers of day with her cooling lotions."[42] In a dense feminization, the passage conflates moonlight, painting, and mothering. The application of "cooling lotions" upon a fevered body, echoing the act of "painting . . . quiet, restful colors," connects the work of the painter with the nighttime ministrations of a mother over a bedridden child.

The starkest feminization of *Apache Medicine Song,* however, concerns Whistler. Remington's painting contains at least three tantalizing although clearly unconscious references to the artist whose nocturnes he had been examining that year. One occurs in the painting's upper right-hand corner, where a fire burns in a hut's entryway (see top of Fig. 25). The entryway is rectangular; its border, lit by the fire within, is a golden frame; the fire itself suffuses this very picturelike entryway with rockety streaks of sparkling light. All in all, the entryway strikingly resembles the Whistler nocturnes, such as the Metropolitan's *Nocturne in Green and Gold,* that Remington saw the very year he made *Apache Medicine Song*. The painting's title, specifically its inclusion of the word *song,*

also obliquely refers to Whistler, recalling that painter's manner of calling his work "Symphonies," "Arrangements," and "Harmonies." Finally, confronting us with its black mouth, the nearest foreground basket vividly recalls Remington's description that same year of a Whistler "as black as the inside of a jug," prompting questions about why Remington would choose this particular metaphor to describe Whistler's bitumen-darkened painting. The answer concerns the kind of multivalent feminization at work in the *John Ermine* passage cited earlier. A basket or jug, as a vessel, was as feminine a symbol for Remington as Whistler's butterfly. It also called to mind Whistler's feminized painting technique: The icon of the artist's aestheticism, his interest in mere paint, was (in John Ruskin's famous phrase) "a pot of paint." Ruskin's accusation – that Whistler had flung "a pot of paint in the public's face" – derided an art destitute of subject matter. Remington's swollen basket, a beautiful object isolated from the surrounding narrative, refers to Whistler, women, and this "pot of paint."

In these unconscious ways Remington identified his painting with a civilization he considered feminized. Certainly the work of artists such as the urbane Whistler and the members of The Ten seemed to him progressive. "Saw Bobbie Reid's new work – splendid – a good long stride," wrote Remington in 1908, praising the work of the artist he was to condemn for insincerity the following month. "By gad a fellow has got to race to keep up now days – the pace is fast."[43] The evocations of forward movement – in particular the phrase "a good long stride" – suggest the evolutionary interest not only in progress but in the mechanics of walking; Reid's impressionist work comes from a higher walk of life, one productive of good long strides.

Yet in *Apache Medicine Song* Remington also unconsciously identifies the act of painting with the primitive. There is something strange about the Apache closest to us (Fig. 27). Of the seven figures he is the only one with his back turned. Space on either side separates him from the other figures. Also, the figure does not so much face as lean into the image. His body is oriented to the picture plane at an angle, so his left hip and left shoulder are closer to us than his hidden right hip and right shoulder. The modeling of his hair where it meets the shoulders suggests his head also leans inward. His right arm, although we feel its presence, is entirely absent. Manifestly the figure is probably meant to be stoking the fire, perhaps with a stick. Yet the figure also dramatically recalls a certain conventional manner of showing the artist in the act of painting. (One thinks of the artist in Vermeer's *Artist in His Studio*, for example.) This is true even to the point of Remington's figure leaning inward and implicitly holding a brushlike stick in his right hand. In particular the back-turned Indian recalls Remington's self-portrait, explicitly in the act of representation, in an IOU to his friend Joel Burdick (Fig. 28). Across the fire from a "perfect animal" (just as Remington was in South Dakota), also across the fire from an array of three Apaches (just as Remington was in Arizona), this back-turned Apache reads as an unconscious Remington self-portrait. *Apache Medicine Song*, as I have argued elsewhere, is just one of many late works that express Remington's unconscious compulsion to represent the act of painting within the very scene he painted.[44]

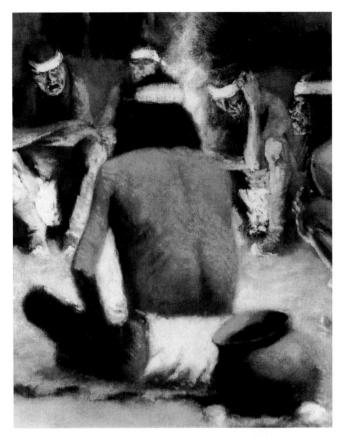

FIGURE 27

Frederic Remington.
*Apache Medicine
Song* (detail).

FIGURE 28

Frederic Remington.
Untitled Drawing. n.d.

*Courtesy Frederic Rem-
ington Art Museum,
Ogdensburg, New York.*

"He worked unhampered by rule, example, or opinion, a veritable child of nature, and he died untamed." So wrote Augustus Thomas, the playwright and friend of the artist, in a posthumous appreciation of Remington. Thomas continued, "Remington thought he believed in 'art for art's sake,' but I know of nothing that he ever did in any of its departments that did not primarily attempt a story. His wish to tell something that had touched him, and tell it at first hand, was as primitive as the instinct of a caveman."[45]

In Thomas's appreciation, Remington's storytelling art is as primitive as the cultures it records. Likewise, in the painter-figure of *Apache Medicine Song*, Remington identifies his story-based mode of art with primitive cultures. Granted, his identification is equivocal. The painter-figure – together with the fully clad figure at left – sits instead of crouches by the fire. Also, the Whistlerian pot (palette) of paint is at the painter-figure's side, suggesting the very medium with which he tells his stories is de facto a civilized or merely pretty substance (this paradox dominates much of Remington's late work). Nonetheless *Apache Medicine Song*, like Thomas's appreciation, posits the realist painter as a caveman. In social-evolutionary logic, the rudimentary tool of the brush recalled the brute phallic sticks of one's racial ancestors. The storytelling brush was as masculine and primitive as *Paleolithic Man*'s penile club. It was as though the memory of these primitive activities should somehow be encoded in the physical practice of applying the paint to canvas.

Like the caveman, the realist painter is doomed. Thomas's appreciation, written in 1913, the year of the Armory Show, is clear about this. So too is *Apache Medicine Song*. Painted in 1908, at the very end of the centuries-old realist tradition – at the very moment when paint's long-assumed mimetic abilities were irrevocably thrown into question – Remington's painting announces its own evolutionary eclipse. The paradigm of representation creeping to replace it would distance itself from the old realist belief in a one-for-one correspondence between painted image and "real" world. The new art, like the shadow of the tree, evokes objects for which the only evidence are the shadows or images themselves. What we see, then, is that the evolutionary paradigms governing Remington's conception of race governed his conceptions of art as well. "I am frankly of the opinion," Remington wrote in his diary on January 16, 1908, "that painting is now in its infancy."

Hidden Histories
The Chicano Experience

Shifra M. Goldman

*The making of a work of art is one historical process among many
other acts, events and structures – it is a series of actions in
but also on history.*[1]

– T. J. Clark

*That moment when the unspoken discovered that they had a his-
tory which they could speak [was] an enormous moment. The
world begins to be decolonized at that moment.*[2]

– Stuart Hall

When we know our histories, we are ready to take action.[3]

– Lucy Lippard

The relationship of Chicano historical paintings to the transcribed history of
art can be seen as analogous to the relationship between oral and written his-
tory. Artists are more poets or preachers than historians; they take rhetorical lib-
erties with material extrapolated from books and their own experiences. Never-
theless, it would be retrograde to argue that their vision has less merit because it
is a personal interpretation of that elusive quality known as "the truth." Beyond
that there is the didactic element: They speak on behalf of, and often to a com-
munity toward whom they feel a sense of responsibility, which provides a bal-
ancing factor and an accountability not necessarily exercised in academia.

In this chapter I trace some of the experiences and representations of Chi-
cano artists as they sought an artistic and political voice during the 1970s,
through the work of two muralists who focused primarily on historical themes:
Leo Tanguma of Denver, Colorado, and Emigdio Vásquez of Orange, Califor-
nia.[4] In my role as narrator and paradigmatic constructor of a Latin American
and Latino social art history, I choose to include to the degree possible the evi-
dence not only of the painted images and concepts, but the observations by the
artists themselves about their ideas and their work. I also want to stress that the

reconstruction of such a history is not a question of essences, but of political power; it is part of a process constantly being modified as new circumstances and situations arise. Thus the early metaphysical and Chicano-centric moral focus of Leo Tanguma's work later redirected itself toward national and international unity among Third World peoples facing oppression, whereas Vásquez's sociology of the Chicano working class recognized that the civil rights struggles of the 1960s and 1970s had produced a new breed of Chicano leaders whose activities changed the nature and face of the power struggle within the period of one generation, just as it changed the labor conditions and aspirations of Chicano youth.

To excavate a hidden history often means to fracture or overturn the existing and exclusionary hegemonic history; it means to replace the well-worn heroes and heroines (and heroines there surely are) with new faces, personalities, and agendas. It means to revamp the way history is considered and to reevaluate its agents and processes. When setting forth the rationale for his groundbreaking book, *Europe and the People Without History*, Eric R. Wolf, for example, pointed out that "[W]e can no longer be content with writing only the history of victorious elites or with detailing the subjugation of dominated ethnic groups. . . . We need to uncover the history of 'the peoples without history' – the active histories of 'primitives,' peasantries, laborers, immigrants and besieged minorities."[5]

In fact, Chicano muralist Leo Tanguma made that very claim a central part of his 1972–3 Houston mural, *Rebirth of Our Nationality*, by integrating into his painting a banner text that read "To Become Aware of Our History Is to Become Aware of Our Singularity."[6] Wolf commenced writing his book in 1974, a year after Leo Tanguma (a descendent of "laborers, immigrants, and besieged minorities") unfurled his message. The thought occurs that there is some connection between these two circumstances, one that certainly cannot be traced directly, but which existed in the charged social atmosphere of the 1970s that translated the protest and counterculture of the 1960s into new concepts and more complex modes of action. With his book, Wolf expanded his former anthropological investigation into a global search for an analytical history that would account for the ways in which the social system of the modern world came into being. Postulating that human populations construct their cultures in interaction with one another and not in isolation, he pushed his research back to the year 1400 to examine the forces propelling Europe into commercial expansion and industrial capitalism, and to 1492 to reconsider the interaction of cultures since that pivotal date which so markedly signaled European expansionism. Wolf's study was an early venture toward the kind of global considerations that today mark the parameters of this discourse and have changed the ways in which we consider the construction of nationality, ethnicity, and political economy.

At the same time, on a popular level, Tanguma's was the first articulation by a Chicano artist of the debates that were to rage during the 1980s about pluralism and multiculturalism and that marked the reframing of the modernist discourse on universalism versus regionalism (now reconfigured as

globalism versus localism) – all terminologies ultimately coined and deter-mined by the dominant society.[7]

For Tanguma in 1973, the central target was the uncovering and retran-scribing of a hidden history – that of the Mexican populations of the Americas – and by so doing, to appeal to his community to know and understand its history and to act on that knowledge. I do not ascribe to Tanguma the kind of scholarly investigation to which Wolf was dedicated; nevertheless, the muralist was working with a clear sense of history and the interrelations that led to the oppression of the Mexican and Chicano peoples in the United States, which he had experienced firsthand.

Art has to be a part of the movement, the upsurge of the fight for justice. You cannot separate it from the problems, the suppressed culture, suppressed social life that our people have. We claim that this is our land [the United States Southwest] regardless of what people say. The Anglos took it over from us by all the means available to them. So when we reassert our nationality, we bring with it all the indictments against the people who brought oppression on our people for so long.[8]

On a more personal note, he described the psychological face of oppres-sion that plays as key a role as his politics in the conceptions of his murals: "I grew up with all the complexes of inferiority like any ordinary Chicano. But unless you find some measure of self-respect, those feelings will remain sup-pressed. If you discover yourself and your worth as an individual . . . the feeling that every individual is worth something, you can find yourself in society."[9] Finally, reflecting on his choice of history as a theme, he explains, "Muralism is an art that expresses a message with historical narrative . . . it must be a philo-sophical painting with a message."[10]

Emigdio Vásquez, who is of Tanguma's generation, was shaped by a corre-sponding biography.

I have always been sympathetic to the struggles of the working class. I consider myself part of that economic class. I trace my roots to the Mexican Revolution of 1910, because that event gave my father the impetus to migrate to the United States. My father's stories of the Revolution in Mexico and of worker strikes in the United States influenced me greatly. He told me many stories of the conditions of the mines in Ari-zona and how life was for Mexican-Americans during the Depression.[11]

Although Vásquez drew his material mainly from the environment and expe-riences of Chicanos, he did not consider that too narrow a subject field for a general audience to appreciate. Such a judgment, in his opinion, was some-what myopic and racist. "If the viewer is not a resident of the *barrio*, the paint-ing should give him [sic] some inkling of how the people of this community lived and of some of the political struggles that they went through. I think art can contribute to the raising of consciousness."

Tanguma and Vásquez, although very different in their styles and state-ments, share many common grounds. Both worked as agricultural and indus-

trial laborers; both were self-taught until they enrolled in art classes later in their life after they had painted a number of murals; both came from working-class families who had migrated from Mexico; both have combined art with political activism and, in this, conform to the general practices of many Chicano artists who emerged from the militant 1960s; both worked with teams of community and young people they initiated into their ideas and trained as public artists; both have suffered the neglect (and poverty) that (until very recently) attended Chicano artists generally; and finally, both are respected pioneers of the Chicano art movement.

Images of Mexicans in the visual arts of the United States were practically nonexistent before the 1960s except in documentary photography and mass media such as newspapers and popular magazines. If nineteenth-century history records the Mexicans' loss of their lands, the twentieth century signals their proletarianization and the making of a permanent underclass. Not only were images of Mexicans excluded due to racism, but equally because of the scorn exhibited by the artistic establishment toward images of people at work.[12] Such images as do appear before 1960 glamorized the Spanish *conquistadores* and missionary fathers from the period of New Spain, or idealized *caballeros* and *vaqueros* (Mexican horsemen and cowboys) as free and daring spirits within the mythology of the Old West. Occasional references to Mexicans and Mexican Americans as workers (which 90 percent were by the 1950s) presented them anonymously as symbols in static conflict-free situations rather than as actors on the historical stage. Even those stereotypical images that proliferated in the mass media of the twentieth century did not appear with frequency in the fine arts. Although the New Deal period saw the greatest explosion of working-class images in the history of U.S. fine arts, Mexicans – unlike black, Asian, and white workers – were largely invisible. Not until Chicano artists were propelled on the scene by the civil rights movements and farm workers' strikes of the 1960s did Mexican and Chicano workers become the subject matter of painters and printmakers. As one astute observer noted, "Those colorful murals that one can see nowadays throughout the Southwest in which figures like Captain Luis de Velasco are depicted in all their finery might well be balanced by a few murals showing Mexican migratory workers sweating in desert cement plants, in the copper mines of Morenci, the smelters of El Paso, and the great farm-factories of the San Joaquin Valley."[13]

Considering the proliferation of Spanish conquerors and missionaries in U.S. murals of the 1930s and 1940s, it is interesting to note the historical revisionism that began with the earliest Chicano murals. History of the Americas emphatically does not start with Columbus or with the Spanish conquistadores. When shown, they are integrated into a much older panorama that finds its genesis with Native Americans of the continent. In fact, Chicano artists insisted on the primacy of Indian civilizations, making it a cornerstone of their philosophy and of their representations. The consciousness of the Indian presence is underlined by its inclusion, both historically and metaphorically, in countless Chicano works of art – among them the murals of Tanguma and Vásquez.[14]

Leo Tanguma (b. 1941), the son of Mexican parents who worked as migrant farm laborers, was born in Beeville, and lived in Baytown, Texas, until he left for Denver in 1983. A political activist with the Chicano movement of the 1960s, he spent the first portion of his artistic life in Houston as a self-taught muralist who carried forward his political ideas in his painting. Tanguma's work is based on the expressionist trends of Mexican muralism, which he very much admired, making a pilgrimage in 1972 to visit David Alfaro Siqueiros (then working on his Polyforum murals, the last he completed before his death in 1974), and meeting Siqueiros's main assistant, Mario Orozco Rivera, as well as Fanny Rabel and Pablo O'Higgins. Siqueiros advised Tanguma to abandon folkloric themes and boldly paint his own North American reality. The Mexican muralist, last of the *tres grandes* (Big Three) of the postrevolutionary mural movement, also set Tanguma an example with his baroque-influenced but totally contemporary *escultopintura* (sculptural painting) that fused real with painted space and shape. Despite terrible discouragement and major financial sacrifice, Tanguma never abandoned the vision of combining a universal political statement with innovative and monumental plastic form. As his style developed from early attempts, Tanguma fused the driving and expressive linear forms of José Clemente Orozco with the dramatic solid ones of Siqueiros. At the mercy of a hostile social and artistic climate in Houston during the formative years of the Chicano arts movement, and with a trail of destroyed wall murals, Tanguma finally abandoned completely the use of a permanent ground for his works, and elaborated Siqueiros's ideas of escultopintura into portable free-standing three-dimensional mural surfaces painted on all sides.

> Never will it be lost
> Never will it be forgotten
> That which they came to do
> That which they came to record in their paintings
> Their renown, their memory, therefore in the future
> Never will it perish.
> Always we will treasure it
> We have their blood and their color
> We shall tell it
> We shall pass it on to those who are yet to live, yet to be born
> The children of the Mexicans.

With these words of tribute to the vanished Teotihuacanos (or possibly the Toltecs) by Tezozómoc,[15] Leo Tanguma's mural, the 18- by 240-foot *Rebirth of Our Nationality* (Fig. 29), closed its pictorial history of the newly emerging Chicano movement. Painted between 1972 and 1973 on an exterior wall of Houston's Continental Can Company,[16] it is not only one of the few remaining murals by the Chicano artist in that city, but the crowning achievement of his

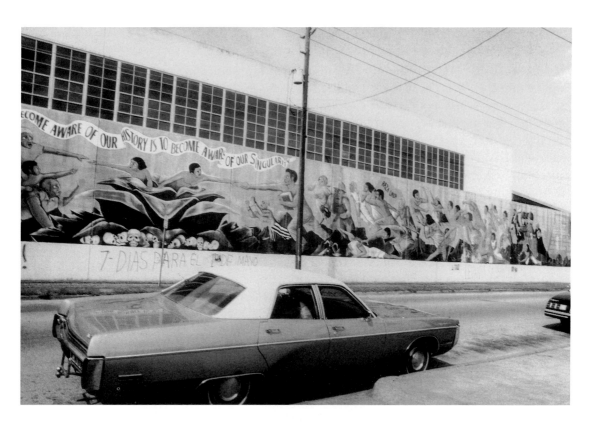

FIGURE 29

Leo Tanguma.
*Rebirth of Our
Nationality*. 1972–3.
Mural detail.

*Continental Can Com-
pany, Houston, Texas.
Photograph by the
author.*

early wall-painted work. *Rebirth* established compositional devices and figural treatment that are still part of the artist's style. The ideas, spatial organization, intensity of directional movement, and articulation and detail of individual figures (who represent different periods of history, different occupations, different classes) are already established. The color is still restrained and cool, and the figures not as densely layered in this linear work as they would be in later ones. It does, however, have three levels of action, a structure Tanguma would use again. The symbols that persist in later work include a dead figure in underground space and the green feathered serpent Quetzalcóatl, a long-enduring and powerful pre-Columbian deity.

Neither Tezozómoc's actual tyrannical history nor that of the Mexica Aztecs (who gave Mexico their name in the postindependence period) figured in the Chicano mythology developed in the late 1960s. As usual, history was rewritten with a view to its relevance to the present. Thus historical murals, considering they are works of art with a poetic and subjective dimension, must be seen as fictions because they are constructed on a partiality of culture and historical truths based on the vision of the artist. In the discursive practice of metahistory, "It is not a matter of choosing between objectivity and distortion, but rather between different strategies for constituting 'reality,'" in different ways, each of which has its own ethical implications.[17] Activists, poets, and artists adopted the name Aztlán (the mythical home of the Aztecs) for the U.S. Southwest, and saw themselves as the descendants of the Aztecs. Translated

from the Nahuatl, the reference to the "children of the Mexicans" (or Mexica) was sufficient to establish an indigenous heritage that validated racial pride and confirmed historical origins for a people who had been stripped of both. At the same time, there was a more contemporary reason for such identification. During the 1960s, Indian communities and nations in the United States again began raising the topic of violated treaties and expropriated lands. The most widely publicized and dramatic event was the 1973 occupation by the Oglala Sioux of Wounded Knee village at the Pine River Reservation in South Dakota, an action in which outside friends, including Chicanos, joined. Moreover, the surge in Indian protest paralleled that of the newly organized Chicano movement. For example, Reies López Tijerina organized the Chicano land rights movement in New Mexico, laying claim to millions of acres originally owned by Hispano-Mexican communities. Thus the Indian identification, whether historical or actual, was seen as instrumental to the Chicano battle.

The dynamics of *Rebirth* derives from two linked groups of people who, from left and right, diagonally thrust themselves toward a huge central rose (a key motif for the Mexican Virgin of Guadalupe) embedded in vegetation and a pile of skulls (life and death) from which the new Chicana and Chicano reach out to embrace the legacy of their history and accept the challenge of its struggles in the form of tendered gifts. At the extreme left, a man carrying architectural plans and a T-square and wearing a hard hat represents technology. Behind him is a small figure of a conquistador unsheathing his sword; below a white-haired woman handing over a candle represents moral enlightenment. "I'm trying to show," said the artist, "that as our people become more educated, they face the decision of whether to accept technology blindly without an awareness of what technology can do. Would we want our sons [and daughters] to grow up in a world so loaded with the pleasures and conveniences offered by technology that we forget moral values?"[18] Holding books, historical Mexican plans for liberation,[19] modern union contracts, and waving the red, black, and white thunderbird flag of the United Farm Workers, men, women, and children advance toward the center.

On the other side, which begins on its far end with skeletal military figures, is a fallen pre-Columbian warrior with corn growing from his body, an Indian woman with blood-stained palms, the feathered serpent, a seated Maya lord, and a group of figures rallying beneath the wind-whipped flag of the Chicano-led La Raza Unida party, along with a ballot box. On both sides of the symmetrical mural, miners, artists, writers, students, and even chained prisoners participate in the forward drive toward the rose. According to the artist, this is the "awakening of the self, the awareness of La Raza. As our people become more aware of our history . . . our community can become cohesive and we can work to solve our problems."[20] Response to the mural was positive. An unveiling was held and well attended. The final proof of its importance and the respect it garnered was its continued existence unmarred by graffiti, except for an ultra-left slogan painted below the mural in later years, which the artist rejects.

With this mural, Leo Tanguma established his artistic language, not only on the level of iconography, but also on that of form. On the first level is the constant use of metaphor: for example, his employment of the torch or candle as a signifier of light, enlightenment, and liberation. In some cases, a metaphor or a symbol emphasizes the "mixed race" of Mexicans and Chicanos. In other cases, the artist questions the reliance on mythologies and political signifiers that originated in Mexico. After being brought to the United States, these mythologies and signifiers were (and are) constantly revised and transformed to respond to the social and psychological needs of Mexican people living in a society that marginalized them. Among the latter, we can cite the use of various flags that represent social movements organized by Chicanos (like those of the United Farm Workers Union), or, conversely, flags of groups that represent adverse political pressure or regression (like that of the United States' flag itself); the dreadful La Llorona (the ghostly Weeping Woman constantly seeking her lost children) used with children in the manner that the "bogie man" is invoked among non-Mexican families, whom Tanguma redeems and transforms into a loving mother restored to her children; or the Christian cross, which becomes an overarching structural symbol suggesting liberation theology in Latin America.

Like Siqueiros, Tanguma establishes not only the protagonists, but the antagonists as well – often rendered with the exaggerations of caricature, a style influenced by José Clemente Orozco. His moral narratives clearly define good and evil, another aspect of metaphor. Among the latter are brutal police, drug dealers, seductive women, military types, or – on a psychological level – oppressive stereotypes and false masks that hide the individual from his or her own potential. For this purpose, mirrors as agents of light and truth might be considered as analogous to the painted surface itself. The mirrors are often held by respected elders of the community to guide the youth to self-knowledge. By the same token, spiritual leaders (Christ, the Virgin of Guadalupe, the pre-Columbian feathered serpent god Quetzalcóatl), as well as respected political leaders, are invoked.

Aesthetically, Tanguma uses space as a moral indicator: The agents of evil (brutal police, drug pushers, cynical military men) are often encountered below ground or in a special section of the mural where their nefarious functions are spelled out. His composition and disposition of figures set up fields of energy, of rhythm and movement that are crucial components of meaning. These components cannot necessarily be traced in *Rebirth,* some of them are still vestigial; however, a number of them do appear in the Houston mural as a portent. Tanguma's future development, which began when he moved from Houston to Denver, is signalized by the appearance of the second level of his artistic language: his formal changes from flat to three-dimensional structural surfaces and the abandonment of permanently sited murals for portable ones.

The list of Tanguma's public murals is a long one. Without considering those executed while he was in military service or those in private residences, there were thirteen in Houston at various stages of completion, of which (by last count) four are still intact: his 1970 mural *We Must Overcome This Oppres-*

sion; Rebirth; and two murals at a black housing project, *Free at Last?* and *We Must Never Forget* (1979–80). After his relocation to Denver in 1983, he completed six portable murals, all still extant. The liberating environment of Denver – home to the earliest gallery and some of the earliest murals of the national Chicano movement, as well as the invigorating political and cultural atmosphere of the Crusade for Justice led by Rodolfo "Corky" González in the late 1960s – provided the energy that marked the new phase in the artist's life. After the death of his wife, and the "death" of so many of his murals and mural projects in Houston, Tanguma took his children, mother, and sister to join the Tanguma clan in Colorado, and there married Jean Stanford. A year after his arrival he began the second, mature phase of his work. Despite difficulties, he found places to work (often in churches or schools), sponsors, and an appreciative audience. Not only was his new work large, but its sculptural form began to swing out and project into space with a new creative elation matched by the complexity of the composition, the fluidity of the brushwork, and the heightening of the color. He had always used metaphors for social ideas; now these metaphors extended into the color, value, structure, and composition themselves.

In 1988 Tanguma embarked on a major free-standing structural mural in two sections, *La Antorcha de Quetzalcóatl* (The Torch of Quetzalcóatl) (Fig. 30) painted over a period of several months in one of the public galleries of the Denver Art Museum where visitors could observe the process and talk to the artist.[21] Understanding the mural begins with its name, which employs

FIGURE 30

Leo Tanguma. *La Antorcha de Quetzalcóatl/The Torch of Quetzalcóatl.* 1988–9.

Photograph courtesy of Denver Art Museum.

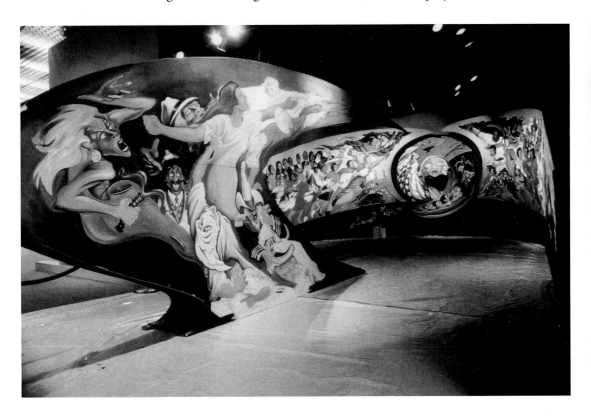

symbols from two different cultures: the European and the Native American. Most North Americans associate a blazing torch either with the Greek Olympics or with the Statue of Liberty. Siqueiros himself had used a torch held high by a female figure in his Palace of Fine Arts mural, *The New Democracy* (1945). Quetzalcóatl dates back to the great Valley of Mexico civilization of Teotihuacan (200 B.C.–A.D. 750), if not earlier. Combining the green-tailed Central American bird *(quetzal)* and the northern rattlesnake *(cóatl)*, Quetzalcóatl symbolizes the union of heaven and earth, and represents the most positive and affirmative deity of the pre-Columbian pantheon.

Tanguma's mural itself must be considered from two viewpoints: the structural and the painterly. It goes beyond the mere sculptural into the architectonic: It is experienced as broad curved masses that flow outward, and as shaped spaces around and within which foot traffic can navigate. Within this overall plan, the curved forms of the two-part major section (11 feet 9 inches by 72 feet), which diminish in size to spatulate terminations, seem to be two embracing arms or two wings of a bird's body drawing the viewer toward the climax: a central spiraling oval like a bird's head turned back on itself. The winged sections can be spread out or closed in to form various radiuses. The fixed central structure (8 feet 6 inches by 23 feet) can be viewed as a coiled serpentine shape lunging toward the bird shape and terminating in a scooped concavity.

The artist's brilliantly painted figures are guided by the structural imperatives of the surfaces. Because Tanguma envisioned this mural as one without any corners, it follows that the figures as well as the ground needed to be composed in a seamless manner, radiating toward the central spiral where all ideas begin and end. Impelling this driving motion are diagonal thrusts, swirls, eddies, and other pictorial devices to organize the unusual shape, which is, moreover, linked by a series of historical and cultural concepts (Fig. 31). The artist explains his own dynamics as follows: The concave center of the main structure contains an opening in which an oval-shaped spiral form is set. This contains the tripartite head of a *mestizo* (the fusion of Indian and Spaniard). A Chicano (the self) emerges from a "cocoon of flags" from Europe and the United States and advances toward two red flags. "La Llorona" swirls down to embrace her children and as she does so, her face drops its masks to become beautiful, emotional, and human. Rather than a frightening image, she has become a statement of reconciliation who needs to be reunited with her children (the Chicanos) in order for peace, healing, and self-respect to prevail. Mexico finds her "lost" children at last.

"Toward this central depiction," says Tanguma, "comes a multitude of Chicano people to realize the symbols of their own identity [Fig. 32]. Yet I've shown others as well: Anglos, blacks, and Native Americans coming to share the beautiful moment of our self-encounter. Along the base are depicted symbols of oppression, like a burial ground underneath our feet."[22] On another plane are the martyrs and heroes of the Chicano struggle and of other peoples' struggles: Father Hidalgo of Mexico, Archbishop Oscar Romero of El Salvador, Augusto Sandino of Nicaragua, Sor Juana Inez de la Cruz (learned nun of the

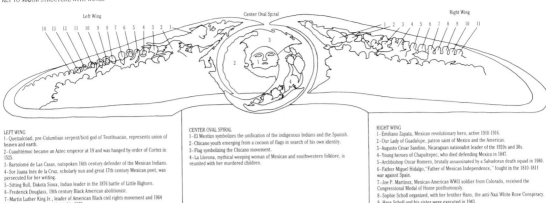

Left Wing Center Oval Spiral Right Wing

14 13 12 11 10 9 8 7 6 5 4 3 2 1 3 1 2 3 4 5 6 7 8 9 10 11

2

LEFT WING
1–Quetzalcóatl, pre-Columbian serpent/bird god of Teotihuacán, represents union of heaven and earth.
2–Cuauhtémoc became an Aztec emperor at 19 and was hanged by order of Cortez in 1525.
3–Bartolomé de Las Casas, outspoken 16th century defender of the Mexican Indians.
4–Sor Juana Inéz de la Cruz, scholarly nun and great 17th century Mexican poet, was persecuted for her writing.
5–Sitting Bull, Dakota Sioux, Indian leader in the 1876 battle of Little Bighorn.
6–Frederick Douglass, 19th century Black American abolitionist.
7–Martin Luther King Jr., leader of American Black civil rights movement and 1964 Nobel laureate, was assassinated in 1968.
8–Benito Juárez, Zapotec Indian whose reform measures as justice minister limited the powers of the military and the church in Mexico, later became president and successfully repelled the French invasion of the 1860s.
9–Frida Kahlo, 20th century Mexican surrealist painter.
10–Jill Yvette Ramos, a Mexican-American high school student and activist from Wichita, Kansas, who died in a car accident in 1988.
11–Josefa, lynched in Downeyville, California, after killing the man who raped her.
12–Ernesto "Che" Guevara, Argentine/Cuban revolutionary leader.
13–Joaquin Murietta took up defense of Mexican community in California after American occupation in the 1850s.
14–Emma Tenayuca, socialist leader of Pecan Shellers Union from San Antonio, Texas.

CENTER OVAL SPIRAL
1–El Mestizo symbolizes the unification of the indigenous Indians and the Spanish.
2–Chicano youth emerging from a cocoon of flags in search of his own identity.
3–Flag symbolizing the Chicano movement.
4–La Llorona, mythical weeping woman of Mexican and southwestern folklore, is reunited with her murdered children.

RIGHT WING
1–Emiliano Zapata, Mexican revolutionary hero, active 1910-1916.
2–Our Lady of Guadalupe, patron saint of Mexico and the Americas.
3–Augusto César Sandino, Nicaraguan nationalist leader of the 1920s and 30s.
4–Young heroes of Chapultepec, who died defending Mexico in 1847.
5–Archbishop Oscar Romero, brutally assassinated by a Salvadoran death squad in 1980.
6–Father Miguel Hidalgo, "Father of Mexican Independence," fought in the 1810-1811 war against Spain.
7–Joe P. Martinez, Mexican-American WWII soldier from Colorado, received the Congressional Medal of Honor posthumously.
8–Sophie Scholl organized, with her brother Hans, the anti-Nazi White Rose Conspiracy.
9–Hans Scholl and his sister were executed in 1943.
10–Anne Frank, young Jewish girl executed by the Nazis in 1945.
11–Micardio Garcia, Mexican-American WWII soldier from Sugarland, Texas, received the Congressional Medal of Honor.

FIGURE 31

Leo Tanguma. *La Antorcha de Quetzalcóatl/The Torch of Quetzalcóatl.* Key to major structure with wings.

Reprinted by permission of the Denver Art Museum. © Denver Art Museum 1988.

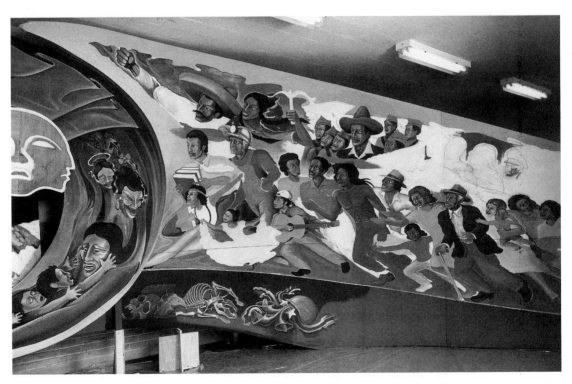

FIGURE 32

Leo Tanguma. *La Antorcha de Quetzalcóatl/The Torch of Quetzalcóatl.* Detail of major structure, right wing (unfinished).

Photograph courtesy of Denver Art Museum.

Mexican colonial period), Anne Frank (Jewish victim of the Nazis), African American liberation fighters Harriet Tubman and Frederick Douglass with a twentieth-century counterpart like Martin Luther King, Jr. Also shown are famed Native American chief Sitting Bull, Nelson Mandela of South Africa, Chicano leaders Corky González and César Chávez, and Texas unionist Emma Tenayuca. Closest to the spiral are Quetzalcóatl (expelled by the Toltecs), Cuauhtémoc (last Aztec emperor), Emiliano Zapata (hero of the Mexican Revolution), Fray Bartolomé de Las Casas, the colonial priest who spoke against Spanish mistreatment of Mexican Indians, and the Virgin of Guadalupe. This wide compendium of personages, mingled with generic representatives of workers, male and female, illustrates a worldwide selection of historical and mythological figures whose ideals and actions lead toward a goal of human betterment and achievement. Certainly Tanguma's vision is a utopian one: to criticize the present so the future can be constructed along more equitable and humanist lines. The arching form set in the midfloor space refers to North American society in general, striving to eliminate the evils of racism and achieve justice and solidarity.

In this way, in monumental scale, muralist Leo Tanguma expanded his local, regional, and continental vision with a dramatic narrative that established new heroes and new histories to supplement those deficient stories appearing in the standard texts. His central structure functions as an enormous codex (handpainted pre-Columbian picture book) that can (metaphorically and literally) expand or contract, with a long painted finger pointing out the revisions necessary for a people's history.

Emigdio Vásquez

Emigdio Vásquez (b. 1939) was born in Jerome, Arizona, a major copper-mining area dominated by the Phelps Dodge Corporation. Phelps had broken the successful organizing efforts of the Western Federation of Miners, which by 1903 had made substantial gains in bringing Mexican Americans into existing unions. In 1906 the owner of Phelps personally armed the Arizona Rangers to cross the international border and help break the Cananea miners' strike in Sonora, Mexico (about which Siqueiros painted a major mural[23]) and in 1917, using vigilantes, deportations, and other extralegal measures, Phelps Dodge broke the organizing drives of the Industrial Workers of the World in Bisbee and Jerome. Vásquez's Mexican-born father worked in the mines during the 1920s and 1930s when no union existed, and the memories he shared with his son influenced Vásquez's paintings. In 1941 the family moved to an old barrio in the rural town of Orange[24] in Southern California, where Emigdio Vásquez dedicated himself to murals that recreated a people's history of Orange County and to easel paintings of the Mexican/Chicano lifestyle.

If Leo Tanguma's art experience was directed from the start toward murals with an expressionist style and a metaphoric language elaborating social

themes, Emigdio Vásquez approached history with a documentary spirit and a straightforward realistic style. Although he painted seventeen murals between 1976 and 1991, he still considers himself primarily an easel painter who delights in recording the life of his barrio. At the heart of Vásquez's enterprise, however, is the portrait, whether it be a government leader, social activist, or his neighbors on the street and the corner bar. The "people" are not an anonymous mass; they are composed of individuals, each with his or her physiognomy, personality, and attire. The persons in his genre paintings have as distinct an appearance – and therefore dignity and respect – as those who are nationally or internationally known. Vásquez's murals, like his easel paintings, are works of accumulation, based on sketches and photographs. Over the years, the artist sought his personalized images in family photographic albums, through the photos and sketches he himself made, and in published documentary photographs from the New Deal and later periods. He often built a painting from a photographic composite, but was totally disassociated from photorealism in that his works were impregnated with social meaning and issues. In this respect, knowingly or not, he is closer to the pioneering use in historical murals of photodocumentary images by Siqueiros, who integrated such materials into his militant and dramatic murals by projecting them mechanically onto his walls as early as 1939. Vásquez himself eschews what he considers the superficial technical virtuosity of photorealism.[25]

Although Vásquez in recent years has been painting the changing aspects of Orange County and of his barrio streets, many works function as a form of social archeology through the reclamation of memories from his childhood: a hobo jungle near the railroad tracks that he visited as a child, a 1950s bar scene, zoot suiters standing outside a corner grocery store that no longer exists, the lines at the employment office, his memories of orange pickers warming their burritos for lunch over an open fire, and so forth.

Vásquez's oil painting *The Gandy Dancers* (Fig. 33) of 1974 is an example of serving collective memory with photodocumentation. It pictures the Mexican laborers who maintained the railroads from the last quarter of the nineteenth century when the Southern Pacific and Santa Fe Railroads, following the old Spanish trails, began expansion into the Southwest using Mexican labor to construct their tracks. "From that day to this," wrote Carey McWilliams in 1948, "Mexicans have repaired and maintained Western rail lines," constituting 70 percent of the section crews and 90 percent of the work gangs and earning a dollar a day.[26] Although the image was adapted with color from *The Family of Man* exhibition catalog,[27] Vásquez remembers such scenes from his childhood. In fact, his memory is a collective one based not only on his personal recollections, but bolstered (like that of most children) from the stories of his father and other old-timers who narrated their remembrances of the Mexican Revolution, the Great Depression, the Orange County citrus strikes of 1936, and the war years of the 1940s. In the raking light of early morning, the men work as teams, pushing their weight against the railroad ties. The tracks stretch into the distance in a desolate country area; one can

Emigdio Vásquez.
Gandy Dancers. 1974.

*Photograph by the
author.*

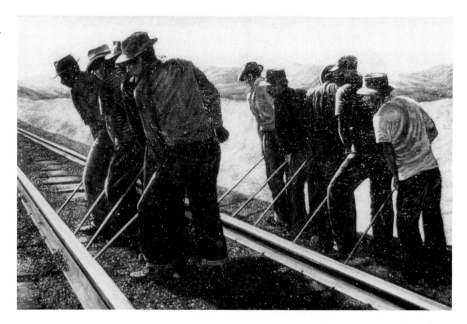

sense the continuing monotony of the work and the men sweating long hours under the sun.

When Vásquez first began his paintings, he was not necessarily concerned with making any overt social statements. As the works evolved, however, they became not only documentations but also personal expressions of a proletarian neighborhood, its culture, and, necessarily, its struggles.

It was then I made the commitment to work in an expanded direction that would concern itself with the depiction of social realities and experiences of Chicano working people. But most important, I wanted to engage in a forceful critique of the system that fostered and nurtured the many social inequities of that experience. My purpose is not to create an esoteric form of ethnic art; [rather] I feel that there is a commonality of experiences amongst all humanity that makes it possible for all people to relate to each other's experiences.[28]

Cumulative not only in its technique (composites of photographs from historical sources and those made by the artist himself in his community, newspaper clippings, etc.), Vásquez's easel paintings and murals are cumulative in their social iconography in that he is constantly adding new experiences to the old not through a rupture with the past, but by an updated repetition. Did Mexicans serve as agricultural labor when they migrated to the United States in the 1920s? They were still serving as such during the organizational heyday of the United Farm Workers in the 1960s. Were Mexican Americans drafted to serve during World War II? They were again drafted during the Vietnam War, in such unprecedented percentages that the huge Chicano Moratorium was organized in 1970 to protest that fact. The word *cumulative* is used rather than *repetitive* because each event occurs in a different social

and temporal frame that changes its character. Additionally, memory and knowledge of the past tempers consciousness, causing the participants to seek new strategies and tactics. In actuality, due to a complex mesh of factors, the more recent actions were not only more militant but also more successful in the context of the 1960s. It is precisely this invocation of the past, of the heroes and struggles generally unknown in the pages of North American history books, that constitutes the power of revealing a "hidden history" and assuring continuities in the present of its most positive features.

Vásquez has long held to a socialist agenda, but as something for the future, something embedded in the potentials of his narrative but seldom made explicit, and never concretized as a process. Disagreeing with the Soviet Union's theory and practice of socialism, Vásquez cherished the idea as a utopian possibility based on the classic concept of the international working class as a carrier of change. His task was to set forth the manifold aspects of the working class as illustrated among his own people, within his own community.

In Vásquez's 1979 mural, the 8- by 64-foot *Tribute to the Chicano Working Class*[29] historical reconstruction ranges from the pre-European past to the contemporary period. The mural begins with an Aztec eagle warrior, and continues with a Chicano, a Mexican revolutionary, a railroad boilermaker, a rancher, a miner (doubtless based on his father's experiences), and migrant crop pickers. These are followed by portraits of César Chávez and a representative of the Filipino workers in the California fields who cofounded the United Farm Workers Union in the 1960s. Vásquez drew on a number of photographic sources for his images, which are presented in a horizontal arrangement as portraits of historical personages and working people. For example, the stern-faced dignified older man in blue overalls and shirt, striped cap, and goggles is taken from the captioned picture book, *450 Years of Chicano History*,[30] which, with *The Family of Man* catalog and New Deal photographs from the Farm Security Administration (many reproduced in *450 Years*) has proved a pictorial gold mine for his paintings. From the same book he took the two women working in agriculture, one standing to harvest spinach, the other stooping for tomatoes, that make the connection between the boilermaker, the miner, and the ranch hand on the left. As close-ups, the portraits have great immediacy, power, and presence and suggest the continuities of history in their arrangement. Considering the attitude toward working-class themes in the United States and the prevalence of racism that made the Mexican peoples either stereotyped or invisible in U.S. history, they correspondingly attain a solid presence with great dignity and singularity. For the artist, no further social comment is required.

The most monumental work of Emigdio Vásquez's mural production is the 6- by 106-foot linear history executed in 1980 on a parking lot retaining wall for the Salvation Army in Anaheim, California (Fig. 34). Titled *Nuestra experiencia en el siglo XX* (Our Experience in the Twentieth Century), it follows Mexican and Chicano history from the 1910 Mexican Revolution to the present. Reading from left to right, history commences with a large portrait

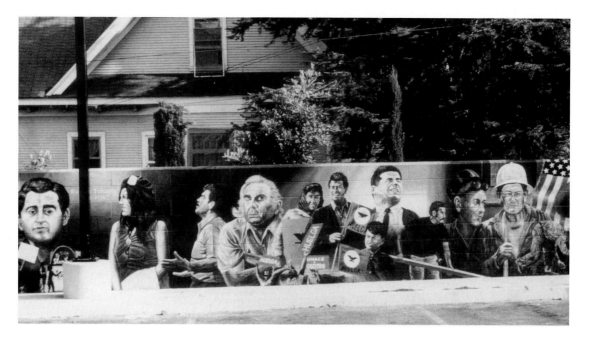

FIGURE 34

Emigdio Vásquez.
*Nuestra experiencia
en el siglo XX (Our
Experience in the
Twentieth Century).*
1980. Mural detail.

*Salvation Army Parking
Lot, Anaheim, Califor-
nia. Photograph by the
author.*

bust of Ricardo Flores Magón, an intellectual and activist who, with his brother Enrique, led the earliest movement in the first decade of the twentieth century against the Porfirio Díaz regime eventually toppled by the Mexican Revolution. Flores Magón addresses a large crowd, topped by portraits of peasant leader Emiliano Zapata and other revolutionaries. This scene connects with the large exodus of Mexicans during the revolution who migrated from rural Mexico to the industries of U.S. cities and low-paid jobs in northern agribusiness. A miner and an orange picker appear, as does Texas pecan worker organizer Emma Tenayuca.

Shifting from the narrow focus on Mexican and Mexican American history to the situation of the United States as a whole, Vásquez pictures the stock market crash of 1929, followed by a jaunty portrait of President Roosevelt near the NRA (National Recovery Administration) logo. The tremendous impact of the Great Depression on working people is underscored by the positive steps taken by the administration to alleviate joblessness and hunger. The symbols of World War II that follow (a recruitment poster, men in uniform and in battle) frame a bitter experience of the Mexican American community: a particularly ugly xenophobic attack by United States servicemen on Pachuco zoot suiters – the young men (and women) who wore the extravagant costumes and hairstyles of the 1940s that identified a working-class subculture in defiance of the mainstream. The Sleepy Lagoon case (1942) and the "zoot suit" riots (1943), inflamed by the press in Los Angeles, became a cause célèbre in the Chicano community in the 1970s when the events were dramatically conflated in Luis Valdez's play and movie *Zoot Suit.*[31] So deeply outraged was the Chicano community, so embedded are these historical events in the Chi-

cano psyche, that the zoot suit became a major icon in the 1970s as well as a symbol of resistance, particularly in California and in Texas where the zoot suit culture was also strong. A number of murals and many hundreds of other works testify to the importance of this neglected history, which falls within the lifetime (and the practices) of older Chicano artists (including Vásquez), and has been excavated by research into old family albums.[32] Vásquez's references to the zoot suit era, however, do not address the violent episodes of the World War II period; rather he places the Pachucos (all male, although there were Pachucas with distinctive costumes, jewelry, and cosmetics) in the barrio, hanging out on street corners, with their hot rod/low-rider cars in the background. His consistent aim seems to be one of integrating the Pachucos into the neighborhoods in which they lived, rather than painting them in more dramatic situations. This approach to the subject matter was consistent with his eyewitness approach to events that occurred during his lifetime. He certainly saw Pachucos in these situations and surroundings and therefore recorded them from memory; like others of the same generation (now in their fifties), he was a participant in the Pachuco scene.

Vásquez continued his mural odyssey with the explosion of the first atom bombs in Japan, the emergence of Joseph McCarthy in the 1950s, and the wars in Southeast Asia, particularly that of Vietnam in which statistics reveal an unprecedented number of Chicanos lost their lives. The images of Chicano servicemen and the demonstrations against the Vietnam War (of which the national 1970 Moratorium, attended by up to 30,000 people in East Los Angeles, was the largest protest, as well as the most powerful indicator of Chicano discontent) continue his documentation. A series of well-known leaders, represented by portraits, makes available the epoch of the 1960s and 1970s: journalist Rubén Salazar who was martyred by sheriff's deputies during the Moratorium; a young woman in the paramilitary uniform of the Brown Berets; Corky González of Denver; Bert Corona of Los Angeles who led (and leads) many important political movements and whose portrait, to my knowledge, has appeared in no other painting; Dolores Huerta and César Chávez of the United Farm Workers; and Reies López Tijerina of the New Mexico land grant movement. These form the insurgent heroes of Chicano history. The last quarter of the mural pictures typical working people – the constant motif of all of Vásquez's production – assembled to round out his history and carry it to the end of the century.[33]

With this mural, the most extensive and continuous narration of all his work, Vásquez reinterprets history from his (and his community's) vantage point. I think the term *community* as used here should be seen as distinct from the more general terms *audience* or *the public*. The latter two are unknown or abstract quantities hotly being debated by politicians, advertising, and mass media corporations (considering such devices as Gallup polls, Nielsen ratings, marketing and opinion research) and the art community (museums specifically, but also funders of public art projects). In Vásquez's case – as in Tanguma's –

community refers to very specific groups of people: the Mexican American/Chicano people of the United States. Even more particularly, it refers to those communities of Houston, Denver, and Orange County where the artists have spent great portions of their working lives. A further consideration is the fact that both artists work with teams whose views on subject matter and treatment are taken into account. As we have seen, nevertheless, this close attention to community needs and values in no way prevents the artist from exploring a larger vision or confines him to parochialism. In fact, as artist, poet, and philosopher, that is explicitly his role. History is simply his vehicle. In the case of Vásquez, it is the progress of the narrative – in other words, *which* episodes in history and *which* personalities have been chosen – that is a clear indicator of his conception of history, as contrasted, for example, with the (perhaps) more objective narrative of a professional historian.

I have chosen these two artists for consideration from among the hundreds of Chicano artists who emerged from the political movement in the 1960s, made their presence known in the 1970s with public art in the form of murals and posters, who exhibited easel paintings, prints, sculpture, and photography in alternative centers and galleries, and who entered mainstream museums and galleries in limited numbers from the 1980s through the present. Tanguma and Vásquez were my choices – although they surely were not the only artists dealing with historical themes – because they are part of the *pioneros* (pioneers) of the emerging Chicano art movement, because they consistently documented and interpreted Mexican/Chicano history, because both developed the art of muralism (with an aesthetic quite different than that of easel painting) to a very high level of accomplishment. Both have produced a considerable body of work within a society that does not value the mural as an art form, particularly when it is produced and sited in the streets.[34] Both have seen their murals as a major form of communication with their own communities, primarily, and secondarily with society at large and both have continued to paint murals although muralism as an art form has been drastically reduced since the 1970s due to the withdrawal of much public and private funding. Finally, both are didactic, although Tanguma is more overtly so than Vásquez, who is content with picturing this history from a sympathetic "insider's" point of view. Some of the differences between them derive from their very different personalities and from their personal histories. Tanguma is a tireless activist who – like Siqueiros – perceives his mural production as an adjunct to his political activities and ideologies, to his role as a teacher and organizer in a state like Texas whose racism is far more corrosive than California's. Vásquez's activism is confined to promoting the Chicano arts possibilities in the conservative (and still racist) confines of Orange County. His political commentary appears in his murals and also in the hundreds of easel paintings that complement them but display a much wider choice of subject matter.

In conclusion, in considering the murals of Leo Tanguma and Emigdio

Vásquez, the comment of Jamaican sociologist Stuart Hall seems especially appropriate:

Face to face with a culture, an economy and a set of histories which seem to be written or inscribed elsewhere, and which are so immense, transmitted from one continent to another with such extraordinary speed, the subjects of the local, of the margin, can only come into representation by, as it were, recovering their hidden histories. They have to try to retell the story from the bottom up, instead of the top down.[35]

Indeed, the past is not a closed system, but a dialectical field of forces whose artifacts can be actively engaged through theory, interpretation, transformation, parody, and subversion.[36] To recall the past, to reveal its hidden dynamic, is in itself one political act among many.

Installing History

Lisa G. Corrin

When the organizers of *Picturing History: American Painting 1770–1930* concluded their sweeping exhibition with Thomas Hart Benton, they gave the impression that historical art in America had faded with the New Deal. Although it may seem that historical art as it was defined by artists of the eighteenth and nineteenth centuries was no longer commonplace after the heyday of the WPA, an interest in creating visual representations *of* history and *about* history has continued. Over the past sixty years, historical art has remained a critical genre in particular for those whom early history painting had been least concerned: people of color and women. In general, artists have adapted conventional prescriptions for the genre in order to augment or revise "official" histories. Examples include Robert Colescott's parodies of canonical American history paintings such as *George Washington Carver Crossing the Delaware* (after Leutze), Jacob Lawrence's paintings of the life of Harriet Tubman and Frederick Douglass, and Judy Chicago's *Dinner Party.*

However, more recent historicizing art is less concerned with recording "objective" facts than with the underlying assumptions that determine how history is written, interpreted, and valued, with *how* historical images mean, not merely *what* they mean. This preoccupation with the methodological and institutional context that drives culture has given rise to the genre of installation art. It is installation art, informed by critical theories of postmodernism, which has currently replaced painting as the primary medium for "picturing history" of the past and in the making.

Postmodern theory problematizes painting, arguing it is too closely linked to the marketplace, too confined by a unitary viewpoint (the artist's), disclaiming the medium as the vestige of white European cultural patriarchy.[2] This position stands in opposition to the autonomous value system of modernism, in which painting is mystically free of those ideological forces that underpin its production. The "ideal" viewer for painting, according to the modernist, is constituted by *his* capacity to be "centered" by the "instantaneous presence [in a successful painting] that both responds to and encourages a condition of disinterested self-sufficiency within the viewer, one that transcends the accidents of actual use, setting, and conditions of viewing."[3] This requires an initiation into the priestly order of high art insiders and a thorough knowledge of its aesthetic and unworldly "history." By contrast, the post-

modern critique posits painting as a vehicle for a confluence of social, political, and economic forces and the viewer as a primary agent in the deconstruction/reconstruction of meaning.

Installation work makes three assumptions. First, that the content of a work of art cannot be separated from its context. Thus, the ideologically coded environment of the "white cube" gallery setting is part of the "meaning" of the objects within it.[4]

Second, installation redefines the roles of "artist," "art," "viewer," "curator," and "museum." This is achieved by displacing the artist-author, and activating the relationship between artist and the audience, transforming the viewer into a participant who can produce an infinite range of independent "meanings" in the work. Homogeneous and totalizing definitions of "public" and "viewer" give way to the participant-viewer whose personal background offers open-ended possibilities for heretofore unexpected interpretations and challenges to the looking experience within this sort of "democratic theater."[5] There can be no "final closure of meaning upon a point of original certainty" in an installation work because meaning is "endlessly deferred."[6]

Finally, installation challenges the participant-viewer to question and theorize the context of the looking experience. The viewer enters an installation and steps directly into the artwork. There is no separation of the viewer from that which is viewed. Calculated to impact on our senses, this total surround disrupts the usual static experience of looking at art and catalyzes a dynamic process of questioning. At the forefront of this questioning is the issue of contextuality – the visual experience in an expanded field of knowledge – which asks, What is our relationship to this environment? What is the relationship between the objects within it? What does it make us feel? What does it make us think?

Blurring the boundary between art and its institutional frame, installation has the flexibility, as critic David Deitcher has stated, "to function all at once as a means of deconstructing the museum and of reconstructing it. . . ."[7] Perhaps inevitably, the museum and its practices have become a symbolic and central subject for installation works.

Ever since Duchamp signed a urinal, conferring on this mundane object the status of art, the contextual "frame" through which art is made, distributed, valued, and defined has been a subject in its own right for conceptual artists such as the Fluxus Group, Marcel Broodthaers, Joseph Kosuth, Louise Lawler, Michael Asher, Hans Haacke, and many others.[8] As artist-critic Victor Burgin has pointed out,

The impulse of conceptual art was . . . to *open* the institution and its practices, to open the doors and windows of the museum onto the world around it. . . . Conceptual art opened onto that *other* history [a history of representations] a history which opens onto history. Art practice was no longer to be defined as an artisanal activity, a process of crafting fine objects in a given medium, it was rather to be seen as a set of operations performed in a *field* of signifying practices, perhaps centered on a medium but certainly not bounded by it.[9]

Contemporary artists have continued the institutional critique begun by Duchamp, contesting the subjective and exclusive criteria that define the museum's view of history and how museums "reinforce for some the feeling of belonging and for others the feeling of exclusion."[10]

These museological installations view the museum as the embodiment of the dominant belief systems of a culture, as a sort of social and historical microcosm. Like history painting of the past, this new genre of historicizing art parallels revisionist reading within the discipline of history itself. Interrogating the role of the museum, the curator, the artist, and the audience in "picturing history," installation examines how the structures of cultural institutions reflect social values when they act as arbiters of taste and interpreters of the past. Above all, this work is attentive to the political implications of representation.

To take a postmodern position is to take nothing for granted. The impulse behind historicizing installation art may be characterized as a grave loss of faith in the "master" narratives that have governed how history is written, who writes it, who learns it, and how it is passed on. Yet, despite a debunking of these master narratives, historicizing installations continue to respond dialectically to the quintessential characteristics and aspirations of history painting in the grand style, substituting a "critical" historicizing art consistent with the project of postmodernism.

In historicizing installation art, narrative sequences that follow a linear trajectory are considered a primarily Western mode of temporality. Installation, which seeks to undermine a unitary presentation of events or ideas, encourages the participants to determine their own viewing strategy. Narrativity, in the past often a by-product of allegory, becomes, in installation art, a multistoried presentation with infinite possibility for a free, complex play of differential associations. Time is expressed as a gradual unfolding of "metonymic and metaphoric linkage" precipitated by the viewer.[11]

At its core, didacticism has been replaced by an ethics of questioning. Although the open-endedness of the work may be perceived in opposition to the single-minded pedagogical intent of history painting, the interactive questioning process that ensues within the installation environment has a no less performative agenda. Chantal Boulanger encapsulates this agenda in her characterization of the medium: "the *act* and *consequence* of placing something in a certain position."[12] Installation makes clear that acts of representing, looking, and interpreting all have performative implications.

Historicizing installation assumes that unitary claims about truth are suspect. This position is operative whether the installation presents a revised reading of past historical narratives or examines how the facts were constructed as truth to begin with. Whichever form historicizing installations take, the artist functions at various times as art historian, theoretician, archivist, archaeologist, historian, or curator in order to perform the "research" necessary to lend the work credibility. Forgoing the title *artist*, it is historicity itself – an analysis of the underlying structures and master narra-

tives comprising the presentation of history – that directs the activities of the "cultural producers" engaged in this "reconstituted" history painting.

A case in point is David Bunn's *Sphere of Influence* (1988–9). This site-specific installation, created in the "raw" warehouse space of the Santa Monica Museum, was part of a series of projects that took place concurrently with the construction of the museum's new facility.[13] The pivot of Bunn's piece, situated at the exact centerpoint of the space, was a brass plumb bob suspended from the rafters, its point dangling over a compass diagram mounted on a pedestal indicating north, south, east, and west. Encircling this central arrangement was a multitude of viewing devices or "instruments of discovery" ranging from the familiar – binoculars, telescopes, video camera and monitor – to the anachronistic – a camera obscura and kaleidoscope – to the invented – plumbing tubes and nozzles – to the symbolic – a picture frame and window.[14] Each device was trained on a "sighting," an unfinished architectural detail chosen by the artist, then labeled with date and descriptive caption. A window, for example, looked onto a sheet of plywood, labeled: "Sighted July 2: The Natural. As a matter of course it begins here. The stuff to build with. Plying the Trade, we peel back the layers and begin the search." Binoculars focused on a splattered stain of reddish paint were labeled "Sighted July 1: Action. The East, New York." The paint splash conjured a host of art world associations – abstract expressionism or East Village graffiti – as well as more "mundane" cultural activity – the remains of a drive-by shooting.

"The free-hanging plumb bob," according to critic Christopher Knight, "which quietly summons such loaded connotations as 'gravity' and 'the force of nature,' deftly locates the modern conception of art as occupying a place of privilege and of the museum as providing a universal viewpoint."[15] *Sphere of Influence,* with its many geographic references and potential new discoveries at every turn, posits the viewer, like the artist, as an explorer. Yet within this "museum-cum-observatory" the viewer is dominated in his or her discoveries by a symbolic centerpoint – the plumb bob – the museum's unitary view of the world. Bunn's reference to *Low Down,* a computer-generated sound sculpture by Michael Brewster, made it clear that audience participation was required to complete the meaning of the work.[16] Determined by ambient sound in the museum space, varying high-frequency tones were activated as viewers moved among Bunn's "sightings." Unlike the circumscribed system of the museum, these audience-driven wavering sounds were a reminder that questioning of the museum by the viewer offered an opening for fresh experiences.[17]

Bunn's need to defy the artifice of "institutionally managed information," to find openings for other ways of knowing the world, is explored in *Digging Up South America* (1990) and the associated *Ruminations on a Stone* (1991), a continuation of a Santa Monica "sighting" that occurred outside the designated *Sphere of Influence.*[18] A crack in the floor of the museum had suggested the geographic contour of South America, a shape that preoccupied him. Two years later he found "South America" still extant within the floor of the newly completed museum. Receiving permission to "mine" the fragment, Bunn exca-

vated the fragment, and with it, its historic, political, and museological accretions. In addition to the original "sighting" displayed on a Bolivian rosewood plinth, Bunn made thirteen rubbings, named for the thirteen countries located in South America (Fig. 35). With reference to *Sphere of Influence,* Bunn placed these rubbings around the stone, a reminder, once more, of the central position of the museum view of reality that dominates and orders all others. Bunn's ability to select suggestive visual metaphors that illuminate our historical position was sharpened as he assumed the role of geographer, cartographer, topographer, and geologist. Against his role as a "classifier" he pitted the viewer's power to freely associate and "excavate" meaning. Bunn's own excavation illustrated that the museum remains a "colonizing" space, exerting control over the ways we understand culture and ourselves.

Like Bunn, Sylvia Kolbowski's installations focus on the museum's role in disseminating the dominant view of cultural history. *Enlarged from the Catalogue: The United States of America* (1988), for example, scrutinized the official history of America as told through the history of a collection and its interpretation.[19] The piece, exhibited at Postmasters Gallery, and later in the exhibition *Desire and the Museum* at the Whitney Downtown, developed after the artist analyzed the catalog of the holdings in American art of the Metropolitan

FIGURE 35

David Bunn.
Paraguay. 1990.
Collection of the artist.

FIGURE 36

Lawrence Gipe. *Panel
No. 3 from The Century of Progress
Museum: The Propaganda Series (Fortune
and Luce)*. 1992.

Courtesy Blum Helman
Gallery, New York. Private collection, Los
Angeles.

Museum of Art, New York. It consisted primarily of nine display cases containing collaged, densely silkscreened images of objects reproduced in the museum's catalog. Thus manipulated, the objects became nearly impossible to name. A "map" of the floor plans of the American Wing of the Met overlapping the floor plan of the Postmasters Gallery located the usual display place of the objects to aid viewers in their identification. A reading space was also created for perusing copies of the American Wing catalog that had been altered by the artist to include other texts. Kolbowski's visual puns and highhanded parody of the hermetically sealed language of the museum were employed to dissect the linear tale of art history that has omitted the cultural history of women and people of color. The general aura of dislocation – of scale – or place – of details – underscored the arbitrary ordering that determines the iconography of the museum.

The title of Lawrence Gipe's *Century of Progress Museum* (1992) is derived from a slogan for the 1933–4 Chicago World's Fair.[20] The series of paintings in its "collection" take as their source the black and white images of American industry and technology from factory and investment magazines of the 1930s and 1940s such as Henry Luce's *Fortune* and *U.S. Steel News* and emblems of

American economic might such as the skyscrapers that were being built simultaneously (the Chrysler and Empire State buildings) (Fig. 36). Gipe's commanding monochrome canvases are literal renditions of the photo-documentary images that filled the pages of such publications. The patina of age is added with applications of sepia and varnish. Lurid red "taglines," the easily digested epitaphs of the advertising and propaganda world, are graphically executed to create a direct connection between what is represented above and his cynical discourse below.[21] Gipe's appropriation of advertising methods and his choice of painting as his medium for the translation of these ironic and nostalgic celebrations of progress is not gratuitous. His use of painting to render these imposing (and oftentimes explicitly phallic) images of cannons, steam engines, warheads, factory interiors, and the face of Roosevelt on Mt. Rushmore, are a reminder of how seductive and effective aestheticizations of the nationalistic aims of modernism have been in promoting an agenda of American superiority.

Gipe's use of the museum format for his presentation of these disillusioned icons of capitalist arrogance provided him additional "tools" for his indictment of "Great American Myths." To Gipe, the museum, with its own superficial and even pernicious rhetoric of "democracy" is complicit in supporting these claims. In the context of Gipe's paintings, the museum's own persuasive language – boldly colored exterior banners, an enticing brochure composed in the circus language of Barnum's curiosity museum and the nostalgic attractions of Disneyland, period footage on continual-loop video, "souvenir" drawings, and appropriately uplifting "canned" music – was revealed to be irrefutably similar to that of propagandists. Gipe's work compels us to reflect on how passive consumption of historical images within the institutions that present them indicts us in perpetuating their ideological aims.

Renee Green is also a bibliophile and archivist, appropriating texts from books, records, reports, and catalogs for display as artifacts within museological installations. In works such as *Bequest*, a fictive museum in the Worcester Art Museum, Green's "research" is directed toward the linguistic systems and historiographic methods through which people of color and women have been represented by institutions – the museum, the book, the "objective" world of the scholar.

Green's installations consist primarily of texts arranged in a visual field to focus attention on them as objects in their own right together with "artifacts," often reproductions of paintings, manuscripts, textiles, or antiques. Texts may appear as quotes, as strings of binary oppositions, or as adjectives suggestively juxtaposed to provoke metaphorical associations. Green's appropriated quotations are elaborately footnoted, adding a complexity and intertwining of ideas to true stories of marginalized groups and how they have dealt with their place as outsiders. Out of context, the visual and written language of exclusion becomes most distinct. As Elizabeth Brown has pointed out, the rhetoric of racism in Green's work "becomes the object of – rather than the vehicle for – scrutiny."[22]

In order to keep our interest in these carefully culled texts, Green has resorted to the kinds of subtle manipulations associated with advertising and retail design: precise calculations of font sizes and the lengths of lines; the distances between texts and props; the "funky" downtown combination of black floors, fluorescent lighting, aluminum industrial shelving, and minimal black and white signage for the "collectanea" in *Import/Export Funk Office.* The effect can be like a billboard announcing straightforwardly the function of a relationship, or elegant and seductive to lull the viewer into Green's sensibility.

Green's fictive museums reveal the complicity of collections in colonizing, exoticizing, or appropriating other cultures. In *Idyll Pursuits,* Green displays reproductions, artists' itineraries, and literary texts to question the authenticity of the visions of South America and the American wilderness depicted by the Hudson River and Luminist painters of the nineteenth century. "Artifacts" in her "collection" of faux museums in *Mise-en-Scene* include a decorative arts museum exhibiting such objects as fabric swatches woven with idyllic landscapes with master/slave encounters; a natural history museum replete with Africana and the stuffs of Victorian dioramas; "L'Esclave," a museum restaurant; and botanical gardens with cultivated black-eyed Susans. *Mise-en-Scene* effectively illustrates how the racist ideology that drove the slave system continues unabated within the refined spaces of museums of many disciplines.

Green's work often examines the mechanics of the Enlightenment classification system and how it effectively delimits ways of knowing but can be dissected to reveal its deeper agenda. Her installations achieve this by activating the viewer to split a single field of meaning. Meaning is only accessible to us after we have gone through the same analysis of the carefully focused texts as the artist. As in David Bunn's work, Green is transfixed by the potential role of the spectator in generating multiple associations between texts that are determined by our individual cultural baggage. Green seeks out the possibilities of "slippages" – places where "the word and the meaning aren't necessarily equated . . . so more connections can be made" – such as the juxtaposition of objects and words that do not correspond.[23] In effect, the viewer learns by doing. Moreover, Green wants "people to ponder all the kinds of cultural objects they come into contact with, and to question the books they read and the films they watch. . . . We must become aware of the constructedness of every part of our experience and not just take it for granted."[24]

If there is a recurrent theme in historical and historicizing installations such as Green's, it is the complicity of museums in the construction of a history that is indifferent to the cultural other. In fact, the deconstruction of an arbitrary history based on white patriarchal power is the shared objective of all artists practicing in this medium. The politics of "difference" dominate historicizing installations and take the form of museums of the "Other" in works by Millie Wilson, James Luna, Elaine Reichek, and Luis Camnitzer.

The Museum of Lesbian Dreams, an ongoing collection of constructions developed by Millie Wilson, showcases mainstream stereotypes about lesbians that often pit diagrammatic "scientific" truths and lurid accounts of "deviance"

against the experiences of lesbians themselves.[25] Part curiosity museum, part art museum, Wilson's constructed "artifacts" assimilate the discourse of sexual "otherness" to the postmodern critique of the singular historical narrative, often recruiting the modernist fathers of art history in her pedagogical project. Many of Wilson's constructions appropriate art historical references, especially works by Duchamp and the surrealists or "neutral" and apparently "disengaged" minimalist artists such as Donald Judd, Dan Flavin, and Albers, injecting their cool geometric forms with the heated polemics surrounding sexual politics.

"Red Top" is postwar slang for a dyke who only likes blondes. I take the silhouette of the androgynous woman which appears on lesbian pulp novels – this sign for a "type" – and put her *on top* of this Juddian modular wall piece. This becomes one more piece in which I place a sign for deviant femininity on top of something that looks like a well-behaved Minimalist statement.[26]

Thus, in works in the *Museum*'s "collection" such as *Red Top*, "high art" speaks for the community marginalized in its wake.

James Luna's *The Artifact Piece* (1987), a "living history" installation, was displayed at the Museum of Man in San Diego, a museum best known for its collection of photographs of Native American life at the turn of the century by Edward S. Curtis. Luna, a Luiseno/Dieueno Indian artist, has used museum practices to draw attention to the ways Native Americans are viewed by the dominant institutions that govern American society and the contradictions inherent in assimilating an ethnographic and aesthetic view of Indian culture. In *The Artifact Piece*, Luna positioned his own body in the sort of ubiquitous artifact display case where we expect to find the ethnographic objects – arrowheads, tools, ceramic pots, and beadwork – that traditionally represent native peoples in anthropological museums. The installation was accompanied by two other "arrangements." One contained personal objects belonging to Luna such as family photographs and records; the other contained "medicine objects" used by Luna during rituals on the reservation. According to Luna, "The art audience perceives my work differently than the Indian audience. . . . Yet there is an affinity between these worlds, and I try to strengthen it."[27] In *Wake Up Sleeping Nations* (1988), a performance at the Museo del Barrio, the museum space became a tribal council meeting room. On display were animal skulls, libations, and wax masks of sleeping human faces. Wrapped in a blanket, the artist moved between these "props" performing a symbolic ritual connected to contemporary Native American politics. Each object carried a culturally specific meaning that shifted based on the framework of the audience – whether Native American or members of the New York art crowd. Luna's performance also explored the challenge of maintaining traditional Native American values within mainstream American culture, particularly for an artist. Judith McWillie has pointed out that these works "were remarkable in their premonition of current critical debates about cross-cultural appropriation, they were also profoundly personal in their aspect of ritual self-disclosure, a

motif that emerges in nearly all of Luna's work. . . ."[28] Luna's work raises critical questions regarding the privileging of Western aesthetics, a position that relegates the art of native cultures to the realm of the ethnographic museum.

Elaine Reichek's kitsch-obsessed *Revenge of the Coconuts: A Curiosity Room* (1988) combined her photo-collaged world of high-minded explorers, noble savages, and innocent colonials with symbolic South Sea "artifacts" – overripened coconuts that appeared to have fallen off the potted palm in the middle of the gallery. The collages and the coconuts were carefully contrived stand-ins for the exoticized Eurocentric image of the islands. Reichek's "museum," devoted to the pristine tropical paradise of the imagination, underscored the ridiculous and unbridgeable distance between clichéd colonial views of native "others" and the experiences of indigenous peoples.[29] In works such as *A Postcolonial Kinderhood* (1994) at the Jewish Museum, New York, Reichek has continued to use the arrangements of material culture objects in a museum format as a strategy for addressing anxieties about assimilation. This installation included faux-Colonial revival artifacts (a four-poster bed with the addition of a quotation attributed to George Washington welcoming "the children of the Stock of Abraham" to America on the headboard and a bedspread embroidered with the German "Was willst du von meinem Leben?"[30]); family mementos (photographs); and manipulated objects (antique towels monogrammed "JEW"). The project was Reichek's first to deal with her own cultural identity rather than a transference of a more generic interest in the identity problems of cultural "otherness." *A Postcolonial Kinderhood* was a particularly personal and poignant visual articulation of "the pressure to embrace the image of the American as promoted in popular culture, and the reality of . . . [her] ethnic and cultural difference" by an artist who, recalling the spaces of her childhood, remembered them as devoid of her identity as a Jew.[31]

In *Los San Patricios* (1992), Luis Camnitzer used the language of museum display to disinter the invisible ethnic and religious biases that determined the Mexican-American War. Fragments of history – "documents," period etchings, relics, contemporary photographs, and familiar icons of material culture – were mounted in wall montages resembling exhibits in a natural history museum. Camnitzer's rereading of the story of the San Patricio Battalion, a group of Irish-Catholic immigrants who deserted to the Mexican cause, suggested their "disloyalty" to the Protestant-dominated American army was a loyalty to their religious and cultural heritage. Camnitzer's installation was an emotionally charged one, its structure recalling religious architecture, with the shape of a cross giving way to that of a weapon. Dismissing the myth of history as an endless litany of incontrovertible facts, *Los San Patricios* made transparent the subjective and even camouflaging nature of historical constructions. Camnitzer's work is an art with a moral imperative. "We live the alienating myth of primarily being artists. We are not. We are primarily ethical beings sifting right from wrong, just from unjust. . . . In order to survive ethically we need a political awareness that helps us understand our environment

and develop strategies for our action. Art becomes the instrument of choice to implement these strategies."[32]

For artists like Camnitzer, engaged in historicizing installations, using the practices and props of the museum is one strategy for illustrating how cultural institutions embody social biases by supporting a view of history that privileges white Euro-American experiences over all others. The validity of this position is corroborated by Johnnetta Cole, president of Spelman College.

The institutions of cultural expression cannot be divorced from the society that forms their base. At the same time, art has the power to confront that base. While I would like to see every institution – the institutions of education, the institutions of government – be a positive agent for change in our society, the arts can play a special adversarial role. The profound disappointment – indeed I'm prepared to say the obscenity – of today's art world is that this unique responsibility is not being honored.[33]

As long as historicizing installations such as those already described here are circumscribed within the museum by being "exhibited" as works of art, their ability to affect social change is also circumscribed. With few exceptions, the "meaning" of these works has only rarely been permitted to extend to the curatorial and administrative offices or seats of governance, the locus of institutional power, which is the real target of their ballast. A unique example to the contrary was *Mining the Museum,* an installation by Fred Wilson organized by The Contemporary and the Maryland Historical Society in 1992.[34] Unlike most historicizing installations about the museum in which the artist's participation remains restricted to aesthetic manipulation and presentation, Wilson's project entailed a one-year residency in which he became incorporated into the museums' staffs, serving at various times as "artist," curator, registrar, educator, director, and, symbolically, as trustee.[35] During that period, it was agreed Wilson would not be refused access to any objects in the collection he wished to use in his installation.

"The museum," Wilson has stated, "is where those of us who work toward alternative visions receive our so-called 'inspiration.' It is where we get hot under the collar and decide to do something about it."[36] What Wilson finds or does not find in museums that makes him so "hot under the collar" has been the subject of his installations since 1987 when he curated *Rooms with a View: The Struggle Between Culture, Content, and Context in Art* for the Bronx Council of the Arts' Longwood Gallery. Three rooms simulated the galleries of ethnographic, Victorian, and contemporary museums. Their "collections" were works of art by thirty of Wilson's contemporaries which, out of the context of the downtown gallery spaces, looked variously like natural history artifacts, antiques, or valuable modern art.

Wilson continued his exploration of the museum with *The Other Museum* (1990–1) at White Columns and the Washington Project for the Arts and *Primitivism: High and Low* (1991) at Metro Pictures Gallery. In both projects, Wilson's created "mock" museums using "collections" that parodied those of

ethnographic collections. Wilson's "collections" were amassed from museum storerooms, museum shops, antique shops, flea markets, and photo archives, and included discarded stuffed birds, insects in pressed glass, African trade objects, original photographs and historic prints, reproductions of canonical works of art, plastic skeletons and plaster casts installed in museum vitrines, on pedestals, and interpreted with maps, descriptive labeling, video- and audiotapes. As in *Rooms with a View,* his lush darkened rooms painted in deep reds and blues simulated either the theaterlike spaces of natural history museums with costumed "natives" set in dioramas or Victorian-style period rooms; minimal white galleries connoted the art museum.

Wilson is fluent in the language of the museum, using it with deftness and humor to put into question its authority. His installation gestures articulate, in the museum's native tongue, its cultural appropriations, misreadings, and "sins of omission."[37] Wilson's manipulation of the museum environment illustrates how these institutions reinforce a narrative of human history governed by white, Western, colonial values, how they "keep imperial attitudes going within the museum" by segregating the aesthetic from the historic.[38] In Wilson's museums, traditional African objects were not "acquired," they were "Stolen from the Zonga Tribe." African trade masks in *The Other Museum* (1990–1) were blindfolded with the flags of colonial European nations. "The Bwana Memorial Gallery of African Art" in "The Colonial Collection" opened with a photograph depicting the gallery's namesake in safari khakis carrying a backpack impossibly large for African treks, suggesting his regalia had likely never seen the outside of a photographer's studio. Accompanying each parody, Wilson interjects "context," the social, political, and historical events that are typically disconnected from these objects when exhibited in museums.

Throughout these museums he implores the viewer to activate the hidden stories by objects, reminding us they have an existence outside art history. For example, through the flickering eyes of a wood and raffia mask a video of spliced films of the wars between the British and Zulus placed the "acquisition" of the mask in a historical context. A second "talking" mask invited dialogue, "Don't just look at me, speak to me, I'm still alive." A map of the world turned upside down asks whether or not our view of the world is merely a matter of perspective and, by placing Africa on top of the map, implicates the hierarchy created by a language used to describe the "other" hemisphere: down under, subcontinent lower hemisphere, dark continent. A group of skeletons in *Primitivism High and Low* recalled the painful controversy over the remains of native peoples. The flashing eyes of a mask placed over the face of a figure in life-size reproduction of Picasso's *Les Demoiselles d'Avignon* lured the viewer into peering through its eyes to meet those of Senegalese artists posing a challenge to Western aesthetic criteria: "If my contemporary art is your traditional art, is my art your cliché?"[39]

In 1991, Wilson was invited by The Contemporary, a museum organizing exhibitions in temporary sites in Baltimore, to visit the city to consider creating an installation using not these usual faux artifacts, but the permanent col-

lection of an area museum. Wilson chose the Maryland Historical Society after one year of regular visits and created the installation *Mining the Museum*.[40] The Historical Society's willingness to participate was, in part, due to its inability to reconcile its relationship with the diverse populations it is compelled to address. The museum's director stated it most plainly when he asked, "How is it possible to make Chippendale relevant to kids in the projects?"[41] The desire to be more inclusive, to listen to the "other" voices in the museum's audience, was the subject of several in-depth reports sponsored by the American Association of Museums and had occupied numerous panels and workshops sponsored by the organization.[42] *Mining the Museum* was timed to coincide with the annual American Association of Museums' national conference because its objective was to provoke dialogue not only about museums, but within museums.

Although it had been assumed Wilson would create an "exhibition" about African American history, *Mining the Museum* ultimately used the museum's collections and archives to create an installation about one particular institution and its history, about how it sees people of color and about how people of color see the museum. His extensive research and his use of actual artifacts – colonial period portraits of Maryland's "first" families, Baltimore repoussé silver, plantation inventories, fine cabinetry, diaries, Chesapeake Bay decoys, and pages from the watercolor notebooks of Benjamin H. Latrobe – so totally conflated his role as historian, curator, and artist that it became impossible to refer to his project as either an "exhibition," "installation," or a work of historical fact or fiction.[43] By blurring the boundaries between the activity of the artist and that of the historian, Wilson's work attracted as much notice among museum professionals outside the field of contemporary art as it did among his peers engaged in "museumist" work. In this way, Wilson's "intervention" into the activities of a "real" museum illustrated that the postmodern critique is not merely an aesthetic position, but a political initiative.

Wilson opened *Mining the Museum* with a display that included a silver globe of the world with the letters "T-R-U-T-H" emblazoned in gold on its surface surrounded by empty Plexiglas mounts used for exhibiting decorative arts (Fig. 37). Once a trophy awarded for truth in advertising, this simple juxtaposition announced that "truth, universal truth, is at best contested terrain" in the museum.[44] Indeed, in Wilson's museum, "'Truth' has been replaced by the twins 'Relativity' and 'Legitimation.'"[45] This is underscored by his placement of two sets of three pedestals each on either side of the "Truth Trophy." On its left, three white marble pedestals bear the busts of Henry Clay, Napoleon, and Andrew Jackson, three men who had almost no direct connection to Maryland history. On its right, three empty black marble pedestals bear the plaques "Harriet Tubman," "Benjamin Banneker," "Frederick Douglass," all of whom had profound impact on the state's history, but none of whom was commemorated by a portrait in the collection. Why, we must ask, did no one feel compelled to remember these individuals? Who wrote the history that made this decision? Who gave them the power to decide? Truth, in Wilson's

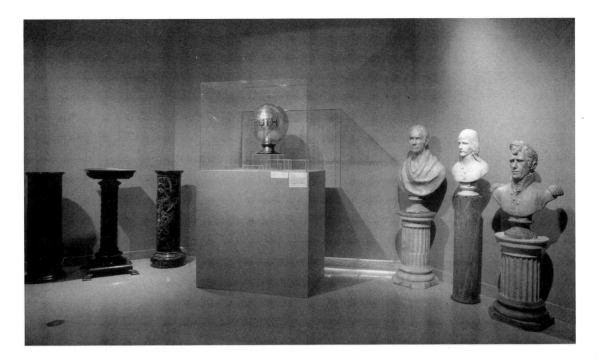

museum, is revealed as constituted by power relations rooted in domination and subjugation.

Like other historicizing installations, the narrative sequence of *Mining the Museum* does not unfold along a linear trajectory. Its organizing principle is the excavation of the African American and Native American presence within colonial society and a refutation of the perception that enslaved Africans were passive victims. Wilson's installation rises and falls around the visceral and emotional experience of the viewer who is catapulted by the opening gesture into a series of interconnected spaces that ask more questions than they answer. To Wilson, a museum is a place to question, where we should come to expect the unexpected. It is a place to make us think and to experience the world from new perspectives, perspectives "other" than our own.[46] Wilson encouraged the viewer to ask, as he had done, "Where am I in the museum?"

Wilson, of African American and Native American descent, could not find himself, that is, *his* history easily in the Maryland Historical Society. (Like most museums of its kind, the collection had developed out of a gentleman's interests in the antebellum era.) But finding his history, Wilson was able to illustrate, was a matter not so much of identifying specific objects focusing on the experiences of people of color, but of how one "framed" any object in the collection. Wilson's project became focused on giving "voice" to those left out of the museum's "official" history and restoring their identities by looking at the collection from their point of view.

"Where did I come from? Where did I go? Where do I sleep? What are my dreams?" asked African American boys relegated to the margins of Robert Street's *Children of Commodore John Daniel Danels* (1826). Their voices and

FIGURE 37

Fred Wilson. *Mining the Museum.* 1992. Detail of Truth Trophy surrounded by pedestals.

Photograph by Jeff Goldman. Courtesy The Contemporary and the Maryland Historical Society.

faces were drawn out of the darkness of the corners when visitors triggered motion detectors connected to spotlights and audiotapes secreted within the gallery wiring. "Who washes my back? Who combs my hair? Who calms me when I'm afraid?" asked the diaphanous profile of a house servant whose eyes turn to the central composition of *The Alexander Contee Hanson Family* by Robert Edge Pine (1787). "Am I your brother? Am I your friend? Am I your pet?" asked a boy when the gallery lighting bounced from his silver "dog" collar to the bird he had retrieved hunting with his master, Henry Darnell III, in a portrait by Justus Engelhardt Kuhn (1710). The resonance of the biblical allusion to Cain and Able, "am I my brother's keeper?" stirred the conscience, inevitably positioning the viewer on one side of the question or the other.

As the visitor continued to search for the answers to the children's questions, Wilson's displays provided clues. A series of ordinary tourist engravings of Baltimore's well-known downtown sights was obscured by translucent glassine paper. With the aid of small cutouts, Wilson revealed intimate activities of the daily lives of African Americans in the early part of the nineteenth century, driving wagons and sitting on the steps of the famous Washington monument.

While seeking to uncover the history of people of color within these objects, Wilson recovered information about specific individuals that had been unrecorded in the museum's registrar files. A photographic enlargement of the bowler-hatted figure of a black man in a group portrait, *Picnic at Wye House,* was found to be a former house servant who, after emancipation, had become a caterer and had supplied the refreshments for this reunion event. A review of an inventory for Perry Hall, dating from roughly the same year as a rare series of views of the plantation with slave quarters and field hands, brought forth the probable identities of the enslaved workers. Wilson then used their names to conjecture possible life stories for Easter, Joshua, Joseph, Richard, and Ned, from the fields (*Perry Hall Slave Quarters with Field Hands at Work* by Francis Guy, c. 1805) to the markets (*Market Folks* by Benjamin H. Latrobe, c. 1819) to their status as runaways (various broadsides for the retrieval of runaway slaves, c. 1819 and c. 1825), and later as rebels against enslavement.[47] The space devoted to rebellion against the slave system was marked by a continual projection against the walls of names of African Americans who had fought against it, a list given up after a year of excavations in the archives, in a museum that housed the pikes used by John Brown during the famous raid on Harper's Ferry but did not know who had used them.

Elsewhere in the installation, Wilson illustrated how the museum classification system, by compartmentalizing historical experiences, has been an effective structure for denying the parts of history it has preferred to forget. "Metalwork 1793–1880" juxtaposed fine silver with slave shackles (Fig. 38); "Modes of Transport" considered who traveled, why and how, bringing together a model slave ship, sedan chair, and a Victorian pram with a Klan hood substituted for linens. Named after the area in furniture storage in which Wilson found a whipping post that had been used in front of the city jail until

FIGURE 38

Fred Wilson. *Mining the Museum.* 1992. Detail, "Metalwork."

Photograph by Jeff Goldman. Courtesy The Contemporary and the Maryland Historical Society.

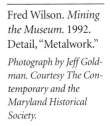

the 1930s, "Cabinetmaking 1820–1960" exhibited the cruciform-shaped object set above a semicircle of period chairs as an ironic reminder of the consequences of misguided classifying practices.[48] Wilson questioned the grounds upon which these practices could neutralize the klan hood, the whipping post, a boot jack in the form of a black woman with legs splayed, how easily such an aesthetic system, by separating these artifacts from their historical function, can anaesthetize us to their horror.

Wilson's agenda may have been institutional change, but, as he later stated, "The time of creating *Mining the Museum* was a healing process for me. A lot of what I do is about healing myself. . . ."[49] He is no less concerned with providing opportunities for the audience and the museum to heal themselves.

Wilson offered that possibility in his resolution of the installation. A blue corridor stretched between a diary by Mrs. Enoch Louis Lowe recounting her fear of "a negro uprising" like the infamous massacre led by Nat Turner in the Dismal Swamp, and another diary, that of the African American astronomer Benjamin Banneker, who wrote of his own terror of racist violence, despite the protection afforded him as a friend of Thomas Jefferson. Within this gulf between two people tragically divided by the politics of race, Wilson chose to display a basket, a jug, and a rocking chair, all made by African Americans, with a shawl, a beaded neck rope and amulet, an ivory letter opener, and brown beads on a cord, all made by Africans in what was to become Liberia, a colony founded by the Colonization Society. The blue corridor has none of the jarring juxtapositions or clever texts of the previous spaces. Yet this is a stirring, spiritual place in *Mining the Museum*. United in one place, these objects are joined together to remind us of their shared history in Africa. They also speak to the gulf between native Africans and enslaved Africans in America.

For Wilson, the politics of race is not the subject of past history. For people of color, the past is embedded in the present, its struggles left unreconciled.

Thus his inclusion of a contemporary object, a computer, in the final room of the exhibition that dealt with Banneker, a man who looked to the stars, is a reminder that the future is only as hopeful as our willingness to look the past in the face squarely. For Wilson, the museum supplies a space for "mining" the past for missing details, exploding the myth of history as fixed and unchanging, for undermining the artificial constructs that support exclusionary views of culture. *Mining the Museum* revealed that the racist policies of the Maryland Historical Society, which began when the museum was founded by members of the Colonization Society, an enterprise with questionable motives, continued unchallenged for 150 years within its daily practices, in its collection, ordering, and interpretation of its artifacts.[50] Wilson's presence there "challenged the institution to be responsive to the history of all Marylanders in the future."[51] Yet the ultimate measure of the success of the installation as an effective work of postmodern historicizing art will be whether the museum community merely appropriates Wilson's coy manipulations relegating them to clichés or whether it has supplied a catalyst for facing its difficult history with courage and honesty.

For those who engage in this type of historicizing, museumist work about cultural otherness (and those who present it), it remains to be seen whether such moral consensus along with the desire to instill real open-endedness for the viewer is a feasible combination, or whether the will to reassert the rights of the disenfranchised and the will to erase all closure are too contradictory to allow for a performative effect. Ironically, such work entails participation by the museum in order to fulfill both of its agendas and it can only attempt to fuse the two successfully under the umbrella of the institution it critiques on both accounts. Indeed, as artist Francesco Torres has argued, the medium of installation has forced the museum, the receptacle of history, to commit to a practice that has not been endowed with the patina of history, and in so doing, to be complicit in its deconstructive agenda.[52] However, the future of historicizing art does not fully rest in the hands of artists, but remains largely with the institutions they have tried to undermine. Until museums are willing to confront their own histories, the activist potential of historicizing installations will be minimal. It may be that despite the museum's willingness to host historicizing installations, that it will remain hindered by society's profound "fear of the other." In such a case, historicizing installation art will be confined to what has been described as "the borderlands . . . porous, restless, often incoherent territory, virtual minefields of unknowns for both practitioners and theoreticians."[53]

Narrativity

The chapters in this part interrogate the notion of narrative, that is, the story element that gives shape and coherence to a given sequence of historical events. Diana Strazdes shows that the kind of narrative held to so firmly by the great triumvirate of West, Copley, and Trumbull was subverted soon after by Washington Allston. Reacting to the limitations placed on meaning and expression by the traditional unities, Allston opted for a more poetical, metaphorical, open-ended treatment in keeping with his romantic temperament and literary bent. Although his predilection for poetry as a basis for *istoria* has roots in Aristotle as well as Alberti, his desire to bypass ordinary narrative form in order to reach the viewer more directly is also protomodern. Joni Kinsey's study of a sequence of landscape paintings by Frederic Church from 1859 to 1866 poses questions about the story landscape tells. Church's tendency to emblematize natural forms in response to historical events would seem to place his work at variance with the kind of progressivity usually thought central to narrative. Kinsey points out, however, that the (literal) framing and (strategic) placement of two pairs of paintings enhance their ability to "speak" to each other and instruct the viewer about the Civil War, thus creating a different but valid kind of history painting. Eric Rosenberg's thesis that narrative and meaning are only completed in the act of reception defines both his methodology and Thomas Eakins's *The Gross Clinic*. He presents a play of meanings emerging from the world of the receiver of the 1870s that is "material," "dialectical," and "historical," and ultimately incomplete. Thus *The Gross Clinic* is the site for varied, even contradictory narratives about health (political and medical), rational scientific development, art and artifice, gender, and modernism. Rosenberg finds that the story of the surgical operation is subverted by critics' suppression of the narrative component in favor of a concern with pictorial style. Stephen Polcari defends the idea that the abstract expressionists – whose artistic premises negate the aims of the nineteenth-century history painters – aspire to an especially elevated level of history painting. According to Polcari, the abstract expressionists reacted to

historical events by means of heroicizing, quasi-Reynoldsian grand ideas clothed in abstract form. This kind of history painting does not (re)present events but instead asks piercing questions about the human condition. Polcari locates the cause of the anti-narrative impulse in the frightening realities of twentieth-century life. Mark Thistlethwaite does not share Stephen Polcari's view of modernism but instead credits postmodernism with a reinvention of history painting. In his overview, Thistlethwaite analyzes examples of post-1960 art that have historiography for their content and "discontinuous, inter-penetrating, and inconclusive" ways of narrating. Such narrative often takes unusual form, involving the conscious presence of the narrator and the encouraged participation of the viewer, both of which underline the "socially transactive nature" of narrative, especially in its postmodern manifestation.

Washington Allston
Great Painting as Mute Poetry

Diana Strazdes

From the beginning of his career, Washington Allston believed in a high, noble, and immutable standard of painting. He followed that standard with such consistency and at such personal sacrifice that eventually his contemporaries took him as the American embodiment of it. In referring to his ambitions as "the highest department of art," however, he did so without reference to subject. Instead he judged his paintings' worth by their degree of resemblance to poetry. Allston's goal to make painting like poetry presented important implications for narrative content; by following that path, he left the "story" in history painting behind.

From the fifteenth through the eighteenth centuries, Horace's precept *ut pictura poesis* and Simonides's aphorism "painting is mute poetry and poetry a speaking picture" provided a means by which picture making could attain the status of a liberal art. Leon Battista Alberti, who coined the term *history* in the early fifteenth century to describe the efforts of a serious artist, advised painters to take subjects from classical poetry. Ludovico Dolce in the mid-sixteenth century, Giovanni Paolo Lomazzo in the later sixteenth, and Charles du Fresnoy in the mid-seventeenth stated that painting should not merely borrow topics from poetry but emulate its manner of expression, even though none stated explicitly how this would be accomplished.[1]

Among history painters, Allston is distinguished for the degree to which he strove to make his paintings like poetry in both form and substance. Three principles guided his approach. The earliest to develop proposes that great painting, like great poetry, communicates to the emotions. The second principle, traceable to Allston's study in Paris and Rome from 1803 to 1808, maintains that the profoundest emotions are conveyed when narrative is suspended and the viewer's imagination fills in what is not shown. The third principle, in place by the time Allston returned permanently to America, holds that metaphor, the essence of poetry, encourages contemplation of metaphysical truths that should be at the heart of artistic expression. Consequently, from 1818 to his death in 1843, Allston created "poetical" and "historical" paintings that relied less and less on strict narrative, even as American painting was poised to enter its great age of storytelling, in which pictures of history and genre were based on highly mimetic, minutely crafted incidents.

Allston's upbringing led him to understand that familiarity with art and literature was an important part of a polite education. During his years at Harvard College (1796–1800), his genteel dabbling in drawing and watercolor turned into an ambition to pursue painting professionally. From the beginning, he considered it to be an act of the mind and, as a consequence, his early self-training was centered as much in theories of painting as in the practice of it.

Harvard's philosophically liberal and relatively undemanding academic environment left considerable room for Allston's literary and artistic interests to develop. Along with the travel accounts, horror stories, and poetry he borrowed from the Harvard College Library, he read various books on art, mainly preceptors for amateurs such as an article on drawing in Thomas Dobson's *Encyclopedia* (1790) and aesthetic theories written for the popular taste, which conveyed remnants of mid-eighteenth-century British proto-romanticism.[2]

Three books were largely responsible for Allston's first understanding of great art: *An Inquiry into the Beauties of Painting* by Daniel Webb (1760), *Letters Concerning Taste* by J. Gilbert Cooper (1755), and *An Essay on Original Genius* by William Duff (1767). Webb's book, which repackaged precepts from Jonathan Richardson's *Theory of Painting* (1715), told artists to borrow their subjects from history, poetry, and dramatic literature and to endow observed nature with simplicity and grace, as did the great Italian painters of the sixteenth century.[3] For Allston, such principles became mixed with those counseling reliance on innate genius and untamed nature, not rules or precedent. Both Cooper's *Letters Concerning Taste* and Duff's *Essay on Original Genius* ranked imagination over manual skill and insisted that genius cannot be taught. Cooper emphasized the superiority of sensations over reason and gave elevated status to the animating power of landscape. Duff promoted the "sublime" as the most profound stimulus to the emotions and "the proper walk of a great Genius" and encouraged the artist to distrust any restraints on imaginative expression.[4] Each book drove home three principles that remained with Allston for the rest of his life: Painting is an intellectual endeavor, great painting resembles poetry, and a painter's highest achievement consists in engaging the viewer's emotions.

Allston left Harvard with a particular enthusiasm for landscape as a vehicle for poetic painting. In this enthusiasm he was substantively influenced by James Thomson's *The Seasons* (1730), the most influential example of a school of pictorial nature poetry that encouraged mid-eighteenth-century Britain to make landscape into both a metaphor for feeling and a direct vehicle for sentiment. As a college sophomore, Allston made a small drawing of Thomson's *Damon and Musidora*, which he displayed in his room,[5] and at the beginning of his senior year he wrote, as a classroom assignment, verses in imitation of Thomson's poem.[6]

The idea that nature could easily, profoundly, communicate with the emotions brought landscape to the fore as a major art form for Allston. In college

he thought landscape an appropriate conveyor of religious feelings and he considered Claude Lorrain's work (of which he had not yet seen a genuine example) to represent a celestial level of painting. Allston set down his suppositions in a classroom assignment in 1799, in the tale of a young painter who enthusiastically goes to Rome to find great art.[7] The youth's journey culminates in the Sistine Chapel, which fills him with sublime feelings as he beholds its walls, which Allston described as being lined with landscapes by Claude.

Allston's own first paintings were largely landscapes that capitalized on the romance of vagabonds, who seem to absorb some of the wildness of their remote mountainous surroundings, or pirates roaming along desolate shores. In these works, Allston relied on the example of Salvator Rosa, whose purportedly murky, agitated settings were associated with adventure. Like much of the mid-eighteenth-century audience, Allston disproportionately admired Salvator's relatively few "banditti" paintings, which seemed to picture human feeling unrestrained by the requirements of civilization.

Allston's interest in images more strictly associated with history painting developed just prior to his departure for Europe. His first such effort, *A Tragic Figure in Chains* (1800), a terror-inducing depiction of a madman, he painted on graduating from college. Before leaving for England in May 1801, he spent some months painting at home in Charleston, South Carolina. At the library there he saw engravings for John Boydell's *Shakespeare Gallery* and Henry Fuseli's *Milton Gallery*.[8] He painted some now lost compositions in oil, presumably as samples to bring to London with him, *Satan Rallying His Hosts* from Milton's *Paradise Lost*, *Satan at the Gates of Hell Guarded by Sin and Death*, *The Head of Judas Iscariot*, and *The Head of Saint Peter Hearing the Cock Crow*. Thus fortified, Allston left for London in May 1801, with the remarkable recommendation from his mother that "his fort[e] is historical painting, and his genius is very great."[9] In fact, Allston's earliest studies on the arts had given him more guidance regarding genius than regarding historical painting.

First Trip to Europe: New Principles to Govern Painting

In London (1801–3), Allston became a protégé of Benjamin West. He entered the Royal Academy schools where, judging from his length of enrollment, he completed the required two years of drawing from plaster casts and spent a brief part of 1803 in the life academy. In certain respects, Allston's period of study in London confirmed his predispositions about great painting. He developed an intense admiration for West, then engaged on the horrific *Death on the Pale Horse*, and for Fuseli, then painting largely imaginary subjects that had to do with communicating the emotionally charged "sublime." His decision to paint a now lost *Marius at the Dungeon at Minturnae* just before leaving for Paris suggests he sought comparably charged subjects for his first history paintings.

By this time, Allston had become acquainted with Joshua Reynolds's *Discourses*.[10] Reynolds, who has been called the last great proponent of the doctrine of *ut pictura poesis*, synthesized in his *Discourses on Art* much of what had been written about painting in the previous two centuries.[11] In them, he consistently promoted a higher branch of painting that is not strictly imitative, appeals to the imagination and higher principles, and fills the mind with great and sublime ideas. Reynolds refused to identify great painting in terms of subject, calling it instead the "great style" or the "grand style" and thus basing his criteria for excellence on quality of pictorial expression. The "great style" depended on an idealized treatment of subject achieved by combining nature's beauties and correcting its defects. It also depended on simplicity and loosened chronological specificity to help ensure universal meaning.[12] Reynolds named the Italian old masters as possessing the best grasp of both these concepts and he counseled an abiding familiarity with their works and ideas.

Allston surely also attended the first lectures that Fuseli delivered in 1801 and 1802 as the Royal Academy's professor of painting, which emphasized that the great works of art stir the emotions most deeply. In an attempt to provide an indisputably lofty definition of the best painting, Fuseli placed at the summit something he called "epic" painting, which astonishes. In choosing the term, he confirmed his opinion of the greatest painting as a form of poetry. The next level of painting was occupied by the "dramatic," which he defined as a type of subject that appeals to the imagination and stirs the emotions. "Historic" subjects, although "advantageous with and adapted for art," Fuseli ranked a poor third.[13]

During the ten months that Allston spent in Paris (1803–4), he inspected the newly installed Musée Napoléon in the Louvre palace, which presented by far the largest number of masterpieces of painting and sculpture he had ever seen in one place. Allston made life drawings, probably in Jacques-Louis David's studio, met David's students thanks to introductions by John Vanderlyn, saw David's recent paintings (including the partly finished *Leonidas at Thermopolae*), and viewed the productions of the Salon of 1804. By these means he became familiar with the current tendencies of French neoclassicism.

As it happens, the main catalog of the Musée Napoléon (which Allston probably purchased for its engravings) described historical painting in a manner that confirmed Reynolds's principles of the "great style." Its division of paintings as "genre," "portrait," landscape," and "history" did not strictly describe subject matter but rather connoted degree of idealization.[14] Dutch and Flemish paintings were represented mainly in the portrait and genre sections. "History" meant mainly the classicizing painters of the sixteenth and seventeenth centuries such as Raphael, Guido Reni, Domenichino, and Charles Le Brun. The subject matter included scenes from classical literature, but it also included single allegorical figures of classical subjects; all religious subjects, including devotional portraits; and certain Poussin landscapes. In contrast, the sole depictions of modern historical events in the Musée Napoléon, battle scenes, were classified as genre, as were most Dutch Bible subjects, including Rembrandt van Rijn's *Christ at Emmaus*.

The many seventeenth-century classical landscapes on display in the Musée Napoléon sparked in Allston a new interest in the expressive possibilities of that type of painting. Six major landscapes by Nicolas Poussin were shown together for the first time: *Orpheus and Eurydice,* the four paintings known as *The Seasons,* and *Diogenes Throwing Away His Bowl.* These made a strong impression on Allston, who must have seen that their scale, geometry, and simplicity followed the same rules of composition as classical-manner history painting and that their dignity and grandeur were consistent with history painting's broader principles. Poussin became the standard for Allston's *Italian Landscape* (c. 1804), a pastiche of features from *Orpheus and Eurydice,* and *Landscape with a Lake* (1804), an adaptation of the setting of *Diogenes Throwing Away His Bowl.*

While in Rome (1805–8) Allston produced his first works on a genuinely grand scale. Within a few months of his arrival, he completed *Diana and Her Nymphs in the Chase* (Fig. 39), which marked in him a new attitude toward the place of landscape in the hierarchy of serious art. The work, measuring 5 1/2 by 8 feet, was the size of a history painting and in Rome it was both exhibited and praised as such.[15] Although its composition reminded viewers of Italianate seventeenth-century painting and its deep greens recalled those of the Venetian school, its coloring was recognized as completely new. The translucent glazing caused mountains and water to disappear as one came near the picture, reminding the viewer that these pictorial elements were closer to ideas than to things.

FIGURE 39

Washington Allston. *Diana and Her Nymphs in the Chase.* 1805.

Courtesy of The Fogg Art Museum, Harvard University Art Museums, Cambridge, Massachusetts. Gift of Mrs. Edward W. Moore.

Diana and Her Nymphs in the Chase combines an accurate image of Mount Pilatus with an imagined context that refers to past art. The mountain is transcribed from a careful sketch that Allston made of Mount Pilatus as he passed Lake Lucerne on his way to Italy, an experience that profoundly moved him. It represents Allston's first use of a reference to his own experience in an otherwise idealized image. Such combining – and confusing – of the ideal with the real results in "dislocation" as Bryan Jay Wolf has described it, the creation of a work of art in which the extent of imitation is never clear.[16] The phenomenon became a feature in nearly all Allston's mature works.

However, this very technique can also help make the thoroughly ideal seem real, which is how Allston's contemporaries in Rome reacted to *Diana and Her Nymphs in the Chase*. Samuel Taylor Coleridge told of "a lady of high rank and cultivated taste, who declared . . . that she never stood before that landscape without seeming to feel the breeze blow out of it upon her."[17] Brightly lit and dominating the center ground, the silent yet expressive mountain took on the main role in a tableau whose subject was the grandeur of nature. To make an aspect of an imagined situation instantly recognizable yet universally significant was the essence of history painting as it was revived in the late eighteenth century. But in *Diana and Her Nymphs in the Chase,* the story remains mute; the moral lesson is in the comprehensive order of nature.

While in Rome Allston also demonstrated a no-less-important change in attitude toward narrative painting, which caused him to suppress action and visible emotion. His new approach is exemplified in *Jason Returning to Demand His Father's Kingdom* (c. 1807–8), whose black-crayon study (Fig. 40) Allston transformed into a vast canvas, measuring 14 by 20 feet, the largest he ever attempted. With over thirty figures, *Jason Returning to Demand His Father's Kingdom* presented a tremendous challenge not only to his stamina, but also to his knowledge as a figure painter, given that Allston was making this leap without a great deal of previous study in anatomy or perspective. In coloring, it would have relied on translucent glazes of cool colors over a red ground, like *Diana and Her Nymphs in the Chase*. Although Coleridge reported that Allston worked on the painting for two years, it was never finished.

Allston's painting was in part inspired by Bertel Thorvaldsen's recently finished sculpture, *Jason,* and by Vincenzo Camuccini's mammoth canvases of classical subjects. Its friezelike frozen composition derived directly from the severely simple classicism then being promulgated in Paris by David and his school. In theme, *Jason Returning to Demand His Father's Kingdom* seems to have been a commentary on the loss of artistic masterpieces from Rome. The figures are all quotations (in reverse) from works of art that had been recently taken from their places of origin: the Parthenon frieze, the sculptures taken by the French armies from the Vatican, and the Raphael tapestries removed from the Sistine Chapel, the *Blinding of Elymas* and *Healing of the Blind Man*. The classical heritage, therefore, would be the kingdom reclaimed by the young hero. Allston chose to depict the moment of Jason's confrontation with his uncle Pelias, who had usurped Jason's father's kingdom of Ioclos. The heir,

FIGURE 40

Washington Allston. *Jason Returning to Demand His Father's Kingdom: Sketch.* c. 1807.

Courtesy of The Fogg Art Museum, Harvard University Art Museums, Cambridge, Massachusetts. Washington Allston Trust.

grown to manhood in exile, returns to demand his birthright. In this tense moment, Pelias sees that Jason wears one sandal and instantly remembers an oracle saying that such a person would mean his doom. The selection of this moment deprived the picture of an outwardly expressive central scene; the accompanying figures appear on stage in disconnected vignettes, their purpose merely to set off the tense confrontation between Jason and Pelias.

Jason Returning to Demand His Father's Kingdom applied the device of the "fruitful moment" as described by Gotthold Ephraim Lessing in his seminal critical work of the neoclassical age, *Laokoön* (1766). Allston, who may not have read Lessing's treatise, had seen this principle applied in Paris, in works such as David's *Leonidas at Thermopolae* (Fig. 41), in which the protagonist exhibits a psychological tension that turns him frighteningly calm. This "fruitful moment" encourages artists to suppress action and visible emotion in favor of a silent moment that is more imagined than seen. By choosing such a moment, artists can present greater emotional turbulence than they could possibly depict convincingly, because the bulk of the storytelling proceeds in the viewer's mind rather than on the canvas. Allston's grasp of this principle changed permanently his history paintings. Henceforth, he nearly always arranged his compositions around a portentous event implied by an arrested or tense action.

145

FIGURE 41

Jacques-Louis David.
*Leonidas at Ther-
mopolae.* 1802–14.

*Musée du Louvre, Paris.
Photo courtesy
Giraudon—Art
Resource, New York*

The Addition of a Religious Dimension

During his second residence in England (1811–18), Allston responded to pre-vailing artistic practice by returning to religious subject matter on a large scale. He experimented with greater variety of subject matter than before or after, including comic and genre subjects as well as landscapes and portraits. Nevertheless, his chief ambition in England was to establish himself as a history painter. He built his reputation on biblical canvases on the subject of miracles and prophecies, producing a steady stream of technically innovative works.

Even though Allston's biblical paintings continued the tradition of judicious quotation from earlier art so they became reminiscent of old master pictures, they displayed certain qualities unique to him. Allston experimented a great deal with coloring, finding the insubstantial effect of glazing conducive to the suggestion of spirituality.[18] His subjects tended toward calm, tense, or arrested moments connected with a moment of divine revelation, which left much to the viewer's imagination. The figures in his compositions often seem to merely display themselves rather than engage in purposeful action. Allston thought seriously about the limits of pictorial representation; he decided, for instance, that he could appropriately represent neither Christ nor a miracle in progress.

In 1815 Allston took delivery of *Jason Returning to Demand His Father's Kingdom,* which had been stored in Livorno since 1808. He found that the picture and its classical subject had lost all relevance for him and he placed it on consignment (for the value of the canvas) with his paint supplier in London,

where it remained until 1844. Although abandoned, *Jason Returning to Demand his Father's Kingdom* continued to have a place in Allston's work, for, in certain fundamental aspects, it was redone in *Belshazzar's Feast* (Fig. 42), which Allston began in 1817. In *Belshazzar's Feast* Allston repeated the stage-like architectural setting, the classical arrangement of stilled figures, and the focus on psychological tension between two antagonists, a tension newly amplified by a divine act, the handwriting on the wall.

If the link between painting and poetry took on a more intense meaning for Allston after he returned to the United States, which it seems to have done, then its origins are traceable to his time with Coleridge, who not only introduced Allston to the work of Dante and Spenser, but also to the German idealism of Immanuel Kant and Friedrich Wilhelm Joseph von Schelling, which Coleridge was reformulating as a basis for poetic expression. From the moment they met in Rome, Coleridge relied on Allston as a guide in forming his standards for art.[19] Coleridge expressed his admiration in an essay titled "On the Principles of Genial Criticism Concerning the Fine Arts," written to coincide with an exhibition of Allston's paintings in Bristol in 1814.[20] In it, Coleridge ignored the doctrinaire divisions between history painting and other types of painting, describing the ideal beauty of Allston's *The Dead Man*

FIGURE 42

Washington Allston.
Belshazzar's Feast.
1817–43.

The Detroit Institute of Arts, Detroit, Michigan. Gift of the Washington Allston Trust.

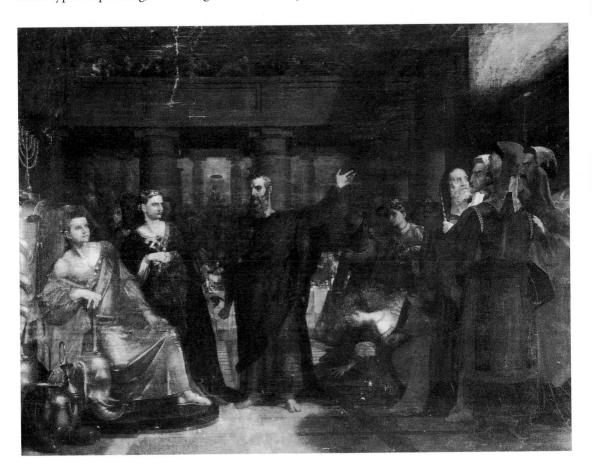

Restored to Life by Touching the Bones of the Prophet Elisha (1811–14) and *Nymphs in the Chase* in essentially the same terms.

Allston's imaginary double portrait, *The Sisters* (c. 1816), has been convincingly interpreted by Gerald Eager as a tribute to Coleridge in the form of a metaphorical representation of painting and poetry as "sister arts," the term Reynolds used to describe painting and poetry.[21] The picture, which Allston kept until the 1830s, lends itself to being viewed with the same attention to metaphor and multiple meanings associated with the reading of poetry. It shows two young women, one blond, one brunette, linked in embrace. The blond woman (Poetry) is shown against an interior space and turns her ear, indicative of the sound of poetry, to the viewer. The brunette woman (Painting) is shown against a landscape, toward which she turns. Yet Painting and Poetry take on features associated with the other; as Eager notes, the hidden face of Painting conveys the evocativeness of poetry; the face of Poetry is derived from a painting then thought to be by Titian, of his daughter.

The effect of Reynold's *Discourses on Art* on Allston was redoubled during Allston's second residence in England. At this time he took to referring to serious painting as "the Art," using Reynold's customary term, and he made sure his students Samuel F. B. Morse and Charles Leslie read the *Discourses on Art*. Particularly pertinent to this period of Allston's career was his acceptance of Reynold's insistence that painting should present a simple and harmonious ideal. Bolstered by Reynolds, he continued to rely on the old masters as a measure of his ideas and as a point of departure for his work. Allston continued to believe that the old masters lead one to a unique understanding of "the Art."

Allston's Approach to History Painting Back in America

By all accounts, Allston's residence in England was productive in terms of patronage and critical success, even in the face of such obstacles of anti-American sentiment as a result of the war between Britain and United States, his wife's death, and his financial reversals. Nevertheless, by 1816 he contemplated returning to America after building a cash reserve and a stock of projected paintings. In preparing for his return, Allston placed history painting uppermost in his professional plans. He became convinced that his history paintings should deal with religious subjects and that *Belshazzar's Feast* would be exhibited publicly, in a one-work exhibition of the sort that had recently gained favor in London.

Allston returned to Boston in the fall of 1818. Although mindful of the uncertainties of his future in the United States, he became nearly exclusively involved in the painting of ideal subjects, which ranged from large history paintings to small "poetical" works. He painted almost no portraits or genre scenes and, although he used the word *commission*, he never allowed a patron to define either his subject matter or its treatment. He urged Leslie and Morse not to forsake ideal art and to set aside money so they could intermittently devote themselves to that ambition.

Allston disappointed his friends in England by neither returning to visit nor sending his paintings to the Royal Academy for exhibition (as Leslie urged him to do). He seldom traveled outside Boston, did not participate in exhibitions in other cities, never established a studio with assistants like West's, and demurred from a role in the Boston Athenaeum other than as contributor to exhibitions. Although he promoted Morse and Vanderlyn for commissions for the U.S. Capitol, he refused a commission for himself, despite much urging. His reluctance to involve himself more actively with professional artists' groups puzzled many of his colleagues and led some to describe him as in retirement. Indeed, Allston's interests centered nearly as much on literary, philosophical, and religious issues as on painting. His circle of friends consisted mainly of men and women of letters rather than other painters. To this audience, he took on the role of enthusiastic advocate for ideal art and proved particularly generous in educating the tastes of young amateurs.

Allston tried to replicate the patronage system prevailing in England, which relied on enlightened private purchasers to become acquainted with the artists' new productions through studio viewing or regular public exhibitions. Unfortunately, this system failed to function as he hoped. Boston offered fewer patrons of means than London and they were willing to pay much less for canvases than Allston had anticipated. Because Allston was unwilling to adjust to his market and produce more paintings in less time (the labor he expended on even his smallest pictures is legendary), he found it difficult to sustain an income from his work, even though he had more requests for paintings than he could handle. Fundamentally, he was never comfortable in the role of an artist obliged to live on the income from his painting; he wished to maintain the status of a gentleman who could subsidize his own worthy but not necessarily marketable endeavors. Further, in part because Allston would not press his patrons to lend to exhibitions such as the Royal Academy's, his work was relatively rarely available to the public.

His financial limitations time and again confounded Allston's progress on *Belshazzar's Feast,* the first of a number of large history paintings that Allston planned to paint in America. When he lost the lease on his Boston studio, he lacked money to acquire a replacement large enough for the painting. Whenever he needed funds to meet living expenses, he stopped work to paint smaller canvases that could be sold readily. And because he felt obliged to set aside his other large projects until he could complete *Belshazzar's Feast,* it eventually became his only large history painting in prospect. As a result, it gained even more the quality of that artifact of the Romantic era, the "absolute masterpiece," the greatest test of the artist's technical abilities and the sum of his creative powers.[22] And because Allston was engaged in no other paintings with such complex settings, its technical challenges became ever more vexing as time passed.

For *Belshazzar's Feast,* Allston devised a composition that he felt was perfectly suited to his artistic predispositions.[23] It soon was understood to be, as Washington Irving described it, "a grand and poetical conception, affording scope for all the beauties and glories of the pencil."[24] David Bjelajac has

suggested a reason for Allston's satisfaction with the subject: It proved a durable metaphor linking religious millenialism with the American national consciousness through Daniel's prophetic revelation.[25]

Whenever Allston found time to work on *Belshazzar's Feast,* he was impelled to revise it according to his current thinking about art and, in effect, repainted the work. Its coloring became darkly translucent and quite different from that indicated in his initial oil sketch for the painting. He made the central grouping of Daniel and Belshazzar more isolated from the narrative around them. He changed the perspective by lowering the line of sight and by adding a distant architectural background. He enlarged the foreground soothsayers. Late in the process of painting, he created a much praised vignette of three women bowing to Daniel, whose faces are bathed in light that invites meditation upon them.

Allston's painting method created real difficulties with *Belshazzar's Feast.* He once told Elizabeth Palmer Peabody that, had he the money, he would have operated a large studio with student assistants. Here, however, he was not being altogether honest, for he did not use a working method in which he could sketch, finish, and leave the bulk of the work on a painting to assistants. Allston placed ever-increasing emphasis on an idiosyncratic and time-consuming glazing technique that required nearly all the work on a canvas to be done by him.

Allston completed only three history paintings during the last twenty-five years of his career: *Jeremiah Dictating the Destruction of Jerusalem to Baruch the Scribe* (1820), *Saul and the Witch of Endor* (Fig. 43), and *Spalatro and the Bloody Hand* (1831, destroyed). Smaller canvases than *Belshazzar's Feast,* all are relatively simple compositions stripped to just two main figures and a few background accessories. The figures themselves are posed in a classical manner on a shallow foreground, their contours clearly delineated. All rely on a frozen moment of psychological revelation whose implications are the most thought-provoking aspect of the picture. All have been criticized as deficient in drama.[26]

Saul and the Witch of Endor demonstrates well Allston's decreasing concern for coherent narrative, especially if his version of the subject is compared to the Bible narrative it purports to illustrate. The biblical text (1 Sam. 28: 3–20) emphasizes a sequence of actions in which Saul, who has banned conjurers from his country, finds himself embattled against the Philistines and his appeals to Yahweh for a sign go unanswered. In disguise Saul seeks a witch, asking her to conjure the spirit of Samuel. When the ghost appears, the witch suddenly recognizes Saul, who prostrates himself before the ghost. The ghost then tells Saul that, because of his disobedience, Yahweh has abandoned him and that tomorrow he will die. Saul reels from the news. In Allston's painting, the witch is shown simultaneously conjuring the ghost (by tracing a circle not yet completed) and recognizing Saul upon the appearance of the ghost of Samuel, who already speaks to Saul. In the background, Saul's two soldiers appear to run in fright as the ghost appears. Saul, however, is shown at a different moment, in shock from the message the ghost relates. Allston, in attempting to tell more of the story than any one moment would permit,

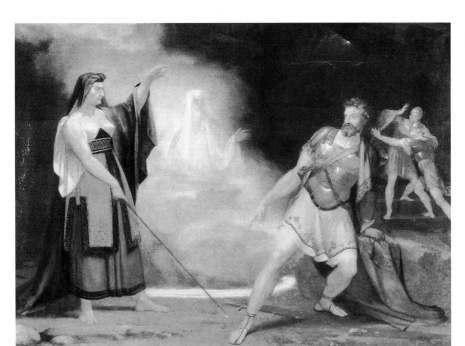

FIGURE 43

Washington Allston.
*Saul and the Witch of
Endor.* c. 1820–1.

*Mead Art Museum,
Amherst College,
Amherst, Massachusetts.
Museum Purchase.*

ignored the principle of dramatic unity. He obliges the viewer to consider each figure on the canvas as an emblem of separate fragment of the narrative, which the viewer reassembles mentally.

Allston followed the same approach in the changes he made to *Belshazzar's Feast* beginning around 1820. Strictly speaking, that narrative (Dan. 5: 1–29) proceeds as a series of actions – the handwriting appearing during Belshazzar's banquet, his palsied reaction, the soothsayers' inability to interpret it, the queen's recommendation that Daniel be summoned, Daniel's arrival after the banquet. Allston's first sketch of the scene (1817) captured a plausible single moment: Daniel's appearance in a hall of mainly empty tables and servants clearing away vessels. He gradually changed that into a composition which covered more of the story but destroyed dramatic unity in doing so. In the large canvas, he decided to show the banquet in full force; plundered vessels from the sanctuary in Jerusalem are piled by Belshazzar's throne in a less functional manner than previously. The same scene contains Daniel's appearance after the banquet. And as Daniel explains the writing on the wall, three women already pay homage to him as third in rank in the kingdom, an honor Belshazzar bestowed after Daniel's prophecy. As with *Saul and the Witch of Endor,* Allston, in confronting the traditional dilemma of dramatic unity, decided that his instructional goal would be better attained by abandoning coherent narration.

Allston's Smaller Paintings as Poetry

The other paintings that Allston produced, his still smaller "parlor pictures," are simple compositions, usually landscapes with figures or single figures in a land-

151

scape, so pared down that most are stripped of what would be called narrative. Allston's friends tended to blame these pictures, painted to earn money between campaigns on *Belshazzar's Feast,* for Allston's failure to progress on his great painting. Yet he hardly compromised his standards in such works, for they were perfectly consistent with those he had long ago set for great and noble art, which allowed a wider range of subjects than "historical pictures." He can therefore be considered as consummately dedicated to the high ideals of history painting without having completed a large body of large narrative images. Indeed, Allston's smaller and least narrative works best demonstrated what by rights should count as his innovation in history painting: to make a painting function as poetry does.

Allston's interest in Reynolds, promoter of the sisterhood of painting and poetry, remained much in evidence during his first six years back in the United States. In 1819 Allston stated, "If I ever write on the subject, I shall let them know here how much the Art owes to Sir Joshua."[27] Having read James Northcote's *Memoirs of Sir Joshua Reynolds* (1813) and reported how familiar to him the descriptions of Sir Joshua's manners, habits, and modes of thinking had become, he commented, "I feel almost persuaded at times I had actually been acquainted with him."[28] And thanking Gulian Verplanck "for the honourable mention of *my* Sir Joshua," Allston admitted, "I feel as if I had a property in his mind; quoad that *painter,* he has laid the foundation of my own, most of my speculations are built on it, and it is mine by right-of-settlement."[29]

Coleridge played a part in Allston's embrace of metaphor in his later painting, for Coleridge considered metaphor the basis of all art. He further held that the poet's ability to imaginatively reconstruct the visual world in a unified, ideal way gives shape to the invisible forms of God's creation. These ideas were a more psychological recasting of Neoplatonism, which melded easily with the religious direction of Allston's own thinking. By 1819 Allston completed a group of smaller works that he described as having been "on the stocks" (meaning they were already partially on canvas when he had arrived in Boston). These included *Beatrice* (c. 1816–19), *The Flight of Florimell* (1819), and *Moonlit Landscape* (1819). Each was indebted either to Coleridge's literary preferences or to his thinking about poetry as idealized, evocative metaphor. *Beatrice* melds divine inspiration and poetic inspiration, and Renaissance idealism with the Christian Platonism that Coleridge perceived in Dante.[30] *Flight of Florimell* evokes the emblematic nature of Spenser's poetry, a subject of a course of lectures prepared by Coleridge for early 1818.[31] *Moonlit Landscape* reflects much of Coleridge's theory of the imagination in the context of what seems to be a personalized metaphor of the voyage of life theme from epic poetry.[32]

Allston's *Lectures on Art,* written during the 1830s, bore a considerable debt to Coleridge. Allston employed Coleridge's lamp metaphor to describe the mind that creatively illuminates and adds to what it observes. Allston made use of Coleridge's "primary" ideas, those that occur spontaneously, and "secondary" ideas, those that result from external stimulation. Most impor-

tant, Allston restated Coleridge's conviction that the invisible unity and harmony of the universe can be revealed only by the poetic mind.[33]

Allston's effort to stimulate a poetic frame of mind in the viewer can be seen in his paintings of solitary meditative figures. From their earliest appearances during his stay in England through the 1830s, most of these paintings were connected with poetry, either by depicting characters from poems or in some other readily visible manner. Their common features include a virtual absence of movement and a suggestively lit figure holding an accessory to spark the viewer's curiosity. The result was a painting in which the viewer is attracted immediately into the thoughts of the figure depicted. When *Beatrice* was exhibited at the Boston Athenaeum in 1827, both Margaret Fuller and Peabody admitted spending long periods before it, convinced that Dante's Beatrice was telling them about herself at a profound level.[34]

The Spanish Girl in Reverie (Fig. 44), long acknowledged as one of Allston's finest renditions of a meditative figure, invites the viewer's contemplation through its evocative coloring, the young woman's dreamy state, and the viewer's natural speculation on why she sits in thought. Allston supplied the answer in an accompanying poem, "The Spanish Maid," which records her musings about her lover, gone to war.[35] The poem shifts constantly from her recent and distant memories to sad and happy thoughts about the future, all juxtaposed against the emptiness of the present. The continual shift of tempo-

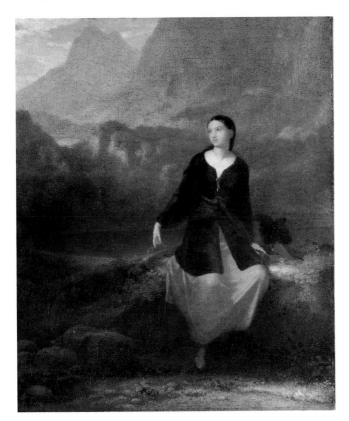

FIGURE 44

Washington Allston.
*The Spanish Girl in
Reverie.* 1831.

*Metropolitan Museum of
Art, New York. Gift of
Lyman G. Bloomingdale,
1901.*

FIGURE 45

Engraving after
Euterpe, muse of lyric
poetry.

In S.-C. Croze-Magnan,
Le Musée Français:
Recueil complet des
tableaux, statues, et des
bas reliefs qui composent
la collection nationale
(Paris, 1803), vol. I.

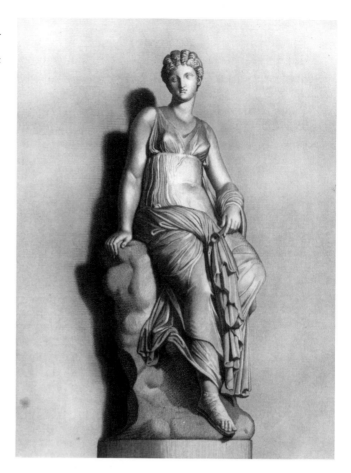

ral references in the poem offers what strictly narrative painting, confined to a single moment, cannot do. By encouraging the viewer to indulge in the Spanish maid's mental processes, Allston has managed to associate his painting with that poetic freedom from temporal constraint.

The Spanish maid in the painting is herself a metaphor for poetry. Her pose replicates that pose of *Euterpe,* the muse of lyric poetry. Allston saw this famous Greco-Roman sculpture from the Vatican Museum while in Paris in 1804 and he probably owned an engraving of it (Fig. 45). His reference to classical sculpture connects *The Spanish Girl in Reverie* to the tradition of great and noble art, just as similar references in his historical paintings do.

Not generally acknowledged is Allston's achievement of accessibility to a potentially broad audience while maintaining his intellectual standards. Even as *The Spanish Girl in Reverie* and its cousins speak to the viewer who recognizes their artistic cross references,[36] the paintings also convey suggestions of poetry, universality, and timelessness directly to the less informed viewer by means of color and composition. Allston thereby allowed his principles to be understood on an immediate, emotional level as well as a traditionally intellectual one.

With remarkably long-lasting conviction, Washington Allston judged painting by its philosophical content and by the mental involvement it required of the viewer. His way of thinking about great painting was bound up with the venerable definition of it as mute poetry. This definition, introduced to him in his college reading of popularized mid-eighteenth-century art theory, was reinforced by his recurrent study of Reynolds's *Discourses on Art,* refined through his deep appreciation for Coleridge's theories, and encouraged in the congenial philosophical currents around Boston. Allston proceeded far beyond the usual lip service to the proposition that painting is mute poetry and instead gave serious attention to the ways in which painting could structurally become a poetic art. He made the features found in poetry his personal cornerstone for serious painting: idealization, communication to the emotions, and metaphorical content.

For Allston, idealized imagery provided a way to endow painting with universal meaning. Unlike other American artists of his time, he never became dissatisfied with allusions to past art; rather, he showed an enduring fondness for the classicizing Italian schools of the sixteenth and seventeenth centuries. By the 1820s he was demonstrating that, by uniting simple forms with harmonious colors, he could convey Coleridge's belief in the unity of God's creation. This version of Neoplatonism, which informed not only Allston's painting but his *Lectures on Art,* and even his thoughts on religion, paralleled the philosophical ideas current in New England between the 1820s and the 1840s.

Allston's understanding of the emotional communication in painting underwent a major change in the course of his career. He gradually concluded that it was far less important to show emotions acted out in the picture than to instill them in the viewer. In his first works, he attempted to represent emotional states directly. But from 1806 on, as he became an adherent of the doctrine of "the fruitful moment," the main actors in his paintings tended to appear as impassive agents while the most dramatic events in his pictures were left to the viewer's imagination. By making his compositions outwardly less expressive, he wanted the viewer to look past the image; the engagement that mattered was that between the viewer's and the painter's thoughts.

By presenting images suggestive of "universal truths" while leading the viewer to meditate on subjects not depicted, Allston caused his paintings to function metaphorically. With his increasing interest in metaphor went a decreased concern for both imitation and narration. When, for example, in *Jason Returning to Demand His Father's Kingdom,* the painting turns on the psychological tension between Pelias and Jason, it helps that the dozen figures surrounding them are involved in no particularly compelling action. When, in *Belshazzar's Feast,* the people of Jerusalem represent the American nation and Daniel's prophecy signifies that God saves only those who remain devout and uncorrupted by materialism, then it becomes important to diminish aspects of

a palace banquet irrelevant to this main meaning. When, in *The Spanish Girl in Reverie,* the picture's purpose is to convey the flow of thoughts from past to future to present, then physical activity is beside the point.

As it happens, the features of Allston's later painting that have defined him as a Romantic artist also identify him as a painter whose instinct was metaphorical rather than narrative. His desire to create "mood" (as emphasized by Edgar P. Richardson), his frequent "parody" of past art, which makes his subject impossible to understand as strict limitation of visual reality (as proposed by Bryan Jay Wolf), and his preference for multiple layers of personal meaning (as noticed by numerous late-twentieth-century observers) all indicate a painter who uses images in a metaphorical manner.

Did Allston discard the moral messages traditional to history painting? After all, the "story" in history painting is a means to convey moral lessons to the public. It would seem that, strictly speaking, such a capacity would be absent in Allston's most "poetic" paintings. Also, one could claim that his never completed history paintings could not teach the public because they were not publicly exhibited. However, these suppositions do not seem to hold in Allston's case, for two reasons. First, Allston came to believe that recognizing the harmonious underpinnings of God's creation was a worthy end in itself. (In his lectures on religion he associated God with harmony and in his lectures on art he made harmony the basis for all great art.) Therefore, the conveying of beauty and metaphysical unity in painting had the value of a moral lesson. Second, Allston's perseverance in painting despite its lack of financial reward caused him to become a moral example to others. So well known was his personal sacrifice that he conveyed moral lessons through his paintings simply by continuing to work on them.

Furthermore, Allston's character was so understood to be a part of his pictures that his persona and his paintings were seen as interchangeable. A similar tendency, it may be worth noting, was already in place in Reynolds's *Discourses.* For instance, Reynolds said that artists, properly trained "shall have the purest and most correct outline" and must "acquire perfect form," that Michelangelo "possessed the poetical part of our art in a most eminent degree," and of Titian, that "there is a sort of senatorial dignity about him, which, however awkward in his imitators, seems to become him exceedingly."[37] Regarding Allston, William Ware made a point of saying that Allston placed his whole being in each of his paintings.[38] Elizabeth Palmer Peabody was accustomed to call each of the artist's pictures "an Allston."[39]

Allston's continued labor on *Belshazzar's Feast* is the most evident example of how he transferred the virtue associated with history painting to himself. Although his friends took his failure to complete his great work as an indictment against the nation's ability to encourage its serious artists, it is obvious that the canvas was too big and complicated to execute (and to revise continually) without assistance and Allston's style of painting too laborious for the picture to be completed in a timely manner. Although it pained Allston

to see *Belshazzar's Feast* languish, that it ever would be completed seemed eventually to be immaterial to him, as William Gerdts and others have noted.[40] The moral lesson of the work lay in Allston's continuing dedication to it, which made seeing the work itself immaterial. It became more important that Allston continue working on the painting than that it be finished. Allston's devotion to "the Art," no matter what the financial sacrifice, made him a living metaphor for virtue.

History in Natural Sequence
The Civil War Polyptych
of Frederic Edwin Church

Joni L. Kinsey

*Submitted to the process of thought, a unity in diversity of
phenomena; a harmony, blending together of all created things,
however dissimilar in form and attributes; one great whole
animated by the breath of life.*

– Alexander von Humboldt,
Cosmos: Sketch of a Physical Description of the Universe

Frederic Edwin Church's monumental landscapes of the late 1850s and early
1860s have long been recognized as his most significant works and some of
the most important paintings in American art. They are also among the most
widely written about paintings of the nineteenth century, both in their own
day and in ours. And yet, for all the scrutiny they have received, these spectac-
ular canvases have been discussed only sporadically in conjunction with the
most climactic event of their era, the American Civil War. Perhaps this is
because most of the paintings Church produced during the period are notice-
ably lacking in references to the conflict: The majority of them depict either
the tropics or the arctic rather than the landscape of the United States, and
they contain few, if any, human figures. Discussions of these pictures have gen-
erally revolved around the aesthetic theories of John Ruskin and the forma-
tion of a landscape school in America, Alexander von Humboldt's influential
writings about Central and South America, northern expeditions in search of
Sir John Franklin and the elusive Northwest Passage, and Church's own travels
to these disparate regions in the 1850s.[1] That such connections are valid there
can be no doubt: Church's own library at his estate, Olana, in Hudson, New
York, contains numerous books and letters on these subjects, and contempo-
rary reviews of each painting's solo paid-admission showing recounted exactly
these relevant inspirations, as well as emphasizing the uniqueness of the
regions depicted. But even though Church titled his iceberg painting *The
North* (1861) (Fig. 47) for its first two years, advertising that the ticket pro-

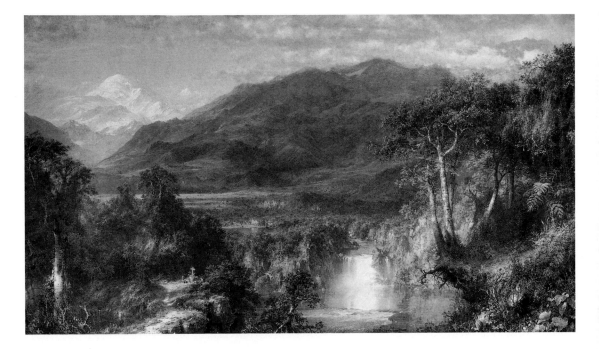

FIGURE 46

Frederic E. Church.
Heart of the Andes.
1859.

*Metropolitan Museum of
Art, New York. Bequest
of Mrs. David Dows,
1909.*

ceeds would go to the Union's Patriotic Fund, and then produced, again to benefit the fund, a small political picture, *Our Banner in the Sky* (1861) (see Fig. 14), the artist's relationship to the war comprises a surprisingly small percentage of the sizable Church criticism.[2]

The scattered discussions that do mention his pictures in the context of the war do so primarily in terms of a single picture or at most of paired works: Franklin Kelly, for example, has argued that *Twilight in the Wilderness* (1860) represented "the nation on the eve of civil war, whereas *Our Banner in the Sky* represents the morning of the war itself."[3] David Huntington linked *Cotopaxi*

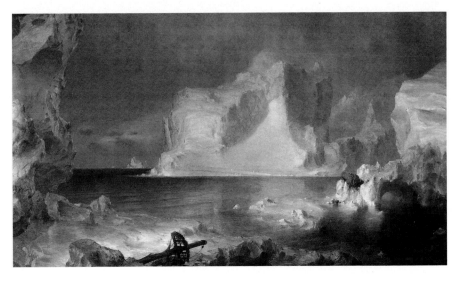

FIGURE 47

Frederic E. Church.
The North (or *The
Icebergs*). 1861.

*Dallas Museum of Art.
Anonymous gift.*

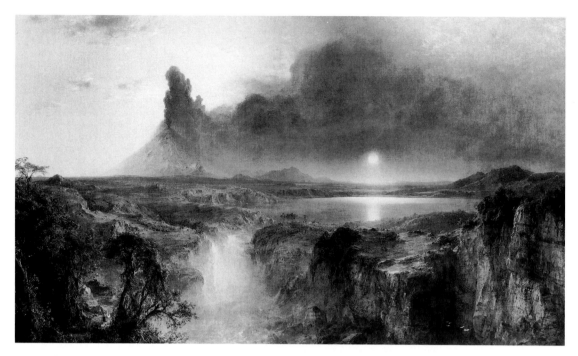

FIGURE 48

Frederic E. Church. *Cotopaxi.* 1862.

The Detroit Institute of Arts, Founders Society Purchase with funds from Mr. and Mrs. Richard A. Manoogian, Robert H. Tannahill Foundation Fund, Gibbs-Williams Fund, Dexter M. Ferry, Jr., Fund, Merrill Fund, and Beatrice W. Rogers Fund.

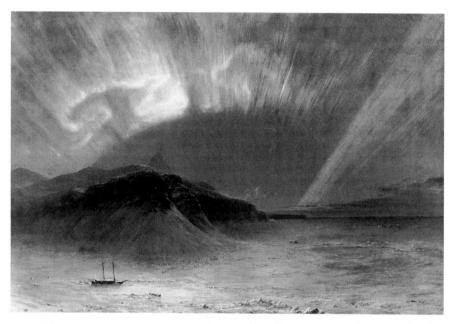

FIGURE 49

Frederic E. Church. *Aurora Borealis.* 1865.

National Museum of American Art, Smithsonian Institution. Gift of Eleanor Blodgett.

(1862) (Fig. 48) to the conflict through Rev. Horace Bushnell's sermons and said that the picture was "a painted parable of the Civil War, addressed to Union eyes."[4] Elsewhere he wrote, "To think of *Cotopaxi* as the *Guernica* of our Civil War is to be close to the mark."[5] Huntington also perceptively related the *Aurora Borealis* (1865) (Fig. 49) to the vivid display of the northern lights in December 1864, a phenomenon seen as far south as Fredericksburg, and one that was heralded by many, including Herman Melville, as a sign of impending Union victory.[6] Notably, however, even Huntington, who has dealt with the issue more extensively than anyone else, does not comment on the remarkable conjunction of the two pictures, *Aurora* and *Rainy Season in the Tropics* (1866) (Fig. 50) as dual rainbows, north and south, that stand at the end of the war as echoes of the prophetic rainbow after the biblical flood.[7] No one has considered Church's work from 1859 to 1866 as a series, a sustained contemplation of the cataclysmic events of those years in landscape form, a form I am calling "history in natural sequence."

It is only when the pictures are brought together and considered with their historical context that their remarkable synergism emerges. Indeed, the great potential of uniting discrete images is to effect conjunction within disjunction, continuity within discontinuity, unity in multiplicity. The relationship initiated when two or more images are juxtaposed results in resonances and implications not available for each alone, and this complicates both the images' references and significations and the viewer's process of understanding them.

FIGURE 50

Frederic E. Church.
Rainy Season in the Tropics. 1866.

The Fine Arts Museums of San Francisco. Mildred Anna Williams Collection.

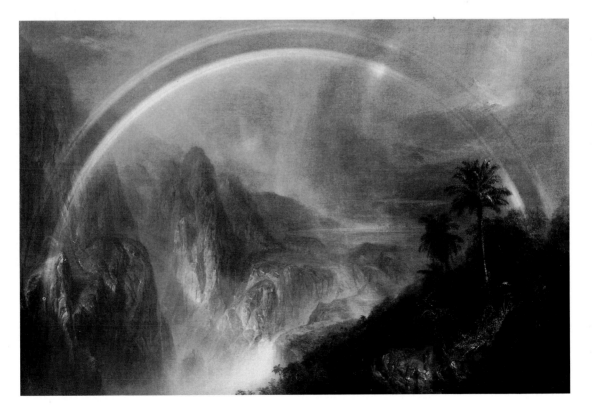

Perceiving Church's works as linked to each other underscores their role within a continuous artistic process. Each image leads to another; sometimes a painting may be a response to the picture that preceded it, sometimes it may be a variation on a theme, at other times it may act as a counterpoint, a balancing opposite to another. When these correspondences are conjoined and understood in the context of contemporaneous events, the polyvalence multiplies; works simultaneously refer to their ostensible subjects at the same time as they conduct an implicit dialogue with each other and with the connotations their subjects carry for viewers.

Understanding objects as related in these ways does not require them to be a literal narrative, a series in the traditional sense. Church did paint pictures during the period 1859 to 1866 that seem unrelated either to the issues of the Civil War or to the works considered in this chapter. At the same time, however, the war between the states dominated virtually everything for Americans in the 1860s; it was disjunction in a very real sense, a terrible multiplicity from what had been, at least in the ideal, union. It would be remarkable if an artist as perceptive as Church was not affected by such a pervasive and disastrous turn of events, either personally or artistically. Indeed, as we see in this chapter, the subjects he painted during those years were inextricable from the war and the issues that surrounded it. Church's visual commentary is oblique until his paintings are united, but when they are conjoined and analyzed with historical events, the polyptych they form evokes a powerful struggle to reconcile polarities and unify opposites. It is in this paradox that their eloquence emerges; the paintings stand together as a metaphor for the conflicts of their time.

Since their creation Frederic Church's paintings of the late 1850s and early 1860s have been linked in various configurations, but for reasons not related to the Civil War. In 1865 *Aurora Borealis, Cotopaxi,* and *Chimborazo* were exhibited together in London as a triumvirate, and Church arranged for chromolithographic reproductions of *The Icebergs* and *Aurora* to be issued as pendants, although the project was never completed.[8] About the same time exhibition reviews explained that *Cotopaxi* and *Chimborazo* (1864) were "pendants to the 'Heart of the Andes' and a magnificent triptic [sic] would they form together."[9] Another critic claimed the same three works were "a series. They are parts of a whole in the painter's design," even though the three pictures were not exhibited together.[10]

More recently Gerald Carr has observed that *Heart of the Andes* (1859) (Fig. 46) and *The Icebergs* are the same size (6 by 10 feet) and that the traveling frame for the tropical picture was subsequently used for the arctic scene and remains with that work even today.[11] Similarly he recognized that *Aurora Borealis* and *Rainy Season in the Tropics* share dimensions (although at 4 1/2 by 7 feet they are slightly smaller than the other pair), and that Church painted the two simultaneously.[12] In her 1985 exhibition of Church's *Cotopaxi* pictures, of which there are several, Katherine Manthorne discussed these volcano scenes as a "related series of images," primarily in light of the works' geological subject matter.[13] And in a recent article Timothy Mitchell refers to *Heart of the Andes, The Icebergs,* and *Cotopaxi* as "companion paintings."[14]

Considering the varieties and persistence of these groupings, it is surprising that Church's work has not been interpreted more thoroughly as multi-panel history painting.[15] Single images have been investigated in great detail, but commentary on groupings of pictures, even those just mentioned (with the exception of the *Cotopaxi* works), has been relegated for the most part to footnote comments or to brief acknowledgment within discussions of other issues.

The impulse toward serial painting would have been natural for Church because he was the only pupil of the great American painter of allegorical landscapes, Thomas Cole, who from the mid-1830s until his death in 1848, a period overlapping Church's study with him, had been preoccupied with such series as the famous *Course of Empire* (1836) and *The Voyage of Life* (1842). Many other artists of this era also conceived of works in groups, usually pendant pairs, although occasionally in larger complexes.[16] In fact, Church has been traditionally distinguished from his esteemed teacher precisely because he did not force landscape into a moralizing narrative format, especially that of the time-worn religious or historiated allegory.[17]

Seeing Church as a painter of sustained vision, however, should hardly sully his reputation; understanding his work as extended metaphor not only deepens our respect for his art, but also adds to our appreciation of his intellect. George Kubler's comments from *The Shape of Time* emphasize such expressive potential:

As the linked solutions accumulate, the contours of a quest . . . are disclosed, a quest in search of forms enlarging the domain of aesthetic discourse. That domain concerns affective states of being, and its true boundaries are rarely if ever disclosed by objects or pictures or buildings taken in isolation. The continuum of connected effort makes the single work more pleasurable and more intelligible than in isolation.[18]

In keeping with the metaphorical tenor of discussions of the Civil War from the 1860s, it is appropriate to speculate that Frederic Church might have created pictures which individually are ostensibly about something else, but corporately refer to the national conflict. In the same way as the country itself was polarized, his pictures stand as conjoined opposites. This relationship deepens their significance as important works of art, singly and jointly, and once recognized can fundamentally add to our appreciation of Church as a painter of American history as well as of landscape.

A primary challenge in linking these images to the Civil War lies in their subject matter. Quite obviously, neither the South American tropics nor the arctic exist within the borders of the United States. Nevertheless, these regions figured prominently in discussions of the American North and South in the 1850s and early 1860s, and were intricately connected to issues that ultimately led to armed hostility. Furthermore, as he was gathering information for his paintings during this time, Frederic Church was closely involved with individuals who were at the forefront of these developments.

Church traveled to South America in 1853 and again in 1857, expressly to

paint tropical landscapes.[19] Much has been made of the influence of Humboldt's *Cosmos* in inspiring these impulses, and rightly so as Church himself attested, but perhaps of equal importance for the general interest in the tropics and for Church's work in particular are the lesser known writings and theories of Matthew Fontaine Maury, head of the Naval Observatory in Washington.[20] Maury was the author of *The Physical Geography of the Sea*, the leading mid-century text on oceanography, and he supervised a U.S. government expedition to the Amazon valley in 1851.[21] He was a Virginian, an editor of *The Southern Literary Messenger* and frequent contributor to *The National Intelligencer* and other publications, and was known through his writings for his persistent call for expansion and colonization of South America by the American South.[22] In a typical work, an influential 1851 article entitled "Commercial Prospects of the South," he wrote,

Let the *South* not forget to look to the *South*. . . . Behold the valley of the Amazon, and the great river-basins of South America. Unexplored there, is a wilderness of treasures. . . .

The facts . . . commend the enterprise as strongly to the North as to the South; and if the South do[es] not make haste soon to take it up and embark in it, we may rest assured the north [sic] will not be slow.[23]

Maury enticingly enumerated the commercial promise of the southern continent and concluded with an extensive argument that has direct relevance for Church's tropical pictures and their connection to Civil War issues:

[U]nless means be devised for gradually relieving the slave States from the undue pressure of this class upon them; unless some way be opened by which they may be rid of their surplus black population – the time will come – it may not be in the next nor in the succeeding generation – but sooner or later come it will, and come it must – when the two races will join in the death struggle for its mastery. The valley of the Amazon is the way; in this view, it is the safety-valve of the Union . . . the cord which is to lift that valve whenever the pressure of this institution . . . shall become too powerful upon the machinery of our great Ship-of-State.[24]

Maury's views were widely published and discussed not only in the South where they were embraced, but in the North and in London as well.[25] Frederic Church knew of Maury and his ideas through such publications; he owned two editions of his oceanography book as well as the Amazon expedition report, but he had more direct contact with the writer through Cyrus W. Field, his traveling companion on the 1853 South American trip.[26] Church and Field knew each other through family connections, had traveled together through the South (Virginia, Kentucky, and possibly North Carolina) in 1851, and Field owned a number of Church's pictures.[27] According to biographer Samuel Carter, Field, having already made his fortune in papermaking, was looking for new investment opportunities and was inspired by Maury's proposals for commercial development in South America.[28] Field initiated the trip, inviting

Church for his ability to "present the country visually to millions of prospective viewers . . . [and] investors," and including businessman Chandler White as well, whom he sought as a potential partner in future investments. White, who never caught up with Church and Field in Ecuador, contacted Maury before leaving: "I am about to embark for South America . . . on an excursion of pleasure and commercial exploration. Where can I get an account of Lt. Herndon's trip?"[29]

This was the Amazon expedition report that Church owned. It had been written under Maury's direction by his brother-in-law, William Lewis Herndon, and it reiterated Maury's own geopolitical enthusiasm.[30] Not only would the tropical regions of the Southern Hemisphere be profitable commercial extensions of American industry and agriculture, Herndon argued, they would also present a viable alternative to expanding slave territory within the continental United States. The message was explicit: It was the Manifest Destiny of the American South to grow southward (into precisely the countries through which Church traveled in 1853 and 1857), and this colonization was essential to the preservation of the Union.

Both Herndon and Maury reiterated this claim in their personal correspondence. Herndon wrote William A. Graham, the secretary of the navy,

Should no opposition be offered by the Govt. [sic] holding the mouth of the [Amazon] river (and I should think it could not be so blind to its own interest as to offer it or venture to stand in the way of the march of civilization) none would or could be offered here, and I am satisfied, that any one may come, may bring his slaves, and may cultivate as much land as he can without let or hindrance.[31]

Maury wrote, "[T]he time is . . . rapidly approaching when in order to prevent this war of races and its horrors, they [Southerners] will in self-defence, be compelled to conquer parts of Mexico, and central America, & make slave territory of that. . . ."[32]

The conquest Maury and Herndon envisioned was related to the larger movement carried on by what were known as the Filibusters who fomented revolution in a number of Central and South American countries throughout the late 1840s and early 1850s. The Filibusters were infamous, so much so that before Church's 1857 South American trip his friend Theodore Winthrop wrote the artist joking, "Please ascertain also whether the chances for an individual and gentlemanly filibuster are good in Ecuador and New Granada."[33]

That Cyrus Field was interested in the commercial prospects for colonizing South America is confirmed in a letter written to Maury by an aide in Guayaquil who had met Field there. Referring to Field as a "very sharp New York merchant," he continued,

Mr. Field observed, with a map of South America in his hands, there is but one hope for Ecuador and that is the opening of its Amazonian territory to immigration and Steam Navigation. . . . I have told Mr. Field that I have repeatedly called the attention of the President [of the United States] to the importance of the free navigation of the Amazon. . . ."[34]

Because Church was with Field throughout the expedition, it seems certain he was equally well aware of the political speculation that was focused on the South American tropics at the time.

Serious consideration of colonizing South America with slaves diminished after 1855, although it was revived briefly in 1862 (that time for the settlement of liberated slaves), and after the war several thousand Confederates emigrated to Brazil.[35] Although short lived, Maury's ideas and the credence they were given demonstrate that South America, and the tropics more generally, were compelling to Americans throughout the period for more than their exotic climate and scientific offerings. In this context, Church's great painting of 1859, *Heart of the Andes,* takes on a charged political tenor. The lush vegetation, variety of terrain, and prominent river all correspond closely with Maury's descriptions, and the small cross in the left foreground and the tiny village beyond echo his assertion that "there is no colonizer, civilizer, nor Christianizer like commerce."[36] Notable, as well, is the looming snow-capped mountain in the distance. Here the peak, one of the links in the so-called volcanic "ring of fire" that ranges through the Pacific and up the coast of North and South America, is dormant, but considering Church's contemporaneous views of erupting volcanoes it seems ominous in its latent potential, much as the American South seemed to the North in 1859 when this picture was unveiled.

In his pamphlet that accompanied the *Heart of the Andes* exhibition and was reissued in 1863, Church's friend Theodore Winthrop repeatedly referred to this mountain as "The Dome" in a curious sequence that seems to have less to do with a geological formation than it does with architecture, specifically the U.S. Capitol dome, which was at that time still under construction.

[T]he Dome mounts upward. . . . Its convex lines of ascent are bold as the lines of the first model, while its calm, rounded summit repeats the deliberate curves of the snow-clad terrace beneath. There is no insubordination among the parts, nothing careless or temporary in the work. Skill and plan have built up a mass, harmonious, steadfast, and adamantine. This is a firm head upon firm shoulders, whatever else may crumble in a century, and fall to ruin in an aeon. Cities of men may sink through the clefts of an earthquake, but this mountain is set up to be a symbol of power for the world's life. . . . The Dome was an emblem of permanent and infinite peace: – this central mass of struggling mountain, with a war of light and shade over all its tumultuous surface, represents vigor and toil and perplexity.[37]

It is intriguing to speculate that Winthrop's metaphorical language, with its references to "a war of light and shade" over the dome, implicitly correlates Church's picture and political events; elsewhere, for example, he discusses light as "solemn, peaceful," and shadows as "deep but not despotic." Such hyperbole was not unusual in nineteenth-century prose, but with the tropics already associated with slave colonizing, such vocabulary may have taken on even more poignancy for American viewers.

Unfortunately, Church himself was remarkably silent on the subject of tensions between North and South. Very few of his written records have survived that might reveal his reactions to the situation. He appears to have

received a summons to join the northern army in the spring of 1860 but prevailed on Winthrop to secure his release, saying,

There could not have been a time chosen more unfortunate for me than the present and I beg that you will use your influence in getting me relieved. If I am interrupted now – I shall very probably be obliged to give up attempting the Icebergs until next winter . . . again my father is ill and I am afraid that I may be called away at any time to see him.[38]

Such reluctance should not reflect on Church's patriotism. Deferments were common at the time and later; during the war it was possible to hire a substitute to go in one's place. In fact, the artist seems to have been a staunch Unionist. His publicity manager, a Scot named John McClure, who oversaw the tours of his major works, regularly wrote him with pro-Union commentary such as "That the dark clouds which now overhang the country will soon pass away I fervently believe – It will begin to break up from 4th March and ere the month is out sunshine will spread over the land – with returning confidence we shall have good times whatever the southern chivalry may do. . . ."[39] Moreover, Winthrop, Church's best friend who had written the *Heart of the Andes* pamphlet, was the first Union officer to die in battle. The two reportedly spent evenings in the winter before the war discussing the impending conflict, and Winthrop enlisted immediately after Fort Sumter was fired upon on April 12, 1861, only to be shot down two months later at the Battle of Big Bethel in Virginia.[40]

Church's most striking commentary on the war was through his paintings. Only days after Fort Sumter, he unveiled the companion to *Heart of the Andes*, his great painting of icebergs, which he titled *The North* at the last minute.[41] It did not receive its present title, *The Icebergs*, until its exhibition in London in 1863, the new name intended to appeal to a British audience that was inclined to side with the Confederacy because, among other things, the English textile industry depended on its supply of raw cotton.[42] The proceeds from these exhibitions, also single-painting paid-admission spectaculars, were donated to the Union fund, along with those from sales of the overtly patriotic chromolithograph, *Our Banner in the Sky*, which Church dashed off in the weeks following the outbreak of the war.[43] *Heart of the Andes* was also exhibited to the Union's benefit, at the Metropolitan Fair in Aid of the Sanitary Commission in 1864, although not with *The Icebergs*.[44] In that display, the special prosceniumlike frame that Church had designed for the picture was festooned with fringed velvet draperies and surmounted by portraits of George Washington, John Adams, and Thomas Jefferson. The unusual juxtaposition of the first three presidents of the Union hanging above the tropical picture underscored the patriotic sympathies of the New York audience through a patently political gesture, and further confirmed the association of that southern landscape with the American South.

Reviews of *The North* in the spring of 1861, while remarking on the unfortunate timing for an exhibition, as soldiers marched through the streets,

subtly reminded viewers of the work's patriotic implications: "Look for your-self and you will henceforth gaze at the North Star with more respect since it points to a continent of waters filled with these icy cathedrals. . . ." The north star, of course, was an especially important symbol during this time. Frederick Douglass's Rochester newspaper was entitled *The North Star,* and Douglass himself, along with John Mercer Langston, was called the "aurora borealis of the north."[45]

Even though the two pictures were not displayed together until the National Gallery of Art's 1989 retrospective of Church's work, *Heart of the Andes* and *The Icebergs* were recognized as related even before the latter was completed. After the first work's remarkable success, the press eagerly antici-pated the second in articles about the artist's sketching trips to Labrador, tan-talizing readers with comments such as "[W]e may in time expect the Heart of the Icebergs, if these cold and glittering piles can be said to have a heart."[46] After the work's completion, nearly every review mentioned the first painting in conjunction with the second and some wrote implicitly about the two's relationship to each other and to current events:

[N]one appreciate any point of beauty in nature or art so well as those who have entered into the spirit of its *opposite.* In these two paintings of Mr. Church we have, to a degree striking enough to become a historical and classical instance, an illustration of the fact that "diversity of sentiment does not interfere with unity of excellence. . . ."[47]

Indeed, when the two pictures are considered together, the most striking char-acteristic is their *dissimilarity:* One is warm and inviting, the other cold and forbidding. They seem, at first glance, unrelated manifestations of differing impulses, united only in their common appeal to a fascination with the exotic. Considering the fervor of the secessionists who were increasingly vocal in the closing years of the 1850s, however, such polarities were an appropriate reflec-tion of America itself. Such opposition, expressed through actual polarities, tropical and arctic, may have been Church's response to this fundamental disharmony, an effort to create unity if only on canvas.

As with *Heart of the Andes,* Church produced *The Icebergs* after an ardu-ous journey to distant regions, this time an 1859 trip to Newfoundland in the company of Rev. Louis Legrand Noble who wrote his book *After Icebergs with a Painter* about their adventures together.[48] Paralleling the earlier picture, the circumstances within which *The Icebergs* was researched and painted suggest stronger ties to both that picture and to contemporary events than has previ-ously been recognized. These events are also revealing in regard to Church's other arctic work, painted at the end of the Civil War, the *Aurora Borealis.*

Americans' fascination with the tropics throughout the 1850s was rivaled only by interest in the polar north. Indicative of this is Matthew Maury's *Phys-ical Geography of the Sea;* from the publication of the first edition in 1855 to its seventh in 1859 (both of which Church owned), the chapter on polar regions was expanded from four pages to thirty-one. The fervent activity that brought

about such new information had two major goals. One was the rescue of the famed Sir John Franklin, a British explorer lost with his crew on an 1845 expedition in search of the legendary Northwest Passage. The other was the definitive location of that passage, or open polar sea as it was also called. The general beliefs that a commercially viable route existed across the Arctic Circle and that Franklin could have been still alive there over ten years after his disappearance are today regarded with astonishment, but at the time they were accepted nearly universally, and the U.S. government sponsored a number of expensive and dangerous missions based precisely on these notions.

Of the many intrepid explorers who pursued these ends, none was more famous than Elisha Kent Kane, who had made several trips to the polar regions and had written two spellbinding accounts of his adventures.[49] As evidence of his popularity, his 1856 book *Arctic Explorations* was said to have lain "with the Bible on almost every parlor table in America," and, when Kane died in 1857, his body lay in state in Independence Hall in Philadelphia after a transcontinental procession and public mourning that would be surpassed only by Lincoln's the following decade.[50]

Church's interest in these events is confirmed by his collection of books, including Kane's, but his sources for information on the polar north were much more immediate. In 1855–6 he had given drawing lessons to Isaac I. Hayes, a surgeon on Kane's 1853 expedition. In 1857 and 1858 Hayes lectured at the American Geographical and Statistical Society in New York and at the Smithsonian, eliciting support for his own expedition, which he launched in the summer of 1860 with the financial support from a variety of investors, including Frederic Church.[51]

Hayes's trip was less a rescue effort for the ill-fated Franklin than it was a quest for the open polar sea. Locating the Northwest Passage would bring fame and fortune to the finder, but even more importantly, great potential for the American North, which had a tremendous investment in the shipping industry. In 1860, just as the American South was looking South for expansion, the North stood to profit enormously by an easy passage through the northern continent.

At the same time, another important endeavor was focusing attention on Newfoundland, one which promised even greater returns and pointed toward a new era in unifying nations. The transatlantic telegraph cable was laid in 1858, almost entirely through the efforts of Church's friend Cyrus Field, who began work on the project immediately after their return from South America in 1853, with financial support from northern and British investors and technical assistance from, among others, Samuel F. B. Morse and Matthew Maury.[52] Field, like Church, was a supporter of Hayes's 1860 expedition.[53] After years of research, development, and production, as well as a difficult and dangerous crossing during which the cable was laid, the cable worked for a few months in 1858 and, at the height of public celebration and acclaim for Field, who was dubbed "the Columbus of America," it stopped.[54] Undaunted, Field continued work, and although the war seriously hampered progress, a new

cable was successfully laid in 1866. In both attempts the cable stretched from Valentia, Ireland, to St. John's, Newfoundland, and even in the years between the first and second attempts a telegraph station and harbor were maintained there in the vain hope that contact might resume through the 1858 cable.[55]

On his 1859 excursion in search of icebergs, Church's ultimate destination and his base camp for his forays into the ice-filled Atlantic was St. John's.[56] This haven must have been suggested to him by Cyrus Field who had visited the point continually in the process of planning the cable's linkage. In any event, Church could not have been there without being reminded of the historic role the place had momentarily played the previous year and that it was poised to resume.

Church's painting contains a provocative detail: A broken mast lies prominently in the central foreground, the only evidence of humanity in the frozen landscape. This key element was included in different locations in two preliminary sketches, but was not added to the final painting until late 1862, shortly before the London showing.[57] In the words of a New York reviewer during the first months of the work's exhibition in the United States, "[There is in *The Icebergs*] . . . no trace whatever of human association, not a living creature of any description, no ship, no boat, not even the semblance of a wreck."[58]

Why would Church add this foreboding element at this time? Gerald Carr has speculated it was to provide viewers with an identifiable feature amid a landscape that was so foreign as to be completely abstract, but considering events of the time, other arguments seem more compelling. In those months the fate of the Atlantic cable was more uncertain than ever, but even more significant, as Maury had so dramatically stated a decade before in his plea for a solution to the slave issue, the "Ship of State" was in treacherous waters. Hayes's ship was christened *The United States* for its 1860 expedition, and the vessel that carried Church from Boston to Halifax on his voyage to St. John's was named *The Great Republic*. Indeed, the ship metaphor, omnipresent at mid-century, may be found in everything from Webster's reply to Hayne to Longfellow and Melville's poetry:

> Cedar of Maine and George pine
> Here together shall combine.
> A goodly frame, and a goodly fame,
> And the UNION be her name! . . .
> Thou, too, sail on, O Ship of State!
> Sail on, O UNION, strong and great . . .[59]

In late 1862 the fate of the Union looked bleak, and perhaps Church added the broken mast to refer to the frozen hope of the nation following its wreck upon the shores of secession.

Such metaphorical allusion is also key to understanding the *Cotopaxi* pictures painted during the war. This distinctive Andean volcano was among Church's favorite subjects, appearing in several of his paintings from the 1850s as a gently smoking peak at the summit of a tranquil tropical landscape. In the

1862 version the scene is transformed into a cataclysm; floating ash bursts from the cone, creating a ghastly light that suffuses a primordial landscape below. We look into the sun; Mt. Cotopaxi is in the distance and its billowing smoke blows to the right, filling the sky with a thick haze. A vast lake, with a waterfall that pours into the foreground ravine, bifurcates the composition, effectively separating north and south. Lurid colors range from chilling lavender on the cone itself to a faint greenish yellow on the surrounding plain, and the intense orange light gives an unearthly glow to the rocks and water.

In her extended study on Church's Cotopaxi pictures, Katherine Manthorne speculates on the 1862 painting's relation to the Civil War, saying that the apocalyptic scene "was perhaps intended, like Cole's *Desolation* from *The Course of Empire* . . . as an omen to his countrymen of the error of their present actions." She notes other appearances of volcanic images during times of revolution, including James Hamilton's *Last Days of Pompeii* (1863), a work virtually contemporary with Church's *Cotopaxi,* which Hamilton paired with *The Foundering* (1863), a seascape that depicts a doomed ship flying a Confederate flag. She also quotes David Huntington's comment that "A painting such as *Cotopaxi* accomplishes in pictorial terms what 'The Battle Hymn of the Republic' and 'The Gettysburg Address' accomplish in speech."[60] Such perceptive insights might have been even more persuasive if supplemented with metaphorical references to volcanic imagery written during the Civil War. In his 1862 essay on *Cotopaxi,* which was intended as a pamphlet for the painting's exhibition, for example, Rev. Louis Noble's vocabulary draws direct analogies between Church's fiery image and the war that had engulfed the nation. In his prose the scene becomes a battlefield, "the playgrounds of storm & blackening smoke"; the eruptions have "destroyed millions of property, & many thousands of human beings." For Noble the fallen boulders on the ground are the "rafters to the mighty tent that God pitches on this great battlefield of nature's forces," and the solid projectiles spewed from the cone "red-hot stony rockets."[61] Such metaphorical allusion was closely echoed, if perhaps more eloquently, by Herman Melville in his Civil War *Battle Pieces:*

> Convulsions came; and where the field
> Long slept in pastoral green,
> A goblin-mountain was upheaved . . . Solidity's a crust –
> The core of fire below;
> All may go well for many a year,
> But who can think without a fear of horrors that happen so?[62]

And in his supplement added after the war, Melville concluded;

Why is not the cessation of war now at length attended with the settled calm of peace? Wherefore in a clear sky do we still turn our eyes toward the south, as the Neapolitan, months after the eruption, turns his toward Vesuvius? Do we dread lest the repose may be deceptive? In the recent convulsion has the crater but shifted? Let us revere that sacred uncertainty which forever impends over men and nations. . . .[63]

In the midst of war, one that witnessed more American lives lost than in all the wars that had preceded it, one that threatened the very existence of the United States, the terrifying apparition of an erupting volcano was perhaps the only visual image that could contain the horror and convincingly symbolize the war's profound potential for ultimate destruction. Church's painting, especially considering its position in sequence after *Icebergs,* would *not* be, to continue Manthorne's analogy to Cole's *Course of Empire,* the *Desolation* scene, which is the denouement of that series; rather it is *Destruction,* the climactic convulsion of an epic saga.

Church's own denouement to his Civil War landscapes came with the *Aurora Borealis* (1865) and *Rainy Season in the Tropics* (1866), slightly smaller works than *Heart of the Andes* and *Icebergs,* but their counterpoint at the end of the war. The two pictures effectively complete the sequence begun with the tropical and arctic paintings of 1859–61, and this time seem truly unified polarities. Unlike the first two, which were striking in their dissimilarity and their disjunction, the later pair harmonize in their formal compositions and in their luminosity, glowing with a renewed optimism in natural and historic events.

The southern scene, while still intimidatingly precipitous, is once again inhabited, and the lustrous double rainbow that emerges from the morning mist promises life and redemption after the maelstrom. Franklin Kelly has remarked on this rainbow, noting its reference to the biblical event, "Painted at the end of the Civil War, *Rainy Season in the Tropics* reaffirmed the hope for mankind with a visionary intensity that suggests that he no longer saw the tropical landscape with purely scientific objectivity."[64] As we have seen, even Church's early interests in far southern landscapes may have been influenced by political awareness. This painting, created at the end of such a horrifying period, could thus represent the successful conclusion of what loomed in *Heart of the Andes* and threatened so menacingly in *Cotopaxi.*

Rainy Season in the Tropics is most eloquent, however, when paired with *Aurora Borealis.* The arctic landscape eerily reflects the same arcing effect as the tropical rainbow in a spectacular green and fuchsia display of the northern lights. Church was not alone in thinking of the northern lights metaphorically at the end of the war. Thousands had observed their unusual appearance after the Battle of Fredericksburg in December 1864, with each side interpreting it as an omen, and at the end of hostilities Herman Melville, in his *Battle Pieces,* included a poem directly paralleling the theme of the painting, "Aurora Borealis: Commemorative of the Dissolution of Armies at the Peace."

Moreover, the specific iconography of the painting suggests even more direct personal and nationalistic references for the artist. The mountainous scene is a definable place. When Isaac Hayes returned in 1861 from his quest for the open polar sea, claiming to have found it, he brought Church a sketch of the northernmost point he had visited. From that vantage a distinctive frozen peak was visible, and in honor of his drawing teacher, the most famous American artist of the day, he named it Mount Church.[65] He also brought

with him a sketch of his ship, which Church included in the foreground. This ship, unlike the wreck in *The Icebergs*, is intact and quite obviously safe in its winter mooring because a tiny light within shines out into the night. Appropriately, Hayes's ship was christened *The United States* and Church's inclusion of it amid the glowing northern lights refers not only to Hayes's achievement, but as well to the preservation of the ship of state.

The special significance of Frederic Church's paintings from the Civil War may emerge only when they are considered together as a polyptych or multi-paneled grouping. That each work has meaning unto itself there is no question, but when conjoined, their implications multiply, drawing us into the most harrowing period in American history. The very real polarities of North and South, ignited by the issue of slavery, played out over years of bloodshed, and complicated by aspirations of expansion, were metaphorically echoed in the landscapes of one of the most gifted painters of their time. That the works initially appear unrelated to the conflict is belied by events and the sequential relationships of the images themselves. When understood as a polyptych, the paintings reveal a remarkable synergism that evokes their era as no single object can. The series not only adds to our understanding of Church as an artist of sustained vision, but confirms his position as a history painter. For Frederic Church only nature could convey the epic sequence of events that surrounded him. The two were inseparable, just as the Union was in the 1860s and his paintings should be for us today.

"... one of the most powerful, horrible, and yet fascinating pictures ..."
Thomas Eakins's *The Gross Clinic* as History Painting

Eric M. Rosenberg

[L]eaving out of consideration the subject, which will make this fine performance anything but pleasing to many people ...

– William Clark, Jr.,
Daily Evening Telegraph, April 28, 1876

[T]he more we praise it, the more we must condemn its admission to a gallery where men and women of weak nerves must be compelled to look at it. For not to look at it is impossible.

– Anonymous critic,
New York *Daily Tribune*, March 8, 1879

[T]he operator ... is ... lecturing as quietly as if the patient were a blackboard.

– W. C. Brownell,
"The Younger Painters of America – First Paper," *Scribner's Monthly*,
New York, 1880

W hat are these fragments of response to Thomas Eakins's *The Gross Clinic* (Fig. 51) about? (1) A performance (a lecture, a painting), its subject/performer (operator, lecturer, patient?), and the extent to which performance (blackboard and its contents; canvas and its pigment; *meaning*) might be antithetical to subject (leaving subject "out of consideration" makes "performance" "fine"); (2) Looking and its etiquette (where one is forced to look; where and how looking proves impossible); the typology of place (a gallery); the extent to which the appropriateness and inappropriateness of action to setting defines

identity (who looks and who does not; who resists the impossibility of not looking or in response to the lecturer, perhaps, not hearing); (3) The mingling of praise and condemnation – the necessity of contradiction to representation and reception: a fine performance that is anything but pleasing; (4) The interchangeability of roles and the proximity of difference – the effacement of empiricism, rationality, legibility, literalness – according to the viewer's struggle to comprehend, to complete the narrative offered by the painting by writing his or her own terms of understanding. Thus an operator is a lecturer; a patient is a blackboard; an audience for art is weak-nerved rather than inquisitive, hedonistic, or acquisitive; a gallery is a place that poses a threat rather than promising pleasure.

Should we choose to read *The Gross Clinic* literally – to find surgeon, patient, relative, students, tools, and amphitheater wholly congenial to the scene, satisfactory embodiments of meaning, in other words – we should find comprehension subverted by the fragments of reception just offered. Our imagined faithfulness to what we *see,* in other words, is arguably anything but historical although we imagine faithfulness as constituting history. The play of paradox and contradiction bars these representational dramas from attaining anything resembling closure (from existing as utterable language, representing narrative) – the first requirement of modern historical representation – with-

"... one of the most powerful, horrible, and yet fascinating pictures ..."

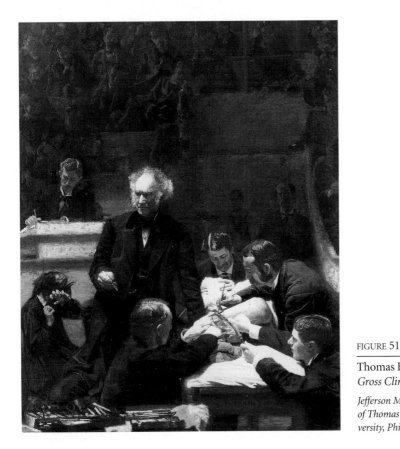

FIGURE 51

Thomas Eakins. *The Gross Clinic.* 1875.

Jefferson Medical College of Thomas Jefferson University, Philadelphia.

out the complicit and sometimes polemic participation of the creative viewer, then and now. To claim the painting is about what *we* see or for that matter what we *see* is to fundamentally misread what is here/there.

According to Paul Ricoeur,

> [A] text . . . recognized by structural analysis . . . is a mediation between man and the world, between man and man, between man and himself; the mediation between man and the world is . . . *referentiality;* the mediation between men, *communicability;* the mediation between man and himself, *self-understanding.* A literary work contains these three dimensions: referentiality, communicability, and self-understanding. The hermeneutical problem begins . . . where linguistics leaves off. It attempts to discover new features of referentiality which are not descriptive, features of communicability which are not utilitarian, and features of reflexivity which are not narcissistic. . . .[1]

This is to suggest that the work of representation in any guise is fictional vis-à-vis its putative, inherent subject. That is certainly the point of the criticism gathered by *The Gross Clinic* in the few years after its Centennial debut in Philadelphia in 1876. In other words, it is just as likely that the blackboard "seen" by one critic in the place of the patient will be used to rewrite, or fictionalize the painting's narrative – to go beyond the descriptive, the utilitarian, the narcissistic. That is the point of the metaphor in the first place. Not to offer more material analysis of the problem – the wound and its treatment – but to offer a way beyond that "reality." After all, the most specific site of action, the wound, marked a landscape few would have conceptualized as viewer friendly.

Of course, if we resist the myriad implications of an elision of painting and literature, if we insist that what is painted is best understood by further articulation of the descriptive, the utilitarian, and the narcissistic, other fascinating and provocative forms of historical account result. Recent attempts to narrate *The Gross Clinic* have operated more in alignment with the structuralist paradigm described by Ricoeur. Such versions see referentiality in the subject of study as "descriptive," communicability as "utilitarian," and reflexivity as "narcissistic."[2] According to Ricoeur, these impulses are pre- or extrahermeneutical and when practiced in this context argue for the status of the painting as pre or extrarepresentational. But my purpose here is not necessarily to argue the greater importance of a hermeneutic drama for Eakins's painting than many other paintings of the late-nineteenth century, or the primacy of that hermeneutic narrative over a structural linguistic one, whereby *communicability* reads as the form of the medical profession or *reflexivity* as the extent to which the relationship between Eakins and his father as emplotted in *The Gross Clinic* is defined by the aporia of castration anxiety. In the end I do not believe that other versions of the story *are* any less hermeneutical.

Even for a critic like W. C. Brownell in 1880, the painting could not be allowed to function as illustration – as descriptive, utilitarian, and narcissistic – to be about what it claimed to be about, in other words. Rather, for Brownell, it was only as art, as style that the painting's narrative was ironically disguised – by handling and by touch. By 1880 these signs signaled artistic triumph, regardless of the story. That the painting could contain the grounds for

its own rehabilitation announced its malleability. In turn *The Gross Clinic*'s identity as *history* painting is now determined in part by the extent to which it has performed a catalytic function for the *historiography* of American art. The painting has recently provided a setting for the exercise of critical art-historical methodology and has already engendered challenging rereadings across the space made for the painting by those very practices; the painting has afforded a type of *symposium without walls*.[3] *The Gross Clinic* has performed and facilitated the performance of the job of *history*.

Let me explain further. First summarily and synoptically: As reconstructed by critics such as the anonymous writer for the New York *Daily Tribune* in 1879, W. C. Brownell in 1880, and the art historians Elizabeth Johns and Michael Fried in recent years, Eakins's painting and its circumstances of production and reception have philosophized history on at least four levels.

1. As a painting comparable to past instances of contemporary representation dressed in the language of traditional history painting. Here history is held to be sequential, cross culturally transmittable, evolutionary, and the result of struggle, survival of the fittest – what Jacques-Louis David's *Marat* (Fig. 52) and Theódore Géricault's *Raft of the Medusa* (Fig. 53) were to France, *The Gross Clinic* can be to America; meanwhile the American painting

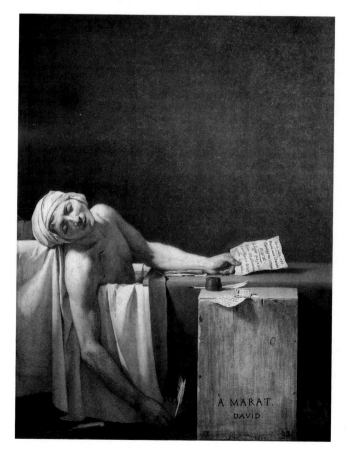

FIGURE 52

Jacques-Louis David. *Death of Marat*. 1793.

Musées royaux d'Art et d'Histoire, Brussells.

learns from these past examples and surpasses them as a sign of civilization (and perhaps its downfall).

2. As a record of the extent to which mastery of materials could elevate the stylistic over the emplotted, dramatic narrative/subject, writing a counternarrative of civilized culture signified by the elevation of *means* of representation and denigration of horrific subject. In this case, history is the conquest of fundamental signs of identity and human function, signs identifiable as naturally innate – language, for instance.

3. As a record of social nexus ordered by a perceived elision of modern life by the cult of professionalism. Now history is the story of the triumph of civilization over external nature and the resultant imposition/celebration of class distinctions.

4. *And* as the extent to which that world was the product of its own subconscious internalization of hierarchic familial and professional relations and associations reconfigured as representation and its *act* within realms such as medicine, painting, and Oedipal relations. Finally, history is surreal, unconscious, recognizable perhaps only in others and as other, in oneself only as difference.

FIGURE 53

Théodore Géricault.
*The Raft of the
Medusa.* 1819.

Musée du Louvre, Paris.
© *Photograph R.M.N.*

Much of the reason for the painting's resonance since 1875 has to do with the fact that it forces us to excavate so thoroughly its historicity. This however

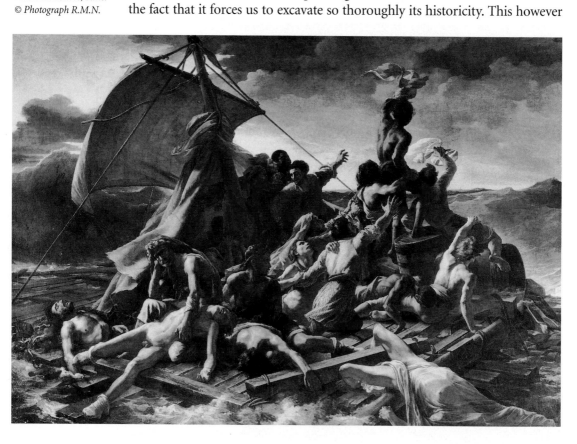

is precisely because its seeming yet overwhelming literalness produces – or as frequently is read as – impenetrability and its challenge.[4] Thus Brownell's blackboard in 1880. The blackboard offers as many different opportunities for writing about the painting in 1880 as have come down to us since that moment.[5] One is, of course, literal, the transformation of patient from specimen to bearer of pedagogy. Here is an assumption of writing as a fundamental conduit for the understanding of the painting's meaning. The painting is writing, in other words, and the painting becomes history by functioning first for the reader/viewer as historiography; it must be written first, spoken, or *painted* as part of a discourse committed to ascertaining how history works or how it might be philosophized. Along the way, the painting is sanitized, as writing takes place *on* something – a blackboard in this case – rather than in it and some kind of withdrawal from the depths of the wound is facilitated; surfaces are reaffirmed and the issue of style – as opposed to subject – can be seen lurking in the wings awaiting its cue.

As I said, the blackboard engenders a host of associations – that certainly was the critic's point – some oriented toward escape. Even the critic has taken flight by way of dense and sophisticated critical machinations. Wish fulfillment is enacted by the transference of patient from being to blackboard. It is the reference to the blackboard at all that allows for the allusion to lecturing, and it is only by the force of this suggestion that the reader/viewer can turn back and negate the sight of bloody scalpel and fingers. Meanwhile it is argued that the painting's literal narrative has purchase only to the extent that we recognize it as written, written as anything we want it to say. Writing, in fact, restores the primacy of paint.

But in literal terms, those described by paint, it is very difficult to believe lecturing is the correct word for what the surgeon is doing, and difficult to believe that anyone might have bought/buys this metaphor wholesale in 1880 or now. Lecturing implies prolonged verbal engagement with an audience. The presence and force of the bloody scalpel do not suggest sustained detachment from the operation itself. On one hand, it is absurd to think that Gross will stand before us with dripping knife for long. He is, in fact, making a remark. On the other hand, lecturing would be contrived as other to operating and thus while seeming an impossibility in purely narrative terms, the dynamics of painting require that his pose be held for eternity, and thus a remark becomes a lecture and the operation falls away.

In 1879 the New York *Daily Tribune* spoke about what might appear in place of the obvious subject should such a diversion be encouraged.[6]

Larger and more important ... is Mr. Eakin's "The Anatomist," one of the most powerful, horrible, and yet fascinating pictures ... painted anywhere in this century – a match, or more than a match, for David's "Death of Marat," or for Gericault's "Wreck of the Medusa." But the more we praise it, the more we must condemn its admission to a gallery where men and women of weak nerves must be compelled to look at it. For not to look at it is impossible.[7]

Not only is *The Anatomist* associated with a tradition of contemporary history painting – the title alone invokes vague historical precedents like *The Anatomy Lesson of Dr. Tulp*, rather than contemporary specificity – but its historical place is assured by its entry into a struggle from which it is seen to emerge victorious. The painting is "a match, or more than a match," for David's *Death of Marat* of 1793 and Géricault's *Raft of the Medusa* of 1819. The act of painting a work with both historical and contemporary resonance means applying historical weight to contemporary events. But it also means embodying cultural superiority as evidence of historical centrality and determining the extent to which what is also cast as an evolutionary process – the increase in the quality of history painting over time, as powerful, horrible, or fascinating – mirrors potential shifts in political, social, military, and cultural hegemony, in this case from France to America.

At the same time, the passage couches history in the fortunes of the body. The focus of *Marat* is the dead body of the revolutionary hero, physically desecrated, polemically destroyed, allegorically resurrected. The *Medusa* pictures bodies ravaged by exposure to the elements, deprivation, cannibalism, sheer psychological desperation, and ultimately, as the story would unfold, political corruption. *The Gross Clinic*'s subject is also the body. But of the examples mentioned, it is the only one that offers material bodily repair as its most immediate result and aim. Of course the Medusa's figures are trying to save themselves, a sign, in reference to *The Gross Clinic*, of an earlier evolutionary moment, prior to the advent of outside agents of health and ideological order able to restore wholeness. Health *is* recuperated in Eakins's narrative, and the picture of the healthy society must emerge "a match, or more than a match" for David's and Géricault's. Along the way a modern historical evolution is described, culminating in the promise of American progress but beginning with barbarity, the site of healing as the site of murder, then leading to resourcefulness enacted without knowledge, dependent on fate, and ending in the confidence of body placed in the hands of intellectual and physical, scientific mastery.

Thus a new space must be found in which to "look" at this painting, or refuse to look. (*The Gross Clinic* is to be denied its status as spectacle at the same time as it coheres as art. Healing is now a more private affair. It does not hold in a gallery. Could this then describe some of the hesitancy of the Centennial jury?) The gallery where the viewer would now expect to find Marat or the Medusa is for those weak-nerved types who would embrace these French paintings as ultimate cultural representations, who need a version of history to look at in a contained space. By arguing for the decentralization of gallery viewing in the experience of the painting, the critic maintains *The Gross Clinic* is not a painting in the modern sense. It is life – it is popular – and not for those who seek to satisfy their visual construction of self and nation in a gallery. This construction betrays the threat of the painting: It is dangerously close to being intended for those now able to do without art as artifice. It is open to cooptation by the wrong elements, those who do not frequent galleries. (We see further manifestation of this threat shortly.)

181

"...one of the
most powerful,
horrible, and
yet fascinating
pictures..."

Thus a confrontational contemporary subject capable of mingling horror and inspiration also encourages the reviewer to *write* another history for the painting within that which he or we identify as real. This second account utilizes the terms of the first, but associates Eakins's means with an art-historical tradition. Granted, it is not one that deviates so greatly from recognition of *The Gross Clinic*'s contemporary subject. After all, *Marat* and *The Medusa* are also historicized by the forms – shared monumentality, the *Medusa*'s baroque composition, Marat's Christ-like slung arm reference to the Lamentation – of high narrative representation applied to a French Revolution subject and an exposé of subsequent political corruption.

But the critical strategies of the writer for the *Daily Tribune* (and Brownell) were also dependent on the extent to which the painting could be historicized in order to defuse its original contemporary force. Among other things the writer for the *Daily Tribune* was giving material precedent to Brownell's designation of "dramatic realism in art," a stylistic trope, a language of representation that must also have succeeded in ridding both David's and Géricault's paintings of their narratives. "Dramatic realism in art" was another way of making history a palliative to the contemporary and vice versa. The *Daily Tribune* critic would have understood the status of *Marat* and *The Medusa* as purely historical paintings, as paintings of past *events*, elevated by the comprehension and memory of historical significance, distanced now from the contemporary, objectified.

There are still ways, however, in which the connection of these paintings to Eakins's canvas finds meaning for *The Gross Clinic* in a wider contemporary context. This means reading or seeing the possibility of contemporary revolution, social upheaval, and corruption – the defining narratives of the aforementioned French examples – inscribed in the historical prototypes that frame the critic's comments *in 1879*. By revolution, however, I do not mean only that which gives voice and form to political ideology, but to aesthetic ideology as well. Revolution was a narrative with very direct and contentious purchase for historical and art-historical self-understanding in America in the 1870s. In this sense, the painting could still serve as a trace of contemporary life despite early attempts to write away these implications.

In uncanny anticipation of its complicated historical legacy, *The Gross Clinic* had to be made illegible and its signifiers set free by contemporary critics to float aimlessly in the viewer's imagination, awaiting ideological reconfiguration, the type that might be written on a blackboard, only to be erased again, in anticipation of the next day's lecture. As Brownell argued, evidence of style – the means of avoidance construed as sign of success – was evidence of civilization – the opposite of blood, and historical battles, and the picture of the irrational and hysteria, the place one gets to *after Marat* and the *Medusa*. According to Brownell, style "distinguished barbaric from civilized art more than any one quality . . . it is at least the product of cultivation." Style had to predominate.

It would prove impossible, however, to deny the violent resonance of *The*

Gross Clinic. The *Daily Tribune* trumpeted the extent to which the painting called attention to a history feared by dominant formations like the Centennial jury.[8] *Marat* and the *Medusa* could hardly have been neutral references to an insular tradition of contemporary history painting, one that as readily invoked Rembrandt's *The Anatomy Lesson of Dr. Tulp.* Allusions to *Marat* and the *Medusa* were as likely as not politicized; they were specific antecedents, redolent of social upheaval, of revolution, of violence rather than healing, of the horrible.

According to Samuel Bernstein, on Commune fever in the United States, "[French] Anarchy, assassination, slaughter, incendiarism, streets covered with human gore . . . were monotonously reported in the [American] news."[9] And in 1876 and 1877 the daily papers were calling Grant's associates and nemeses Marats, Dantons, and Robespierres, bent on the overthrow of the federal government, the resumption of civil war, and secession. In December 1876, the *Herald* ran this notice:

[T]he revolutionary period in our own country . . . began just 16 years ago, on December 20, 1860 . . . Cassius and Brutus and Casca, Danton, and Marat and Robespierre, have their American counterparts . . . President Grant is their willing or unresisting tool. The hero of 1865 is the puppet of 1876. A triumvirate of demagogues reigns in his place . . . the result cannot be different with us from what it was when France was given up to Marat, Danton, and Robespierre.[10]

The association of Eakins's painting with such allusions was a complex and dangerous affair. Were a critic to remember the fortunes of *The Gross Clinic* at the Centennial the reference to the *Medusa* might also call to mind those given short shrift by the Fair.[11]

Such associations, however, only beg the question: Would the reader have to have knowledge of these paintings, have to decide for him or herself whether *The Gross Clinic* did, in fact, very directly, even literally call up *The Death of Marat* or *The Raft of the Medusa* in order for the critic's associations to be legible in any way?

If so, one might match Gross with Marat, being careful not to equate these figures too easily. What do we do with such an association if it is also possible to see the Frenchman's wound as that of Gross's patient, the bloody knife below Marat's body as Gross's knife? All of a sudden our equation adds up to Gross as Charlotte Corday, a political and gender reversal that elides empathy between the patient's female "advocate" and the patient "himself." We might then cast Gross as conservative to his "others's" radicalism – their inhabited states of hysteria and the unconscious, the latter characterizing Marat as well. If we assert that the path from communism to the realm of the feminine was not far for some critics in the 1870s this is more plausible.[12]

It is also instructive to recall the blackboard. It references school teaching as much as any other activity. School teaching was just as suggestive of women's work, certainly to a greater extent than surgery. As the patient becomes blackboard, he becomes an entity to be molded and fashioned by Gross rather than cured; an unruly schoolchild perhaps, innocent now. And if

we recall that redirection and erasure of subject were among the most persistent critical strategies for the acceptance of *The Gross Clinic*, then it would make sense that Gross's status as surgeon – as subject – would be diminished as he was identified with the *form* of a woman. Finally, if we assume the critic's references did not posit the victims of the Medusa as comparable with Gross's assistants, but with the patient and his female companion, these assertions about Gross's relationship to Corday – set in contrast to the only woman in the painting – are suggested more readily.

183

"... one of the most powerful, horrible, and yet fascinating pictures ..."

Gross's identity as other to the pictured woman is enhanced if we read further her representation. The woman in Eakins's painting is the repository of anguish, rendered irrational by the force of "rational" male activity surrounding her and the extent to which her identity as woman is bound up in the character of the patient's "wound."[13] After all, it is this which causes the woman to recoil in horror and shame as she shields her identity from the viewer, and fear as she protects that same identity with her shriveled hand. It can hardly be called coincidental, or mere analogy, if not consciously constructed, that the incision takes the form of an orifice recently penetrated by the phallic intervening scalpel, now retracted by the surgeon in order to make room for the actions taken by his assistants. A type of rape is metaphorically cited, and the only securely identifiable female in the picture appears to the viewer as traumatized, as hysterical.

Despite the possible excess of this argument it has been too easy to forget that *The Gross Clinic* described more than one arena of illness in late-nineteenth-century America. The figure embodying reception within the picture, the woman, suggests disease in her very response to the "actual" medical problem being corrected. Attenuated emotional response, behavior that could be characterized as other to order, maturity, and reason, and the extent to which those signs coalesce as something like epileptic constriction, the physical manifestation of the woman's psychological duress in *The Gross Clinic*, were all associated with hysteria at this time. According to Carroll Smith-Rosenberg,

Hysteria was one of the classic diseases of the nineteenth century ... a protean ailment characterized by such symptoms as paraplegia, aphonia, hemianesthesia, and violent epileptoid seizures. Under the broad rubric of hysteria, nineteenth-century physicians gathered cases that might today be diagnosed as neurasthenia, hypochondriasis, depression, conversion reaction and ambulatory schizophrenia.[14]

In addition to the most blatant association of epilepsy and hysteria, the woman's surrender of manual motor mobility could signify paraplegia. The erasure of her facial identity and replacement of same by that very epilepsy might read as aphonia, the loss of speech or voicelessness. Her depiction in profile, visually negating one half of her body while the other's normalcy is nullified by epileptoid reaction could read as a type of hemianesthesia, or the loss of sensation on one side of the body. Certainly the viewer *sees* this loss when refused apprehension of one half of her body or when a type of anesthesia is administered to her "charge."

The dysfunctional anatomy attended by Gross becomes quite secondary to the catalog of ailments embodied by the woman. This, even though the metaphorical relationship between incision and vaginal penetration may be informed by the fact that much female hysteria in the nineteenth century was experienced or thought to originate with "pain and tension" in the "uterine area."[15] The maladies that symptomatized hysteria virtually speak to a history of nineteenth-century psychosomatic female disease, illness that Gross quite clearly fails to treat or even notice.[16]

That Gross's back is turned to the woman speaks to a struggle of sorts that attended the relationship between hysterics and their doctors in the late nineteenth century. Doctors were warned that entering into the treatment of a female hysteric required iron-willed resolution and refusal to bow to the serendipitous behavior of the patient.[17] Often this required a type of physically violent purging of the woman's neurosis.[18] As Smith-Rosenberg has it, "Much of the treatment prescribed by physicians for hysteria reflects, in its draconic severity, their need to exert control – and when thwarted, their impulse to punish." At the same time, hysteria could also relate to the increasing disintegration of the role of the nurturing female in nineteenth-century society, a role that even took the form of "physician" in more rural areas when left to tend to the ailments of the family in the absence of the working father. As this place was usurped by the spreading professionalization of the endeavor, the woman no longer fulfilled the role of the "Ideal Mother."[19] It is perhaps this social shift that is mourned by the woman in Eakins's painting, the pain alleviated by hysteria. In Gross's case awareness of this tension, which speaks to the force of female identity in the male arena, produces ignorance and disavowal, channeled through physical, surgical intervention.

But something of a moment earlier than that addressed by Smith-Rosenberg also seems applicable to the picture of hysteria embodied by this woman. According to Michel Foucault, a fundamental shift occurs between eighteenth- and nineteenth-century conceptions of the *modus operandi* of the clinic, what he calls "(the disappearance of the general morbid entities that grouped symptoms together in a single logical figure, and their replacement by a local status that situates the being of the disease with its causes and effects in a three dimensional space) . . .":

The new structure is indicated . . . by the minute but decisive change, whereby the question: "What is the matter with you?", with which eighteenth-century dialogue between doctor and patient began (a dialogue possessing its own grammar and style), was replaced by that other question: "Where does it hurt?", in which we recognize the operation of the clinic and the principle of its entire discourse.[20]

The distance created in *The Gross Clinic* between ignored, displaced, hysterical, occluded, and occluding – but still figuratively whole – woman and treated, isolated, fragmented, focused patient – the respective spaces of clinical diagnosis they represent – are framed by Foucault's history. The woman is pictured as if there is something wrong with her while the specific ailment of the patient,

no comment whatsoever on character – a state in its definition, specificity, and orientation, in fact, capable of erasing all traces of otherness (the fragment as machine part) – is treated. The woman is of an earlier moment, the "male" patient the sign of modernity. Moreover, if we take literally the question "What is the matter with you," then we find another reason for the woman's occlusion. Matter refers to physicality, and it is her physicality that the woman prefers not to share, in empathy perhaps with her charge or in fear that what has happened to him might also occur to her. If we choose instead to translate Foucault's latter phrase as "What is wrong with you," already implied by my reading, then the assumed incorrectness of the woman's body to the male gaze is assured.

It seems to me that Foucault's historical argument might also be extended formally, art historically, in terms of an art history already available to Eakins and his critics. The woman, in the baroque contraction, contortions, and convolutions of her hands and the decoration of her headdress, despite its very nineteenth-century blackness, recalls the fripperies of rococo sensibility or the rhetorical gestures of neoclassical painting. The relative mobility and theatrical strangeness of the woman's hands suggest a paradigm other to that of the patient, and to the language of "dramatic realism" and a thematic of absorption. Her attitude, her hysteria, its visual expression is premodern. This is not the hypnotic state of the woman in Edouard Manet's *A Bar at the Folies-Bergère* or the impassive flaneurial gaze of *Olympia;* nor is it the inward-turning Susan Eakins in her husband's numerous portraits, or the nude figure modeling for the allegorical sculpture of the Schuylkill, or Winslow Homer's monumental stone-still female archetypes. This is rather the mourning women on the right side of *The Oath of the Horatii*, the figure with head buried in hands in the *Death of Socrates* or a figure out of Greuze. The irrational, wild, freakish nature of the woman is the residual barbarity of the world pictured by these invoked French prototypes. The form of the woman is what is left of a barbarous example of diseased radicality – the form for a moment, in 1793 and 1819 – of contemporary history painting, now replaced by the rational scientific developments that surround her and from which she recoils. The patient, on the other hand, is both the new nineteenth-century fragment, the vignette, the bridge to realism, *and* the blunt-cropped, haphazard production of sight that suggests Géricault, photography, Courbet, Manet, and impressionism.

In the end, of course, the woman must be similarly identified. Her hands are differentiated from the rest of her body – highlighted, disembodied, unrelated to the black of her dress. Her inwardness and absorption are modern states of mind. She has simply appeared in the wrong space and a bit early. In another twenty years or so she would reappear over and over again in the new clinic, the psychoanalyst's room, where the talking cure for hysteria might cause her to remove her hands from her face so that it in turn might be objectified.

This conflation of past and present is acceptable, however, because comparisons between barbarity and a historicizing definition of French character and the signs of modernity were very much possible in 1879. In an unpub-

lished essay of that very year Mark Twain had this to say about the relationship between French radicalism and savagery:

> It must . . . be admitted that in one point the Comanches rank higher than the French . . . they do not fight among themselves, whereas a favorite pastime with the French, from time immemorial, has been the burning and slaughtering of each other. No other creature's religion has wrought such marvels of murderous atrocity as the meek and lowly religion of the Frenchman. However, the last sentence is in a sense unfair . . . since the Comanche has no religion, and hence no pressing motive to reform his brother by killing him.[21]

Twain equates the "savage" or "red man" with the Frenchman and his penchant for internal violence, for endless social upheaval, for the type of behavior that resulted in a *Death of Marat* or a *Wreck of the Medusa*.

Twain concludes the piece by imploring rational American missionaries to civilize French primitives. Along the way Twain mentions the Commune twice as evidence of the continual violence and fickleness of the French citizen. All of France is seen to be one large dangerous class in need of "American missionaries, armed with official rank for their protection, furnished with the ribbon of the legion of honor to render them inconspicuous and avert notice and jealousy. . . ." Is this not what the *Daily-Tribune* was doing in 1879 – and seeing in *The Gross Clinic* – simultaneously providing and noticing the disguises by which Eakins's painting might slip into the modern tradition of history painting by assuming some of the look of *Marat* and the *Medusa*, in order to subvert the tradition, make it American, and thus prove "a match, or more than a match"?

Such colonial pursuits, in fact, fuel Twain's narrative: "Let us all aid in helping the Frenchman. Let us all take to our hearts this disparaged and depreciated link between man and the simian and raise him up to brotherhood with us."[22] In the end, however, these were, if satiric, also incendiary words, given the "missionary" work being done to and among American savages – the "Centennial War" being waged among the Comanche and his brothers and sisters in the west – while Eakins's painting hung at the Centennial.[23]

The Gross Clinic's proximity to Marat and the denizens of the *Medusa* heightens dangerous associations with Eakins's painting. Hysteria's identification, its image in short, orders relations between male and female, professional and amateur, races *and* classes, history and the present, recidivism and progress. The "dangerous" classes themselves were characterized as given to mob hysteria, a signal of their diseased disposition and the "otherness" of their political position, a position equable with that of the *Raft's* demographics. The threat of the effects of the Paris Commune in America, as already suggested, dates back to the early 1870s. The *Times*, on January 20, 1874, put the situation succinctly:

> There is a vast hydra-headed class here . . . grown up . . . in the life of the streets, ruffianly, brutal, and uncontrolled, who, if urged by hunger or stimulated by . . . a great wrong . . . would fill our streets with a desperate throng . . . strike at property and

187

"... one of the
most powerful,
horrible, and
yet fascinating
pictures ..."

order and all we most value. There is a "dangerous class" in New York, quite as much as in Paris, and they want only the opportunity or the incentive to spread abroad the anarchy and ruin of the French Commune.[24]

These were qualities threatening American society after the Civil War and qualities invoked by *Marat* and the *Medusa* and certain members of the American government, qualities Gross also struggled to order in his work, in his example, by his faith in a moral, but ideological scientific reality, one that mirrored Eakins's own attitude toward representation, but which might also have something to do with the ideology of science that concurrently "mapped" the west at the expense of "others."

In fact, very direct analogies were drawn in the 1870s between social disruption and disease. In the same month in 1874 that saw the *Times* complaining about the dangerous classes, the *Railroad Gazette,* a New York journal, argued that "strikes are no longer accidents but are as much a disease of the body politic as the measles or indigestion are of our physical organization."[25] If this were the case would it not seem likely that the success or failure of medical performance and representation would also embed and be embedded in layers of broad social meaning?[26] The issue at hand would appear to be corruption in its many guises. The problem then becomes archaeological. If we excavate the metaphoric quality of one situational dialectic, how many different cognate applications might that situation have within an essentialized definition of social discourse at the moment of representation?

The morass of "social" diseases impacted in *The Gross Clinic*'s personification of woman and invocation of Marat and the Medusa threatened to explode into an image of social disintegration similar to that found daily on the streets of New York. The *Raft*, for instance, may have been recognized as a breeding ground for the social equivalents of aphonia, hemianesthesia, epilepsy, and paraplegia, for the experience on the part of its inhabitants of a condition similar to that embodied by the woman in *The Gross Clinic,* and as the vessel charged with carrying the refugees of Custer's western campaign.

But the *Daily Tribune* writer called the figure of the woman "wholly hostile."[27] In this phrase itself were the seeds of her recuperation as vision of danger and threat, and danger and threat to vision. The words alone return to her something deprived her appearance by Eakins. "Wholly hostile" implies that in at least one way the repudiation of physiognomic identity afforded her by the painter is in fact a sign of her unity and closure. The critic recognizes this in his choice of words. She *is* the sign of hostility, to such an extent that she is little or nothing else. The writer also asserts that this figure has been painted into a corner. She can only attain wholeness in social parlance by signifying hostility, embodying its sign. Her presence in the picture, according to his semantic construction, is only possible because of her hostility. Were she capable of any other behavior or visual identity she would not be capable of representation.

Charles de Kay's review of the 1879 Society of American Artists exhibition in New York addresses the same problem: "The ugly, naked, unreal thigh, the pincers and lancets, the spurting blood, and the blood on the hands of the

Professor and his assistant are bad enough, but Mr. Eakins has introduced an additional element of horror in the shape of a woman, apparently the mother of the patient, who covers her face and by the motion of her hands expresses a scream of horror."[28] Many signs of distaste are located in Eakins's painting – blood, the operation itself, the pincers and lancets, the "ugly, naked, unreal thigh" – but one is singled out for special treatment, described as additional and thus beyond the normal plane of horrible representation, that is, "the shape of a woman." Her horror is compounded by the fact that immediately after her repulsion is located in her shape, she is identified as "apparently" the patient's mother; this designation *follows* on her ugliness. The woman's disgusting appearance can only mean she is related to the "ugly, naked, unreal" patient that formally balances her.

Most importantly, de Kay asserts that the woman's presence is "additional," ancillary to the image at large. She has perhaps been wheeled onto the stage in order to set in relief the misery of the larger subject, as some kind of diversion. The critic might even see the woman as potential, comprehensible relief from the other horror. An audience repelled by the phantasmagoria of the operation might seek solace in the more usual representation of woman as hostile. In the end, however, she fails to provide this release. She is another type of horror, but she is also the most horrible, according to de Kay's syntax and semantics, and enters the overall fabric of the representation rather than being other to it. She is thus recognized unavoidably as a dominant form of ideology's conception of woman within a particular context. And her presence ensures the wholeness of that ideological imperative vis-à-vis the whole painting.

Despite the stasis sought for the woman's figure by the application of such terminology, its very quality demands dialectic and discursive response. Hostile to what and to whom? Hostility always implies a receiver, even if it is oneself. She could be hostile to the action that surrounds her, the figures who enact the represented narrative, the viewer who looks on, as well as herself. The form of her hostility, the clenched hands, the hidden face, the contraction serve as much to erase her own identity as they do to transmit hostility outside of herself. In any case hostility marks the woman as impediment to the larger narrative as surely as it signifies her expected form and its sense to the larger proceedings.[29]

She *is/is not* the viewer, placed within the painting, yet refusing to look, placed before us but refusing our gaze. The woman references the very dance of the gaze recommended by critics in the first years after the completion of the painting. The woman both embodies our horror before the subject, confronting the viewer with his or her own inadequacy in that role and fails to live up to what *we are/the critic has been* forced to do before the painting, that is, look. She is also an other to the audience of male medical students who mirror the critic/viewer's role, taking notes before the surgical "picture."[30]

I do not want to suggest, however, that her refusal of vision is absolute. It can only embody such representational character because she has at some unpictured time chosen to look. She appears before us precisely because of what she has seen – her form is born of reaction, not blind assumption or imagination. Not only does this elevate her in part to a level commensurate

with the male figures in the painting, but it also further instantiates her as historical – her truth is only secured by what has come before. This constitutes a massive differentiation from the males in the picture as their heroism depends on what will later emerge – the health of the patient as a result of the success of the operation. Male heroism is, in other words, utterly contingent.

The woman is simultaneously the viewer and less than the viewer, not an unlikely role given the predominance of male viewers for this type of painting and the extent to which it describes a male world in which she is clearly out of place (in which history is out of place) or at least inconsistent. Her presence jeopardizes the unity sought by this world of professional men, both in the painting gallery and the surgical amphitheater. This may also describe her trauma, her horror at being surrounded by men and forced to attend to their world.[31] Thus the male doctors attack the woman's fragmented embodiment in the form of the patient, the figure with whom she most blatantly empathizes and whose anguish, now chloroformed into unconsciousness, she outwardly assumes. As an active, "hostile" viewer/nonviewer on the left side of the composition, her sentiments must be rendered inert in the form of the patient on the right, providing balance and unity to a structure threatened by their narrative lack, a lack that is only erased outside of the picture as we read and write narrative's completion ourselves based on what we see. Here is our *picture* of hemianesthesia – cured only by reception – and the formal and symbolic needs Eakins satisfied by inclusion of the woman.

Thus it would be wrong to assert that a mode of reception informing and informed by *The Gross Clinic* was solipsistic in its recognition and performance of hostility, born solely of the politics of viewing that obtained in the new space of the art/exhibition gallery. Within the larger social structure of New York at this time, "hostility" toward the class of viewer most frequently training his or her gaze on *The Gross Clinic* was also rehearsed as a description of human character – to characterize the savages in the west, or, as already demonstrated, the dangerous classes in the city: African Americans, radicals, women, the unemployed.

Perhaps most importantly, hostility as embodiment of critical reception had its representational analog. Albert Pinkham Ryder's *Spring* (Fig. 54), a seemingly innocuous pastoral, was on view in the same exhibition as *The Gross Clinic* in 1879 and both illustrated and mentioned in Brownell's article:

Mr. Ryder [has] a number of . . . freaks in respect of their serene and conscious disregard of the conventions. . . . His pictures are marked by an almost contempt for form; they assume an attitude of almost hostility to the observer bent on making them out. . . .[32]

Eakins's woman and Ryder's painting, two forms of hostility impacting visual representation in the same exhibition, one taking the form of figural, narrative, "realistic" representation, the other couching illegibility and hostility in stylistics, or more precisely the lack thereof, and both framed by the language of communism and dangerous classes.

189

"...one of the most powerful, horrible, and yet fascinating pictures ..."

FIGURE 54

Albert Pinkham
Ryder. *Spring.*
c. 1879.

*The Toledo Museum of
Art. Gift of Florence Scott
Libbey.*

Eakins's *The Gross Clinic* and Ryder's barely named paintings formed two sides of a whole for Brownell because violent subject and violent technique both evoked wider manifestations of the contempt and hostility, rebellion and upheaval continuously identified with social life in New York. No matter what the intentions of painters like Ryder and Eakins, there were some who could only read *The Gross Clinic* and *Spring* as signs of social description and the need for its evisceration. In Ryder's case erasure was achieved for Brownell by poetry; the painter is said to have an excess of that; in Eakins by what Brownell will call the art of Eakins's dramatic realism – that is what makes possible re- or misreading of the patient as blackboard.[33]

As the connection was made plain between communism and painting in 1878, so the following year *Scribner's Monthly* opened its November issue with a piece entitled "The French Quarter of New York." The article proceeded to describe an area "that lies west of Broadway, south of Washington Square, and north of Grand Street." There,

The Commune has its emissaries and exiles. . . . There are secret meetings in obscure little cafes . . . where the last movements of the Nihilists are discussed, and the would be regicide is commended over draughts of absinthe and more innocent beer. . . . A

191

"... one of the
most powerful,
horrible, and
yet fascinating
pictures ..."

placard flutters from the wall, announcing a . . . celebration of the eighth anniversary
of the bloody revolution of March 18th, 1871, under the auspices of the "Société des
Refugiés de la Commune." . . . All the occupations of the quarter are "light," requiring
taste and adroitness rather than physical strength . . . in the colony are large numbers
of skilled artisans . . . brought from France for a term of years by such firms as
Tiffany's, and who are handsomely paid.[34]

It is difficult to believe that viewers of *The Gross Clinic* in New York, in the
same year as the *Scribner's* article, could have envisioned any type of work
appropriate for the depicted woman other than "light." One might argue that
her form – its necessity – is determined by the painting's absence of "taste and
adroitness"; that in place of the painting's violence she might require some-
thing "light," be sustained in a rational state not by the savagery of her present
surroundings but a situational other than looks appreciably different than the
space she presently inhabits.

Brownell, in the following year, found something comparatively "light" in
the painting and began to construct a matrix of approval that could rational-
ize this image of woman within the context of such a scene:

His "Surgical Operation" . . . mentioned as a masterpiece of realism in . . . technique, is
equally a masterpiece of dramatic realism, in point of art . . . the operator . . . is . . . lec-
turing as quietly as if the patient were a blackboard. Many persons thought this canvas,
we remember, both horrible and disgusting; the truth is that it was simply unpoetic.[35]

For Brownell *The Gross Clinic* was redeemed, made light, by technique, by
style, by the extent to which "dramatic realism" conveyed legibly – so legibly
that it could be read only as "art" – the unknown, the feared, disease; by the
extent to which the painting ordered the inchoate – pictured it, of course – but
also removed it.

Calling Eakins's work unpoetic actually distanced it significantly from
Ryder, as *he* was faulted by Brownell for being overly poetic: "Mr. Ryder . . . has
possibly a proportional excess of poetry. . . ."[36] But technique and art – poetry
– are still the poles of Brownell's vision – life/history are now nowhere to be
found. Dramatic realism describes something representational: It lacks all
access to the real, to the narrated. And that is the point. Should the viewer so
desire, the language of representation might deny encounter with material
reality at the same time as it is invoked.

As already noted, Brownell likens Gross's patient to a blackboard on which
Gross could "write" his explorations, and through "dramatic realism" make
"art," emplotment being worthy of recognition only to the extent that it could
be established aesthetically. Gross was able to erase the narrative or social
impact – the reception of his work – with stylistics, with realism, allowing him
and his associates to perform their scientific explorations in the closed world
of male interaction rendering the woman "hostile" along the way. Gross was
allowed to deny responsibility, to remake at will a hostile situation.[37] Ironically,
this places the painting in the proximity of colorist work, which, in order to be
tolerable, could and had to mean anything to anyone.[38]

Gross's "blackboard" offers the possibility of effacement necessitated by a violent, bloody, and invasive passage. This was akin to saying that the handling of chaos and anarchy produced private meanings and should not be allowed to represent violence, blood, intervention. That is what the representation of woman in Eakin's painting declares, for surely, like the blackboard/patient, her identity is erased, her face suppressed, blocked by grotesquely constricted hands which call up violence, fear, apoplexy, denial, shock. And, as her identity is erased, so she too becomes like colorist painting, the open field provided for private meaning.[39]

At the same time, the woman's pose suggests nothing so much as a desperate plea for the privacy of reception, which is, after all, the only realm in which criticism wished to discover colorist work or the historically incendiary subject at this time.[40] The woman/patient become metaphors for the painting in the midst of a Salon crowd, an Academy or Society audience predisposed to judge colorist painting harshly, to "condemn" its placement in a gallery. That is why she and Ryder's *Spring* are both hostile.

Through denial of the complex web of mediating discourses worked by and working reception of the painting when exhibited in 1879, *The Gross Clinic* masked sympathy with the burden of tradition while fighting much that was radical, illegible, shifting, and uncertain in American society. That is why this narrative only appeared when the painting was exhibited in the same show as work by Ryder and other tendentious young painters. The painting's plea for historical resonance only had purchase in constructed dialogue, polemic, confrontation with its other, and in terms of that relationship's reception.

The story I have tried to tell, then, is perhaps best restated by Ricoeur, as he asserts and restates that which so many others have recently claimed:

[P]lot is not a static structure but an operation, an integrating process . . . completed only in the reader or in the spectator . . . in the *living* receiver of the narrated story. By integrating process I mean the work of composition which gives a dynamic identity to the story recounted: what is recounted is a particular story, one and complete in itself.[41]

The process of integration is essential – it is social, it is political. Eakins did not leave us a dynamic composition unto itself. The Gross Clinic is already its own "particular story, one and complete in itself." There is no way that it can be ours unless we open it up and perform on it that which it pictures. The process could be bloody, but it is also hopefully recuperative and reconstructive to the extent required by the given situation.

For it is the politics of "operation" that touch every corner of this story and determine the extent to which its embrace cuts across many recountings to write particular narratives over and over again. Not in the splendid world of elevated, isolated heuristic but in the world of the "living" receiver and in the outward recognition of that world, then as much as now, as material, dialectical, and historical, and as, finally, incomplete.

Abstract Expressionism as Historical Myth

Stephen Polcari

How would one find history in abstract expressionism? It does not seem to fit any conventional definition of history painting. It does not commemorate historical events specific to time and place. It has no recognizable individual figures, and no comprehensible narrative of dynastic, military, or doctrinal religious event dominates it. There are no obvious references to the Depression and World War II, the key events of the artists' generation; no paeans to Roosevelt, no hagiographies of Eisenhower, no narratives of Patton, no representations of Normandy or the A-bomb, and no triumphal celebration of the victory of the United States in the 1940s. In short, the standard subject of grand historical painting, the extolling of the accomplishments and virtues of the ruler and the ruling class, is missing.

Instead, abstract expressionist art is a sacred art relating ritual and myth, cultural heroes, and sanctified process and event. These subjects are atemporal in the manner of myth, generic rather than specific in reference, magical and symbolic in representation, and discursive and emblematic in form. Abstract expressionist art sometimes narrates events, such as human figures hunting, in ritual act, and in combat, but the figures, or rather, figural hybrids, are anonymous and unspecific. The deeds it narrates are archetypal and not limited to time, place, incident, or individuals of the 1940s (although, of course, its "typical" is both general and particular to their world). Political, that is, governmental allusion, is deliberately avoided, which is quite striking in view of the world struggle then taking place, when the moral choices were clear. In short, the sacred character of abstract expressionism makes it difficult to characterize its historical references, in other words, its profane side.

Yet abstract expressionism was not possible without contemporary history. As I have written elsewhere,[1] it addresses an immediate and monumental subject – the crisis and severe dislocation of Western civilization in the post–World War I and Depression era – and its climax in one of the greatest catastrophes in human history, World War II, in which the most monstrous regime and crimes in history took place. Abstract expressionism is a product of this intellectual, moral, and historical drama. As the great military historian John Keegan has written, understanding history and war requires "not so much a plunge into the archives as a voyage through a nation's literature."[2]

Abstract expressionism seeks to immortalize its historical situation through secular religious sanction and universal monument. Contemporary history was identified with myth and the preindustrial past, which the artists considered "primal," and interpreted as allegory with great ancient, Western, and tribal art historical means. Although few recognizable individuals or individual events characterize its narratives, the history of its time intrudes and shapes themes and subjects and their repeated occurrences. These themes or subjects are articulated in imagery and form drawn from and inspired by the new modes of understanding of the twentieth century – depth psychology, natural history, cultural and physical anthropology, art history, and comparative religion and mythology. In other words, abstract expressionism locates historical event and topic in the modern concepts of the psyche, culture, nature, time, and space.

Further, abstract expressionism hopes to instruct, to provide a lesson concerning moral life. Its history painting is a record of the human spirit. Art that is historical indicates what is important to human beings in both the external and the internal worlds. Abstract expressionism so addresses the inner life of many of its age that it sought to elevate its lesson to universal truths. This is the province of both myth and history painting, as history is extended to cosmic truths, psychological and sacred principle, abstract forces, and general ideals. The complex and deepened nature of a historied abstract expressionism thus is our subject.

Abstract expressionist art employs the standard elements of history painting – subjects and forms attributed to and explained by the Bible, classical religion, ancient history, and cultural heroes, applied to the specific needs of contemporary history. In its use of such common allusions, abstract expressionism was quite an orthodox form of history painting.

That might give the impression that abstract expressionism is intended to praise interwar and war events, that is, because it addresses history in an elevated, grand-style manner similar to old master painting, it "approves" of it. Nothing could be further from the truth, for abstract expressionism is a critical art. It is a product not of officialdom in idea and form, but of its opposite, the adversary culture. It bears witness to and opposes the waste, stupidity, cruelty, and violence of human beings and war. In its way, by imagining darkness, it is an art of protest, challenging official ideas of the value and necessities of Western society, and ultimately, of war and suffering. Sacrifice for country is questioned and not affirmed. What abstract expressionism is protesting is very complex and contradictory, much more so than for World War I, which began the collapse of confidence in Western civilization.

The reaction of many artists and intellectuals we sometimes call the avant-garde after World War I was to dismiss and vilify the social and political establishment. The adversary culture that blossomed then fused modern art with pacifism and the subversion of Western civilization. From George Grosz's caricatures of military, industrial, and religious personages, to the surrealists' attack on civilization itself, with its emphasis on reason, control, order, and the like, much adversary culture after that war sought revolution and the

overthrow of those old men who had sent millions of young men off to die. Lines of opposition were clear cut.

Opposition necessitated a much more complicated and deeper response during and after World War II. No one had any illusions about the glory of war by then. No one welcomed its coming as many had in 1914. But the United States had not begun the war and those they were fighting reinvigorated the concept of evil in modern history. There was never any serious question among Americans of fighting World War II once it had begun except among such lunatic fringe as Dwight McDonald, the Marxist literary critic, and other "intellectuals" of the *Partisan Review* (which only eventually approved fighting the war in 1943). These very important points differentiated the Second from the First World War, and they required a different response.

The problem was this: how to oppose war and deny official sanction of its values, and yet fight the necessary fight, what has even been called "the good war." The adversary culture learned, although they might not admit it, that sometimes war is necessary, whether you want or like it or not. Your choice may be the lesser of two evils. That was an essential lesson to the World War II generation. But how was one to make art of this dilemma?

The solution was a generational one. It was summed up in the words of James Jones, writer and Pacific veteran, that it was not so much a question of being anti–American government as being anti–human nature.[3] You made art that alluded to traditional commemorative form but you did it for humankind, for the universal and not for patriotism. The abstract expressionists made adversarial art that attacked war and human aggression themselves, not the country and civilization under murderous assault by barbaric foes. Its iconoclasm attacked war in general, not just the states waging it.

A reflection of this fact is that abstract expressionist art lacks historical explicitness. Who are the protagonists in abstract expressionist painting? Who are the mythic figures in their works, Adolph Gottlieb's Minotaur, and Seymour Lipton's Moloch? Not the Nazis, not the Japanese, not the Americans, but perhaps, in a sense, all three. It is the instinct for violence that is being denounced, for it unleashes most of these creatures however expressed as figures of myth and unconscious. Because abstract expressionism depends on indirectness, on metaphor to render abstract forces, it relies on the anonymous and implies the universal. In this, it is in accord with general American responses to the Second World War. Postwar memorials decried the cost of the war, rather than celebrating its nationalist, partisan glory. Unlike the reaction to World War I, when war and aggression were seen as the products of certain sociopolitical systems, now war was increasingly seen as a universal human scourge.[4]

A central element of abstract expressionism is thus its fusion of history and myth. Abstract expressionism combined world culture, especially the traditions of the West and the tribal, with modern history to construct a ritualistic and mythic statement as an appropriate comment on the events of their time. In this it is traditional again, for history painting often combined the ancient and modern in its representations.

In modernizing the ancient, abstract expressionism was not unique in its

use of the archeological and the tribal, for even recent historical art had done so. American art of the 1930s used legend and folktale to narrate historical evolution over time, and the contemporary Mexican muralists had employed pre-Columbian imagery and form to narrate Mexican history. For example, Diego Rivera had employed representations from pre-Columbian codices to illustrate his chronicles of the Mexican people in the National Palace and elsewhere. David Alfaro Siqueiros had used pre-Columbian masks to envisage and traditionalize the workers in his baroque work of the early 1930s, and José Clement Orozco described the history of Latin America through the legendary life of the hero and god Quetzalcóatl in his Dartmouth College murals. In perhaps the greatest history painting of the twentieth century, *Guernica,* Picasso employed classical and mythical form as symbols in his representation of a specific historical event of 1937, the bombing of the center of Basque civilization. Picasso's painting also fused those elements with modern form and compositional structure, a combination that proved very influential on the abstract expressionists.

This articulation of contemporary events with ancient or mythological reference can be seen in abstract expressionist work, for example, in William Baziotes's *Pompeii* of 1955 in which he compares recent events to one of history's most famous natural disasters. *Pompeii,* Baziotes informs us, with its gray clouds, spreading pumice, and spiky biomorphic forms, represents "death and ruin," an apt analogy for modern history, especially the 1940s.[5]

Mythological killing and combat scenes fill abstract expressionism. The hunt, for example, has been a frequent subject of history painting. From the

FIGURE 55

Adolph Gottlieb.
Omen for a Hunter.
1947.

© 1979 Adolph and
Esther Gottlieb Foundation, Inc., New York.

Assyrian to the baroque, depictions of the hunting of enemies as the sport of kings with the resulting greater glory of the dynasty or nation were common. Adolph Gottlieb, however, updated the topic in the Africanized *Omen for a Hunter* of 1947 (Fig. 55) and *Pictograph-Symbol* of 1942. With a series of compartmental pictographic images of animals being hunted in a maze by beasts of prey, these works suggest modern killing. There is no dynastic glory here, however. Gottlieb is direct: He tells us simple killing is loose in the contemporary world.

Gottlieb updated combat, too, turning to the classic mythical struggle of man and beast. In *Nocturne* of 1945, he creates a confrontation of Theseus and the Minotaur, of man and the manbeast. Modern war is thus personified as the legendary battle of man and the dark gods, a very ancient and traditional theme. In 1951 Gottlieb painted *Night Flight,* which consists of several layers of imagery (Fig. 56). One of them – the exploding white forms and falling dark marks – recalls aerial bombing. Other abstract expressionists portrayed aspects of combat and struggle. For example, Bradley Walker Tomlin centers combat in a labyrinthian web as mythic creatures and beasts struggle to extricate themselves from entrapment by swirling lines and forces in *Maneuver for Position* of 1947 and *Death Cry* of 1948.

FIGURE 56

Adolph Gottlieb.
Night Flight. 1951.

© 1979 Adolph and Esther Gottlieb Foundation, Inc., New York. Photograph by O. Nelson.

In his late abstractions known as the Burst series, beginning in 1957, Gottlieb turns confrontations and combat into distilled, abstract pictorial conflicts. Usually the Bursts consist of two elements, a sunlike disc above and an exploding, moving form below. This confrontation represents, I have written elsewhere, the "versus habit" in which the division of the world into armed camps numerous in this century has led to the codification of continual polarization as the endless and eternal struggle of humankind.[6]

Gottlieb further developed this theme in his post-Burst abstract work. Perhaps the more dynamic, panoramic, sweepingly violent *Conflict* of c. 1965 (Fig. 57) with its allegorical and profound cosmos of intense colors and abstract rolling, struggling, broken shapes and shards best represents this historicizing mode, for its composition and style ultimately recall the grandly orchestrated battles of the old master tradition such as Uccello's *Battle of San Romano* and the new modern one, *Guernica*.

Theodore Stamos examined and described human conflict and event in an even more Olympian perspective of the cosmos, too, in his *Cosmological Battle* of 1945. Here a horned creature seemingly dominates and threatens the earth and sky. Like Gottlieb, Stamos has used modern biomorphic form and

pictorial style to render very traditional ideas of an extraterrestrial battle and menace of the gods.

Mark Rothko extended that concept with his duels of duality, that is, the confrontation within totemic figures of the complex forces of life and death, death and renewal. *The Entombment* of 1945, for example, consists of such a conflict. The painting is a modern version of the traditional lamentation or pietà, with the dead Christ in the lap of a biomorphic Virgin, who appears as the mythic Ephesian Artemis with multiple breasts. She is life giving and renewing even as she receives her dead son. The forces of life and death thus vie with one another within a single individual as they do within humankind according to the 1940s.

Rothko explored this theme throughout his figurative work, even though his forms became increasingly abstract. Indeed, it became the basis of his iconic abstractions. The abstractions, beginning around 1950 and continuing for the rest of his life, consist most often of two or three moving rectilinear shapes, one frequently light and the other dark. The shapes often allude to the familiar pietà or lamentation form with a horizontal and a vertical shape in varying stages of beginning or ending. Those shapes represent, as before, life (light) and death (darkness), or if you will, creation (peace) and destruction (war), in perpetual interchange. Contemporary history is conceived as the sacred struggle of light and darkness in modern pictorial terms.

Rothko's *Entombment* series brings forth another standard subject of history painting, the sacrifice. In traditional sacrifice, an individual usually gives up life for his or her country, exemplifying unselfish patriotism. For example, Benjamin West's *The Death of General Wolfe* shows the hero dying on the field of battle in the classical Patroclus/pietà pose, his death providing a moral lesson. Rothko's *Entombments* provide a moral lesson, too, but it is not a call for sacrifice for the nation. Instead, Rothko implies that his reference to Christ is an attempt to sanctify the human life being wasted. Only the resurrection of life should be gained from such sacrifices.

Rothko had expressed a related thought earlier with *The Sacrifice of Iphigenia* of 1942 and *Sacrifice* of 1943 (Fig. 58). Evoking ancient priestly rite and sacrificial altar, Rothko uses the classical story from Euripides to suggest the sacrifice of the innocent to war. In other words, Rothko views the patriotic sacrifice of the innocent as a waste. This view is clearly that of someone of the adversary culture, or at least of someone who refuses the official view of eternal glory for giving one's life away.

Seymour Lipton also frequently alluded to the sacrifice of the innocent. Lipton's *Moloch* series takes as its theme a biblical god for whom children were put to death. The sacrifice is horrific, as Lipton's sculptures of the gaping mouth and claws of the fearsome beast leave no room for standard history painting's images of a rational death deliberately undertaken. In Lipton's view, death is foul, not ennobling or uplifting. As he wrote, "Around 1945 I became interested in Mayan and other historical deadly devouring imagery. They became important to me in terms of the hidden destructive forces below the surface in man."[7]

Lipton took the imagery of sacrifice even further. He often did sculptures

FIGURE 58

Mark Rothko. *Sacrifice*. 1943.

The Peggy Guggenheim Collection, Venice. Solomon R. Guggenheim Foundation, New York. Photograph by Carmelo Guadagno.

of altars (e.g., *Altar* of 1947), and he made his two *Pietàs* of 1946 and 1948 increasingly abstract and biomorphic in form. The latter one (Fig. 59) in particular has taken on a general biomorphic shape, generalizing the form as emblematic, iconic image. With such an emblem, Lipton makes sacrifice seemingly part of nature, that is, "natural," and thus part of human evolution. The emblem also makes sacrifice a seemingly universal theme.

In its way, then, biomorphism is the modern equivalent of the classic costume, which was used in baroque and neoclassical history painting to suggest the idea of universality in time and place. Lipton thus conceives of sacrifice and death as part of the ebb and flow of human suffering, and not the political self-sacrifice of people for their particular country. The universal and religious for Lipton, and no doubt for abstract expressionism as a whole, evident in their Pietàs and other Christian imagery, is part of an emphasis on the commonly human, the community, and thus part of the refutation of the narrowness of patriotism. The universalization of Christ's Passion maps meaning onto mass death in the 1940s.

Jackson Pollock plied his own archetype of suffering. In *Naked Man with Knife* of 1938–41, he presented another kind of sacrifice – blood sacrifice. Borrowing from an image by Orozco in which peasants are murdered – stabbed – by a knife-wielding soldier (drawing from an illustration of Mariano Azuela, *Under Dogs,* 1929[8]), Pollock strips the protagonists of their uniforms that place them in time and place. Instead, the nudity of Pollock's figures removes them from history, and the murder becomes a ritual act in which the victim is killed on a bier. Thus ritual sacrifice replaces Orozco's political history. And in this painting, as in Pollock's work throughout, ritual act leads to renewal: Sir James Frazer describes innumerable human sacrifices for the regeneration of the land and tribe in his *The Golden Bough,* the book of the cultural history of humankind relied on by most abstract expressionists.[9]

As we have seen, abstract expressionism draws on biblical, classical, mythological, tribal, and Christian stories for its images. Yet its individual paintings and sculpture do not usually signify a clear narrative with a precisely defined or dramatic moment of decision. Historical art requires a legible story but most abstract expressionists are intentionally antinarrative and nonlinear. Indeed, the traditional stories are applied to their imagery only after the imagery's invention. Their creative process relies on unplanned inventiveness, not illustration.

In his early works, the *Pictographs,* Gottlieb, for example, denied rational narrative and linear time. As he described them,

FIGURE 59

Seymour Lipton.
Pietà. 1948.

*Courtesy Babcock
Gallery, New York.*

First I'd put down the grid of lines. The grid was an anti-formal device, an arbitrary structuring. What I had in mind were 14th century predellas which were pictures with a series of boxes each containing an event in the life of Christ. My pictographs were similar but different. They were divided by lines but the images were to be seen simultaneously and instantaneously. There were different focus points and many different times while the predellas were chronological and had a line of focus.[10]

In his pictographs, Gottlieb used psychological free association as his narrative device. Sense was to be made by the free flow of imagery and focus over the compartments of the pictograph, without any beginning or end. The ever-shifting unconscious mind, which denied historical, linear explication, was his structuring device.

Rothko's art, too, denied narrative linearity. In his abstractions, he specifically set up his rectilinear zones of space to interact, oppose, or simply repeat one another. He told the critic William Seitz in 1952 that he often held his shapes in Nietzschean antitheses or confronted unity in momentary stasis.[11] In this he echoed mural painting of the 1930s. For example, Orozco's Dartmouth murals represented the interactions of historically constructive and destructive forces of Western and non-Western cultures. A Dartmouth professor, Albert Dickerson, prepared an official pamphlet explaining the murals at their completion in 1934. In it, he described the complex play of different panels of Orozco's epic: "The full significance of the separate panels does not appear except in relation to the composition as a whole."[12] He further wrote, "The complex orchestration of the work with its contrasts and repetitions must be studied with constant reference to the thematic analogies between the two main divisions."

Rothko's abstractions enact similar but more unspecific unities, confrontations, and dissolutions over space and time. An early catalog essay written by David Porter for Rothko's exhibition at Peggy Guggenheim's Art of This Century Gallery in 1945 described his work as seeking a mythic unity "in which the individual symbol acquires its meaning, not in isolation, but rather in its melodic adjustment to the other elements in the picture." Later when his work had turned abstract, he described their dynamic interaction as indicative of the process of "mythic action."[13] In this way, large expanses and periods of history are condensed in a play of the forces of light and dark.

More typical for abstract expressionism, however, is the concentration in one work of a section of a larger process that is only implied. Paintings worked in tandem and as groups to form a loose federation of interactive and referential ideas and themes. Individual paintings and sculpture are not random or singular works, but articulate an underlying general whole of history, myth, and the sacred.

The abstract expressionist pictorial "formula" for dramatic history consists of few protagonists or many small shapes or lines enlarged to encompass a great area in order to give epic, monumental status; strong color for emotional intensity; and continuous, unfolding movement, as though nothing

were ever finished but in a perpetual process of contrast, if not conflict, in history. In the early work, this dramatization was carried out by many small semifigurative, mythic hybrids in ritual events. In a sense, this work was more like genre history painting in its ordinariness of format, scale, size, and event. In the later abstractions, abstract expressionist drama employs not ritual, figurative symbol but pictorial, ideographic emblem, becoming a simple, monumental, and direct pictorial diction expressing the gravities and elementals of history, life, and death over space and time.

Thus in abstract expressionism, iconic images are removed from their specific historical referents, and no events of modern history are told in a legible story. Instead, we have epic, mythic action, and heroic drama in ultimately abstract pictorial form. Emotional content, not description, and dynamic composition convey the monumental conflicts and fragmentations in Rothko's battles of light and darkness, Gottlieb's contrasts of expanding and conflictive form, Robert Motherwell's black and white pageant, de Kooning's demotic turbulence, Pollock's magical fields of force, and Barnett Newman's and Richard Pousette-Dart's luminous geometry. In this, abstract expressionism is again closer to Leonardo's *Battle of Anghiari* and its type of concentrated conflict than to neoclassic history painting. It exalts history to the level of cosmic significance, and in so doing, it captures the enormity of events in their time.

This elevation raises the question of the hero, an essential feature of history painting. Heroic idealization, monumentalization, and the struggle between heroic personalities are fundamental to old master historical representations. Historic figures may be equated with ancient gods and heroes to promote public virtue. Heroes translate human experience into a concept or paradigm in which the public is meant to perceive and understand its history.

Humanity and human nature *at large,* however, suffer or aspire in abstract expressionist art. They take the place of the single hero. In Bradley Walker Tomlin's *All Souls' Night* of 1947, for example, the seated hybrid forms in a row are ultimately unidentifiable. This painting of a sacred Festival of the Dead refers to no one specifically, but to general humanity. Similarly, in the most important work devoted to the hero, Barnett Newman's *Vir Heroicus Sublimis* of 1950–1, a large, expansive, dazzlingly red work, Newman identifies the hero for his generation: man, sublime and heroic; not Americans or the Allies, workers, or the Third World, sublime and heroic. The painting represents a spiritual heroism of humanity in general, or rather, the spirit of the adversary culture conceiving of itself as humanity, as it often does.

That seems also to be the case with the other "heroes" of abstract expressionism: David Smith's *The Hero* of 1951–2 (Smith may have intended some political content here but it has not been explored); Lipton's *The Hero* of 1957; and Pousette-Dart's *The Path of the Hero* of 1950. The latter two address the religious questing and journey of humankind, perhaps with some influence of fashionable existentialism and the sacred search of Joseph Campbell. (Campbell's *The Hero with a Thousand Faces* was published in 1949, a year before

Newman's, Smith's, and Pousette-Dart's works, and he immediately lectured at the Club, the artists' meeting place.) The abstract forms and general references to the nature of humanity and its life course thus suggest that the abstract expressionists used "the hero" to address general principles of life as they conceived them, and to elevate the audience through the use of neutral universal forms and values. Again, the principles took place in universal and unspecific time and space, not chronological and site-specific settings.

That is true even of the satiric heroes, for example, Isamu Noguchi's *Monument to Heroes* of 1943 (Fig. 60) and Willem de Kooning's mythic idols and women, although the latter depicted humanity, mostly women, as a general modern, social type. These works mock the heroic – Noguchi's "heroes" are merely bones blowing in the wind – or question their sources and powers as

FIGURE 60

Isamu Noguchi. *Monument to Heroes.* 1943. On view at the Isamu Noguchi Garden Museum, New York.

Courtesy Isamu Noguchi Foundation, Inc. Photograph by Rudolph Burckhardt.

de Kooning does with an image of vulgar, lethal mythic creatures as destructive as constructive.

The opposite of the heroic is the treacherous, the figure or figures who represent the dark force that must be overcome. For the abstract expressionists, the dark force took several forms. One was obviously the unconscious, the source of destructive instincts and demonic gods. The abstract expressionists were members of a Freud-dominated generation, and the unconscious was to be feared as the home of the irrational, the instinctual, and the uncontrollable. Such a conception informed their imagery and themes and lay behind their explanations of the history. (However, the unconscious was conceived of differently by the equally influential Carl G. Jung. For him, it could be a positive, liberating force for humankind.)

The dark was also a figure in nature or more specifically, natural history. Several of the artists drew from their trips to the American Museum of Natural History where the skeletons of one of the most fearsome killers in the history of the world, the tyrannosaurus rex, were on display. Lipton in his *Moloch* and *Moby Dick* series, Baziotes repeatedly, Herbert Ferber, Theodore Roszak, and others echo those forms.

Yet the vile and monstrous appeared not just as imagery, not just as the idea of the unconscious and nature, but in the very style of abstract expressionism itself. Traditional history painting is conceived in elevated and often classical, pictorial language, imparting a calm dignity to tragic subjects. Abstract expressionism, aside from moments such as Newman's art and the illuminating light of Rothko, Pousette-Dart, and even Pollock, is not simply elevated but demotic. Its pictorial language is that of the ripped edge; the splattered form and paint; the fragment and shard; the swath of a crude brush; the cheapness of house paint; the vulgarity of de Kooning's men, women, and city; and the lack of fineness, finish, and precision of earlier European modernism. For the abstract expressionist generation, tragedy is not inspiring but coarsening and contaminating. Linear planes and rough-hewn shapes are unrefined and thus anticlassical and not uplifting. Abstract expressionist pictorial language is broken, unfinished, wrenched, crude, and wild, a visual equivalent to the obscenity of history and the experiences of its participants – soldier and civilian – in its time. It is a subliminal witness to lived experience welling up from within and breaking down previous civilizing barriers and limits. The language of decorum and the everyday was defeated before events.

Yet for all of the lack of specificity of abstract expressionism, there are particular events in it. Abstract expressionism represents a realism, not military or political or stylistic, of course, but emotional and psychological, even beyond the violent strife of its style. It recognizes that war and disaster produce intangible effects and complicated psychological situations – feelings and fears – that are just as real, just as important to human beings as tangible historical happenings. Abstract expressionism takes advantage of modern forms of knowledge of the causes, evidence, and expression of behavior and incident. Historical event and fragmentary narrative (or anti-narrative) articulate modern occurrences

within modern concepts of what constitutes history, life, and human nature. These are the means and meanings of modern experience and reveal what it is to be human in the mid-twentieth century. As Adolph Gottlieb said,

Today when our aspirations have been reduced to a desperate attempt to escape from evil, and times are out of joint, our obsessive, subterranean and pictographic images are the expression of the neurosis which is our reality. To my mind certain so-called abstraction is no abstraction at all. On the contrary, it is the realism of our time.[14]

Thus abstract expressionism defines historical experience as including the materialization of fears, hopes, brutalities, and wishes for transcendence and transformation that reportage of topical events may gloss over or miss completely. It aims at a most modern level of the real – a confluence of the psyche, nature, culture, and (secular) spiritual striving where the complexity of human culture and feeling intersects with historical circumstances. As such it enlarges, yet disperses, the field of history painting.

History and history painting ultimately collapsed into and became the conflicts, principles, and overall human struggles of modern times as expressed in modern thought. These struggles were later considered (in the 1950s and beyond) those of general modern life. (It is at this point that abstract expressionism has been traditionally apprehended by critics and scholars. Indeed, this criticism begins and ends with generalizations made by those unaware of the historical inspiration of the extrahistorical symbolic and sacred.) Eventually, for the modern artists and public, modern experience has become normal, modern reality, appropriately represented in everyday terms (according to the original critics) by modern painting and sculpture.

Common in history painting is the commemoration of the dead, who may be memorialized with a burial, a tribute, or an apotheosis. Abstract expressionism employs many of the standard forms of commemoration. We have seen the use of the entombment composition. To this may be added the "broken column" image, which appears in Newman's *The Broken Obelisk*. This sculpture commemorates the dead with modern and ancient iconic and typological forms that become a kind of votive monument, perpetuating in condensed symbol the sweep of history and hope of his time. Newman fuses an ancient symbol of death, the Egyptian pyramid, with an inverted broken column, a commemorative monument suggesting rising and continuing life since ancient times. The inversion similarly turns the meaning of the iconic images over. Symbols of death become Newman's concept and form of aspiration, expansion, and extension, in other words, renewal. His paintings of burgeoning color, including *Vir Heroicus Sublimis,* rely on similar horizontal and vertical expansions to signify growth, new hope, and the emergence of new life itself.

Ultimately, with its themes of death, destruction, and resurrection, the eschatological doctrine of last and final things such as death, resurrection, immortality, and judgment seems relevant. Such themes often appear in the art of historical disasters and war, as a way of asking the most crucial questions of

historical events. As a recent novelist writing of World War I put it: Terror, war, and the collapse of human law compress "eschatological questions."[15]

Abstract expressionism's suggestion of death and rebirth ultimately resulted in a modern myth for the second half of the twentieth century: the triumph of the human spirit in the face of every adversity. In so doing, the standard historical celebration and triumphalism of traditional history painting left its monarchial, dynastic, and officially religious roots to express the heroic spirit of everyman, and his survival and success despite history. As James Joyce had said earlier in the twentieth century, as the adversary culture grew in the post–World War I period, history is the nightmare from which he is trying to escape.

The search for a modern myth was a self-conscious project of much interwar cultural life. American artists and writers of the thirties had sought a unified understanding of the history of America, and Holger Cahill, the director of the WPA art projects, called it the "American myth."[16] In the 1940s, that search was expanded to the universal. Rothko called this search "myth-making" and for him the Persephone myth of perpetual renewal after death was central. The Passion of Christ with its triumphal resurrection after suffering and death was another popular version of this concept with Newman's *The Stations of the Cross* series of 1957 to 1966 its maturation and completion. This idea eventually evolved into myth of the indomitability of humanity in the face of disaster. It is now a commonplace, typified by the book jacket blurb on Primo Levi, in which Levi, a Holocaust survivor, is taken to represent the triumph of the human spirit in spite of all adversity: "*Survival in Auschwitz* is Levi's classic account of his ten months in the German death camp. . . . a lasting testament to the indestructibility of the human spirit."[17] Perhaps the *Chicago Tribune*, also cited in the book, condensed the myth in the fewest words – "A triumph over the experience of Auschwitz."

In the end, abstract expressionism is not history painting by conventional definitions, yet it is not merely a generic art expressing only universal principles or the autobiographic. It is a modern imaginary art shaped by history, alluding to it, taking a position in it, and transforming it into modern religious-philosophical thought and stance. It uses spiritual images to express moral ideas, and the standards of history painting – historical psychology, powerful feeling, moral suasion, and compositional drama addressed to a knowing, educated audience – survive in it. Abstract expressionism set the historical and psychoaesthetic temper of its time into modern form, thought, and drama with its marvelous weaving of contemporary events, ancient and tribal forms, and universal values.

Ironically, great history painting had been celebratory. Abstract expressionism is not. It is sublime and tragic, lifting contemporary history into new but ancient forms of allegory and myth in themselves.

Revival, Reflection, and Parody
History Painting in the Postmodern Era

Mark Thistlethwaite

In 1953 Larry Rivers shocked and infuriated artists and critics alike when he exhibited a large figurative work entitled *Washington Crossing the Delaware*. The painting was, in Rivers's words, "cordially detested"[1] and baffled its audience who did not know whether the artist's gesture was ironic, serious, or insipid. Today, forty years later, scores of artists turn to history – secular, religious, imaginary – for their subjects, without encountering the intense hostility and negativism Rivers suffered. Joyce Treiman, Roy Lichtenstein, Earl Staley, Jerome Witkin, Audrey Flack, Peter Saul, Robert Colescott, Mark Tansey, Sue Coe, and Terry Allen are just a few of many who have created works that possess to varying degrees characteristics and aims traditionally associated with history paintings. What accounts for the revival of a mode of art seemingly buried by modernism? The (un)easy answer is "postmodernism." Postmodernism has accommodated and encouraged history painting far more readily than modernism ever did or could.

Throughout the modern period, history painting has generally been perceived as, at best, a retardataire genre. Certainly realizing this, Rivers partially intended his *Washington Crossing the Delaware* as a combative gesture: "It was a way for me to stick my thumb out at other people . . . [and] saying I'm an artist and I'm jumping into the ring."[2] Like Robert Rauschenberg's *Erased de Kooning Drawing*, also of 1953, Rivers's work announced the artist's entry into art history at the height of modernism by challenging the mythic aspirations of abstract expressionism. For the modernist, the concept of history painting – narrative, figural, didactic – seemed woefully outmoded and outdated.[3] History painting appeared old-fashioned, implausible, and inappropriate to the industrialized modern age and ill suited to capture the essence of modern life, delineated early on by Charles Baudelaire as "the fleeting, the transitory, the contingent."[4] Instead, modernism privileged photography with its seductively authentic sense of realism as "the" medium for capturing the veristic aura and immediacy of the contemporary historical event; "Photographs are the popular historicism of our era; they confer nothing less than reality itself . . . historical knowledge declares its true value by its photographibility."[5] Additionally, modernism rejected the legitimacy of a hierarchy of genres that situated history painting at the top because, as Robert Rauschenberg succinctly asserted,

"There is no poor subject."[6] Finally, modernism's emphasis on individualism, originality, and innovation undermined history painting's seemingly basic characteristic: the depiction of the past.

These factors – the advent of photography, the collapse of the hierarchy of genres, and the "tradition of the new" – subverted history painting's viability while reinforcing the avant-garde perception that history painting was, appropriately, dead. Although modernism severely undercut the mode's tradition and stature, it could not entirely dispose of it: Jacob Lawrence, Diego Rivera, and, to a degree, Thomas Hart Benton, modernized the genre, while the abstract expressionists evinced an elevated ambition akin to that of earlier history painters. As Karl Kroeber has sensibly pointed out, "One's analysis of the fate of narrative art [i.e., history painting] in modern art, then depends very much on which artists one chooses as exemplary."[7] Still, modernism's "anti-ideology ideology" effectively opposed the narrative,[8] until a revived concern and exploration of history painting emerged in the early 1960s as modernism began to give way to postmodernism.

Virtually every discussion of postmodernism commences by attempting to define it while lamenting the difficulty and futility of such a endeavor; no agreed upon meaning yet exists. This is to be expected because the postmodern condition embraces, in Jean-François Lyotard's term, an "incredulity to metanarratives" and so to define postmodernism would be, contradictorily, to create a metanarrative.[9] I employ the term to signal a historical moment – 1960+ – and an attitude, not a style. "Postmodernism" signifies "[that] across a broad range of cultural manifestations a massive reexamination of Western discourse is underway."[10] A "transformative discourse," postmodernism modifies modernism's penchant for reductivity, exclusivity, and the tradition of the new with pastiche, popular culture, and an encompassing "non-historical treatment of time."[11] Postmodernism accepts and expects "discontinuity, incompleteness and paradoxes."[12] Despite, or perhaps because of, its elusiveness and the dense and often arcane poststructuralist (especially, deconstructionist) theories and postindustrial/late capitalism criticisms that underpin much postmodernist thought, the term has undeniably entered daily public discourse. For example, within a three-day span in 1992, *The Dallas Morning News* chronicled Parisian fashions in an article titled "Under Deconstruction" and reviewed a new staging of Corneille's neoclassic 1636 comedy *The Illusion* as "a beguiling, postmodern magic act" and as "exemplifying the best of the postmodern enterprise: It appropriates history with a nonchalance, reconfiguring old fragments into fresh wonders."[13] This ready acceptance of postmodernism with its casual sense of history also colored a *New York Times* writer's characterization of historians as "socially acceptable spin doctors."[14] Such familiarizing of history occurs at a moment when some people declare the end of history.

In the postmodern era, history is clearly a contested and unclear notion. Critiquing and rebuking the concept of history as a grand narrative (or metanarrative), postmodernism regards history as a multitude of fictions that tells us as much about history as about its writers and the linguistic conventions

they employ. Although not a uniquely postmodernist point of view – for instance, the modernist E. H. Carr partially argues for this notion in his *What Is History?* (published, tellingly, in 1961, at the beginning of the postmodern era) – postmodernism emphatically privileges this view of history. Hayden White, whose writings have shaped much of the postmodern discourse on history, characterizes historiography as "a form of fiction-making," while asserting that

[s]ince no given set or sequence of real events is *intrinsically* "tragic," "comic," "farcical," and so on, but can be constructed as such only by the imposition of the structure of a given story type on the events, it is the choice of the story type and its imposition upon the events that endow them with meaning.[15]

Engendering this perspective, postmodernism interrogates notions of historical narrative and truth, which has led to writing that blurs the distinctions between fact and fiction while foregrounding the author as constructor-creator. A striking example is Simon Schama's 1991 *Dead Certainties,* "a work of the imagination that chronicles historical events" and plays "with the teasing gap separating a lived event and its subsequent narration."[16] Although questioning the relationship between "fiction" and "history" is not new, this active merging of the two is, and is indicative of postmodernism's willful, and frequently playful, blurring of boundaries.

In *Metahistory* – "the most revolutionary book in the philosophy of history over the past twenty-five years" – Hayden White regards all history writing as fundamentally ironic.[17] "Irony" along with "paradox" and "parody" are basic elements of the postmodernist view in general. These traits, for instance, characterize one of the seminal art writings of the postmodern era, Robert Venturi's *Complexity and Contradiction in Architecture.*

In this "gentle manifesto," Venturi essentially offers a postmodernist creed:

I like elements which are hybrid rather than "pure," compromising rather than "clean," distorted rather than "straightforward," ambiguous rather than "articulated," perverse as well as impersonal, boring as well as "interesting," conventional rather than "designed," accommodating rather than excluding, redundant rather than simple, vestigial as well as innovating, inconsistent and equivocal rather than direct and clear. I am for messy vitality over obvious unity. I include the non sequitur and proclaim the duality.

I am for richness of meaning rather than clarity of meaning. . . . I prefer "both-and" to "either-or," black and white, and sometimes gray, to black or white.[18]

Venturi's manifesto was directly affected by pop art, the movement that signaled the birth of postmodernism in the visual arts.

Pop art eschewed the highly personal, romantic, and esoteric images of abstract expressionism in favor of representations of the familiar and commonplace; viewers may not have known what Andy Warhol intended when he depicted a Campbell's soup can, but at least they knew what it was. Pop ques-

tioned and challenged the tenets, originality, and individualism of modernism and, in doing this, pop adopted an ambivalent and ironic stance: Did pop represent an outright rejection of modernism or an avant-garde pushing art even further? Did it celebrate or condemn the consumer society that it embraced/critiqued? Pop's sense of inclusivity and its deliberately ambiguous attitude appear forcefully not only in Venturi's book, but also in Claes Oldenburg's 1961–2 "I am for an art . . ." statements: "I am for an art that is political-erotical-mystical, that does something other than sit on its ass in a museum. . . . I am for an art that takes its form from the lines of life itself, that twists and extends and accumulates and spits and drips, and is heavy and coarse and blunt and sweet and stupid as life itself."[19] Such openness reverberates in Andy Warhol's 1963 view on pluralism: "How can you say one style is better than another? You ought to be able to be an Abstract-Expressionist next week, or a Pop artist, or a realist . . . an artist ought to be able to change his style without feeling bad. . . . And I think that's what's going to happen, that's going to be the whole new scene."[20] The words of Venturi, Oldenburg, and Warhol, along with their art, announced postmodernism in the visual arts. The modernist elevation of the integrity and authority of the artist's personal style began to give way to the postmodernist questioning of uniqueness and its acceptance of a multiplicity of styles.[21]

Pop's sense of ambiguity, openness, and irony permitted the possibility of history painting. For instance, James Rosenquist's *F-111* (1965) exemplifies the reemergence and restructuring of history painting. The huge painting – longer than the 86-foot-long fuselage it depicts – surrounds the viewer on three walls and pushes to an extreme the abstract expressionist commitment to environmental painting engulfing the viewer. Rosenquist's composition offers a compendium of forms and references to contemporary society. Like a traditional history painting, the work depicts an image of significant human accomplishment – the plane and the promise of technology. It also exemplifies the conception of history painting that arose in the nineteenth century which understood, as Gustave Courbet did, historical art to be contemporary art. Unlike past history paintings, however, *F-111* denies or subverts the mode's coherent narrative structure. Rosenquist's kaleidoscopic painting demands an active involvement of the viewer in piecing together elements of the composition. This is not to say that the work is a rebus in which all the elements ultimately click into a coherent statement, rather to indicate that viewers are encouraged to provide their own interpretations of the "laminated realities" that Rosenquist offers.[22] The dynamically open-ended work derives from the fragmentation, overlapping, and simultaneity of cubism, "the" style of modernism, and directly extends the topicality found in Picasso's collages. Not truly cubist, Rosenquist's work parodies cubism in the sense in which Linda Hutcheon identifies "parody" with postmodernism: repetition with critical distancing which signals ironic differences.[23] Created at a time when a formalist understanding of cubist works reigned, Rosenquist's composition ironically politicized what was thought to be cubism's neutrality. In a century in which

cubism both captures and conditions our way of seeing and at a historical moment in which it increasingly appears that the "center will not hold," Rosenquist's *F-111* offers a significant example of the form that history painting can take. As did pop art generally, Rosenquist's work with its discontinuous, interpenetrating, and inconclusive narrative profoundly shaped postmodernist painting (for instance, that of David Salle).

The pop artist who most affected postmodernism and who most obviously functioned as a history painter was Andy Warhol. Much of his work, especially the *Race Riot* and the *Disaster* series of the mid-1960s, falls easily into the category of history painting. These compositions not only chronicle their time, but suggest didactic messages, although these remain open to various interpretations. Especially striking as history paintings are Warhol's images dealing with the assassination of John F. Kennedy, by way of focusing on his widow. Taking a photodocumentary stance, these compositions picture Jacqueline Kennedy in somber colors – blues, grays, pale golds, and blacks – to convey a powerful sense of loss and tragedy. Yet, typically pop, Warhol both subverts and extends meaning through compositional repetition and his title.

The silk-screened photographic reproductions that form the basis of Warhol's compositions raise issues of how we perceive and conceive of contemporary history. In the twentieth century, the photograph occupies pride of place as the authoritative mode of capturing reality. Through his repetition and manipulation of the image, Warhol questions this authority by reminding us of a photograph's lack of uniqueness. He asserts the reproductive nature of photography by repeating the image, which raises profound and endlessly debatable questions: Does repetition allow for greater historical knowledge? Does repetition dull our senses to history's importance and significance? Which of the repeated views capture the authentic moment? Does an authentic moment exist? What is an "authentic" moment? Traditionally, history painting chronicled the unique event; through multiple images, Warhol disturbs and confounds this sense of uniqueness while implicitly addressing authoritative imagery in an age of mechanical reproduction. Warhol's repetitive forms also raise questions about "narrative."

Narrative concerns inform much postmodernist theory and criticism. Postmodernism revived the mode by interrogating its nature: What is narrative in painting, how is it conveyed, how does a written narrative differ from a narrative image? Spatially oriented, rather than temporally so, pictures excerpt a narrative or suggest what narratively precedes and succeeds the image. History paintings are inherently narrative; they tell stories, yet, for theorist Wendy Steiner, most paintings, unlike literature from the time of Renaissance, do not convey the essence of narrative: "repetition of identity across time."[24] She argues that pictorial images prior to the Renaissance featured a truer sense of narrativity as the repetition of identity, whereas "post-Renaissance art . . . represents a suspended moment of perception with an 'unnatural' clarity and compression of meaning. . . ."[25] Warhol's work, in revitalizing this older tradition (a tradition, ironically, older than the notion of history painting itself)

fulfills Steiner's criteria. Through the repetitive image of Jackie Kennedy, Warhol provides a narrative that unfolds over time, differentiating it from post-Renaissance history paintings while linking it to the linearity of reading a book or viewing a film. Karl Kroeber, who disagrees with Steiner's views, nevertheless considers narrative to be a form in which its repetition centers on a narrative's fundamental quality of being retold. Warhol's repeating images of Jackie Kennedy can be seen then to signify the continual retelling and, hence, renewal of the story of the presidential assassination. Remarkably rich in interpretative possibilities and thoroughly postmodern, Warhol's pastiche composition combines the premodern (Steiner's description of narrative), contemporary (the subject of the work), the modern (photographic reproduction, silk screen, and reference to film), and the postmodern (the narrative parodied).

In focusing on Jackie Kennedy, Warhol also renders history in terms of the celebrity. Although Mrs. Kennedy's demeanor in the aftermath of the tragedy assumed the mantle of the heroic, recalling the bereaved but stoic widow in Benjamin West's *Agrippina Landing at Brundisium with the Ashes of her Husband Germanicus* (1768), she had already attained celebrity status. She had become, as Daniel Boorstin has defined the celebrity, "a person who is well-known for his [sic] well-knownness."[26] By titling works *Jackie (The Week That Was)* and *16 Jackies* (1964), Warhol familiarizes the heroine and reinforces her celebrityness. Such titles, along with the compositions' repetitive forms, popularize the historical, but consequently diminish the event's uniqueness and authenticity. In Warhol's hands, and in those of many postmodernists who follow him, history becomes as familiar, celebrity driven, and personal as the latest "news" on the television show *Entertainment Tonight*.

The popular success of the pop artists, who were initially also called the "New Realists," generated a new interest in narrative art. The 1970s witnessed a revival of portraying historical moments, which related undoubtedly to the interest in the history of the United States sparked by the Bicentennial celebration. Further, the increasingly widespread acknowledgment and acceptance of postmodernism's inclusivity sanctioned narrative painting. One sign of this change was a 1977 *Artforum* article titled "Notes on Narrative and History Painting." It is hard to imagine such an essay appearing in the preceding two decades, as its author, Sidney Tillim, acknowledged: "There was a time when I did not think it possible to represent George Washington *seriously*, but under the impetus provided by certain current events I found it entirely plausible."[27]

Tillim, who defines history painting as "representational painting with a particular cultural imperative," argues that history painting is possible at a time "where the underlying beliefs of society are changing, a didactic morality provides the security once implicit in tradition."[28] Tillim's own paintings of this time focused on minor and unfamiliar incidents from the colonial period, such as *John Adams Accepts the Retainer to Defend the British Soldiers Accused in the Boston Massacre* (1974). The small-scaled, detailed character of his figures more closely resembles magazine illustrations than the idealized, heroic imagery of eighteenth-century or nineteenth-century painting. Two contemporaries of

Tillim who succeeded in resurrecting the more traditional manner of history painting are Alfred Leslie and Jack Beal.

During the 1950s, Alfred Leslie participated actively in the abstract expressionist scene, yet, in the early 1960s, he shifted his interest to figuration. The death of his friend the poet-critic-curator Frank O'Hara in July 1966 and the total destruction by fire of his New York studio and the resulting deaths of several firemen in October of the same year led the artist to commence an important cycle of five large paintings. This series, which occupied him from 1967 to 1978, focused on the death of O'Hara, who was struck by a jeep taxi at night on Fire Island. The artist indicated that the paintings, known as *The Killing Cycle,* were intended as a memorial to O'Hara. The images aim to convey bravery, tragedy, and sacrifice, as well as to comment on the stupidity of contemporary life while affirming the artist's own Christian beliefs.[29] The very ambitiousness of the project – literally and conceptually – testifies to its connection to past history painting and to what Leslie sees as the moral imperative of the abstract expressionists. Leslie has stated that these painters with whom he was so familiar "remind me of the great artists who lived in the past (Caravaggio, David, West, Copley, Cole). What I learned from them was not stylistic, but moral. They taught me the moral obligations of an artist to art, they taught me to be a reformer like they were."[30] Unlike Tillim's figures, those of Leslie take on heroic proportions, often appear close to the picture plane, and recall, in their theatricality, baroque painting. Although denying a conscious influence, Leslie's work, especially *The Loading Pier* (1975), shows a clear affinity to, if not the direct influence of, Caravaggio's *The Entombment of Christ* (1602–4). Discovering the striking relationship to the baroque master's image after completing *The Loading Pier,* Leslie remarked,

Had I realized the strong resemblance to the Caravaggio, I would have changed it, because it was too strong and pulled the painting off into another direction. Had I realized it then, I would have seen that people would have thought that Frank O'Hara was like the figure of Christ . . . or a fallen hero. That would be the last thing in the world that I would have wanted to come into the picture. . . .[31]

That Leslie did not alter the painting's composition allows it to be read as an example of the kind of historicizing and appropriating – subconscious, perhaps, in this case – of art history frequently occurring in postmodernist painting. Indeed by 1969, Leslie clearly thought of his work as postmodern.[32] Leslie has indicated that he referenced Joshua Reynolds's style in *The Accident* (Fig. 61). Reynolds, the first president of the Royal Academy in London, argued for the supremacy of history painting in the grand manner, and Leslie's heroically scaled and dramatically lit figures continue the mode. His figures, which usually seem to be capable of only ponderous movement, do convey a powerful sense of presence as they directly confront the viewer. The artist has asserted repeatedly that his paintings are intentionally confrontational in order to influence people's conduct. Clearly, Leslie aims to revive and extend the tradi-

tion of history painting, yet, in his desire to achieve what he calls "theatrical realism," he imbues his figures with a specificity quite distinct from Reynolds's admonishment to render generalized, idealized forms.[33]

The five-composition configuration of *The Killing Cycle* resembles earlier cycles of American history paintings, such as Thomas Cole's *Course of Empire* (1836) and *Voyage of Life* (1840). Leslie's series begins with the vertical format of the *Narrator* (1973), then moves to three horizontally oriented canvases – *The Cocktail Party* (1967–8), *The Accident*, and *The Telephone Call* (1971–2) – and concludes with the vertical *The Loading Pier*. The vertical compositions frame the cycle and provide a sense of entry and closure. Although the compositions can hang as individual works, the narrative aspect of *The Killing Cycle* succeeds best when viewed as an ensemble. The one painting that most depends on the others for its meaning, yet also sets the tone for the whole group, is the *Narrator*.

The *Narrator* shows Leslie himself, holding a sheet of paper, looming large before the spectator. Not only does the inclusion of a narrator carry theatrical and literary allusions, but, as a self-portrait, also implicates the artist as an active agent in the story. Leslie acknowledges his role in interpreting and presenting history, both to his audience – who witnesses him embedded in the narrative cycle – and to himself. He was, after all, confronting himself while painting himself. Such self-reflexivity typifies postmodernism. In the *Narrator*, Leslie privileges himself as a participant and interpreter of history. Such blatant

FIGURE 61

Alfred Leslie. *The Accident.* 1969–70.

The Saint Louis Art Museum. Collection of Mr. and Mrs. Robert Orchard.

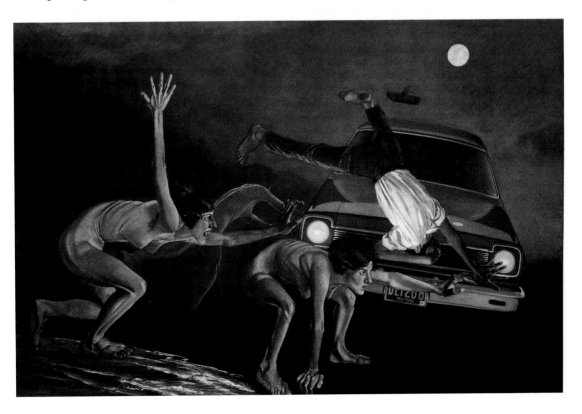

personal identification and inclusion rarely occurs in earlier history painting, although artists have included family members, as did Benjamin West in *Penn's Treaty with the Indians* (1771–2) and John Singleton Copley in his *The Death of Major Peirson* (1784), and Grant Wood used his own house in *Parson Weems' Fable* (1939), a work that also presents a narrator at the front of the picture plane directly engaging the viewer. The dramatic and obvious appearance of the artist as narrator, however, appears patently postmodern in its emphasis on the personal. Like postmodern historiography, the *Narrator* emphasizes the artist/author as the creator of a particular piece of fiction. By presenting the narrator confronting his audience, the painting also dramatically visualizes Karl Kroeber's description of narrative as "the discourse of encounter."[34]

The desire to elevate art that clearly characterizes Leslie's work also occurs in Jack Beal's work of the mid-1970s. Declaring, "Aesthetics isn't everything" and ceasing his abstract-oriented figurative compositions of the 1960s, Beal concerned himself with art that "should point a path toward a better way."[35] Like Leslie, he asserted that the artist must strive to be an important moral force in society. His 1977–8 series of six large paintings depicting contemporary personifications of virtues and vices manifests this elevated intention, as does a mural project treating the subject of labor.

In 1974 Beal received a commission through the General Services Administration Art-in-Architecture program for murals in the new Department of Labor building in Washington, D.C. Titled the *History of Labor,* the work consists of four panels, each measuring about 12 feet square, depicting colonization, settlement, industry, and technology. In this cyclical history, labor moves from seventeenth-century heroic activity to twentieth-century work that portends inevitable destruction. Despite its pessimism, Beal aims to affirm the value of hard work. The general idea of this cyclical series recalls Cole's *Course of Empire* (1836), which offered a cyclical view of civilization from the Savage State to Desolation. Beal's work also resembles paintings by Thomas Hart Benton and various regionalist-influenced murals created under the aegis of the Works Progress Administration (WPA) during the 1930s and 1940s. Like Benton's work, Beal's compositions feature jostling forms that result in relentlessly dynamic images. That Beal's work so readily recalls an earlier style affirms his postmodern acceptance of the past.

A regionalist sensibility also resonates in much of the work of Roger Brown. From the 1970s through today, Brown has been one of the most committed and consistent history painters by rendering a tremendous variety of subjects that include President Richard Nixon at the Great Wall of China, the disaster at the Three Mile Island nuclear power plant, the Attica prison riot, and the assassination of John F. Kennedy. Similar to Benton and Grant Wood, Brown utilizes a highly mannered style. Like Wood in a work such as *Midnight Ride of Paul Revere* (1931), Brown employs stylized and decorative forms, which often result in content being overwhelmed by style. If postmodern art is, as some see it, a new mannerism, then Brown's work is paradigmatically postmodern. Brown's stylistics lead often to paradoxical or ambiguous con-

tent, to which the viewer responds uncertainly. In essence, Brown's style mutes, even undermines, the significance and impact of the event he portrays. This subversion is particularly striking and ironic because Brown, whose art evolved out of the aggressive forms of the Chicago imagists, characteristically renders scenes of great violence. Although violence seemingly represents for Brown the essence of history, his mannered way of depicting the "slaughter-bench of history" aestheticizes the violence. His stylized images reflect ironically how our society sanitizes and accommodates violence. The viewer's uncertainty as to the appropriate response – smile, cringe, sigh, and so on – to Brown's visually delightful images of profoundly disturbing subjects typifies postmodern openness. Much less paradoxical is the work of Leon Golub.

An artist not usually associated directly with postmodernism, Golub gained wider recognition due to the favorable climate of postmodernism. Golub, like Alfred Leslie, successfully reflects and extends the tradition of history painting in the grand manner. This is perhaps a strange claim given the lack of idealization characteristic of Golub's figures, yet his use of generalized figures of a heroic size and scale in dramatic narrative situations warrants the assertion. The artist admires nineteenth-century history paintings for their dramatic flair in putting "events on stage."[36] He appreciates Jacques-Louis David's efforts to "create public art" and he views his own paintings as part of a public vision "trying to make transparent what are the effects of power in our society."[37] Violent in imagery and technique, Golub's often colossal compositions are shockingly grotesque and overtly moralistic and didactic.

Although generalized, Golub's figures thematize an aggressively disturbing reality suggestingly specific to link them to mercenaries and death squads and to events in Vietnam and El Salvador, as well as at home. Indeed, the artist later retitled the *Assassins* series of 1972–3, *Vietnam*. As in traditional history painting, the general and the specific interwine to image the topical and timeless. The extraordinary impact of Golub's compositions results from their large size, their violent and disturbing subject matter, and their roughly handled form (Fig. 62). Golub, like Jackson Pollock before him, often works with raw canvas laid on the floor. After building up an image with acrylic paints, he pours solvent over it and then scrapes and gouges it with a meat cleaver. Hacking out parts of the canvas and hanging it without stretcher bars, Golub imbues his work with a crudity and violence appropriate to the subject. The artist's technique not only mirrors the aggressive nature of his subject matter, but also evinces the influence of Jean Dubuffet's *art brut*.

Dubuffet's roughly worked primitivistic images and his fascination with and collection of art of the insane have powerfully affected Golub. This influence along with his highly individualized technique and style affirms Golub's essential romantic sensibility. He has stated that while admiring David's aim, "I'm not in sympathy with that clean Neoclassical look . . . Romanticism is more open-ended. Meaning is experience, not just handed down from on high."[38] Golub's images parallel the romantic expressiveness and moral indignation of Francisco Goya's *Execution of the Third of May, 1808* (1814) and *Disasters of War*

prints (1820/1863). Although Golub often relies on photographs and mass media sources not available to Goya, both artists convey the corruptive and violent consequences of power in a way that assaults the viewer's imagination. As in traditional history painting of the grand manner, Golub's big work with its large-scale figures affects the spectator both emotionally and intellectually. The visceral images shock, even repel, while provoking the observer to wonder at the human capacity for inhumanity. The spectator's "both-and" response parallels Golub's own conception of his creative self as "the perpetrator, the victim, the voyeur, and the orchestra leader."[39] Golub's acceptance of a state of multiphrenia aligns with psychologist Kenneth Gergen's analysis of postmodernism's "saturated self."[40]

A self saturated in history describes Peter Dean and charges his paintings. Since the early 1970s until his death in 1993, this artist rendered subjects drawn from political and social history that depict the Vietnam War, murders in New York City (including that of John Lennon), the assassinations of Abraham Lincoln and John Kennedy, and parades honoring the pope and an astronaut. Superficially, his various series of large expressionist images – especially those relating to the Vietnam War – resemble those of Leon Golub. However, Dean's densely packed, wildly colored, bizarre scenes differ significantly, as the painter has indicated: "My Vietnam paintings are not anything like Leon's. His are more specific; mine are more fantastical. There is a Dragon Lady in the painting [*Saigon Holiday*, 1972], and a winged man with guns on his wings. I wanted to deal with the war but not in a literal sense."[41] Dean's paintings feature a more idiosyncratic, often humorous and highly personal view of history, which recalls, at times, the work of pop artist Red Grooms.

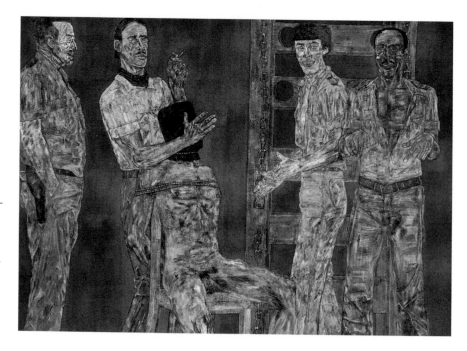

FIGURE 62

Leon Golub. *Interrogation II.* 1981.

The Art Institute of Chicago. Gift of the Society for Contemporary Art. Photograph © 1993, The Art Institute of Chicago. All Rights Reserved.

Emotionalism, fundamental to expressionism, coupled with postmodern self-consciousness characterize Dean's form and content. For instance, Dean writes of his representation of the murder of John Lennon, *Death of a Folk Hero* (1981), "It upset me to see a fellow artist wantonly killed so I painted the event."[42] This work forms part of the *Assassination Series*, a body of work resulting, largely, from his serving on a New York grand jury and hearing thirty-two murder charges. The artist's account of the origins of another series – the *Personal Event* pictures – further exemplifies the highly personal character of this artist's interpretations:

In 1979 Pope John actually came down Spring Street – where I live in New York City on the edge of Little Italy. He gave me a little rabbit sign and a big smile. There weren't many people on the street, mainly because it was raining like crazy. Pope John was the Polish Pope which is why the little Italian ladies didn't come out to see him. They should have been out there even in the rain, but they were watching on TV – I checked later.

When the Pope gave me the sign it triggered me to start the Personal Event series. I had painted personal events before but the new series was about things that actually happened to me or my friends. I had been painting landscapes for the last two years and I needed to get back to figurative work. The Pope did it. He inspired me. He was very friendly.[43]

Dean's interweaving of the personal with contemporary and past history appears also in his 1983 painting *Massacre, Boston – El Salvador*, about which he said,

I believe that all contemporary revolutions are patterned after the American Revolution – a revolution based upon the most radical ideas. The ideas of our founding fathers were so advanced, so progressive and so brilliant that, by comparison, our leaders today are counter-revolutionaries. Guys like Thomas Paine and Thomas Jefferson would not be invited to sit down to dinner at the White House. . . .

In this painting the Sandinistans are wearing masks because this is a modern revolution in a small country. Photography has become a weapon. Their pictures could be taken and later used to identify them. . . . The helicopters signal that it is a modern event but I believe that history is repeating itself in Latin America. . . . I used Jackson Pollock's dribble technique for gun fire. It creates a sense of confusion and allows the eye to follow the bullets. Pollock has always been important to me because he makes the viewer's eye move very erratically around the canvas. Even de Kooning's paintings are read in the traditional Renaissance way. My paintings read like Pollock's even though they are figurative. The eye jumps around picking up a bit of information here, a bit more there.[44]

This bouillabaisse of names – the American Revolution, "guys like Thomas Paine and Thomas Jefferson," Sandinistans, photography, helicopters, Pollock, and the Renaissance – wonderfully exemplifies the fluid, inclusive, and pastiche nature of postmodernism. Likewise postmodern is Dean's sense of history as personal, quirky, and synchronic.

Similar traits characterize Alfred Quiroz's renderings of World War II, the Vietnam War, the Grenada invasion, and Columbus's "discovery." Looking like they bounded out of underground comics of the Vietnam era, Quiroz's garishly colored, eye-popping figures enliven his satirical tableaux on war, racism, and power. The riotous humor of the works is broad and biting; one of the images from his "Happy Quincentary Series" is titled *Columbus Introduces Eurocentric Philosophy to America*. To propel his visual narratives, this artist sometimes employs a repeated figure.

His *Awdee Aw-dee* (Fig. 63) portrays World War II's most decorated soldier – Audie Murphy – in a tripartite format that casts him as actor, military hero, and concerned citizen. Although each portion of the composition forms a discrete episode, the work achieves unity through its overall style and the recurrent image of the man and his gun. In the left section, Murphy the actor of B westerns waves his six-shooter before a camera, in the central portion he sleeps with service revolver in hand while uneasily dreaming of his wartime heroics, and on the right side smiling Citizen Murphy leads police on a drug bust of hippies. A movie camera, *Life* magazine cover, and newspaper headline mediate Murphy's entry into popular consciousness. In each section of the painting, a large gun is physically and, one imagines, psychologically inseparable from Audie Murphy and constitutes a major attribute of whatever role he plays. Quiroz's focused attention on a man and his gun provokes questions and concerns not only about Murphy, but also about a society in which individuals and weapons are so intimately connected. In *Awdee, Aw-dee,* as in his other paintings, an out-of-control atmosphere colors Quiroz's view of history as comical, but deadly serious. Similar to the work of Peter Saul, Quiroz's raucous and boisterous history paintings achieve a satirical force through their

FIGURE 63

Alfred Quiroz.
Awdee, Aw-dee.
Medal of Honor
Series #11. 1987.

Collection of the artist.

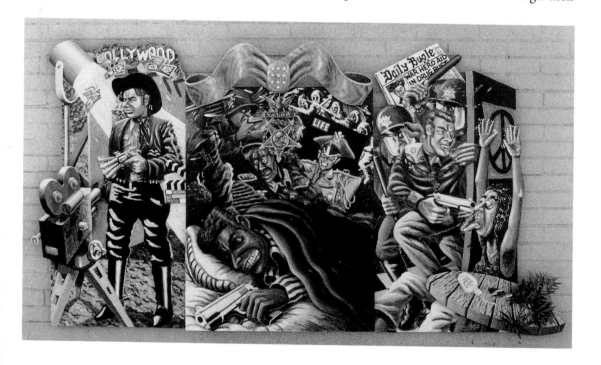

claustrophobic edginess. Quite different in manner, but no less postmodern, is the somber, more contemplative image of Christopher Brown.

In work begun in 1989, Brown has utilized Civil War photographs as points of departure for his painterly compositions. Earlier, the artist had created compositions based on Thomas Eakins's paintings of professional oarsmen. In that series as in the recent one, Brown combines realism and abstraction. A particularly striking example of this occurs in *November 19, 1863* (Fig. 64).

This large painting – measuring 104 inches square – depicts a randomly dispersed crowd rendered in a loose, expressionist fashion. As viewers, we peer down on people who appear to be milling about. Insufficient detail is given to the figures – they are slightly out of focus – to identify them, although some appear to wear military uniforms. The tilted perspective, the painterliness, and unfocused figures generally recall impressionist compositions, and, as such, predispose the viewer to regard the scene as an evocation of the past. Given the date "1863" in the title and the military uniforms, the picture presumably relates to the Civil War. The title parallels the visual image in being both specific and cryptic. Few viewers probably recognize the significance of the title; it is the day that Abraham Lincoln delivered his Gettysburg Address.

Brown's image relates to a photograph of the event taken at considerable

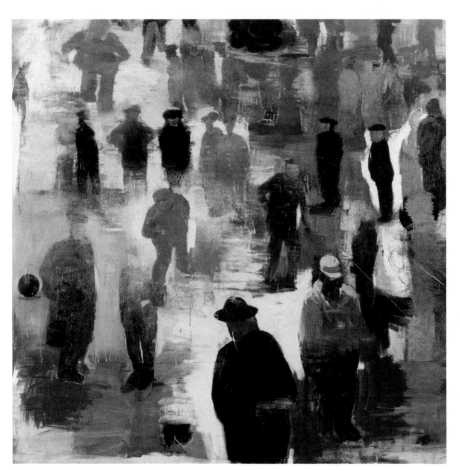

FIGURE 64

Christopher Brown. *November 19, 1863.* 1989.

Collection of the Modern Art Museum of Fort Worth. Museum Purchase, The Anne Burnett and Charles Tandy Foundation Endowment Fund.

distance from the speakers' platform. Lincoln is indistinguishable in the huge crowd we see from behind, except for a few stragglers who incongruously and self-consciously face the camera. Brown's painting emphasizes these figures and even more than the photograph distances the "great moment" by putting it outside the frame. Brown plays off the photograph by not focusing on Lincoln, which underlines the oftentimes ordinariness of history as it occurs. *November 19, 1863* confirms the postmodern attitude that history is not constructed of grand narratives, but of smaller incidental and accidental episodes. History becomes history only when ordered as such. Here the artist's title brings historical sense to a random crowd and its narrative.

In its genrelike quality, *November 19, 1863* extends a nineteenth-century interest in rendering history not as extraordinary, but as ordinary. Brown's composition achieves, however, a randomness far surpassing that of earlier genre-influenced history paintings. Different also from earlier history paintings is the point of view that Brown assigns the spectator. The artist elevates and distances the viewer to signify a literal and metaphorical "view of history." This, coupled with Brown's unfocused imagery, acknowledges and exemplifies history as something perceived from a particular perspective. A similar interest in emphatically structuring compositions to remind viewers that history is known from particular angles of vision, as well as through various narrative modes, occurs in the art of Dotty Attie and Deborah Small.

Since the mid-1970s, Dotty Attie's work has taken the form of intimate fragments of recognizable premodern paintings arranged horizontally and sequentially. Like a number of other postmodern historicizing artists – including Mark Tansey, Robert Colescott, and Russell Connor – her works appropriate and comment on art history. Unlike others, she includes with her fractured visual imagery a written narrative that, by not directly corresponding to what is seen, becomes both allusive and elusive in nature. In a recent work, *An Eminent Painter* (1989), Attie arranges the thirty-six parts of the composition – based on John Singleton Copley's famous history painting *Watson and the Shark* (1778) – to resemble a segmented framed painting accompanied by museum wall texts.

At the center of her work, Attie arranges sixteen fragments focusing on the central violence shown in the Copley: the shark attack, the intensely expressed efforts of the rescuers, and the desperately reaching hand of Watson, thrice rendered. Four corner squares provide a narrative concerning Copley, not Watson, and the precarious position in which the impending Revolution placed him. Copley's father-in-law was a Loyalist merchant whose tea was famously dumped into Boston harbor. Under competing pressures of family and career, Copley acted as an intermediary between opposing political factions; the upper-right-corner square states, "His son-in-law, John Singleton Copley, who, mindful of his place as the most eminent painter in the colonies, strived to remain friendly to both sides, was unable to refuse the role of mediator." The next panel to be read – in the lower left – states that after the tea was thrown in "Copley's failure was evident." Having failed in his diplomatic role

and "Despite his fear of the sea, Copley realized that it was at last time to pursue his studies abroad, and taking leave of his wife and children, hastily sailed for England." This final panel implicitly ties Copley's fear of the sea to the shark attack on the swimming Watson, while laconically suggesting the sense of desperation that characterized Copley's escape to England.

Attie's written narrative, along with painted panels of picture moulding, frame her appropriation of the Copley painting. Attie's incorporation of these panels appears to be, in part, a parody of museum wall texts and their sometimes suspect relationship to the works they describe. In *An Eminent Painter,* the written narrative relates only suggestively to the visual narrative, yet complements it as a parallel text and prompts the viewer to synthesize image and text into still another narrative. With its openness of narrative(s) and physical arrangement (space between every panel), Attie's *An Eminent Painter* deconstructs and reconstructs Copley and his work. She (re)presents Copley's narrative painting in her own fashion, affirming Kroeber's belief that "all significant narratives are retold and meant to be retold – even though every retelling is a making anew."[45] In her retelling, Attie nudges questions about artistic intention, connections between painters and their works, and the manner in which artworks are presented and read.

This interest in the intersection and clash of text and image – of reading and viewing – conditions much postmodern art. In a number of visually active and intellectually stimulating installations, Deborah Small mines the postmodernist "shifting network of signs, texts and aporias of meaning that draws attention to the interaction of reader/subject and text in fundamental social, material and discursive terms."[46] Her 1991 installation *Our Bodice, Our Selves* impressively exemplifies history painting gone postmodern.

Taking as its theme the captivity narrative, *Our Bodice, Our Selves* merges texts and visual images. In treating this literary phenomenon that emerged in 1682, one wall and part of another include words and images dating from the seventeenth through the nineteenth centuries. Appearing prominently among the many and varied images – which include quilts, book illustrations, engravings – are repeated depictions of the abduction of Daniel Boone's daughter. Adjacent to this is a wall striking in its accumulation of paperback romance novel covers, so-called bodice rippers (Fig. 65). These paperbacks, typically having glitzy, embossed covers, carry titles such as *Savage Dreams, Night Flame,* and *Cheyenne Captive.* Virtually all depict a white woman, with her garment well off her shoulder, swooning in the arms of a heroically muscular Native American male. Interspersed among the covers are details of western landscapes.

Aside from its visually rich and dynamic character, Small's work fascinates and intrigues because of its theme and the social issues it raises about narration, historical interpretation, relationships, and power. Conditioned by the laminated realities of Rosenquist and the repetition and grid format of Warhol, Small's work offers a prime example of postmodern history painting. Here history appears as collage, a modernist invention, but one that seems

essentially more postmodern; Kenneth Gergen, Richard Rorty, and others have described the collagelike character of postmodernism.[47] *Our Bodice, Our Selves* treats history not as a linear progression, but as phenomena fractured, fictive, and available to a variety of interpretations. Small actively orders a variety of competing images without privileging one over another. She links the present and the past, high and low art, and serious social commentary and punning title. Like traditional history painting, Small's large work exhibits a didactic agenda, but, being postmodernist, one that interrogates as much as it inculcates the piece's meaning(s). Her work parallels many of Kroeber's thoughts on narrativity, especially in regard to a story's socially transactive nature (by someone, to someone, about something) and the notion that "narrative is instrinsically evaluative," that is, an effective story appeals to the audience's judgmental powers.[48] *Our Bodice, Our Selves* dynamically draws the viewer

FIGURE 65

Deborah Small. *Our Bodice, Our Selves* (detail). 1991.

into its narratives while sparking judgments about what is said, how it is said, and why what is said matters.

Our Bodice, Our Selves exemplifies both Suzi Gablik's advocacy for a "reconstructive" postmodernism and Richard Rorty's notion of "redescription."[49] Gablik understands postmodernism to have two sides, one deconstructive, the other reconstructive. The former typically dominates, although the two should be complementary. Gablik aims to create "a framework for reconstructive postmodernism which, although less visible in the mainstream than deconstructive art, implicates art in the operative reframing of our entire world view and its Cartesian cognitive traditions."[50] Small's work appears to hold in creative tension both deconstructive and reconstructive dimensions, with the aim of affecting societal ideologies. Her installation *Our Bodice, Our Selves* also embraces Rorty's idea of redescription being an ironist tool to redescribe things to create a new pattern and paradigm; that is, by using the old (e.g., words, images, beliefs) in new ways a new line of questioning and view may be generated.[51] In interrogating concepts of history, power, and feminism in the context of a work that resonates with visual and intellectual rewards, Deborah Small creates one of the most striking and significant postmodern history paintings.

The postmodern era has witnessed, accommodated, and privileged a wide variety of artists engaged in and committed to history painting, a narrative mode of art seemingly buried by modernism. Far more artists could have been included in this overview; however, the artists selected do present a fertile cross section of the qualities and possibilities of postmodern history painting. In spite of their pluralistic styles and formats, the artists examined here share the desire to affect viewers' perceptions and conceptions and to acknowledge the fictive and personal character involved in interpreting, understanding, and using history. As postmodernists, they challenge directly and indirectly the anti-narrative and non-narrative impulse associated with modern painting, and, like Simon Schama's historical writing, aim to "dissolve the certainties of events into the multiple possibilities of alternative narrations."[52] Differing significantly from previous history painters in their approach to style, format, and narration, these postmodern artists do continue, nevertheless, to explore the possibility of narrative pictures to provocatively question, critique, shape, and reshape societal practices, values, and sense of history.

Didactic Intent

<div align="right">

P A R T

III

</div>

Historicity and narrativity do not by themselves suffice for history paint-
ing. Another component must be factored in – the intent to convince, instruct,
moralize. If, borrowing again from Hayden White, all images of the past have
"ideological implications," we should expect history painting to function as
ideological carrier. The following essays suggest this is so. The American Acad-
emy of Art's early-nineteenth-century promotion of history painting is shown
by Carrie Rebora to have been for specific ends: the establishment of good
taste and civic virtue in a young Republic seemingly threatened by the
"masses." However, importance given to didactic message over aesthetic merit
ultimately undermined the Academy's and director John Trumbull's mission.
For without public interest in history painting, public education by means of
that instrument became impossible. Bryan Wolf positions George Caleb Bing-
ham as an ideological painter dealing with "the status of labor" in antebellum
America and regional distinctions in *Boatmen on the Missouri* of 1846. For
Wolf, this painting of river boatmen at work and at play mediates the develop-
ing split between mental (intellectual) and physical (wage) labor, and resulting
class divisions. Wolf takes the labor question further by seeing the artist as
worker/mythmaker who "works" to make his pictorial "work" look like play,
thereby rendering ideology invisible. Other concerns of the uneasy period
before the Civil War found expression in a little acknowledged yet distinctive
group of history paintings that Wendy Greenhouse examines. These depic-
tions of "sympathetic heroines" in conflict with "domineering males" drawn
from the British historical past not only offered fresh opportunities for Ameri-
can painters. They illumined America's past and present in relation to Europe
and Victorian ideals of women's position in society, specifically America's sense
of national superiority and emphatic stress on female domesticity. The pictor-
ial decoration of state capitols constructed around the turn of the century
raised questions of regionalism and nationalism. Emily Cutrer frames her dis-
cussion of these larger issues in an analysis of how Minnesotans' orchestration
of subjects from state history reflected the state's view of its past, and how

Texans' use of "invented tradition" based on historical events constructed their state's identity. The "multiple agendas" behind the mural for Jersey Home-steads, New Jersey, which Ben Shahn painted in the 1930s with the collaboration of Bernarda Bryson, and Shahn's distinctive handling of them are the focus of Susan Platt's essay. She sees the mural not so much as a narrative about individuals living in the New Jersey housing project as an ideological statement about an ethnic group, its immigration, unionization, and coopera-tive living under the New Deal. While meeting the requirements of govern-mental art projects, Shahn managed a subtle yet radical reference to a Marxist interpretation of history. To Patricia Hills, May Stevens tells a "revisionist, fem-inist history" through her paintings – her own in the artistic/intellectual milieu of the second half of the twentieth century, and that of a past political activist and her mother. For the first phase of her history painting, Stevens pictorially referred to the ambitious and controversial work of Gustave Courbet, himself a painter of modern life. For the second phase, Stevens used past historical tex-tual and photographic sources in combination with images drawn from per-sonal memory. Paintings in both phases of her autobiographical series display Stevens's polemical intent and feminist conviction.

History Painting at the American Academy of the Fine Arts

Carrie Rebora

The focus of action in John Trumbull's *The Sortie Made by the Garrison of Gibraltar* (Fig. 66) is the communion of two men. Garrison commander Gen. George Elliot extends his hand in a gesture of assistance to the dying Spanish officer Don José de Barboza, who raises his hand to refuse British aid. When he painted the canvas in 1789 in London, Trumbull hoped to bolster his reputation as a history painter in England and wisely selected a scene of British victory. That General Elliot shares the center of the composition with his enemy is important. Trumbull configured the narrative so as to offer not just an illustration of a historical event, but, as he put it, a scene of "gallant conduct."[1] He intended, in other words, for the painting to be striking even to viewers unfamiliar with the specific battle. This ulterior motive, his desire to represent an instance of noble behavior in spite of dire circumstances, was on his mind when he exhibited the *Sortie* at the American Academy of the Fine Arts in New York in 1828. The exhibition was to be a grand event, in which a single painting revived a dying institution by reminding viewers of the Academy's mission to instill virtue, morality, and gentility in all Americans.

Trumbull's *Sortie* was neither the first didactic history painting exhibited at the American Academy nor the last, but it exemplifies the significant role of history painting at this institution. The concepts that established the Academy found their most compelling expression in history paintings. History paintings revived the Academy early on and were featured in annual and special exhibitions between 1816 and 1836. Without history paintings, it is likely the Academy would have met its demise much sooner than it did. Indeed, history paintings kept the Academy open beyond what might be considered its functional existence.

Trumbull introduced history paintings to the American Academy to augment the collection of plaster casts of classical statues that had been the basis for founding the institution. In December 1802 Edward and Robert R. Livingston, mayor of New York and American minister to France, respectively, invited their friends and colleagues, New York's most prominent citizens, to join them in supporting what they called "the formation of good taste" in America.[2] They raised $4,000 and set up a board of directors. None of the founding members of the Academy, including the Livingstons, had much

experience with the arts, but were taken by the notion that Greek and Roman statues held the strange and wondrous power to instill good taste and moral sense in all who cast their eyes upon them. This myth was not new and certainly not unique to the Livingstons. Around the Western world, casts of classical statues proliferated during the eighteenth and nineteenth centuries. Tourists relished guidebook descriptions and essays by authors as diverse as Diderot and Hogarth, who promoted the influential nature of classical statuary. The amazing authority of these statues rested in their ideal beauty, their association with classical antiquity, and their power to imbue viewers with correct aesthetic taste and moral behavior.

And just as the Livingstons and their friends believed in the magic of the casts, they were captivated by the idea of academies. They selected the name *academy* not because they planned to offer classes or lectures, but rather instinctively, because the name harkened back to classical times. Robert, who was aptly called "the American Cicero," promoted the Academy by comparing New York to Greece, where "citizens improved by the contemplation of Pure

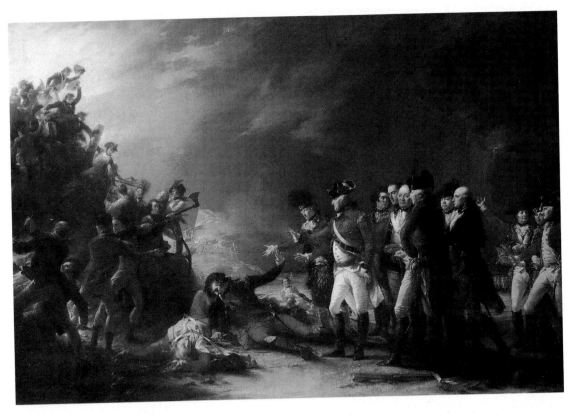

FIGURE 66

John Trumbull. *The Sortie Made by the Garrison at Gibraltar.* 1789.

The Metropolitan Museum of Art, New York. Purchase, Pauline V. Fullerton Bequest; Mr. and Mrs. James Walter Carter and Mr. and Mrs. Raymond J. Horowitz Gifts; Erving Wolf Foundation and Vain and Harry Fish Foundation, Inc. Gifts; Gift of Hanson K. Corning, by exchange; and Maria DeWitt Jesup and Morris K. Jesup Funds, 1976.

sublime models soared above those groveling vices." And Edward promised "that the American Republic, like those of Greece and Rome, will prove another honorable and instructive example of the intimate connection of Freedom with the arts."[3]

All of this language was almost purely rhetorical. Words and concepts that drew connections between the ancient classical world and modern-day America were colloquialisms of the day and, in this case, as in other circumstances, they masked a lack of expertise in painting, sculpture, and the history of art, knowledge of which might be considered essential for leaders of an art academy. Classical rhetoric provided a vocabulary with which to discuss the arts.

Rhetoric also help society's leaders to set themselves apart from the general population. The Academy, in fact, was meant to do the same. Even though Edward Livingston described the Academy as "a public undertaking," he explained that its success depended on "men in easy circumstances."[4] The Academy was just one of many institutions founded during the first decades of the nineteenth century by bankers, doctors, lawyers, politicians, merchants, and other wealthy professionals who thought they could protect their status in the republic they had established by extending their influence to a wide range of subjects. Viewed in general, these institutions exemplify the ways in which noblesse oblige thrived in the early American republic. In other words, the American Academy, the New-York Historical Society, the American Antiquarian Society, the Literary and Philosophical Society, the Lyceum of Natural History, the Pennsylvania Academy of the Fine Arts, the Boston Atheneum, and other societies were established not so much for their purported function as to advance the notion that the city's leaders were responsible for cultivating good taste and strong morals in all men and women. Civic leaders assumed leadership in the fine arts in accordance with the traditional eighteenth-century paradigm of social behavior and its network of obligations and dependencies. Such behavior assumed that lower class individuals would defer to the upper class for leadership and guidance, and that these people would benefit by their actions.

A statement that epitomizes this trend in upper class thinking at the time comes from John Pintard, the principal founder of the New-York Historical Society and a member of the Academy and virtually every benevolent cultural institution in the city. He described New York's lower classes as "composed of malleable stuff, readily susceptible of polish . . . [but] more disposed to catch the vices than virtue of refined society."[5] Such distrust coupled with the desire to protect America from destructive vices was prevalent among the founders of most of the early nineteenth century's cultural institutions. Fear, indeed, might be named as the predominant raison d'être for most of these institutions, fear the great nation of America, so young and so easily threatened by the potential for democracy to run amuck, would be ruined by those Robert R. Livingston so endearingly called "the masses," the "irresponsible, immoderate, and injudicious" masses.[6]

Cultural and scientific institutions in the early national period had basi-

cally two interrelated functions. They made society's leaders feel they were contributing to the enlightenment of American citizens, and they created opportunities for peculiar forms of leadership and dominion. Membership in an academy or athenaeum seems to have been most appealing to individuals seeking to enhance their social role.

Such institutions were crucial to those trying to assert their gentility. By the early nineteenth century, the idea that gentlemen were defined by their birth, family, and wealth had been replaced by the notion that gentility was a product of virtuous behavior and erudition. Thus even landed gentry like the Livingstons, whose societal status would seem secured for generations, felt the need to demonstrate their rank. Learned societies were founded and maintained as bastions for men eager to prove and demonstrate they were gentlemen. For instance, when it was announced Mayor De Witt Clinton would speak at the Academy exhibition reception in the fall of 1816, the *National Advocate* reported that the hall was crowded with people curious to hear the mayor speak on "a theme on which [he] was supposed never to have tried his powers."[7] Clinton's participation in the Academy and other philanthropic societies can be easily linked to his campaign to be elected governor of New York; it was in his best favor to become known as a man of varied and intelligent interests. To the amazement of many, he spoke quite eloquently. He said the Academy was evidence of the "rapid progress of a great moral revolution" and declared it was the responsibility of the city's leaders to guide artists, to teach them "the decencies of life," and to uplift all Americans. He made it clear that he, too, trusted that works of art would somehow weave virtue and morals into the fabric of American life. By this time, however, academic rhetoric was wearing thin with regard to the plaster casts. They attracted so very little attention. At the American Academy nothing was done to encourage artists to study the casts, nor was the collection publicized in any way. The Livingstons had shown them in an old riding ring until about 1811 when they were moved into the ramshackle Government House. In 1815 Clinton had them installed in a makeshift gallery in the old Alms House. They became a joke. Washington Irving bemoaned the forlorn collection of "heroes and heroines" that was supposed to have transformed American life. He recommended that the Academy officers might attract attention to the casts by dressing Apollo in "a pair of scarlet plush breeches," Venus in "a brocade whoop petticoat," and the Borghese Gladiator in "a full suit of general's regimentals."[8]

Irving's solution to the Academy's problems, although offered in jest, was not so far removed from what actually happened. The Academy officers began exhibiting paintings to accomplish the Academy's mission of public enlightenment. They favored history paintings, scenes in which heroes, Christ, saints, and literary characters, usually posed in imitation of classical figures, were put forth as paragons of virtue and moral behavior. As they had put their trust in statues, the officers now put their faith in history paintings. History paintings brought the classical statues to life.

John Trumbull was responsible for this shift in exhibition priorities. The

Harvard-educated son of a former governor of Connecticut, Trumbull was a peer of the Academy members and shared their concern for the proper direction for art in America. What set him apart was his profession. Trumbull was not only capable of leading the Academy, but also exemplified the Academy director's ideal American artist, who dedicated his brush to the highly serious task of celebrating the strength of the nation and the nobility of its citizens. Trumbull could just have been the Academy's star exhibitor in the annual shows, but the better role for him was president. The members elected him in 1817 and reelected him nineteen times, until 1836, when he retired from office of his own volition.

Trumbull recognized that the moralizing effect the directors sought could only be found in paintings where patriotic and virtuous narratives could be clearly, even spectacularly, presented to the public. For the Academy's first exhibition in the refurbished Alms House, he helped the other officers assemble quite a number of history paintings. He submitted twenty paintings to the gallery, including eight historical subjects: *The Death of General Warren at the Battle of Bunker's Hill* (Fig. 8), *The Death of General Montgomery in the Attack on Quebec* (1786), *The Saviour and St. John Playing with a Lamb* (1801), *Christ and the Woman Taken in Adultery* (1811), *Our Saviour and Little Children* (1811), *Lady of the Lake* (1811), *Lamderg and Gelchossa* (1809), and *The Earl of Angus Conferring Knighthood on De Wilton* (1810). These paintings of military officers dying heroic deaths, Christ offering forgiveness and compassion, and literary figures demonstrating filial responsibility and humility so pleased the Academy directors that they paid Trumbull $200. They called it "his reasonable proportion of profits" from the exhibition, but in truth it was a gift, in gratitude for his generosity to the Academy.[9]

The Academy also exhibited two history paintings by Benjamin West, who had been recently celebrated in a biographical essay in the *Analectic Magazine* for July 1816. The writer stated that "[A]rtists such as West embellish all the institutions of society, and bestow an additional charm on our existence. . . . they extend the national reputation: they augment the stock of moral and intellectual pleasure, which ought to form the chief temporal pursuit of every rational being."[10] The officers set their sights on West's *King Lear in the Storm* (Fig. 67) and *Ophelia Before the King and Queen* (1792), paintings on loan to the Pennsylvania Academy of the Fine Arts from Harriet Livingston Fulton, and the only history paintings by West in America. Robert Fulton had placed the pictures at the Philadelphia Academy in 1808 to entice art patrons in that city to commission West for more paintings.[11] David Hosack, the noted surgeon and American Academy director, persuaded Fulton's widow that the collection, which included the paintings Robert Smirke had executed as illustrations for Joel Barlow's *Columbiad* and Raphael West's *Orlando and Oliver*, should be moved to the American Academy, the institution founded by her cousins.

Neither Hosack nor the other Academy directors had seen the paintings. If Trumbull knew them, he did not discuss the appearance or subject matter of the pictures with other board members. What the pictures looked like mattered

much less than the simple fact of their authorship. They were by West, which guaranteed they would be morally compelling pictures. The fact that they were Shakespearean scenes, rather than some more peculiarly American subjects, seems not to have mattered to anyone; the Academy directors probably felt the same way as West himself did about these pictures. The artist did not assign importance to the specific scenes; he studied no more Shakespeare than it took to formulate a composition. The precise stories of King Lear and Ophelia and Laertes were peripheral to the intense drama, the grand action by heroic figures bravely facing adversity.

In his address at the opening of the exhibition, De Witt Clinton beckoned "the painter of history" to perpetuate "the deliberations of our statesmen – the exploits of our heroes."[12] He also clearly spelled out that effective paintings were the key to their plan, which was to hold exhibitions in order to inculcate viewers with the good deeds illustrated in history painting, including scenes derived from literature and the Bible. He said the Academy would become a "temple," where "the fire will be kindled . . . [and] the future great men of America . . . [will] repair to view the monuments of art . . . and to catch the spirit of heroic virtue." Every painting mounted at the Academy for the next twenty years of annual and special exhibitions figuratively represented another log on the temple fire, set to blaze into the hearts and minds of viewers.

From 1816 on, the Academy's vitality hinged on the directors' ability to attract viewers with highly moralistic paintings. They succeeded in 1816 by showing paintings by Trumbull and West to approximately one thousand viewers each week for six weeks.[13] Their optimism about maintaining this pro-

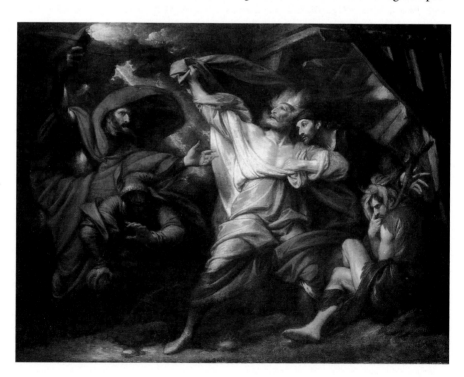

FIGURE 67

Benjamin West. *King Lear in the Storm (King Lear: Act III, Scene IV)*. 1788, retouched 1806.

Henry H. and Zoë Oliver Sherman Fund. Courtesy Museum of Fine Arts, Boston.

pitious state was fueled by two circumstances: Mrs. Fulton agreed to leave West's two paintings at the Academy indefinitely and Trumbull accepted the Academy presidency, assuring that the gallery would always be full of his paintings. What he actually said in accepting the presidency was that he would "constantly endeavor to . . . advance to the utmost of my powers the honour and interests of the institution."[14] Since Trumbull's powers were concentrated in his art, his endeavors involved the creation and display of his paintings.

Trumbull's first presidential act was the sale of four history paintings to the Academy in exchange for lifelong biannual interest payments on their appraised value. His paintings of *Christ and the Woman Taken in Adultery, Our Saviour and Little Children, The Earl of Angus Conferring Knighthood on De Wilton,* and *Peter the Great at the Capture of Narva* became fixtures at the American Academy, providing the context for the pageant of history paintings that Trumbull arranged over the next two decades, and inspired the directors to think seriously about acquiring other paintings for a permanent collection. Within a year, however, their vision of a grand collection became illusory, as income from exhibitions declined and the Academy's debt increased.

Trumbull ameliorated the situation with another of his history paintings. He decided that an exhibition of his *Declaration of Independence* (Fig. 68), then destined for the U.S. Capitol, would attract visitors and pay old debts. The exhibition of this enormous canvas during the autumn of 1818 was an astounding success. The *Commercial Advertiser* reported that no "work of the

FIGURE 68

John Trumbull. *Declaration of Independence.* 1818.

United States Capitol Art Collection. Photograph: Architect of the Capitol.

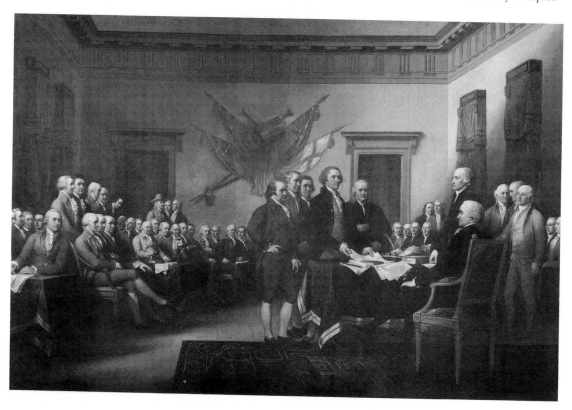

kind in the world . . . is so well calculated to excite [the] public."[15] The exhibition gained more attention after the *National Advocate* printed a dialogue between Trumbull and a critic identified as "Detector," who questioned the historical accuracy of the composition.[16] In order to attract even more attention, Trumbull scheduled a benefit for the New York Institution for the Deaf and Dumb. On November 9 upward of thirteen hundred people took advantage of what was advertised as a unique opportunity of viewing the noble gentlemen in "this historical portrait of our national establishment" while acting nobly themselves by supporting the city's handicapped citizens.[17]

As in most matters at the Academy, both Trumbull and the institution benefited from the exhibition. The exhibition had surpassed their expectations for filling the Academy's coffer and fulfilling its institutional mission. Painted for the government, depicting a momentous event in American history, and produced by a Revolutionary War officer, the *Declaration of Independence* transformed the Academy's gallery into a national shrine for several weeks. None of the accounts of this exhibition mention the painting as a work of art; for example, none mention technique or style, or make any qualitative judgment about the painting's general appearance. The painting's success was bound up in the sheer number of viewers it attracted – during the first month over six thousand people saw the painting, all apparently drawn in by its patriotic effect and the controversy over the questionable accuracy of the scene. The *American Journal of Science* reported that the painting worked "to invigorate patriotism, and to prompt the rising generation to emulate such glorious examples."[18]

From this exhibition, the Academy directors seemed to have learned that in terms of attracting crowds, a painting's subject and its general visual impact was more important than the manner in which it was painted. Trumbull's small Revolutionary War paintings and his other history paintings, shown at the Academy exhibitions in 1816 and 1817, had barely caught attention, but his *Declaration* pulled visitors off the streets. In part this was due to the newspaper articles generated by the exhibition, but the Academy directors attributed the exhibition's success to the painting's size. They decided that other exhibitions of large-scale historical paintings were also a feasible way for the Academy to edify viewers while paying expenses.

The Academy kept its annual exhibitions of portraits, small history paintings, and old masterpieces open year round and inaugurated special exhibitions, which became the institution's life blood, the attention getters, the money makers. The only problem was that the directors could not depend on Trumbull to paint an enormous canvas every year. During the winter of 1820–1, they exhibited Rembrandt Peale's *The Court of Death* (1820) which had been successfully exhibited in Baltimore and Philadelphia.[19] The fact that neither Trumbull nor the directors had seen the painting was in keeping with their past conduct. They knew from reviews and publicity reports that it illustrated a histrionic view of the afterlife in which the allegorical figure of Virtue was spotlighted as worthy of emulation. Peale's subject was in keeping with the Academy's ideological program and this was all that mattered to the directors. The New York *American* previewed the exhibition by reporting that Peale had

"applied [his brush] to its noblest purpose – the expression of moral senti-ment, . . . calculated to remove the misconceptions of prejudice and terror, and to render useful the rational contemplation of death."[20] In Peale's own adver-tisement for the exhibition, a letter to the editor of the *American,* he said he was not concerned with receiving praise from "lovers of painting," but that he hoped *The Court of Death* would appeal to "the great mass of society, for whose contemplation it was especially intended."[21]

During its nine-week exhibition, *The Court of Death* attracted nearly four thousand viewers, but since this attendance did not match the popularity of Trumbull's *Declaration of Independence,* the officers, and some newspaper crit-ics, were disappointed. Within two weeks of the opening, the *American* reported that "the effect produced upon the spectators [should] be an evi-dence of success," but that "a very small portion of our population" had been to see the painting.[22] The painting, in other words, was judged a success in terms of its effect, but it did not affect enough people. Too few viewers, the critic wrote, had availed themselves of "the vastly different sensations, which the view of a fine historical or moral painting excites."

The same standards of success, or lack of success, were applied to Trum-bull's exhibition of the *Surrender of General Burgoyne at Saratoga* (1821) dur-ing the winter of 1822. In this case, the painting presented not a moral mes-sage, but a representation of recent American history featuring the valiant and ceremonial surrender of one officer to another. The *Evening Post* described the painting at length, offering not only a description of the painting but also details about the northern campaign of 1777 that led to Burgoyne's surrender, and the *Commercial Advertiser* said that "the event [recorded in the painting] is perhaps prouder to an American's feelings, than any other leading military affair which took place during the revolutionary struggle."[23] In three months, 2,500 viewers went to the Academy to see *Burgoyne,* a disappointing turnout that cut at the very heart of the Academy's goals. The directors certainly could not exercise their responsibility toward the general public if the general public would not come into the gallery. And the art they wanted the public to see, such as this nationalistic painting by the most esteemed artist in the country, did not draw a large audience. Still, Trumbull and his directors remained dedi-cated to the Academy and Trumbull became increasingly preoccupied with the American Revolution as his subject matter during the 1820s and 1830s.

Trumbull's devotion to recording the deeds and faces of revolutionary heroes, in fact, provides the artistic parallel to his devotion to the Academy. That his Academy and his paintings, both dedicated to promoting the elevated values of his generation, were becoming less interesting to most people made him cling to them all the more. During the early 1830s Trumbull began work on another series of Revolutionary War paintings and made a formal address before the Academy members, his first ever, in order to say he still felt "bound by the most imperious duty to guard vigilantly [the Academy members'] inter-ests and [their] honour."[24] By maintaining the Academy and painting the war, Trumbull insulated himself from change.

Trumbull's advocacy of West's work during his Academy presidency

makes sense in this context. Despite their professional differences decades before, he clung to West during the 1820s and 1830s as an artist who had shared his artistic vision and expressed the values of a dying generation in his paintings. His first nod toward West occurred early in 1818, when he convinced the Academy's directors to commission a portrait of West from Sir Thomas Lawrence.[25] The larger than life-size portrait (1818–21) depicts West lecturing to his students at the Royal Academy, with his copy of Raphael's painting of *The Death of Ananias* on his easel for demonstration purposes. In the gallery of the American Academy, where the portrait of the late Royal Academy president hung with his *King Lear* and *Ophelia* and Trumbull's history paintings, the two history painters and academy presidents were linked.

Trumbull defended West against critics as he would have defended himself. When, in June 1824, a critic in the *American* reported that *King Lear* "would discredit a sign post artist," Trumbull explained that the painting had been "regarded by the best judges of the subject in London as one of his most masterly productions" and that the *American's* critic, like so many other New Yorkers, was not experienced enough to make "an estimate of the relative merits of painters."[26] Trumbull then worked with Academy director Henry Rogers to borrow West's *Death on the Pale Horse* (1817) from the artist's sons and *Christ Healing the Sick* (1815) from the Pennsylvania Hospital.[27]

When nothing came of these efforts, Trumbull turned to America's greatest West imitator, William Dunlap, whose copy of West's *Christ Rejected* opened at the Academy on November 4, 1824. For the Academy, the substitution of Dunlap for West was not much of a compromise because few had seen West's original canvas. The directors would judge Dunlap's copy on the basis of whether or not it could simulate the effect of West's history painting, which was, as usual, designed to illustrate not only the specific scene but a wide range of ideal human and divine passions. The copy was successful for the Academy and for Dunlap, who recorded that it "yielded me profit."[28] Trumbull then agreed to exhibit Dunlap's *Death on the Pale Horse* during the autumn of 1825. Dunlap composed this 20-foot painting with foreground figures larger than life from William Carey's published description and the engraving of West's picture. According to the New York *Commercial Advertiser,* Dunlap's exhibition was "drowned with success."[29]

Dunlap provided the American Academy with a viable and lucrative substitute for West, but Trumbull decided to close the *Death on the Pale Horse* exhibition early when he learned that Dunlap was banding with Samuel F. B. Morse to found the National Academy of Design. Trumbull's reaction to this apparent betrayal was rash. He replaced *Death on the Pale Horse* with Jacques-Louis David's *Coronation of Napoleon* (1808–22), the 400 square foot replica he had painted for touring purposes. David's painting did not meet any of the directors' thematic criteria, but on the contrary represented despotism and luxury. And the painting must have looked terrible. The *American* reported that "[S]pacious as is the [Academy's] gallery, it does not afford room to place [the painting] in its full dimensions, or in advantageous light."[30]

In retrospect, this episode speaks volumes about the American Academy,

where an enormous replica replaced an enormous copy. Trumbull's next move makes the American Academy seem even more a place where decisions were made in a hurried, anxious manner. On January 23, 1826, the *Commercial Advertiser* reported that "the venerable president has had the boldness (we will not call it audacity) to place his picture of the woman accused of adultery, by the side of the great European."[31] Trumbull hung West's paintings of *King Lear* and *Ophelia* and his own painting of *Christ and the Woman Taken in Adultery* in the gallery with David's *Coronation*, turning a fiasco into an opportunity to promote himself and West.

Over the next decade, most of the special exhibitions at the American Academy had the same haphazard quality. Many exhibitions featured Trumbull, who knew that his work promoted the Academy members' values. For example, when the tensions brewing between the American Academy and the National Academy of Design mounted during the summer of 1828 and anonymous writers attacked the American Academy in the *Morning Courier* and *Evening Post*, Trumbull decided to show his *Sortie*, which he had not exhibited since 1804. The 6- by 9-foot *Sortie* was Trumbull's first large history painting and arguably his best, with much more detail, precision, and compositional vitality than any of the canvases he painted for the Capitol. But its exhibition in London in 1789 was unsuccessful; the British audience Trumbull had meant to enthrall criticized the representation, and Trumbull kept the painting in his studio for many years, feeling hesitant about attracting additional criticism.

He might have rationalized the risk by considering that the 1789 failure was based on viewers' response to his representation of the specific historical scene. The average New Yorker in 1828 would probably not have been able to give even a vague account of what happened on Gibraltar during the night of November 26, 1781. Now, almost fifty years after the fact, the victorious British sortie against encroaching Spanish troops bore neither specific nor general meaning for Americans. He hoped it would be acclaimed as a scene of victory and defeat, of modest pride and noble death. Trumbull thought that American viewers would appreciate the painting (he hoped someone would purchase it) and encouraged their interest by writing an anonymous review for the *Commercial Advertiser*. He described the historic sortie, but stressed that the event was less important than "the pathetic scene offered by the principal groupe" in which "youth and age – prosperity and adversity – are placed before us in one of the most elevated scenes of what man calls glory, in their most affecting contrast."[32]

As a prime example of art aimed at demonstrating and inspiring noble conduct, moral behavior, and essential virtue, the painting promoted the Academy's founding principles, but by 1828 those values could not be salvaged by a single painting, however evocative or beautiful it was. The *Sortie*, moreover, was not deemed evocative or beautiful. The exhibition was not reviewed, except for Trumbull's own essay, and no one in New York, not even an Academy director, offered to buy the painting.

Trumbull's indefatigable penchant for arranging special exhibitions was bolstered by his belief that he was representing an entire class of Americans by

his efforts. This explains why he did not simply abandon the American Academy in 1828. He remained president for eight more years, standing up for the rights of art patrons and mounting a parade of elaborate and large history paintings. Most of the exhibitions failed miserably on all counts – aesthetically, didactically, and financially – but this did not crush the Academy. Trumbull's goal, it seems, was simply to keep the Academy open, as if the physical continuity of the institution represented the persistence of his values.

The history paintings that hung in the gallery during the late 1820s and 1830s transformed the Academy from an institution representing the ideals of eighteenth-century gentlemen to an exhibition hall where the size and extravagance of works of art counted more than their subject. In this way, the Academy competed for visitors with popular New York spots such as the Arcade Baths, Masonic Hall, and Niblo's Garden, which operated as a brasserie with paintings on the walls. History paintings, especially large canvases, were regularly mounted at these venues by traveling entrepreneurs and agents who made a lucrative business of attracting visitors for a limited period of time and then taking the paintings in their charge to another city. Although Trumbull maintained that the Academy functioned on a higher, more serious level than these halls, he was compelled to operate as an entrepreneur himself, and as Academy president spent a good deal of time arranging exhibitions of increasingly theatrical paintings.

In 1829 Trumbull contracted Hugh Reinagle for an exhibition of his 18-by 12-foot copy of English artist John Martin's *Belshazzar's Feast* (1821). The exhibition was a colossal failure. A writer for the *New-York Mirror* visited the gallery and reported that "there was not a single individual present, and during the hour we remained."[33] In 1831 he tried to revive the Academy's former mission to enlighten the American public by mounting an exhibition of the complete series of his "subjects of the American Revolution."[34] He showed his original small paintings of the battles of Bunker Hill, Quebec, Yorktown, Saratoga, the Declaration of Independence, and Washington's resignation and larger versions – with figures half life size – of the battles of Trenton and Princeton, which he had recently completed (both 1830). He also exhibited numerous portraits and miniatures, and a few landscapes. The exhibition was poorly attended. Almost all of this work had been shown at one time or another in the Academy's annual exhibitions, so it was not new to New York's gallery-going public. The exhibition lacked novelty, which certainly played a part in attracting visitors, and more crucially the subject matter was no longer enthralling. In 1817 the Academy successfully roused patriotic fervor with Trumbull's *Declaration of Independence;* in 1831 scenes of late-eighteenth-century history were uninteresting. At best, as the reporter for the *Daily Advertiser* wrote, the paintings appealed "to all persons who have an hour or two to devote to the gratification of a patriotic curiosity."[35]

Trumbull might have been offended by this characterization of his work, but had evidently anticipated his exhibition might not attract attention. He flanked his exhibition with Horatio Greenough's *Chanting Cherubs* and

George Cooke's *Wreck of the Frigate Medusa* (c. 1831) in the adjoining galleries. And after this, he worked harder to show more diverse and spectacular history paintings. In 1833 the Academy drew crowds with provocative exhibitions of Claude-Marie Dubufe's *Temptation of Adam and Eve* and the *Expulsion from Paradise* and Francis Danby's apocalyptic *Attempt to Illustrate the Opening of the Sixth Seal* (1828). In the spring of 1834, Trumbull arranged an exhibition of *The Angel Announcing the Birth of Our Saviour* (1834) by Thomas Cole. That autumn, Trumbull contracted David Wright of London for an exhibition of five large "dioramic pictures" showing a *View of London, The Loss of the Kent East Indiaman* by William Daniel, the *Destruction of the City and Temple of Jerusalem, A. D. 70* by C. John M. Whichelo "from a design by B. West," *The Interior of Trinity Chapel in Canterbury Cathedral,* and *Captain Ross's Interview with the Natives of Felix Harbour* by unknown artists. Adding to the spectacle, four suits of armor representing the ages of Henry I and VIII, Charles I, and an ancient German ruler posed at the base of the staircase leading into the gallery.

If this sort of outlandish exhibition did not convince Trumbull that his Academy was no longer even a shadow of its founders' elite establishment, then his failed 1836 exhibition of Revolutionary War paintings did. He tried once again to interest the public in his work, but to no avail. During this exhibition, the adjacent gallery was rented for an exhibition of the painting Trumbull had tried to get twelve years before, West's *Death on the Pale Horse.* Trumbull commented that with the two exhibitions side by side "the world will have a fine opportunity of comparing the Master and the Scholar," but the dismal attendance figures prove that very few were interested in comparing West to Trumbull.[36] Still more hurtful for Trumbull was the fact that West's painting was shown at no benefit to the American Academy. The exhibition was arranged by William Dunlap and Henry Inman of the National Academy of Design to benefit the Pennsylvania Academy of the Fine Arts. The American Academy was simply used for its gallery.

The American Academy began as a patrons' institution, founded by civic leaders who felt responsible for the enlightenment and edification of others. They did not intend to teach artistic technique or connoisseurship, but sought to impress viewers, including artists, with first sculpture and then paintings that they thought would convey moral lessons and rules of behavior. They exhibited paintings and sculpture in order to influence viewers; they emphasized the effect art could have on people. And when the art they exhibited did not attract viewers into the gallery, they showed art that was spectacular and theatrical. In the process of trying to attract viewers, Trumbull and his directors forfeited the fundamental ideas that originally supported their actions. The Academy closed in 1842 due to a lack of funds and leadership, but it had actually met its demise fourteen years earlier, when Trumbull's *Sortie* failed to captivate viewers, when an illustration from history of the "gallant conduct" of noble officers seemed more old-fashioned and curious than inspirational.

History as Ideology
Or, "What You Don't See Can't Hurt You, Mr. Bingham"

Bryan J. Wolf

For those of us who grew up in the 1950s, the cultural landscape was dominated by a grandfatherly man who appeared each week on TV surrounded by cartoon characters and animated objects. I am referring, naturally, to Walt Disney, from whom I learned the pleasures of wearing coonskin caps, the perils of taking apples from warty old women, and the principles of the separation of work and play. This latter lesson came in no uncertain terms from a distinguished litter of pigs, two of whom learned it the hard way, while the third, being a Victorian moralist at heart, appears to have known from birth that the only good home is a brick home.

I have not forgotten Disney's lesson. Even now, when I stroll through museum halls on a professional jaunt, I am as likely to hum "who's afraid of the big bad wolf" as to think Solemn Thoughts About Great Art. In fact, the more I pursue my professional life, pondering nineteenth-century American culture and admiring paintings like Bingham's *Boatmen on the Missouri* of 1846 (Fig. 69), the more appropriate Disney's insights become. Who are those three hatted men in their wooden craft if not actors in yet another parable about work and play: the two little pigs in front and the hard working brother in the back?

I suspect that Bingham, like Disney a century later, was concerned with challenges to a prevailing work ethic; although I detect no wolf lurking in the underbrush of Bingham's painting, I do see the huff and puff of a steamboat in the background. That steam-driven engine in turn represents as profound a challenge to our nineteenth-century boatmen as the vile old wolf did to Disney's porcine (and moralizing) characters. Only as I see it, Bingham has reversed Disney's priorities: His point is not that work and play don't mix, but to the contrary, the two coexist as interchangeable elements. The riverboat world of rugged republican values marks that place in American history where, if we are to believe Mr. Bingham, work and play do mix.

What threatens Bingham is precisely the separation that Disney affirms. Bingham's painting works to *unify* potentially disparate spaces, blurring the boundaries between work and leisure. His isolated figures, who communicate

with the viewer rather than with each other, are nonetheless bound in a complex fugue of lines, forms, and colors within a unified social space that affirms, rather than denies, work as a form of play. This social world, in turn, is linked to the background landscape that frames it: The head or torso of each man is associated with one of the three different bands of foliage in the background. The effect is not only to reinforce the already stable world of the boat by positioning it comfortably within a landed perspective, but to ground the human community within the world of nature, a way of seeing that removes the boatmen from the grunge and sweat of everyday history. Bingham's boatmen have been "naturalized": They form an organic part of the river world, as timeless in their activities as the clouds that drift overhead.

The composition of the painting enforces the claim of its figures to occupy a moment outside time. The painting's planar construction – that flattening of space into a wall of woods in the middle ground and a shallow foreground with figures – converts at the intersection of water and land into a gentle diagonal that angles to the far right, where the steamboat provides the focus for the recessional sweep backward. When the painting is viewed in its planar mode, the separation of foreground and background spaces is overcome by the monochromatic palette, narrow range of tones, and integration of lines. When seen in its recessional mode, the stasis of the foreground tableau countermands the gentle sweep of the river to the right. Whatever route we take, the result is the same: stability wrested from time and change.[1]

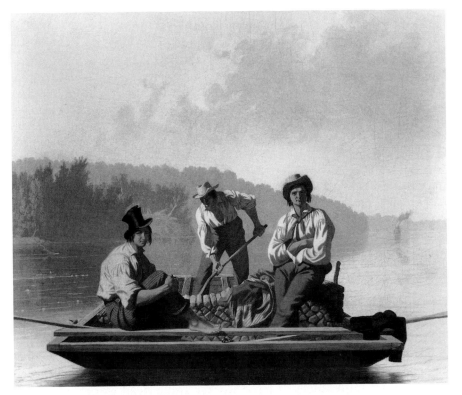

FIGURE 69

George Caleb Bingham. *Boatmen on the Missouri.* 1846.

The Fine Arts Museums of San Francisco. Gift of Mr. and Mrs. John D. Rockefeller, III.

Why this relentless drive toward unity, a drive thematized in the notion that work and play can – and in fact *must* – mix? To answer that question we need turn to a very different scene, a moment in the communitarian life of Brook Farm, a utopian community started by Unitarian minister George Ripley in 1841 in West Roxbury, Massachusetts. Ripley's goal at Brook Farm, not unlike Bingham's four years later in *Boatmen on the Missouri*, was to "etherealize" work, to render labor a conduit for spiritual insight and welfare. Ripley expected the Brook Farm community to engage in literary, artistic, and cultural activities as avidly as it tilled the land and cleaned the chicken coops. He was joined in this belief by Nathaniel Hawthorne, who moved into Brook Farm on April 12, scarcely weeks after the utopian experiment had started. Hawthorne hoped to find at Brook Farm an income, or at least a means of support, sufficient to make possible his impending marriage to Sophia Peabody, his fiancée of two years. He invested $1,500 in the agrarian adventure and in September was elected a trustee and chairman of the community's finance committee. He also milked cows, pitched hay, and forked manure. At the end of the year, Hawthorne departed Brook Farm, his beliefs tarnished, his hands calloused, and his literary imagination in a deep state of suspension.

Six weeks into his life at Brook Farm, Hawthorne had given the first hints of his growing disillusionment. He had written Sophia Peabody, "It is my opinion that a man's soul may be buried and perish under a dung-heap, or in a furrow of the field, just as well as under a pile of money." And ten years later, when he would transform his disillusionment with the Brook Farm experiment into *The Blithedale Romance*, Hawthorne, drawing on an earlier notebook entry, summarized what had gone wrong:

The peril of our new way of life was not lest we should fail in becoming practical agriculturists, but that we should probably cease to be anything else. While our enterprise lay all in theory, we had pleased ourselves with delectable visions of the spiritualization of labor. . . . Each stroke of the hoe was to uncover some aromatic root of wisdom, heretofore hidden from the sun. Pausing in the field, to let the wind exhale the moisture from our foreheads, we were to look upward, and catch glimpses into the far-off soul of truth. In this point of view, matters did not turn out quite so well as we anticipated. . . . The clods of earth, which we so constantly belabored and turned over and over, were never etherealized into thought. Our thoughts, on the contrary, were fast becoming cloddish. Our labor symbolized nothing, and left us mentally sluggish in the dusk of the evening. Intellectual activity is incompatible with any large amount of bodily exercise. The yeoman and the scholar – the yeoman and the man of finest moral culture, though not the man of sturdiest sense and integrity – are two distinct individuals, and can never be melted or welded into one substance.[2]

Hawthorne's language requires that we read between the lines. On the surface, the passage provides a critique of the many reform movements of the antebellum period like Brook Farm, as well as a rejoinder to transcendental thought as it emanated from Concord. Ralph Waldo Emerson's *Man Thinking*, a paradigm of unalienated labor, has been rescripted by the narrator of *Blithedale* as "two distinct individuals," a hand worker and a head worker. As Miles

Coverdale wryly notes, "Intellectual activity is incompatible with any large amount of bodily exercise."

This quiet undoing of Emersonian unities, however, is not Hawthorne's central concern. What frightens Coverdale instead is the failure of ideology itself (Coverdale calls it "theory"), the collapse of an artisanal vision of labor that applies as much to writers as to farmers and "yeoman." The threat posed by a world where "thoughts" turn into "clods" and "labor" will not be "spiritualized" is that writing, like other forms of productive activity, might similarly be classified as drudge work, as hourly labor. Writing, like hoeing, might turn out to be a commercial activity shaped by market – rather than aesthetic – imperatives. Hawthorne's true battle here is not with recalcitrant clods of earth but with his own literary situation. He embraces the possibility of an agrarian idyll because he resists thinking of himself in the same terms that apply to wage laborers and "female scribblers," both of whom receive their value from the market. What he possesses that they lack is a crafts ethos, a notion of himself poised somewhere between artist and gentleman writer, anywhere in fact but in the competitive domain of best-sellers and popular fiction. To be a gentleman farmer, as the "theory" of Blithedale promises, is to retain the artisanal unity of head and hand that separates the writer from the factory worker.

What happens in *Blithedale,* however, is that the agrarian workplace comes to internalize the conditions of urban culture. The problem is not simply that Emersonian theory, like utopian experiments, unravels, but that the ideological dike which protects Hawthorne from the forces of the market gives way. What Coverdale confronts in the schism between the yeoman and the scholar is the inadequacy of agrarian ideology itself: its inability by the mid-1840s to rewrite labor conditions within a rapidly industrializing society according to an older and more benign script. Hawthorne had shielded himself from the market – not from competing within it, but from *acting* as if he were competing within it – by ideological fiat.[3] Like many of his contemporaries, he had turned to artisanal ways of thinking – to a belief in the autonomy of the worker and the integrity of the work process under his control – in order to ensure his own independence as a writer. But his experience at Brook Farm called that independence into question, not because the writer could not be at the same time a farmer, but because the very notion of labor had been drained of its preindustrial, and hence redeeming, associations.

And that returns us to Bingham's *Boatmen on the Missouri.* Hawthorne's text provides us with the terms we need for understanding Bingham's painting: the status of labor in antebellum culture, the relation of the artist to new market conditions, and the role of ideology in mediating the rift between "intellectual activity" and "bodily exercise." Bingham will cast Hawthorne's concerns with "yeoman" and "scholar," for reasons we explore shortly, into the language of work and play. He will convert Hawthorne's agrarianism into a frontier rhetoric and substitute the Missouri River for a New England farm. But the ideological imperatives that link both men remain the same.

Bingham positions himself in *Boatmen on the Missouri* within the new art

market of the 1840s. The painting responds to the fears of middle class, and largely eastern, patrons that republican values, essential to the maintenance of the nation, have been endangered by the collapse of artisanal ideology and the emergence of a wage labor system. The painting carves out a space for Bingham as a painter not of politics, as Nancy Rash has suggested, but of ideology, which may, after all, be only politics by another name.[4] It helps us understand the cultural role played by regional artists within a national economy, and it carries us from questions of labor (what impact a proletarianized work force had on middle-class perceptions) to issues of *seeing* (why do those two men in their leisurely postures stare without apology at the viewer?). And along the way, we need to think again about questions raised by Walt Disney, namely the relation between Bingham's painting to middle-class forms of leisure, entertainment, and cultural uplift.

The Question of Labor

In *The Dark Side of the Landscape,* an influential account of the representation of peasants and agricultural workers in England in the late eighteenth and early nineteenth centuries, John Barrell has noted the gradual displacement of the laborer from the foreground to the background in images of rural life. Breaking from Claudian precedents, British painters responded to the demand for scenes of British life in the eighteenth century by populating their landscapes with "the ploughmen of England" rather than the "shepherds of Arcadia." This substitution, which was designed to ratify the effects of a century of enclosure and modernization, reassured the viewer "that the poor of England were, or were capable of being, as happy as the swains of Arcadia, their life as delightfully simple and enviable." Such reassurances, however, caught the poets and painters of rural life in a contradiction: They were torn between pressures to "reveal more and more of the actuality of the life of the poor" and a countervailing need "to find more effective ways of concealing that actuality."

Artists resolved this problem by a fortuitous combination of aesthetics and ideology. Images of Arcadia yielded in the literary and visual imagination of the period to the notion of Merry England, and when the latter proved untenable for historical reasons, the figure of the jolly hayman was replaced by that of an industrious and sober peasantry. Over time, as the real conditions of the working poor intruded further on the fantasied imagery of rural life, the peasant evolved into an object of elite pity. His condition was aestheticized by picturesque conventions into a pretty sadness. By the time of John Constable, the framing devices of the picturesque could no longer hide the tension between laborers and elite, and the worker disappeared into a set of blurred strokes in the background of the painting, a "romantic image of harmony with nature" that "merged" the workers "as far as possible with their surroundings."[5]

Barrell's account posits an inverse relation between the historical distress of the worker and the worker's aesthetic position within the painting. The more implacable labor difficulties became, the more insistent the tensions

between labor and capital, the less visible and more idealized the worker appeared within the painting. If we turn from Barrell to Bingham, expecting to see in the latter a variant on the pattern described by the former, we encounter a problem. We know from many decades of labor historiography that the situation of workers in antebellum America was anything but happy. Herbert Gutman has identified the years 1843 to 1893, an era he terms the "Middle Period" in the transition from an agrarian to an industrial economy, as a time of "profound tension . . . between the older American preindustrial social structure and the modernizing institutions that accompanied the development of industrial capitalism." The decades following 1830 produced "frequent strikes and lockouts and other forms of sustained conflict," from the Luddite-like parades of Brooklyn rope makers, who destroyed machine-made rope in the early 1830s, to riots between Irish workers and native firemen in Boston that involved more than one-sixth the population of the city in a two-hour melee. By the 1840s, when Bingham commenced his career in earnest, strikes had spread from the shoemakers of Lynn, Massachusetts, to the coal miners in Ohio's Hocking Valley.[6]

This increase in labor tension was tied both to the downward mobility of the worker, as artisans lost control of the workplace and found themselves wage laborers on the shop or factory floor, and to the increasing inability of the worker to earn a "just" wage. Between 1839 and 1843, wages for workers in the factories of New England fell 30 to 50 percent. By 1844 the labor that had once supported a "mechanic" and his family adequately could no longer cover the costs of living. And in the summer of 1847, a writer for the *Voice of Industry* complained that

the laboring man's prospect ahead just now is most drear and disheartening. Provision, such as flour, meat, potatoes, butter, meal, are nearly one hundred per cent higher than ordinary prices, fuel is extraordinarily high and rents have advanced. . . . The mechanic or laborer who has a family to support finds that to-day's wages only pay to-day's expenses; he can lay up nothing for the winter season when his expenses are greatly increased, and, in the laborers' case, work and wages are always diminished.[7]

What was bad news for the worker should, from our vantage point, be good news for Barrell's thesis. We would expect that the social tensions generated by the transition into an industrial economy would produce in American art, as in its British counterpart from an earlier era, a growing reluctance among writers and painters to record the life of the laborer close up. In fact, we might predict on the basis of Barrell's model that Bingham's figures would trade places with the miniaturized steamboat in the background.[8]

The question is why they don't. Why are Bingham's figures given to us as laborers, set squarely in the foreground, where they eclipse the boat to their rear? The answer, I believe, lies in two sets of issues: (1) the intersection of ideology and commerce that undergirds Bingham's work, and (2) the notion of seeing that Bingham develops through that intersection. A quick chronology makes the point:

- Between 1840 and 1845, Bingham lobbied Whig political acquaintances and friends like James Rollins, editor of an anti-Democratic newspaper, for patronage. He repeatedly sought, but failed to receive, a commission from the Missouri legislature for portraits of Washington and Jefferson.[9]
- In the summer of 1843, during an extended sojourn on the East Coast, Bingham visited the Pennsylvania Academy of the Fine Arts. He recognized immediately the possibilities that genre painting offered a young man who "could be nothing else but a painter." His ambitions were further fueled by his discovery of the American Art-Union, an organization that had evolved in the early 1840s from the Apollo Association in New York into a national institution designed to encourage American art and disseminate it among the genteel middle classes.
- In the spring of 1845 the Missouri legislature debated a joint resolution commissioning Bingham to paint a "historical picture" of Andrew Jackson arraigned before the court in New Orleans. The picture was to hang in the House of Representatives. The commission was $1,000, an astronomical sum for a painter whose usual fees were closer to $50. The plan collapsed when the Senate defeated the measure two days after it had been approved by the House.
- Half a year later, in December 1845, Bingham sold four paintings for the first time to the Art-Union. *Fur Traders Descending the Missouri,* the only riverboat scene among the group, was purchased for $75, a sum higher than that received for the other three paintings.
- In May 1846 Bingham submitted his second riverboat scene, *Boatmen on the Missouri,* to the Art-Union. It was purchased for $100.
- Five months later, Bingham's *Dance on the Flat Boat* was purchased by the Art-Union. The painting was retitled *The Jolly Flatboatmen* and distributed as an engraving to over two thousand Art-Union members.

What this chronology suggests is that Bingham's emergence as a popular painter under the auspices of the American Art-Union is tied to his corresponding failure to succeed with more traditional forms of patronage, in particular, large public commissions. At the same time as he was discovering how fickle a patron the state might be (a lesson that would be reinforced in 1846, when Bingham would be denied the seat in the Missouri legislature to which he had been elected), he was also learning how to tailor his painting to a national audience.

The Art-Union's outlook was formulated in 1844 in its annual report:

To the inhabitants of cities, as nearly all of the subscribers to the Art-Union are, a painted landscape is almost essential to preserve a healthy tone to the spirits, lest they forget in the wilderness of bricks which surrounds them the pure delights of nature and a country life. Those who cannot afford a seat in the country to refresh their wearied spirits, may at least have a country seat in their parlors; a bit of landscape with a green tree, a distant hill, or low-roofed cottage; – some of those simple objects, which all men find so refreshing to their spirits after being long pent up in dismal streets and in the haunts of business.[10]

The representatives of the Art-Union understand landscape painting in this passage as a substitute for both land ownership and the spiritualizing effects it produces. They establish an ideological agenda for the arts, including genre painting, that is threefold: to convince the city dweller, "as nearly all the subscribers to the Art-Union are," that art stands in alliance with agrarian values, and that this alliance represents a patriotic and republican form of resistance to the debilitating pressures of commerce; to assure the rising middle classes, those who aspire to gentility without the financial resources actually to purchase a country residence, that paintings will serve as an adequate marker of their cultural status, their right to be designated people of the better sort; and to legitimate the very notion of art itself, not only in its patriotic and status values, but as a custodian of what gets designated ideologically as the "real." Art repackages the world according to class imperatives, affirming that what it presents is no less real for its being bound between gilded frames or set outside the "dismal streets" and "haunts of business" that characterize the viewer's quotidian experience.

The key to the Art-Union's rhetoric, in other words, lies in the apologia it provides for painting as an aesthetic system, a cultural space, where ideology can be *realized*, where class belief disappears qua belief and reappears instead as the natural and commonsensical. Painting, for the Art-Union, is that place where ideology acquires the force of conviction. We know this from the double move the Art-Union statement makes: The author acknowledges that painting is only a "parlor" trick, a transposition of real countryside into "a bit of landscape." But even as this transposition is acknowledged, its effect is counteracted by a reminder to the reader that painting is not a fiction but a remembering: "A painted landscape is almost essential to preserve a healthy tone to the spirits, lest they *forget* . . . the pure delights of nature and a country life." [emphasis mine]. Painting functions mnemonically. It provides the viewer with a window onto the world, not in the baroque sense of a stylized convention of portraiture, but in the more ideologically fraught sense of recalling that which has passed from sight. Painting maps the real for the viewer by bringing what is true, but obscured, back into visibility. Otherwise art sinks into cultural nostalgia and escapism; its images come with quotation marks around them, reminders that what they present is wish fulfillment merely.

And that is not what the Art-Union has in mind. It asks from its artists what Hawthorne sought at Brook Farm, "the pure delights of nature and a country life," the reassurance that rural values *live*, that they continue to influence and make a difference in the life of the republic. Bingham's contribution to this process, this casting of aesthetics into new forms of social reassurance, lies in his invention – not singlehandedly, because it is being invented simultaneously across the country – of a mode of *regionalism* that reserves for a particular place, the West, those values demanded by ideology and installed in an imaginary space constructed by his own art. Bingham creates a West that has less to do with history than with the need for eastern audiences to convince themselves, in the face of class tensions and increasingly visible labor conflict, that the proletarianized masses they were recognizing for the first time could

be misperceived as yeoman and artisans. We need to think of regionalism, then, as Angela Miller has suggested, as a *national* development. The growth and encouragement of American regional cultural styles in the early decades of the nineteenth century – the rise to public prominence of figures like the Yankee sharper, the country bumpkin, the western adventurer – has less to do with pride of place than with the way regionalism provided a brilliant solution to a question of class that we have also called a question of labor.[11]

The West provided Bingham with the equivalent of Barrell's background. It allowed eastern audiences, who were confronting for the first time the class nature of the altered conditions of the workplace, to see the figures most symptomatic of those conditions not as a hostile mob but as custodians of a system of values shared between classes. The West became a place where the laborer, like Hawthorne's yeoman, retained his independence and his manliness, and thereby confirmed for the eastern patron the benign nature of emergent class divisions. That is why Bingham's figures need not diminish in scale as their labor problems, historically speaking, increase. They have the concept of region to rescue them. They can remain large, detailed, and reassuring in the foreground of the paintings that host them because they do not live in New York. The West *is* Barrell's background, only it has developed a life of its own and settled down to a cozy routine of riverwork, husbandry, and "theory" somewhere along the shores of the Missouri River.

Let us summarize where we stand. We have noted that the term labor straddles a series of different, but interrelated, discourses in Bingham's antebellum world. It comes with what we might term "full" and "emptied" meanings. When it is "full," the notion of labor performs, as Hawthorne's "theory" would have it, in defensive fashion to invoke an artisanal ideology. This is a labor of plentitude, a vision of work as a self-expressive activity, where the union of head and hands stands as guarantor of individual as well as national independence. Such labor is linked to republican traditions. It signals a nostalgia for preindustrial mores, a nostalgia with deeply political undercurrents. When, for instance, workers went on strike in antebellum America, they linked their cause to the rhetoric of the American Revolution, casting their fate as tied to the health and future of an egalitarian society. Protesting tailors linked their actions to that "holy combination of that immortal band of Mechanics who . . . did throw into Boston Harbor the Tea," and a crowd of working-class citizens, infuriated by rising food prices in 1837, dumped flour, rather than tea, in a symbolic protest against what Herbert Gutman, quoting E. P. Thompson, calls "the extortionate mechanisms of an unregulated market economy."[12]

The market economy brought with it wage labor and an alternative – and more troubling – set of meanings. Such labor appeared to the worker to be emptied of its expressive potential because it marked a loss of control over the workplace. Wage labor was incompatible with agrarian and artisanal ideology: It removed the very conditions of independence that assured the laborer would remain a virtuous citizen within a free society. It created a class of work-

ers profoundly threatening to urban and commercial middle-class populations, at the same time as it set the agenda for an imaginary resolution to that threat.

And this is where Bingham enters the picture: He turns to the notion of region and double-codes it. He includes images that are virtual in-jokes to his viewers: a bear cub in *Fur Traders Descending the Missouri* that stands, as only westerners would be likely to know, as an allusion to the state symbol, the bear of Missouri; a canoe that alludes to the state's Indian name, "missouri," a reference to "the people who use canoes."[13] And yet even as his riverboat pictures confirm western viewers in their regional identity, they reinvent that identity for an eastern audience hungry for ideological reassurance. They reinstall preindustrial work habits within a western context, and in the process celebrate a new form of regionalism that dissolves class boundaries while replacing them with the less threatening boundaries of region.

Regionalism, in other words, is a form of ideological plea bargain. It staves off the anxieties attendant on class formation and industrialization in antebellum society by substituting an alternative, and culturally more benign, set of differences. What regionalism effects is a form of ideological closure. It seals off the question of class by rendering it invisible. It alters the discursive field, we might say, by shifting the language of difference from the perception of class to the perception of region. And what it offers on the other side of the regional divide it negotiates is not a mob of disenfranchised workers, a proletariat of uncertain intentions, but a picturesque version of a world very close to that of the viewer himself, a version of the westerner as everyman, a yeoman on a boat.

The notion of region is thus a brilliant ideological solution to the problem of class: It displaces difference from a social and economic set of conditions that threaten the body politic to an aestheticized category concerned with variations in space, language, and "types." In so doing, in rescripting anxieties about labor into perceptions about place, class disappears – or is deflected – from middle-class ways of seeing. The cognitive space is filled with regions instead. And ideology is naturalized. When we see regions we do not see the ideological work that makes them possible. Rather what we see is the "real," a version of ourselves in western drag.

The Problem of Seeing

Bingham's concern with labor, like Hawthorne's ill-fated sojourn at Brook Farm, represents a denial of changes within an urban labor market. But like all acts of denial, *Boatmen on the Missouri* carries within itself the very issues it seeks to evade (or rescript). Those issues surface through a *thematics of seeing,* a concern with visibility in the painting that reproduces questions of labor at the same time as it focuses those questions on the painter's own mode of laboring. The painting presents its two foreground figures not only as workers

in a moment of leisure, but as figures who stare relentlessly out at the viewer. To understand the function of Bingham's two staring boatmen, we need to digress, once again, to another scene from Hawthorne. I am referring to an incident that occurs early in *The Scarlet Letter,* a novel published four years after Bingham's painting. Like Bingham, Hawthorne is concerned in this passage with the notion of seeing and the social and ideological uses to which it might be put. Hester Prynne, whom we first meet in the novel at the threshold of the prison door, has been led from the prison to the marketplace, where she sees a scaffold with a pillory rising above it. Hawthorne describes the scene with care:

[T]his scaffold constituted a portion of a penal machine. . . . It was, in short, the platform of the pillory; and above it rose the framework of that instrument of discipline, so fashioned as to confine the human head in its tight grasp, and thus holding it up to the public gaze.[14]

What interests Hawthorne about the pillory is the type of discipline it imposes. Hawthorne plays down the physical aspects of the pillory – its immobilization of the body – and emphasizes instead its *mental* work. The pillory confines "the human *head* in its tight grasp." It enforces what Hawthorne will later call a particular "point of view," one associated with the public space of the "market." It holds up the sinner to the "public gaze." The pillory thus functions less as an instrument of punishment than as an agent of social control: It defines Hester's sin not as moral transgression but as social deviance, and it seeks to correct all deviation by the manipulation of perception, altering one's point of view. We learn from Hawthorne, without having to detour through Foucault, Bentham or the panopticon, that seeing operates along ideological lines.[15] It functions instrumentally toward the goal of socialization. How one sees determines who one is, for, as Richard Brodhead and other critics of antebellum culture have reminded us, the new disciplinary procedures of the nineteenth century tended to accomplish their acculturative work outside the institutional authority of church and state.[16] Seeing, for Hawthorne, comes with its own politics.

So too do Bingham's staring boatmen. Although Bingham's figures lack both scaffold and pillory, they nonetheless inhabit a public space defined around point of view. They disrupt the fiction of a self-contained pictorial world by staring directly out at the viewer, piercing the picture plane and entering ours. They position us by their gaze (and the architecture of their placement) at a spot midway between them, so that we front the laboring figure to the rear as a mirrorlike analogue to ourselves. Like Hester before the marketplace crowd, we not only share their public space, but assume their point of view. Note, for instance, the semicircle that moves from the top hat of the left figure, down through his body and across the pile of wood until it reaches the hat of the other seated figure: That semicircle places us as spectators at its center, thereby functioning as an optical surrogate for Hawthorne's pillory.

Note also the play in the canvas between a "naive realism" that appears to

extend our space into theirs and a more complicated symbolic blockage that
denies us access to their world at all levels but the visual. We may feel tempted to
leap across to their boat from our apparent position on a craft directly in front
of them. But a series of horizontal forms contravenes our intents: The front edge
of the craft, the plank behind it supporting the top-hatted figure to the left, and
the oars, whose extension beyond the picture plane on each side not only invites
our sense of realism through its cropped effect, but also interdicts our forward
passage. The two staring boatmen in turn function like statuary lions before
some palace door: They guard the space around them at the same time as they
redirect the lateral blockage of the foreground into vertical channels.

This modulation from horizontal to vertical occurs most dramatically in
the *woodpile* that supports the figure to the right. Extending across the width
of the boat, it reinforces the series of lateral forms in the immediate fore-
ground even as its extension up in space suggests a fortresslike wall (coming
up or down I can't tell) that both inhibits our access and further demarcates
the craft's architectonic spaces. The woodpile works laterally as a barrier to all
bodily entrance at the same time as its verticality points us to the exchange of
glances that forms the only mode of interchange available to us. If the coats
strewn casually about the craft suggest the informality of a world intimately
related to our own, then the formal, if understated, blockages betray a
restraint, a problematic of disclosure, that we have yet to unravel.

What we are witnessing, I suspect, is Bingham hard at work in the con-
struction of a particular mode of viewing. He is laboring, like the eldest of the
three pigs, to create two rather contradictory modes of seeing: the first a seeing
so natural, so innocent, so unproblematic, that it resembles play more than it
does work, and the second a seeing overdetermined in its meanings and hege-
monic in its function. This latter form of seeing, given to us through the trope
of work, allegorizes the artist's own task in the canvas. The artist must not only
create the fiction of a shared space and values between viewer and painting,
but he must then efface the markers of his efforts. He must make his socially
constructed viewing world appear natural. For that I take it is the key to the
painting: It seeks to convert seeing from a form of work into a mode of play,
figured here as the studied leisure of two staring men.[17] Bingham's men are
staring because there are two forms of work in the painting, one acknowl-
edged and the other not: physical labor (that poor little pig in the back) and
mental labor, which in this painting occurs as seeing, a thematics of vision,
which, as you remember, we are supposed to think of as play.

Recall our relation to the background man, the figure with the wooden
implement in his hands. If he represents, to return to our fortress metaphor,
the treasure within, the visual focus that in a traditional landscape painting
would be a luminous center or horizon line, then he also shares in the paint-
ing's other forms of blockage: His face fails to meet ours, his body remains
highly shadowed, and he stands at a greater distance from the viewer, a
denizen of the world on the other side of the wooden "wall." He is to some
degree effaced within the painting, part of a problematic of revelation and
concealment, access and blockage, that everywhere defines Bingham's canvas.

If we ask for explanations for his averted presence, then we might turn at this point to the steamboat, the representative of a commercial and industrial revolution that will – if it hasn't already – relegate our entrepreneurial free traders to the margins of nineteenth-century history. Bingham's decision to marginalize the steamboat instead while allowing his traders to define the visual field must be read as a form of resistance to the world they allude to, a measure of just how deeply mythic the canvas is designed to be.

So where do we stand, or more accurately, how do we see? We are spectators before a painting that teaches us how it wishes to be read. It places us at the center of a world realistically conceived, enforcing on us an assumption of accessibility and equality that we previously termed "naive realism." Not that there is anything "naive" about this painting – to the contrary, what is most interesting about the painting is the sophistication with which it teases us into accepting an apparently unproblematized notion of realism. By thematizing perception it renders explicit the drama at its core: a struggle between contested versions of seeing in a world where traditional forms of labor are undergoing profound changes. The painting offers us two types of seeing: an innocent and natural vision that undergirds its realistic space and a carefully wrought mode of perception that functions, like Hawthorne's pillory, to enforce its own point of view. The former – the "natural" mode of seeing – hearkens back to a preindustrial form of exchange. It invokes a way of seeing that occurs between equals, naturally, without mediation, without any social or economic barrier to interrupt what the painting defines as the everyday give-and-take among peers. The latter mode of seeing represents a contradictory construction. It understands seeing as an acculturative process, a form of social work with a prescriptive agenda. Seeing, from this point of view, is anything but innocent. It labors to create a universalized vision, a shared point of view, that internalizes a set of market conditions it refuses to acknowledge.

This latter mode of seeing I would call "hegemonic," an effort to assert an ideologically constructed relation to the world as natural. The catch, of course, is that the two modes of vision are really the same: The effort at hegemony can succeed only as long as the mode of seeing that the painting offers is understood as normalized, commonsensical, and universal. This is a painting, in other words, about the labor of constructing an "innocent eye," a "natural" mode of seeing, in a world, I should add, where seeing is never innocent but always works to specific social ends, a fact acknowledged by Bingham's ambivalence over whether seeing is really work (social control) or play (natural and universal).

Lest you begin to suspect at this point that the only real labor going on in the discussion is my own, and that it bears only marginal relation to the image before us, I would like to suggest in schematic form the significance of seeing and its relation to work in antebellum culture. Bingham's concerns in *Boatmen on the Missouri* need to be read against the background of other forces and other paintings of the period.

Item: In the nineteenth century, as Burton Bledstein has demonstrated, an emergent professional class staked its claim to power on new forms of

intellectual labor tied to a monopoly of knowledge and the ability to control the flow of information. Class formation was thus aligned with literacy, education, and cultural production. Perception – ways of seeing – functioned within this world of intellectual labor to reinforce the processes of class formation. As early as 1806 Charles Willson Peale's *Exhumation of the Mastodon* assumes a division between those who labor with their heads and those whose work is confined to brute body. The painting divides into a foreground filled with laboring figures and a middle ground presided over by Peale and his family. Peale holds in his hand a diagram of bones that articulates his role within the project: He is the codifier and classifier who possesses the knowledge – that abstracted diagram – underwriting the expedition.[18] What is so telling about the image is the use that Peale makes of a traditional tripartite division of space inherited from Enlightenment painting. John Singleton Copley's *Watson and the Shark* similarly divides its space into a gothic foreground, a middle ground human community, and a utopian landed sphere in the background (Fig. 70). Copley's painting allegorizes the work of society: the process of acculturation by which raw and unredeemed energies, incar-

FIGURE 70

John Singleton Copley. *Watson and the Shark.* 1778.

Museum of Fine Arts, Boston. Gift of Mrs. George von Lengerke Meyer.

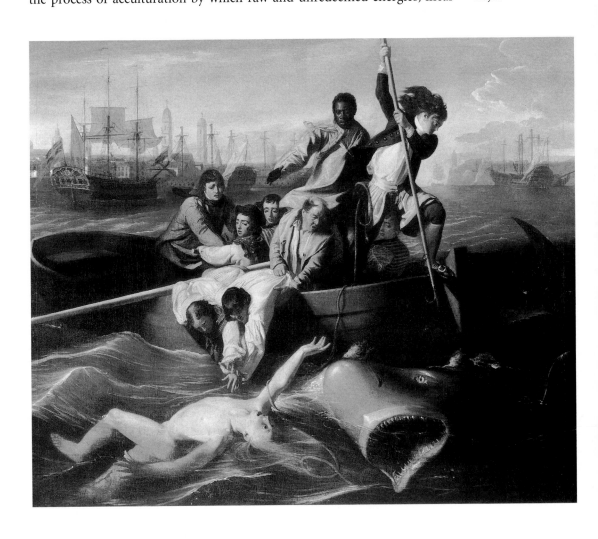

nated in the naked Watson and the bestial shark, are redirected or assimilated into socially acceptable forms (the world of the boat and land). Peale reproduces Copley's spatial divisions, but he introduces an element of class differentiation missing in *Watson and the Shark*. Peale's narrative divides labor into two different modes, manual and mental. He then segregates each form of labor to a different spatial plane that in turn underlies emerging class differences. That union of eye and hand so central to crafts ideology, a union figured within republican rhetoric as the worker's independence, now unravels in Peale's painting into alternative social spheres: those who labor with their hands but possess no guiding knowledge and those who labor with their minds and in so doing distinguish themselves from the hired "mechanics" before them.

We might term this separation and specialization within the work sphere a mode of *ekphrasis,* a rhetorical term that refers to the use of a written program in interpreting visual images. Peale has turned *ekphrasis* into the basis for class differentiation. Those with access to the text control the forms of cultural production, a production literalized here in that wry and Rube Goldbergian–like contraption for recovering the mastodon bones. Even in Peale's later *Artist in his Museum* (1822), the young boy in the background is guided through the museum not just by an adult, but with the assistance of a written text.

Bingham's painting must be understood as the descendant of Peale's *Exhumation*. By this I don't mean Bingham alludes directly to Peale's canvas or that his boatmen are about to start digging for bones rather than pitching wood. Rather *Boatmen on the Missouri* is a painting about how to bring together what Peale, and the professionalized culture he adumbrates, tears asunder. It is an image that inscribes the division of labor, and the class divisions which follow from it, into its own pictorial world. As such, it has less to do with life on the Missouri than the cultural and intellectual landscape of the artist. The painting works as a self-portrait of the artist as an aspiring professional. It sets into play the heterogeneous forces that drive his work: the commercialization of the West; the commodification of the image of the yeoman; and the notion of seeing in its contradictory valences as both a lingua franca among equals and the arena of intellectual labor among the professional classes. *Boatmen on the Missouri* is not only about the invention of the West as an ideological necessity (and a market opportunity), but about the type of intellectual work performed by the artist who creates shared ways of seeing, imaginary spaces that work hegemonically to enforce a particular set of values. Bingham's painting is thus hard at work in two tasks: It seeks to suppress the division of labor, the rift between intellectual and manual activity that underwrites its composition, and it naturalizes its labor of seeing so as to appear "innocent." It renders its own intellectual work invisible at the same time as it invests manual labor with the aura of preindustrial values. Or to revert to the language of Walt Disney, it asserts that work and play can mix.

And this returns us to the question of an innocent eye. We are prepared at last to understand what is at stake in Bingham's complicated narrative of seeing.

1. Bingham's characters are compartmentalized into separate spheres of work and play in a manner parallel to Peale's. The difference is that Peale's distinction between manual and mental labor legitimates a realignment of class divisions along informational or professional lines whereas Bingham works everywhere to reintegrate eye and hand. He does so in order to invent a region, efface a class, and sell paintings in a market defined by national parameters.

2. Unlike Copley, who uses a crafts ideology in portraits like *Paul Revere* or *Nathaniel Hurd* to hold mind and body together, Bingham turns instead to an alternative version of republicanism, to a myth of the yeoman farmer, which he then updates in accordance with the rough and tumble requirements of the Missouri river world. His heroicized boatmen provide that combination of independence and stability once reserved for the boys back home on the farm.

3. The spectator in the world of *Boatmen on the Missouri* is a *utopian* creation. We are placed midway between the two staring figures, and opposite the laboring one, because we are asked to unite within ourselves the functions they variously represent. We enter the painting as idealized visual constructs, at once members of a imaginary public sphere shared with Bingham's characters and resolvers of the compartmentalized and dualistic space they inhabit. We have become, in our unifying role, Emerson's *Man Thinking*.

4. To say we are present as an innocent eye is to stress two aspects behind the notion of innocence: (a) its utopian dimension (we, as imagined viewers, unite what they represent separately); and (b) its ideological dimension (we are innocent precisely because the painting denies that our seeing is work, that our position as viewers has been constructed as deliberately as the spaces and figures on the boat).

5. The program of the painting then is mythmaking, and from this canvas we learn what Bingham means by myth. He means by myth a point of view, a way of seeing, that comes to substitute for history. That is the work of seeing: It creates a myth, a narrative, that we might call antihistorical, for its goal is not an accurate account of the past or present, but an account that substitutes unity for division, continuity for change, and regional identity for class difference. Such myths are hegemonic, for they absorb all history into themselves.

6. For Bingham this work of mythmaking is the work of the eye. In *Boatmen on the Missouri*, where seeing is thematized within a rhetoric of work and play, the ultimate seer is the viewer, whose presence and whose way of looking is the final end product of the painting's labor. Bingham labors to create *our* innocence.

7. Bingham uses the techniques of "naive realism" in order to keep the work of seeing invisible. The labor of the eye in inventing history – the process of mythmaking – must not appear as *labor*. That is why Bingham insists so intently that work is really play, that no real work is being done, that all

vision is simply natural. To suggest otherwise would be to admit the labor that undergirds utopia, the ideology that informs "innocence."

8. And finally, we are in a position to answer the question of how Barrell's account of the rural poor in England relates to marginalized workers in mid-nineteenth-century America. The answer is threefold: Bingham's western figures flourish, rather than diminish, as the industrial revolution progresses because (a) they are tied to a fantasy of preindustrial values that remains alive by being framed within regional boundaries; (b) they efface class as a divisive cultural category by substituting spatial and regional markers for economic ones; and (c) they engage in a complicated dialectic of seeing that naturalizes class perceptions at the same time as they deny their intellectual labor. Bingham's paintings hide their ideological work within a larger ethos of innocent seeing. These three points together spell out the nature of Bingham's hegemonic agenda.

Coda

We might contrast Bingham's effort to render the work of seeing invisible in *Boatmen on the Missouri* with William Sidney Mount's rumination on a similar theme in *The Painter's Triumph* of 1838 (Fig. 71).[19] Mount depicts an artist in his studio standing next to an admiring spectator. The upholstered Windsor chair behind the ingenuous visitor suggests that the latter might be the subject

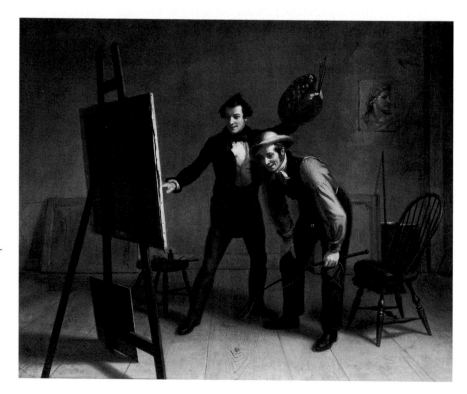

FIGURE 71

William Sidney Mount. *The Painter's Triumph.* 1838.

Courtesy the Pennsylvania Academy of the Fine Arts, Philadelphia. Bequest of Henry C. Carey (the Carey Collection).

of the canvas he is looking at.[20] Both viewers gaze delightedly on the foreground painting we see only from the rear. In a sweeping diagonal gesture, the artist points down with his right hand to the unseen canvas and back with his left hand (palette and brushes in tow) to the image of a classical figure on the studio wall. This double gesture suggests that the "triumph" of the artist is to mediate between past and future, drawing on the models of the past to temper the present in order to produce a vision of an idealized future. The artist in Mount's good-natured painting functions at two levels: He both constructs myths and hides them. The artist accommodates classical conventions (the background) to contemporary circumstances (the middle ground) while forging for his audience a vision of their collective aspirations (foreground). His task is to create a cultural self-portrait, and his triumph lies in his ability to mythologize the present – to dress it up with past glories and future hopes – in a manner that flatters the audience without alerting it to the mythmaking that has occurred. The triumph of the artist is to *naturalize* his audience's assumptions. What they take to be natural he has worked to create.

Mount's painting acknowledges the machinery at work in many mid-nineteenth-century paintings. His spectator hails from the country, a happy rube when compared to the cosmopolitan sophistication of the artist. Like Bingham's western figures, he is given to us as countryish (another version of Bingham's "regionalism") because his seeing is innocent. He knows what he likes and he likes what he sees. What he does not know is that the artist is having fun at his expense. The painting lampoons the innocence of the spectator whose eye accepts as *real* what we know to be a clever combination of flattery, manipulation, and social commentary.

Like Bingham, then, Mount's success lies in his ability to hide his success – to make his audience believe that what it accepts as a careful reproduction of nature is really only a calculated rendition of culture. Unlike Bingham, however, Mount lets his viewer in on the joke. What the painter paints is not the *real* but *ideology realized.* Mount makes explicit what in Bingham is both implicit and suppressed: the process of naturalization by which the artist transforms social imperatives into "natural" ways of seeing. For that is his triumph, the heart of his intellectual work: to render his images so natural, so available, so matter-of-fact that the innocent eye will accept them without further inquiry into the cultural baggage they carry with them.

Not all painters of the period, of course, constructed seeing as an innocent act. Richard Caton Woodville, in *Waiting for the Stage*, 1851, gives the question of seeing a distinctly conspiratorial cast (Fig. 72). Woodville depicts two men at a game of cards in a cluttered interior. The bearded card player on the far side of the table waits for the top-hatted traveler opposite him to make his move. A third figure stands between the two players, immersed apparently in a paper that he reads. The paper is titled *The Spy;* its hint of sinister mystery is reinforced by the darkly tinted glasses the man wears, shading his eyes from scrutiny. The painting is divided between imagery of reassurance, tied to familiar objects within the room like the stove, cuspidor, tea kettle, decanter, and desk, and a countervailing imagery of *dislocation*. This latter imagery

stems from the signs of transience in the painting: the card player's carpetbag, the random notes posted in the frame of the mirror, the burning candle, the blackboard with its dangling chalk and crudely limned head, the birdcage with its absent bird, and the standing man himself, dressed as a dandy and sharpster, a forerunner of Melville's confidence man.[21]

Woodville's gambit in the painting is a deconstructive one: He sets three figures into a shared space, fills that space with familiar objects, places two men in a relation that assumes, despite its competitive edge, equality and direct dealing, and then withholds the egalitarian reassurance his painting promises. What happens in the painting instead is that the markers of stability and comfort are ironized: The standing man functions as a "spy," intruding himself on the world of the card players without acknowledging his dissem-

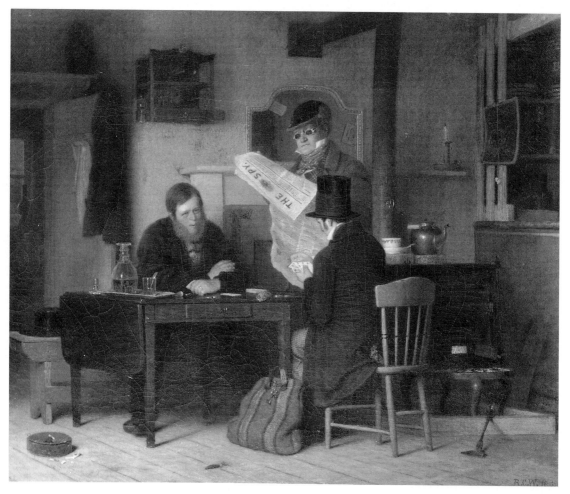

FIGURE 72

Richard Caton Woodville. *Waiting for the Stage.* 1851.

In the Collection of the Corcoran Gallery of Art. Museum Purchase, Gallery Fund, William A. Clark Fund, and through the gifts of Mr. and Mrs. Lansdell K. Christie and Orme Wilson.

blance (he feigns reading). He disrupts the gemeinschaft quality of their world by adding a note of surveillance and hinting, by his conspiratorial stance, that he may well be in cahoots with the hatted player whose face remains hidden from the viewer.

The issues of surveillance that the painting raises bring our story full circle. Woodville's standing figure mediates not only the social space between the two seated players but their cognitive relations as well (success in the painting turns on the question of knowledge – who sees the most, who knows what cards the other possesses without revealing his own hand). He incarnates a notion of intellectual labor that is depicted as secretive, unmoored, manipulative, deracinated, and untrustworthy. The painting taps into the deep fantasies of conspiracy rampant in the antebellum imagination (fears about Catholics, Masons, abolitionists, et al.), at the same time as it recasts its conspiratorial logic into a specifically *visual* idiom.[22] The problem is less political cabal than a mistrust of appearances. We are being spied on; things are not what they seem. And the reason, the painting suggests, for this discomfiture lies in the central figure: He represents the corruption of vision, the conversion of ordinary ways of seeing into perverse ones. His presence transforms binary relations into tertiary ones, direct encounters into mediated ones, a game of cards between two men into a relationship triangulated by an outsider and tinged with suspicions of wrongdoing. In fact, if we accept the painting's conspiratorial suggestions, then the only egalitarian relationship within the painting turns out to be, ironically, the pairing of the two conspirators, while the innocent card player, the man with the rust-colored beard, proves to be the outsider.

Woodville's thematics of seeing form an arresting counterpoint to Bingham's own concern with sight. The three men in Woodville's painting, like the triad in *Boatmen on the Missouri,* divide into groups of two and one (how those groupings are parsed in the Woodville image depends on how one reads the painting). To revert to our Disneyesque rhetoric, we might see the standing figure in the background of *Waiting for the Stage* as yet another little pig hard at work. Like Bingham's background figure, his eyes are averted, he is linked to the world of commerce and travel, and he occupies the center of the image. Unlike Bingham's figure, his work is both invisible and corrupted. He represents not the naturalization of class-defined mythologies (the intellectual labor grounding Bingham's art), but its opposite, the infection of the body politic by ways of seeing that abstract and transgress local values.

If Bingham recreates the public sphere for us as a preindustrial male world, defined by values of independence, egalitarianism, and mutuality, then Woodville offers instead an alternative space founded on the values of a market culture, a world defined, through its trope of travel, as mobile, transient, antilocal, and ultimately anticommunity. Bingham gives us a scene of motion – river travel – and then arrests that motion so thoroughly we are convinced, as viewers, that what we see is permanent and unchanging. He achieves stasis in the midst of motion. Woodville works toward opposite ends. His theatrical mise-en-scène begins with the familiar and the accessible, but like a house of

cards, his cozy world comes tumbling down, a simulation of stability that proves quickly false. For Woodville seeing has aligned itself against the local, the known, and the familiar; perception internalizes within its everyday operations the patterns of a national culture that is predatory, calculating, and corrosive. Seeing has less to do with Bingham's hegemonic ideology – the construction of an imaginary national community – than it does with the dissolution of the very values that painters like Bingham espouse.

We might describe Woodville's painting as postnatural in its assumptions. It refuses the localized world of Bingham's regional characters as anything more than the occasion for a little larceny, and insists instead on ways of seeing that thrive in a voyeuristic and predatory fashion, feeding off the "natural." What was once innocent (the painting's opening gambit) no longer is, and the reason is that the worlds of leisure and play – social spaces tied to the production of culture – have become instead the site for work. Only this is not the sort of work that Bingham would acknowledge or Walt Disney approve. It is the work of a market world understood as perverse and postnatural. It is work that deconstructs culture and its own hegemonic imperatives. And who but the big bad wolf, whistling here in the dark, would want that?

Imperiled Ideals
British Historical Heroines in Antebellum American History Painting

Wendy Greenhouse

The glorification of the national past has long been accepted as the characteristic preoccupation of antebellum American history painting. In an era of swaggering nationalism in matters artistic as well as political, a theme like the landing of the Pilgrims at Plymouth Rock soon became what one critic modestly called "a somewhat hackneyed subject."[1] With a chauvinistic energy characteristic of their westward territorial conquests, Americans were staking claims to a history they could call their own. So thoroughly did they enshrine the national fathers that 150 years later, our view of them is still inescapably in thrall to fabrications of the 1850s like Peter Frederick Rothermel's *Landing of the Pilgrims* (1854) and the ubiquitous *Washington Crossing the Delaware* (1851) by Emanuel Leutze.

Just as antebellum genre painters portrayed a hearty masculine world dominated by farm and frontier, contemporary history painters rendered the national past largely in terms of manly heroes pursuing ideals and missions vindicated by the subsequent course of American history.[2] Leutze's determined Washington, setting out across the Delaware to subdue the Hessians, finds a natural counterpart in the self-possessed farmers, adventurers, speculators, and riverboatmen who contend with field and frontier in contemporary genre painting. There is a noticeable absence of women in their rugged worlds. Women do appear in antebellum views of the American past, but in subordinate roles that only underscore its interpretation as a manly saga of heroes pursuing righteous and ultimately successful causes. Thomas Pritchard Rossiter's *The Regicide Judges Succored by the Ladies of New Haven* (1848), for instance, identifies its heroines with the cause of liberty for their role in giving sanctuary to the three men who had condemned to death the tyrant Charles I. Leutze's *Mrs. Schuyler Burning Her Wheat Fields on the Approach of the British* (1852), which illustrates an apocryphal story from Elizabeth Ellet's *The Women of the American Revolution* (1848), honors a woman for heroic action on behalf of and according to the direction of her absent husband: setting his crops alight to prevent them from falling into the hands of invading British troops.[3] However valorous, these women never seem really endangered. They are stand-ins

for heroic men who truly shape the course of events whose happy outcome we already know. As they appear in antebellum images of American history, then, women affirm the view of the national past offered by *Washington Crossing the Delaware:* uplifting, upbeat, and ultimately male-dominated, a saga of cooperation between the sexes – each, of course, in its appointed place.

These conventions might be too obvious to bear noting were they not so conspicuously abandoned in a parallel group of history paintings exemplified by Leutze's *The Image Breaker* of 1847 (Fig. 73). This melodramatic work pictures a furious English Puritan who, having accidentally discovered the evidence of his daughter's secret conversion to Catholicism, raises his arm to sweep away her improvised altar as she cowers, terrified, at his feet. Engraved for distribution to the American Art-Union's nationwide membership in late 1850, just as the artist was putting the finishing touches on his patriotic *Washington Crossing, The Image Breaker* stands as the latter's subversive antithesis.[4] Whereas *Washington Crossing* celebrates triumphant republicanism, benevolent fatherhood, and

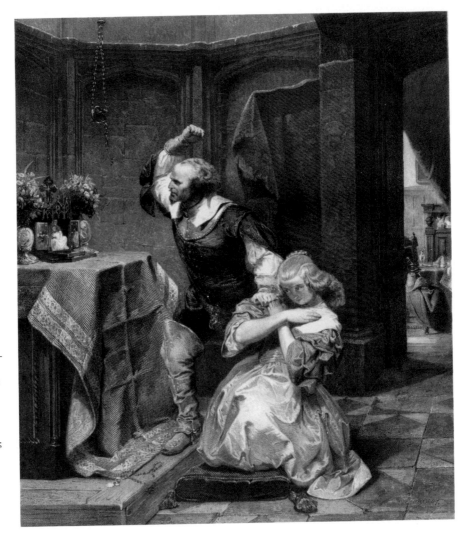

FIGURE 73

A. Jones after Emanuel Leutze. *The Image Breaker* (painted 1847).

Engraving published in Ornaments of Memory; or, Beauties of History, Romance, and Poetry. With Eighteen Engravings, from Original Designs *(New York, 1856).*

Manifest Destiny, *The Image Breaker* condemns religious hypocrisy and intolerance, and gender and generational strife. Although little known today, it is representative of a surprisingly large body of antebellum American history paintings not only in its European setting, but in its use of conflict between a man and a woman to symbolize larger political and religious discord.

Even in the notably nationalistic decades that preceded the Civil War it is hardly surprising to find antebellum American history painters reaching beyond the bounds of strictly "American" subjects. The national past's brevity and lack of "picturesqueness" presented serious obstacles to patriotic artists, as even the American Art-Union, for all its oft-repeated promotion of home-grown subject matter, admitted.[5] In search of less hackneyed subjects than Pilgrim Thanksgivings, American history painters turned their attention abroad to European history, especially to the history of the mother country. Between the early 1840s and the Civil War some fifty American artists executed more than 130 scenes from British history of the Tudor and Stuart eras. Although these were outnumbered by American historical subjects, just as landscape and portraiture overshadowed history painting in the antebellum period, they received comparable critical attention and attracted the talents of many of the same history painters.[6] These artists were led by Leutze (1816–68), whose works have survived in disproportionately large numbers and will unavoidably dominate our discussion.[7] But a host of other important artists dabbled in these subjects as well. In New York in the late 1840s, for instance, Daniel Huntington (1816–1906), author of the highly acclaimed painting *Mercy's Dream* and widely regarded as one of America's most promising young history painters, executed in rapid succession eight scenes from Tudor history. Rothermel (1812–95), Philadelphia's leading history painter, treated subjects from Elizabethan and Stuart history well past the Civil War. Bostonian William Rimmer (1816–79) and Charleston native John Beaufain Irving (1825–77) (while a student of Leutze in Düsseldorf) made their artistic debuts with subjects from British history, and the expatriate James W. Glass, Jr. (1825–55) dedicated his brief career to picturing the English Civil War.[8]

In portraying British history subjects, American artists were certainly influenced by contemporary French and British artists who had already turned in large numbers to the dramatic and picturesque treatment of national history. The works of Paul Delaroche, Charles Robert Leslie, the French *style troubadour* painters, and other history painters were widely distributed in America in reproductive engravings and gift book illustrations, and familiar to American artists and patrons who traveled abroad. For instance, for his ambitious *Lady Jane Grey Preparing for Execution* (1835), young South Carolina artist George Whiting Flagg, working in Paris, seems to have looked both to Delaroche's painting *The Execution of Lady Jane Grey* (1834), recently exhibited to great acclaim at the Paris Salon, and to an earlier work, English painter John Opie's rendition of Mary Queen of Scots being blindfolded before her execution, which was engraved for Bowyer's Historic Gallery in 1812.[9]

Although the artists' models may have been foreign imports, the motivation for treating such subjects apparently came from home. How else can we

account for the enthusiastic patronage of American portrayals of British history not only by numerous important private collectors,[10] but by an organization like the American Art-Union, which was unabashedly subservient to what it tactfully called "a various taste"?[11] In its short existence (1840–52) the Art-Union exhibited and distributed about half the British history pictures American artists painted in the antebellum period, and engraved five of them either as membership premiums or as illustrations in its *Bulletin*.[12] Clearly the Art-Union assumed that such subjects as Sir Walter Raleigh parting with his wife before his execution, as portrayed by Leutze (the Art-Union's premium for 1846),[13] and Queen Mary signing the death warrant of Lady Jane Grey, in a painting by Huntington (Fig. 74) (the 1848 premium), would be as instantly legible to literate Americans as Columbus's landing and Washington's crossing, and freighted with every bit as much meaning.

That meaning is largely lost today, a fact reflected in the relatively poor survival rate of American portrayals of British history; both Huntington's *Queen Mary* and Leutze's *Sir Walter Raleigh,* in fact, are known today only from the engravings. Few modern Americans can identify Lady Jane Grey or (Tarheels excepted) do more than vaguely associate Sir Walter Raleigh with tobacco and gallantry. Yet in their presumption of the viewer's familiarity with the British past, these images strongly suggest that literate antebellum Americans knew the history of the mother country at least as well as they knew their own.[14] Along with biblical and classical history, British history dominated the

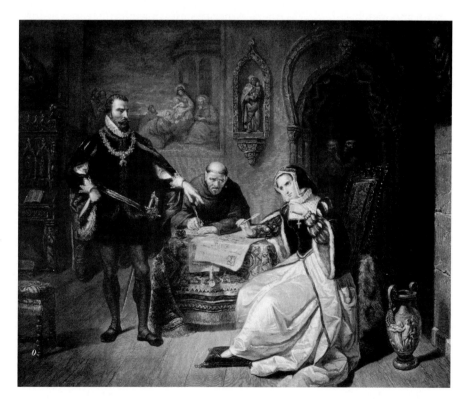

FIGURE 74

Charles Burt after
Daniel Huntington.
*The Signing of the
Death Warrant of
Lady Jane Grey*
(painted 1848).

*Engraving distributed by
the American Art-
Union, 1848. Collection
of the author.*

historical literature available to Americans. Well before American history became a standard instructional subject, British history had a central place in school texts (which continued to be British imports well after the Revolution) and in college curricula.[15] Hume's and Macaulay's histories, Sir Walter Scott's *Waverly* novels, and Agnes Strickland's ponderous multivolume *Lives of the Queens of England* commanded a disproportionately large American, compared to British, readership.[16] As a nation America in the 1840s, 1850s, and 1860s was just distant enough from the Revolution, just culturally self-confident enough, and sufficiently dominated by a white, Anglo-Saxon Protestant elite to cherish her British roots. England's history *was* America's: "We cannot, therefore, understand ourselves or our institutions, but by a careful perusal of English history," argued Samuel Griswold Goodrich in the introduction to his popular *Pictorial History of England* of 1846.[17]

The significance of that history for antebellum Americans is suggested by Leutze's rendering of a subject he called *The Courtship of Anne Boleyn* (or *The Court of Henry VIII*) (Fig. 75). "One of the most popular pictures we have ever had among us," according to one enthusiastic critic,[18] it was exhibited at the New York Gallery of Fine Arts in 1846 and the National Academy of Design the following year. In this intimately scaled picture Leutze depicts the moment when the king falls in love with Anne Boleyn at a royal banquet, a subject for which the artist could turn to standard historical accounts such as Strickland's *Lives* , as well as to Shakespeare's then widely performed play *Henry VIII*.[19] In an era when the latter was regarded as "the best history of that time,"[20] critics were undisturbed by Leutze's casual conflation of historical fact and Shakespearean fiction, by which he brought together in one scene the full cast of

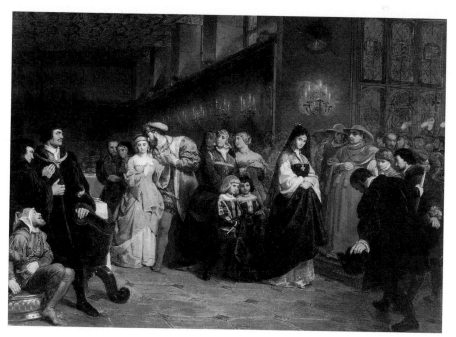

FIGURE 75

Emanuel Leutze. *The Courtship of Anne Boleyn* (or *The Court of Henry VIII*). 1846.

National Museum of American Art, Smithsonian Institution, museum purchase.

characters entangled in Henry's passion for Anne – including two, the princi-pled statesman Sir Thomas More and long-suffering Queen Catherine of Aragon, not included in Shakespeare's dramatization of this moment. In pic-turing their reactions as well as the royal flirtation itself, Leutze emphasizes the conflict attendant on Henry's marital ambitions, thus projecting from this inti-mate scene its momentous result: the English Reformation.

Antebellum Americans found that event remote from neither their national past nor contemporary concerns. Viewing their nation as the culmi-nating product of the ideals and achievements of the Reformation, they for-mulated the doctrine of Manifest Destiny as a modern secular fulfillment of the Pilgrim Fathers' "errand into the wilderness." The spreading of white, Protestant civilization to America's boundaries would complete the unfinished Reformation of the Old World in the New.[21] Thus for Leutze and his contem-poraries, the power of destiny and the blessing of heaven alike connected the Reformation to the discovery of America, the Revolution, and the conquest of the western frontier in a "long cycle" of the westward march of freedom into a glorious star-spangled future.[22]

Yet the viewers of *Anne Boleyn* saw in it not only the germ of national institutions and the national mission. They also invested the Reformation with a topical urgency in the face of contemporary religious crises: the rapidly shift-ing balance between declining Puritan sects and immigrant Catholicism, the rise of militant Know-Nothingism, and the powerful impact on mainstream American Protestantism of the Oxford Movement, a radical rapprochement with Rome. Such "recent events of a painful character in the Protestant ranks, lead us to look again with intense interest to those days of struggle and dan-ger," noted Daniel Huntington, a concerned Episcopalian, as he turned in the late 1840s to subjects from Reformation history.[23] If indeed Americans had "the battle of the Reformation to fight over again in the middle of the nine-teenth century," in the words of one partisan journal,[24] history paintings that evoked the perils and promise of that stirring era could provide powerful inspiration.

The images of the British past already introduced testify that Huntington's bleak view of "days of struggle and danger" was widely shared. American his-tory paintings picture Tudor and Stuart England uniformly as an age in which the representatives of virtue and enlightened thinking are by definition doomed to tragic ends. And in almost every case, these representatives are sympathetic heroines doomed by their femininity and their goodness, an unhappy sisterhood whose tragic suffering separates them dramatically from their fortunate early American cousins. Typical is Lady Jane Grey, the reluctant royal usurper of mid-sixteenth-century England. Virtuous, pious, retiring, forced against her better judgment to accept an illegitimate crown, and beheaded at the tender age of sixteen, Jane was celebrated in Victorian Amer-ica as the embodiment of what Barbara Welter, in her classic study of the nine-teenth-century feminine ideal, identified as the four cardinal virtues of wom-anhood: piety, purity, passivity, and domesticity.[25] Jane's calm resignation to

her fate and her perfect composure at her execution were the subject of the earliest American treatment of Tudor history, Flagg's *Lady Jane Grey Preparing for Execution*, as well as one of the last, *Lady Jane Grey on Her Way to Execution* by Edward Harrison May (1864). Both present a historical heroine with no other reason for being, apparently, than to inspire posterity by her example of self-sacrifice and self-control, the theme of numerous accounts of Jane published in preceptive women's magazines throughout the period.[26]

Character aside, Jane Grey was also a natural object of sympathy because she was a Protestant martyr of the English Reformation: neglected by both Shakespeare and Scott, whose works did so much to popularize British history in the United States, she was instead familiar to Americans from Foxe's *Book of Martyrs*, the sixteenth-century martyrology that took its place alongside Bunyan's *Pilgrim's Progress* on the bookshelf of every conscientious American Protestant. In fact, the most widely disseminated picture drawn from her story, the American Art-Union's print after Huntington's *Signing of the Death Warrant* (Fig. 74), is not so much about the martyrdom of Jane Grey as it is a reiteration of the familiar stereotype of "Bloody" Mary Tudor, persecutor of innocent Protestants. By showing Mary in the act of signing away yet another Protestant life, this image of the English Reformation exhorted nineteenth-century Protestant Americans to be both grateful for their freedoms and vigilant against the menace of popery.

For all this, however, Huntington's Mary Tudor is a curiously sympathetic figure, for she appears not in the act of actually signing the death warrant, but hesitating, pen poised above document and her brow contracted with anxious indecision, despite the stern command of the Spanish ambassador at left. This reluctant queen appears less an oppressor than a victim herself, as much of her status as a woman thrust into the male world of political power and intrigue as of the persecuting tendencies of Romanism. This interpretation is reinforced by the conventions of the American portrayal of Tudor and Stuart history (already suggested by Leutze's *The Image Breaker*) according to which feminine frailty is relentlessly coerced by masculine authority with an inevitability that transcends religious partisanship.

In light of these conventions it is not surprising to find Mary Queen of Scots the most adored historical heroine in antebellum America.[27] Mary's suffering as a woman – her unhappy marriages, the persecution that met her efforts to practice her religion, her long imprisonment and execution at the hands of Elizabeth I – apparently cancelled out both her Catholicism and her tarnished moral reputation. Concluded Emma Willard in her textbook of world history, "The misfortunes of the lovely queen of Scots, insensibly lead the heart to regard her with sympathy, and throw a veil over her imprudence, it may be her crimes."[28] Thus, despite her Catholicism, Mary's story could lend itself to a protest against religious bigotry. Rothermel's *Murray's Defense of Toleration*, engraved for the American Art-Union *Bulletin* in 1851, shows the tolerant Protestant Lord Murray preventing a mob of furious Reformers from breaking up the Catholic mass being said for Mary's court.[29] While the queen herself,

kneeling in prayer, is almost lost in the background, a generic mother and child, seated in the foreground, supply the obligatory element of pathetic reproach. In a similar spirit, Leutze's *John Knox and Mary Queen of Scots* (Fig. 76) portrays the confrontation between the two as a symbolic conflict of male and female qualities. The pretty young queen, eyes downcast, endures Knox's hostile diatribe in indignant silence. As he harangues her, holding out a copy of his treatise denouncing female monarchs, Knox appears less a righteous Reformer than a fanatical misogynist dogmatically opposed to the feminine attributes of gentleness, sensibility, and intuitiveness, qualities that redeemed Mary in nineteenth-century eyes. The opposition of her femininity and Knox's coercive masculinity is echoed behind the two figures in portraits representing the queen's rigid Scot-

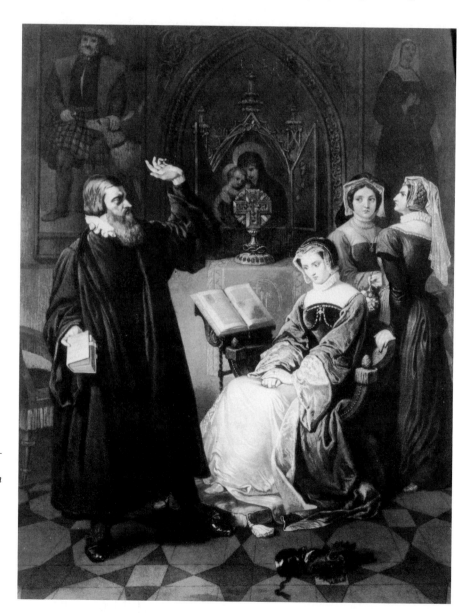

FIGURE 76

John Sartain after Emanuel Leutze. *John Knox and Mary Queen of Scots* (painted 1845).

Engraving distributed by the Philadelphia Art-Union, 1848. The Historical Society of Pennsylvania.

tish father and her French mother, in an imploring pose; between them, and dividing Knox and Mary visually, is an image of the Virgin and Child, who seem to glance reproachfully at the tyrannical Reformer.

Leutze's *John Knox and Mary Queen of Scots* was engraved for distribution by the Philadelphia Art-Union in 1848. This was also the year the American Art-Union distributed its engraving after Huntington's *Death Warrant,* and at least one critic was struck by the correspondence between the trials of Mary Stuart, harassed by Knox, and those of Jane Grey, whose Reform faith was besieged by zealous priests during her final imprisonment.[30] As critics of both Leutze's *John Knox and Mary Queen of Scots* and Rothermel's *Murray's Defense* remarked, the appeal of long-suffering womanhood overshadowed the righteousness of the Protestant cause advocated by their male oppressors.[31] Indeed, Mary's persecution by Knox and the reformed Scottish nobility, along with her tragic end, inspired an "interest of painful intensity"[32] that overwhelmed disapproval of her misguided religious faith and irregular personal life tainted with charges of murder and adultery. In a typical image, Louis Lang's *Mary Queen of Scots, Dividing Her Jewels* (1861), a maternal Queen of Scots is memorialized, worshipped by a crowd of faithful attendants as she distributes her possessions the night before her execution;[33] in another work Lang suggested Mary's status as martyr with the apt title *The Last Supper of Mary Queen of Scots* (1860).

These and many other American history paintings reduced the individual stories of a host of British historical heroines to a few stereotyped situations in which virtuous womanhood faces inevitable defeat at the hands of domineering males or the forces of their world. Even portrayals of male victims of that world, such as Leutze's *Raleigh Parting with His Wife* and a similar work it apparently inspired, *Sir Thomas More Parting with His Daughter* (1856) by his student John Beaufain Irving,[34] downplay the fate courageously suffered by heroes who oppose monarchical tyranny and emphasize instead its tragic consequences for the faithful women they will leave behind as they go bravely to the scaffold. The net effect of these images was not only to present Old England as a hostile environment for virtue and enlightened values – in contrast, of course, to America. Whether they portray tragic queens or generic heroines, these pictures also warned American womanhood of the dangers of public life and, by contrast, proclaimed the moral superiority of the domestic sphere to which the contemporary feminine ideal confined them. The relentlessly negative terms in which this message was cast (even such an embodiment of virtue as Jane Grey loses her head) reinforced the principles of self-abnegation and the heavenly reward central to the Victorian ideal of womanhood.

Queen Elizabeth, the only figure who defies this pattern, is surely the exception that proves the rule. Although, like nineteenth-century Englishmen, Americans viewed the Elizabethan period nostalgically as a golden age,[35] they found little to admire in the character of the queen herself. They condemned her celebrated virginity as proof that she had betrayed her femininity, and judged her character a moral failure in proportion to her political success.[36] Sir Walter Scott's enormously popular novel *Kenilworth* offered ample confirmation. In it, the incident of Raleigh laying down his cloak for the queen, which

inspired paintings by both Leutze (1845) and Rothermel (1854), highlights not so much his gallantry as her vain and dictatorial character. In a similar spirit, one of numerous American magazine accounts of Elizabeth damned her with faint praise when it pronounced her character "rather that of a very great personage than of a good woman."[37]

Elizabeth only seemed to offer sympathetic material as a beleaguered Protestant during Bloody Mary's reign, when her story recapitulated those of Jane Grey and Mary Stuart undergoing their trials of faith.[38] In 1860 Leutze painted *Princess Elizabeth in the Tower,* an image of the imprisoned princess raising her hand to her breast and her grateful glance to heaven after surviving the persecuting Archbishop Gardiner's test of her religious orthodoxy.[39] Yet even this view of Elizabeth is appropriately ambiguous: In Leutze's work a prie-dieu and a statuette of the Virgin and Child in the foreground remind us that Elizabeth survived her interrogation thanks to the pragmatic talent for dissembling that was to make her the consummate survivor on the throne. She "stood true to the momentous issues of the Reformation, . . . not . . . so much from high religious motives as from personal considerations" was a typical disapproving assessment.[40] Nineteenth-century American Protestants who could admire the steadfast religious conviction even of Catholics like Mary Tudor and Mary Queen of Scots were equally ready to condemn the political expediency that guided Elizabeth's adherence to religious reform.

While few interesting heroines enlivened the history of the Stuart era, England's Civil War did offer American history painters a rich fund of incident in which their own national trauma could be represented affectingly by the conflict between genders and generations. For two decades before the outbreak of the Civil War Americans drew parallels between the national character types of the hard-nosed northern Yankee and the aristocratic southern gentleman, and their supposed ancestors: the stern English Puritan and the chivalric Cavalier.[41] The widening rift between North and South increasingly appeared as the inevitable product of inherent opposition between contrasting aspects of the national culture that went back to America's origins. For Americans on both sides, the seventeenth-century clash between Puritans and Cavaliers attracted new interest as source and precedent for their looming national conflict.[42]

Nothing served as well as the image of the divided family to sum up the horrors of civil war – war that would divide actual families as well as the national family of states. Antebellum writers were drawn to themes of ideologically opposed brothers, fathers, and sons separated by partisan politics, and the most potent of all metaphors for the destruction wrought by civil conflict: the daughter torn between duty to her father and love for the brother or lover who has joined the enemy.[43] Leutze took up this subject in his 1850 painting *The Puritan and the Wounded Cavalier* (Fig. 77), in which a young woman appeals to her father to aid his enemy.[44] The tension between the rigid Puritan and his tenderhearted daughter overshadows the poignancy of the handsome young Cavalier's desperation and the compassion of the kindhearted Cromwellian soldier who has brought him to this doubtful refuge. Details plot a complex story in which ideological conviction and family feeling interweave and con-

flict: The daughter wears the keys of the household, indicating her motherless status; the Puritan's mourning dress and his troubled expression project the mingled emotions of a father who sees in the young man before him both a likeness of the son he has lost and that son's slayer, according to the American Art-Union *Bulletin*.[45] In the background, the smoke of the distant battle at right and the dilapidated condition of the Puritan's home, where weeds sprout from the decayed entranceway, are further signs of the dispute whose ideological origin now seems petty compared to its toll on natural social and familial bonds. Like Raleigh's wife and Sir Thomas More's daughter, the Puritan's passionately imploring child represents the power of these bonds and the triumph of heart and conscience over the abstract political principles that divide men;

FIGURE 77

Emanuel Leutze. *After the Battle* (or *The Puritan and the Wounded Cavalier*). 1850.

Montclair Art Museum Permanent Collection.

the grief and anxiety of loyal women, the focus of these pictures, symbolize the true cost of civil strife to the domestic fabric of the national family.

Richard Caton Woodville's *The Cavalier's Return* of 1847 (Fig. 78) seems at first glance a departure from the gloomy drama of the pictures explored so far. In a tranquil interior a family is reunited as the mother urges her shy young son toward his father. Yet the picture's very title and its seventeenth-century English setting together suggest all the disruption of civil war, which here has literally invaded the hearth. The Cavalier's sword and spurs, hastily discarded in the left foreground as he made his way toward welcome refreshment, testify to an absence on business both grim and prolonged, since his own child now approaches him shyly, as if a stranger. The Cavalier is now not so much a father as an intruder in the quiet refuge of his own home, into which he brings the conflict convulsing the larger world outside. By evoking the English Civil War in costume, setting, and title, Woodville thus imposes somber overtones on what would otherwise read as a cozy affirmation of home and family, transforming a trivial domestic incident into a subtle warning against the disruptive force of manly affairs.

The pictures we have so rapidly surveyed present an Old England in which the charm of nostalgia is eclipsed by disruption and conflict personalized in the fates of sympathetic heroines. Whether famous queens or generic

wives and daughters, Catholic or Protestant, these women are presented as the natural magnet for the viewer's empathy. Embodiments of the nineteenth-century feminine ideal in their tenderheartedness and passive resignation to fate, they are also advocates for the family as a metaphor for a moral society founded on the organic virtues of compassion and tolerance. Yet all these high ideals are cast in relentlessly negative terms, as we repeatedly witness the victimization and passive surrender of heroines on the basis of the very qualities we are being instructed to admire and emulate. Although this seems a curiously subversive promotional strategy, it ably serves two diverse ends. First, as already noted, it reinforces the fundamentally negative foundation of True Womanhood. Not only is public life incompatible with the retiring, domestic feminine ideal, according to these images, but we are also to learn that the sacrifice and suffering they illustrate are inherent elements of that ideal: Woman never so fully fulfills herself as a woman as when she "wears her victim crown," in the words of one poetic description of "Woman's Lot."[46]

Second, virtue's perpetual defeat in the events from the British past pictured by Americans also profiles the complex relationship that nineteenth-century Americans saw between their nation and its mission on the one hand and Europe and its past on the other. Clearly, the bleaker that past, the more righteous and inevitable did America appear as the enlightened answer to it. The violent history of England's Reformation and Civil War, in particular, simultaneously offered both just such a flattering contrast, and flattering continuities in the origins of cherished institutions upon which Americans founded their claim of national superiority. Yet the parallels were also startingly close. British history, like a dark mirror of contemporary America, thus presented a medium for self-doubt and self-criticism in a period when the brief American past, a shrine to national superiority, could only reflect patriotic self-congratulation. While a grimly confident Washington crossing to victory at Trenton inspired antebellum Americans with a positive example of national unity, the English Puritan's violent oppression of his defenseless daughter reflected their anxieties about the threat of national disunion.

This use – or abuse – of British history in antebellum America offers a perspective on the whole idea of the past that has important implications for our understanding of the history painting that resulted. Whether Americans were celebrating their freedom from the enervating yoke of tradition that seemed to burden European societies or proclaiming America as the triumphant climax of world history, they were redefining their relationship with the very idea of the past. As they gradually abandoned the cherished Enlightenment conviction of America's independence from the patterns and cycles of the Old World's history, they gave increasing weight to the continuities between European and American history. The European past became an early, and prefiguring, chapter of the national history. For aspiring history painters of the generation of Leutze and Rothermel, this opened up new opportunities in a field that experience suggested would never be fertile in America. To add to the traditional classical and religious subjects that had so little local currency, and the recently popular but narrowly repetitious range of strictly

American subjects of national Fathers, Pilgrim and Founding, there were now the far more picturesque and varied scenes from European history from the Middle Ages on. The impetus for American artists to picture them came not only from the example of contemporary European treatments, but from familiarity with such subjects on the part of a domestic audience that devoured history and historical fiction of all kinds – Scott and Macaulay, as well as Hawthorne and Irving – while remaining elusive as patrons of historical art. To define the "history" in history painting these artists no longer looked so much to artistic convention and tradition as to popular perceptions about the past. Yet both the American public's approach to the past, charged as it was with a sense of high mission, and high critical expectations for art to serve as a medium of moral instruction encouraged American history painters to apply the didacticism of the academic ideal even to new subject matter. The American portrayal of the British past was solemn in comparison to the European interpretation, which often flirted with picturesque escapism.[47]

Although a minor episode in antebellum American history painting, the portrayal of the Tudor and Stuart eras demonstrates the problems and possibilities of the genre in an era of extraordinary change in American art. It suggests the wide range of subjects to which enterprising history painters resorted to entice a public that was still notoriously reluctant to support the higher branches of the visual arts. It underscores the intimate relationship between the national preoccupation with the past and the evolution of the genre of history painting. And in its recurring image of the oppressed woman as a measure of the horrors of religious and civil conflict, the American portrayal of British history illuminates by contrast the dimensions of the relentlessly sanguine view of the national past, in which benevolent Founding Fathers are forever setting forth for certain victory.

Negotiating Nationalism, Representing Region

Art, History, and Ideology at the Minnesota and Texas Capitols

Emily Fourmy Cutrer

At the end of the nineteenth and beginning of the twentieth centuries, many leading U.S. architects and artists worked together on official public commissions, and, in the process, created what Richard Guy Wilson has termed a "national American art."[1] Revealing the period's belief that the physical environment not only reflected, but also shaped, the attitudes of the society in which it arose, these architects and artists fashioned a visual language that supported an image of the United States as an orderly, unified, and progressive world power. Expositions such as Chicago's World's Columbian Exposition (1893); federal building projects such as the Library of Congress (1897); and monuments like the Washington Arch (1890) or the Dewey Triumphal Arch and Colonnade (1903) in New York City are only a few of the period's better known examples of the use of public art and architecture to create a vision of national unity and identity.

The numerous state capitols designed and constructed during the period produce the same effect. Between 1876 and World War I, more than thirty individual states commissioned new or extensively remodeled statehouses, and nearly all of these buildings repeat the dominant elements – the projecting wings and crowning dome – of the nation's most significant architectural monument: the U.S. capitol. Thus it is tempting for the cultural analyst to view these statehouses topographically, to see them as a network of signs – a kind of architectural interstate highway – connected across a map of the United States, and to conclude that they signify a willingness on the part of the states to join the nation in something more than a political sense. Seeming clones of the nation's capitol, these buildings are material complements to developments in post–Reconstruction America. They visually reflect, reinforce, and prescribe a nationalist culture that the national market economy and a strengthened federal government also helped to construct.[2]

Yet although U.S. economic, political, and territorial identities were solidifying into a national hegemony, cultural nationalism was not – as this network

of state capitols might indicate – so easily constructed. Indeed, the development of nationalism in late-nineteenth-century America must be seen as a series of negotiations whereby local and regional concerns informed and were incorporated, to a greater or lesser degree, into those of a larger entity. In the case of the state capitols, this process of negotiation was generally played out in art programs. By drawing on the individual states' histories, the paintings and sculpture that decorate the buildings complicate their architecture's apparent subordination of state to nation. Although one might assume that a state's history is the natural subject of its capitol's decoration, in most cases, there was little, if anything, "natural" about the history depicted. Rather, the art programs in America's state capitols developed in response to specific regional concerns and functioned as sites where a state's citizenry negotiated pressing social and political relations.

An important aspect of the art programs' historical context was critical discussion about an appropriate national iconography, set off by the 1897 completion of the Library of Congress.[3] Picking up where the ephemeral World's Columbian Exposition had left off, the library had become, in the words of one contemporary critic, "our national monument of art."[4] In addition to numerous works of sculpture and an abundance of ornamental painting, the building also housed 112 murals with subjects ranging from classical literature to allegorical depictions of the United States as inheritor of the ages' wisdom. Significantly, the features that critics chose either to praise or to condemn were the allegorical, atemporal, and decorative aspects of the program. The conservative classicist Kenyon Cox, who would later write that "American historical subjects [were] particularly unfitted for pictorial treatment" and that "true monumental decoration is always symbolical rather than real in [its] treatment of history,"[5] naturally was pleased with the library's mural decoration (including his own contribution). Charles M. Shean, president of the National Society of Mural Painters, however, decried it as a lost opportunity for the nation to develop an iconography based in its own experience. Charging that the painters "seem to have assumed" their countrymen, who paid for their work, "were without a history or a literature," Shean sarcastically commented that when American art reached its full stature, it would no longer need the "tiresome collections of classic paraphernalia: Fame with her trumpet. The Winged Victory. The Laurel Crown and the Palm of Victory," he predicted, "will fade and vanish away." In their place would be scenes from actual history, "imbued," as he found the murals at the national capitol, "with the spirit of lofty endeavor."[6]

The positions articulated by Cox and Shean informed the discussions and planning of art programs in a number of state and local public buildings. In the case of state capitols, some would end up with a kind of marriage between the two genres, as Pennsylvania did in its House of Representatives. Requested to do a series of paintings based on significant events from the state's history, muralist Edwin Austin Abbey chose to do only a few in spaces that seemed to him appropriate. For the area behind the chamber's rostrum, however, he argued with the commissioning architect that "there are certain spaces where

realistic subjects are absolutely out of place and abstract subjects are as absolutely needed."[7] The result, a kind of compromise between the architect's request that he avoid allegory and Abbey's own sense of spatial and dramatic demands, was the enormous composition *The Apotheosis of Pennsylvania* in which the state's major historical figures mount an architectural scaffold leading to an allegorical figure, "Genius of the State."

In other statehouses, architects and painters failed to arrive at such an ingenious, if eccentric, compromise. The result was an unspoken, and in many cases, no doubt, unrecognized alliance between allegory and the forces of nationalism on one hand and historical realism and local or regional identification on the other. Two significant examples of this tendency can be found in the capitols of Minnesota (1905) and Texas (1888).[8] Although completed more than fifteen years apart and in regions with obvious cultural differences, they share not only an architectural prototype in the national capitol but also a concern, in their art programs, for the relation between region and nation.

No doubt viewed by its architect, St. Paul native Cass Gilbert, as a way to expand his professional reputation beyond the state's borders, the Minnesota capitol in many ways seems to have been designed as much for an East Coast audience as for the Minnesota citizenry. Certainly, for a state building project, it attracted a great deal of national attention. New York City newspapers covered its progress, and such prominent national and professional journals as *Architectural Record* and *International Studio* ran articles about the building, its architect, and its decoration. Its artistic lineage was at least partially responsible for this attention. Although Cass Gilbert was a Minnesotan, he had trained with the leading architectural firm of the American Renaissance, McKim, Mead, and White, and he gratified some of his ambitions with a move to New York in 1899 when he was awarded the widely publicized commission for the U.S. Customs House.[9] The artists responsible for most of the building's ornamentation, moreover, had outstanding national reputations. The superintendent of the art program, Elmer E. Garnsey, had been assistant art director at the World's Columbian Exposition and superintendent of all painted ornamentation at the Library of Congress. Among those responsible for murals were Kenyon Cox, Edwin Blashfield, and Edward Simmons, whose work had been prominent in both the Chicago and Washington, D.C., projects, and John La Farge, pioneer of the mural movement in America, who was to complete one of his last large-scale projects with this commission.[10] Predictably, the result was an opulent building, designed and decorated in "High" American Renaissance style.

Despite the commissioning board's warning that "care must be taken not to fill the building with Greek gods and goddesses," Gilbert's preference appears to have been for a building, like the Library of Congress, where the walls fairly dance with nude male heroes and what one artist termed the era's predilection for "young women in their nighties."[11] Indeed, Gilbert worked closely with the artists to devise a program of murals that bore only the most tangential relationship to actual Minnesota history.[12] Edward Simmon's allegorical cycle for the rotunda is typical. In it, a classically proportioned male

figure progresses through four panels personifying the "triumph" of western agricultural civilization over "savagery." In Blashfield's mural for the House of Representatives, *Minnesota the Granary of the World,* farmers and soldiers at least wear modern dress, but they occupy the far corners and the misty background; female figures in diaphanous gowns represent the agricultural bounty of the state and dominate the composition. Only La Farge's murals for the Supreme Court chamber depict actual historical figures, yet even they were persons – Moses, Socrates, Confucius, and Count Raymond of Toulouse – with little obvious connection to the experience of Minnesota's citizens. Without a verbal gloss, a visitor to the capitol would have had little means for understanding the decoration's relevance to the state, and a traveler stopping throughout the United States to view new public buildings might well wonder where his tour had taken him. If it were Tuesday, it might just as easily be New York, Iowa, or Wyoming as Minnesota.

Only one major space, the Governor's Reception Room, a relatively less accessible and public chamber than the Rotunda, Senate, or House, provides any obvious clue to the state's identity. The impetus to decorate the room with scenes from Minnesota's history, however, seems to have come from the state's citizens rather than the building's architect. Despite the fact that Gilbert designed the room to house a number of easel paintings, he was less interested in those commissions than he was in the murals for the rest of the building.[13] As a result, the contracts for most of the paintings were not even signed until 1905, nearly two years after those for the allegorical murals, and then with public reaction to the building influencing Gilbert's choice of subjects and painters.[14]

When Elmer Garnsey first took charge of the painted decoration of the interior in 1903, local groups developed some concerns about the artistic work in the building. In January 1904, within a month after an article appeared in the Minneapolis *Journal* announcing the assignment of the capitol's decorative work to prominent artists from the East Coast, local painters brought suit against the capitol board to release Garnsey. As one newspaper article indicated, Garnsey's hiring practices damaged not only local employment figures, but also local pride; "We have just as good men lying idle in the two cities," its author claimed, "as any of those men brought in here." Following the suit's dismissal, most detractors merely complained that the completed building was not functional.[15] "Everything has been sacrificed to esthetic effect," one local critic complained shortly after the capitol was occupied, and within a week, another writer reported that "Already the building is jokingly spoken of as the 'beauty pile.'"[16]

Ultimately more significant to the capitol's art program, however, were the reactions of some of the state's leading citizens, more to what was left out of the initial decoration than to what was put in. Two weeks after the building was occupied, the Minneapolis *Journal* ran an article from a local attorney and Civil War veteran lamenting the fact that, as the headline put it, the "'Old First' [was] Forgotten in [the] Capitol Frescoes." Warning that the state "can't afford to overlook non-allegorical history," prominent political and business leader William D. Washburn called for commemoration of the First Minnesota

Infantry Regiment's participation in the Battle of Gettysburg.[17] One of the most illustrious units in one of the nation's most decisive battles, the First Minnesotans suffered the highest rate of casualties on that field and were invaluable in saving the day for the Union. Washburn's fellow veterans seconded his call, and within a few weeks the capitol board authorized Gilbert to commission four paintings depicting not only the First Minnesota's activities at Gettysburg, but the contributions of the Second, Fourth, and Fifth regiments as well.[18]

In seconding Washburn's suggestion, one veteran relayed his fellow "old soldiers' wish . . . that the story of the First at Gettysburg deal entirely with the facts" and avoid any "gush."[19] Indeed, one of the notable elements of the paintings commissioned at public demand was their attempt to incorporate an "authenticity" that contrasted with the "idealism" of the murals elsewhere in the building. Thus, in commissioning the four Civil War paintings, the capitol board stipulated that the artists consult with survivors and, where possible, visit battle sites. Similarly, once the canvases were completed, the most important critical criteria seem to have been the paintings' attention to historical detail.

Typical was the reaction to *The Second Minnesota Regiment at the Battle of Mission Ridge* painted by Douglas Volk, the only Minnesota painter commissioned to do any work for the state's capitol. As one commentator noted approvingly, Volk had "not ignored the literal side"; he had visited the battleground, met with survivors at an anniversary commemoration, and incorporated numerous likenesses into the scene. As a result, the local critic added, Volk had "so truthfully presented the main features of both landscape and action" that he overheard a veteran looking at the canvas and talking "in a manner that showed he had forgotten all about artist and painting and was carried back to the morning when, as a boy, he had charged up the height" with the troops.[20]

Yet, even more significant than the individual paintings' seeming historical authenticity is the overall effect of the paintings assembled in the governor's reception room (Fig. 79). The four Civil War paintings honoring Minnesota's contribution to the Union cause are joined in the room by two additional paintings, one by Volk depicting Father Hennepin discovering the Falls of St. Anthony and another by Francis Millet representing the signing of a treaty in 1851 between U.S. officials and the Sioux living in upper Minnesota, both also based on eyewitness accounts.[21] Although these two paintings would seem to have little to do with the Civil War scenes, except insofar as they all deal with Minnesota history, they, in fact, play into a significant reconstruction of that history and Minnesota's image of itself at the turn of the nineteenth century.

As an ensemble, the paintings suggest that Minnesotans of European descent had always lived peaceably with their Indian neighbors. Volk's painting shows Indians gathered subserviently as Father Hennepin raises his crucifix to bless (claim) the Mississippi's headwaters in the name of his European God. Millet's *Treaty of Traverse des Sioux* (Fig. 80) depicts tribal delegations passively witnessing U.S. representatives as they shake hands with leaders of the Sioux

FIGURE 79

Governor's Reception Room, Minnesota State Capitol. c. 1907. This photograph shows both Douglas Volk's *The Second Minnesota Regiment at the Battle of Missionary Ridge*, 1906, and his *Father Hennepin at the Falls of St. Anthony*, 1904, in their architectural context.

Courtesy Minnesota Historical Society.

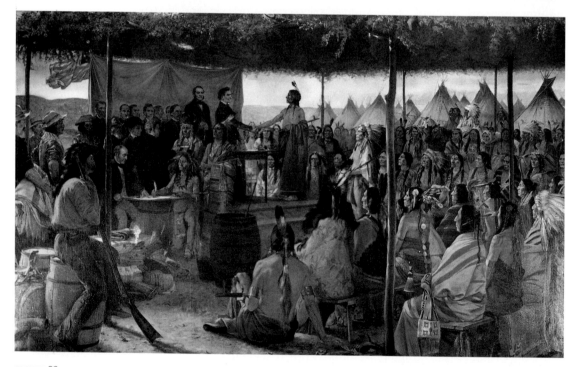

FIGURE 80

Francis Millet. *Treaty of Traverse des Sioux.* 1904.

Courtesy Minnesota Historical Society.

nation or help them to sign the first of two treaties with the U.S. government, treaties that together ceded nearly 24 million acres of the Indians' ancestral lands to Anglo-American expansion.[22] Nothing indicates the end results of those treaties – the narrow reservations to which the Sioux were assigned, the late annuity payments, or the unscrupulous traders who arranged for land payments to go into their pockets rather than to the Indians. No image documents or dramatizes what historians have traditionally termed the Great Sioux Uprising of 1862, a bloody conflict brought on, in part, by the Americans' failure to honor fully terms of the 1851 treaty. In fact, while Minnesotans may well have behaved bravely on Civil War battlefields hundreds of miles from home, they also found themselves engaged in a bloody conflict of their own making in their own backyards. And not only the cause of the hostilities but the way in which they were played out brought little honor to the state. Although Minnesota regiments did help to defend Anglo-American settlers, many of the crucial engagements against the Sioux were not fought by Minnesotans at all but by Confederate prisoners of war incarcerated in the state.[23]

Not surprisingly, no evidence indicates that anyone at the time the paintings were first assembled recognized the bitterly ironical juxtaposition of the Civil War images with those treating Euro-American and Indian contact. Gilbert, who was himself responsible for the paintings' placement, was more concerned that color schemes harmonized than he was with content. At the same time, certainly little, if any, of the content was discordant with the dominant culture's view of itself. Indeed, the paintings fit all too well an attitude expressed in an *International Studio* review of the building that "it is none too soon to bid good-bye to the tomahawk, to see the pow-wow give place to the caucus, the wigwam to the capitol."[24] By ignoring a significant aspect of the state's Civil War experience, the paintings created a history that supported, with selective evidence, a general notion of Anglo-American dominance, on one hand, and a more specific sense of its martial honor, on the other.

The main difference between the paintings in the governor's reception room and the allegorical murals elsewhere in the building in this regard, was, of course, the realist mode in which the history scenes were painted. The history paintings' specificity, their accurate detail, and their basis in actual events begged the question of their truthfulness and did little to unsettle their viewers' attitudes or perspective on the events portrayed. Thus they allowed the Minnesotans who had lobbied for their inclusion to identify more thoroughly with the "grand themes" of the capitol's artistic decoration than the allegorical scenes apparently could.

At approximately the same time the painters of the Civil War canvases received their commissions, a group of veterans organized a celebration to mark the transfer of regimental colors from the old statehouse to the new. On June 14, 1905, designated as "Flag Day" by the state's governor, more than a thousand Civil War veterans and other citizens took advantage of special railroad rates to come to St. Paul and take part in the parade and dedication. Although the Civil War participants were joined by veterans of the recently

fought Spanish-American War, the day belonged mainly to their own number. Archbishop John Ireland, who delivered the ceremony's main address (and who also had successfully lobbied for the painting of Father Hennepin), had served as chaplain to the Fifth Minnesota Infantry during the war. At the same time, the body of Col. William Colville, leader of the First Minnesota's charge at Gettysburg, who died after traveling to St. Paul for the celebration, lay in state in the new building during the proceedings. Significantly, the names of neither the architect nor the commissioning board appeared on the day's program.[25] Rather than recognizing those who had planned and built the nationally acclaimed architectural monument, the citizens and their politically astute governor wished to celebrate the heroes the state had created.

This ceremony, which attracted more participants than the laying of the capitol's cornerstone seven years before, thus underscores the significance of the history paintings adorning the walls of the governor's reception room. With its emphasis on real artifacts – the regimental colors and actual human beings, Civil War veterans both living and dead – the celebration, like the paintings, apparently fulfilled Minnesotans' need for something tangible through which to understand the abstractions the building and its murals otherwise represented. If the building and its allegorical murals failed to fully engage Minnesotans' imagination, "realistic" representations of the state's past – either through art or ritual – apparently did.[26]

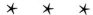

The lesson was not so hard learned in Texas where the capitol's art program avoided overt allegory from the start. In fact, the building's architect, Elijah Myers, who was responsible for the Colorado and Michigan statehouses as well, never integrated a significant program of art and decoration into the project.[27] Although at least one early elevation included a sculptural program, and several local citizens and artists held informal discussions about art for the capitol, artistic decoration was not an immediate and major concern in 1888 when the building was completed. Myers's omission left an opportunity for the state's citizens to fill the empty spaces, and as a result, over the next several decades, a number of Texans used it, consciously or not, to work out their own image of the state and its history.[28]

Sharing the belief of America's dominant culture that art should be the material of moral education, these Texans commissioned works depicting historical figures or moments they believed were the most capable of inspiring the virtues they valued. And, to an even greater extent perhaps than Minnesota's, this constructed history or "invented tradition,"[29] to use Eric Hobsbawm's phrase, was place specific. The artistic program, in other words, that eventually dominated the Texas capitol used historic events to construct a Texas identity – one that derived from the region's historically dominant ideologies of Manifest Destiny and rugged individualism and found its literal embodiment, moreover, in a specific type – what one contemporary designated "the hardy stalwart son of Texas."[30]

Of course, these ideologies and this type were quickly losing their relevance. By the end of the nineteenth century, as numerous historians have pointed out, Texas, like the rest of the nation, was undergoing significant social and economic transformation. Its agriculture was increasingly commercialized as land owners consolidated their holdings, particularly in South and West Texas. Owners of lumber, cattle, and eventually, oil interests developed their resources creating at least an incipient move toward big business, if not industrialization. In addition, urban areas threatened to dominate the once overwhelmingly rural state as communities such as Galveston, San Antonio, Dallas, and Houston surged in population. Thus, just as its seat of government was coming to resemble those throughout the United States, Texas, itself, was becoming more like the rest of the nation both socially and economically. And as in other parts of the United States, economic change, political strife, and cultural dislocation went hand in hand. Thus Hayden White's generalization that an interest in history is "characteristic of transitional ages," that it "arises when received traditions . . . appear to have lost their relevance," is particularly pertinent to the development of the artistic program that took shape at the Texas capitol at the turn of the century.[31]

Indeed, the approach and entrance to the building is a lesson in Texas history as seen through the eyes of a nineteenth-century Anglo-American male. Large monuments celebrating the state's contributions to the Confederacy, as well as a memorial to the defenders of the Alamo, line the walkway to the building's front vestibule. Just inside the entrance, a combination of statues, portraits, and history painting introduce the visitor to the major themes incorporated in nearly all of the building's artwork. Depicting historical figures and events that were instrumental in wresting Texas from Mexico, they construct a narrative of the state's eventual domination by Euro-Americans. The rotunda, which lies just beyond, is a pantheon to the state's leaders, with portraits of governors spiraling upward in the dome. Similarly, portraits of heroic individuals line the walls of the legislative chambers. Taken together, they neatly resolve one of the central paradoxes of art in a democratic republic. By recording personalities that were notable, not for their individual accomplishments alone but also for their records of personal sacrifice and public contribution, they both immortalize unique individuals and glorify their communal endeavor.

The paintings in the entrance and rotunda are generally quite conventional and subdued, and, in fact, even though they deal with specific Texas events and individuals, they look like paintings one might encounter in the public buildings of any state. Such is not the case, however, with the enormous history paintings that have hung at the rear of the Senate chamber since the early twentieth century – Henry Arthur McArdle's depiction of the two decisive battles of the 1836 Texas Revolution, *Dawn at the Alamo* (1905) and *The Battle of San Jacinto* (1895).[32] Indeed, these two paintings take the themes inherent in the rest of the building's art program and express them in extravagant and melodramatic detail. Garish, technically flawed, and almost primitive in appearance, the paintings are the work of a marginally trained art instruc-

tor, who never received a commission from the state of Texas but asked, instead, to hang his work in the capitol. Nevertheless, even today, when they continue to be a main stop on the state's official capitol tour, they epitomize, construct, and maintain a particular notion of Texas and Texans that bears close examination.

Like most of the artists responsible for work in the Texas capitol but, tellingly, unlike those associated with Minnesota, McArdle had no national reputation and few connections with the eastern art establishment. An Irishman, who emigrated to Baltimore at the age of fourteen, trained at the city's mechanical arts school, served as a topographical artist with the Confederate Army, and later taught art at the Baylor Female College, he did have a fierce identification with his adopted state, an identification he just as fiercely transferred to canvas.[33] Encouraged by a historian and art dealer, James T. DeShields, McArdle began painting Texas history scenes as early as the 1870s. In the case of the two Revolutionary scenes, his passion led him to spend decades tracking historical accounts of the battles, locating witnesses and survivors, and collecting artifacts of clothing and weapons. Even more mindful than his peers in Minnesota of the need to vouch for the paintings' authenticity, he gathered his notes and correspondence into two leather-bound volumes that today function as a kind of concordance to the paintings. Included in these volumes is McArdle's statement of aesthetic purpose: "No color, however magnificent, no line, however subtle, can make a work of art. Without expression, truth, and a story told, the canvas had better been left untouched."[34] Yet despite his emphasis on historical accuracy, McArdle's "truth" frequently transcended fact; the "story" was always preeminent.

As part of a narrative, the two paintings read from left to right on either side of the entrance to the Senate chamber. The story begins, of course, with the Alamo (Fig. 81), and at first glance, McArdle's canvas, filled with depictions of furious hand-to-hand combat, seems to replicate the disorder naturally associated with battle. Situated at ground level within the walls of the fortress-mission, the scene is most reminiscent of the deaths of the Trojan heroes and the burning of "the topless towers of Ilium" in Homer's poem. Although with McArdle's key it is possible to identify a number of individuals, the overall effect is one of mass confusion. Bodies litter the ground, opposing individuals are locked in mortal combat, and large numbers of Mexicans breach the mission's walls. McArdle's abrupt cropping of the bottom and sides pulls the viewer into the melee; the edges of the canvas literally chop off figures and thus suggest a continuity between the painting and the world outside it.

As McArdle's insistence on "story" would suggest, however, he was not presenting a random snapshot of the battle but a carefully composed and manipulated image. Despite his dogged research and his frequent claims of veracity, the artist has given here neither a precisely factual nor a remotely objective view of the storming of the Alamo. As historians have pointed out, for example, McArdle's placement of major Texan heroes Davy Crockett, William B. Travis, and Jim Bowie is inaccurate. Crockett defended the south

wall of the mission while Travis, his commander, fell on the north. Yet McArdle places them in juxtaposition, and Bowie is shown in the middle of the fighting, when he actually died in the sickroom of the Alamo's chapel.[35] McArdle, however, was well aware of these and other of his inaccuracies. In his written gloss of the painting, for example, he admitted with apparently unintended understatement that Jim Bowie was "idealized."[36]

For McArdle, however, the "idealized" Bowie was more true to the spirit of the event than a factual depiction would have been. Undoubtedly the inclusion of so many other identifiable individuals in the same place and at the same time was as well. Indeed, by bringing the Alamo's best known heroes together, McArdle was only doing on canvas what the battle's chroniclers have done in other media. Most accounts of the Alamo, from print to film, have dealt with the Texans not only as a group, but also as specific individuals. Anyone who has read a book or seen a movie about the famous siege undoubtedly knows that Bowie, Crockett, and Travis, for example, played some significant role in the event and could probably recount something of each hero's background.[37] Unlike paintings, however, film and written accounts allow a narrative structure with an unfolding sequence of events. McArdle, in contrast, had to present every significant event and individual simultaneously because he was dealing not with a simple image but with myth.

A narrative or sequence of events with a complex structure of symbols and figures, myth *exemplifies,* in Richard Slotkin's formulation, rather than *argues* its ideology. The players in such a story, the figures in other words, who act out a culture's myth are thus significant because they embody and define a

FIGURE 81

Henry A. McArdle. *Dawn at the Alamo.* 1905. William Barrett Travis is the large figure standing on the wall on the right side of the canvas. Davy Crockett appears below and to the left.

Courtesy Archives Division, Texas State Library.

people's history and provide them with rules and models for behavior. Ultimately, they affirm and reinforce the social relations or "distribution of authority and power that ideology rationalizes"[38] in much the way that Bowie, Crockett, and Travis inform traditional accounts of the Alamo. Indeed, in McArdle's story of the Alamo each figure represents an essential element in the social structure. Travis, the South Carolina–born lawyer, embodies, on one hand, the virtues of the aristocratic South, a distinction that was not lost on McArdle. Even though scholars have gone to great pains to prove that Travis did not wear a uniform in the battle, McArdle outfits him in the costume befitting his social and military rank, and he strides across the barrack's roof like a colossus above the general melee and apart from the volunteers. Numerous formal devices, such as the Mexicans' bayonets, as well as the grotesque distortions of his figure, draw one's eye to the garrison's commander and emphasize his significance and his individual acts of bravery, as they also connect him to the figures on the ground. Bowie and Crockett, on the other hand, embody a somewhat different plot line. Both were archetypal frontiersmen, untutored in the social graces but "naturally" aware of the virtues of liberty and democracy. Significantly, McArdle shows them in the thick of things wearing the everyday dress of volunteers, those who presumably fight, not because they have to, but because they believe in their cause.

In keeping with their mythological/archetypal character, these three, along with the other Texans, unite in the face of a common enemy that is itself archetyped. Indeed, the virtues or code of behavior that McArdle's heroes represent find their most telling expression in the contrast between the painter's heroes and their Mexican foes. In each of the major conflicts in the canvas, the Anglo-Americans strike heroic poses while the Mexicans graphically fulfill John Adams's 1804 injunction to John Trumbull that art should perpetuate "to posterity the horrid deeds of our enemies."[39] Time and again they seem to take unfair advantage of the defenders and, in comparison, appear cowardly and animal-like. One, for example, stands frozen with a ferocious leer on his face, poised to bayonet Travis in the back. A similar expression mars the face of the Mexican soldier at whom the stricken Bowie lunges with his legendary blade.

Perhaps the most striking contrast is between Crockett and the Mexican soldier whose rifle he pushes aside (Fig. 82). By placing the two figures virtually face to face, McArdle revealed his Manichaean vision of the combatants. Crockett and his foe are not merely two men; they are two races that represent opposing forces of law, religion, and morality. Significantly, the light that falls on the Texan emphasizes his whiteness; his shirtsleeve and chest virtually glow; his hair, which in reality was dark, here appears sandy – almost a halo. With his outstretched arm, he is strong, fearless, and noble. In comparison, the Mexican is evil, and the light that also falls on him only accentuates his darkness. Although not actually crouching, he appears to crumple under Crockett's arm, and his face is almost apelike in its ferociousness and stupidity. Like many of his fellow Anglo-Texans, those who saw to it that the painting hangs in the Texas Senate, McArdle subscribed to views that not only assumed the racial and cultural inferiority of those with dark skins, but also associated

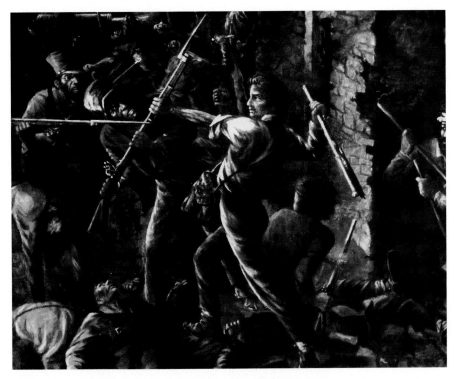

FIGURE 82

Henry A. McArdle. *Dawn at the Alamo* (detail), showing Crockett in the center holding off his
Mexican opponents.

moral depravity with persons of mixed breed, such as Crockett's opponent
appears to be.[40]

As a result, his painting is a kind of visual morality play dealing with the
opposites of light and dark, good and evil, and like most myths has a religious
significance that the canvas's formal organization further exemplifies. Indeed,
the confusion in McArdle's painting is more apparent than real. Just as the
individuals in the Alamo's story are ultimately united by their overarching goal
or ideal, the isolated incidents in the painting are connected in a larger
scheme. Dominating its underlying structure is a central triangle with Maj.
Robert Evans and Crockett marking the bottom points and a scarlet flag at the
center of the canvas, its apex. That flag, with its brilliant color and location, is
one of the numerous devices that McArdle used to call the viewer's attention
to the structure in the center mid-ground. Intended as a gun platform to
enable a cannon to fire over the walls, McArdle exaggerated its proportions in
order to emphasize its symbolic importance. The structure becomes a sacrifi-
cial altar, and the story that is being acted out upon it has the same crucial sig-
nificance to the Texas myth as the cross has to Christianity.[41]

The figures who struggle atop the platform are, in effect, allegorized ver-
sions of the individuals who fight to either side and below (Fig. 83). As in the
rest of the painting, the Mexicans physically overwhelm the Texans, but their

victory, as the episode attests, is ultimately meaningless. Significantly, the flag that descends in a classic gesture of defeat is not, as one might expect, that of the Texans. Rather, it is the red banner of "no quarter" that a Mexican soldier drops as he topples during his ascent. To the Texans, this flag represented one of the most abhorrent aspects of the Alamo, the refusal of the Mexican leader Santa Anna to take prisoners, and the death of every Alamo defender has, of course, lent mythic proportions to the struggle. It also spurred the losing side to vengeance, giving the army of Gen. Sam Houston its bitter battle cry at San Jacinto: "Remember the Alamo." Thus, the Mexicans, as McArdle's story implies, brought about their own downfall. In *Dawn at the Alamo*, the officer who carries the flag is shot, not by a Texan, but apparently by another Mexican officer on the gun platform.

By calling attention to the contrasting clouds above and below, the banner also literally points to what is to come. While the sky above the Alamo is a

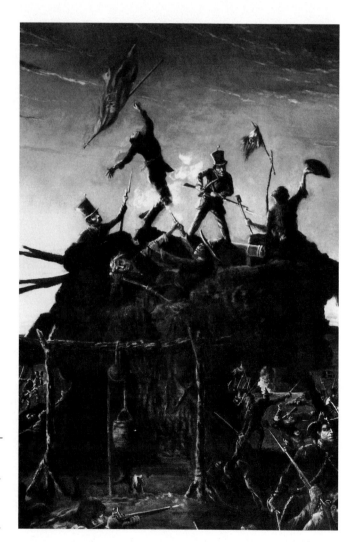

FIGURE 83

Henry A. McArdle.
Dawn at the Alamo
(detail), the gun plat-
form.

*Courtesy Archives Divi-
sion, Texas State Library.*

dark and blood-red reflection of the action beneath, "the blaze of orange and gold" in the lower distance signals the sunrise. In both his notes and on the picture frame, McArdle pointed out that the morning had symbolic significance. The dawn of the new day was also, as he emphasized, *"the dawn of liberty to Texas."*

The *Battle of San Jacinto* (Fig. 84), which hangs to the right of *Dawn at the Alamo,* brings the narrative to its conclusion. A similarly huge canvas, it depicts what the painter saw as the natural result of the Mexican actions at the earlier battle. Sam Houston's army of the newly formed Republic of Texas storms the enemy's breastworks to apply what McArdle termed "retributive justice." Scores of Mexicans lie dead on the field; hundreds of others fight vainly or flee from the Texans' assault. Like its companion piece, the work is intricately detailed; even in five ledger-size sheets, McArdle was unable to provide an adequate written description. Of the hundreds of figures on the canvas, more than fifty are portraits that he carefully identified in an accompanying key.

Despite his antiquarian's love of anecdote, McArdle realized truth might be lost in too "slavish" a transcription of the battle's conduct. Thus, as in *Dawn at the Alamo,* he uses the sky and time of day to unify the painting and carry its transcendent meaning. The "dark, inauspicious and threatening clouds," he wrote, "overspread the heavens" and signify the "suffering, danger and death under which Texas had struggled." Nevertheless, the "rays of the setting sun break through the gloom" and indicate that "Light and freedom and liberty" result from the scene below.[42] *San Jacinto,* in other words, brings to fruition the dawning of liberty at the Alamo, and in its strong movement to the right suggests that the story begun in the first canvas continues into the future.

FIGURE 84

Henry A. McArdle. *The Battle of San Jacinto.* 1898.

Courtesy Archives Division, Texas State Library.

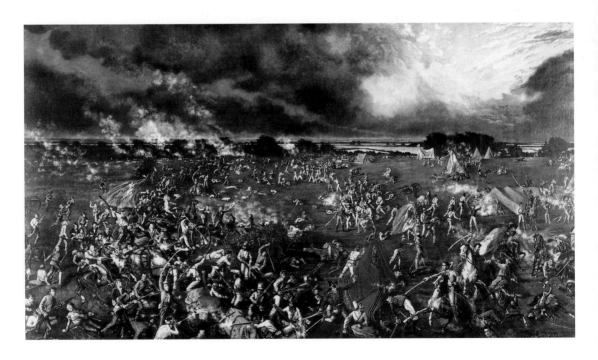

Thus McArdle fulfilled what Slotkin might say is one of the essential functions of mythmaker; he "successfully disguised [history] as archetype" by transforming it "into a body of sacred and satisfying legends."[43] If his paintings did indeed have popular support, it may well have been because they played into and suggested solutions for the concerns and insecurities of his primary audience. On one hand, his general stereotype of the Mexican as cruel, brutish, and untrustworthy both reflected and justified contemporary Anglo-Texan attitudes and policies. It mirrored characterizations found in such best-selling novels as Amelia Barr's *Remember the Alamo* of 1888, and it certainly could have helped justify some of the state's more questionable social and economic developments. At the same time, for example, that members of Texas's Anglo-American elite were constructing at the state's capitol the myth of their origins, a myth that by and large excluded any positive role for the Mexican, they were also seizing property from Hispanic landholders in South Texas.[44]

Significantly this period also witnessed the founding of a number of organizations such as the Texas State Historical Association, the United Daughters of the Confederacy, and the Daughters of the Texas Revolution, organizations dedicated to studying and preserving a view of the region's history similar to that offered in the capitol's art program. That such organizations as well as a public art celebrating Texas's Anglo-American origins should appear just when the state was undergoing a major social and economic reorientation is more than coincidental. It indicates the need for some to find stability in an era of rapid and bewildering change. It also suggests that the region's elite – those whose fathers had participated in the state's founding, those who were responsible for honoring their fathers' memory, as well as those who were profiting from economic changes and enjoying an affluence available to few of an earlier generation – were not only commemorating the past to shape the future. They were also using the past to mediate the ambiguous and contradictory nature of their own experience.

Michael Kammen has noted that during the decades on either side of 1900, "local pride was much more likely [than national pride] to energize the observances that really engaged people."[45] If Minnesota and Texas are any indication, a public art that portrayed local or regional history held more appeal as well. Although abstract allegorical murals may have been the norm in many of the more prominent projects of the American Renaissance, they failed to evoke the kinds of responses elicited by representations of a people's specific remembered past. Ironically, seemingly realistic depictions of history succeeded better at allegory's purpose than did overtly allegorical paintings themselves because, in part, as McArdle's *Dawn at the Alamo* so clearly demonstrates, their frequently one-sided treatment of people and events lent them a symbolic or allegorical dimension of their own. By dealing with historical events through the frame of contemporary anxieties, history paintings such as those found in the Texas and Minnesota capitols negotiated the concerns of their Anglo-American audience on several fronts. On one hand, they provided models for dealing with shifting social and economic relations on

the local level, and on the other, they eased the transition of regional cultures into a nationalist focus. For even if the events depicted in the Minnesota and Texas capitols were particular to those states, they did little to undercut or call into question the dominant ideologies of the United States. Indeed, Father Hennepin's claiming of the Mississippi's headwaters and Sam Houston's triumph at San Jacinto are, in a sense, only chapters in a larger narrative, a myth exemplified by one of the more well-known history paintings in the national capitol, Emanuel Leutze's *Westward the Course of Empire Takes Its Way.*[46]

The Jersey Homesteads Mural
Ben Shahn, Bernarda Bryson, and History Painting in the 1930s

Susan Noyes Platt

In a mural for the community of Jersey Homesteads (now Roosevelt), New Jersey, Ben Shahn, in collaboration with Bernarda Bryson,[1] redefined contemporary history painting by depicting three unusual subjects: Jewish immigration, union organizing, and the planning of a cooperative community in the early New Deal Resettlement Administration (Figs. 85, 86, and 87).[2] The mural, completed in fresco in 1937–8, departs from the tradition of the unified tableau, based in the theory of Diderot, that focuses on a single moment in which the action hangs in the balance, the *peripeteia*. In the traditional tableau there is frequently a single identifiable heroic figure, who with gesture and pose implies the leadership of the moment in history depicted. This concept of history descends into still photography as the "decisive moment." Instead of the *peripeteia*, the mural created in Jersey Homesteads, New Jersey, presents groups of figures acting as part of an ongoing process. The only suggestion of a decisive moment is provided by one central enlarged and isolated figure, but that figure, a union leader, is intentionally anonymous and emerges from a group (Fig. 86). The decisive moment is replaced by historical process, a process based

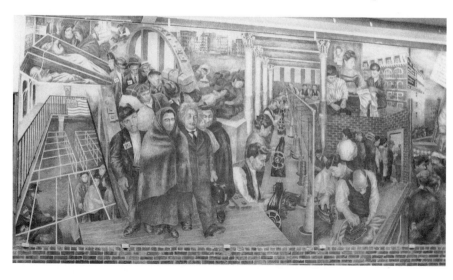

FIGURE 85

Ben Shahn, with the assistance of Bernarda Bryson. *The Jersey Homesteads Mural* (*Left:* Immigration and Sweatshops). 1937–8.

Roosevelt (formerly Jersey Homesteads), New Jersey. Photograph by the author.

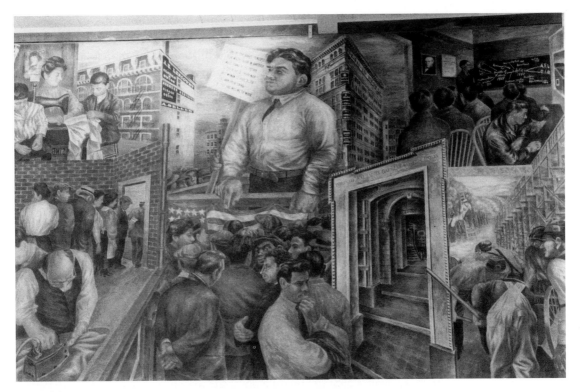

FIGURE 86

Ben Shahn, with the assistance of Bernarda Bryson. *The Jersey Homesteads Mural* (*Center:* Sweatshops and Union Organizing).

Photograph by the author.

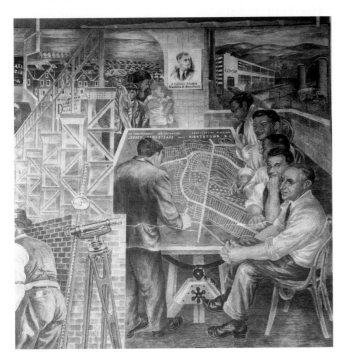

FIGURE 87

Ben Shahn, with the assistance of Bernarda Bryson. *The Jersey Homesteads Mural* (*Right:* Building a Cooperative Community and New Deal Planning).

Photograph by the author.

on economic and political forces. Although some identifiable portraits are included, these specific individuals act within as group, not as heroic individual leaders. At the same time, however, there is in some of the individual scenes the symbolism, if not the heroism, of traditional tableaux. The tableau without heroism, but laden with symbols, is a common approach in New Deal murals. But usually history is depicted as static: The anonymous worker, farmer, or homesteader becomes the symbol of historical stability. In Shahn's mural the worker in groups is, instead, a symbol of historical process and change.

In addition, there is a major element in the Jersey Homesteads mural of what Barthes calls the "obtuse" or "third" meaning, that of emotion, beyond narrative discourse. In Roland Barthes, as developed in *Camera Lucida*, the element beyond narrative is personal memory. As elaborated on by Victor Burgin the third meaning is psychological; more than simple recollection it includes the idea of the fantastic and imaginary.[3] In the Jersey Homesteads mural Shahn's personal memories as well as his autobiographical and psychological investment in the imagery he is painting imbues it with this "third" meaning. Burgin also distinguishes between the symbol and the hieroglyph. The symbol is closer to a narrative device, existing within a historical context; the hieroglyph, in Burgin's lexicon, is linked to the imaginary, outside of narrative discourse. In Shahn's mural this analysis can provide helpful insights, although the symbol and the hieroglyph often coincide in the same image. The narrative symbol coincides with the hieroglyph of the imagined. For example, the depiction of the new arrivals hall at Ellis Island is both a symbol of a historical event and a personal memory of Shahn's own life experience.[4] The mural, in fact, coincides throughout with Ben Shahn's own memories and experiences as they intersect with historical events: He came to the United States from Lithuania as a Jewish immigrant in 1906 at the age of eight, participated in radical activities in the Artists Union in New York, then joined the New Deal.

The unusual approach to history painting in Jersey Homesteads is in part the product of the specific moment in Shahn's career in which the mural was executed. Shahn turned to painting contemporary history shortly after the 1927 execution of Nicola Sacco and Bartolomeo Vanzetti for the murder of a postmaster in South Braintree, Massachusetts. Although the innocence of the accused became a widely adopted cause all over the United States and Europe, the judge refused to stay the execution. Shahn was deeply troubled by the profound injustice of the event, and saw it as comparable to the Crucifixion itself. He turned to individual sacrifice based on social injustice as a central subject of his work for several years.

The Passion of Sacco-Vanzetti of 1931–2 uses contemporary individuals as paradigms for the great tragic heroes of history. In early 1931 Shahn began clipping images and headlines from the newspapers as raw material for his contemporary history painting. Other topics he researched, all widely popularized favorites of the left in the early 1930s, were the cases of Tom Moody, accused of throwing a bomb in 1916, and the Scottsboro boys, nine young blacks accused of attacking two white women in Chattanooga, Tennessee.[5] Although Shahn was dealing with popular causes, his style was more con-

frontational than other artists on the left. His images were simplified and flattened, based in part on the frontality of newspaper documentary photographs. One reviewer likened the Sacco and Vanzetti series to the history paintings of Emanuel Leutze and Baron Gros; he saw Shahn as a "valuable witness to our epoch."[6] Shortly after Shahn enlarged three of the series as mural-sealed panels for an exhibition. Consequently, Shahn himself was drawn into contemporary political events: An effort was made to withhold his Sacco and Vanzetti mural study from the exhibition at the Museum of Modern Art in the fall of 1932.[7]

A more profound trauma resulted from his work with Diego Rivera at Rockefeller Center where Shahn assisted in the creation of the now infamous fresco *Man at the Crossroads*. As a result of the inclusion of a portrait of Lenin, the work was ordered suspended by the rental agents who feared, more than the Rockefellers, that the portrait would make it difficult to rent the building. Ten months later the mural was destroyed. Shahn was a leader in organizing protests about the original work stoppage. He went on to assist Rivera from July to December 1933 with the creation of a cycle at the New Workers School based on the history of the United States according to the radical Marxist-Lovestonite analysis of class struggle, labor struggle, and revolutionary rebellion. The murals were crowded with clusters of numerous identifiable portraits, a typical Rivera technique for the depiction of history. As first installed, it partnered earlier and later historical figures on opposite walls, a dialectical technique that Shahn would later use.[8]

The importance of these events within Shahn's development as a history painter is fundamental. He was at the very center of one of the major ruptures of the art world of the 1930s. The suspension of the work at Rockefeller Center galvanized a broad spectrum of artists to protest in the streets. In addition, Shahn had an in-depth technical and theoretical apprenticeship under Rivera. Although according to Lucienne Bloch who also assisted Rivera,[9] Shahn was mainly in charge of the historical research for the murals, he would also have learned by observation the complex process of fresco painting, as well as the idea of organizing large historical events in terms of groups that represent a revolutionary process. In Rivera's mural at the New Workers School the structure of the paintings is entirely static. The figures pile up one above the other in a quotation of the type of space and time used in pre-Columbian art: History proceeds not in linear progression, but in symbolic events. Rivera's murals include numerous portraits of historically notable leaders, but those leaders do not stand out above the crowd, they are embedded within it.

Between 1933 and 1935 Shahn created two proposals for large-scale murals, both related to historical issues that were less about individual martyrs and more about changing systems of injustice: The first focused on demonstrations both for and against Prohibition, the second on prisons with a focus on contrasting old and new methods of correction. In their structural and pictorial differences they suggest the changes in Shahn's approach to history painting as a result of his contact with Rivera, changes that are central to the Jersey Homesteads mural.

The Prohibition series of gouaches are, like *The Passion of Sacco-Vanzetti*, separate, static images. Frontal facing rows of demonstrators are the primary composition. The prison series, created in collaboration with Lou Bloch and with the assistance of Lydia Nadajena, who drew the perspective, is far more complex. Intended for the Riker's Island Penitentiary, it was based on exhaustive research. The perspective used deep space projections in alternation with flat shallow spaces in a way that would be adopted in a modified form at Jersey Homesteads. Shahn began to work in terms of a filmlike sequencing of images connected with formal devices, particularly the alternation of the deep shot and the close-up. The alternating deep and flat space also paired old and new methods of penology on opposite sides of a narrow corridor.

At this time Shahn also began to use the Leica camera. As an instrument to record the Depression in New York City streets it provided more intimate and personal views than newspaper mug shots. Although his photographs were primarily taken in public streets and parks, or as views of people through windows and on city stoops, they begin to image the individual and humble, in contrast to large publicized and received examples of social injustice such as the Scottsboro Boys. This more intimate approach was probably, in part, a response to Bernarda Bryson's own deep-seated concerns about individual deprivation. The Leica opened Shahn's perspective both psychologically and physically, allowing informal images (albeit often taken with a right angle lens without the subject's knowledge). In his early photography, he functioned apparently without programmatic intent or a self-conscious, unified agenda, at a time of the dissolution of social mechanisms. Independent of a single ideology, he collected images of the Jewish ghetto, of poverty, of the life of the streets of New York, of artists' demonstrations.[10]

From 1933 to 1935, Bernarda Bryson also provided a new perspective for Shahn. Bryson came from Ohio as a newspaper reporter to interview Diego Rivera while he was working with Shahn at the New Workers School in the summer of 1933. An active advocate of social causes, Bryson was such an articulate thinker and speaker that on moving to New York in the early fall of 1933 she immediately became a leader of radical causes in New York, particularly the Unemployed Artists Association and the Artists Union. Her contact with Shahn developed most prominently during the summer of 1934 when they began to work together on the newspaper *Art Front,* the newspaper of the Artists Union.[11] Ben Shahn provided layout, promotion, and editorial suggestions, such as filmic sequences of photographs of the artists' demonstrations. Both his involvement with Bryson and the newspaper work deeply engaged him in the mass labor and economic issues of the Depression, as well as in the artists' particular plight. Bernarda has stated about the idea of collaboration with Ben Shahn that "our relationship went deep into theory. Both in art and in life. I am sure that I had great impact upon Ben's thinking – even upon his writing, but not upon his art."[12]

Such a statement underlines both Bryson's strong intellect as it worked in synergy with Shahn's throughout the rest of his life as well as her own social

conditioning concerning Shahn as an autonomous artist. Yet, irrefutably, his work in conjunction with Bryson in the mid-1930s, demonstrates their strong interaction. Such an intellectual and technical collaboration is definitely a factor in considering their imaging of history. It is one of the reasons why Bryson and Shahn stand out distinctly from other members of the American scene mural movement as it was later formulated by the New Deal. Their work, taken collectively, encompasses many media and many intellectual concepts that are not simply programmatic responses to a government initiative.

In the fall of 1935 Bernarda Bryson and Ben Shahn both went to work for the newly created Resettlement Administration of the New Deal in Washington, D.C. It was through this program that they created the Jersey Homesteads mural two years later. The Resettlement Administration provided them with conceptual and artistic agendas as well as the political contacts that led to the creation of the Jersey Homesteads mural. First developed under the leadership of Rex Tugwell, an idealistic economics professor from Columbia University, the Resettlement programs were intended to provide new housing and a better standard of living for impoverished workers in both urban and rural areas. The larger goals were relief of suffering, development of self-sufficiency, and maintenance of the family.[13] Shahn and Bryson were part of a close-knit group of radical thinkers that provided creative ideas for using art to promote the new programs.

Initially, Shahn was hired to publicize the programs of the Resettlement Administration with posters and graphics. As research for this activity, he proposed the idea of visiting the mining areas of Pennsylvania and Appalachia. He and Bryson took an epic two-month trip (with Bryson doing all the driving) intended for the purpose of photographing resettlement clients. They ended up driving through Pennsylvania, West Virginia, Kentucky, Tennessee, Arkansas, Louisiana, and Mississippi. From September to October 1935, Shahn and Bryson approached impoverished rural workers. Bryson would often engage people in conversation while Shahn would capture them informally with a right angle lens. Although they were working with the support of the government, their photographic journey was not made simply to create propaganda. Bryson and Shahn engaged serendipitously with the South, with the people they met, with its life.[14]

The images that came out of their journey (an itinerary that would later become almost ritual for socially concerned writers and artists) were fundamental to the development of the more famous Farm Security Administration images. Shahn and Bryson were pioneers in this use of photography by the federal government, although they were soon followed by Dorothea Lange, Walker Evans, and many others. Later Depression photographers were, however, more programmatic in their intentions and more edited by the ideology of the government to project a sense of the role of the government in creating a new stability out of desperate conditions.[15]

Although Shahn's photographs are often used in his murals, a film project in collaboration with Walker Evans reinforced the idea of cinematic scale and sequence. The film requested by the Resettlement Administration was a

promotion for a new greenbelt community just outside Washington, D.C. The Shahn/Evans film was never created, but its form as well as its conceptualization is revealing:

> We propose to make a film, the subject matter of which will be people – the greater half of our nation. We want to show how they live now, and to show a way of life in planned communities such as the greenbelt town offers. To do this we will employ a device of flash-backs [sic] into the histories of five typical American workmen who apply for work on a greenbelt project. . . . For some of the material we will rely upon stock or news shots. For the rest we will rely upon the actual conditions and people as we find them. . . . Through such a film we hope, first to build up a public sympathy and understanding of the need of housing for some 40,000,000 Americans; second to popularize the idea of the planned community. We wish not only to awaken in our audience some feeling of responsibility and concern for the great segments of population shunted into the cast-off segments of our cities, the worked-out farms of our country; but we wish to articulate for our audience their own needs in housing, to spread some understanding of what housing can and ought to be for people of low income.[16]

Although the film addressed Greenbelt, Maryland, its techniques and concepts could also describe the program of Jersey Homesteads and its mural. The idea of history in flashback suggests the concept that probably underlay the immigration scene at Jersey Homesteads.

During these same months Bernarda Bryson was involved with creating historical images. She was asked to set up a lithography workshop as part of the special skills division of the Resettlement Administration that encouraged the idea of crafts such as furniture design, ceramics, and printmaking. Bryson began to create a "Frontier Book" inspired by a Roosevelt speech that the new frontier was that of the social frontier. The book was to have covered the importation of immigrants, the middle passage, as well as the movement west and the vanishing frontier. She also created lithographs and watercolors based on the history of the Underground Railroad, a topic with which she was intrigued not only because of her social principles, but also because her own grandparents' home was a stop on the Underground Railroad in Athens, Ohio.[17] Bernarda Bryson's historical images in these prints, although on a much smaller scale than murals, also mediated between memory, personal experience, and the national narrative discourse.

It was at this point, following several years of working on a small scale with lithography and photography, as well as film and mural conceptions, that Ben Shahn and Bernarda Bryson took on the commission to create a mural for Jersey Homesteads, their first executed mural-scaled fresco. According to Bernarda Bryson the community was founded as follows:

> It began expressly with a group of New York workers in the garment trades. They discussed nostalgically how great it would be to have a factory in a rural area where – during off seasons for instance – they would not be languishing unemployed in teeming city areas, but could have a plot of land, a garden and so on. In pursuance of this dream, each of some eight to fifteen families raised five hundred dollars each. They had

heard of Benjamin Brown who was noted for having instituted cooperative projects in the United States . . . and in Russia. They went to him. He located a tract of land contiguous to his own in New Jersey. Hearing of the oncoming New Deal projects, Mr. Brown took a delegation of the garment workers to Washington where they met with Harold Ickes, Secretary of the Interior, who immediately approved the project.[18]

The New Deal provided a huge infusion of funds for the building of the community, and named it Jersey Homesteads in order to invoke a reference to the pioneers. After several calamitous events,[19] the government hired Alfred Kastner, a German architect from the Bauhaus and student of Gropius, assisted by Louis Kahn, to build the town. Although the local residents might well have preferred a traditional style of architecture (as indicated by the frequently gingerbread transformations that have taken place in the houses over the decades since they were built), the utopian Bauhaus principles of functional architecture for workers dominated the entire planning. The government, although it provided the essential funds for the building of the community, also, in essence, preempted the possibility of individual initiative from the residents.

Kastner invited Shahn, with Bryson as his assistant, to create a fresco in the town, and designed what was originally the community building with the mural in mind. The dimensions of the wall and the lighting and viewing of the mural were all part of the original planning process. The first anonymous description of the mural read as follows:

Mr. Shahn is to work out a script for the mural with a number of variations to same. The theme is to center about contemporary life to the Jewish emigrant, to touch on immigration and emigration, his assimilation into the country, industrialism and unionism with contrapointal adoption of programs elsewhere, and immigration to Palestine.[20]

Initially the mural was conceived by Shahn entirely as a narrative that invoked Jewish history, hopes, and memories. His narrative about the mural is filled with intimate characterizations of Jewish life, most of which do not emerge in the final mural. On the other hand, as a passionate narrative written at a time when Shahn was leaving Jewish life behind, it clearly demonstrates his personal relationship to the mural's subjects, particularly with respect to his place as a Jewish immigrant who aspired to be free of the bonds of tradition and to assimilate into the life of the United States:

The mural should begin with the life of the Jews in [a] Russian Ghetto. They are seen living in humbleness and fear, caring for their own as best they can, keeping up homes for their aged and schools for their young. They are deeply buried in their religion, finding there some compensation for their exclusion from the civil life about them. A fragment of a dream of return to the Holy Land is shown, and the nostalgic prayer: "On the coming year let us all hope that we will be reunited in Jerusalem."

Around a table the Jews sit at the feast of the Passover. Behind them rages a pogrom. An inflammatory anti-Semitic myth often spread among the Russian peasants holds that at the Passover the Jews must have the blood of a Christian child. Because of

this, pogroms sometimes begin at this time. The tragic conclusion of the pogrom is seen in a coffin, surrounded by a mournful family.

The Passover symbolizes the departure of the Jews from Egypt, the land of bondage. So, with the feast of the Passover, and out of the background of Ghettos and pogroms comes a stream of immigrants to America with hope in their faces. Above them hovers the dream of America – a land of fruit and flowers, big cities with streets paved with gold, the Statue of Liberty – symbol of a new life to the immigrant.

Looking away from the stream of immigrants is shown a dim loft in a New York sweatshop, three Jewish workers bend over long lines of machines straining to see in the dim lights. Other workers bend over gas irons smothered in clouds of steam. Others laboriously operate antiquated and back-breaking machinery. Here the Jews, disillusioned in their dream of America, again dream of the return to Zion. Or some think longingly of the open fields which they have seen in America, and yearn for the soil and the ancient agricultural pursuits of their race. A scene in the New York ghetto is shown. The older immigrant Jews, cast in a mould by generations of fear, are found living in segregated groups, carrying on their traditional trades and customs, not venturing into fields which were forbidden.

Out of this scene of the New York ghetto and the older Jews surges a new generation – the young American Jews. Free from fear and oppression, they are now fully assimilated into their surroundings. They take part in the life of the country, its culture, its sports, its business, politics, and professions. Many of them work in the needle trades, but these are no longer sweatshop workers. They are meeting in unions of the needle trades, they are addressing crowds of workers, they picket in a strike. . . .

A young Jewish worker stands with his two children where a pathway divides. Over him hangs a dark reddish cloud in which the horrors of Jewish persecution in Hitler Germany are shown. The cloud hangs low with a suggestion of imminence. Before him one path leads toward the Holy land, toward Tel Aviv, and the New Jewish settlements in Palestine. He looks longingly – shall he return to the homeland? But he seems rooted to the ground. He is an American, his children are Americans. . . . A second branch of the path leads in the direction of another old dream of the Jews – a return to the land. Here is shown the co-operative community with its various aspects of communal living. . . . There is seen here an adding to and an enriching of the group, without sacrifice of the racial and cultural treasures. The Jew is shown able to realize his potential growth . . . practicing his trade and living on the land.[21]

As first characterized by Shahn in this narrative, in the spring of 1936, the entire Jersey Homesteads mural focused on Jewish oppression, immigration, and dreams. His narrative speaks of the history of a generation of Jewish immigrants whose parents arrived in the early part of the twentieth century. The narrative could easily have been based not on research but on the conversations in his home of the conditions in Russia and the hopes in the new country. The conflation of personal memory, personal experience, and received history parallels that of the images of the completed mural.

A directive of a year later significantly altered this original plan, upon which Shahn had based two sketches.[22] The memo of April 15, 1937, reflective of the ideology of the now well-established government art programs sponsored by the Treasury Department and the Works Progress Administration, read that

The theme of the picture may be described as the "American Scene." Its dominating composition shall show the arrival of the immigrants at the left, acclimatization and organization into the American community in the center, and the revitalized pursuit of human observations [sic] under the newly acquired democratic technique at the right.

The time, dress, and incidents used are characteristics of today and their application shall be without prejudice against race, creed, or color.[23]

The compromise for Jersey Homesteads was that Shahn was permitted to present a specifically ethnic history, as long as he showed it blending into the American scene and not as disruptive or lacking in decorum. As finally completed, the mural, with only minor changes, met the approval of the authorities in Washington, D.C., all enthusiastic about Shahn personally in spite of his radical apprenticeship with Rivera. The approval stressed the fact that "the mural emphasized the human side of the story as against political or religious. Its presentation is quiet and it deliberately avoids the portrait of struggle or conflict or any other sensational matter as not befitting the dignity of the theme."[24]

On the left the mural is dominated by a large wedge-shaped group of immigrants walking briskly toward the foreground across a red bridge with Albert Einstein among the leaders. Next to Einstein and actually leading the group is a dominating female figure that is Shahn's mother,[25] as well as the archetypal Jewish matriarch; she wears a shawl covering her head, the traditional dress of a Jewish woman, and borrows from images of Shahn's own great-grandmother. To her right is Raphael Soyer, although his features also suggest Shahn's father. Further back, almost buried in the midst of the crowd, is another famous scientist, Charles Steinmetz, the brilliant hunchbacked electrical engineer who became known as the "modern Jove" when he created lightning in his laboratory in 1922.[26] Many of the figures prominently wear badges that identify their number on the ship manifest, without which they could not enter the United States. Badges were also used during early pogroms to identify Jews, as well as in Nazi Germany. Such a device underlines Shahn's intention to overlap historical time within a dynamic of social change.

The group purposely conflates several eras of immigration. Steinmetz and Shahn's own family came as political radicals to the United States fleeing late-nineteenth- and early-twentieth-century Jewish pogroms in Russia,[27] whereas Einstein came to escape from Hitler's repressive policies in 1933. Bryson recently stated that emphasis on the large group of immigrants combined with specific individuals was intended to underline that immigrants made major contributions to the society to which they came.[28] Einstein was also living in nearby Princeton and was a supporter of the Jersey Homesteads community.

Shahn used many approaches to suggest action and drama without utilizing heroic individuals or traditional gestures: Several different diagonal perspective constructions are based on Renaissance techniques. At the same time he punctuates the coherent mass of the immigrants by assertive portraits, photographs drawn from family albums, Lewis Hines's photographs, and anonymous newspaper images. These contradictory modes conflate the idea of memory and history, or in Roland Barthes's terms, the punctum and the

studium. They combine symbols of history, both spatial and figurative, drawn from Shahn's research in photographic files, with the hieroglyphs of his own imaginary and real personal history.

The mural is even further complicated by adoption of the Brechtian epic theater technique of groups of workers as symbols of active social forces. The mural also invokes the spatial and temporal collage of such films as Sergei Eisenstein's *Potemkin,* in which long shots and close-ups, flashbacks, contemporary events, and even hallucinations are combined: In the immigration segment smaller scenes refer to related developments. The intolerant actions of the Nazis appears in a ghetto scene in the upper left corner. Prominently, in the lower left, is the Registry Hall at Ellis Island. It is shown starkly without benches as it was when Shahn arrived, but entirely empty except for one isolated family and a single man, an accurate depiction, since men frequently immigrated separately from their families. Above the immigrant group are families sleeping in a city park. These images all inhabited Shahn's memory. They replace the original plan for these spaces of nineteenth-century pogroms, Russian ghetto life, and the Jewish Passover.

The central section of the mural focuses on the process of unionization. It includes several types of garment workers: assembly line workers with sewing machines, pressers bending over steam irons, and home piece, workers dominated by a maternal figure. All of these figures are compressed into tight spaces in contrast to the expanding wedge of the immigration scene. In this section Shahn was also using photographic images of sweat shop conditions, but he has a less personal connection to the scenes because his own family were skilled craftspeople. The stasis of the sweatshops is countered by the line of the workers (among whom, significantly, is Bernarda Bryson) filing into a union hall with brickwork that ties the mural to the brick of its setting, originally the community center of the town. Because Bryson was a key figure in encouraging Shahn's activities in the Artists Union, her placement is revealing.

At this point there is a sense of break (or scene change) in the sequencing of the mural as it shifts to the process of unionization. The last two parts of the mural are also distinguished by having only one female, a traditional mother in the background; with the emergence of the union the action is by men, although historically young girls played a dramatic role in the process of unionization.[29] The only dominant individual figure in the mural is the large speaker based on a "soapbox orator" from Shahn's own photographs in New York on the Lower East Side, now metamorphosed into a union leader. Again the sense of a zoom close-up against a film set is suggested: Behind the speaker are the buildings of businesses that figured in the early oppression and tragic events that led to the creation of the union. Standing out clearly is the famous Triangle Shirt Factory where a horrific fire in 1911 killed 146 young girls who were trapped behind locked doors intended to give access to stairways.

The union organizer is the largest figure in the mural and the closest to a hero, but he is understated: He does not gesticulate except to point down to the workers below him, several of whom are also based on Shahn's own photographs. The words of the speech are written on a sign (suggesting a silent

movie with captions). They are drawn from a speech by John L. Lewis, first leader of the Congress of Industrial Organization (CIO). The leader resembles Lewis, but is, as with most of Shahn's so-called portraits, a composite of several people.

Directly below the union leader is a pensive worker who emerges from the crowd, brooding on the speaker's message and pausing between the past turmoil of the milling workers and oppressed factory workers and the future, represented by a sequence of ordered doorways that are replicas of the doorways of successive union halls, based again on photographs. This central part of the mural is by far the most complex. The process of unionization is an abstract idea, much less specific than the process of immigration. Shahn had few visual references other than newspaper images from which to work. He himself was a part of the process only in the context of the artists' demonstrations of the mid-1930s, so he observed it as a commentator. He is working with his own images of workers, rather than his remembered memories of immigration. The abrupt spatial and thematic segments seem to function as a metaphor of the difficult psychological transition that he himself was undergoing, from his roots in the restricted immigrant community of his youth, to the turbulent world of the activist mid-1930s, and thence to the New Deal world of Washington, D.C., where he had a home with Bernarda Bryson for the first time.

The next section of the mural displays ordered and purposeful groups. It juxtaposes the benefits of unionization, a scene of education on the history of labor in a classroom,[30] and the cooperative construction of a factory building in an agricultural setting. The workers constructing a factory are a specific reference to the Jewish garment workers who originally founded Jersey Homesteads in 1932.

The conclusion of the mural is the New Deal. The last scene shows the specific men who took on the support of the utopian community that represented the ideals of the Resettlement Administration, including Rexford Tugwell, David Dubinsky, head of the International Garment Workers Union, and Heywood Broun, a spokesman for labor. They are seated around a table, with the plan of the community tilted up as both an emblem of the planning of the town itself and of the planning process of the entire Resettlement Administration.

Although the individuals in the New Deal scene are more specific than in any other section of the mural, that specificity is paired with their activity as a group understood as part of a process, rather than an individual initiative. It was around this table, with the planners of the Resettlement Administration, that Shahn could have placed himself and Bernarda Bryson, for they both were involved as artists in its early programs. Behind the prominent New Deal group is a small "flashback" of a young family leaving a poorly planned community to join the new cooperative. The spatial stasis of the segment of New Deal administrators contrasts with the dynamic processes of immigration and unionization. It invokes the interest of the New Deal in reestablishing stability and traditional family units.

Without showing any sign of the extensive strife of the labor movement,

Shahn, with great subtlety, made one theme a clear reference to the Marxist interpretation of history in terms of economic forces driving social change and the power of the worker. Shahn legitimizes the radicality of his interpretation through devices that link the mural to traditional history painting. Not only does he structurally quote the spatial relationships of Renaissance murals, he also invokes a biblical allegory of Moses leading the Jews into the Promised Land, with Einstein performing the sage role of Moses in the biblical emigration. The prominent female with covered head at the foreground of the painting subtly refers to the madonna as well as a symbolic Jewish matriarch. This conjunction of a Marxist view of historical process with Jewish and biblical references, and conveyed with formal devices that are both conventional and avant-garde, provides the basis for Shahn's success in bypassing the potentially heavy censorship of the American scene theme.

The themes themselves are not entirely unique among New Deal murals. Another example of sweatshops appears in George Biddle's murals for the Justice Department, completed in 1935.[31] Biddle creates static tableaux that become symbols of deprivation. Despite his deep concern for the subject, he makes whimsical errors: In the sweatshop he put himself at a sewing machine, although nothing could have been further from the experience of the wealthy scion of a Philadelphia family that dated back to before the Revolution. Shahn was closer to the subject matter. Although his own family was not part of the textile sweat shops, his understanding of the psychological conditions gives his three sections of sweat shop workers an intensity through his brilliant use of compressed space. The figures are physically jammed together or lined up on a long, deep narrow table. As suggested in his outline, the narrowness of life and mind in New York was as oppressive as the ghetto of the Russian pale. Biddle's images suggest emotional despair and isolation from the rewards of society; Shahn's scenes project resignation and claustrophobia.

Another thematic comparison can be made with Edward Laning's Ellis Island cycle of murals completed in the spring of 1937, just before Shahn commenced work. Although the overall theme *The Role of the Immigrant in the Development of America* is entirely different, the arrival scene is similar. A close comparison reveals again the immediacy of Shahn's mural. The arriving group faces us more directly and includes specific people. It also suggests the tightness of a compact community, whereas Laning's immigrants are more isolated. Laning includes a reunion scene of husband and wife, rather than Shahn's accurate "holding pen" of the Registry Hall at Ellis Island. Laning suggests the symbol of the holy family with a mother/father/child as the prominent cluster in the foreground, whereas Shahn's central figure beside Einstein is a powerful mother figure without child, a reference to the fact that families were frequently separated in the immigration process. Last, Laning's use of large half-naked figures draws not only from the academic tradition but also from the symbols of American work, as seen in the pioneering murals of Thomas Hart Benton. Benton's murals were, in fact, a fundamental reference point for many of the murals of the 1930s.

Benton's painting, above all *America Today*, was accessible throughout the 1930s in the New School for Social Research in downtown New York.[32] In a series of nine active scenes that branched out from an energizing gyro engine he presented America from farm to city, including such industrial subjects as "Coal Mining" and "Steel." These panels were dominated and unified by huge foreground male bodies (often posed for by Jackson Pollock) with a background of smaller scaled details. They interrelated in sequences based on the early western film sets that Benton himself had worked on in the teens. Significantly his film set source was more oriented toward the traditional tableau than those of Shahn, who was familiar with the more avant-garde techniques of Eisenstein and Brecht. Benton transformed the academic formula of the heroic leader by monumentalizing different types of workers and activities in front of a "set," very much like early Hollywood westerns. Benton's link to Marxism is in the glorification of the worker but he emphasized specific activities and individuals, rather than groups and process.[33] In contrast, Shahn's link to Marxism is in his Brechtian use of dense communal groups that invoke economic forces.

Although no other New Deal murals are known to refer to the idea of union organizing, a mural by Marion Greenwood does address urban resettlement. Marion Greenwood's fresco *Blueprint for Living* in the Community Center of the Redhook Housing Project in Brooklyn, like Shahn's, addressed a New Deal Resettlement program. Completed in 1940, the mural also contrasts the old and new, and like Shahn's depicts the actual building of the new town. Greenwood had worked in Mexico as a fresco painter, and was highly regarded by Diego Rivera. Her monumental workers are simplified and modernized, with an emphasis on the act of building and the sense of community. The image was integrated with the architecture of the room. On the other hand, she clearly conforms to government ideology in showing the men working and the woman as a mother.[34]

The Jersey Homesteads mural was more autobiographical and oriented to Marxist theories and Jewish history than any of Shahn's own later mural cycles. During 1938–9 Ben Shahn and Bernarda Bryson worked together on a second major mural cycle at the Bronx Post Office. *Resources of America* consists of thirteen paintings created in egg tempera rather than fresco. Much less an integral part of a specific community than the Jersey Homesteads Project, and sponsored by the Treasury Section of Fine Arts, a more established group of art sponsors than the by-then-defunct Resettlement Administration, the cycle of thirteen paintings was tied to the ideology of the New Deal and American workers as emblems, rather than to a narrative about the inhabitants of the community itself.

Bryson and Shahn won the commission jointly, a result of their close friendships with the administrators of the New Deal. Bryson's conception, as it survives in sketches, was linked directly to New Deal programs. She includes such subjects as a mother and child in front of slum housing, a destitute city dweller, and the building of new housing and parks; she also included a

rancher, a miner, a farmer, a railroad foreman, and dam builders. The focal point of her cycle was Franklin Roosevelt, framed by an artist and a teacher (both women). The murals as executed for the Bronx Post Office followed Ben Shahn's proposals rather than Bryson's, as Bryson felt that "Either set of original designs would have been a complete concept in itself. To break up either would have been destructive to it. I chose to follow Ben's designs."[35] On the other hand, Shahn and Bryson were working so closely at this point that such a statement may be exaggerated. Some evidence shows that Bryson worked from Shahn's photographs in her sketches and that he embodied some of her approaches in his conception.

As installed, the mural has Walt Whitman as the focal figure instead of Roosevelt. Two large-scaled single panels focus on workers picking and baling cotton, both based on Shahn's photographs taken in 1935–7. Other panels depict textile factory workers including a girl spooling and a man weaving, an electrical engineer holding a plan, an agricultural scene of a thresher and worker, and a hydroelectric dam. The connection to New Deal programs is looser than in Bryson's plan, but the overall theme is the same in terms of the building of society.

In both the sketches and completed mural, the imagery is segmented in many separate panels, the result of the post office design. The imagery is symbolic rather than narrative. Shahn's handwritten notes on a letter authorizing the murals comment, "Ideal situation would be simplicity of symbol and integrity of artist."[36] The relationship of the typical viewer in the Post Office to the murals' subject matter was remote, except in so far as the Bronx had a working-class population and the mural depicted workers. As history painting, the Bronx imagery presents isolated symbols of American industry, several of which are the same as those presented by Benton in his New School murals (agriculture, mining, hydroelectricity). Furthermore, the subjects are less connected to Shahn himself, except in relationship to his photographic trips sponsored by the Resettlement Administration. His radical and complex approach to murals at Jersey Homesteads has now become a more programmatic and generalized image of the American scene.

In the following year, 1939, Shahn returned to the theme of immigration in a proposal for a post office in St. Louis. Although these sketches also encompassed several other themes such as the four freedoms and the history of the frontier and river life, the immigration images are a striking contrast to the subtle understatement of the Jersey Homestead painting. In the two immigration designs dramatic images of Nazi guns, concentration camps, and desperately fleeing Jews unequivocally present the violent destruction of the compact Jewish community seen in the earlier painting. The murals were not accepted.[37] Another mural executed in 1939 was based on *The First Amendment* and included a dramatic diagonal organization and a dialectical relationship of the capitalist and the worker to left and right, both quotations from Rivera's format at Rockefeller Center in *Man at the Crossroads*.

Shahn's final painted mural completed in fresco in 1940–2 was the *Mean-*

ings and Benefits of Social Security. In this painting, he returned to Rivera's dialectical model by pairing images. In this case, one wall showed conditions before Social Security, and the other, after Social Security. Using several of his own earliest New York photographs as well as other sources, Shahn depicted no famous people, only ordinary people. He contrasted the handicapped and unemployed, old and young, with, on the facing wall, people enjoying sports and building buildings. The *Meanings and Benefits of Social Security* is by a loyalist to the New Deal who avidly believed in its programs.

Shahn as a history painter, with the frequent assistance and collaboration of Bernarda Bryson, created through his several murals a variety of images that present both specific representations and hieroglyphic emblems of the New Deal and its programs. Yet only in the Jersey Homestead murals, with its layered density of personal and political references, did he fully develop the many aspects of history that constantly interact and reinforce each other, particularly the intersection of the symbolic historical tableau and the hieroglyphs of his personal memory. In its unusual subjects, its experiment with the intersection of narrative history and personal memory, and its use of spatial relationships borrowed from a wide spectrum of historical sources, the mural is one of the most complex images of the entire decade of the Depression.

Yet, in the end, the Jersey Homesteads mural depicts simply a myth. In spite of Shahn's optimistic image of stabilization, Jersey Homesteads, because of economic forces beyond its control, was already failing as an industrial and agricultural cooperative by the time Shahn and Bryson completed the mural. By January of 1938 there was a tenant crisis, problems with organized labor and the idea of the cooperatives, a lack of jobs, and a break with the Resettlement Administration. Anti-Semitism from nearby communities such as Hightstown, a center for the Ku Klux Klan, was also painfully isolating for the original Jewish residents. In addition, many of them found living in the country unpleasant and even frightening compared to the urban life to which they were accustomed.

The houses were put up for private occupancy. Ben Shahn and Bernarda Bryson moved into the community. Today, only a few descendants of the garment workers remain. The town is predominantly writers and artists, or academics from nearby institutions. Today, Jersey Homesteads, renamed Roosevelt, has no industry or cooperative agricultural programs supporting the community, the result certainly of current economic and political forces as powerful as those that drove the creation of the community in the first place. Ben Shahn is not available to paint this contemporary chapter, but the economics that drive suburbia would probably not particularly inspire him.

May Stevens
Painting History as Lived Feminist Experience

Patricia Hills

For twenty years the contemporary artist May Stevens – painter, poet, feminist, and activist – has been engaged in the ambitious project of presenting both a personal and a revisionist history. Reflecting back on this project, in 1993 she wrote,

History painting is as problematic today as the sculptural tradition of the monument. As history is suspect so is the art that confirms it, solidifies [it] into irrefutable symbol – propaganda for the winning side. In my "history paintings" . . . – *Artist's Studio, Soho Women Artists, Mysteries and Politics,* . . . *Ordinary/Extraordinary* (the series), *One Plus or Minus One* – official versions of history are deconstructed in favor of hearing silenced voices and unrecorded lives.[1]

Hers is an unofficial history, cast with specific women, who also serve as types, and who have grown into tropes for voice and silence.

The first phase of her history painting, focusing on herself and her circle of artist and writer friends, developed from 1974 to 1978 in three 10-foot paintings: *Artist's Studio (After Courbet)* (Fig. 88), *Soho Women Artists* (Fig. 89), and *Mysteries and Politics* (Fig. 90).[2] During the course of working out her ideas in these three works and their studies, she became highly self-conscious about her goal – to paint a history that she knew, that she felt, and of which she had become a part. It was a history of activist feminists attempting to integrate the demands of family, radical politics, and artistic creativity.

The second phase overlapped with the first. It began in 1976 when she published two montages as a two-page spread in the feminist journal *Heresies,* contrasting the Polish communist Rosa Luxemburg with her own mother, Alice Stevens, a working-class housewife from Quincy, Massachusetts (Fig. 91).[3] She explored those very different lives through a dozen small mixed media works and many large paintings, which she called the *Ordinary/Extraordinary* series.[4]

As history paintings the two phases differ. Similar to traditional history paintings, the three studio pictures are acts of celebration; they acknowledge and honor people at moments of historic change. But rather than people from

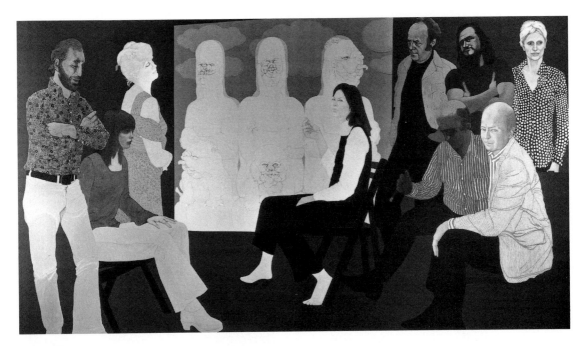

FIGURE 88

May Stevens. *Artist's Studio (After Courbet)*. 1974.

Collection of the artist.

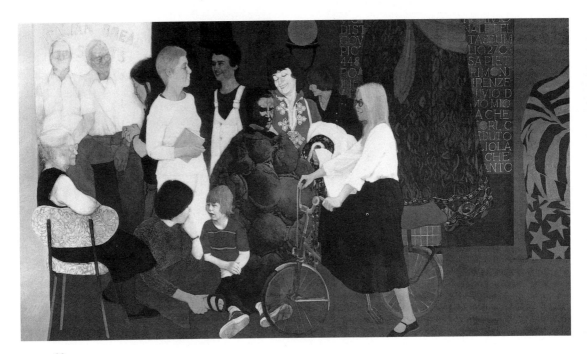

FIGURE 89

May Stevens. *Soho Women Artists*. 1977–8.

Collection of the artist, on extended loan to the National Museum of Women in the Arts. Photograph by eeva-inkeri.

FIGURE 90

May Stevens. *Mysteries and Politics*. 1978.

Museum of Modern Art, San Francisco.

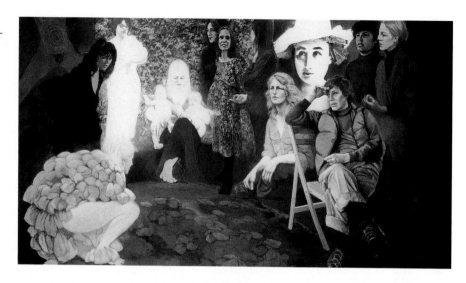

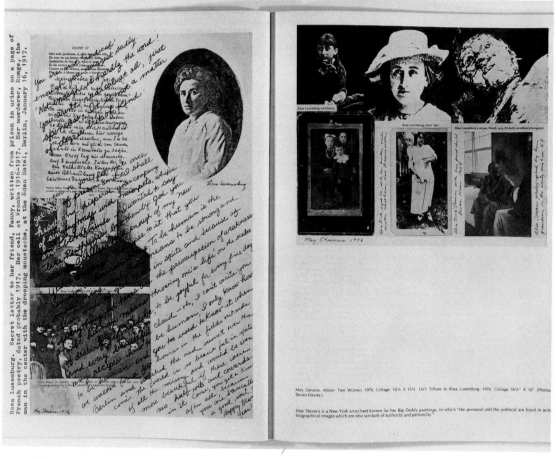

FIGURE 91

May Stevens. From *Heresies: A Feminist Publication on Art and Politics*, No. 1 (January 1977), pp. 28–9. Left: *Tribute to Rosa Luxemburg*. 1976. Right: *Two Women*. 1976.

the past, Stevens chose contemporary friends intent on changing the art world of the 1970s. In painting them she evolved toward a consciousness of self as a lived experiencing of history. In the second phase of the *Ordinary/Extraordinary* series, Stevens did not celebrate; instead she explored history and memory for clues to her own awakened feminist consciousness. As Stevens said in 1978, as she was finishing the first group of paintings and already into the second phase, "Consciousness operates on many levels – the past stretches back to pre-consciousness, punctuated by images and voices that never totally leave us; our minds slip from memory to desire without a seam. . . ."[5] To Stevens, a heightened feminist consciousness increased the yearning for knowledge, heretofore only partially articulated, about her intellectual and class origins. That yearning has become Stevens's quest for the right metaphors, images, and words to communicate to us her powerful feelings about voice and silence, about life and loss. In the process, she has pushed the limits of painting – in essence mute – into a discursive mode, sometimes so literally that words written across the surfaces of the canvases vie with the visual images in the creation of meaning.

<p align="center">✶　✶　✶</p>

Her initial resolve to paint a revisionist, a feminist, history grew out of her involvement with the highly charged women's movement in New York in the early 1970s. Before then, during the late 1960s, she had participated in the artists' movement to protest the Vietnam War. Stevens, her husband Rudolf Baranik, Leon Golub, Denise Levertov, Mitchell Goodman, and Irving Petlin in 1966 had organized Artists and Writers Protest Against the War in Vietnam, which sponsored an "Angry Arts" week in New York in 1967.[6]

The anger she personally felt toward the military-industrial establishment, the "hawks" in Congress and their supporters, influenced the direction of her art. From paintings done in 1967 based on the image of her working-class mother and father seated at home before a television set, she developed an iconic image of American racism and militarism dubbed "Big Daddy." She used a flat poster style, well suited to satirize this smug patriarch, whom Lucy Lippard called "frighteningly ordinary."[7] Big Daddy almost always held a bulldog in his lap and was eventually draped with yards of American flag bunting. In the late 1960s and early 1970s Stevens did variations on the theme in at least eight large acrylic paintings (from 10 to 12 feet wide) and numerous small gouache paintings, which were regularly shown in antiwar exhibitions. Even then, she was moving toward history painting with these Big Daddy spoofs of the "state portrait," the ruler portrait that achieved the heights of grandiosity in the eighteenth-century portraits of the French kings and had its modern counterpart in official photographic portraits of then president Gerald Ford posed in front of the American flag.[8]

The protest by artists against the Vietnam War permutated into other dissents and actions. The organization Artists and Writers Protest Against the War in Vietnam was one of many groups absorbed into the Art Workers

Coalition (AWC). This later, umbrella organization held mass meetings and agitated for changes in the art world, much in the spirit of the 1968 European and American students who had sought to reform the universities and the social structures of society as a whole and who had called for an end to cold war militarism and imperialism. In their protests the AWC targeted museums for what the AWC called their elitist boards of trustees, their exclusive curatorial policies, and their passive stance toward the immorality of the Vietnam War. The AWC held an Art Strike in 1970 that effectively managed to raise the issues of racism and sexism in exhibition policies and persuaded museums to mount exhibitions of art by African American artists. They also took up the cause of community involvement in the arts and succeeded in obtaining funds from philanthropic organizations to open storefront museums.[9]

Meanwhile, Stevens and her politically active women friends began to redirect their energies to an analysis of their own situation as women. Having become skilled at organizing meetings and participating in protest demonstrations, they now turned to investigate their own status as women artworkers. Consciousness meetings sprang up that offered women forums in which they could share experiences, build self-esteem, and receive support for their professional lives. Thus emboldened, they joined together to create their own cooperative galleries and to publish literature that addressed issues of concern to women artists. "The personal is the political" became the slogan that stirred women to consider the ways their own personal circumstances were, in fact, not unique. "Political" became broadly defined to mean the awareness of the structures of power and of the societal norms that had imposed specific and common experiences on women and that had kept women subordinate to men. To be a feminist came to mean not just questioning patriarchical authority but engaging in social change. They took to heart Marx's thesis: "The philosophers have only *interpreted* the world in various ways; the point, however, is to change it."[10] And as these women changed their world, they also made a new history – one that featured women in the center and not at the margins.[11]

In this context, in 1974, Stevens began her first ambitious history painting, *Artist's Studio (After Courbet)* (Fig. 88), a group portrait of the artist in her studio surrounded by close friends, both men and women. In the two years between the time she finished this painting and began work on the next, *Soho Women Artists*, she had clarified the issues into specific questions. It was not just the question of whose history, since she had already resolved to represent a feminist history. Now she asked: What individuals would stand for that history? Would they function as individuals, types, or symbols? How would the representations express her own experiences and hopes for the future?

Moreover, the choice of artistic means challenged Stevens. What kind of aesthetic was relevant: The poster style of her Big Daddy paintings? An old master style of illusionist painting? Collage? Montage? Xerography? What about paint application, texture, pattern, color, line, composition, scale, and poses and gestures for the figures? Who in the history of art might serve as models for her new ambitious art? As she plunged more deeply into these questions, the formal

aspects of her art evolved dialectically in response to her urgency to make the issues specific but also to broaden and universalize the content.

Artist's Studio (After Courbet) effected the transition from the Big Daddy paintings to the collective portraits of feminists portrayed in *Soho Women Artists* and *Mysteries and Politics*. Stevens's specific reference to Gustave Courbet was to a historical precursor who had shocked his contemporaries when he exhibited *Stonebreakers* and *A Burial at Ornans* at the Paris Salon of 1850–1. Courbet did not reject the label *realist* bestowed on him by hostile critics at that time, but he felt the need to elaborate. He published his credo in a "Realist Manifesto," issued on the occasion of the independent exhibition of his major work, *The Painter's Studio: A Real Allegory Summing Up Seven Years of My Artistic Life*, 1854–5:

To know in order to be able to create, that was my idea. To be in a position to translate the customs, the ideas, the appearance of my epoch, according to my own estimation; to be not only a painter, but a man as well; in short, to create living art – this is my goal.[12]

Audacious and self-possessed, Courbet aimed to take on the authority of spokesperson for his time and place.

In his studio interior Courbet offered an image of the dramatis personae of his social and political world of 1855. In the center he portrayed himself painting a picture with an artist's model and a small boy looking on. To the right, he represented his supporters – his patrons, the critic Champfleury, the poet Baudelaire, and the socialist philosopher P.-J. Proudhon. To the left he pictured a gathering of genre types, such as a hunter, peasants, a beggar woman suckling her child, and a priest, all of whom a realist painter might bring into the studio as models, but who in this case, according to recent scholarship, were Courbet's "real allegories" of people prominent on the stage of French politics. To a knowledgeable contemporary viewer, Courbet's choices of genre types and their poses would have disclosed their identities.[13]

Like Courbet in his *The Painter's Studio*, Stevens asserts her ego when she places herself and one of her own paintings in the center of the canvas. But whereas Courbet continues to work on his landscape, Stevens turns away from *Metamorphosis*, a painting that depicts the transformation of the phallic male head of Big Daddy into a dog's head while the bulldog takes on the physiognomy of the man. Instead of holding a paintbrush, her hand makes a rhetorical gesture – to punctuate a didactic point. The self-portrait looks in the direction of three painters at the left – Arnold Belkin, Felicity Rainie, and Sylvia Sleigh. Behind Stevens at the right stand Rudolf Baranik, critic Joachim Neugroschel, and artist Nancy Spero; seated are artist Leon Golub and critic Lawrence Alloway. They are readily identified individuals, like each of the characters from the right side of Courbet's painting.[14] The inclusion of *Metamorphosis* is apt because *Artist's Studio*, painted after seven years of Big Daddy paintings, began Stevens's transformation into a history painter.

However, with *Artist's Studio* Stevens maintained a stylistic continuity to her Big Daddy paintings. She created a flat cobalt space against which the figures seem to float, eliminated studio props other than chairs, clearly demarcated the silhouettes of the figures, reduced modeling to a wash of tints, and emphasized pattern, such as the flowered, striped, and dotted shirts of Belkin, Golub, and Spero.[15]

Like Courbet, Stevens was both ambitious to take up grand themes and felt the necessity to explain to her audience the issues relevant to her. Shortly after its completion, in the winter of 1974–5, Stevens discussed the painting with critic Cindy Nemser and elaborated on her borrowings from Courbet. Some of the placements loosely followed Courbet's example: She placed Alloway in the lower right like Baudelaire and replaced Courbet's nude with her husband, Baranik, because she felt his supportive presence behind her represented "a certain truth in our relationship."[16] Like Courbet, Stevens gave her figures poses that would reveal something about their personalities: "It was fun to show Arnold Belkin strutting and Sylvia Sleigh playing the grand lady while Joachim is making a narcissistic gesture by thrusting out his pectoral muscles."[17]

However, to Stevens the painting was more than a sum of its parts. The specific became the paradigmatic – the particular group she represented stood for a movement in art:

These are the people with whom I feel quite close. We have a great deal in common in terms of our interests in the art world. While the styles and viewpoints of the artists and critics may differ, all these people are interested in the political aspects of art as well as being very deeply concerned with painting. Remember Courbet was a very active political person and was a socialist and a real fighter and I would conceive of all these people as fighters, too.[18]

By bringing them together on canvas Stevens sought to commemorate a moment in history when politics and art interpenetrated.

In her conversation with Nemser, Stevens voiced an uncertainty about her next painting. She felt "tremendously moved" by Courbet's *Burial at Ornans,* and thought that someday she would turn to it, but for the time being "it doesn't seem personally relevant and I wouldn't want to do it as a theoretical exercise."[19] Stevens would, however, inevitably come back to Courbet's theme – of procession and funeral – in the paintings *Demonstration* (Fig. 92), of 1982, and *Voices* (Fig. 93) and *Procession* (Fig. 94), of 1983 – at a time when she could internalize the meaning of such social rituals.

But before that happened she would immerse herself in the women's movement. Even though she never rejected the men who were close to her and had been pleased with the success of *Artist's Studio,* her conversation hinted toward a newer direction when she confessed to Nemser,

I find more energy among women artists and women art students than in any other segment of the art world. Women are alive and active and doing things. They are optimistic and positive and feel things are opening up. . . . The women's movement has

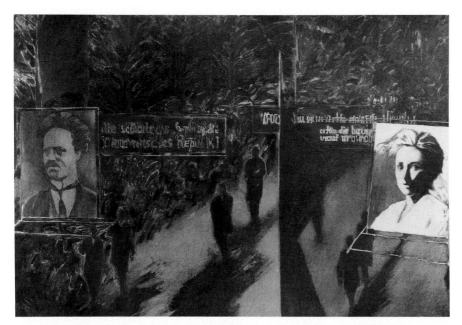

FIGURE 92

May Stevens. *Demonstration.* 1982.

Collection of Donald Kuspit, New York. Photograph by David Heinlein.

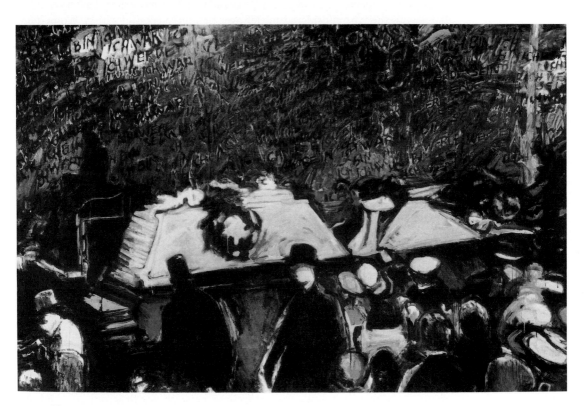

FIGURE 93

May Stevens. *Voices.* 1983.

Collection of the artist. Photograph by David Heinlein.

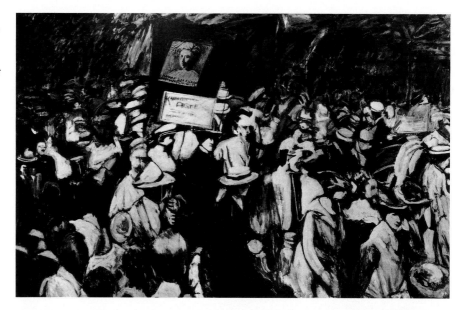

changed the whole art world. The increase in the number of cooperative galleries is due to women making their own structures and thereby legitimizing the kind of thing that was in the past considered for leftover or non-successful artists. Women are changing stylistic attitudes as well. The new openness and acceptance of a multiplicity of styles is because women, who have not been so controlled and have not been so conformist about adjusting to gallery requirements, have been making all kinds of work which is now surfacing. Their art has made it possible for men to do all kinds of different art too and for it to be looked at and accepted. That tight Greenbergian narrowness is pretty much over.[20]

The energy with which women artists and critics supported each other and heralded the stylistic pluralism of the early 1970s did indeed undermine the canon of high modernism that the critic Clement Greenberg had represented.

Sometime after her conversation with Nemser, during 1976, Stevens joined with a collective of twenty women to organize *Heresies: A Feminist Publication on Art and Politics.* The editorial group of six who put out the first issue came together at Stevens's loft on Wooster Street, argued over the focus of the theme of art and politics, and designed the layout.[21] The collective published their manifesto in the first issue, which deserves to be published at length as an example of the spirit and attitudes of its authors.

We hope that *Heresies* will stimulate dialogue around radical political and esthetic theory, encourage the writing of the history of *femina sapiens,* and generate new creative energies among women. It will be a place where diversity can be articulated. We are committed to the broadening of the definition and function of art. . . . As women, we are aware that historically the connections between our lives, our arts, and our ideas have been suppressed. Once these connections are clarified they can function as a means to dissolve the alienation between artist and audience, and to understand the relationship between art and politics, work and workers. As a step toward a demysti-

fication of art, we reject the standard relationship of criticism to art within the present system, which has often become the relationship of advertiser to product. We will not advertise a new set of genius-products just because they are made by women. We are not committed to any particular style or esthetic, nor to the competitive mentality that pervades the art world. Our view of feminism is one of process and change, and we feel that in the process of this dialogue we can foster a change in the meaning of art.[22]

The contents of that first issue included essays on feminism and socialism, on women in prison, and on sexuality by writers such as Barbara Ehrenreich, Martha Rosler, Eva Cockcroft, Adrienne Rich, Carol Duncan, Harmony Hammond, Ruth E. Iskin, Lucy R. Lippard, and Joan Braderman; artwork was contributed by Louise Bourgeois, Nancy Spero, and May Stevens, among others.

It was in this issue that Stevens, as part of her own personal effort to develop a history of "femina sapiens," published the two-page montage spread that pointed the direction toward which her art was tending. The left side of the page, titled *Tribute to Rosa Luxemburg,* contains three images – a portrait of Luxemburg, her cell in the Wronke prison, and a group portrait of her murderers taken on the night of January 16, 1919. These images are layered on a page of French poetry on which Luxemburg had sent secret messages. Over the poetry page and two of the photographs (but not Luxemburg's oval portrait), Stevens has written an English translation of Luxemburg's letter to a friend, Mathilde Wurm; it says in part,

To be human is the main thing, and that means to be strong and clear and of good cheer in spite and because of everything, for tears are the preoccupation of weakness. To be human means throwing one's life "on the scales of destiny," if need be, to be joyful for every fine day and every beautiful cloud – oh, I can't write you any recipes how to be human. . . .[23]

Here was a woman revolutionary – a woman permanently recorded in the chronicle of events – who could delight in the mundane, who could see that beauty and joy were what ultimately defined us as human beings. To Stevens, such personal feelings are not in contradiction to Luxemburg's politics, but are confirmation to the correctness of her politics.

The effectiveness of *Tribute to Rosa Luxemburg* draws on the aesthetic of montage, with words and photographic images from different contexts layered and juxtaposed in order to create new meanings. In Stevens's montage, meaning resides in the formal relationships as well as the choice of the three historical moments – Luxemburg's portrait taken when she was developing as a leading theoretician, her jail cell, her murderers after her death. Her absence from the last two photographs gives her presence a greater vividness. Negation establishes affirmation, and the memory of people and events lingers on in the residue of their actions. *Tribute to Rosa Luxemburg* was the genesis of the *One Plus or Minus One* series that culminated in Stevens's 1988 show at the New Museum for Contemporary Art.[24]

The right-side montage, *Two Women,* consists of a top band of images of Rosa Luxemburg – as a child of twelve, as a woman of forty, and as the bloated corpse that floated to the surface of the Landwehr Canal in March 1919. These images contrast with the bottom band of snapshots of Alice Stevens as a child with her two siblings, as a young matron holding her firstborn, and as an elderly woman. Captions specify the occasions of the photographic shots. They are printed texts for Luxemburg because the identifications came from books, and scripted in Stevens's hand for her mother because Stevens was naming them from her own memory. *Two Women* would lead to the "Ordinary/Extraordinary," the series that would occupy Stevens for the next fifteen years (1976–91).

But during 1977–8 Stevens was not yet ready to construct a large painting that explored the contrast of her mother and Luxemburg. She had still to represent her women contemporaries, who thrilled her with their commitment to community, art, and change, and the artist's studio offered a viable venue for their representation. From the vantage point of today, Stevens realizes she was striving toward the "visualization of women conducting our lives through our own efforts, arguing out problems and discussing solutions; an intellectual ferment, a moving into areas scarcely *thought* before."[25]

Soho Women Artists brought together some of the women of the *Heresies* collective, including herself, Harmony Hammond, Marty Pottenger, Miriam Schapiro, Lucy Lippard, and Joyce Kozloff. Other artists, not at the time connected to *Heresies,* but active in the women artists' movement, included Louise Bourgeois, encased in her coat of breast forms, and Sarah Charlesworth, who enters the scene on her bicycle. Behind the scene of women gathering on the street for a conversation are fragments of Stevens's paintings *Big Daddy Paper Doll, Artemisia Gentileschi* with its lettering, and *Big Daddy Draped.* Like a casting director for a movie, Stevens had carefully considered her selection of the women, and then sent out a young photographer to bring back snapshots of them. She also borrowed existing photographs of her subjects. She studied the prospective images and chose poses appropriate to her conception of her subjects' personalities and the role she saw each playing in the feminist alternative art world.

Above all, Stevens wanted to highlight feminists as a community acting collectively, because the feminist project of the 1970s was not to replace men in the social and professional hierarchies or to create a feminist isolationism. Rather, feminists wanted to understand the social, political, and economic power structures that benefited white men in America and to create more viable systems and progressive attitudes about class, race, and gender. Hence Stevens removed herself from stage center and placed herself modestly at the rear left with her profile almost disappearing as she turns to face another Soho community, such as Signora D'Apolito who sold bread at a neighborhood bakery and two elderly Italian gentlemen who kept watch on the street. Next to her in that rear register are Harmony Hammond, back to back with Stevens and facing Marty Pottenger, a performance artist.[26] Hammond, already well

known for having come out as a political lesbian, was particularly committed to the work of the collective while at the same time raising a young daughter as a single mother. Pottenger worked for a living as a skilled carpenter. Next to them stands a smiling Miriam Schapiro, a feminist activist who had been an influential mentor to young women artists at the California Institute for the Arts. In response to then current theories of women's craft heritage as a shaper of women's sensibilities, Schapiro's paintings had become richly decorative with scraps of embroidered fabric collaged onto canvas surfaces. Stevens intended the decorative frogs on the blouse and the decorative lining of her coat to signal Schapiro's artistic preoccupations.

Lucy Lippard, already an internationally known critic who in the early 1970s became a major voice for activist feminism, stands in profile behind Schapiro. Stevens saw Lippard as "so active, so quick, but also quite modest. She does not like to be celebrated or displayed. She is not a cult-of-personality person. Her politics are close to mine – committed and New England."[27] Lippard's *From the Center,* a collection of essays on women artists published in 1976, charts Lippard's commitment to the women's movement.

At the hub of the circle of women stands Louise Bourgeois encased in her sculpted greatcoat of breast forms, a coat which, to Stevens, endows her with not just physical bulk, but psychological power. A model for young feminists, Bourgeois's sculptures were both sexual and abstract with breast forms metamorphosing into phallus forms and the reverse. Seated on the floor are Kozloff and her son Nicholas, taken from one of the images that her photographer had brought back to her studio. Stevens admits that the pose appealed to her, perhaps because Kozloff was similarly seated on the floor with Nicholas, then a baby, when on January 3, 1970, Kozloff had participated in an artists' protest action in front of Picasso's *Guernica* at the Museum of Modern Art.[28] Finally, the figure of Sarah Charlesworth enters at the right; a conceptual artist, Charlesworth worked with Joseph Kosuth and had been active with Stevens and Baranik in Artists Meeting for Cultural Change. These specific women also stood for the categories of art with which feminists tended to involve themselves – decorative art, political art, sculpture, performance, women's spirituality, and feminist criticism.

Also in the winter of 1977–8 Stevens painted *Mysteries and Politics* (Fig. 90), which included more *Heresies* members: Mary Beth Edelson, Joan Snyder, Pat Steir, Elizabeth Weatherford, Amy Sillman, and Suzanne Harris, along with performance artist Betsy Damon, activist artist Poppy Johnson, and art historians Carol Duncan and myself. Stevens now wanted to make a more explicit reference to the theoretical ideas that brought her women friends together as well as to sharpen the contradictions in their lives – such as struggles over the juggling of family, politics, and their professional work. Present among the contemporary women are the historic figures of her mother, Alice, cradling in her arms her firstborn – Stevens herself – and the large imposing head of Rosa Luxemburg, Stevens's ideological model, an intellectual who never had children. Both images came from the center of her page-art montage *Two Women,*

and they underscore the theme of the painting: the deep desire for family versus the pull of intellectual life. In 1994 she characterized the painting:

It is about mind-body division. Alice is mother and not intellectually or politically active, but devoted to family and children. And Rosa represents the intellectual life. She affects the world on the public scale in a powerful way. Both of these realms are valuable. It is possible to bring them together, but also problematical.[29]

Hence the painting includes intellectuals and artists, three of whom hold babies or are pregnant.

Three artists fill the left vertical band of the painting: Betsy Damon in her performance costume as the "Seven-Thousand-Year-Old Woman"; above her, Pat Steir, who represented to Stevens the poetic mysteries of magic and women's association with witchcraft; and, at the top, Mary Beth Edelson, whose image came from a postcard announcing one of her performance events. These three collectively represent female sexuality – from initiation to old age. Alice, dressed in white and holding her infant, contrasts dramatically to the darkly dressed Steir; the glowing white of her robe leads to Poppy Johnson, an antiwar protester at the time of the *Guernica* demonstration and who now dandles her twins, a girl and a boy, on her knees. Next come the two Marxist art historians – at the very rear of the canvas: Carol Duncan, who wrote on feminist issues in European art history, contributed an essay to the first issue of *Heresies,* and was part of a collective that wrote the *Anti-Catalogue,* a critique of the exhibition catalog for the John D. Rockefeller, 3rd, collection.[30] Next to Duncan is myself. I had been active in the Museum Workers Association in 1974 and 1975, and had come to know Stevens and Baranik.[31] Stevens saw me as representing "the activist woman becoming pregnant" because I was then carrying my third child, Andrew. Stevens, in a dark maroon jacket, turns toward me as she gestures toward Johnson and her mother.

Sculptor Suzanne Harris sits next to painter Joan Snyder, whose farm in Pennsylvania sometimes served as a retreat for the *Heresies* group. Dressed in country clothes, and also pregnant, Snyder represents earthiness to Stevens. Behind Snyder and next to the image of Rosa stands Amy Sillman, a onetime student of Stevens and the youngest member of the collective. At the far right is anthropologist Elizabeth Weatherford. Married to the artist Murray Reich, she turned her research toward women's issues and later to American Indians and the filming of their history. These artists and intellectuals communicate across a space strewn with shapes like flower petals and open to the viewer who wants to step in.[32] Collectively they are, in Stevens's phrase, "an image of a way station in the development of the second wave of feminism."[33]

Thalia Gouma-Peterson and Patricia Mathews, in a scholarly, but controversial essay for the *Art Bulletin* in 1987, made the distinction between a first and a second wave of the feminist art movement, to which Stevens now alludes.[34] With the first wave came the celebration of past and present women artists and the resurrection of the careers of the lesser known. Gouma-Peterson and Mathews had in mind Stevens, Miriam Schapiro, Sylvia Sleigh, Joan

Semmel, Joyce Kozloff, Harmony Hammond, and Judy Chicago, among others, when they declared,

The first decade of feminist art thus was buoyed not only by anger, but by a new sense of community, the attempts to develop a new art to express a new sensibility, and an optimistic faith in the ability of art to promote and even engender a feminist consciousness.[35]

The first wave stressed the similarities of women and their spiritual affinities to each other and to nature; on the level of theory many artists and writers looked for the "essential" experiences of women, such as birth and craft production. Judy Chicago, in her 1975 book *Through the Flower: My Struggle as a Woman Artist,* developed a theory that posited a "centralized" imagery (imagery of the vagina rather than of the phallus) as vital in conveying women's experiences. Stevens's studio pictures and her large painting *Artemisia Gentileschi* (1976), painted for the "Sister Chapel," can be seen as growing out of that first wave. The second wave of artists and writers, however, shifted their emphasis toward a critique of traditional art historical methodologies, of patriarchy, and of ideologies that had generated the experiences of racism and sexism, and of class and age discriminations.

With her *Ordinary/Extraordinary* series, Stevens was already moving into this new time frame – what we now call the second wave. The contrast between Alice Stevens and Rosa Luxemburg now provided the issues for Stevens to explore the implications of the social construction of gender and class.[36] For example, social norms permitted a middle-class woman to choose between family life and an intellectual life, but not to choose both, whereas most working-class women had no choice at all. The contrast also allowed Stevens to shift her focus in the painting of history. No longer content to chronicle the lives of women, she sought to analyze and to uncover her own beginnings – on the one hand, as a dutiful daughter and then a mother; on the other, as an intellectual and political activist. Further, she sought to inquire how such figures as political radicals and working-class women come to a consciousness of themselves, how they find a voice, and how they are silenced.

Thus, after she completed the studio paintings, she began to elaborate on the page art montage from *Heresies – Two Women,* which had featured Luxemburg and her mother. She became preoccupied with the details that marked the differences and commonalities between the two women – her Irish Catholic mother from South Boston and the Polish Jewish communist leader Rosa Luxemburg. In 1976 she publicly described her mother:

My mother had to leave grade school because her father died and her labor and pitiful salary were needed at home. She went to work for the mill owners on the hill as a mother's helper. My mother was a very good student in elementary school, loved reading and mathematics, but she never got another chance to learn.[37]

When Alice married she stayed at home to care for her growing family. She had never developed larger political or intellectual interests and in time she

began to retreat from the world, moving mutely about the house until it became necessary eventually to institutionalize her.[38] In 1964 Alice was moved to a nursing home in Framingham, Massachusetts. When Stevens published her 1980 artist's book, she included a two-page essay describing how her mother had sunk into a deadening domesticity after marriage:

She lived in a 4-room house on a working class street for 20 years. Over the years she spoke less and less. She drew in; lost year by year the habit of speaking. She smiled. She nodded. I could make her laugh, or blush. Sometimes she held me, rocked me. But she had no words to give. What she wanted to say became too big to be sayable, and the habit of not speaking too fixed. Or, as she said, much later: Too big to put your tongue around.

Some days the restraints broke, and words came. Words about cars that drove by in the night, but she knew who they were. Words about voices that came over the radio, but she was not fooled, she knew who they were. Words about turning pictures to the wall: it wasn't safe to look at them. . . .

They put her away in a place for people who can't speak, or speak in tongues. After many years she stopped being angry. Then she was calm, distracted, utterly amiable. But her foot moved constantly, involuntarily. And she had gained the ability to speak, but lost a life to speak of. . . .

Once she said, 80 years old, living in a nursing home, eating the food, waiting for change, forgetting more each day, sliding toward a slimmer consciousness, slipping softly away: Everybody knows me.[39]

The last sentence became the title for the first large painting Stevens devoted to her mother (Fig. 95). The painting consists of the three images of Alice Stevens included in *Two Women* – as a child, young matron, and older woman. She described the formal and metaphoric qualities of the painting in 1984:

The words are Alice Stevens'. I've used them to say that the life of a woman, lived in these limited, confined, circumstances is commonplace, familiar. . . . The images read across the canvas, each in its segmented world; child with siblings, young woman with

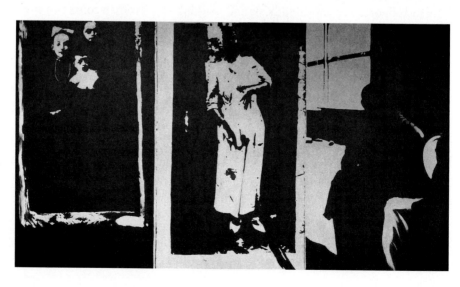

FIGURE 95

May Stevens. *Every-body Knows Me.* 1981.

Collection of Fraunces B. and Eugene P. Gorman, New York. Photograph by eeva-inkeri.

baby, old woman with nothing to do. The metallic pewter paint dissolves the space in the painting, creates a hovering light that goes darker then lighter as one reads across the surface. It dematerializes, flatness is contradicted by this shifting light. There is also a change in the disposition of the image within its shape. The first two are frontal, iconic emblems of the past, fixed in time like religious images staring out at the viewer. The third is different, the figure is inserted into a diagonal space, a space that seems to go somewhere. A head is turned, a body gesture that seems to be asking, expecting. It is more in the present, alive.[40]

The third image also came from the past; back in 1967 Stevens used it in *The Family*, along with the image of Stevens's father with his arms folded across his chest – the father who had metamorphosed into Big Daddy. Now it was her mother's turn to be singled out for ambitious art.

For *Everybody Knows Me* Stevens adopted the aesthetic of the photocopy that has undergone repeated recopying and has subsequently lost its halftone properties. This aesthetic enhances the metaphor about the muting of memory and the suppression of the nuances of history. The silver and gray images come from a family album – elusive, without depth, and communicating mere fragments of former lives and feelings.

In 1981 Stevens began another painting of her mother (that was eventually to become *Go Gentle*, [Fig. 96]), but set it aside to work on three large paintings based on Luxemburg's life and death. Since 1976 she had continued to develop small mixed media works on the subject, such as *Eden Hotel, You Are Not Radical, To Be Human Is the Main Thing*. At the same time, Stevens avidly read Luxemburg's political theories, letters, and diaries, studied old photographs, and learned a considerable amount about the revolutionist's life and thought.

FIGURE 96

May Stevens. *Go Gentle*. 1983.

Museum of Fine Arts, Boston. Gift of Carl Andre.

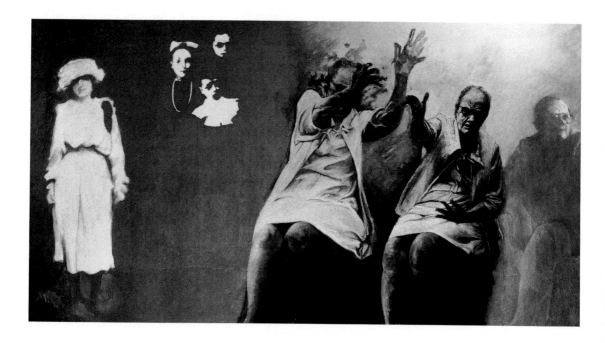

The Polish communist Rosa Luxemburg differed sharply from Alice Stevens. Luxemburg's extraordinary life defined a woman radical, a member of the Second International and a co-founder, with Karl Liebknecht, of the German Communist party. She, like Alice Stevens, was institutionalized – but not because she did not speak, but rather because she spoke out too often as a radical communist. She wrote dozens of books and pamphlets on the theory and practice of radical socialism and carried on voluminous correspondence. She was thrown into a German prison for her agitation for socialism and calls for resistance to the First World War. But even in prison she gave voice to her thoughts, and her letters were smuggled to friends and comrades.

As mentioned earlier, Stevens was particularly struck by Luxemburg's humanity and ordinariness, as revealed in the private writings. Corresponding with me in 1979, before she had begun any of the large paintings, Stevens quoted the following from Luxemburg's writings: "It is only through a misunderstanding that I am in the midst of this whirlpool of world history, whereas in reality I was born to look after the geese in the fields."[41] When, in 1980, Stevens produced a thirty-two-page artist's book, *Ordinary/Extraordinary*, dedicated to the two women, she provided herself with an occasion to quote extensively from Luxemburg's writings. For example, from a letter written from prison on May 12, 1917, and quoted by Stevens, Rosa wrote with sly amusement:

It is above all now the tendency of my taste, in scientific work as well as in art, to treasure only the simple, the calm and the noble: I now find the much-praised first volume of Marx's capital, with its superabundance of rococo ornamentation in the Hegelian style an atrocity (for which from the party standpoint I should be placed in a house of correction for 5 years and disgraced for 10).

or, as in a letter to Leo Jogiches from Berlin on September 14, 1899, in which she playfully chides him for zealousness:

My dear, do me a favor and stop underlining words in your letters; it sets my teeth on edge. The world is not full of idiots who, as you think, understand only when bashed over the head with a club.[42]

As fate would have it, Luxemburg died exactly in this fashion: bashed over the head with the butt of a gun.

In late 1981, Stevens's only child, Steven Baranik, died at the age of thirty-three. The event brought about a prolonged period of mourning for herself and her husband, and her art was inevitably affected. Courbet's *A Burial at Ornans* would now become "personally relevant" when she turned to the subject of Rosa Luxemburg and painted three large paintings that represented the political leader's memorialization: *Demonstration* (1982), *Voices* (1983), and *Procession* (1983).

The first depicts a demonstration held in West Berlin in 1967 commemorating the anniversary of the deaths of Luxemburg and Karl Liebknecht. In Germany the postwar radical left still revered both Luxemburg and Liebknecht

as socialists and as advocates for peace, but in her painting Stevens wanted to give Luxemburg precedence over Liebknecht. Stevens described *Demonstration*, and the other two paintings, during a dialogue held with Donald Kuspit at the Boston University Art Gallery in March 1984:

The consciousness in the painting is Rosa's. Karl is impassive, a pictured face. Rosa's look is alive, it charges the scene. She looks beyond the picture edge and plane.... The painful dryness in this painting, that persists in spite of the loosening of the handling, has to do with a great feeling of impoverishment, loss, the taking away, absence.[43]

Only when time had passed, increasing the gulf between the present and the past, does Stevens acknowledge that her "feeling of impoverishment, loss, the taking away, absence" had as its core her sorrow over her son's death.[44] But although these private emotions fueled the energy to paint the series, she never faltered from her goal to tell the story of Luxemburg, specifically, and all political movements, generally, that have been generated by women and men desiring social change and justice.

The second painting of the trilogy, *Voices* (1983), depicts the coffins carried through the streets when the political left held a funeral for Luxemburg and Liebknecht following their deaths. (Luxemburg's was an empty coffin because her body had not yet been retrieved from the Landwehr Canal.) Stevens said of this painting,

Black and white figures surround the coffin shapes, the coffins more animate than individual men and women who become the crowd, turned in, away to the side.... Overhead [are] Rosa's last words from *Die Rote Fahne*, where she wrote: "The revolution has been crushed, but it will rise again. And it will say with trumpets blazing, 'I was. I am. I will be.'" Ich war. Ich bin. Ich werde sein. Over Rosa and Karl's coffins, over and over again these words pile up, turn and fall and rise. They are like sounds. They make a vaulted space or a series of vaultings for the sound to resonate in, connoting and denoting. The signifier becomes the signified. In these three paintings Rosa has gotten smaller and finally disappeared. Her meaning has become absorbed into the painting, into the context and the resonance of her life. She is her afterimage.[45]

With *Voices* the image of Luxemburg has disappeared, and in the upper part of the canvas, the paint application has become thicker, creamier, and filled with color. Underneath, the shapes of the two coffins have acquired a commanding significance.

With *Voices*, Stevens had added to painting that which is supposed to be foreign to it – an incantation of words that float above the subjects: "Ich bin, ich war, ich werde sein" ("I am, I was, I will be"). These are not the graphic words of a placard carried by a crowd, but the words of memory, of voice, and above all of revolution. They rise and fall, push forward and back, and drift across the space.

In that same dialogue with Kuspit, Stevens described *Procession* (1983), the last of the three:

In *Procession*, 1983, there is also dryness, an almost scraped and bleached and crudded surface. Here the mourners walk carrying their placards and we see Rosa's intelligence lit, her keen glance assessing the situation. Again more sentient than her stunned compatriots. The stark contrasts: browns, granular, ground in, but quite flowing through – breaking down barriers connecting one form to another – almost like strokes of a strobe light, frozen figures, almost shadows burnt into the earth by an atomic blast. All the peace marches and demonstrations I ever went to are in these crowds. Above the heads, their heads in pinks and purples, handwriting, words, Rosa's words, – all but gone.[46]

In this group of three paintings, each picture develops from and supersedes the stylistic solutions of the previous one. *Demonstration,* like *Everybody Knows Me,* has a flat surface, silver and pewter colors, and is based on a photographic source. However, the strokes are more painterly and words enter the picture as signage on political placards. *Voices* eliminates the pictures of Luxemburg and Liebknecht, becomes even more painterly, and adds touches of color. The slogans on the placards disappear, but words insinuate themselves as emissaries of Luxemburg's thoughts. With *Procession* the crowd has returned with greater corporeality, incited into action by the sheer numbers of their own gathering.

Although what I describe might be simply called "stylistic development," to Stevens this supersession of one idea over another – replacement without destruction – was a principle of her dialectic outlook on life, her politics, and the way she understood both history and the workings of consciousness.[47] She constantly adds new ideas and insights to her paintings without rejecting out of hand the older ideas. She does not think in terms of a clash of opposites, but, instead, lets the old ideas absorb the new and the new supersede the old until she arrives at a fresh synthesis. She looks backward even when looking forward. In the summer of 1990, when I first broached my plan to write on her as a history painter, she confessed; "I tend not to be a rejector but to reconcile – to search the past for what is useful. A lot of things can be useful, because there is something there that can be reinterpreted."[48]

To the artist in Stevens, the past also includes past solutions to paintings. To let a painting develop means to let those past solutions offer themselves as possibilities for development into the next paintings. Believing in such principles led Stevens to adopt the montage aesthetic for her paintings. Montage, of course, suits this additive, superseding approach to an engaged content: the juxtaposition on canvas of images from old photographs and texts from disparate sources creates disjunctions and elisions that keep the pictures open for future possibilities and for historical interpretation.

After the completion of *Procession,* Stevens then returned in earnest to *Go Gentle* (Fig. 96), which she had begun shortly after *Everybody Knows Me.* The partially completed painting already included a vignette of the heads of Alice and her two siblings, from the photograph in *Two Women,* flatly painted in two colors, and the standing figure of Alice, in a blousey dress and a large hat, who with the faint modeling appears like a dimming memory. At center right in the canvas Stevens first inserted her own figure and then removed it, but traces of a rich umber remained. She then worked into the painting the doubled image of her mother, recalled from a time when she had visited her

mother in the Framingham nursing home and playfully threw at her dande-lions that were growing on the spring lawn. But now she paints her mother with a full chiaroscuro modeling and deep colors. Stevens described the paint-ing during her dialogue with Kuspit:

Stages in a woman's life are shown in the same pewter tone, which I like for its warmth, the brown undertones it has, the earthiness. The two forward moving figures almost break the separateness of the picture world from our world: one figure accosts the viewer, struggles to get through, the other folds down, closes in, slips quietly away, fingers dissolving, becoming part of the air as she becomes inward, leaf colored.[49]

At the very right is an echoed image of Alice subsiding into the sfumato of the painting's ground.

The salience of the two central images of Alice is striking. The solid enor-mous knees defy the flatness of the canvas with their strongly projected illu-sionism. Her hands, agitated and out of focus, claw at the air before her and then withdraw as she sinks back into a life of ebbing consciousness. The title of the painting, *Go Gentle*, comes from Dylan Thomas's poem, "Do Not Go Gen-tle into That Good Night," where the poet cries out to his father to struggle against death. Stevens, in contrast, no longer hopes for such rage. The artist, and daughter, now offers her mother permission to go gently – in peace.[50]

Donald Kuspit, in his essay for the Boston University Art Gallery catalog, viewed the *Ordinary/Extraordinary* series up to that point as "an overlay of optimism on a profound personal pessimism" – about the politics of the world. It was, after all, 1983 when he wrote his essay, at a time when the Rea-gan-Bush administration was financing covert operations to maintain U.S. influence in developing countries, to extend capitalism, and to destroy revolu-tionary movements around the world. The demonstrations by New York artists against U.S. imperialism were ongoing and persistent. With this context as background, Kuspit could conclude his essay with assurance:

The blurred grandiosity of her images makes her the master not only of this moment in history, but of the moment when revolution and personal life confront one another in equal uncertainty. It is this confrontation, yet also peculiar mutuality, between the collective and the personal, that the challenge of Stevens' work consists.[51]

Although Stevens often did not agree with Kuspit's interpretation of her art, this observation struck a chord with Stevens, who quoted it in a letter to me of June 25, 1985.[52]

Go Gentle was just the beginning of a series of paintings of her mother. Between 1982 and 1985 Stevens made three other large paintings in which the image of her mother is doubled or even tripled: *Fore River* (1983), *A Life* (1984), and *Signs* (1985). But in 1985 – the year her mother died – Stevens turned again to Luxemburg. She painted her mother and Luxemburg sitting on park benches in a green grassy space, *Forming the Fifth International* (1985), and thereby attempted to bridge the gap between them.

There followed *The Murderers of Rosa Luxemburg* (1986) and *Rosa Luxem-*

burg Attends the 2nd International (1987), both of which drew their imagery from group photographs and formed the basis for *One Plus or Minus One,* the 1988 exhibition at the New Museum of Contemporary Art.[53] The first resonated with Stevens's concern about death squads in Latin America throughout the 1980s; the second probed the issue of women as participants in political movements dominated by men. The dialectics of the present moment in past history informs both works.

Elaboration of Absence (1991), painted in four panels, is the last work to refer specifically to the life of Rosa Luxemburg. The compelling and repeating motif of a circle of women prisoners taking their exercise in the prison courtyard in the top panel refers to the period and place of Luxemburg's four-year incarceration for resistance to World War I. The silvery whirlpools of water in the second panel remind us of Luxemburg's watery tomb in the Landwehr Canal; the large blurred glowing forms in the third panel suggest searchlights directed into foggy vapors.

In the most recent paintings words have come to the fore, but no longer the political or the personal words of Luxemburg. *Elaboration of Absence,* just mentioned, included a text fragment from Carlo Ginzburg's *Ecstasies: Deciphering the Witches' Sabbath* (1991) as the fourth panel. Two more recent paintings, *Missing Persons* (1990–3) and *Sea of Words* (1991–3), combine the imagery of boats in water with Stevens's own script. In *Missing Persons,* three empty boats are moored together in a vaporous atmosphere that obscures their full substantiality. Into the water that laps at their bows Stevens has written, in barely decipherable handwriting, words culled from Angela Carter's "The Sadeian Woman," a feminist analysis of pornography. *Sea of Words* pictures three small distant boats on a shimmering sea of water over which is layered in gold, ocher, black, gray, white, and silver Stevens's transcriptions of texts from Virginia Woolf and Julia Kristeva.[54] *Women's History: Live Girls* (1992) represents lithe young prostitutes soliciting cars and parading the streets in images that have been layered over the figures of nineteenth-century women prisoners circling the prison yard – the same motif as in *Elaboration of Absence.* Behind the young women more words pulsate from the neon signage of mean urban streets.[55]

With these paintings, Stevens seems to have entered a third phase of her relationship to history. In the first phase she created history paintings that celebrated contemporary activists; in the second phase she grew more analytical as she explored the history of radical politics (of Luxemburg) and memory (of her mother) as sources for modern consciousness; in this third phase she leaves history behind and turns toward a sociology of women, but the work continues to be informed by her own experiences as a radical feminist. She has not rejected her mother or Luxemburg as sources of inspiration and solace, but they are now distanced and stilled, part of the geology of the past that gives meaning to the current situation for women in the world. And so Stevens perseveres with words etched into her canvases – words that also probe, disturb, and will not go away – words that echo, "I am, I was, I will be."

Notes

Introduction

We gratefully acknowledge the reading of drafts of this chapter by Deborah Bright, Patricia Hills, Peter Jelavich, and Richard Shiff.

1. John R. Spencer, Introduction to Leon Battista Alberti, *On Painting* (New Haven and London: Yale University Press, 1966), trans. John R. Spencer, pp. 23–5.
2. Ibid., pp. 76–7.
3. Sir Joshua Reynolds, *Discourses on Art*, edited with introduction by Stephen O. Mitchell (New York: Bobbs-Merrill, 1963), p. 40.
4. John Galt, *The Life and Works of Benjamin West, Esq* . . . (London: 1820), II, p. 48; and Joseph Farington, *The Diary of Joseph Farington* [1793–1821] (New Haven and London: Yale University Press, 1982), VIII, p. 3064, cited in Helmut von Erffa and Allen Staley, *The Paintings of Benjamin West* (New Haven and London: Yale University Press, 1986), pp. 57, 222.
5. John Trumbull, *Autobiography, Reminiscences and Letters by John Trumbull from 1756 to 1841* (New York: 1841), p. 9, cited in Jules David Prown, "John Trumbull as History Painter," in *John Trumbull: The Hand and Spirit of a Painter*, exh. cat. (New Haven: Yale University Art Gallery, 1982), p. 42.
6. J. Gray Sweeney, *The Columbus of the Woods: Daniel Boone and the Typology of Manifest Destiny*, exh. cat. (St. Louis: Washington University Gallery of Art, 1992), p. 33.
7. Matthew Baigell, "Frederic Church's 'Hooker and Company': Some Historic Considerations," *Arts* (January 1982), p. 125; and Franklin Kelly, *Frederic Edwin Church and the National Landscape* (Washington, D.C. and London: Smithsonian Institution Press, 1988), p. 6.
8. William Truettner, "Prelude to Expansion," in *The West as America*, exh. cat. (Washington, D.C.: National Museum of American Art, 1991), pp. 59–63.
9. Peter Novick, *That Noble Dream: The "Objectivity Question" and the American Historical Profession* (Chicago: University of Chicago Press, 1988), pp. 36, 42.
10. The phrase derives from a review of "The New Pictures" in *Harper's Weekly*, 8 (March 26, 1864), p. 194, cited by Linda S. Ferber and Nancy K. Anderson, *Albert Bierstadt, Art & Enterprise* (New York: Hudson Hills Press, 1990), p. 42.
11. Richard Hofstader, *Social Darwinism in American Thought* (New York: George Braziller, 1969), p. 51; Linda D'Angelo Logan, "The Geographical Imagination of Frederic Remington: A Chapter in the Geosophy of the American West," Ph.D. dissertation, Clark University, Worcester, Mass. (1987), pp. 112–13.
12. Truettner, *The West as America*, p. 49.

13. Novick, *That Noble Dream*, pp. 87, 95.

14. So wrote a friend of Millet's, quoted in Barbara Weinberg, "The Career of Francis Davis Millet," *Archives of American Art Journal*, 17, 1 (1977), p. 14.

15. Clarence W. Alvord, "Musings of an Inebriated Historian," *American Mercury*, 5 (1925), p. 436, cited by Novick, *That Noble Dream*, p. 132.

16. Benton acknowledged specific historians' work – Bancroft and the twentieth-century historian Charles Beard – as sources for his *The American Historical Epic* project in the 1920s; see Erika Doss, *Benton, Pollock, and the Politics of Modernism: From Regionalism to Abstract Expressionism* (Chicago and London: University of Chicago Press, 1991), p. 54. Frances Pohl lists Shahn's sources as the artist's memories of his own past, historical records, and oral history consisting of "conversations with members of the [Jersey Homesteads] community." See Pohl, *Ben Shahn, New Deal Artist in a Cold War Climate, 1947–1954* (Austin: University of Texas Press, 1989), p. 83.

17. See Stephen Polcari, *Abstract Expressionism and the Modern Experience* (New York and London: Cambridge University Press, 1991), pp. 31–56; and Cecile Whiting, *Antifascism in American Art* (New Haven and London: Yale University Press, 1989), pp. 170–96.

 Erika Doss, for one, sees Jackson Pollock's abstractions, although admittedly non-narrative and nonrepresentational, as demonstrating concern with "proposed personal and political reform." These notions do not make Pollock's paintings history paintings any more than does Thomas Benton's assertion that *The Year of Peril* wartime series (1942) was "dedicated solely to arousing the public mind" makes them history paintings. See Doss, *Benton, Pollock, and the Politics of Modernism*, pp. 282, 347–8.

18. Linda Hutcheon, *A Poetics of Postmodernism: History, Theory, Fiction* (New York and London: Routledge, 1988), p. 101.

19. John Higham, *History: Professional Scholarship in America* (Baltimore: Johns Hopkins University Press, 1989), p. 235.

20. Novick, *That Noble Dream*, p. 523.

21. Wanda M. Corn, *Grant Wood, the Regionalist Vision* (New Haven and London: Yale University Press, 1983), p. 120; and Whiting, *Antifascism in American Art*, pp. 100–3.

22. Mark Thistlethwaite, "The Most Important Themes: History Painting and Its Place in American Art," in William H. Gerdts and Mark Thistlethwaite, *Grand Illusions: History Painting in America* (Fort Worth, Tex.: Amon Carter Museum, 1988), pp. 35–44.

23. F. R. Ankersmit, "Historiography and Postmodernism," *History and Theory*, 28, 2 (1989), p. 137.

24. Hayden White, "The Burden of History," *Tropics of Discourse, Essays in Cultural Criticism* (Baltimore and London: Johns Hopkins University Press, 1978), p. 47.

25. Hutcheon, *A Poetics of Postmodernism*, pp. 122–3.

26. Lionel Gossman, "History and Literature: Reproduction or Signification," in *The Writing of History: Literary Form and Historical Understanding*, eds. Robert H. Canary and Henry Kozicki (Madison: University of Wisconsin Press, 1987), p. 32.

27. Roger de Piles argued for three levels of truth – simple, ideal, and perfect – in *Cours de Peinture par Principes* (1743); reprint, with a preface by Jacques Thuillier, n.p.: Editions Gallimard, 1989, pp. 19–28. See the discussion in Charles

Mitchell, "Benjamin West's 'Death of General Wolfe' and the Popular History Piece," *Journal of the Warburg and Courtauld Institutes,* 7 (January–June 1944), pp. 22–3. Jonathan Richardson, although urging fidelity to "nature" and to historical truth, agreed it was sometimes desirable to "add to the story for the advantage of it," in *The Works of Jonathan Richardson* (1773; reprint, Hildesheim: Georg Olms Verlag, 1969), p. 25.

28. Ann Uhry Abrams, *The Valiant Hero: Benjamin West and Grand-Style History Painting* (Washington, D.C.: The Smithsonian Institution Press, 1985), pp. 147–53.

29. *New York Evening Mirror* (November 7, 1851), quoted in Natalie Spassky, *American Paintings in the Metropolitan Museum of Art,* vol. 2 (New York: The Metropolitan Museum of Art, 1985), p. 18.

30. Clarence Cook, "Artists as Historians," *The Quarterly Illustrator,* 3, 9 (January, February, and March 1895), p. 103.

31. Hutcheon, *A Poetics of Postmodernism,* p. 96.

32. Ankersmit, "Historiography and Postmodernism," p. 152.

33. Hayden White, *Tropics of Discourse,* pp. 83–4.

34. Hayden White, "The Narrativization of Real Events," in W. J. T. Mitchell, ed., *On Narrative* (Chicago and London: University of Chicago Press, 1981), p. 6.

35. Ibid., p. 1.

36. White, *Tropics of Discourse,* p. 85.

37. Gotthold Ephraim Lessing, *Laocoon, Nathan the Wise, Minna Von Barnhelm,* trans. William A. Steel (New York: Dutton, 1930), pp. 55–74.

38. Wendy Steiner, *Pictures of Romance, Form Against Context in Painting and Literature* (Chicago and London: University of Chicago Press, 1988), pp. 7, 8.

39. Paul Ricoeur, "Narrative Time," in *On Narrative,* pp. 174, 175.

40. Steiner, *Pictures of Romance,* pp. 35, 144.

41. Michael Kammen, *Meadows of Memory* (Austin: University of Texas Press in association with the Amon Carter Museum, 1992), pp. 99–102.

42. Seymour Chatman, "What Novels Can Do That Films Can't (and Vice Versa)," in *On Narrative,* p. 118. Steiner uses those words to describe Chatman's (and others') belief; see Steiner, *Pictures of Romance,* p. 14.

43. Nelson Goodman, "Twisted Tales; or, Story, Study, and Symphony," in *On Narrative,* p. 111.

44. Ricoeur, "Narrative Time," in *On Narrative,* p. 165.

45. A.J. Gurevich, "Time as a Problem of Cultural History," in *Culture and Time* (Paris: UNESCO Press, 1976), pp. 229–45.

46. David Carr, *Time, Narrative, and History* (Bloomington: Indiana University Press, 1986), p. 179.

47. Gossman, "History and Literature," in *The Writing of History,* p. 25.

48. Steiner, *Pictures of Romance,* p. 177.

49. Barbara Novak, *Nature and Culture: American Landscape and Painting 1825–1875* (New York: Oxford University Press, 1980), p. 19.

50. William Cronon, "Telling Tales on Canvas: *Landscapes of Frontier Change,*" in *Discovered Lands, Invented Pasts: Transforming Visions of the American West* (New Haven and London: Yale University Press, 1992), pp. 43–4.

51. Raymond Williams, *Keywords: A Vocabulary of Culture and Society* (New York: Oxford University Press, 1985), p. 148.

52. Steiner, *Pictures of Romance,* p. 35.

53. White, *Tropics of Discourse,* pp. 69, 129.

54. Williams, *Keywords*, p. 156. See also Terry Eagleton, *Ideology: An Introduction* (London and New York: VERSO, 1991).

55. White, "The Value of Narrativity," in *On Narrative*, pp. 20, 19, 23.

56. William Cronon, "A Place for Stories: Nature, History, and Narrative," *The Journal of American History*, 78, 4 (March 1992), pp. 1375, 1370, 1367.

57. Carr, *Time, Narrative, and History*, p. 46.

58. Cronon, "A Place for Stories," p. 1370. In his essay, Cronon combines teleology with narrative: "However serious the epistemological problems it creates, this commitment to teleology and narrative gives environmental history – all history – its moral center."

59. David Avalos, quoted in Susana Torreuella Leva, "Recapturing History: The (Un)official Story of Contemporary Latin American Art," *Art Journal*, 51, 4 (Winter 1992), p. 72.

60. Hutcheon, *A Poetics of Postmodernism*, pp. 91–4.

61. White, "The Narrativization of Real Events," in *On Narrative*, pp. 251, 254.

62. Barbara Herrnstein Smith, "Narrative Versions, Narrative Theories," in *On Narrative*, pp. 228, 229, 231.

63. Ibid., p. 228.

64. Adam Gopnik, "The Art World: The Death of an Audience," *New Yorker* (October 5, 1992), p. 144.

65. Larry Rivers has asserted that he began his *Washington Crossing the Delaware* (1953) because he wanted to tackle something considered "*disgusting, dead* and *absurd*" by the New York art world and in that perverse way attract notice. After all, in the 1950s, "what could be dopier than a painting dedicated to a national cliché – Washington crossing the Delaware." Rivers, quoted in Helen A. Harrison, *Larry Rivers* (New York: Harper & Row, 1984), p. 35.

Chapter 1

1. This definition of the mural as an art form, which includes bas relief and tapestry, is central to the book I am writing: *The Mural in America: A History of Wall Painting from Native American Times to the Present.*

2. John C. Neihardt, *Black Elk Speaks* (New York: Washington Square Press/Pocket Books, 1972), Chapter 14, p. 136. What follows is derived from John Neihardt and Stephen Larsen, *The Shaman's Doorway: Opening the Mythic Imagination to Contemporary Consciousness* (New York: Harper & Row, 1976), pp. 103–17. See also Michael F. Steltenkamp, *Black Elk: Holy Man of the Oglala* (Norman: University of Oklahoma Press, 1993), which recounts Black Elk's later years as a Roman Catholic catechist, and its Chapter 7 for his possible use of Catholic proselytizing aids to articulate his vision.

3. Larsen, *The Shaman's Doorway*, p. 82.

4. Neihardt, *Black Elk Speaks*, p. 138.

5. See Trudy Baltz, "Pageantry and Mural Painting: Community Rituals in Allegorical Form," *Winterthur Portfolio*, 15, 3 (Autumn 1980), pp. 211–28.

6. John C. Ewers, *Murals in the Round: Painted Tipis of the Kiowa and Kiowa-Apache Indians*, exh. cat. (Washington, D.C.: Renwick Gallery of the National Collection of Fine Arts/Smithsonian Institution, 1978). For other painted tipis see section beginning on p. 33 titled "The Universal Hoop."

7. Siegfried Gideon, *The Eternal Present: The Beginnings of Art* (New York: Bollingen Books XXXV.6.1/Pantheon Books, 1962), pp. 514–15.

8. Ralph T. Coe, *Sacred Circles: Two Thousand Years of North American Indian Art,* exh. cat. (Kansas City, Mo.: Nelson Gallery of Art—Atkins Museum of Fine Arts, 1977).

9. Coe, *Sacred Circles,* p. 12.

10. For a fully developed discussion of directional symbolism, see Francis V. O'Connor, "An Iconographic Interpretation of Diego Rivera's *Detroit Industry* Murals in Terms of Their Orientation to the Cardinal Points of the Compass," in *Diego Rivera: A Retrospective* (Detroit Institute of Arts/Norton, 1986), pp. 215–17.

11. For shamanism, see Angeles Arrien, *The Four-Fold Way: Indigenous Wisdoms Applied to Contemporary Times* (New York: Harper & Row, 1992); Gary Doore, ed., *Shaman's Path* (Boston: Shambala, 1988); Mircea Eliade, *Shamanism: Archaic Techniques of Ecstasy,* Bollingen Series LXXVI (Princeton, N.J.: Princeton University Press, 1964/1972); Joan Halifax, *Shaman: The Wounded Healer.* (London: Thames & Hudson, 1982); Michael Harner, *The Way of the Shaman,* 2nd ed. (San Francisco: Harper & Row, 1990); Larsen, *The Shaman's Doorway,* 1976; A. Lommel, *Shamanism: The Beginning of Art* (New York: McGraw-Hill, 1967); Shirley Nicholson, *Shamanism: An Expanded View of Reality* (Wheaton, Ill.: Quest, 1987); and Roger Walsh, *The Spirit of Shamanism* (Los Angeles: Tarcher, 1990).

12. For rock art, see Kenneth B. Castleton, *Petroglyphs and Pictographs of Utah,* 2 vols. (Salt Lake City: Utah Museum of Natural History, 1978 and 1979), Robert F. Heizer and Martin A. Baumhoff, *Prehistoric Rock Art of Nevada and Eastern California* (Berkeley: University of California Press, 1962/1975); Polly Schaafsma, *The Rock Art of Utah* (Cambridge, Mass.: Peabody Museum of Archeology and Ethnology, Harvard University, 1971) and her *Indian Rock Art of the Southwest* (Albuquerque: University of New Mexico Press, 1980); Gerald A. Smith and William G. Turner, *Indian Rock Art of Southern California* (Redlands, Calif.: San Bernardino County Museum Association, 1975); and Klaus F. Wellmann, *North American Indian Rock Art* (Graz, Austria: Akademische Druck und Verlagsanstalt, 1978). I want to thank the photographer Leon C. Yost and the artist Erma Martin Yost for guiding me, in the fall of 1987, to the rock art sites described in this essay – and Leon especially for his fine photographs.

13. Heizer and Baumhoff, *Prehistoric Rock Art,* pp. 6–7.

14. Wellmann, *North American Indian Rock Art,* p. 18; quoting Smith and Turner, *Indian Rock Art of Southern California,* p. 3.

15. See Schaafsma, *Indian Rock Art of the Southwest,* pp. 10, 179–81 and passim; and Wellmann, *North American Indian Rock Art,* pp. 20, 134.

16. Wellmann, *North American Indian Rock Art,* p. 107. Technically, this mural is in the northern San Rafael style. See Schaafsma, *Indian Rock Art of the Southwest,* pp. 176–7.

17. Heizer and Baumhoff, *Prehistoric Rock Art,* p. 216.

18. See William Ayres, ed., *Picturing History: American Painting 1770–1930* (New York: Rizzoli/Fraunces Tavern Museum, 1993), for many examples; and Simon Schama's *Dead Certainties Unwarranted Speculations* (New York: Knopf, 1991) for a cautionary tale.

19. See Joseph Campbell, *The Mythic Image,* Bollingen Series C (Princeton, N.J.: Princeton University Press, 1974), pp. 330–91, for illustrations and commentary on the Kundalini, and Fig. 162, p. 180, for the sky-goddess, Nut. This mural is

very early and its origins are unknown. See Schaafsma, *The Rock Art of Utah,* p. 61, for one of the few commentaries on it.

20. See Anthony F. Aveni, ed., *Native American Astronomy* (Austin: University of Texas Press, 1977) in general, but specifically Kendrick Frazier, "Solstice-Watchers of Chaco," *Science News,* 114, 9, pp. 148–51; and Anna Sofaer, V. Zinser, and R. M. Sinclair, "A Unique Solar Marking Construct," *Science* (October 19, 1979), for similar examples.

21. Author's field observations, October 1987.

22. Dorothy Dunn, *American Indian Painting of the Southwest and Plains Areas* (Albuquerque: University of New Mexico Press, 1968), pp. 73–5. For kiva murals, see also Frank C. Hibben, *Kiva Art of the Anasazi* (Las Vegas: KC Publications, 1975); Watson Smith, *Kiva Mural Decorations at Awatovi and Kawaika-a* (Cambridge, Mass.: Reports of the Peabody Museum of Archaeology and Ethnology, Harvard University, 37, 1952 [Reports of the Awatovi Expedition, No. 5), and his *Prehistoric Kivas of Antelope Mesa, Northwest Arizona* (Cambridge, Mass.: Papers of the Peabody Museum of Archaeology and Ethnology, Harvard University, 39, 1972 [Reports of the Awatovi Expedition, No. 9); and Frank Waters, *Masked Gods: Navaho and Pueblo Ceremonialism* (Chicago: Swallow Press/Sage Books, 1950).

23. Waters, *Masked Gods,* p. 174.

24. See Hibben, *Kiva Art,* here and in what follows.

25. For Northwest Coast art, see Bill Holm, *Northwest Coast Indian Art: An Analysis of Form* (Seattle: University of Washington Press, 1965); Bill Holm and William Reid, *Form and Freedom: A Dialogue on Northwest Coast Indian Art* (Houston: Institute for the Arts, Rice University, 1975); Robert Bruce Inverarity, *Art of the Northwest Coast Indians* (Berkeley: University of California Press, 1950); and Allen Wardwell, *Objects of Bright Pride: Northwest Coast Indian Art from the American Museum of Natural History,* exh. cat. (New York: Center for Inter-American Relations/American Federation of Arts, 1978).

26. Wardwell, *Objects of Bright Pride,* p. 15.

27. See George T. Emmons, "The Whale House of the Chilkat," *Anthropological Papers of the American Museum of Natural History,* 19, 1 (New York, 1916), pp. 1–33 for a ground plan and color renderings; Holm and Reid, *Form and Freedom,* pp. 20 ff. and Editors of Time-Life Books, "Legacy of the Whale House" in *Keepers of the Totem,* American Indians Series, 1993, pp. 58–65, for further reproductions. See also Marilee Enge, "Treasures of the Tlingit," *Anchorage Daily News* (April 4–8, 1993), for a five-part history of this work. The Whale House, which has long belonged to the Gaanaxteidi Klan, is presently in storage in Seattle, Washington, under court jurisdiction pending determination of its ownership. I want to thank India Spartz of the Alaska State Library at Juneau for the 1993 articles, and Steve Brown, curator of Native American art at the Seattle Art Museum, for helping date this work. He attributes the house posts to the woodcarver Kadjisdu.axtc, who flourished c. 1810.

28. Edmund Carpenter, "Deeply Carved Art of the Northeast Coast," in *The Menil Collection: A Selection From the Paleolithic to the Modern Era* (New York: Harry N. Abrams, 1987), p. 164; the tapestry is reproduced in color at Plate 129, pp. 172–3.

29. For the Plains Indians, see Richard Conn, *Circles of the World: Traditional Art of the Plains Indians,* exh. cat. (Denver: Denver Art Museum, 1982); John C. Ewers, *Plains Indian Painting* (Stanford: Stanford University Press, 1939), and his *Murals in the Round: Painted Tipis of the Kiowa and Kiowa-Apache Indians,* exh. cat.

(Washington, D.C.: Renwick Gallery of the National Collection of Fine Arts/Smithsonian Institution, 1978).

30. For a detailed discussion of this tipi, see Candace S. Greene, "The Tepee with Battle Pictures," *Natural History* (October 1993), pp. 68–76.

31. Robert Silverberg, *The Old Ones: Indians of the American Southwest* (Greenwich, Conn.: New York Graphic Society, 1965), p. 13.

32. See Ayres, *Picturing History: American Painting 1770–1930,* for works that more or less idealize the acceptance of Europeans by the native populations.

Chapter 2

1. David Forgacs, ed., *An Antonio Gramsci Reader: Selected Writings, 1916–35* (New York: Schocken, 1988), pp. 393–4.

2. *The Death of General Warren at the Battle of Bunker's Hill, 17 June 1775* (1786); *The Death of General Montgomery in the Attack on Quebec, 31 December 1775* (1786); *The Death of General Mercer at the Battle of Princeton, 3 January 1777* (c. 1789–c. 1831); unfinished version (c. 1786–8); *The Capture of the Hessians at Trenton, 26 December 1776* (1786–1828); *The Declaration of Independence, 4 July 1776* (1787–1820); *The Surrender of Lord Cornwallis at Yorktown, 19 October 1781* (1787–c. 1828); and *The Surrender of General Burgoyne at Saratoga, 16 October 1777* (c. 1822–32).

3. John Trumbull, *Autobiography, Reminiscences and Letters* (1841; annotated edition, Theodore Sizer, ed., *The Autobiography of John Trumbull,* New Haven: Yale University Press, 1953; reprint, Kennedy Graphics, Inc. and De Capo Press, 1970). The earliest printed reference to *The Death of Warren* by Trumbull occurs as a brief text in "Explanation of the Two Prints Representing the Battle of Bunker's Hill, and the Attack of Quebec," published in London in 1798. This provided the core for the text of *Catalogue of Paintings by Colonel Trumbull, including Nine Subjects of the American Revolution* (New York, 1831). When the eight paintings (plus others) were permanently installed at the Trumbull Gallery at Yale College (now the Yale University Art Gallery), a catalog was issued, *Catalogue of Paintings by Colonel Trumbull: including Eight Subjects of the American Revolution . . . now Exhibiting in the Gallery of Yale College* (New Haven, 1832), which was reprinted several times thereafter. All subsequent references are to this edition of the *Catalogue,* followed by page number. For a full citation of all of Trumbull's catalog notes, see Irma B. Jaffe, *John Trumbull: Patriot-Artist of the American Revolution* (Boston: New York Graphic Society, 1975), p. 337.

4. For dating of the painting, see Jules David Prown, "John Trumbull as History Painter," and David Barquist, Catalogue Entry, in Helen Cooper, ed., *John Trumbull: The Hand and Spirit of a Painter,* exh. cat. (New Haven: Yale University Art Gallery, 1982), pp. 31, 48–50.

5. The battle was (mistakenly) fought on Breed's Hill rather than Bunker's Hill but has consistently been referred to as Bunker's Hill, a custom to which Trumbull conformed and I have elected to follow also.

6. There are numerous accounts of the battle. One of the most reliable modern analyses is to be found in Mark Mayo Boatner, *Encyclopedia of the American Revolution* (New York: McKay, 1974), pp. 120–30.

7. Sizer, *Autobiography,* p. 19.

8. Accurate casualty figures are hard to come by. The most precise count is given in

Howard H. Peckham, ed., *The Toll of Independence: Engagements and Battle Casualties of the American Revolution* (Chicago: University of Chicago Press, 1974), p. 4.

9. *The Annual Register 1765–1783* [London], reprinted in David H. Murdoch, ed., *Rebellion in America: A Contemporary British Viewpoint, 1765–1783* (Oxford and Santa Barbara: Clio, 1979), p. 263.

10. Ibid.

11. Theodore Sizer, *The Works of Colonel John Trumbull*, rev. ed. (New Haven: Yale University Press, 1967), p. 95 and Fig. 145.

12. John Trumbull to Jonathan G. W. Trumbull, December 1, 1835, Sterling Library, Yale University, John Trumbull correspondence.

13. Anne Norton, *Alternative Americas: A Reading of Antebellum Political Culture* (Chicago: University of Chicago Press, 1986), p. 24.

14. Biographical details about Warren are taken from John Cary, *Joseph Warren* (Urbana: University of Illinois Press, 1967).

15. The (intact) body has been moved twice since: to St. Paul's Church and then to its final resting place at Forest Hills Cemetery.

16. Merrill Jensen quotes Abigail Adams without either confirmation or denial in *The Founding of a Nation: A History of the American Revolution 1763–1776* (New York: Oxford University Press, 1968), p. 216, as does Kenneth Silverman, *A Cultural History of the American Revolution* (New York: Columbia University Press, 1976), p. 279. Cary, *Joseph Warren*, p. 22, refers to the supposed decapitation as "legend."

17. William Gordon, *The History of the Rise, Progress, and Establishment of the Independence of the United States of America*, 2 vols. (London, 1788), II, pp. 49–50.

18. Mrs. Mercy Otis Warren, *History of the Rise, Progress and Termination of the American Revolution*, 2 vols. (Boston, 1805; reprint, edited by Lester H. Cohen, Indianapolis: Liberty Classics, 1988), I, p. 122.

19. Richard Frothingham, *Life and Times of Joseph Warren* (Boston: Little, Brown, 1865), p. 518. In the versions of *The Sortie Made by the Garrison of Gibraltar, 27 November 1781* that he painted, as well as *Capture of the Hessians at Trenton, 26 December 1776*, Trumbull also depicted mercy on the part of the victor. In the latter instance, the victor, of course, was Washington. The catalog notes state, "The magnanimous kindness displayed by Washington, on this occasion, offers a sublime example of true heroism, and well deserves to be imitated by all military men. The artist chose this subject, and composed the picture for the express purpose of giving a lesson to all living and future soldiers in the service of his country, to show mercy and kindness to a fallen enemy – their enemy no longer when wounded and in their power" (p. 18).

20. William Dunlap, *A History of the Rise and Progress of the Arts of Design in the United States* (1834; reprint, 2 vols., New York: Dover, 1969), I, p. 357.

21. Benjamin Silliman, typescript of "Note Book" [1858], p. 65, Sterling Library, Yale University.

22. Jaffe, *Patriot-Artist*, p. 88.

23. It is worth noting that the young man holding Warren is one of the few figures not identified in Trumbull's original key, another indication that he is a purely fictional character and the incident an invented one.

24. An unpublished graduate paper by Paul F. Watson dated 1963 in the Trumbull file at the Yale University Art Gallery notes the connection.

25. See Kenneth Silverman's pithy description of the patriot soldiers "as buckskinned shepherds from some Adoration of the Magi via West," *Cultural History*, p. 48.

26. See Jerry Don Meyer, "The Religious Paintings of Benjamin West: A Study in Late Eighteenth and Early Nineteenth Century Moral Sentiment" (Ph.D. dissertation, New York University, 1973); and John Dillenberger, *Benjamin West: The Context of His Life's Work with Particular Attention to Paintings with Religious Subject Matter* (San Antonio: Trinity University Press, 1977).

27. See Philip S. Foner, *Blacks in the American Revolution: Contributions in American History*, no. 55 (Westport and London: Greenwood Press, 1975), p. 42.

28. Of all of the rich material on this topic, I have found the summary in John Hope Franklin's classic study, *From Slavery to Freedom: A History of Negro Americans*, 3rd ed. (New York: Knopf, 1967), pp. 126–44, to be the most helpful.

29. George H. Moore, *Notes on the History of Massachusetts* (New York: D. Appleton, 1866), pp. 144–5.

30. Samuel Swett, *Historical and Topographical Sketch of Bunker Hill* (New York: Ezra Strong, 1835), p. 96.

31. Salem and Poor were often confused in the earlier literature, as, for example, in Joseph T. Wilson, *The Black Phalanx* (Hartford: American Publishing Company, 1897), p. 38. Franklin, *From Slavery*, pp. 131–2, is aware of their separate histories. See also Benjamin Quarles, *The Negro in the Making of America*, 2nd rev. ed. (New York: Collier, 1969), p. 46; Foner, *Blacks in the . . . Revolution*, pp. 42–3; and especially, Sidney Kaplan and Emma Nogrady Kaplan, *The Black Presence in the Era of the American Revolution*, rev. ed. (Amherst: University of Massachusetts Press, 1989), p. 20.

32. Trumbull would have been well aware of Copley's heroization of a black soldier in his *Death of Peirson*, showing him firing at the French sharpshooter who had killed Peirson.

33. The error may have begun with Sizer, who refers to Peter Salem in *Works*, Figs. 51 and 146. Trumbull made a separate painting on wood of Grosvenor and his attendant (c. 1797), which Sizer listed as *Lieut. Grosvenor and his Negro Servant, Peter Salem* in *Works*, p. 95. Jaffe continues the misidentification in *Patriot-Artist*, Fig. 51, and it has been repeated ever since. David Barquist in *Hand and Spirit of a Painter*, p. 50, n. 4, was the first art historian to suggest this was incorrect.

34. Sizer, *Works*, p. 95, makes the correct identification based on information given by Benjamin Silliman in his "Note Book." Biographical details on Grosvenor come from Clarence Winthrop Bowen, *History of Woodstock Connecticut: Genealogy of Woodstock Families*, 8 vols. (Norwood, Mass.: Plimpton Press, privately printed, 1935), VI, pp. 24–7.

35. David O. White, *Connecticut's Black Soldiers 1775–1783* (Chester, Conn.: Pequot Press, 1973), pp. 27, 57, 60. White tentatively identifies the figure as Cesar Negro.

36. *Heads of Families at the First Census of the United States Taken in the Year 1790* (Washington, D.C.: Government Printing Office, 1908), p. 149. Members of the Trumbull family listed are shown as not owning slaves at this time.

37. Silliman, "Note Book," p. 67.

38. Gordon S. Wood, *The Radicalism of the American Revolution* (New York: Knopf, 1992), p. 51.

39. Frothingham, *Life and Times*, p. 166.

40. My understanding of the system of deference has been considerably enhanced by Wood, *Radicalism*, passim, but especially pp. 63 and 85. The quotation is from p. 51.

41. Wood, *Radicalism*, p. 51.

42. Charles Francis Adams, ed., *The Works of John Adams*, 8 vols. (Boston, 1850–6),

VI, p. 530, cited by Albert E. Van Dusen, *Connecticut* (New York: Random House, 1961), p. 171.

43. Sizer, *Autobiography*, p. 22.

44. Clifford Geertz, *The Interpretation of Cultures* (New York: Basic, 1973), p. 218.

45. Robert W. Uphaus, "The Ideology of Reynolds' *Discourses on Art*," *Eighteenth-Century Studies*, 12, 1 (Fall 1978), p. 66.

46. Ibid., pp. 65–6.

47. Ibid., p. 64.

48. Ibid., p. 70.

49. Interestingly, Edmund Burke, along with John Singleton Copley and Benjamin West, were the three persons responsible for arranging Trumbull's release from prison in England in 1781.

50. Geertz, *Interpretation of Cultures*, p. 239.

51. Susan Rather takes note of the cultural vigor of the provinces and its effect on English national culture in "A Painter's Progress: Matthew Pratt and *The American School*," *Metropolitan Museum Journal* 28 (1993), pp. 169–83, especially pp. 179–80.

52. Edward M. Said, "Yeats and Decolonization," in Seamus Dean, ed., *Nationalism, Colonialism, and Literature* (Minneapolis: University of Minnesota Press, 1990), p. 74.

53. For a discussion about terminology and concepts, see Ronald J. Horvath (and commentators), "A Definition of Colonialism," *Current Anthropology*, 13, 1 (February 1972), pp. 45–57.

54. Geertz, *Interpretation of Cultures*, p. 239.

55. Hayden White, *Metahistory: The Historical Imagination in Nineteenth-Century Europe* (Baltimore: Johns Hopkins University Press, 1973), pp. 6–11.

56. William Dunlap, Trumbull's most vehement critic, anticipated this argument in *Arts of Design* I, p. 357: "Trumbull chooses for his picture the moment of the overthrow of his countrymen, and the triumph of their enemies. The death of Doctor Warren, however amiable, accomplished, and intelligent he may have been, is an incident of minor consequence compared with the repeated defeats of the veterans of Great Britain, by Prescott, Putnam, and the brave undisciplined Yankee yeomen their associates, before the hill was carried by reinforcements sent from Boston."

57. I am indebted to a number of people for points of information or interpretation for this essay: Georgia Barnhill and other members of the staff at the American Antiquarian Society, Janice Chadbourne at the Boston Public Library, the New England Historic and Genealogical Society, David Brigham, Ira Gruber, Patricia Johnston, Emily Ballew Neff, and David Steinberg, and most especially, Dean Burnham.

Chapter 3

1. For the André story, see Anthony Bailey, *Major André* (New York: Farrar, Straus & Giroux, 1987), a novel; and Robert McConnell Hatch, *Major John André, a Gallant in Spy's Clothing* (Boston: Houghton Mifflin, 1986), a biography.

2. See Ebenezer Hazard to Jeremy Belknap, October 2, 1980, *Proceedings of the Massachusetts Historical Society*, I (1791–1835), pp. 77–78. An engraving of the demonstration, printed in the *Pennsylvania Gazette*, is reproduced in Michael

Wynn Jones, *The Cartoon History of the American Revolution* (New York: Putnam's, 1975), pp. 146–7.

3. Jedidiah Morse, *Annals of the American Revolution* (Port Washington, N.Y.: Kennikat Press, 1968, reprint of the 1824 edition), pp. 344–45.

4. Philip Freneau, "The Spy," in Fred Lewis Pattee, ed., *The Poems of Philip Freneau, Poet of the American Revolution* (Princeton: The University Library, 1903), II, pp. 39–71. Also see Robert D. Arner, "The Death of Major André: Some Eighteenth-Century Views," *Early American Literature,* XI (Spring 1976), pp. 56–7.

5. Shortly after André's execution, British officials imprisoned John Trumbull, Arnold's former adjunct general, who was then studying painting in Benjamin West's London studio. Trumbull claimed his arrest was contrived as retaliation for André's execution. See William Dunlap, *History of the Rise and Progress of the Arts of Design in the United States,* reprint of 1834 edition (New York: Dover, 1969), I, pp. 351–3; Theodore Sizer, ed., *The Autobiography of Colonel John Trumbull: Patriot-Artist, 1756–1843* (New Haven: Yale University Press, 1953), pp. 63, 366.

6. Anna Seward, "Monody on Major André," 1781, in Walter Scott, ed., *The Poetical Works of Anna Seward . . .* (Edinburgh: John Ballentine, 1810), pp. 85, 87. Also *Gentleman's Magazine* (November 1780), p. 540.

7. Seward subsequently expressed her regrets to Washington and he was reinstated as a hero in her future writings. See Margaret Ashman, *The Singing Swan* (New Haven: Yale University Press, 1931), pp. 85–6.

8. One portrait attributed to Reynolds is now at the Columbus (Georgia) Museum, the other in a private English collection. John Sartain engraved a portrait of André said to be from a Reynolds portrait, but it does not resemble either of these. Catalog from the Mallet sale at Sotheby's (London, 1935), Witt Library, London. See Donald H. Cresswell, "Prints of the American Revolution: A History and Checklist of Graphics Produced from 1765 to 1790," Ph.D. dissertation, George Washington University (1977), pp. 152–3, 296–7.

9. See Walter J. Meserve, *An Emerging Entertainment, the Drama of the American People to 1828* (Bloomington: Indiana University Press, 1977), pp. 107–9, 145; William Dunlap, *History of the American Theatre* (New York, 1832), pp. 221, 223–4. Also see George C. D. Odell, *Annals of the New York Stage* (New York: Columbia University Press, 1927), II, pp. 17–19; Arthur H. Quinn, *A History of the American Drama from the Beginning to the Civil War,* 2nd ed. (New York: F. S. Crofts, 1943), p. 86. For how Dunlap's life intersected with elements of the Andre story, see Robert H. Canary, *William Dunlap* (New York: Twayne, 1970), pp. 15–39, 91–2.

10. William Dunlap, *André, A Tragedy in Five Acts* (New York: The Dunlap Society, 1887).

11. Because of severe criticism, Dunlap rewrote the scene for the second performance, ibid., p. 223; Quinn, *History of the American Drama,* p. 86; and Meserve, *An Emerging Entertainment,* p. 108.

12. Dunlap, *Theatre,* p. 223.

13. Ibid.; Canary, *William Dunlap,* pp. 99–101; Odell, *Annals,* II, p. 82; Meserve, *An Emerging Entertainment,* p. 109; and Joshua Hett Smith, *An Authentic Narrative of the Causes Which Led to the Death of Major André* (reprint; New York: Arno Press, 1969).

14. Mason Locke Weems, *A History of the Life and Death, Virtue and Exploits of Gen-*

eral George Washington, Mark Van Doren, ed. (New York: Macy Masius, 1927), pp. 173–4. For other historians' opinions, see David Ramsay, *The History of the American Revolution* (New York: Russell & Russell, 1968, reprint of the 1793 edition), II, pp. 196–204; and John Marshall, *The Life of George Washington* (Philadelphia, 1805), IV, p. 283.

15. A description of the Sully painting appears in William B. O'Neal, *Primitive into Painter, Life and Letters of John Toole* (Charlottesville: University of Virginia Press, 1960), p. 74. Also see Edward Biddle and Mantle Fielding, *The Life and Works of Thomas Sully* [1783–1872] (Philadelphia: Wickersham Press, 1921), p. 335. A photograph of the Eichholtz (for study purposes only) is available at the Frick Art Reference Library, New York.

16. See James Buchannan to John Pintard, August 17, 1821; and James Thacher to David Hosack, February 4, 1834, Manuscripts Division, New York Historical Society. Also see Winthrop Sargent, *The Life and Career of Major John André* (New York: William Abbatt, 1902), pp. 460–1.

17. See Egbert Benson, *Vindication of the Captors of Major Andre* (reprint of the 1865 edition of the original 1817 publication, Boston: Gregg Press, 1972), p. 14; and *Ceremonies of Laying the Cornerstone of David Williams Monument . . .* (Albany, 1876), p. 36.

18. James Fenimore Cooper, *The Spy: A Tale of Neutral Ground* (New York: Scribner's, 1931), pp. 40–1, 52, 61, and passim. For some of the literary criticism, see James Franklin Beard, "Cooper and the Revolutionary Mythos," *Early American Literature,* XI (Spring 1976), p. 88; and Barton Levi St. Armand, "Harvey Birch as the Wandering Jew: Literary Calvinism in James Fenimore Cooper's *The Spy,*" *American Literature,* 50 (1978), pp. 348–68. Artist and theatrical entrepreneur William Dunlap painted a scene from Charles Powell Clinch's *The Spy* that is now at the State Historical Society of New York in Cooperstown. Also see illustrations in *The Port Folio,* n.s. 14 (August 1822), opposite p. 89 and XVII (March 1824), opposite p. 177. For information on the play, see Meserve, pp. 244–5; and Donald A. Ringe, *James Fenimore Cooper, Updated Edition* (Boston: Twayne, 1988), pp. 12–15 and passim.

19. J. F. Cooper, *Notions of the Americans, Picked Up by a Travelling Bachelor* (New York: Ungar, 1963), I, pp. 210, 218–19.

20. Like many creative Americans of his generation and background, Cooper's views on democracy changed markedly between his youthful enthusiasm and the pronounced skepticism of his later career. For Cooper's views on American politics, see Beard, pp. 84–105; John McWilliams, Jr., *Political Justice in a Republic, James Fenimore Cooper's America* (Berkeley: University of California Press, 1972), p. 57; Daniel Marder, *Exiles at Home: A Story of Literature in Nineteenth Century America* (Lanham, Md.: New York & London: University Press of America, 1984), pp. 22–65; Eric J. Sundquist, *Home as Found, Authority and Genealogy in Nineteenth-Century American Literature* (Baltimore & London: Johns Hopkins University Press, 1979), pp. 1–40; and Dorothy Waples, *The Whig Myth of James Fenimore Cooper* (reprint of the 1938 edition by New York: Arcon Books, 1968), pp. 63–4 and passim.

21. J. K. Paulding published a number of anti-British tracts, including *United States and England* (1815), *A Sketch of Old England by a New England Man* (1822), and *John Bull in America* (1825). For J. K. Paulding's opinion of his first cousin, see JKP to Gasherie De Witt? [sic], Dec. 28, 1837, *The Letters of James Kirke Paulding,* Ralph M. Aderman, ed. (Madison: University of Wisconsin Press, 1962), p. 93.

22. William Paulding's address in *Report of the Select Committee on Erecting a Monument to the Memory of John Paulding with an Address by the Mayor of the City of New York* (New York, 1827), p. 8. Also see J. K. Paulding to ?, December 20, 1827, Paulding Papers, New York Public Library.

23. James K. Paulding, *Life of Washington* (New York, 1835), II, pp. 68–72.

24. For information on efforts by artists and poets to publicize New York, see Angela Miller, *The Empire of the Eye, Landscape Representation and American Cultural Politics, 1825–1875* (Ithaca and London: Cornell University Press, 1993), pp. 65–105; Thomas Bender, *New York Intellectuals* (New York: Knopf, 1987), pp. 121–40; and James Callow, *Kindred Spirits, Knickerbocker Writers and American Artists, 1807–1855* (Chapel Hill: University of North Carolina Press, 1967); and for recent publications on regional history, see Clarence Mondale, "Concepts and Trends in Regional Studies," *American Studies International,* XXVII (April 1989), pp. 13–37.

25. For the artists' competition, see *New York Mirror,* Oct. 5, 1833, p. 110, and G. C. Verplanck to William Dunlap, January 14, 1833, Manuscript Division, New York Public Library. For tourism, see *New York Mirror,* X (August 1832), p. 47, and XII (May 23, 1835), p. 375; plates in the ibid., X, XI, and XII (1832–35); and William Guy Wall's *The Hudson River Portfolio,* published between 1821 and 1825.

26. Mrs. [Frances] Trollope, *Domestic Manners of the Americans* (London, 1832), p. 292.

27. David Lawall argues convincingly that the painting of Durand's *André* at the Worcester Art Museum is not the original and that it was done in 1835 instead of 1833–4 as often claimed. However, since the Worcester painting is the only extant version by the artist, it is pictured in this study. See David B. Lawall, *Asher B. Durand: A Documentary Catalogue of the Narrative and Landscape Paintings* (New York & London: Garland, 1978), p. 20, hereafter cited as *ABD, Doc. Cat.*

28. Lewis Clover, Jr., to John Durand, November 26 (or December 2), 1878, and Lewis Clover, Sr. to Lewis Clover, Jr., December 14, 1878, in "Original Documents: Durand's Picture of the 'Capture of Major André,'" *Magazine of American History,* XXIV (October 1890), pp. 321–2.

29. Little is known about Clover, but his son, an artist and evangelical minister, apprenticed under Durand and is said to have posed for the figure of André. Clover Diary in the Manuscripts Division, New York Public Library; and "Original Documents," pp. 321–2. During the 1840s and 1850s, L. P. Clover, Jr., was active in Democratic politics. See L. P. Clover, Jr., to Robert Tyler, March 21, 1855, and to James Gordon Bennett, October 15, 1849, New York Historical Society.

30. Quoted in Lawall, *Asher Brown Durand: His Art and Theory in Relation to His Times* (New York and London: Garland, 1977), p. 166, hereafter cited as *ABD*.

31. A portrait of Paulding by J. J. Jarvis does bear a striking resemblance to the face of John Paulding in Durand's painting. For Paulding's influence, see John Durand, *The Life and Times of A. B. Durand* (reprint of the 1894 edition, New York: Da Capo Press, 1970), pp. 120–1.

32. *The Knickerbocker,* V (June 1835), pp. 555–6.

33. Perhaps it is no coincidence that a Pennsylvania banknote of 1834, engraved by Durand's former student George W. Hatch, contains a picture of André's capture. *New York Mirror,* XI (January 11, 1834), p. 223.

34. From the post of navy agent for New York in the 1820s, Paulding rose to national prominence in 1838 when his friend Martin Van Buren appointed him secretary of the navy. Lawall suggests that the political message of Durand's *Major André*

might be Whig and not Democratic, for Guilian C. Verplanck had run an unsuccessful campaign for mayor of New York in 1834 as the anti-Jackson candidate. The name *André* could symbolize *King Andrew,* as Lawall implies, and the money he offered his captors could be a metaphor for the U.S. Bank battle that was a central issue in the mayoral campaign. See Lawall, *ABD,* pp. 169–71.

35. For information on this very popular print, see Lawall, *ABD, Doc. Cat,* pp. 19–20; and *Art Digest,* April 15, 1936. There are also several painted copies including one by J. B. White at the University of Michigan, Ann Arbor; R. M. Staigg at the Historic Hudson Valley Association, Tarrytown, New York, and some by anonymous artists found in photographs at the Frick Reference Library. In addition, the composition was repeatedly emulated on a variety of decorative art objects that range from plates to candlesticks. These can be seen in a special display at the Historical Society of the Tarrytowns.

Chapter 4

I extend thanks to Patricia Johnston and Paul Giese for their helpful comments on drafts of this essay.

1. *The Crayon,* 8, 5 (May 1861), p. 120.
2. George M. Fredrickson, *The Inner Civil War: Northern Intellectuals and the Crisis of the Union* (New York: Harper & Row, Harper Torchbook Edition, 1968), passim.
3. James M. McPherson, *Battle Cry of Freedom: The Civil War Era* (New York: Ballantine, 1989), p. 858.
4. The relevant New York newspapers, staunchly loyal to the Union, were the *Times, Evening Post,* and *Daily Tribune.* The *World* supported Lincoln but condemned the Emancipation Proclamation. The New York *Leader,* according to one writer of the period, was a Democratic weekly, a label that did not necessarily indicate a disloyal stand. See Frank Luther Mott, *American Journalism, a History of Newspapers in the United States Through 260 Years: 1698 to 1950* (New York: Macmillan, 1950), pp. 339, 351; William Winter, *Old Friends being literary recollections of other days* (New York: Moffatt Yard, 1909), p. 61.

 Of the periodicals, *Harper's Weekly* and *The Atlantic Monthly* were solidly pro-Union. *The Knickerbocker* took a Republican, then a nonpartisan stand in 1861–3, but by the end of that year became Copperhead (a colloquialism for Northerners opposed to Lincoln's war policies). *The Round Table,* though pro-Union, was often severely critical of the conduct of the war. *The Crayon* and *The New Path,* being devoted to artistic matters, were essentially nonpolitical. See Mott, *A History of American Magazines,* II, p. 140, III, p. 320 (Cambridge, Mass.: Harvard University Press, 1938).
5. Although Forbes never became an Associate or National Academician (NA) at the National Academy of Design, the others were well established by the time of the Civil War: Church, NA 1849; Gifford, NA 1854; Leutze, Bierstadt, and Johnson, NA 1860.
6. New York *Leader,* 7, 10 (April 13, 1861), p. 3. The painters referred to were Frederic E. Church, John Kensett, François Regis Gignoux, George Loring Brown, and Sanford Gifford, all landscapists.
7. *The Crayon,* 8, 5 (May 1861), p. 120; *The Knickerbocker,* 58, 679 (July 1861), p. 48.
8. See *The Crayon,* 8, 5 (May 1861), p. 120 (Whittredge never actually served); New York *Daily Tribune* (May 5, 1861), p. 3; New York *Leader,* 7, 16 (May 25, 1861), p. 1.

9. "Autobiography of Worthington Whittredge, 1820–1910," ed. John I. H. Baur, *The Brooklyn Museum Journal* (Brooklyn, 1942) pp. 42, 43.

10. *A Record of the Metropolitan Fair in aid of the United States Sanitary Commission, held at New York, in April, 1864* (New York, 1867), p. 99.

11. New York *Daily Tribune* (May 26, 1861), p. 3.

12. *The Crayon,* 8, 5 (May 1861), p. 120. The phrase "the slain of Baltimore" refers to soldiers of the Massachusetts Sixth Regiment killed in skirmishes en route to Washington.

13. *New York Times* (May 29, 1861), p. 5.

14. *The Crayon,* 8, 6 (June 1861), p. 133.

15. *The Knickerbocker,* 58, 679 (July 1861), p. 48.

16. Ibid., p. 52.

17. New York *Daily Tribune* (May 5, 1861), p. 3.

18. *The Crayon,* 8, 6 (June 1861), p. 134.

19. New York *World* (January 2, 1868), p. 2.

20. Asserting that American artists had no training or experience in figural painting is not strictly true. Many had studied abroad and had been exposed to different training methods. However, the National Academy of Design in New York did instruct its students principally through drawing from casts; see Lois Fink and Joshua Taylor, *The Academy, The Academic Tradition in American Art* (Washington, D.C.: The Smithsonian Institution Press, 1975); and Eliot Clark, *History of the National Academy of Design, 1825–1953* (New York: Columbia University Press, 1954).

21. New York *Daily Tribune,* August 18, 1861, p. 3.

22. Eight out of 555 paintings in the 1862 National Academy of Design Annual concerned the war; in 1863, 20 out of 471; in 1864, 13 out of 369; and in 1865, 24 out of 647. These numbers are approximate, based on titles given.

23. See Charles Janeway Stillé, *History of the United States Sanitary Commission, being the general report of its work during the war of the rebellion* (New York: Hurd and Houghton, 1868). The Metropolitan Fair of April 1864 in New York and the Great Central Fair that June in Philadelphia, for instance, respectively, had 11 works that pertained to the war out of 360, and 19 (including statuary groups by Rogers of Civil War subjects) out of more than 900 donated or on exhibit. Again, titles were used for the approximate figures.

24. New York *Daily Tribune* (June 16, 1861), p. 2.

25. Raymond L. Stehle, "Five Sketchbooks of Emanuel Leutze," *The Quarterly Journal of the Library of Congress,* 21, 2 (April 1964), pp. 90–92.

 Leutze's painting *Angel Upon the Battlefield,* although dated 1864, contains soldiers in what appear to be uniforms of the Revolutionary War. Parallels were commonly drawn during the Civil War between the nation's two conflicts, one for its birth, one for its continuance.

26. *The [Washington] Daily Intelligencer* (June 27, 1862), p. 1. See also New York *Daily Tribune* (November 12, 1861), p. 7.

27. New York *Daily Tribune* (May 19, 1861), p. 3, quoted by Doreen Bolger Burke, "Frederic Edwin Church and 'The Banner of Dawn,'" *The American Art Journal,* 14, 2 (Spring 1983), p. 39.

28. William Howard Russell, *My Diary North and South,* II (London: Bradbury & Evans, 1863), pp. 109, 80.

29. The promotional brochure for the chromolithograph after the painting reminded viewers of the first unfurling of the "Stars and Stripes" at the surrender of Gen.

John Burgoyne after the Revolutionary War Battle of Saratoga and linked that occurrence to its forced lowering at Fort Sumter by anti-Union forces. In this way, the legitimacy of the war to preserve the Union was made clear.

30. *Harper's Weekly,* 6, 279 (May 3, 1862), p. 274.

31. Beginning in 1861, Forbes continued as an artist-correspondent into 1864; see William Campbell, *The Civil War: A Centennial Exhibition of Eyewitness Drawings,* exh. cat. (Washington, D.C.: National Gallery of Art, 1961), Appendix I (listing of artist correspondents), p. 107.

32. New York *Leader,* 7, 5 (February 3, 1865), p. 1.

33. On-site sketches fueled other paintings by Forbes and etchings that were published in the postwar volumes *Life Studies of the Great Army,* 1876, and *Thirty Years After: An Artist's Story of the Great War* (New York: Fords, Howard, & Hulbert, 1890).

34. A version of the painting (American Art Association Eastman Johnson Sale, 1907, no. 123) bears this possibly autographic inscription: "[a] veritable incident/in the civil war seen by/myself at Centerville [sic]/on this morning of/McClellan's advance towards Manasses [sic] March 23, 1862/Eastman Johnson;" see Patricia Hills, *The Genre Painting of Eastman Johnson: The Sources and Development of His Style and Themes* (New York: Garland Press, 1977), p. 80 and n. 5. Mrs. Johnson in a letter "To the Regents of the Smithsonian," dated December 1, 1906, wrote of the subject as something "which he [Johnson] saw at Manasses [sic] junction–I have the pass –" (Richard Rathbun/Artists Files, Archives of American Art, 2227).

35. Nancy C. Anderson and Linda S. Ferber, *Albert Bierstadt: Art & Enterprise* (New York: Hudson Hills Press, 1990), p. 80, Fig. 48. The composition seems also to have served as the basis for an anonymous wood engraving "The Army of the Potomac – The Picket Guard" published in *Harper's Weekly,* 5, 253 (November 2, 1861), p. 694.

36. Richard Shafer Trump (*Life and Works of Albert Bierstadt* [Ann Arbor, Mich.: University Microfilms, 1970], pp. 74, 216, no. 30) dated the painting 1862, suggesting it resulted from Bierstadt's 1861 pass; the event, however, occurred long before October. Matthew Baigall (*Albert Bierstadt* [New York: Watson, Gouptill, 1981], pl. 10) has dated the painting c. 1863.

37. New York *Leader,* 8, 42 (October 18, 1862), p. 1.

38. *The Round Table,* 2, 32 (July 23, 1864), p. 90.

39. New York *World,* quoted in the New York *Leader,* 5, 29 (July 26, 1862), p. 3. The market for war photographs during the war years is discussed in Keith Davis, "'A Terrible Distinctness': Photography of the Civil War Era" in *Photography in Nineteenth-Century America,* ed. Martha A. Sandweiss (New York: Abrams, 1991), primarily pp. 142–8.

40. "Doings of the Sunbeam," *The Atlantic Monthly,* 12, 69 (July 1863), p. 12.

41. *New York Times,* quoted in Roy Meredith, *Mr. Lincoln's Camera Man: Mathew B. Brady* (New York: Dover, 1974), p. 129.

42. Alan Trachtenberg, "Albums of War," *Reading American Photographs: Images of History, Mathew Brady to Walker Evans* (New York: Noonday Press, 1989), pp. 73, 74.

43. Davis, in *Photography in Nineteenth-Century America,* p. 171.

44. New York *Leader,* 9, 5 (January 31, 1863), p. 1.

45. *The Knickerbocker,* 61, 4 (April 1863), p. 372.

46. *The Knickerbocker*, 63, 1 (January 1864), pp. 82, 94.

47. McPherson, *Battle Cry of Freedom*, p. 324. New York *World*, October 23, 1863, p. 4.

48. New York *Leader*, 9, 1 (January 3, 1863), p. 1.

49. New York *Leader*, 9, 13 (March 28, 1863), p. 4.

50. *The New Path*, 4 (August 1863), pp. 37–44, 40.

51. *The Round Table*, 1, 3 (January 2, 1864), p. 44.

52. See Albert Boime, "New Light on Manet's *Execution of Maximilian*," *The Art Quarterly*, 35, 3 (Autumn 1973), especially pp. 177–81.

53. When exhibited at the Academy in 1872, *Wounded Drummer Boy* (no. 205) was connected with an episode during the Battle of Antietam. Mrs. Johnson repeated that reference in her December 1, 1906, letter previously referred to. Neither John I. H. Baur (*Eastman Johnson, 1824—1906, An American Genre-Painter* [Brooklyn, N.Y.: Institute of Arts and Sciences, 1940], p. 19) nor Patricia Hills (*Eastman Johnson*, p. 81 and n. 6) provide documentary evidence for this claim.

54. See Baur, *Eastman Johnson*, p. 19, and Hills, *Eastman Johnson*, pp. 81–2. The topography represented in *Civil War Scene*, however, does not readily correspond to any of the varied parts of the Gettysburg battlefield.

55. New York *Leader*, 9, 1 (January 3, 1863), p. 1.

56. New York *Leader*, 9, 22 (May 30, 1863), p. 1.

57. New York *World* (April 14, 1863), p. 4; reviews of the same annual continued on April 24, p. 4, and May 2, p. 8.

58. *Harper's Weekly*, 7, 331 (May 2, 1863), p. 274.

59. *The Round Table*, 1, 3 (January 3, 1864), p. 44.

60. *The Round Table*, 1, 12 (March 5, 1864), p. 184.

61. New York *Evening Post* (May 31, 1865), p. 1.

62. Ibid.

63. See Giese, "Winslow Homer's Civil War Painting *The Initials:* A Little-Known Drawing and Related Works," *The American Art Journal*, 23, 2 (1983), pp. 4–19.

64. For a fuller analysis of *The Bright Side*, see Mark Simpson, "*The Bright Side*, Humorously Conceived and Truthfully Executed," pp. 46–63 in *Winslow Homer: Paintings of the Civil War*, exh. cat. (San Francisco: The Fine Arts Museums of San Francisco, 1988); and Giese, "Winslow Homer, 'Best Chronicler of the War,'" *Studies in the History of Art, Winslow Homer*, 26 (Washington, D.C.: National Gallery of Art, 1990), pp. 15–31.

65. *The Nation*, 1, 2 (July 13, 1865), p. 58.

66. James Jackson Jarves, *The Art-Idea*, ed. Benjamin Rowland, Jr. (Cambridge, Mass.: The Belknap Press of Harvard University Press, 1962; originally published 1864), pp. 208, 197. Patricia Mainardi has written about the "death of history painting" in France around the same time from changes in institutional and political support and a corresponding shift in public taste; see Mainardi, *Art and Politics of the Second Empire: The Universal Expositions of 1855 and 1867* (New Haven: Yale University Press, 1987), Chapter 17.

67. Jarves, *The Art-Idea*, p. 197.

68. Paul Kennedy, *The Rise and Fall of the Great Powers: Economic Change and Military Conflict from 1500 to 2000* (New York: Vintage Books, Random House, 1989), pp. 144, 179.

69. John Bigelow, a nineteenth-century military writer, quoted in Herman Hattaway and Archer Jones, *How the North Won: A Military History of the Civil War* (Chicago and London: University of Illinois Press, 1983), p. 703, n. 5; see also p. 685.

70. Fredrickson, *The Inner Civil War*, p. 167.

71. Ibid., pp. 167, 170, 172.

72. Eric Foner, *Politics and Ideology in the Age of the Civil War* (New York: Oxford University Press, 1980), p. 53.

73. According to Stehle, "Four Sketchbooks of Emanuel Leutze," *The Quarterly Journal*, p. 92.

74. New York *Evening Post* (April 28, 1866), p. 1; Eugene Benson, "Historical Art in the United States," *Appleton's Journal*, 1, 2 (April 10, 1869), p. 46; and Giese, "*Prisoners from the Front*, An American History Painting?" in *Winslow Homer: Paintings of the Civil War*, pp. 64–81.

75. Postwar paintings of Civil War subjects lie outside the scope of this chapter.

Chapter 5

1. Perriton Maxwell, "Frederic Remington – Most Typical of American Artists," *Pearson's* (October 1907), p. 399. The phrase "a stirring and crawling of the yeasty thing" is from Jack London, *The Sea-Wolf* (New York: Penguin, 1989), p. 81: "Wolf Larsen paused once or twice at the break of the poop to glance curiously at what have been to him a stirring and crawling of the yeasty thing he knew as life."

2. Remington, "On the Indian Reservations," *Century* (July 1889); reprinted in Peggy and Harold Samuels, eds., *The Collected Writings of Frederic Remington*, pp. 34–5. Dippie identifies this passage with the painting in Brian W. Dippie, *Remington and Russell* (Austin: University of Texas Press, 1982), p. 46.

3. Remington, "On the Indian Reservations"; reprinted in *The Collected Writings of Frederic Remington*, p. 31.

4. Remington, "Lieutenant Casey's Last Scout: On the Hostile Flanks with the Chischis-chash," *Harper's Weekly* (January 31, 1891); reprinted in *The Collected Writings of Frederic Remington*, p. 75.

5. Remington, *John Ermine of the Yellowstone* (Ridgewood, N.J.: Gregg Press, 1968 [reprint of 1902 edition]), p. 112.

6. Frederic Remington diary, April 19, 1908, Frederic Remington Art Museum, Ogdensburg, New York. In the back of the 1908 diary Remington lists purchasing *A Century of Science* on April 16.

7. John Fiske, "The Doctrine of Evolution: Its Scope and Purport," in Fiske, *A Century of Science and Other Essays* (Boston: Houghton Mifflin, 1900), pp. 42–3.

8. Fiske, "The Doctrine of Evolution," p. 47.

9. For correspondence between Remington and Roosevelt concerning *Paleolithic Man*, see Allen P. Splete and Marilyn D. Splete, eds., *Frederic Remington – Selected Letters* (New York: Abbeville, 1988), pp. 359–60.

10. For an excellent account of Roosevelt's views, see Richard Slotkin, "The Winning of the West: Theodore Roosevelt's Frontier Thesis, 1880–1900," in Slotkin, *Gunfighter Nation: The Myth of the Frontier in Twentieth-Century America* (New York: Atheneum, 1992), pp. 29–62.

11. Roosevelt, "In Cowboy-Land," *Century* 46 (June 1893); reprinted in Roosevelt, *Ranch Life in the Far West* (Dillon, Colo.: Vistabooks, 1991), p. 88.

12. London, *The Sea-Wolf*, p. 221.

13. Fiske, "The Doctrine of Evolution," p. 43.

14. "One of those moods had come upon the savage child-mind when the surging blood made his eyes gleam vacantly like the great cat's (Remington, *The Way of*

an Indian; in *The Collected Writings of Frederic Remington* [reprint of 1906 edition], p. 582).

15. According to Eva Remington, the artist's wife, "*The Story of Where the Sun Goes* interested Mr. Remington very much. . . . He gave a great deal of thought to the color and made many studies first before the picture was completed." (Eva Remington, letter to unknown party, October 14, 1911; quoted in *Sotheby's: American Paintings Drawings and Sculpture, November 30, 1989,* lot 122.)

16. For this argument, see Alex Nemerov, "'Doing the Old America': The Image of the American West, 1880–1920" in William Truettner, ed., *The West as America: Reinterpreting Images of the Frontier, 1820–1920* (Washington, D.C.: Smithsonian Institution Press, 1991), pp. 329–30.

17. Remington, *John Ermine,* p. 194, pp. 226–7.

18. Ben Merchant Vorpahl, *My Dear Wister – the Frederic Remington–Owen Wister Letters* (Palo Alto, Calif.: American West, 1972), pp. 310–16.

19. Remington, *John Ermine,* p. 165.

20. Remington, *John Ermine,* pp. 163, 55, 85, 129.

21. John Seelye, "Remington: The Writer," in Peter Hassrick et al., *Frederic Remington: The Masterworks* (New York: Abrams, 1988), p. 253.

22. Remington, *John Ermine,* pp. 163, 187, 169.

23. Remington, *John Ermine,* p. 156.

24. Remington, *John Ermine,* pp. 130–1, 207, 246.

25. James Ballinger, *Frederic Remington* (New York: Abrams in association with the National Museum of American Art, 1989), p. 112.

26. Remington, *John Ermine,* p. 268.

27. Remington, *John Ermine,* p. 137.

28. Remington, *John Ermine,* pp. 92, 95.

29. Roosevelt, "The Round-Up," *Century* 35 (April 1888); reprinted in *Ranch Life and the Far West,* p. 36.

30. Remington, *John Ermine,* p. 88.

31. Remington diary, January 16, 1908.

32. The Whistler books and Remington's sculpture scrapbook are in the collections of the Frederic Remington Art Museum.

33. Remington diary, March 19, 1908.

34. For the darkness of some of the Metropolitan's Whistler paintings, see Natalie Spassky et al., *American Paintings at the Metropolitan Museum of Art,* Vol. 2 (New York: Metropolitan Museum of Art in association with Princeton University Press, 1985), pp. 372–3.

35. Quoted in Peggy and Harold Samuels, *Frederic Remington: A Biography* (Garden City, N.Y.: Doubleday, 1982), p. 416.

36. Remington, letter to Al Brolley, December 8 [1909]; reprinted in *Frederic Remington – Selected Letters,* pp. 434–5.

37. Jack London, *The Call of the Wild and White Fang* (New York: Bantam, 1963), p. 220.

38. Remington diary, September 17, 1907; July 1, 1908; February 24, 1908.

39. Remington, *John Ermine,* p. 149.

40. Remington, *The Way of an Indian;* reprinted in *The Collected Writings of Frederic Remington,* p. 562.

41. Remington diary, July 6, 1909.

42. Remington, *John Ermine,* p. 86.

43. Remington diary, January 16, 1908.

44. See "Merely Paint," Chapter 7 in Alexander Nemerov, "Past Knowing: Frederic Remington's Old West" (Ph.D. dissertation, Yale University, 1992), pp. 217–70.

45. Augustus Thomas, "Recollections of Frederic Remington," *Century* 86 (July 1913), pp. 354, 361.

Chapter 6

1. T. J. Clark, *Image of the People: Gustave Courbet and the Second French Republic, 1848–1851* (Greenwich, Conn.: New York Graphic Society, 1973), p. 13.

2. Stuart Hall, "The Local and the Global: Globalization and Ethnicity," in *Culture, Globalization and the World-System: Contemporary Conditions for the Representation of Identity,* ed. Anthony D. King (Binghamton: Department of Art and Art History, State University of New York at Binghamton, 1991), p. 35.

3. Lucy Lippard, *From History to Action* (Los Angeles: The Woman's Building, 1984), n.p.

4. Tanguma and Vásquez are far from being the only Chicano artists who sought their identity and purpose in a recapitulation of their hidden history. To their names must be added those of Ray Patlan, Judith Baca, John Valadez, Marcos Raya, Manuel Martínez, Carlos Sandoval, Carlota Espinoza, Daniel Gálvez, Barbara Carrasco, Judith Hernández, Ernesto Palomino, and hundreds more who explored this subject in a multitude of mediums. On murals specifically, see Victor A. Sorell, ed., *Guide to Chicago Murals Yesterday and Today,* 2nd ed. (Chicago: Chicago Council on Fine Arts, 1979), which includes the sites of many done by Chicanos of the Midwest; Eva Sperling Cockcroft and Holly Barnet-Sánchez, eds., *Signs from the Heart: California Chicano Murals* (Venice, Calif.: Social and Public Art Resource Center, 1990). For overall reference and a theoretical essay on Chicano art, see Shifra M. Goldman and Tomás Ybarra-Frausto, *Arte Chicano: A Comprehensive Annotated Bibliography of Chicano Art, 1965–1981* (Berkeley: Chicano Studies Library Publications Unit, University of California, 1985).

5. Eric R. Wolf, *Europe and the People Without History* (Berkeley: University of California Press, 1982), p. x.

6. The term Chicano, used interchangeably at times with *Mexican* or *Mexican American,* refers to the self-designation adopted in the mid-1960s by militant students and young people to affirm their nonaccommodationist politics and their Indian heritage. It marked a separation from the assimilationist generations that preceded them who wished to integrate into the so-called melting pot and a reaffirmation of Mexican culture and the renewed focus on the use of Spanish, which many had lost or were discouraged by prejudiced institutions from using.

7. The target exhibitions of the 1980s that signalized the new discourses were the widely discussed "Magiciens de la terre" (1989) mounted in the Centre Georges Pompidou and La Villette in Paris, which first put forth the slogan of "globalism" in the arts; and "'Primitivism' in 20th Century Art: Affinity of the Tribal and the Modern" (1984) in New York's Museum of Modern Art. Following a storm of negative criticism for both shows, art historian Thomas McEvilley took the position that although one had to be sympathetic to the antihegemonic impulse behind the criticism, it ought to be recognized that the "Primitivism" exhibit was an unconsidered display of neocolonialist mentality whereas "Magiciens" was a great step forward toward a fully postcolonialist phase. At the same time, McEvilley's biased posture was revealed in his own words: "Magiciens," he said, "opened

the door of the long-insular and hermetic Western art world to third-world artists." It is still Western standards and timetables that pertain to this "global village of the '90s." See McEvilley, "Marginalia: Thomas McEvilley on the Global Issue," *Artforum,* 28 (March 1990), pp. 19–21. For further opinions, see Cesare Poppi, "From the Suburbs of the Global Village: Afterthoughts on *Magiciens de la terre,*" *Third Text* (London), 14 (Spring 1991), pp. 85–96; and "The Global Issue: A Symposium," *Art in America,* 77, 7 (July 1989), pp. 86–9+. At no time were the Third World–focused biennials of Havana, Cuba (1986 and 1989) either considered or mentioned.

8. Elvira Valenzuela Crocker, "Tanguma: A Man and His Murals," *Agenda,* National Council of La Raza, Washington, D.C. (Summer 1974), p. 15.

9. Crocker, "Tanguma," p. 17.

10. Ibid., p. 16.

11. Jim Dobbs, "Art For the Community: An Interview with Emigdio Vásquez," *The Ear,* 8 (Spring 1991), Irvine Valley College, Irvine, Calif., p. 11.

12. Patricia Hills in "The Working American" points out that historically we can find relatively few paintings of [North] Americans at work. Most work was considered too mundane or vulgar for the "fine arts," or perhaps too subversive for social and political norms. See the catalog *The Working American* (Washington, D.C.: Smithsonian Institution, 1979), pp. 1–16. Work, as defined in my paper, concerns the blue-collar jobs (in steel mills, mines, railroads, packinghouses, garment factories, and assembly plants) and the "noncollar" jobs (e.g., migratory agriculture labor, domestic work, service industry jobs, casual labor) that have been available to Mexican workers, male and female. Until the Chicano movement prevailed with its educational and civil demands, not many Mexican Americans were employed as white-collar workers or as professionals – possibly less than 10 percent of the national population. For a more extensive treatment of this theme, see Shifra M. Goldman, "Mexican and Chicanos Workers in the Visual Arts," in *Dimensions of the Americas: Art and Social Change in Latin America and the United States* (Chicago: The University of Chicago Press, 1994), pp. 285–312.

13. Carey McWilliams, *North from Mexico: The Spanish-Speaking People of the United States* (New York: Greenwood Press, 1968), p. 163.

14. One of the most spectacular (and certainly the largest) historical mural in the United States is that of Judith Baca, cofounder and artistic director of the Social and Public Art Workshop in Venice, California. Entitled "The History of California" or "The Great Wall of Los Angeles," it also undertakes to recount the "hidden history" of the state of California. Team-painted noncontinuously for a period of five years (1976–83) by multiracial and multiethnic young people directed by professional artists, it traces history chronologically from the California Indians to the 1984 Olympic Games held in Los Angeles. For illustrations and more information, see Shifra M. Goldman, "How, Why, Where, and When it All Happened: Chicano Murals of California," in Cockcroft and Barnet-Sánchez, *Signs from the Heart,* p. 47 and passim.

15. Tezozómoc has been characterized as a ruthless but extremely gifted ruler, warrior, and administrator of the Tepanecs for whom the Aztecs were mercenaries while struggling for their own space and power. See Muriel Porter Weaver, *The Aztecs, Maya, and Their Predecessors* (New York: Seminar Press, 1972), p. 241.

16. In August 1972, the Cultural Affairs Committee of the Chamber of Commerce asked Tanguma to do the Continental Can mural so there would be community art expression in conjunction with the Main Street II Spotlight on the Arts in

October of that year. The 4,320 square foot mural was not completed in time, however. Undaunted, the artist and his crew continued to work without Chamber support toward a new target date of September 1973 for the Raza Art Festival of which Tanguma was chair.

17. Hayden White, *Tropics of Discourse: Essays in Cultural Criticism* (Baltimore: Johns Hopkins University Press, 1978), p. 34.

18. Martin Dreyer, "Painting Pride for Everyone to See: A Chicano Artist and His Giant Murals," *Houston Chronicle,* Texas Magazine (April 22, 1973), p. 10.

19. Many political changes in Mexican history began with a *plan:* a manifesto or statement of principle that animated a movement. The *Plan de Iguala* of 1821, for example, was a call to create a new independent Mexico, free of Spain; the most famous is the *Plan de Ayala* issued by revolutionary Emiliano Zapata in 1911, which was a call for continued rebellion against the unsatisfactory politicians who took power during the revolution and ignored the agrarian reform demanded by Zapata and the peasants.

20. Dreyer, "Painting Pride," p. 10.

21. The artist raised some of the funds from Colorado organizations, but continued to paint even when funds were not available or came late. This had been a pattern in Houston, and was continued when necessary in Denver because of Tanguma's absolute commitment to what he perceived as the needs of his community. His murals were never an expression of personal ego.

22. Letter from Leo Tanguma to the author, July 9, 1988. This letter is included in the essay produced by the author for the brochure issued by the Denver Art Museum in 1988 from which I have excerpted some of the present material.

23. Between 1957 and 1967 (interrupted by a four-year stint in jail for "social dissolution"), David Alfaro Siqueiros painted *Revolution Against the Dictatorship of Porfirio Díaz,* a 4,500 square foot mural in Mexico City based on the Cananea strike, which was considered a precursor to the Mexican Revolution.

24. The history of Mexican peoples in the United States, whether residents for generations before the Southwest became part of the United States, refugees escaping the turmoil of the 1910–20 Mexican Revolution, or immigrants recruited by U.S. labor agents or seeking work on their own, includes the creation of *colonias* on the undesirable lands bordering a large city where jobs were available, or occupying decrepit housing for low rents. As the cities surrounded these areas, they became known as barrios, or neighborhoods, predominantly occupied by Mexican and Spanish-speaking workers. When relatives arrived from Mexico, or poorer areas of the United States, they gravitated to these areas where a support structure already existed. Orange is now one suburb of an extensive, highly developed area known as Orange County (south of Los Angeles) with tract homes and shopping malls, within which pockets of working-class Mexicans make their homes in the older sections.

25. Victor Manuel Valle, "Emigdio Vásquez Interview," *Somos* (Los Angeles) (December 1978–January 1979), p. 42.

26. McWilliams, *North from Mexico,* p. 167.

27. Edward Steichen, ed., *The Family of Man,* exh. cat., prologue by Carl Sandburg (New York: Museum of Modern Art, 1955), p. 77. The original photograph was taken by Wayne Miller for *Life* magazine.

28. Emigdio Vásquez, *The Cypress Street Barrio and My Art,* unpublished graduate seminar paper, California State University, Fullerton (Fall 1978).

29. Titled in Spanish *Proletariado de Aztlán* and commissioned by the Friendly Cen-

ter, Orange, California, on a garage adjacent to the center, the mural was part of Vásquez's master's thesis for California State University, Fullerton.

30. *450 años del pueblo chicano/ 450 Years of Chicano History (in Pictures)* (Albuquerque: Chicano Communications Center, 1976). (A new edition appeared in 1991.)

31. The Sleepy Lagoon case concerned a racist trial and conviction of young Mexican Americans for assault and murder that was reversed on appeal due to a biased trial, the violation of constitutional rights, and the lack of evidence. The zoot suit case arose when hundreds of sailors, marines, and civilians indiscriminately attacked young Pachucos and stripped them of their zoot suits while the police passively stood by. Inflamed by the Hearst press, the attacks went on for several days, expanding to blacks and Filipinos, finally quelled by military police when civil authorities refused to act and the police ordered mass arrests of the *victims*. See Carey McWilliams, *North from Mexico,* pp. 228–33 and 238–58 passim; and Rodolfo Acuña, *Occupied America: A History of Chicanos,* 3rd ed. (New York: Harper & Row, 1988), pp. 254–60. For a cultural analysis, see "Revelando la imágen/Revealing the Image," in Goldman et al., *Arte Chicano,* pp. 29–31.

32. Veteran artist and poet José Montoya of Sacramento, California, was instrumental in resurrecting the history and costume of the Pachucos and Pachucas in drawings and in poetry. A younger generation of Chicano artists celebrated the street culture of the *cholos* and *cholas* (the children and grandchildren of the Pachucos), who continued the tradition of neighborhood graffiti, low-rider cars (from the earlier hot rods), body tattoos, distinctive dress, and identifying neighborhood hand signals.

33. The imperiled existence of all murals – especially those painted in the streets during the 1970s street mural movement that spread across the United States – has not spared those of Emigdio Vásquez. *Nuestra experiencia* has been badly vandalized and is threatened with total destruction by the Salvation Army officials on whose parking lot wall it was painted; another Vásquez mural in an Orange County cultural museum was destroyed due to remodeling, but repainted at another site due to protests and the incongruities of the museum's position. For further information on the street mural movement, see Eva Cockcroft, John Weber, and Jim Cockcroft, *Toward a People's Art: The Contemporary Mural Movement* (New York: Dutton, 1977); and Alan W. Barnett, *Community Murals: The People's Art* (Philadelphia: The Art Alliance Press, 1984).

34. This attitude has come to light during the course of several law proceedings when murals have been destroyed without the knowledge or permission of the artist(s).

35. Stuart Hall, "The Local and The Global," pp. 34–5.

36. Kevin Brownless, "Editor's Preface," *Yale French Studies,* 70 (1986).

Chapter 7

Note: Titles in italics represent the names of artworks including works of installation art. Those within quotation marks represent individual "pieces" or "gestures" within an installation. Those in caps represent the names of exhibitions.

1. See William Ayres, ed., *Picturing History: American Painting 1770–1930,* exh. cat. (New York: Rizzoli, 1993). The exhibition was organized by the Fraunces Tavern Museum, New York City, and curated by Barbara J. Mitnick.

2. For discussions on the postmodern critique of painting see the following: Victor Burgin, *The End of Art Theory* (Atlantic Highlands, N.J.: Humanities Press International, 1987); Benjamin H. D. Buchloh, "Figures of Authority, Ciphers of Regression," pp. 107–35; and Thomas Lawson, "Last Exit: Painting," pp. 153–65, both in *Art After Modernism: Rethinking Representation,* ed. Brian Wallis (New York: The New Museum of Contemporary Art, 1984); and Douglas Crimp, "The End of Painting," *October,* 16 (1981), pp. 69–86.

3. Thomas Crow, "The Birth and Death of the Viewer," in *Dia Art Foundation Discussions in Contemporary Culture,* 1, ed. Hal Foster (Seattle: Bay Press, 1987), pp. 1–8. The major points outlining the "formalist" position may be found in Clement Greenberg, "Avant-Garde and Kitsch," in *The Collected Essays and Criticism,* vol. 1, ed. J. O'Brian (Chicago: University of Chicago Press, 1986); and Michael Fried, "Art and Objecthood," in *Minimal Art,* ed. G. Battock (New York: Dutton, 1968).

4. See Brian O'Doherty, *Inside the White Cube: The Ideology of the Gallery Space* (Santa Monica, Calif.: Lapis, 1976).

5. A phrase used to describe installation by Richard Bolton in a paper delivered in "Multimedia Installations and the Public/Private Institutions," a session chaired by John Hanhardt at the College Art Association Conference (February 19, 1994).

6. Victor Burgin, "The Absence of Presence: Conceptualism and Postmodernism," in *The End of Art Theory,* ed. V. Burgin, p. 33.

7. See David Deitcher, "Art on the Installation Plan," *Artforum* (January 1992), pp. 81+.

8. For extended general discussions of the museum as a subject in art of this century see the following: *Museums by Artists,* eds. A. A. Bronson and Peggy Gale (Toronto: Art Metropole, 1983); *Carnegie International 1991* (Pittsburgh: Carnegie Museum of Art, 1991); *The Desire of the Museum* (New York: Whitney Museum of American Art, 1989); Lisa G. Corrin, "Artists Look at Museums, Museums Look at Themselves," in *Mining the Museum: An Installation by Fred Wilson,* ed. Lisa G. Corrin (New York: The New Press, 1994); Douglas Crimp, *On the Museum's Ruins* (Cambridge and London: MIT Press, 1991); Johannes Meinhardt, "Eine andere Moderne," *Kunstforum International,* 123 (1993), pp. 160–91; and Craig Owens, "From Work to Frame or Is There Life After 'The Death of the Author'" in Craig Owens, *Beyond Recognition: Representation, Power, and Culture* (Berkeley and Los Angeles: University of California Press, 1992), pp. 122–39.

9. Burgin, *The End of Art Theory,* p. 39.

10. Pierre Bourdieu and Alain Darbel with Dominique Schnapper, *The Love of Art: European Art Museums and Their Public,* trans. Caroline Beattie and Nick Merriman (Stanford: Stanford University Press, 1990), p. 112.

11. See Wendy Steiner, *Pictures of Romance, Form Against Content in Painting and Literature* (Chicago: University of Chicago Press, 1988), p. 35.

12. This writer's emphasis. See Chantal Boulanger, "Installation: Beyond *In Situ,*" *Parachute,* 42 (March/April/May 1986), p. 53. Quoted in Beverly Adams, "Installation," *Encounters/Displacements: Luis Camnitzer, Alfredo Jaar, Cildo Meireles,* exh. cat. (Archer M. Huntington Art Gallery, College of Fine Arts, University of Texas at Austin, 1992), pp. 25–33.

13. "Art in the Raw," series sponsored by the Santa Monica Museum of Art, Santa Monica, California. *Sphere of Influence* was presented in 1988 and updated in 1989 according to the artist, "reflecting changes and alterations which had

occurred in the museum space during other exhibitions." Quoted in letter from the artist to this author dated February 3, 1994.

14. "Instruments of discovery" is a phrase used by the artist in correspondence to the author dated February 3, 1994.

15. Christopher Knight, "Bunn Gives Viewer Insights into Sphere of Environment," *Los Angeles Herald Examiner* (August 5, 1988), p. 4.

16. Brewster's piece was referenced via a concave mirrored button reflecting the installation back upon itself. In a conversation with this writer on February 7, 1994, the artist suggested that this concave mirrored button related to the mirror in Jan Van Eyck, *Giovanni Arnolfini and His Bride* (1434), National Gallery, London.

17. See also Howard Singerman, "Lessons from David Bunn," *Third Newport Biennial: Mapping Histories,* exh. cat. (Newport Beach, Calif.: Newport Harbor Art Museum, 1991), pp. 26–33.

18. See exhibition notes by Phyllis Plous, "David Bunn: Ruminations on a Stone" (Santa Barbara: University Art Museum, 1991).

19. *Enlarged from the Catalogue: The United States of America* was originally presented at Postmasters Gallery (New York, November 19–December 18, 1988). It was also included in *Desire of the Museum,* Whitney Museum Downtown (New York, 1989) (with catalog).

20. See Amelia Jones, "The Century of Progress Museum," exhibition brochure (New York: Blum Helman Warehouse, 1992); and Donna Harkavy, "Insights: Lawrence Gipe: Century of Progress," exhibition brochure (Worcester: Worcester Art Museum, 1992).

21. Among the red texts painted beneath Gipe's images were "Complicity," "Acquisition," "Pride," "Loss," "Order," "Desire."

22. See Elizabeth Brown, *Social Studies: 4+4 Young Americans* (Oberlin, Ohio: Allen Memorial Art Museum, Oberlin College, 1990), p. 9.

23. See interview between artist and Elizabeth Brown in Brown, *Social Studies,* p. 26.

24. Quoted from an interview with the artist by Elizabeth Brown, in Brown, *Social Studies,* p. 26.

25. Elements of the *Museum of Lesbian Dreams* have been exhibited at the San Francisco Museum of Modern Art, White Columns, New York, and the Santa Monica Museum. See David Bonetti, "Things Are Not What They Seem," *San Francisco Examiner* (February 28, 1992); Harmony Hammond and Christine Tamblyn in *New Feminist Criticism: Art, Identity, Action,* ed. Freuh, Langer, and Raven (New York: Icon Editions, 1994); Elliott Linwood, "New Additions to Millie's Museum," *Bay Area Reporter* (February 13, 1992), p. 32; Lucy Lippard, "In the Flesh," in *Backtalk* (Santa Barbara: Santa Barbara Contemporary Arts Forum, 1993), pp. 5–21.

26. Stated by the artist in David Hirsh, "Lesbian Dreams," *New York Native* (April 20, 1992), p. 45.

27. Quoted in Judith McWillie, *James Luna: Two Worlds/Two Rooms* (Intar Gallery, 1989), p. 4.

28. McWillie, *James Luna,* p. 5.

29. See Ellen Handy, "Installations and History," *Arts* (February 1989), pp. 62–5.

30. Translated by the artist as, "What do you want from my life?"

31. According to curator Norman Kleeblatt, this is common among "Jewish artists who grew up in suburbia during the 1950's and 1960's." For further comments by Kleeblatt and the artist about her childhood see Suzanne Slesin, "Perils of a Nice Jewish Girl in a Colonial Bedroom," *New York Times* (February 17, 1994), pp. C1–C6.

32. Cited by Paulo Herkenhoff, "Deconstructing the Opacities of History" *Encoun-*

ters/Displacements, p. 55. Originally cited in Luis Camnitzer, "The Ideal of the Moral Imperative in Contemporary Art," in *Luis Camnitzer: A Retrospective Exhibition 1966–1990,* exh. cat. (New York: Lehman College Art Gallery, 1991), p. 48.

33. Quoted in an interview between Johnnetta B. Cole (president of Spelman College, Atlanta, Georgia) and critic Maurice Berger in "Speaking Out: Some Distance to Go," in Maurice Berger, *How Art Becomes History* (New York: Random House, 1992), p. 190. In the same publication, see also Berger's seminal article, "Are Art Museums Racist?," pp. 143–70.

34. The exhibition was conceived and co-curated by this writer. For a full account of the exhibition see Corrin, *Mining the Museum: An Installation by Fred Wilson* (New York: The New Press, 1994).

35. Wilson was given the office of the president of the board of the Maryland Historical Society as his "studio," placing him symbolically in the museum's seat of governance. At that time, the only nonwhite member of the board was the city's African American mayor, who served as an ex officio, that is, nonvoting, trustee.

36. From "Sites of Criticism, a Symposium," *Acme Journal,* 1, 2 (1992), p. 27.

37. A phrase used by critic Judith Stein as the title for her article on Wilson's *Mining the Museum.* See Judith Stein, "Sins of Omission," *Art in America* (October 1993), pp. 110–15.

38. Fred Wilson, unpublished and undated notebooks. Cited by Lisa G. Corrin, ed., *Mining the Museum,* p. 9.

39. Wilson continued his interrogation of "exoticism" and "Orientalism" in *Re:Claiming Egypt,* a faux museum installation for the Fourth International Cairo Bienniale (December 19, 1992–March 19, 1993). The installation was replete with reproductions of pre-Raphaelite paintings of Egypt, neoclassical furniture with Egyptian motifs, engravings, Egyptian-inspired contemporary clothing, vintage photographs, and photographs of Egyptian art installed in Western museums. The project examined past and present fascination with Egypt, including the appropriation of its history by African Americans and kitschification by African American entertainers such as Michael Jackson, Eddie Murphy, Queen Latifah, and the model Iman. A version of this project also appeared in the 1993 Whitney Biennial, Whitney Museum of American Art, New York. See Kathleen Gonchorov, "Re:Claiming Egypt," an essay in the project brochure, distributed through the United States Information Agency, Washington, D.C.

40. "Mining the Museum: An Installation by Fred Wilson" was presented through a unique collaboration between The Contemporary and the Maryland Historical Society. The project was on view from April 4, 1992 to February 28, 1993. See Lisa G. Corrin, ed., *Mining the Museum* with contributions by historian Ira Berlin and curator Lisa G. Corrin, with an interview between artist Fred Wilson and art historian Leslie King-Hammond.

41. In a conversation with the writer in May 1991.

42. See, for example, *Different Voices: A Social, Cultural, and Historical Framework for Change in American Art Museums* (Washington, D.C.: American Association of Museum Directors, 1992); and *Excellence and Equity: Education and the Public Dimension of Museums* (Washington, D.C.: American Association of Museums, 1992). *Mining the Museum* was an illustration of "theory into practice" and constituted one localized model for change.

43. This blurring of the boundaries between fact and fiction was taken up again in Wilson's 1993 Capp Street Project, an installation in a historic Victorian house that Wilson made the home of Baldwin Antinous Stein, an invented relative of

Gertrude Stein, a photographer and camera collector. The docented "tour" of the house began outside with a lengthy discussion of its history including an analysis of the many fashionable faux materials and techniques used in the facade. By the time visitors got inside, they were immersed in the life of Stein, and no longer asked whether or not he was real or invented. The piece utilized all the now familiar special effects in Wilson's (and Disney's) repertoire such as talking artifacts, which provided "clues" of the secret life of the former inhabitant. In the dining room, voices around a table spoke in the gay code of the early years of this century, describing the sexual disposition of common acquaintances. "Is he sophisticated?" "Yes, he's temperamental." The tour guides ignored the voices and went on with their scripted tours. However, visitors showed various degrees of curiosity about the real topic of conversation and the real identity of Stein. According to Wilson, the project was intended to illustrate how easily we go along with the authority of the museum, denying what we know to be contrary to the history it presents.

44. Ira Berlin, "*Mining the Museum* and the Rethinking of Maryland History," in Corrin, *Mining the Museum,* p. 35.

45. Burgin, *The End of Art Theory,* p. 49.

46. This was articulated directly in a lobby video that preceded visits to the installation. Wilson insisted on including a video that immediately told the viewer they could expect something different on the third floor where the exhibition was, and that they should consider what had changed in the museum as a result of his manipulations. The video also functioned as a curator's statement where Wilson could explain that *Mining the Museum* represented *his* personal view of the Maryland Historical Society.

47. In his series of four projects in Piedmont Park commissioned for the 1993 Atlanta Festival, Wilson worked with remnants of the Atlanta's past glories in the form of historic "markers" littered around the park. Researching the origins of these markers, Wilson found that while there was copious information about some, there was often little about others. Picking four of the most evocative and sculptural of the remains, including a staircase, benches and empty pedestals, an empty pool, and a lake, Wilson intervened discreetly in a way that would highlight the park's connection to the African American community. The park was originally the location of the Cotton State Exposition of the late 1890s, held in Atlanta during the postwar reconstruction. There had been considerable resistance to locating the exposition in the South. However, during the great Chicago Exposition Frederick Douglass and Ida B. Wells had unsuccessfully petitioned for a pavilion of black contributions to American culture and technology. When the Atlanta city fathers went to Washington to present their argument for an Atlanta exposition, they brought with them three blacks who were important representatives of the black community. Promising to include the "Negro Pavilion," which had been denied in Chicago, they were ultimately able to gain approval for locating the exposition in their city. When Wilson attempted to find the exact location in the park of the "Negro Pavilion" he was unable to find it, despite the drawings of the exterior he had found during his research. Not easily thwarted, he created his own "marker" on the site of two marble benches and an empty pillar. Attached to the pillar, which was decorated with beaux arts style contemporary garden ornaments, was a plaque to one of the blacks involved in the exposition who later founded Clark College, with a lengthy description of his life and achievements. According to Wilson, "I put in place a memorial which should

have been in place, using the same classicizing style which would have been used" (in an unpublished interview with the author).

48. In *Museums Mixed Metaphors,* his installation using the collection of the Seattle Art Museum in 1993, Wilson employed a more subtle form of this strategy. In a room of nineteenth-century American paintings, he strategically placed Native American objects that related to details in the paintings. A Chase still life of fish, for example, was viewed through a transparent vitrine containing a carved Native American fish platter. Wilson's gesture was an unexpected combination of objects considered "artifacts" generally reserved for anthropological galleries of cultures of indigenous Native American people and "American Art" which contested both the definitions ascribed to "American" and to "Art." See Patterson Sims, *Museums Mixed Metaphors* (Seattle: The Seattle Art Museum, 1994).

49. See Leslie King-Hammond, "A Conversation with Fred Wilson," in Corrin, *Mining the Museum,* p. 34.

50. Elsewhere I have discussed the relationship between the Maryland Colonization Society, whose leaders were the founders of the Maryland Historical Society, and the formation of the society's collection. See Corrin, *Mining the Museum,* pp. 16–18.

51. A statement made by the Society's former director. See "Foreword," Corrin, *Mining the Museum,* p. lxxii.

52. Paraphrased from a presentation by the artist in the CAA session, "Multimedia Installation and the Public-Private Institution" (February 19, 1994).

53. Lucy Lippard, *Mixed Blessings: New Art in a Multicultural America* (New York: Pantheon, 1990), p. 6.

Chapter 8

1. See Rensselaer W. Lee, *Ut Pictura Poesis: The Humanistic Theory of Painting* (New York: Norton, 1967), pp. 3–15.

2. The books Allston charged from the Harvard College Library are recorded in its annual Library Account Books of 1797 to 1800, Harvard University Archives.

3. Daniel Webb, *An Inquiry into the Beauties of Painting and into the Merits of the Most Celebrated Painters, Ancient and Modern* (London: J. and R. Dodsley, 1760), pp. 129–30, 136.

4. William Duff, *An Essay on Original Genius, and Its Various Modes of Exertion in Philosophy and the Fine Arts* (London: Charles Dilly, 1767), p. 150.

5. H. W. L. Dana, "Allston at Harvard, 1796–1800," *Cambridge Historical Society Publications,* 29 (1948), p. 25.

6. Washington Allston, "Cheif [sic], Lovely Spring, in Thee and Thy Soft Scenes, the Smiling God Is Seen," classroom assignment, July 10, 1799, Harvard University Archives.

7. Washington Allston, "Procrastination Is the Theif [sic] of Time," classroom assignment, November 1799, Harvard University Archives.

8. Jared B. Flagg, *Life and Letters of Washington Allston,* 1892 (New York: Kennedy Galleries and Da Capo Press, 1969), pp. 38–9.

9. Rachel Flagg to Elias van der Horst, May 15, 1801, photostat (original unlocated), Museum of Fine Arts Library, Boston.

10. Allston owned and perhaps purchased during his first stay in England, *The Works of Sir Joshua Reynolds . . . Containing His Discourses, Idlers . . . and His Commentary on Du Fresnoy's Art of Painting . . . ,* 3 vols. (London: T. Cadell and W. Davies, 1801). From Allston's library list, Dana Collection, Longfellow National Historic

Site, Cambridge, Mass.

11. Lee, *Ut Pictura Poesis,* p. 69.

12. Joshua Reynolds, *Discourses on Art,* 1797, introduction by Robert R. Wark (London: Collier-Macmillan, 1966), Discourse VIII, p. 133, and Discourse II, p. 38.

13. Henry Fuseli, Lecture II (1801), in Ralph N. Wornum, ed., *Lectures on Painting by the Royal Academicians Barry, Opie, Fuseli* (London: Henry G. Bohn, 1848), p. 419.

14. S.-C. Croze-Magnan, E. Q. Visconti, and T. B. Emeric-David, *Le Musée Français: Recueil complet des tableaux, statues, et bas reliefs qui composent la collection nationale,* 4 vols. (Paris: Robillard-Péronville et Laurent, 1803–9).

15. *Diana and Her Nymphs in the Chase* was reviewed as one of Rome's important paintings of the year in Giuseppe Antonio Guattani, *Memorie enciclopediche romane sulle belle arti, antichità . . . ,* 2 vols., 1 (Rome: Salomini, 1806), p. 64.

16. Bryan Jay Wolf, *Romantic Re-Vision: Culture and Consciousness in Nineteenth-Century American Painting and Literature* (Chicago: University of Chicago Press, 1982), pp. 17–18.

17. Samuel Taylor Coleridge, "On the Principles of Genial Criticism," in his *Biographia Literaria,* ed. J. Shawcross, 2 vols., 2 (Oxford: Oxford University Press, 1907), p. 237. The three-part essay first appeared in *Felix Farley's Bristol Journal* in August and September 1814.

18. David Bjelajac, *Millenial Desire and the Apocalyptic Vision of Washington Allston* (Washington, D.C. and London: Smithsonian Institution Press, 1988), p. 80.

19. In Coleridge's eyes, Allston's paramount interest in ideal beauty kept him from mercenary tendencies. See Carl Woodring, "What Coleridge Thought of Pictures," in *Images of Romanticism: Verbal and Visual Affinities,* ed. Karl Kroeber and William Walling (New Haven and London: Yale University Press, 1978), pp. 91–106.

20. Coleridge, "On the Principles of Genial Criticism," *Biographia Literaria,* 2, pp. 219, 243.

21. Gerald Eager, "Washington Allston's *The Sisters:* Poetry, Painting, and Friendship," *Word and Image,* 6 (October–December 1990), pp. 298–307.

22. See Walter Cahn, *Masterpieces: Chapters on the History of an Idea* (Princeton: Princeton University Press, 1979), pp. 131–56.

23. Allston first described his plan for the work in a letter to Washington Irving dated May 9, 1817. See Nathalia Wright, ed., *The Correspondence of Washington Allston* (Lexington: University Press of Kentucky, 1993), p. 101.

24. Washington Irving to Allston, May 21, 1817, Houghton Library, Harvard University.

25. Bjelajac, *Millenial Desire,* pp. 135–88.

26. Edgar Preston Richardson, *Washington Allston: A Study of the Romantic Artist in America* (Chicago: University of Chicago Press, 1948), p. 137.

27. Allston to William Collins, April 16, 1819, Massachusetts Historical Society.

28. Allston borrowed Northcote's *Memoirs of Sir Joshua Reynolds* from the painter Henry Sargent. Allston to Sargent (partially dated, but surely August 20, 1819, given Allston's report on it to Charles Leslie), Massachusetts Historical Society. Allston to Leslie, November 15, 1819, Massachusetts Historical Society.

29. Allston to Gulian C. Verplanck, July 2, 1824, Massachusetts Historical Society.

30. See Diana Strazdes, "Washington Allston's *Beatrice,*" *Journal of the Museum of Fine Arts,* Boston, Vol. 6 (1994), pp. 63–75..

31. Samuel Taylor Coleridge, *The Literary Remains of Samuel Taylor Coleridge,* ed. Henry Nelson Coleridge, 1836 (New York: AMS Press, 1967), pp. 79–96.

32. See Marcia Briggs Wallace, "Washington Allston's *Moonlit Landscape,*" in *The Ital-*

ian Presence in American Art, 1760–1860, ed. Irma B. Jaffe (New York: Fordham University Press, 1989), pp. 82–94.

33. See Elizabeth Johns, "Washington Allston: Method, Imagination, and Reality," *Winterthur Portfolio,* 12 (1977), pp. 1–18.

34. [Margaret Fuller], ". . . Impressions Produced by the Exhibitions of Mr. Allston's Pictures in the Summer of 1839," *The Dial,* 1 (July 1840), pp. 74, 81; Elizabeth Palmer Peabody, "The Exhibition, in Boston, of Allston's Paintings in 1839," in *Last Evening with Allston and Other Papers* (Boston: D. Lothrop, 1886), pp. 46–7.

35. "The Spanish Maid," in Washington Allston, *Lectures on Art and Poems,* ed. Richard Henry Dana, Jr., 1850 (New York: Kennedy Galleries and Da Capo Press, 1972), pp. 333–5.

36. One such cross reference worth mentioning here is the association that Allston made with the tradition of Melancholia in the *Evening Hymn* (Montclair, N.J.: Montclair Art Museum, 1835). See Chad Mandeles, "Washington Allston's *The Evening Hymn,*" *Arts,* 54 (January 1980), pp. 142–5.

37. Reynolds, *Discourses on Art,* Discourse I, p. 23; Discourse IV, pp. 63, 66; Discourse XV, p. 239.

38. William Ware, *Lectures on the Works and Genius of Washington Allston* (Boston: Phillips, Sampson, 1852), pp. 8–11.

39. Peabody, "Last Evening with Allston," in *Last Evening with Allston,* p. 2.

40. See, for example, William H. Gerdts, "The Paintings of Washington Allston," in William H. Gerdts and Theodore E. Stebbins, Jr., eds., *A Man of Genius: The Art of Washington Allston* (Boston: Museum of Fine Arts, 1979), pp. 130–1, 140, 150–1; and Bjelajac, *Millenial Desire,* pp. 143–4.

Chapter 9

Research for this article was partly funded by a travel grant from the National Endowment for the Humanities. I would also like to thank the staff at Olana State Historic Site, Hudson, New York, for their assistance and Frank Kelly and Kevin Avery for their comments.

1. The Church scholarship is voluminous. For a sizable bibliography see Franklin Kelly, Stephen Jay Gould, James Anthony Ryan, and Debora Rindge, *Frederic Edwin Church* (Washington, D.C.: National Gallery of Art, 1989), pp. 204–6. Here I am referring primarily to several important studies on the artist: Kevin J. Avery, "*The Heart of the Andes* Exhibited: Frederic E. Church's Window on the Equatorial World," *The American Art Journal,* 18, 1 (1986), pp. 52–72; Gerald L. Carr, with an introduction by David C. Huntington, *Frederic Edwin Church: The Icebergs* (Dallas: Dallas Museum of Fine Arts, 1980); David C. Huntington, *The Landscapes of Frederic Edwin Church: Vision of an American Era* (New York: Braziller, 1966); Katherine Manthorne, *Creation and Renewal: Views of Cotopaxi by Frederic Edwin Church* (Washington, D.C.: National Museum of American Art, 1985); William H. Truettner, "The Genesis of Frederic Edwin Church's *Aurora Borealis,*" *The Art Quarterly,* 31 (Autumn 1968), pp. 267–83.

2. Although mention of the Civil War in connection with Church's pictures may be found in many studies of the artist's work, only in a few cases does it comprise a central issue of the discussion. These include Doreen Bolger Burke, "Frederic Edwin Church and 'The Banner of Dawn,'" *The American Art Journal,* 14 (Spring

1982), pp. 39–46; David C. Huntington, "Church and Luminism: Light for America's Elect," in *American Light: The Luminist Movement, 1850–1875,* ed. John Wilmerding (Washington, D.C.: National Gallery of Art, 1980. Reprint ed., Princeton University Press, 1989), pp. 154–90; Franklin Kelly, *Frederic Edwin Church and the National Landscape* (Washington, D.C.: Smithsonian Institution Press, 1988), Chapter 6.

3. Kelly, *Church and the National Landscape,* p. 119.

4. Huntington, "Church and Luminism," pp. 156–60, 179–80.

5. Huntington, Introduction to Carr, *The Icebergs,* p. 9.

6. Huntington, *Landscapes of Frederic Edwin Church,* pp. 61–2. Herman Melville, "Aurora Borealis: Commemorative of the Dissolution of Armies at the Peace," *Battle Pieces* in *The Works of Herman Melville.*

7. In a 1987 article Franklin Kelly's interpretation of *Rainy Season in the Tropics* is similar to mine, but his commentary does not include the *Aurora Borealis.* Franklin Kelly, "Frederic Church in the Tropics," *Arts in Virginia,* 27 (1987), pp. 30–1.

8. Carr, *The Icebergs,* p. 101. For the London showing see W. P. B.[ayley], "Mr. Church's Pictures. 'Cotopaxi,' 'Chimborazo,' and 'The Aurora Borealis.' Considered Also with References to English Art," *The Art-Journal* [London], 4 (September 1, 1865), pp. 265–7.

9. "Mr. Church's Pictures: Cotopaxi, Chimborazo, and the Aurora Borealis," *Art Journal,* new series 2 (December 1865), p. 688.

10. "Cotopaxi," *Harper's Weekly* (April 4, 1863), p. 210.

11. Carr, *The Icebergs,* p. 32, n. 29.

12. Ibid., p. 107, n. 2.

13. Manthorne, *Creation and Renewal,* p. 10.

14. Carr, *The Icebergs,* p. 27; Timothy Mitchell, "Frederic Church's *The Icebergs:* Erratic Boulders and Time's Slow Changes," *Smithsonian Studies in American Art,* 3 (Fall 1989), p. 21.

15. A number of other groupings of Church's paintings have been pointed out. These include the linking of *The Star in the East* (1860–1), *Sunrise* and *Moonrise* (both 1865). The first picture was an anniversary picture for Mrs. Church, and the other two he painted to commemorate the births and deaths of his first two children who died of diptheria in 1865. These were planned as an engraved triptych in 1865. "A Ramble Among the Studios in New York," *Hartford Daily Courant* (March 22, 1865), p. 2.

16. Examples of such groupings are numerous, but little information exists on the topic itself. I have also discussed Thomas Moran's three major western paintings from the 1870s as a triptych in my *Thomas Moran and the Surveying of the American West* (Washington, D.C., and London: Smithsonian Institution Press, 1992) and I am presently researching the subjects of polyptychs in American art in a second book.

17. This observation has been made by many. For an example see Kelly, *Church and the National Landscape,* p. 42.

18. George Kubler, *The Shape of Time: Remarks on the History of Things* (New Haven and London: Yale University Press, 1962), p. 45. Cited in Manthorne, *Creation and Renewal,* p. 10.

19. For more on these trips, see David C. Huntington, "Landscape and Diaries: The South American Trips of F. E. Church," *Brooklyn Museum Annual,* 5 (1963–4), pp.

65–98; Kelly, "Frederic Church in the Tropics," pp. 16–33. Regarding artists' interest in South America, including Church, see Katherine Emma Manthorne, *Tropical Renaissance: North American Artists Exploring Latin America: 1839–1879* (Washington, D.C., and London: Smithsonian Institution Press, 1989).

20. For Humboldt's influence on Church see Stephen Jay Gould, "Church, Humboldt, and Darwin: The Tension and Harmony of Art and Science," in Kelly et al., *Frederic Edwin Church*, pp. 94–107. I am not the first to mention Matthew Maury in conjunction with Church; Huntington cites his influence on the artist's interest in the polar regions in his introduction to Carr, *The Icebergs*, and Manthorne, in *Tropical Renaissance*, pp. 51–3, recounts his activities in inciting interest in commercialization and colonization of South America.

21. M. F. Maury, *The Physical Geography of the Sea* (New York: Harper & Brothers, 1855). William Lewis Herndon, *Exploration of the Valley of the Amazon, Made under the Direction of the Navy Department by Wm. Lewis Herndon and Lardner Gibbon, Lieutenants, United States Navy,* Senate Exec. Doc., 32nd Congress, 2nd session, no. 36 (2 parts, Washington, D.C., 1853–4).

22. See, for example, Inca [pseudonym for Matthew Fontaine Maury], *The Amazon, and the Atlantic Slopes of South America* (Washington, D.C.: Franck Taylor, 1853).

23. M. F. M.[aury], "The Commercial Prospects of the South," *The Southern Literary Messenger,* 17 (October and November, 1851), pp. 690, 696. The emphasis is Maury's.

24. Ibid., p. 698.

25. Editorials on the specific issues Maury presented may be found in many of the leading periodicals of the early 1850s. See, for example, "Exploration of the Valley of the Amazon," *New-Englander,* 11 (August 1854), p. 379; and "Exploration of the Valley of the Amazon," *London Quarterly Review,* 3 (January 1855), p. 511. Cited in Whitfield Bell, "The Relation of Herndon and Gibbon's Exploration of the Amazon to North American Slavery," *Hispanic American Historical Review,* 19 (1939), pp. 494–503.

Maury himself also lectured throughout the East in 1856, including in New York where Church had a studio, and in Albany, just a short trip upriver from his home in Hudson. Charles Lee Lewis, *Matthew Fontaine Maury: The Pathfinder of the Seas* (Annapolis: U.S. Naval Institute, 1927), p. 103.

26. Manthorne, *Tropical Renaissance,* p. 53; and Huntington's introduction to Carr, *The Icebergs,* p. 9. Church's copies of Maury's books remain in his library at Olana.

27. Church had met Field about 1845–6 through their families' papermaking businesses in Lee, Massachusetts. See Samuel Carter, *Cyrus Field: Man of Two Worlds* (New York: Putnam's, 1968), pp. 47, 54, 79–82; and Kelly, *Church and the National Landscape,* p. 16. Field's paintings by Church include *Lower Falls, Rochester* (1849), *West Rock, New Haven* (1849), and *The Natural Bridge, Virginia* (1852). See Kelly et al., *Frederic Edwin Church,* p. 160; and Manthorne, *Tropical Renaissance,* p. 74.

28. Carter, *Cyrus Field,* pp. 81–2.

29. Ibid.

30. Herndon, *Exploration of the Valley of the Amazon.* See also Bell, "The Relation of Herndon and Gibbon's Exploration of the Amazon to North American Slavery."

31. Herndon to Graham, Sept. 24, 1851, cited in Bell, "The Relation of Herndon and Gibbon's Exploration of the Amazon to North American Slavery," pp. 497–9.

32. Maury to Mrs. William M. Blackford, December 24, 1851. Library of Congress, Division of Manuscripts, Maury Papers IV, p. 521.

33. Charles H. Brown, *Agents of Manifest Destiny: The Lives and Times of the Filibusters* (Chapel Hill: University of North Carolina Press, 1980). Winthrop to Church, April 25, 1857, Olana State Historic Site, cited by Manthorne, *Tropical Renaissance*, p. 50.

34. C. Cushing to M. F. Maury, September 30, 1853. National Archives, Record Group 78 (Naval Observatory Records), Letters Received May–October 1853, Box 12, Entry 7.

35. Bell, "The Relation of Herndon and Gibbon's Exploration of the Amazon to North American Slavery," pp. 502–3.

36. Maury, "Commercial Prospects of the South," p. 695.

37. Theodore Winthrop, "Heart of the Andes," *Life in the Open Air and Other Papers* (Boston: Ticknor and Fields, 1863), pp. 347–8, 351. Winthrop had accompanied Church in 1856 to Maine and had also traveled to Central America twice: with the Pacific Mail Steamship Company in 1852 and as a volunteer with the U.S. Exploring Expedition to the Darien Peninsula in 1854. Manthorne, *Tropical Renaissance*, p. 11.

38. Church to Theodore Winthrop from New York, March 16, 1860. Church Papers, Olana State Historic Site.

39. John McClure [in Cincinnati] to Frederic Church, February 19, 1861, Olana.

40. Sifakis Stewart, *Who Was Who in the Civil War* (New York: Facts on File, 1988).

41. The painting was advertised as "'The North' – Church's Picture of Icebergs" and was displayed at Goupil's Gallery in New York beginning April 24, 1861. Carr, *The Icebergs*, p. 80.

42. Carr, *The Icebergs*, p. 72.

43. For more on *Our Banner in the Sky,* see Burke, "Frederic Edwin Church and 'The Banner of Dawn.'"

44. Church exhibited five works at the 1864 New York Metropolitan Sanitary Fair: *Niagara* (1857), *The Andes of Ecuador* (1855), *Heart of the Andes, Setting Sun,* and *Evening.* See Kelly et al., *Frederic Edwin Church,* p. 165.

45. *Christian Register* (Boston, March 15, 1862). Clipping from Church's papers, Olana. Cited in William and Amy Lee Cheek, *John Mercer Langston and the Fight for Black Freedom* (Urbana: University of Illinois Press, 1989), p. 435.

46. *The Evening Post* (New York) (Aug. 5, 1859). Cited in Carr, *The Icebergs,* p. 59.

47. Clipping identified only as "Church's View in the Arctic-Regions," New York, April 25, 1861. Church papers, Olana State Historic Site.

48. Louis Legrand Noble, *After Icebergs with a Painter: A Summer Voyage to Labrador and Around Newfoundland* (New York and London: D. Appleton, 1861).

49. Elisha Kent Kane, *Arctic Explorations in the Years 1853, '54, '55* (Philadelphia: Childs and Peterson, 1856), and *The U.S. Grinnell Expedition in Search of Sir John Franklin* (New York: Harper & Brothers, 1854). See also George W. Corner, *Doctor Kane of the Arctic Seas* (Philadelphia: Temple University Press, 1972).

50. William Truettner, "The Genius of Frederic Edwin Church's *Aurora Borealis,*" p. 271; and Corner, *Doctor Kane,* pp. 252–7.

51. Isaac I. Hayes, "Lecture on Arctic Explorations," *Annual Report of the Smithsonian Institution* (Washington, D.C.: U.S. Government Printing Office, 1861), and Hayes, *The Open Polar Sea: A Narrative of a Voyage of Discovery Towards the North Pole in the Schooner "United States"* (New York: Hurd and Houghton, 1867).

Church's name is listed in the list of subscribers, p. xii. A review of *The Icebergs* stated precisely these inspirations: "Dr. Kane's narrative – Dr. Hays's [sic] talk – Lady Franklin's visit – were so many inspirations. . . ." Clipping identified only as "New York, April 25, 1861" in Church's papers, Olana.

52. See Jaquelin Ambler Caskie, *Life and Letters of Matthew Fontaine Maury* (Richmond: Richmond Press, 1928), pp. 117–18; and Lewis, *Matthew Fontaine Maury,* pp. 77–80. For Field's involvement see Isabella Field Judson, *Cyrus W. Field: His Life and Work, 1819–1892* (New York: Harper & Brothers, 1896); and Carter, *Cyrus Field,* pp. 94–8 and passim. Intriguingly, the American steamer that laid much of the 1858 cable was christened *The Niagara.*

53. Hayes, *The Open Polar Sea,* p. xi.

54. Carter, *Cyrus Field,* pp. 165–74.

55. Ibid., pp. 175–80.

56. Noble, *After Icebergs with a Painter.*

57. Carr, *The Icebergs,* pp. 69, 71, 82–3.

58. *Albion* (New York, May 4, 1861), p. 213. Cited in Carr, *The Icebergs,* pp. 82–3.

59. Carr, *The Icebergs,* p. 43. Henry Wadsworth Longfellow, "The Building of the Ship," in *The American Poets 1800–1900,* ed. Edwin H. Cady (Glenview, Ill.: Scott, Foresman, 1966), p. 171. Melville's "The Berg," although of uncertain date, is even more provocative: "I saw a ship of martial build/ (Her standards set, her brave apparel on)/ Direct as by madness mere/ Against a stolid iceberg steer. . . ." *The Works of Herman Melville,* 16 (London: Constable, 1924), pp. 240–1.

60. Manthorne, *Creation and Renewal,* p. 48.

61. Louis L. Noble, "Cotopaxi: A Picture by Frederic E. Church Painted from Studies Made in the Summer of 1857," manuscript in Church's papers, Olana. The essay remained unpublished until it was included in its entirety in Manthorne, *Creation and Renewal,* pp. 61–4.

62. Melville, "The Apparition: A Retrospect," *Battle Pieces* in *The Works of Herman Melville,* p. 115.

63. Melville, "Supplement," *Battle Pieces* in *The Works of Herman Melville,* p. 186.

64. Kelly, "Frederic Church in the Tropics," pp. 30–1.

65. Hayes, "Lecture on Arctic Explorations," p. 158.

Chapter 10

I would like to express my deep gratitude to Miriam Stewart, Henri Zerner, T. J. Clark, Norman Bryson, Sarah Burns, Elizabeth Johns, Linda Bamber, Blake Stimson, and students in my American art courses at Tufts University for their critical and encouraging readings of this material as it took shape. In no way whatsoever should these readers be associated with the chapter's deficiencies.

1. Paul Ricoeur, "Life in Quest of Narrative," in *On Paul Ricoeur: Narrative and Interpretation,* ed. David Wood (London: Routledge, 1991), pp. 26–7.

2. See Elizabeth Johns, *Thomas Eakins, The Heroism of Modern Life* (Princeton: Princeton University Press, 1984); and Michael Fried, *Realism, Writing, Disfiguration, on Thomas Eakins and Stephen Crane* (Princeton: Princeton University Press, 1987). I want to be clear that in Fried's case I am not saying he disavows aporias in narration. He clearly deals with how the "unutterable in language" is represented. And yet in his version aporias become utterly utterable and seemingly

immanent and to that extent he is dealing less with aporia as a transitive figure of reception than as an intransitive sign of production and artistic intention.

3. See Marcia Pointon, *Naked Authority* (Cambridge: Cambridge University Press, 1990), pp. 35–58. Pointon takes Fried to task for avoiding the significance of the woman in *The Gross Clinic*. But Pointon's focus on the psychoanalytic character of the woman's place is as willfully circumscribed in its focus on fetish, lack, and castration anxiety. And Pointon references hysteria in passing, promising further explication but never returning to the subject. On page 49 she states; "We need to ask what it means to represent female hysteria (if that is what it is) in the male arena of medicine." That very problem has been rigorously accounted for by Carroll Smith-Rosenberg. See "The Hysterical Woman: Sex Roles and Role Conflict in Nineteenth-Century America," pp. 197–216, in Carroll Smith-Rosenberg, *Disorderly Conduct: Visions of Gender in Victorian America* (Oxford and New York: Oxford University Press, 1985).

4. See Walter Benjamin's definition of surrealism from the 1929 article of the same name: "[W]e penetrate the mystery only to the degree that we recognize it in the everyday world, by virtue of a dialectical optic that perceives the everyday as impenetrable, the impenetrable as everyday." Walter Benjamin, *Reflections* (New York: Schocken, 1986), pp. 189–90.

5. Fried's argument for the significance of writing and its representation is stimulating and provocative and I have learned much from it. See *Realism, Writing, Disfiguration,* passim. Fried does not, however, reference the blackboard "seen" by Brownell in 1880. See W. C. Brownell, "The Younger Painters of America – First Paper," *Scribner's Monthly,* 20, 1 (May 1880), pp. 1–15.

6. See Gordon Hendricks, "Thomas Eakins's *Gross Clinic,*" *The Art Bulletin,* 51 (March 1969), p. 62. The piece appeared in the *Tribune* on March 8, 1879.

7. Ibid.

8. *Daily Tribune,* March 8, 1879.

9. Samuel Bernstein, "The Impact of the Paris Commune in the United States," *The Massachusetts Review* (Summer 1971), p. 436.

10. "Demagogism and Reaction," *The New York Herald,* December 20, 1876. See also C. Vann Woodward, *Reunion and Reaction, The Compromise of 1877 and the End of Reconstruction* (Oxford and New York: Oxford University Press, 1966), p. 12 for a discussion of the political and social situation of American government in late 1876 and early 1877.

11. See Daniel Sutherland, *The Expansion of Everyday Life, 1860–1876* (New York: Harper & Row, 1989), pp. 268–9. According to Sutherland, " . . . [a] counterculture 'Centennial City' . . . sprang up outside Fairmount Park . . . to accommodate . . . people who could not afford admission to the Centennial grounds." The subordination of Eakins's painting at the Centennial might implicate it in a politics of exclusion that requires further sorting out but may relate very directly to the fears of radicalism and social disorder seen simultaneously in painting and populace.

12. See Raymond Westbrook, "Open Letters from New York," *The Atlantic Monthly,* 41 (January 1878), pp. 96–7. Westbrook refers to a type of international colorist painting, the work of what he calls the "Roman-Spanish" School (which included, for some, painters like Boldini and, for others, Monticelli, an artist referred to elsewhere as Albert Pinkham Ryder's doppelgänger), as "rank communism."

13. See Fried, *Realism, Writing, Disfiguration,* pp. 62–4, for a comparable reading.

14. Smith-Rosenberg, *Disorderly Conduct,* p. 197.

15. Ibid., p. 201.
16. Ibid., p. 197. As Carroll Smith-Rosenberg notes, "Hysterical women, fearful of their own sexual impulses – so the argument went – channeled that energy into psychosomatic illness."
17. Ibid., pp. 210–11.
18. Ibid.
19. Ibid., p. 199.
20. Michel Foucault, *The Birth of the Clinic* (New York: Vintage, 1975), pp. xviii–xix.
21. Mark Twain, "The French and the Comanches," in *Mark Twain, Letters from the Earth*, ed. Bernard DeVoto (New York: Harper & Row, 1942), pp. 146–51.
22. Ibid., p. 151.
23. See "The News from the Frontier – A Centennial War," *New York Herald* (June 21, 1876), p. 1.
24. "The Communists," *New York Times* (January 20, 1874), p. 4.
25. Reprinted in Herbert Gutman's "Trouble on the Railroads in 1873–1874, Prelude to the 1877 Crisis?" published in his *Work, Culture and Society in Industrializing America* (New York: Vintage, 1977), p. 295.
26. As Henry Nash Smith recounts, "[R]eviewers complained again and again that [Henry] James insisted on introducing them to the dissecting room of the anatomist, with repulsive associations of blood and stench and callousness. When 'dissection' becomes 'vivisection,' the notion of callousness acquires overtones of sadism." The quote is from Henry Nash Smith, *Democracy and the Novel* (Oxford and New York: Oxford University Press, 1978), p. 145.
27. *Daily Tribune* (March 22, 1879), as quoted in Hendricks, "Thomas Eakins's *Gross Clinic*, pp. 62–3.
28. See "The American Artists – Varnishing Day of the Second Exhibition," *New York Times* (March 8, 1879).
29. See Fried, *Realism, Writing, Disfiguration*, pp. 62–4.
30. See Pointon, *Naked Authority*, pp. 35–58, and Fried, *Realism, Writing, Disfiguration*, passim, for accounts of the role of the viewer both within the painting and outside of it.
31. See Smith-Rosenberg, *Disorderly Conduct*, pp. 197–216, for a broader discussion of the causes of female hysteria in nineteenth-century America.
32. Brownell, "The Younger Painters of America," p. 10.
33. The critic for the *Daily Tribune* clearly felt this way by March 22, 1879. See Hendricks, "Eakins's Gross Clinic," pp. 62–3.
34. "The French Quarter of New York," *Scribner's Monthly*, 19, 1 (November 1879), pp. 1–9. Ryder did decorative work for Cottier's firm in the 1870s, would soon move into the Benedick Building on Washington Square East, bordering the *quartier français*, knew Tiffany. It is not unlikely that he brushed shoulders with these imported workers both in the *quartier* and at Cottier's, hearing stories of the Commune from some of its survivors. See Elizabeth Broun, *Albert Pinkham Ryder* (Washington, D.C.: Smithsonian Institution Press, 1989), pp. 42–55 for more on Ryder's decorative work in the employ of Cottier's firm.
35. W. C. Brownell, "The Younger Painters of America," p. 12.
36. Ibid., p. 12. According to Ricoeur, "Life in Quest of Narrative," p. 23, "It is the function of poetry in its narrative and dramatic form, to propose to the imagination and to its mediation various figures that constitute so many *thought experiments* by which we learn to link together the ethical aspects of human conduct and happiness and misfortune. By means of poetry we learn how reversals of for-

tune result from this or that conduct, as this is constructed by the plot in the nar-rative." By lacking poetry, according to Brownell, *The Gross Clinic* failed to pro-vide those "thought experiments" which might explain the painting's seeming horror, render it an explicable representation of aporia rather than the still unut-terable image perceived by so many at the time. *The Gross Clinic* could not *speak* its subject without the mediating discourse of reception. Thus, Brownell, like oth-ers such as William Clark, Jr., had to construct a poetic realm for the painting, an alternative narrative, wherein reception found the unity lacking in the painting's primary subject. That realm was "dramatic realism, in point of art. . . ."

37. Brownell knew just how close the formal could come to other realms of meaning. He had made it plain in the same article: "[I]t is more generally understood [now] . . . that such phrases as 'large masses,' 'broad values,' 'fluent movement,' 'color as distinct from colors, and tone from either,' *really have meaning* (my ital-ics), despite much current and glib abuse of them in art chatter. . . ." See Brownell, "The Younger Painters of America," p. 2.

38. This is maintained by Westbrook in 1878, in "Open Letters."

39. The "Art Notes" of May 1881 in the *Art Journal* put the situation in the following manner: "A. P. Ryder had a color fantasy [at the fourth annual exhibition of the Society of American Artists] . . . each observer probably interpreted the subject for himself and deduced from the rich combination of colors his own meaning."

40. See my *Intricate Channels of Resemblance: Albert Pinkham Ryder and the Politics of Color* (Cambridge: Cambridge University Press, in press).

41. Ricoeur, "Life in Quest of Narrative," p. 21.

Chapter 11

1. Stephen Polcari, *Abstract Expressionism and the Modern Experience* (New York: Cambridge University Press, 1991).

2. John Keegan, *The Face of Battle* (New York: Military Heritage Press, 1986), p. 77.

3. James Jones, *World War II* (New York: Ballantine, 1975), p. 48.

4. See George L. Mosse, *Fallen Soldier* (New York: Oxford University Press, 1990), pp. 201–25.

5. Baziotes, statement for The Museum of Modern Art, New York, 1955, The Museum of Modern Art Archives. The late date of this and other works poses no problem, for the culture and ideas of the abstract expressionists were formed in the 1930s and 1940s and held throughout their lives, whatever the variations.

6. Polcari, *Abstract Expressionism and the Modern Experience*, p. 180.

7. Cited in Albert Elsen, *Seymour Lipton* (New York: Abrams, 1974), p. 27.

8. See Polcari, *Abstract Expressionism and the Modern Experience*, pp. 238–9.

9. Sir James Frazer, *The Golden Bough* (New York: Macmillan, 1922), passim. The surrealists were also interested in blood sacrifice. See Sidra Stich, *Anxious Visions/Surrealist Art* (Berkeley: University Art Museum, and New York: Abbeville Press, 1990), p. 146.

10. Quoted in Stephen Polcari, "Gottlieb on Gottlieb," *New York NightSounds*, I (March 1969), p. 11.

11. Cited in William Seitz, *Abstract Expressionist Painting in America* (Cambridge: Harvard University Press, 1983), p. 102.

12. Albert I. Dickerson, ed., *The Orozco Frescoes at Dartmouth* (1934; reprint, Hanover, N.H.: Dartmouth College, 1962), n.p.

13. Quoted in Werner Haftman, *Mark Rothko* (New York: Marlborough Gallery, 1972), p. ix.

14. Gottlieb, "The Ides of Art," *The Tiger's Eye,* I (December 1947), p. 43.

15. Mark Helprin, *A Soldier of the Great War* (New York: Avon, 1991), p. 547. De Kooning entitled an oil and charcoal on paper of 1946 *Judgment Day* (formerly known as *Study for Labyrinth*). It consists of twisting and turning humanoid biomorphs and recalls the darting of angels in the upper registers of Renaissance lamentation or Pietàs scenes. Was this a summary comment on the war much like Pollock's drawing *War* of the following year with its stacks of human skulls and fire?

16. Holger Cahill, "American Resources in the Arts," in *Art for the Millions,* ed. Francis O'Connor (Boston: New York Graphic Society, 1973), p. 42.

17. See Primo Levi, *Survival in Auschwitz* (New York: Collier/Macmillan, 1993). Innumerable reviewers praised Helprin's *A Soldier of the Great War* in a similar fashion. Typical are the words of *People* magazine: "Celebrates both the immutable power of death and the defiant strength of the human spirit."

Chapter 12

1. Sam Hunter, *Larry Rivers* (New York: Rizzoli, 1989), p. 45.

2. Hunter, *Rivers,* pp. 16–17.

3. See Mark Thistlethwaite, "A Fall from Grace: The Critical Reception of History Painting 1875–1925" in *Picturing History: American Painting 1770–1930,* ed. William Ayres (New York: Rizzoli, 1993), pp. 177–99.

4. From Charles Baudelaire, "The Painter of Modern Life" (1863), in *Baudelaire: Selected Writings on Art and Artists,* trans. P. E. Charvet (Harmondsworth, England: Penguin, 1972), p. 403.

5. Alan Trachtenberg, "Albums of War: On Reading Civil War Photographs," *Representations,* 9 (Winter 1985), p. 1, quoted in Francis Haskell, *History and Its Images* (New Haven & London: Yale University Press, 1993), p. 4.

6. Quoted in Calvin Tomkins, *Off the Wall: Robert Rauschenberg and the Art World of Our Time* (Harmondsworth, England: Penguin, 1980), p. 182.

7. Karl Kroeber, *Retelling/Rereading* (New Brunswick: Rutgers University Press, 1992), p. 120.

8. Ibid., p. 169.

9. Jean-François Lyotard, *The Postmodern Condition: A Report on Knowledge* (Minneapolis: University of Minnesota Press, 1984), p. xxiv.

10. Elizabeth Deeds Ermarth quoted in a review of her book by David Carr, "Review Essay – Sequel to History: Postmodernism and the Crisis of Historical Time," *History and Theory,* 32 (1993), p. 181.

11. Gary A. Phillips, "Exegesis as Critical Praxis: Reclaiming History and Text from a Postmodern Perspective," *Semeia,* 51 (1990), p. 20; Carr, "Review Essay," p. 180.

12. John Keane, "The Modern Democratic Revolution: Jean-François Lyotard's *La condition postmodern,*" *The Chicago Review,* 35 (1987), p. 11.

13. Tracy Achor Hayes, "Under Deconstruction," *The Dallas Morning News* (April 15, 1992), p. 8E; Jerome Weeks, "The Magic of 'Illusion,'" *The Dallas Morning News* (April 18, 1992), p. 33A.

14. Deanne Stillman, "Again, That Hankering," *New York Times* (August 22, 1993), p. 20.

15. Hayden White, "The Question of Narrative in Contemporary Historical Theory," *History and Theory,* 23 (1984), p. 20.

16. Simon Schama, *Dead Certainties (Unwarranted Speculations)* (New York: Knopf, 1991), pp. 325, 320.

17. F. R. Ankersmit, "Historiography and Postmodernism," *History and Theory,* 28 (1989), pp. 142–3.

18. Robert Venturi, *Complexity and Contradiction in Architecture* (Boston: New York Graphic Society, 1966), pp. 22–3.

19. Ellen Johnson, ed., *American Artists on Art from 1940 to 1980* (New York: Harper & Row, 1982), p. 98.

20. G. R. Swenson (interviewer), "What Is Pop Art?" *Art News,* 62 (November 1963), p. 26.

21. Steven Connor, *Postmodernist Culture* (Oxford: Basil Blackwell, 1989), p. 88.

22. The term "laminated realities" is taken from Kenneth Gergen, *The Saturated Self* (New York: Basic, 1991), p. 136.

23. Linda Hutcheon, *A Poetics of Postmodernism* (New York and London: Routledge, 1988), p. 26.

24. Wendy Steiner, *Pictures of Romance* (Chicago and London: University of Chicago Press, 1988), p. 2.

25. Ibid., p. 4.

26. Daniel Boorstin, *The Image* (New York: Harper & Row, 1964), p. 57.

27. Sidney Tillim, "Notes on Narrative and History Painting," *Artforum,* 43 (May 1977), p. 43.

28. Ibid.

29. Frank H. Goodyear, Jr., *Contemporary American Realism Since 1960* (Boston: New York Graphic Society, 1981), p. 113.

30. Frank H. Goodyear, Jr., *8 Contemporary American Realists* (Philadelphia: The Pennsylvania Academy of the Fine Arts, 1977), p. 13.

31. Judith Stein and David Shapiro, *Alfred Leslie: The Killing Cycle* (St. Louis: St. Louis Museum of Art, 1991), p. 49.

32. Ibid., p. 40.

33. Ibid., p. 68.

34. Kroeber, *Retelling/Rereading,* p. 144.

35. Goodyear, *Contemporary American Realism,* p. 116.

36. Carter Ratcliff, "Theater of Power," *Art in America,* 72 (January 1984), p. 75.

37. Ratcliff, "Theater of Power," p. 81; Lynn Gumpert and Ned Rifkin, *Leon Golub* (New York: The New Museum of Contemporary Art, 1984), p. 61.

38. Ratcliff, "Theater of Power," p. 81.

39. Gumpert and Rifkin, *Golub,* p. 61.

40. Gergen, *The Saturated Self,* pp. 73–80.

41. Carter Ratcliff, *Peter Dean* (Grand Forks: North Dakota Museum of Art, 1989), n.p. [commentary for illustration 3]

42. Ibid. [commentary for illustration 20]

43. Ibid. [commentary for illustration 16]

44. Ibid. [commentary for illustration 22]

45. Kroeber, *Retelling/Rereading,* p. 9.

46. Phillips, *Semeia,* p. 11.

47. Gergen, *The Saturated Self,* pp. 145 ff.; Rorty's thoughts on the collage personality of postmodernism are found in Ankersmit, "Historiography and Postmodernism," p. 147.

48. Kroeber, *Retelling/Rereading,* pp. 26, 41, 32.

49. Suzi Gablik, *The Reenchantment of Art* (New York: Thames and Hudson, 1991),

especially Chapter 2. A paper written by one of my students brought Rorty's notions to my attention: Sara K. Wilson, "Postmodernism: The Meaning and Value of Reconstruction" (May 6, 1992).

50. Gablik, *The Reenchantment of Art,* p. 22.
51. Wilson, "Postmodernism," p. 9.
52. See James Elkins, "On the impossibility of stories: the anti-narrative and non-narrative impulse in modern painting," *Word & Image,* 7 (October–December 1991), pp. 348–64; Schama, *Dead Certainties,* p. 320.

Chapter 13

1. Theodore Sizer, ed., *The Autobiography of Colonel John Trumbull* (New Haven: Yale University Press, 1953), p. 148.
2. Edward Livingston, "Academy of Arts," *Morning Chronicle* (January 22, 1803), p. 2.
3. Robert R. Livingston "To the honourable the Legislature of the State of New York," Robert R. Livingston Papers, New-York Historical Society; Edward Livingston, "Academy of Arts," *Morning Chronicle* (January 22, 1803), p. 2.
4. Edward Livingston, "Academy of Arts," *Morning Chronicle* (January 22, 1803), p. 2.
5. Pintard to his daughter, January 11, 1822, in Dorothy C. Barck, ed., *Letters of John Pintard to His Daughter, Eliza Noel Pintard Davidson, 1816–1833,* 4 vols. (New York: New-York Historical Society, 1937–40), 2, p. 121.
6. See Clare Brandt, "Robert R. Livingston, Jr., the Reluctant Revolutionary," in *The Livingston Legacy,* ed. Richard T. Wiles (Annandale, N.Y.: Bard College), p. 122.
7. "Discourse of Opening the Academy of the Arts," *National Advocate* (October 25, 1816), p. 3.
8. An Amateur, "Academy of Arts," *Morning Chronicle* (December 8, 1803), p. 3. George Gates Raddin, Jr., *The New York of Hocquet Caritat and his Associates 1797–1817* (New York: Dover Advance Press), p. 55, identifies the author as Washington Irving.
9. American Academy of the Fine Arts minutes, December 18, 1816, New-York Historical Society.
10. "Biographical Notice of Benjamin West, Esq., President of the Royal Academy of London," *Analectic Magazine,* 8 (July 1816), p. 59.
11. See Carrie Rebora, "Robert Fulton's Art Collection," *American Art Journal,* 22 (1990), pp. 40–63.
12. De Witt Clinton, *A Discourse Delivered Before the American Academy of the Arts* (New York: T. and W. Mercein, 1816), p. 17.
13. See the 1816 account book, John Pintard Papers, New-York Historical Society.
14. Trumbull to William Dunlap, January 26, 1817, American Academy of the Fine Arts Papers, New-York Historical Society.
15. "National Painting of the Declaration of Independence," *Commercial Advertiser* (October 6, 1818), p. 3. Mr. Dwight, "Trumbull's Independence," *Daily Advertiser* (October 8, 1818), reprinted *Evening Post* (October 9, 1818), p. 2.
16. Detector, "Great National Picture," *National Advocate* (October 20, 22, 1818), p. 3.
17. Quoted from "Deaf and Dumb," *Commercial Advertiser* (November 9, 1818), p. 3. See also Trumbull's advertisement (November 7, 1818), p. 4, and the account of the benefit's success (November 10, 1818), p. 2, in the same newspaper. The *Port Folio* 7 (January 1819), p. 88, briefly noticed the benefit.

18. "Notice of Colonel Trumbull's Picture of the Declaration of Independence," *American Journal of Science,* 1 (1818), p. 202.

19. American Academy of the Fine Arts (AAFA) minutes, December 2, 1820, New-York Historical Society.

20. "The Court of Death," *American* (December 5, 1820), p. 3.

21. Rembrandt Peale, "To the Editor of the American," *American* (December 19, 1820), p. 2.

22. "The Court of Death," *American* (December 18, 1820), p. 2, and "The Court of Death," *American* (February 6, 1821), p. 3.

23. "Academy of the Fine Arts," *Evening Post* (January 7, 1822), p. 2; "The National Painting," *Commercial Advertiser* (January 12, 1822), p. 3.

24. John Trumbull, *Address Read Before the Directors of the American Academy of the Fine Arts, January 28, 1833* (New York: Nathaniel B. Holmes, 1833), p. 5.

25. See Carrie Rebora, "Sir Thomas Lawrence's *Benjamin West* for the American Academy of the Fine Arts," *American Art Journal,* 21 (1989), pp. 18–47.

26. "[The Fine Arts]," *American* (June 4, 1824), p. 2. [John Trumbull], "To the Editors of the *American*," *American* (June 6, 1824), p. 2. See Trumbull's draft, June 6, 1824, AAFA, vol. 2, p. 23. See also "Brief Remarks on the Exhibition of the American Academy of Fine Arts," *Daily Advertiser* (June 8, 1824), p. 2.

27. AAFA minutes, February 21, 1824. His letter to West, unlocated, is transcribed in the minutes of March 6, 1824.

28. William Dunlap, *History of the Rise and Progress of the Arts of Design in the United States,* 2 vols. (New York: George P. Scott, 1834), 1, p. 293.

29. "Death on the Pale Horse," *Commercial Advertiser* (November 16, 1825), p. 2. Exhibition tabulation for 1825, American Academy of the Fine Arts, miscellaneous volume, New-York Historical Society.

30. "David's Picture of the Coronation of Napoleon," New York *American* (January 10, 1826), p. 2.

31. [Untitled notice], *Commercial Advertiser* (January 23, 1826), p. 2.

32. [John Trumbull], "American Academy of the Fine Arts. No. III," *Commercial Advertiser* (June 6, 1828), p. 2. Fragments of Trumbull's draft of this article are in the Trumbull Papers, New-York Historical Society.

33. C., "Belshazzar's Feast," *New-York Mirror* (October 10, 1829), p. 111.

34. See advertisements *Commercial Advertiser* (April 15, 1831), p. 4, *American* (April 16, 1831), p. 4. *Catalogue of Paintings, by Colonel Trumbull; Including Nine Subjects of the American Revolution* (New York: Nathaniel B. Holmes, 1831).

35. "[The pamphlet published by Col. Trumbull]," *Daily Advertiser* (May 25, 1831), p. 2.

36. Trumbull to his niece, Harriet Silliman, April 4, 1836, Trumbull Papers, New-York Historical Society.

Chapter 14

1. For an excellent account of Bingham's stabilizing compositions as an effort to domesticate an otherwise threatening, unfamiliar West, see Angela Miller, "The Mechanisms of the Market and the Invention of Western Regionalism: The Example of George Caleb Bingham," in *American Iconology,* ed. David C. Miller (New Haven: Yale University Press, 1993), pp. 112–34.

2. *The Complete Novels and Selected Tales of Nathaniel Hawthorne* (New York: The Modern Library, 1937; reprint 1965), p. 477.

3. Jane Tompkins, *Sensational Designs: The Cultural Work of American Fiction 1790–1860* (New York: Oxford University Press, 1985), pp. 3–39; and Michael Newbury, "Figuring Authorship in Antebellum America," Unpublished Ph.D. dissertation, Yale University, 1992.

4. Nancy Rash, *The Painting and Politics of George Caleb Bingham* (New Haven: Yale University Press, 1991).

5. John Barrell, *The Dark Side of the Landscape: The Rural Poor in English Painting, 1730–1840* (New York: Cambridge University Press, 1980), pp. 6, 16.

6. Herbert G. Gutman, "Work, Culture, and Society," in *Industrializing America: Essays in American-Working Class and Social History* (New York: Knopf, 1976), pp. 13, 58, 68.

7. Norman Ware, *The Industrial Worker, 1840–1860: The Reaction of American Industrial Society to the Advance of the Industrial Revolution* (1924; reprint New York: Quadrangle, 1964), pp. 26–7, 30. See also Harry Braverman, *Labor and Monopoly Capital: The Degradation of Work in the Twentieth Century* (New York: Monthly Review Press, 1974).

8. In the same years that Bingham was painting his river scenes, Currier and Ives published an almost endless variety of prints depicting the glamour of riverboat culture. What distinguishes almost every one of these images is the glorification of steamboats at the expense of their human operators. Like Thoreau's description of the train as an epicly scaled iron horse, whistling "till it is hoarse for its pains," the steam-driven boats of Currier and Ives similarly take on heroic dimensions. They fill the foreground and middle ground of the firm's most popular prints, shining in their gleaming armor and hazarding both the trials of the river and the competition of other boats. The people in these images are small; they function as afterthoughts, human appendages to the thrill of a technological sublime. When people do appear in conspicuous positions within the prints, they are usually victims of a riverboat disaster: an exploding boiler room or a precipitous collision. Again like Thoreau's Irishmen, who appear as so many "sleepers," or railway ties, underneath the tracks, they are run over by the very machine they make possible. The popular prints, in other words, admit the notion of danger into their worlds only in the form of the accidental. They convert the threat posed by the steamboat, as a harbinger of a new national economy and an industrialized culture, from a *structural* issue tied to the extension of the market into everyday life to a quixotic and haphazard feature, an accident linked only fortuitously to modern work conditions. The prints of Currier and Ives differ in this regard from Thoreau's account of the Irish laborer in *Walden,* whose degraded work status is not only "foregrounded" as a function of the machine, but comes to signify what for Thoreau is the graver danger of his – and the reader's – degraded spiritual status as a condition of modern life.

9. The commission was finally awarded, over a decade later, in 1855.

10. Quoted in Rash, *George Caleb Bingham,* pp. 42–3.

11. On the subject of regionalism as a national style, see Angela Miller, "Mechanisms of the Market," pp. 114 ff. Alex Nemerov has explored the role of western art in the late nineteenth century as tied ideologically to eastern needs in "'Doing the "Old America"': The Image of the American West, 1880–1920," in *The West as America Reinterpreting Images of the Frontier,* ed. William Truettner (Washington, D.C.: Smithsonian Institute Press, 1991), pp. 285–343. For an account of the development of regional types, see Sarah Burns, *Pastoral Inventions: Rural Life in Nineteenth-Century American Art and Culture* (Philadelphia: Temple University

Press, 1989); and Elizabeth Johns, *American Genre Painting: The Politics of Everyday Life* (New Haven: Yale University Press, 1991).

12. Gutman, *Work, Culture and Society*, p. 60.

13. Rash, *George Caleb Bingham*, pp. 54 ff., skillfully points out these double codings directed to different audiences.

14. *Complete Novels*, p. 117.

15. Foucault, *Discipline and Punish: The Birth of the Prison*, trans. Alan Sheridan (New York: Random House, 1979). For an interesting revisionary twist to Foucault's notion of the panopticon, see Alan Wallach, "Making a Picture of the View from Mount Holyoke," in *American Iconology*, ed. David C. Miller (New Haven: Yale University Press, 1993), pp. 80–91.

16. For an application of Foucauldian ideas to the study of American literature, see Richard Brodhead, *Cultures of Letters: Scenes of Reading and Writing in Nineteenth-Century America* (Chicago: University of Chicago Press, 1993), pp. 13–47; and Mark Seltzer, "*The Princess Casamassima:* Realism and the Fantasy of Surveillance," in *American Realism: New Essays*, ed. Eric J. Sundquist (Baltimore: Johns Hopkins Press, 1982), pp. 95–118. The question of surveillance in the visual arts, especially photography, is pursued especially by John Tagg, "Power and Photography: Part I, A Means of Surveillance: The Photograph as Evidence in Law," *Screen Education*, 36 (Winter 1980), pp. 17–55; and Alan Sekula, "The Body and the Archive," *October*, 39 (Winter 1986), pp. 3–64.

17. In paintings like *The Jolly Flatboatman* (1846), Bingham literalizes the notion of play through imagery of song and dance.

18. For a thoughtful and somewhat different account of Peale's *Exhumation*, see Laura Rigal, "Peale's Mammoth," in *American Iconology*, ed. David C. Miller (New Haven: Yale University Press, 1993), pp. 18–38.

19. For a parallel discussion of this painting in a different context, see my "What the Cow Saw, Or, Nineteenth-Century Art and the Innocent Eye," *Antiques*, 37 (January 1990), pp. 276–85.

20. The status of the foreground canvas is unclear. If we read it as horizontal in format, then we can assume it to be a genre painting, not unlike the one we as viewers are looking at. If we read it as vertical, then it is likely to be a portrait.

21. Even the familiar objects of the room carry ambiguous associations: The cuspidor, for example, is tied to the vexed history of tobacco and gambling in antebellum society. See Francis S. Gruber, "Richard Caton Woodville, an American Artist, 1825 to 1866," Ph.D. dissertation, Johns Hopkins University (Ann Arbor: University Microfilms, International, 1987), pp. 128 ff.

22. David Davis, *The Slave Power Conspiracy and the Paranoid Style* (Baton Rouge: Louisiana State University Press, 1969).

Chapter 15

1. "Exhibitions. 'The First Day of Worship,' by Schwartze," *The Crayon*, 7 (May 1860), p. 147.

2. On the conspicuous domination by men in the fictional world portrayed in contemporary American genre painting, see Elizabeth Johns, *American Genre Painting: The Politics of Everyday Life* (New Haven and London: Yale University Press, 1991), Chapter 5.

3. Leutze's *Mrs. Schuyler* is reproduced in Ilene Susan Fort and Michael Quick, *American Art: A Catalogue of the Los Angeles County Museum of Art Collection*

(Los Angeles: Los Angeles County Museum of Art, 1991), pp. 121–3, pl. 39. See also Michael Quick, "A Bicentennial Gift: 'Mrs. Schuyler Burning Her Wheat Fields on the Approach of the British' by Emanuel Leutze," *Los Angeles County Museum of Art Bulletin*, 23 (1977), pp. 27–35.

4. So successful was *The Image Breaker* that Leutze ultimately executed three versions. The last remained in Germany, but the others found their ways into the important art collections owned by New Yorkers John Taylor Johnston and Abraham M. Cozzens.

5. "Twenty-sixth Exhibition of the National Academy of Design," American Art-Union *Bulletin* (May 1851), p. 5.

6. A catalog of American representations of Tudor and Stuart history, including references to critical notices, is contained in the author's Ph.D. dissertation "The American Portrayal of Tudor and Stuart History, 1835–1865," Yale University (1989), vol. 2, Appendix.

7. Most of Leutze's English history paintings were painted in Düsseldorf but intended for the American market. Barbara Groseclose, *Emanuel Leutze, 1816–1868: Freedom Is the Only King* (Washington, D.C.: Smithsonian Institution Press, 1975), p. 25.

8. Glass exhibited his English Civil War genre pictures both in England and in the United States, particularly with the American Art-Union.

9. The original subject of Flagg's picture, in fact, was Mary Queen of Scots. See Ella Foshay, *Mr. Luman Reed's Picture Gallery: A Pioneer Collection of American Art* (New York: Abrams, 1990), pp. 64, 155–6. Both Delaroche's painting of this subject and Opie's *Execution of the Queen of Scots* are reproduced in Roy Strong, *Recreating the Past: British History and the Victorian Painter* (New York: Thames and Hudson, 1978), pl. VIII, figs. 142, 154.

10. These included John Towne of Philadelphia, James Robb of New Orleans, and Marshall O. Roberts, Abraham Cozzens, Charles Leupp, and John Taylor Johnston in New York.

11. *Transactions of the American Art-Union* (1845), p. 7.

12. The Art-Union published only three scenes from American history as premiums, although American subjects appeared in engravings after landscape, genre, and literary paintings.

13. Charles Burt's engraving after Leutze's unlocated painting *Sir Walter Raleigh Parting with His Wife* is reproduced in Maybelle Mann, *The American Art-Union* (Jupiter, Fla.: ALM Associates, 1987), p. 43.

14. In 1835, for instance, one reviewer hailed the appearance of the first volume of Bancroft's *History of the United States* with the observation that although educated Americans were familiar with ancient, European, and British history, they remained "hopelessly ignorant" of their own ("History of the United States," *The American Monthly Magazine*, 4 [Feb. 1835], p. 339). For further discussion of the extent of nineteenth-century Americans' familiarity with British history and their sense of their relationship to it, see Greenhouse (1989), pp. 23–36.

15. See Ruth Miller Elson, *Guardians of Tradition: American Schoolbooks of the Nineteenth Century* (Lincoln: University of Nebraska Press, 1964), pp. 6–7; George H. Callcott, "History Enters the Schools," *American Quarterly*, 11 (Winter 1959), pp. 478–82.

16. Despite its notoriously sympathetic view of the monarchy and its dated style, Hume's history (first published in the 1760s) continued to appear in multiple

new American editions until just before mid-century, when it was overtaken by Macaulay's. The latter, in turn, was estimated to have had four times as many American as British readers (Frank Luther Mott, *Golden Multitudes: The Story of Best Sellers in the United States* [New York: Macmillan, 1947], p. 95).

17. Samuel G. Goodrich, *The Pictorial History of England* (Philadelphia: Sorin & Ball and Samuel Agnew, 1846), Introduction, p. 11.

18. *The Literary World,* 1 (June 5, 1847), p. 419.

19. Leutze probably based his composition on Thomas Stothard's illustration of this scene for Boydell's Shakespeare Gallery, and the action he depicts points to Shakespeare's lines: "Sweetheart,/I were unmannerly to take you out,/and not to kiss you" (Act I, scene iv).

20. "Fine Arts . . . ," *The Anglo American* (Mar. 6, 1847), p. 477.

21. Robert T. Handy, *A Christian America: Protestant Hopes and Historical Realities* (New York: Oxford University Press, 1971); Martin E. Marty, *Righteous Empire: The Protestant Experience in America* (New York: Dial Press, 1970).

22. Leutze quoted in American Art-Union *Bulletin,* 4 (September 1851), pp. 95–6.

23. Daniel Huntington, *Catalogue of Paintings, by Daniel Huntington, N.A., Exhibiting at the Art Union Buildings, 497 Broadway* (New York: Snowden, Printer, 1850), Introduction, p. 10. Huntington's Reformation subjects included *Henry VIII and Queen Catharine Parr, Bishop Ridley Denouncing the Princess Mary, Queen Mary Signing the Death Warrant of Lady Jane Grey,* and three images of Lady Jane Grey and two of Princess Elizabeth in the Tower. All were painted in 1846–8, and all are unlocated.

24. Review of "Neal's History of the Puritans," *The Methodist Quarterly Review,* 5 (January 1845), p. 55.

25. Barbara Welter, *Dimity Convictions: The American Woman in the Nineteenth Century* (Athens: Ohio University Press, 1976), p. 21.

26. See, for instance, G. P. Disosway, "Lady Jane Grey (Beheaded 1554)," *The Ladies' Repository,* 7 (March 1847), pp. 77–8; and William Henry Herbert, "Persons and Pictures from the History of England. No. II. – Jane Grey and Guilford Dudley," *Godey's Lady's Book,* 47 (February 1851), pp. 97–102.

27. See Greenhouse (1989), pp. 171–238.

28. Emma Willard, *A System of Universal History, in Perspective* (Hartford: F. J. Huntington, 1835), p. 248.

29. The American Art-Union *Bulletin* engraving after Rothermel's *Murray's Defense of Toleration* (unlocated) is reproduced in Mann, p. 99.

30. "Two American Pictures," *National Intelligencer* (November 14, 1846), p. 2. One of Huntington's three images of the persecution of Jane Grey was in the collection of John Towne of Philadelphia, who also owned Leutze's *John Knox and Mary Queen of Scots.*

31. *Godey's,* 34 (June 1947), p. 313; *The Albion* (April 19, 1851), p. 189. In Rothermel's painting, for instance, the generic mother observing the conflict "is in full view of the zealots, who, in their zeal to uphold their religion, forget its loveliest attribute, and heed not the sermon which her extremity of want preaches to their eyes" (Thomas Dunn English, "Peter F. Rothermel," *Sartain's Union Magazine,* 10 [January 1852], p. 16).

32. Mary F. Barker, "Mary, Queen of Scots," *The Ladies' Repository,* 10 (April 1850), p. 133.

33. Lang's painting is reproduced in Richard L. Koke, comp., *Catalogue of American Landscape and Genre Paintings in the New-York Historical Society: A Catalogue of*

the Collection, Including Historical, Narrative, and Marine Art (New York: New-York Historical Society in association with G. K. Hall, 1982), no. 1571.

34. Irving's *Sir Thomas More Parting with His Daughter* is reproduced in *Art in South Carolina 1670–1970*, exh. cat., South Carolina Tricentennial Commission (1970), no. 189.

35. The idea of the Elizabethan golden age is reflected, for instance, in Jasper F. Cropsey's ideal landscape called *The Days of Elizabeth* (1853), reproduced in Peter Bermingham, *Jasper F. Cropsey 1823–1900: A Retrospective View of America's Painter of Autumn*, exh. cat. (University of Maryland Art Gallery, 1968), p. 15. Noted the *North American Review*, itself an organ of American cultural independence, "It is with a feeling of joy and exultation, that we trace the history of England during these years of terror and triumph," a period "which must always be interesting to the descendants of Englishmen on this side of the Atlantic, since it was during that period, that the features of our society began to be formed, which have indelibly stamped our own character" (50 [January 1840], pp. 184, 175).

36. Sarah Josepha Hale pleaded that it would be fairer to Elizabeth to judge her as a ruler than as a woman (*Woman's Record* [New York: 1855], p. 301).

37. [Isaac William Wiley], "Queen Elizabeth," *The Ladies' Repository*, 25 (February 1865), p. 70.

38. In 1848 Huntington painted two (unlocated) versions of Elizabeth in the Tower, one for the American Art-Union.

39. Leutze's *Princess Elizabeth* is reproduced in Koke, no. 1651.

40. [I. W. Wiley] (1865), p. 68. See also "Souvenirs of Historical Characters. No. VIII. – Queen Elizabeth," *Arthur's Home Magazine*, 7 (June 1856), p. 356.

41. William R. Taylor, *Cavalier and Yankee* (New York: Anchor, 1963); Mark E. Neely, Harold Holzer, and Gabor S. Boritt, *The Confederate Image: Prints of the Lost Cause* (Chapel Hill: University of North Carolina Press, 1987), Chapter 10.

42. James H. Moorhead, *American Apocalypse: Yankee Protestants and the Civil War 1860–1869* (New Haven: Yale University Press, 1978), pp. 49–65.

43. For literary examples and precedents see Michael Davitt Bell, *Hawthorne and the Historical Romance of New England* (Princeton: Princeton University Press, 1971), pp. 159–73; and Greenhouse, p. 287, n. 106.

44. Leutze's work preceded by a few years two better known images on this theme by British artists: William Shakespeare Burton's *A Wounded Cavalier* (1856) and John Everett Millais's *The Proscribed Royalist* (1853). See Strong (1978), pp. 144–5.

45. American Art-Union *Bulletin* (August 1850), p. 82.

46. "Woman's Lot [poem]," *The Ladies' Garland*, 1 (July 1837), p. 80.

47. The peculiar combination of prudery and moral drama that characterizes the American treatment of conventional female historical and mythological subjects has been noted in relation to contemporary ideal sculpture by Joy Kasson in her *Marble Queens and Captives: Women in Nineteenth-Century American Sculpture* (New Haven and London: Yale University Press, 1990), pp. 19–20.

Chapter 16

I am grateful to Allison Dunn-Jenkins and to Thomas W. Cutrer for their perceptive and helpful comments on this essay. The staffs at the Minnesota His-

torical Society and the Texas State Library, particularly Thomas O'Sullivan and John Anderson, provided me with a great deal of help in locating documents and illustrations. Portions of this essay are revisions of my article, "'The Hardy, Stalwart Son of Texas': Art and Mythology at the Capitol," *Southwestern Historical Quarterly* (October 1988), pp. 289–322, reprinted here courtesy of the Texas State Historical Association.

1. Richard Guy Wilson, "The Great Civilization," in *The American Renaissance, 1876–1917* (Brooklyn: The Brooklyn Museum, 1979), p. 11. The Brooklyn Museum's catalog and Wilson's essay, in particular, were key in developing this generalization. For more recent and specific examinations of this phenomenon, see Michelle Bogart, *Public Sculpture and the Civic Ideal in New York City, 1890–1930* (Chicago: University of Chicago Press, 1989); and Sarah J. Moore, "In Search of an American Iconography: Critical Reaction to the Murals at the Library of Congress," *Winterthur Portfolio*, 25, 4 (Winter 1990), pp. 231–9.

2. See Henry-Russell Hitchcock and William Seale, *Temples of Democracy: The State Capitols of the USA* (New York: Harcourt Brace Jovanovich, 1976) for an overview of the state capitols. Robert Wiebe, *The Search for Order* (New York: Macmillan, 1967) and Alan Trachtenberg, *The Incorporation of America: Culture and Society in the Gilded Age* (New York: Hill and Wang, 1982) are two key texts discussing the move toward a nationalist economy and culture at the turn of the last century. Wilbur Zelinsky's *Nation into State: The Shifting Symbolic Foundations of American Nationalism* (Chapel Hill: University of North Carolina Press, 1988) is also useful. See in particular pp. 211–15.

3. See Sarah J. Moore, "In Search of an American Iconography." In her article, Moore labels those championing the allegorical as "cosmopolitan universalists" and those calling for the depiction of actual historical scenes as "cultural nationalists." I have not used her terminology because I believe it obscures the fact that even allegorical painting, such as that in the Library of Congress, can be nationalist in intent. Certainly Blashfield's *The Evolution of Civilization*, which both she and Richard Murray (see note 4) cite as being the archetypal library mural, celebrates the United States as heir to the knowledge and achievements of Western civilization and thus is nationalist in intent. Similarly, as I shall argue, depiction of historical scenes might serve local and regional needs in addition to national ones.

4. Royal Cortissoz, "Our National Monument of Art: The Congressional Library at Washington," *Harper's Weekly*, 39 (December 28, 1895), pp. 1240–1, cited in Richard N. Murray, "Painting and Sculpture," *The American Renaissance, 1876–1917*, p. 185.

5. Kenyon Cox, "The Subject in Art," *Scribner's*, 50, 1 (July 1911), p. 12; cited in Moore, "In Search of an American Iconography," p. 234.

6. Charles M. Shean, "Mural Painting from an American Point of View," *Craftsman*, 7, 1 (October 1904), pp. 24–6.

7. E. V. Lucas, *Edwin Austin Abbey, Royal Academician: The Record of His Life and Work*, 2 vols. (New York: Scribner's, 1921), p. 404; cited in Heritage Studies, Inc., *The Pennsylvania Capitol: A Documentary History*, vol. 2 (Harrisburg: The Capitol Preservation Committee, 1987), p. 346.

8. See Neil B. Thompson, *Minnesota's State Capitol: The Art and Politics of a Public Building* (St. Paul: Minnesota Historical Society, 1974), for a history of the building. I've used 1905 here as the completion date because the legislature first occu-

pied the building in January of that year; the building was officially turned over to the state by the building commissioners in 1907.

9. For a recent assessment of Gilbert, see Geoffrey Blodgett, "Cass Gilbert, Architect: Conservative at Bay," *The Journal of American History*, 72 (December 1985), pp. 615–36; Blodgett discusses Gilbert's ambitions (p. 618), and correspondence in the Gilbert Papers at the Library of Congress corroborates Blodgett's assessment. See Cass Gilbert to [Mary Gilbert], January 3, 1891, box 6, Gilbert Papers (Library of Congress). In 1899, some six years before the completion of the capitol, Gilbert moved his practice to New York City where he had received the commission for the U.S. Customs House.

10. For an overview of the capitol and its painters, see Neil Thompson, *Minnesota's State Capitol*. On La Farge, see H. Barbara Weinberg, "John La Farge: Pioneer of the American Mural Movement," in *John La Farge* (New York: Abbeville Press, 1987), pp. 161–94.

11. Julie C. Gauthier, *The Minnesota Capitol: Official Guide and History* (St. Paul: State of Minnesota, 1907), p. 16. The quote is from La Farge's assistant, Francis Davis Millet, in Sylvester Baxter, "Francis Davis Millet: An Appreciation," *Art and Progress*, 3 (July 1912), p. 640. Cited in Weinberg, "John La Farge," p. 191.

12. Gilbert apparently began investigating the possibility of working with America's most prominent mural painters shortly after receiving the commission from the state of Minnesota, see Lamb to Gilbert (March 4, 1896), Cass Gilbert Papers, Box 5 (Minnesota Historical Society, hereafter MHS) and Gilbert to Channing Seabury (February 18, 1896), State Capitol Board Collection, Letters Received (MHS). Numerous letters from the artists who eventually received commissions also indicate he was meeting with them and discussing his plans from a period well before they received their commissions until their murals were complete. Indeed, Gilbert established an advisory Board of Decorative Design consisting of those artists in order to assure they would not be subject to the censorship of the State Capitol Commission. Gilbert as well as the artists were all living in New York City at the time. Most of the letters documenting their association are in the Cass Gilbert Papers and the collection of the State Capitol Commission (MHS) as well as the Cass Gilbert Papers at the Library of Congress (LC).

13. Gilbert to State Capitol Commissioners, May 5, 1903, State Capitol Commission Papers, Letters Received (MHS). In this letter requesting contracts for the mural painters, Gilbert urges the commissioners to fund the murals "as the most important portions of the [interior design] work" and to leave any other commissions for art work until later if funds allow.

14. Various newspaper articles and letters to Gilbert and the board document suggestions made by the public for scenes from Minnesota history. See especially, "Painting for New Capitol," *St. Paul Pioneer Press* (June 24, 1903); clipping from *St. Paul Pioneer Press* (November 26, 1904), State Capitol Commissioners Board – Letters Received (MHS); Bishop John Ireland to Cass Gilbert (February 24, 1904), State Capitol Commissioners Board – Letters Received (MHS).

15. "Painters Say They Can Do It," Minneapolis *Journal (MJ)* (January 18, 1904), p. 7; "Garnsey's Work Causes Suit," *MJ* (January 26, 1904), p. 4.

16. "Capitol Is Good Only to Look At," *MJ* (January 7, 1905), p. 5; "Beautiful But Not Useful," *MJ* (January 7, 1905), p. 4.

17. [William D. Washburn], "'Old First' Forgotten in Capitol Frescoes," *MJ* (January 16, 1905), p. 4.

18. "Would Be Glad of Recognition," *MJ* (January 17, 1905), p. 6; "To Give War History," *MJ* (February 8, 1905); "A Great Theme," *MJ* (April 26, 1905), p. 4.

19. "Would Be Glad of Recognition."

20. H. H. Kidder, "Missionary Ridge: Douglas Volk's Picture of Minnesota's Men in the Famous Charge," *The Billman* (December 8, 1906), pp. 538–9; Volk file, Office of the Curator of Art; Minnesota Historical Society.

21. Volk's painting of Father Hennepin is based on an engraving contemporary to the event published in France, and Millett's is based on a painting by Frank Mayer, who attended the treaty signing. See Gilbert to Channing Seabury (April 19, 1904), State Capitol Commissioners Board – Letters Received (MHS); Douglas Volk to Channing Seabury (July 28, 1904), State Capitol Commissioners Board – Letters Received (MHS); Douglas Volk to Cass Gilbert (August 15, 1904), Gilbert Papers (MHS); Francis Millett to Gilbert (November 13, 1904, February 2, 1905), Gilbert Papers, Box 7 (LC).

22. Theodore C. Blegen, *Minnesota: A History of the State* (Minneapolis: University of Minnesota Press, 1975), pp. 167–71.

23. Robert M. Utley gives a useful overview of the uprising in *Frontiersmen in Blue: The United States Army and the Indian, 1848–1865* (New York: Macmillan, 1967), pp. 261–80; see also D. Alexander Brown, *The Galvanized Yankees* (Urbana: University of Illinois Press, 1963). *Galvanized Yankee* is a term used to describe Confederate prisoners of war pressed into service for northern states.

24. "Mural and Sculptural Decoration of the St. Paul Capitol," *International Studio*, 26 (October 1905), pp. 81, 84. Gilbert himself may have been the author of this article which, in fact, did not deal with the history paintings in the governor's reception room. It is significant here, however, as a revelation of the attitude of some that the new capitol was an indication the forces of art and civilization had overcome barbarism in Minnesota.

25. Thompson, *Minnesota's State Capitol*, pp. 78–80.

26. For the significance of such ritual, see *American Historical Pageantry: The Uses of Tradition in the Early Twentieth Century* (Chapel Hill: University of North Carolina Press, 1990).

27. For information about Myers and the capitol, see the special issue of *Southwestern Historical Quarterly*, 92, 2 (October 1988), especially the articles by William Elton Green, "'A Question of Great Delicacy: The Texas Capitol Competition, 1881," pp. 247–70, and by Paul Goeldner, "The Designing Architect: Elijah E. Myers," pp. 271–87.

28. In "'The Hardy, Stalwart Son of Texas': Art and Mythology at the Capitol," *Southwestern Historical Quarterly* (October 1988), pp. 289–322, I provide a more detailed overview and examination of the art in the Texas capitol than is possible within this chapter.

29. For the term *invented tradition*, see Eric Hobsbawm and Terence Ranger, *The Invention of Tradition* (Cambridge: Cambridge University Press, 1983), p. 1, where it is defined as "a set of practices, normally governed by overtly or tacitly accepted rules of a ritual or symbolic nature, which seek to inculcate certain values and norms of behaviour by repetition, which automatically implies continuity with the past." Generally, the emphasis in the scholarship on "invented traditions" has been on the ways in which the state – often new nations or political structures – has used such traditions to construct a national identity, establish social cohesion, and/or consolidate power. Although the contributors to Hobsbawm's and Ranger's volume are more concerned with pageants, coronations,

and other ritual events, art, and particularly an officially sanctioned public art, could also fit their definition.

30. Austin, *Daily Statesman* (April 26, 1891).

31. For information on the social and political context of the 1890s, see Alwyn Barr, *Reconstruction to Reform: Texas Politics, 1876–1906* (Austin: University of Texas Press, 1971); and David Montejano, *Anglos and Mexicans in the Making of Texas, 1836–1986* (Austin: University of Texas Press, 1987). For quotation, see Hayden White, "The Tasks of Intellectual History," *The Monist*, 53 (1969), p. 606, cited in Michael Kammen, *Mystic Chords of Memory: The Transformation of Tradition in American Culture* (New York: Knopf, 1991), p. 12.

32. *San Jacinto* (92 by 167 feet) has hung in the Senate since 1901 and *Dawn at the Alamo* (83 by 143 feet) since its completion in 1905. Sam Ratcliffe makes the point in *Painting Texas History to 1900* (Austin: University of Texas Press, 1992) that the paintings in the entrance to the capitol and in the rotunda that the Texas legislators appropriated funds for in the 1880s, as well as the artist, William Henry Huddle, who completed many of them, were more dignified and respectable than McArdle and his canvases, which had "widespread public approval" (pp. 50–1). His point supports my contention that the public could, as in Minnesota, have a significant voice in what kind of painting actually appeared in a state's capitol. Certainly the legislature did not remove McArdle's paintings after they had been hung in the capitol although it would be more than two decades before it would appropriate funds to purchase them from McArdle's estate. See Ratcliffe, pp. 50–1, for details on this funding.

33. On McArdle, see Ratcliffe, xiv–xv, pp. 35–41; and Pauline Pinckney, *Painting in Texas: The Nineteenth Century* (Austin: University of Texas Press, 1967), pp. 190–5.

34. See "H. A. McArdle's Companion to the Battle Paintings, Historical Documents, Vol. 1 – Dawn at the Alamo"; and "H. A. McArdle's Companion to the Battle Paintings, Historical Documents, Vol. II – The Battle at San Jacinto," manuscript collection (Archives Division, Texas State Library, Austin). These two leather-bound volumes contain McArdle's notes, correspondence, and descriptions of the two paintings. For quotation, see vol. 1, p. 8.

35. See, for example, Ratcliffe, *Painting Texas History*, pp. 39–40. Ratcliffe provides a well-researched account of McArdle's sources and what is accurate and inaccurate in McArdle's depiction of the battle.

36. "Companion to the Battle Paintings . . . Vol. I," p. 10.

37. Susan Prendergast Schoelwer, *Alamo Images: Changing Perceptions of a Texas Experience* (Dallas: DeGolyer Library and Southern Methodist University Press, 1985), pp. 132–62. Schoelwer discusses in fascinating detail the changing images of these three individuals.

38. In this essay I have relied heavily on Richard Slotkin's discussion of myth in *The Fatal Environment: The Myth of the Frontier in the Age of Industrialization, 1800–1890* (Middletown, Conn.: Wesleyan University Press, 1985), especially Chapters 1 and 2. Slotkin's discussion of myth is particularly useful because of the overview he provides of various interpretations and definitions of myth and because the time period, as well as the myths, that he deals with in the book are relevant to the subject of this essay. Quotation, p. 19.

39. John Adams to Abigail Adams (April 27, 1777), *Adams Family Correspondence*, 4 vols., ed. Lyman H. Butterfield (Cambridge, Mass.: Belknap Press of Harvard University Press, 1963–73), II, pp. 224, 225.

40. For a discussion of these views, see Arnoldo De Leon, *They Called Them Greasers: Anglo Attitudes Toward Mexicans in Texas, 1821–1900* (Austin: University of Texas Press, 1983), especially Chapters 2 and 8.

41. In this respect, McArdle's painting conforms to Slotkin's understanding of the process of myth. As he notes in *The Fatal Environment,* myth provides rules for behavior by "transforming secular history into a body of sacred and sanctifying legends" (p. 19). For information on the gun platform and whether or not one was actually constructed at the Alamo, see Ratcliffe, p. 109, n. 72. My interpretation doesn't depend on the outcome of this debate and is not intended as an endorsement of one side or another. In fact, I find the fact that there even is such a debate more telling than the establishment of a "truth" one way or another.

42. McArdle, "Brief Description or Reading of the Painting," in "Companion . . . Vol. II," pp. 25–9.

43. Slotkin, *Fatal Environment,* pp. 19–20.

44. See Montejano, *Anglos and Mexicans,* pp. 76–95. As Montejano points out, "race relations, which drew heavily from the legacy of the Alamo and the Mexican War, were maintained and sharpened by market competition and property disputes," p. 82.

45. Kammen, *Mystic Chords of Memory,* p. 141.

46. See Vivien Green Fryd, *Art and Empire: The Politics of Ethnicity in the U.S. Capitol, 1815–1860* (New Haven: Yale University Press, 1992), pp. 209–13, for a discussion of Leutze's painting and its physical context.

Chapter 17

1. Bernarda Bryson Shahn has described her role as follows: "The conception was Ben's; I did a lot of the painting, of course, under his instructions and/or guidance." Letter to the author (July 5, 1992).

2. A previous study of this mural is by Frances K. Pohl, "Constructing History, A Mural by Ben Shahn," *Arts Magazine* (September 1987), pp. 36–40. See also Frances K. Pohl, *Ben Shahn with Ben Shahn's Writings* (San Francisco: Pomegranate, 1993), pp. 11–21.

3. Victor Burgin, *The End of Art Theory* (Atlantic Highlands, N.J.: Humanities Press International, 1986), pp. 112–21, 129; Burgin argues for a separation of hieroglyph and *peripeteia* but states that Barthes "conflates" them. Barthes's approach is then more accurate for Shahn, who also conflates them. See also Roland Barthes, "The Third Meaning," in *A Barthes Reader* (New York: Hill and Wang, 1982), pp. 317–33; and Roland Barthes, *Camera Lucida* (New York: Hill and Wang, 1981).

4. For the artist's description of this process see Ben Shahn, *The Shape of Content* (Cambridge: Harvard University Press, 1957), pp. 29–30.

5. Gardner Jackson to Ben Shahn (October 13, 1931). Shahn Papers (1991), Archives of American Art, Smithsonian Institution, Washington, D.C. (AAA); On Tom Mooney see file "Tom Mooney," Shahn Papers (1991), AAA; and Diego Rivera, "Foreword," *The Mooney Case by Ben Shahn* (New York: Downtown Gallery, 1933); on Scottsboro Case see file "Scottsboro Boys," Shahn Papers (1991), AAA.

6. Jean Charlot, "Ben Shahn," *Hound and Horn,* 6, 4 (July–September 1933), p. 633. Jean Charlot was a close friend of the Mexican mural painters and a participant in the mural renaissance in Mexico. Another reviewer referred to the works as

part of our "modern revolutionary mythology" (Matthew Josephson, "The Passion of Sacco-Vanzetti," *The New Republic* [April 20, 1932], p. 275).

7. Lincoln Kirstein, *Mural Painting in America* (New York: Museum of Modern Art, 1932). On the censorship incident see Hugo Gellert, "We Capture the Walls!" *Art Front* (November 1934), p. 8.

8. Diego Rivera, *Portrait of America,* with an explanatory note by Bertram Wolfe, (New York: Covici Friede, 1934). See especially panel XII, pp. 183–91 "The New Freedom," ill. p. 185. Lawrence Hurlburt, *The Mexican Muralists in the United States* (Albuquerque: University of New Mexico Press, 1989), pp. 175–93. See also Ida Rodriguez-Prampolini, "Rivera's Concept of History," in *Diego Rivera, A Retrospective,* ed. Cynthia Neuman Helms (New York: Founders Society, Detroit Institute of Art and in conjunction with Norton, 1986), pp. 131–7.

9. Interview with Lucienne Bloch (November 2 and 3, 1992).

10. Laura Katzman is examining in depth Ben Shahn's relationship to photography. See her article "The Politics of Media-Painting and Photography in the Art of Ben Shahn," *American Art,* 7, 1 (Winter 1993), pp. 61–87.

11. Interviews with Bernarda Bryson (August 2, 1991 and March 16, 1992). See Bernarda Bryson interview with Lisa Kirwin (April 29, 1983), AAA. Bryson mentioned here that she was actually able to get her phoned-in reports included in the *New York Times* by knowing how to sound like one of their reporters.

12. Letter to the author (July 5, 1992).

13. Sidney Baldwin, *Poverty and Politics, The Rise and Decline of the Farm Security Administration* (Chapel Hill: University of North Carolina, 1968), pp. 107–18. See also Eleanor Roosevelt, *This I Remember* (New York: Harper Brothers, 1949), pp. 125–33. Eleanor Roosevelt was instrumental in urging help for these workers. There were three programs: rural rehabilitation, land reform, and the community program, which was to combine industry with subsistence farming in a cooperative community.

14. Interview (July 16, 1993). Bryson spoke of going to towns simply because they liked their names, such as Freeze Fork, Kentucky, and Sweet Home, Georgia.

15. Jack Hurley, *Portrait of a Decade, Roy Stryker and the Development of Documentary Photography in the Thirties* (Baton Rouge: Louisiana State University, 1972), p. 50. According to Hurley, Shahn was instrumental in formulating Stryker's use of photography. See also John Tagg, "The Currency of the Photograph: New Deal Reformism and Documentary Rhetoric," in *The Burden of Representation* (London: Macmillan, 1988), pp. 153–83.

16. "We Are the People," typescript, Shahn Papers (1991), AAA.

17. Interview (July 16, 1993).

18. Letter to the author (September 7, 1993). Edwin Rosskam, *Roosevelt, New Jersey, Big Dreams in a Small Town and What Time Did to Them* (New York: Grossman, 1972), pp. 19–29. See also Memorandum, Shahn Papers (1991), AAA.

19. "Two other architects preceded Kastner – one wanted to build tamped earth houses – he was let go. The second designed pre-fab houses and a huge factory was erected off the edge of town for the purpose of manufacturing the slabs. It was badly designed, was stopped and for a number of years stood at the edge of town, empty. Next a contractor made off with four million dollars worth of supplies." Letter to the author from Bernarda Bryson Shahn (September 7, 1993).

20. Interoffice Communication to Adrian Dornbush from Alfred Kastner (March 2, 1936), Shahn Papers (1991), AAA.

21. Shahn Papers (1991), AAA.

22. These sketches are illustrated in Bernarda Bryson Shahn, *Ben Shahn* (New York: Abrams, 1972), pp. 147–8.

23. Shahn Papers (1991), AAA.

24. Letter from Adrian Dornbush to Milo Perkins (January 1937), Shahn Papers (1991), AAA.

25. Bernarda Bryson Shahn, letter to the author (July 5, 1992).

26. Ann Novotny, *Strangers at the Door* (Riverside, N.Y.: Chatham Press, 1971), p. 15. A photograph of Steinmetz with Einstein appears on this page.

27. Seldon Rodman, *Portrait of the Artist as an American, Ben Shahn, A Biography with Pictures* (New York: Harper, 1951), pp. 156–9. Photograph of Shahn's father, mother, and great-grandmother appear in this text.

28. Interview with Bernarda Bryson Shahn (July 16, 1993).

29. Shahn had a pamphlet on the history of the International Ladies Garment Workers Union that outlined the dramas of the early years of the union, dramas that frequently centered around young girls. Educational Department, *The Story of the I.L.G.W.U.* (New York: Abco Press, 1935). Shahn chose to focus on the more publicly recognizable male leaders.

30. The two unions, AF of L and CIO, were still sensitively separate as indicated in a letter that documents Shahn being asked to avoid suggesting a sequential relationship between the two groups in his diagram in the background of the painting. Adrian Dornbush to Milo Perkins (n.d.), Shahn Papers (1991), AAA.

31. Illustrations of the murals by other artists discussed can be found in the following books: Francis O'Connor, ed., *The New Deal Art Projects, An Anthology of Memoirs* (Washington, D.C.: Smithsonian Institution Press, 1972), George Biddle, p. 33, and Edward Laning, pp. 84–5, 96–7; Francis V. O'Connor, *Art for the Millions* (Boston: New York Graphic Society, 1975), Marion Greenwood, p. 51.

32. For illustrations of the mural see Henry Adams, *Thomas Hart Benton* (New York: Knopf, 1989), pp. 157–67, 185–91.

33. Erica Doss, *Benton, Pollock and the Politics of Modernism* (Chicago: University of Chicago Press, 1991) has the most recent and useful discussion of Benton's murals.

34. On the theme of sexual stereotyping in New Deal murals, see Barbara Melosh, *Engendering Culture: Manhood and Womanhood in New Deal Art and Theatre* (Washington, D.C.: Smithsonian Institution Press, 1992). Melosh errs in not distinguishing the changes during the course of the New Deal in gender images; she focuses in painting only on the late Treasury Section Post Office murals.

35. Letter to the author (July 5, 1992). The finished mural does seem to use Bryson's design in the case of some of the workers.

36. Undated handwritten note, Shahn Papers (1991), AAA.

37. One other unexecuted immigration series had been proposed earlier for Greenhills, Wisconsin, that related to the history of the "progressive-liberal movement" and the "major immigrant groups, the Germans, refugees from the unsuccessful German Socialist uprising of 1848, bringing with them great social idealism; the Scandinavians with their fine farming tradition; the Irish, always politically gifted; the New Englanders with their rigid beliefs in personal liberty, free speech, and free education." Undated typescript, Shahn Papers (1991), AAA.

Chapter 18

1. Letter from May Stevens to author, dated November 29, 1993. I want to thank the

following for reading early drafts of the manuscript and for offering useful suggestions: Rudolf Baranik, Melissa Dabakis, and Kevin Whitfield. I am especially grateful to May Stevens, who also read one of the final drafts, corrected punctuation, and clarified errors of fact. I also want to acknowledge with thanks the Humanities Foundation of the College of Liberal Arts at Boston University that provided needed funds for photography.

2. The studio pictures were shown as "Three History Paintings" at Lerner-Heller Gallery, New York, in October 1978; *Soho Women Artists* and *Mysteries and Politics*, along with *Artemisia Gentileschi*, were shown the following February at Franklin and Marshall College. See Alan Wallach, "May Stevens: On the Stage of History," *Arts Magazine*, 53 (November 1978), pp. 150–1; and Folke T. Kihlstedt, "Narrowing the Gap: An Interpretation of Recent Works by May Stevens," in *Mysteries and Politics* (Lancaster, Penn.: Dana Room Gallery, Steinman College Center, Franklin and Marshall College, 1979).

3. I use the term *montage*, rather than *collage*, because it relates more to the montage practice of radicals and Marxists in Germany and the Soviet Union, whose goals were protest, propaganda, and persuasion through words and photographic fragments. See my review, "Montage – The Art of Protest, Propaganda, and Persuasion," *Art New England*, 13 (June 1992).

4. Much has been written about the *Ordinary/Extraordinary* series; see Moira Roth, "Visions and Re-Visions: Rosa Luxemburg and the Artist's Mother," *Artforum*, 19 (November 1980); and Lisa Tickner, "May Stevens," *Block*, 5 (1981); both are reprinted in Boston University Art Gallery, *May Stevens: Ordinary, Extraordinary, A Summation, 1977–1984* (Boston: Boston University Art Gallery, 1984). Lucy R. Lippard, "Masses and Meetings," and Donald Kuspit, "May Stevens Within the Self's Heroic and Unheroic Past," are both original essays in Boston University Art Gallery, *May Stevens*. Other articles include Melissa Dabakis, "Re-imagining Women's History," in Melissa Dabakis and Janis Bell, eds., *May Stevens: Ordinary – Extraordinary* (New York: Universe Books, 1988); Josephine Withers, "Revisioning Our Foremothers: Reflections on the Ordinary, Extraordinary Art of May Stevens," *Feminist Studies*, 13 (Fall 1987), pp. 485–512; and Patricia Mathews, "A Dialogue of Silence: May Stevens' Ordinary, Extraordinary, 1977–1986," *Art Criticism*, 3 (Fall 1987).

5. Quoted in Lippard, "Masses and Meetings," n.p.

6. For a history of the artists' antiwar movement, see Lucy R. Lippard, *A Different War* (Seattle: Whatcom Museum of History and Art, 1990). Earlier, during the mid-1960s, Stevens painted pictures related to the civil rights movement. The two movements overlapped; see Lucy R. Lippard, "Dreams, Demands, and Desires: The Black, Antiwar, and Women's Movements," in *Tradition and Conflict: Images of a Turbulent Decade, 1963–1973*, ed. Mary Schmidt Campbell (New York: Studio Museum in Harlem, 1985).

7. Lucy R. Lippard, *May Stevens: Big Daddy 1967–75* (New York: Lerner-Heller Gallery, 1975), n.p., reprinted in Lucy R. Lippard, *From the Center: Feminist Essays on Women's Art* (New York: Dutton, 1976), p. 237.

8. On March 5, 1994, Stevens sent me a photocopy of such a photograph of Ford. She recalls also thinking about Ingres's portrait of M. Bertin, when she did the Big Daddy pictures.

9. See Chronology to *Tradition and Conflict*, pp. 83–9. By 1971 the Art Workers Coalition had folded, but Baranik, Stevens, and other artists continued with the organization Artists Meeting for Cultural Change; Benny Andrews and other

black artists continued with the Black Emergency Cultural Coalition to keep up the pressure for reform.

10. From the eleventh thesis on Feuerbach written in 1845. See Karl Marx, "Theses on Feuerbach," *Karl Marx and Frederick Engels: Selected Works in Two Volumes*, Vol. 2 (Moscow: Foreign Languages Publishing House, 1955), p. 404. My analysis of the effect of consciousness raising sessions is based on my own experience of two years' membership in such groups, the second year of which was spent with a group of women artists.

11. Lippard's *From the Center* was dedicated "for all the women artists coming out from the center everywhere."

For an intellectual history of women artists and art historians from the late 1960s to the 1980s, see Thalia Gouma-Peterson and Patricia Mathews, "The Feminist Critique of Art History," *Art Bulletin*, 69 (1987), pp. 326–57. However, this essay provoked controversy; see also Norma Broude, Mary D. Garrard, Thalia Gouma-Peterson, and Patricia Mathews, "Discussion: An Exchange on the Feminist Critique of Art History," *Art Bulletin*, 71 (1989); pp. 124–7. As this goes to press, a new useful history has appeared: Norma Broude and Mary D. Garrard, *The Power of Feminist Art: The American Movement of the 1970s, History and Impact* (New York: Harry N. Abrams, 1994).

12. Quoted in Linda Nochlin, ed., *Realism and Tradition in Art, 1848–1900* (Englewood Cliffs, N.J.: Prentice-Hall, 1966), pp. 33–4; translated from Gustave Courbet, *Exhibition et vente de 40 tableaux et 4 dessins de l'oeuvre de M. Gustave Courbet, avenue Montaigne* (7 Champs-Elysées, Paris, 1855), n.p.

13. See Linda Nochlin, "Courbet's Real Allegory: Rereading 'The Painter's Studio,'" in *Courbet Reconsidered* (Brooklyn: The Brooklyn Museum, 1988); Nochlin cites Hélène Toussaint, "Le Realisme de Courbet au service de la satire politique et de la propagande gouvernmentale," *Bulletin*, 67 (1982), pp. 5–27.

14. Most all are couples: Belkin and Rainie; Sleigh and Alloway; Spero and Golub; and of course Stevens and Baranik.

15. The artist pointed out to me that "Some legs both of chairs and of people are missing," like the "Egyptian tomb paintings where oxen pulling carts had only the number of horns and legs necessary to complete the illusion of movement in space." [Marginalia on an early draft of this manuscript dated February 28, 1994.]

16. Cindy Nemser, "Conversations with May Stevens," *The Feminist Art Journal*, 3 (Winter 1974–5), p. 6.

17. Ibid.

18. Ibid.

19. Ibid.

20. Ibid., p. 7.

21. Later issues would focus on decorative art, on the mythology of the Great Goddess, on racism, on Latina art, and so on.

22. *Heresies: A Feminist Publication on Art and Politics*, No. 1 (January 1977). The collective members included Patsy Beckert, Joan Braderman, Mary Beth Edelson, Harmony Hammond, Elizabeth Hess, Joyce Kozloff, Arlene Ladden, Lucy Lippard, Mary Miss, Marty Pottenger, Miriam Schapiro, Joan Snyder, Elke Solomon, Pat Steir, May Stevens, Michelle Stuart, Susana Torre, Elizabeth Weatherford, Sally Webster, and Nina Yankowitz. As a member of the editorial collective, Stevens also wrote a short paragraph on herself as a socialist-feminist artist.

23. Stevens excerpted the passage from a letter of December 28, 1916, published in J. Peter Nettl, *Rosa Luxemburg* (New York: Oxford, 1969), p. 408.

24. See note 53.
25. Letter dated November 29, 1993, to the author, entitled "Some notes on History Painting."
26. The explanation of the figures conveyed to me by Stevens in a conversation of February 6, 1994.
27. Ibid.
28. For the photograph of Kozloff, see Ellen C. Oppler, ed., *Picasso's Guernica* (New York: Norton, 1988), p. 241. Stevens recently acknowledged that the Picasso demonstration image might well have been on her mind.
29. Conversation, February 6, 1994.
30. The exhibition was held at the Whitney in the fall of 1976.
31. I first met Rudolf Baranik when he, Benny Andrews, and Lucy Lippard, each representing different constituencies, came to the Whitney to discuss with director Tom Armstrong their displeasure that the Rockefeller Collection had been publicized as a Bicentennial exhibition. Ironically, I was the curator on the staff in charge of planning and installing the Rockefeller exhibition; sympathetic with their cause, I arranged their meeting with Armstrong. Through Baranik I met Stevens.
32. They look like petals; they are actually the little bags of dry colored pigment that hung from Damon's body.
33. Letter from Stevens to author, dated November 29, 1993.
34. See note 11. The controversy hinged on the word *generation*; following Stevens's lead, I have used the word *wave*, which is closer in spirit to what they actually meant, as elaborated in their reply to Broude and Garrard in the 1989 *Art Bulletin*. As early as 1980 Moira Roth, in "Visions and Re-Visions," noted it was a "time of theoretical appraisal and commotion in feminist art circles," and called on feminist writers to take stock of the new directions and to undertake "a far more critical mode of writing about this art than was possible or necessary in the last decade."

 Roth notes that even earlier, in 1977, Martha Rosler had called for a re-examination of feminist art; see Martha Rosler, "The Private and the Public: Feminist Art in California," *Artforum*, 16 (September 1977), p. 66.
35. Gouma-Peterson and Mathews, "The Feminist Critique of Art History," p. 332.
36. In 1983 Stevens publicly described her two-page *Heresies* spread at the session "Public and Private Images: Recent Trends in Photography," at the College Art Association meeting held in Philadelphia: "Concerned about the antagonisms among us, I chose to attack the middle class nature of the women's movement by juxtaposing the lives of 2 women at opposite ends of the social scale: Rosa Luxemburg, theoretician and revolutionary leader, and Alice Stevens, working class housewife and mother."
37. From a text for a panel discussion, "Art and Class," held at Artists Space on April 9, 1976.
38. The diagnosis of her condition was determined to be schizophrenia, which Stevens recalls manifested itself gradually over the years.
39. Artist's book, *Ordinary/Extraordinary* (New York: privately printed, 1980), n.p.
40. Transcript of a dialogue between May Stevens and Donald Kuspit, with audience participation, held at the Boston University Art Gallery on March 15, 1984.
41. Letter dated March 18, 1979. The quotations come from Maynard Solomon, *Marxism and Art* (New York: Basic Books, 1973).

42. Both quotations from Stevens's *Artist's Book* (1980), privately printed, with funds from the National Endowment for the Arts.

43. Stevens, transcript of dialogue at Boston University, p. 2.

44. Conversation, February 25, 1994.

45. Stevens, transcript of dialogue at Boston University, p. 2.

46. Ibid.

47. I use the term *supersession* here as "Aufhebung" is analyzed by Hegel; see G. W. F. Hegel, *Phenomenology of Spirit*, trans. A. V. Miller (Oxford: Clarendon Press, 1977), p. 68.

48. Taped interview with May Stevens, August 7, 1990.

49. Transcript of Stevens/Kuspit dialogue (see note 40).

50. Dylan Thomas, *Collected Poems* (New York: 1939), p. 128. The first stanza reads:

> Do not go gentle into that good night,
> Old age should burn and rave at close of day;
> Rage, rage against the dying of the light.

51. Kuspit, "May Stevens Within the Self's Heroic and Unheroic Past," n.p.

52. Stevens incorporated Kuspit's quotation on a separate sheet describing *Everybody Knows Me.*

53. The "One Plus or Minus One" series are also history paintings – about women within the hegemony of patriarchy – but it is beyond the scope of the present chapter to analyze them here. See catalog privately printed by May Stevens on the occasion of the New Museum's exhibition, which includes the essay by William Olander printed in the museum's brochure. See also Orchard Gallery, *May Stevens: One Plus Or Minus One* (Derry, N. Ireland, 1988), with essays by Declan McGonagle, May Stevens, and Rudolf Baranik.

54. The texts are from Woolf's "A Room of One's Own" and "A Writer's Diary," and from Kristeva's "About Chinese Women," in which Kristeva describes an ancient Chinese sex manual advising men and women to focus on the woman's sexual pleasure. For an analysis of all of these recent paintings, see Moira Roth, "May Stevens: Women, Words and Water" (Boulder: CU Art Galleries, University of Colorado, 1993).

55. This last painting also includes an audiotape quoting the words of young Detroit streetwalkers. The text, read by Carrie Hamilton, comes from Carol Jacobsen's video *Night Voices.*

Index

References to illustrations are set in italics.